FROM PISANELLO TO CÉZANNE

Master Drawings from the Museum Boymans-van Beuningen, Rotterdam

Ger Luijten and A.W.F.M. Meij

From Pisanello to Cézanne

Museum Boymans-van Beuningen, Rotterdam in association with

Cambridge University Press
Cambridge New York Port Chester Melbourne Sydney

On the cover: Peter Paul Rubens, detail of cat. no. 47

Exhibition Dates:
The Pierpont Morgan Library, New York:
May 15 - August 4, 1990
Kimbell Art Museum, Fort Worth:
August 18 - October 21, 1990
Cleveland Museum of Art, Cleveland:
November 13 - January 13, 1991

Clothbound edition published by the Press Syndicate of
the University of Cambridge
The Pitt Building, Trumpington Street, Cambridge CB2 1RP
40 West 20th Street, New York, New York 10011 USA
10 Stamford Road, Oakleigh, Melbourne 3166 Australia

Published in the Netherlands by Gary Schwartz | SDU Publishers,
P.O. Box 20014,
2500 EA The Hague, The Netherlands

First published in 1990

© 1990 Museum Boymans-van Beuningen, Rotterdam,
the Netherlands

Typeset and printed by Snoeck-Ducaju & Zoon, Ghent, Belgium
Art Director: Derek Birdsall RDI
Design: Omnific Studios

ISBN 0-521-40105-4

Library of Congress and British Library
cataloguing-in-publication data applied for

Foreword

It was more than thirty years ago, in 1957 to be precise, that the then curator of the collection of drawings in the Boymans Museum, Egbert Haverkamp Begemann, published his *Vijf eeuwen tekenkunst: Tekeningen van Europese meesters in het Museum Boymans te Rotterdam* (Five Centuries of Drawing: European Masters in the Boymans Museum in Rotterdam). The director at the time was J.C. Ebbinge Wubben, who opened his introduction to the book with the words: "Of the departments which comprise the true riches of the Boymans Museum, the collection of drawings must today be ranked first in importance." And although much has changed in the museum in the intervening thirty-odd years – such as the purchase of D.G. van Beuningen's collection in 1958 and the establishment of a department of contemporary art in 1960 – Ebbinge Wubben's remark has lost little of its validity.

The 1957 publication contained eighty-seven drawings and watercolors spanning the same period as this new catalogue. Many of the sheets which were then regarded as supreme achievements of draftsmanship make their reappearance in the following pages, where the reader will find 104 drawings reproduced in full color, accompanied by a large number of comparative illustrations in black and white. Anyone forced to make a choice from such a superlative collection is bound to have personal preferences, which in turn are influenced by the tastes of the day. To take just one example, in the 1957 publication there were no drawings by Hendrick Goltzius, the leading master of Dutch Mannerism. Since the early 1960s, though, there has been a growing interest in this movement, at first among scholars, then on the part of museums and collectors, with the result that the present catalogue contains three Goltzius drawings. Moreover, continuing research over such a long period has produced its own crop of changed attributions.

The drawings in this catalogue were selected by A.W.F.M. Meij, head of the Department of Drawings, and G. Luijten, keeper of Prints and Drawings. Both are also responsible for the entries, and in addition Ger Luijten undertook tracing the complex history of the collection from its earliest beginnings right up to the present day. Those who study the catalogue entries will appreciate how much time and effort went into their composition, not forgetting that they were written while the authors were also carrying out their normal duties within the department.

It was Mrs. John Alexander Pope, one of the trustees of Art Services International (ASI), who suggested linking the publication to an exhibition that would tour the United States. That tour has been most ably organized by Lynn Kahler-Berg, Director, and Joseph Saunders, Chief Executive Officer. ASI also provided financial support for the publication of the catalogue.

Clearly no book of this kind could be written without the assistance of colleagues from other institutions. In particular we would like to mention the staff of the Netherlands Institute for Art History (RKD) in The Hague, the Witt Library in London, and that of the Rijksprentenkabinet in Amsterdam. We are also grateful to Mr. Carlos van Hasselt, director of the Fondation Custodia in Paris, for supplying a wealth of valuable information on the relationship between Franz Koenigs, whose collection forms the cornerstone of the Department of Drawings, and that other great Dutch collector, Frits Lugt. The superb design of the catalogue is the work of Derek Birdsall and Andrew Gossett of Omnific Studios in London. The color photographs by Tom Haartsen of Ouderkerk aan de Amstel, were lithographed by Fotogravure De Buck of Wetteren, near Ghent. The book itself is testimony to the craftsmanship of printers Snoeck-Ducaju of Ghent. Michael Hoyle is responsible for the translation into English, assisted by Yvette Rosenberg and Andrew McGormick. As usual Mr. Hoyle did much more for the book than just translate it and together with Nancy Eickel in the USA he should be mentioned as the editor.

Finally, we would like to record our deep gratitude to KLM Royal Dutch Airlines for its generous offer to sponsor the transport of our precious drawings to and from the United States.

Let me close by giving the last word to Mr. Ebbinge Wubben: "The necessary curtailment [of the selection] is a very imperfect reflection of our treasure house of drawings, but that would still be the case were we to reproduce twice as many."

Wim Crouwel
Director
Museum Boymans-van Beuningen

The History of the Rotterdam Collection of Drawings

The birth of the collection of drawings in the Boymans-van Beuningen Museum was anything but auspicious. In 1845, four years after the city had bought the seventeenth-century Schieland House with the purpose of turning it into a museum (fig. 1), the authorities for some inexplicable reason turned down the chance of acquiring one of the major Dutch art collections of the day, which Baron Jan Gijsbert Verstolk van Soelen (1776–1845) had left to his native city. In addition to a superb group of Dutch paintings, which was subsequently snapped up *en bloc* by three more far-sighted English collectors,[1] it contained several thousand drawings, the majority by seventeenth-century Dutch artists, including some quite priceless sheets. Baron Verstolk van Soelen also had one of the most stunning collections of Rembrandt etchings ever assembled. "Gloire aux héritiers," wrote the *Bulletin des Arts de Paris*, with more than a touch of irony, when the collection came under the hammer in 1847 and was largely dispersed abroad.[2]

The city's refusal to accept this bequest coincided with negotiations on the acceptance of another legacy, that of Frans Jacob Otto Boijmans. It still seems odd that Boijmans, a lawyer who was born at Maastricht in 1767, should leave his art collection and his entire estate to Rotterdam and not to Utrecht, his home from his student days until his death in 1847.[3] Around 1829 he had offered Utrecht his collections of paintings, drawings and porcelain on condition that they would be put on display in a building to be known as the Museum Boijmannianum, of which he would be the first director. Not only did the burgomaster of Utrecht, H.M.A.J. van Asch van Wijck, find the terms unacceptable, but it seems that no one had any real idea of the importance of Boijmans's collection, since he had only shown his paintings to a select few. According to the Utrecht architect, painter and biographer Christiaan Kramm (1797–1875), the officials at City Hall were under the impression that the collection was "trumpery": "all that anyone has seen of it are one or two rooms facing the street [that were] indeed hung with mediocre paintings, from which it was naturally inferred that the works crammed into the rooms above were of even lesser merit."[4]

Kramm himself, whose manuscript on Boijmans has survived, was far less damning about the collection. He was on personal terms with Boijmans, who lived in Boothstraat, "where I so often called on him in that repository of art," and portrays him as a widely traveled man who lived only for his collection. "He was insatiable in his acquisitiveness, and since he lived very frugally, with but a single housemaid, his household was of little importance, and his fortune accordingly went into values of an artistic nature."[5] Boijmans was regularly seen in Brussels and Paris, visited Berlin in 1805, and spent some time in Rome in 1806, where he had discussions with Antonio Canova concerning a tomb for Prince Willem V of the Netherlands, who had died that year.[6]

Boijmans also had dealings with contemporary Dutch artists, and avidly collected their pictures and drawings. Occasionally he was so taken with an artist's work that he commissioned a painting from him. His portrait, by the middle-rank painter Hendrik Antonius Baur (1736–1817), has been lost, so the only surviving record of his appearance is a pastel of 1788 by the same artist (fig. 2). In 1823 he commissioned a river scene of a *Steam Ferry off Moerdijk* from Johannes Christiaan Schotel (1787–1838). According to the artist's son, it was Boijmans who stipulated that the painting should be of a steamboat, which was a very modern vessel at the time: "The choice of subject was not always left to my father. Why otherwise would he have painted a steamboat?"[7] In addition to this unusual panel, Boijmans acquired twenty-six drawings from Schotel.

Boijmans belonged to the *Kunstliefde* (Love of Art) society, which had been founded on October 12 1807 as "a modern drawing club from the draped model." It also numbered other prominent connoisseurs among its members, "collectors of drawings by old masters and by the best of living masters," as they were described, and Boijmans and various others held monthly private viewings of their drawings.[8] Kramm relates that, as a southerner, Boijmans was somewhat outside the mainstream of Utrecht society, although he was "on a good footing with the most prominent citizens, and paid especial attention to ladies who practiced art, whom he constantly supplied with good models and advice, which was not always regarded as being prompted by a desire to further art."[9]

After Boijmans's offer was refused by Utrecht, he was approached by his friend M.C. Bichon van IJsselmonde, burgomaster of Rotterdam, and after consulting Kramm, Bichon decided that Rotterdam would accept the gift instead. The bequest was ratified eight days before Boijmans's death, whereupon the donor said that he had chosen Rotterdam partly because it had been the seat since 1843 of the progressive Residence for the Moral Improvement of Youthful Offenders, a cause close to his lawyer's heart. His will also contained a clause stipulating that part of the museum's income was to go to "the fund for young prisoners."[10]

Since all that now remains in the museum is a fairly small part of the original collection of 1,193 paintings, it is difficult to form an idea of its overall quality. A considerable number were sold shortly after Boijmans's death as "dross," and then, on the night of February 15 1864, a further 300 pictures were destroyed in a catastrophic fire.[11]

If anything, even less is known about Boijmans's collection of drawings. In the catalogue which he compiled in 1811, when he was thinking of putting it up for auction (a scheme later abandoned), he described it as a "*belle et précieuse Collection de quatre mille Dessins choisis*."[12] He must have continued adding drawings, for after his death the executors found 116 portfolios and albums containing an estimated 8,000-10,000 sheets.[13] Although it is not known whether the museum disposed of drawings as well as paintings, it is certainly a

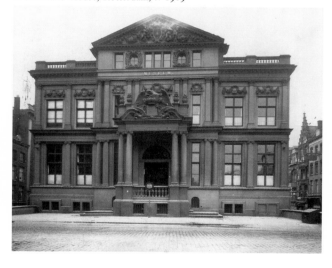

1. Schieland House, Rotterdam, *c.* 1909

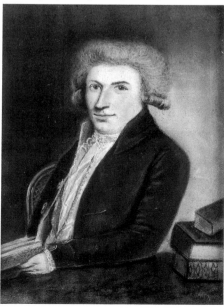

2. Hendrik Antonius Baur,
Portrait of F.J.O. Boijmans, pastel, 1788

possibility, since the 1852 catalogue lists only 2,962 sheets.[14] However, there is also a report of 1847 which shows that the valuer Arnoldus Lamme, a painter and art dealer, considered 90% of the collection of prints and drawings worthy of inclusion in the museum, so it is also conceivable that the first estimate was too high.[15]

Many of the drawings perished in the flames in 1864, including the entire Italian and French schools, as well as hundreds of sheets by Dutch masters. Only eighteen of the thirty-one portfolios were saved, comprising artists of the Dutch School from the letters C to R and part of S.[16]

The 1852 catalogue lists 350 Italian drawings, and it is interesting to note that they included various groups by contemporary artists such as Francesco Bartolozzi (1727–1815), Giuseppe Cades (1750–99), Giovanni Battista Cipriani (1727–85) and Vincenzo Camuccini (1771–1844), which Boijmans may have acquired when he was in Rome in 1806. The remainder constituted a cross-section of sixteenth to eighteenth-century masters of the kind that one would expect to find in a general collection. The Bolognese artists must have been quite well represented, with a fair number by Carracci and Guercino, but it is impossible to gauge the importance of the sheets from the titles alone.

The same applies to the composition of the French School, which accounts for 275 entries. Boijmans evidently had a fondness for eighteenth-century artists, and for Claude Lorrain and Poussin, but we will never know whether the drawings were important or insignificant.

One's curiosity is still pricked, however, and one wonders about the Dutch drawings that were lost in the fire: no fewer than sixteen by Nicolaes Berchem, "nine clothed female figures, red chalk" by Berckheyde, twenty-two sheets by Jan de Bisschop, seventeen by Abraham Bloemaert, twelve Adriaen van de Veldes, and "four histories, Indian ink and red," from the hand of Joachim Wtewael, whose drawings are so sought-after today.

It was not unusual for an early nineteenth-century collector to acquire drawings in groups, partly because of the salesroom practice of offering composite lots by a single artist. This method of collecting has helped shape the nature of the holdings in the Boymans-van Beuningen Museum, which have a breadth that is lacking in collections formed more recently. However, Boijmans never lost sight of quality. Among the early drawings in the present catalogue that were once in his possession are those by Schongauer (cat. no. 1), Altdorfer (cat. no. 10), Petrus Christus (cat. no. 12) and the Master of the Legend of St Lucy (cat. no. 13), Bruegel's *Temperance* (cat. no. 18), the Stradanus (cat. no. 20, from a series of three), and the dramatic *Sacrificial Scene* by Goltzius (cat. no. 22), one of the nine drawings by the artist that he owned. The seventeenth-century sheets from his collection are those by Leendert van der Cooghen (cat. no. 31, also from a larger series), Cornelis Dusart (cat. no. 32), Jan Lievens (cat. no. 38), Nicolaes Maes (cat. no. 39), the beautifully observed *Study of a*

Kneeling Man by Anthony van Dyck (cat. no. 48) and Rubens's *Entombment* (cat. no. 43). Boijmans listed several of these drawings under a different name, although not always with the intention of upgrading them, which was the accusation leveled at him in the nineteenth century. The important early Rubens, for example, appears as "School of Anthony van Dyck."

The first director of the museum, Arie Johannes Lamme, who was also an art dealer, had the task of using the money paid out by the insurers to make good the losses suffered in the fire. As far as the drawings were concerned, his policy was one of replacement, but limited to the Dutch and Flemish schools only. He took this rather to extremes in the case of Willem van de Velde, buying no fewer than 600 sheets at the Gerard Leembruggen sale in 1866 – mainly sea battles and large ship portraits (fig. 3). At the same auction he also acquired various drawings that had once belonged to Baron Verstolk van Soelen, among them works by Jan Both, a large portrait by Hendrick Goltzius, a Ruisdael landscape (cat. no. 28; bought for Dfl. 330), an *Anatomy Lesson at Leiden* (fig. 4), sold as a Frans Hals but in fact by Willem Buytewech, and Jan de Bisschop's *King Charles II at Scheveningen, Setting Sail for England* – a total of sixty-one sheets costing Dfl. 1,350. The most expensive drawing in the sale was Rubens's monumental *Christ on the Cross* (fig. 5), and it too came to the Boymans Museum. It had cost Leembruggen Dfl. 985 at the Verstolk van Soelen sale in 1847, and now made Dfl. 4,050.[17]

All these acquisitions were included in the museum's second catalogue of drawings, which appeared in 1869. That was also the year in which Rotterdam made another major blunder by refusing the collection of D. Vis Blokhuyzen, who had left it to his native city on condition that his heirs received Dfl. 50,000 in return.[18] It was due to this piece of singular ineptitude that his paintings were lost to the country (they included Vermeer's *Lacemaker*, now in the Louvre, and Rembrandt's delightful *Portrait of Maurits Huygens* of 1632, which today hangs in the Kunsthalle at Hamburg), as well as 706 drawings and a magnificent collection of 4,000 prints.[19] Lamme had been succeeded as director of the museum by his son Dirk, but all that the latter could do at the auction (which he had organized himself in his capacity as a dealer) was to try and secure what he could for the museum. In this he had some success, for he bought forty drawings, although his choice seems to have been a bit hit or miss. Not one of the large group of Berchem drawings came his way, and as with the Leembruggen sale, no attempt was made to pick up any Italian drawings. The most notable purchases were the thirteen Passion scenes by Karel van Mander, which were published as prints by Zacharias Dolendo and Jacques de Gheyn, Paulus Pontius's drawing for his print after Rubens's portrait of Gaspar Gusman, Duke of Olivarez, and several landscapes by lesser masters such as Anthonie van Borssom, Adriaen van Nieulandt, Adriaen van Stalbempt and Herman Swanevelt. All in all, it was a rather meager haul.

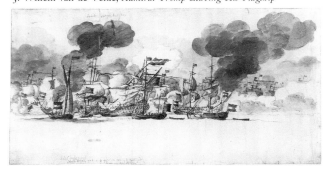
3. Willem van de Velde, *Admiral Tromp Leaving His Flagship*

4. Willem Buytewech, *Anatomy Lesson at Leiden*

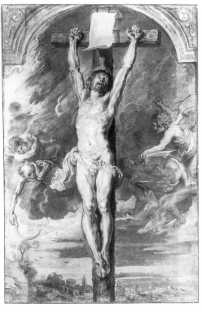
5. Peter Paul Rubens, *Christ on the Cross*

6. Matthijs Maris, *Ecstasy*

7. Jan Toorop, *Portrait of A.J. Domela Nieuwenhuys*, 1924

8. Joseph Anton Koch, *Dante at the Entrance to Hell*, watercolor

With the insurance money spent, the museum entered on a fallow period in which important acquisitions were very few and far between, relieved only by the occasional donation of drawings by Rotterdam masters. In 1883, for instance, it received a group of sketches by Elias, Dionys and Gerard van Nijmegen, members of a local family of artists, followed two years later by some studies by Adriaen van der Werff (1659–1722), and in 1895 by works on paper by Charles Rochussen (1814–94). Only rarely did the museum actually buy a drawing, such as Pieter Saenredam's *Pulpit of the New Church in Haarlem Seen from the South* (1650), but even that cost only a few guilders.[20] Time and again in the annual reports one reads the bleak statement: "The collection of drawings was not enlarged."

That was also the case in 1888, when P. Haverkorn van Rijsewijk was director of the museum. He had succeeded F.J. Obreen in 1883, when the latter moved to Amsterdam as director of the Rijksmuseum. Haverkorn van Rijsewijk, who was a champion of the Hague School, remained in office until 1908, and his tenure was marked by various expensive purchases of work by contemporary artists, which left little available for art of earlier epochs. The Van Gogh *Avenue of Poplars near Nuenen in Autumn*, which he acquired in 1903 was the first to enter a Dutch public collection, and was a gift from a group of Rotterdam art-lovers.[21] In order to buy Willem Maris's *Early Morning* in 1907, which cost 19,000 guilders, he froze the museum's entire acquisitions budget for five years.

Haverkorn van Rijsewijk's contacts with contemporary artists enabled him to lay the foundations for a fairly wide-ranging collection of graphic art of the period, and he also acquired a series of watercolors and chalk studies by Georg Hendrik Breitner and the leading artists of the Hague School. In 1897 he bought the bleak, wintry *View of Leuvehaven, Rotterdam* by Willem Witsen. Jan Toorop, who was a friend of Haverkorn van Rijsewijk, occasionally presented the museum with a drawing, as well as a few of his rare etchings, which he inscribed: "To the Boijmans Museum." In 1905 the museum mounted the first exhibition of Toorop's graphic work.[22]

Haverkorn van Rijsewijk was also a great admirer of Matthijs Maris, "this grand master of contemporary art," as he called him. He published various studies on the artist, and in 1906 succeeded in raising Dfl. 6,000 to add to his purchasing budget of Dfl. 2,500 in order to buy Maris's Symbolist drawing *Ecstasy* (fig. 6). This is one of the few occasions when the museum has appealed to the Rembrandt Society for help in buying a drawing.

In 1908 Haverkorn van Rijsewijk was succeeded by F. Schmidt-Degener, who embarked on a long-overdue reorganization of the museum and radically rearranged the displays, but did not add greatly to the drawings collection. Not only were there insufficient funds, but Schmidt-Degener adopted a policy which he also

followed later at the Rijksmuseum in Amsterdam (1922–41), of "only buying works that not merely augment, but also enrich the collection."[23]

It was only in 1916 that he began buying a few important paintings (*Jehovah and the Angels* by Aert de Gelder, *St Catherine Debating with the Philosophers* by Jan Provoost, and Adriaen Brouwer's *Interior of an Inn*), and also cast his net beyond the Dutch School (Jacopo Amigoni, *Portrait of a Young Cleric*, Richard P. Bonington, *View of the Rialto Bridge in Venice*). Gifts included Pissarro's *Les Côteaux d'Auvers* and a *Merry Company* by the Rotterdam born Willem Buytewech, an artist he was particularly fond of.[24] Very few drawings of any significance were acquired between 1908 and 1922, apart from Jongkind's evocative watercolor, *Banks of the Seine in Paris*, which was presented to the museum in 1916. In 1910 Schmidt-Degener bought a remarkable sketchbook by the Delft artist Hendrik van Vliet (*c.* 1611–75), containing chalk drawings of models for portraits, and some broadly executed sketches of church interiors.

One initiative that was to have a profound importance for the museum's future was Schmidt-Degener's cultivation of Rotterdam collectors, and especially of the port magnate D.G. van Beuningen. It was in 1916 that the latter first presented the museum with a gem of coloristic painting, a *Still Life with Fruit and Bread* by Henri-Horace Roland de la Porte, which at the time was attributed to Chardin. The relationship with Van Beuningen was tactfully continued by Schmidt-Degener's successor, D. Hannema, whose directorship (1922–45) was of inestimable value not only for the collections of paintings and drawings, but also for the applied arts department.

Hannema had only just taken over when an acquaintance of his, the Dutch art dealer J.H.J. Mellaart, who had made his home in London, gave the museum several drawings, including the Oudry in this catalogue (cat. no. 88) and Jacques Louis David's composition sketch for *Caracalla and Gaeta*.[25] In 1927 he followed this up with gifts of a sketchbook by George Romney and drawings by other early nineteenth-century English artists, and two years later with an allegorical female figure by Giambattista Tiepolo from the D'Hendecourt Collection in London.[26]

The year 1923 saw the museum enriched with the collection of A.J. Domela Nieuwenhuys (fig. 7), which was donated after negotiations between the collector and Hannema. In return, Domela Nieuwenhuys and his wife were given an apartment in St Anthony's Home in Rotterdam and an allowance of Dfl. 10,000 a year, which was deducted from the museum's purchasing budget until the benefactor died in 1935 at the age of eighty-five. The collection consisted of 3,000 prints, including fifteenth-century woodcuts and nielli, and 416 drawings, mainly by nineteenth-century German artists. Domela Nieuwenhuys, the brother of the anarchist and leader of the Dutch radical workers' movement, had lived in Germany since 1869, buying most of his

drawings while in Munich (1891–1923) at auctions held by his friend Hugo Helbing. Several of the sheets came from the collection of Bugoslaw Jolles, which was formed in Dresden and Vienna between 1870 and 1895, and of Fritz Hasselman, a Munich architect whose drawings were sold in 1892 and 1894.[27] An important part of the Domela Nieuwenhuys Collection consisted of sheets by Carl Rottmann (1797–1851), Anselm Feuerbach (1829–80), and by Nazarene artists like Joseph Anton Koch (1768–1839), four of whose watercolor designs for frescoes in Casino Massimo in Rome he acquired in 1901 from the collection of E. von Heuss (fig. 8).[28]

This collection of drawings, which was housed in the museum in purpose-built cabinets designed by the architect J.J.P. Oud, was a welcome addition to the eighteenth-century German sheets by such artists as Chodowiecki, Jacob Philipp Hackert, Angelica Kauffmann and Anton Raphael Mengs, which had come with the Boijmans bequest. The non-German drawings in the Domela Nieuwenhuys Collection are of variable quality, although one that somehow slipped in was Goltzius's splendid *Dune Landscape with a Farmhouse* (cat. no. 23), which was bought as a Lucas van Uden in 1895, as well as a few French and German sheets which are mainly of art-historical interest.[29]

The drawings which Hannema acquired for the museum each year after that are evidence of his wide-ranging interests, which went well beyond the borders of Holland. In 1924 there was a pastel by Jean Baptiste Perronneau (1715–83), a portrait done in the Netherlands in 1761 of Elisabeth Christina van der Dussen, wife of the Rotterdam burgomaster Willem Schepers, in 1926 *The Magi and Their Gifts* by Jacques de Gheyn, and in 1928 the *Lion and Tortoise* by Eugène Delacroix, which was offered to the museum by the dealer Paul Cassirer.[30]

The bequest of J.P. van der Schilden, which was received in 1925, strengthened the collection of Hague School watercolors, while the Montauban-van Swijndregt bequest rounded out the collection of eighteenth and early nineteenth-century drawings. Hubertus Michiel Montauban-van Swijndregt began collecting when good drawings could still be picked up very cheaply, with the result that the museum's collection of works from that period is now reasonably complete, despite the loss of the Boijmans drawings in the fire of 1864. The showpieces include a series of gouaches by Josephus Augustus Knip (1777–1847; fig. 9), and watercolors by other artists who visited Italy, among them Daniël Dupré (1751–1817).[31]

On his appointment in 1922, Hannema presented the museum with its first Van Gogh drawing, the very early *Barn with Moss-Covered Roof*. This was followed in 1929 by the magnificent *Bank of the Rhône*, executed in Arles in 1888 (fig. 10), which was given to the museum by two Rotterdam art lovers. Twenty years later the museum acquired a figure study of a *Seamstress* from Van Gogh's Hague period.[32]

Thanks to the sharp eyes of the director and his assistant J.G. van Gelder, who went on to become a professor at Utrecht University, a regular stream of seventeenth-century Dutch drawings were acquired at auction for reasonable prices during the Depression, when art was in plentiful supply. It was at this time that Van Gelder embarked on the study of the drawings of Jan van de Velde which led to his doctoral dissertation in 1933. He had joined the museum in 1925 to run the library and the printroom, and the purchases from this period clearly reflect his interest in Dutch landscape draftsmen. The group of drawings by Willem Buytewech was expanded in 1930 with the *View of Scheveningen*, and with *The Finchery* (cat. no. 25) the following year.[33] The latter was bought at the Cornelis Hofstede de Groot sale in Leipzig, where the museum also secured one of those glittering, long-underrated landscapes by Cornelis Vroom.[34] This was followed a year later by a *Landscape with Pollarded Willow* by Govert Flinck, the signature and date of which make it a key work in the artist's *œuvre*. In 1937, at the sale of the collection of A.W.M. Mensing, the famous auctioneer at the Frederik Muller salesroom in Amsterdam, the museum (assisted by the Rembrandt Society) bought important landscapes by Philips Koninck, Jan Lievens, Pieter Stevens (as Tobias Verhaeght) and David Vinckboons.[35] Shortly afterwards came a landscape by Pieter Bruegel the Elder, and a pen drawing by Claes Jansz Visscher with the inscription "*Lasarij tot haerlem 1607*" (Leper-House at Haarlem).[36]

In the meantime, there had been a dramatic change in the museum's fortunes under Hannema's leadership. In 1935 it had moved into a new building on the Dijkzigt estate on the edge of the city (fig. 11). Spectacular new additions to the collections were now being made, thanks to generous financial support from private individuals and from the Rembrandt Society. In 1931 Hieronymus Bosch's *Peddler* entered the museum from the Figdor Collection in Vienna, followed two years later by a series of oil sketches of the *Life of Achilles* by Rubens. In 1940, shortly before the Nazi occupation, Rembrandt's *Portrait of the Young Titus* was added to the department of paintings. The museum was also pursuing an ambitious exhibitions program, which included such major shows as *Vermeer. Oorsprong en invloed* (Vermeer: Origin and Influence; 1935) and *Jeroen Bosch en de Noord-nederlandsche Primitieven* (Hieronymus Bosch and the Northern Netherlandish Primitives; 1936).[37]

All these initiatives undoubtedly contributed to the decision of Franz Koenigs, a Haarlem collector with whom Hannema was on close terms, to loan his famous collection of drawings and a number of paintings to the Boijmans Museum when its new building opened in 1935. At that time it could not have been foreseen that the museum would acquire the collection outright, giving it one of the richest departments of drawings in the world, although Hannema, needless to say, had been hoping for that from the outset. Those who examine

9. Josephus Augustus Knip, *View at Nemi*, gouache

10. Vincent van Gogh, *Bank of the Rhône*

11. The Boymans Museum shortly after completion in 1935

12. Franz Koenigs, photograph by Marianne Breslauer, c. 1933

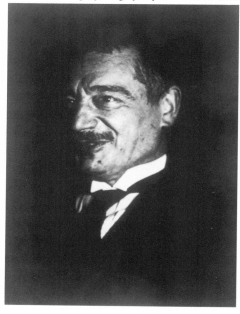

13. Serk Schröder, *Portrait of D.G. van Beuningen*

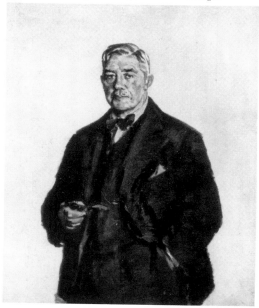

the provenances of the finest drawings in this catalogue will see that the vast majority are from the Koenigs Collection. The title, *From Pisanello to Cézanne*, was accordingly chosen to illustrate the breadth of both his acquisitions and his taste.

Compared to famous national collections of drawings like those in the Albertina in Vienna or the Louvre in Paris, which have a centuries-old pedigree, the Koenigs Collection was assembled in a very brief span of time. Koenigs was at his most active between 1921 and 1930 when, according to Frits Lugt, who has left the fullest sketch of Koenigs as a collector, he was the leading buyer on the international market. "He was prepared to pay any price, provided the sheet was exceptional, and his eye, flair and swiftness of decision amazed all who knew him."[38]

Franz Koenigs (fig. 12) was born in 1881 into a family of bankers and industrialists in the small town of Kierberg near Cologne. In 1913 he succeeded his uncle Felix (himself an avid collector of nineteenth-century German painting) as one of the directors of the Delbrück, Schickler & Cie Bank in Berlin, and that same year he married Anna Herzogin von Kalckreuth. The daughter of the German Symbolist painter, Leopold von Kalckreuth, she became one of the first women in Germany to earn the title "master bookbinder," and later took a close interest in her husband's collection.

Koenigs's move to Holland in 1922, where he and his cousin founded the Rhodius-Koenigs trading company, more or less coincided with the start of his activities as a collector of Old Master drawings.[39] He had already followed his parents' example by forming a small collection of paintings, most of which also came to the Boymans Museum, and when he was in Paris in 1903–04 he apparently bought his first lithographs by Toulouse-Lautrec, who had just died. In 1916, at an exhibition at the Obach Gallery in London, he acquired his first two drawings, landscapes by Jean-François Millet. These, though, were incidental purchases.[40]

From 1921 he set about his task more purposefully. He bought not only at the major international sales of the period, some of which were held at Frederik Muller's in Amsterdam (Prince W. Argoutinsky-Dolgoroukoff, Emile Wauters, Bellingham Smith, Robiano and others), but also acquired collections or groups *en bloc*. In 1923 he succeeded in laying his hands on two albums with more than 500 drawings by Fra Bartolommeo, the provenance of which can be traced right back to the artist's death in 1517 (see cat. nos. 58-59). They had been in the collection of King Willem II of the Netherlands until 1850, when they passed to his daughter Sophie, Grand Duchess of Saxe-Weimar.[41] They were offered for sale by her descendants and bought by Koenigs, along with other sheets from the same collection. However, a number of important works slipped through his fingers and ended up with Julius W. Böhler in Lucerne. Six years later, when Böhler found himself in financial difficulties, Koenigs bought his entire collection of 250 sheets. One

of the prizes was the only drawing which is fairly generally accepted as the work of Giorgione (cat. no. 56) – just one of the famous rarities owned by Böhler.

Koenigs did much of his buying from the dealers Nicolaas Beets and Paul Cassirer, who also bid for him at auctions. Cassirer's firm, consisting of Cassirer himself, Grete Ring, Helmut Lütjens and Walter Feilchenfeldt, played a key part in the formation of Koenigs's collection of nineteenth-century French drawings, a large number of which were bought at the superb exhibition held at Cassirer's Berlin gallery in 1929–30 under the title *Ein Jahrhundert französischer Zeichnung*. Lütjens, who was head of the Amsterdam branch, often acted as Koenigs's agent, and also arranged for the drawings to be mounted in passepartouts and kept the inventory of the collection.[42]

Frits Lugt's acquisitions ledger shows that he too passed on numerous drawings and several important prints to Koenigs.[43] In 1927 he sold him Claude Lorrain's *View of the Sasso* (cat. no. 79) and various other sheets, and on February 1 1930 twenty-five drawings, mostly Italian, from the collection of Luigi Grassi in Florence, among them eleven by Tintoretto or his school – an artist for whom Lugt had no great liking (see cat. no. 67). Later that year Koenigs bought four Rembrandt drawings in a single transaction: *Saskia at a Window* (cat. no. 33), *View of Haarlem*, *The Diemer Dyke near Houtewael* and the *Study for One of the Syndics* (cat. no. 36). Lugt had acquired them from the collector H.E. ten Cate of Almelo, but there was too much money involved for him to hold onto them, so he let them go to Koenigs for Dfl. 105,000. On the same occasion he sold him a *River Landscape* by Philips Koninck, a sketch thought to be by Rembrandt, a *Christ on the Cross* attributed to Theodoor van Thulden (it turned out to be by Anthonie Sallaert), a study by Luca Signorelli, and Pieter Bruegel's *Fortitude*.[44] Lugt had bought the latter two sheets at the Czeczowieczka sale in Berlin, which was one of the last auctions at which Koenigs also appeared as a bidder, for even he was now beginning to feel the grip of the Depression, and was forced to retrench. In 1931 he acquired a further nineteen drawings, including three at the Hofstede de Groot sale, but that marked the end of his purchases.

It was Koenigs's ambition to form an encyclopedic collection of drawings in which the various west European schools would be represented with first-class pieces. The Fra Bartolommeo albums made the Italians the largest group with more than 1,000 sheets but none of the other schools was neglected. There were 281 early German drawings, 304 covering the French seventeenth and eighteenth centuries, 226 from the French nineteenth century, and 699 by artists of the Early Netherlandish, Dutch and Flemish Schools. The English group is the smallest and least impressive. Although he was quite prepared to buy sheets for their art-historical interest rather than their artistic qualities, Koenigs mainly went after famous drawings by the great

masters, with the result that he put together extraordinarily fine series of works by Dürer, Rembrandt, Rubens, Watteau and Fragonard. He was particularly fond of Cézanne among the nineteenth-century artists, and had twenty-three of his drawings, including several watercolors, but he also had impressive groups by Daumier, Degas, Delacroix, Ingres and Manet.[45]

Nowadays drawings of this caliber very rarely come up for sale, and the reason why Koenigs was able to acquire dozens of masterpieces was that he was operating in a buyer's market. The economic crisis of the 1920s and 1930s forced many connoisseurs to dispose of their collections, and Koenigs was one of the few who had the ready money to take advantage of the situation. Even so, not everything was for sale. There are no important drawings by Michelangelo or Raphael in Koenigs's collection, but then there are very few of them listed in the 1920s sale catalogues, for the simple reason that most had already found a permanent home in the Louvre, the Albertina, the British Museum, the Teyler Museum in Haarlem or the Ashmolean Museum in Oxford.

In other respects, too, the Koenigs Collection mirrors the age in which it was formed. There was a vogue for the primitive masters, particularly in painting, and it was evidently shared by Koenigs, seemingly on the principle of "the earlier the better." That is why, in addition to Pisanello, he bought drawings by anonymous early masters of the school of Verona, as well as extremely rare sheets by Flemish primitives, who had emerged into the spotlight after centuries of neglect.

The collection also reflected the boundless admiration for those artists who, in the early decades of this century, were regarded as the forerunners of modern art. Koenigs had an insatiable appetite for Tintoretto, collecting no fewer than forty of his drawings, mainly the very modern-looking figure studies, and also bought an entire series of drawings which were attributed to El Greco on the basis of the exaggerated poses and elongated figures, but which are now ascribed to Alessandro Maganza.[46] Of all the Italian schools, Koenigs was most attached to the Venetians, and in this he was not alone. Apart from Tintoretto, the mainstays were Veronese and the eighteenth-century artists Guardi, Canaletto, and above all Giambattista Tiepolo, who was represented in the collection with fifty sheets. Seventeenth-century Italian drawings were not very highly rated at the time, and Koenigs also passed over most of the artists who had made a name for themselves in Rome or Bologna, with the exception of Annibale Carracci (see cat. no. 72) and Guercino.

It was also typical of the period that Koenigs showed not the slightest interest in the Dutch eighteenth and nineteenth centuries, concentrating solely on seventeenth-century artists, with Rembrandt, of course, towering above all the rest. In the old inventory of the collection, drawings by Rembrandt and his school were given the letter R. In 1935 there were eighty-three

drawings against Rembrandt's name, but recent research has reduced this number to around thirty. They form the core of the Rembrandt collection in the Boymans-van Beuningen Museum, which is one of the largest and most varied in the world.[47]

The story of how the greater part of the Koenigs loan became the property of the Boymans Museum Foundation in 1940 has often been told. Finally falling prey to the Depression, Koenigs found himself in need of a large sum of money, which he borrowed with his drawing collection as collateral. His bank, Lisser & Rosencranz in Amsterdam, agreed to his condition that the drawings should be loaned to the Boymans Museum so that they could be studied and exhibited, and that is what happened. Selections were regularly put on display in the museum printroom, and sheets were sent to loan exhibitions at home and abroad. In 1939, a selection of his French nineteenth-century drawings was exhibited at the Wallraf-Richartz-Museum in Cologne.

At the beginning of 1940, when the German invasion appeared imminent, the Jewish bank decided to liquidate its assets as quickly as possible and leave the Netherlands. Since Koenigs was not in a position to pay back his loan at such short notice, Lisser & Rosencranz offered the museum the choice of buying the collection or packing it for shipment to Lisbon, where it would be sent to America and sold. Hannema immediately got in touch with W. van der Vorm, one of the museum's benefactors, and D.G. van Beuningen, and asked them if they would be prepared to buy the collection and donate it to the Boymans Museum Foundation. Van der Vorm agreed to this joint purchase, but in April 1940 Van Beuningen (fig. 13) bought the entire collection for himself.[48] However, since he was also involved in various other art purchases at the time (he had just bought Van Eyck's *Three Marys at the Tomb* from the Cook Collection in Richmond), he was not in a position to make the museum an outright gift of the drawings. He then reached an agreement with Hans Posse, the museum director from Dresden who was Hitler's agent, and who had himself tried to buy the complete Koenigs Collection for the proposed Führer-Museum at Linz. After months of negotiations the two men agreed on the price of a selection which Hannema helped to choose. This comprised all the German drawings and sheets from the Italian, French, Flemish and Dutch schools – 526 pieces in all. The Spanish, early Netherlandish and nineteenth-century French drawings were left untouched.[49]

As soon as the deal was settled, Van Beuningen decided to donate the remainder of the collection, amounting to some 2,000 sheets, to the Boymans Museum Foundation. The Koenigs had been delighted when Van Beuningen bought their collection, and on April 17 1940, believing that it would pass intact to the museum, they donated two Carpaccio drawings (including cat. no. 55). They did so, as Koenigs said in his cover letter, that "they may to some extent fill a gap that I have always felt existed in the sequence of

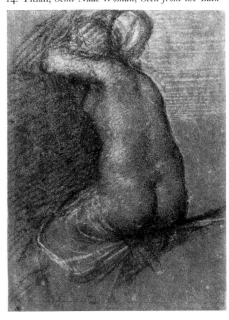

14. Titian, *Semi-Nude Woman, Seen from the Back*

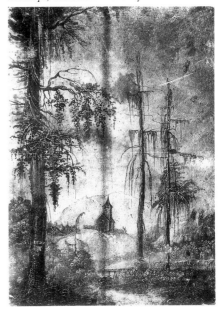

15. Albrecht Altdorfer, *Landscape*, watercolor and bodycolor

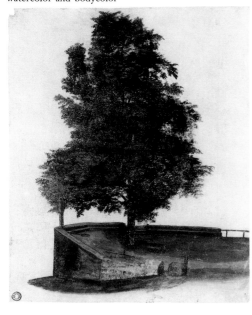

16. Albrecht Dürer, *Linden Tree on a Bastion*, watercolor and bodycolor

17. Adolf von Menzel, *Woman in Bed*

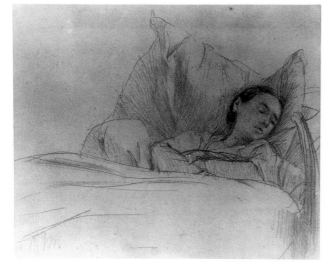

Venetian drawings."[50] By the time the drawings that Van Beuningen had sold from the collection arrived in Dresden in the spring of 1941 for storage before being transferred to the Linz museum, Franz Koenigs was already dead, killed in a railroad accident in Cologne on May 6 1941 at the age of sixty.

Due to this thinning of the Koenigs Collection, the selection included in this catalogue gives an incomplete picture of its original diversity. This is particularly noticeable in the Italian section, which lacks Filippino Lippi and Baccio Bandinelli, as well as Titian, who was represented with a very important figure study which Koenigs had acquired from the collection of W. Bateson in 1929 (fig. 14).[51] In the case of Giambattista Tiepolo the choice has merely been restricted, for although fifteen of the initial fifty sheets have disappeared, the remainder are impressive enough in their own right (see cat. nos. 73-74). In addition, one of the two sheets by Sebastiano del Piombo still remains.[52] Although it is true to say that the collection has been deprived of many major works, it does at least retain the core of the large groups by great masters such as Rembrandt, Rubens, Van Dyck and Watteau.

However spectacular the Dürer drawings in this catalogue, the German School in particular is a *sélection manqué*. Otherwise it would definitely have included one of the famous colored landscapes by Altdorfer (fig. 15) or Wolf Huber, as well as a sheet by Baldung Grien. The fact that Rotterdam still has the seven incunabula illuminated by Dürer from the library of Willibald Pirckheimer (see cat. no. 5) is due to J.G. van Gelder, who one night sneaked them out of the boxes awaiting shipment to Germany. Although they were officially included in the sale, they were not listed on the manifest for Dresden. Two extremely important German drawings which were not part of the transaction were Grünewald's *Virgin and Child in the Clouds* (cat. no. 9) and Dürer's *Portrait of a Young Woman* (cat. no. 4). Koenigs had loaned both of them to an exhibition in New York, and they were only returned after the war. Van Beuningen presented the Dürer to the museum in 1947, while the Grünewald, which was one of his favorites, was purchased along with the entire Van Beuningen Collection in 1958.

After 1945 it was discovered that the part of the collection bought by the Germans had disappeared without trace, but it was always hoped that it would turn up again one day. That hope has not been entirely in vain, for in 1987 a group of thirty-three German drawings (including cat. nos. 2-3 and 8) were returned to the Netherlands by the East German government, and are now on loan to the Boymans-van Beuningen Museum. They were in a box containing various Dürer drawings. This artist's *Holy Family* (cat. no. 3), had been given to the Museum der Bildenden Künste in Leipzig by troops attached to the Soviet Military Administration.[53]

Since all wartime transactions with the German occupying forces involving the confiscation or sale of works of art had been declared illegal by a council of the Allied powers in 1943, the State of the Netherlands has the right to demand the return of the drawings once they are located. In order to assist identification, the Netherlands Office for Fine Arts recently published a book, *Missing Old Master Drawings from the Franz Koenigs Collection Claimed by the State of the Netherlands*, which contains a complete catalogue of all the drawings, with photographs wherever possible. It is to be hoped that the government's efforts will result in these lost works being reunited with the greater part of the Koenigs Collection, which has belonged to the Boymans Museum Foundation since 1940.

Another sheet by Dürer, a large design drawing, had a slightly different history. Because it was framed, the Nazis treated it as a painting, and after the war it turned up in the American sector of Germany. It was returned to the Netherlands in 1948. A few years later the Boymans Museum received it on loan, together with a number of other works, including Fragonard's *Outdoor Auction* (cat. no. 93). The latter had been in the Amsterdam collection of Fritz Mannheimer (1890–1939), and when his confiscated drawings were recovered the majority of them were loaned to the Rijksprentenkabinet in Amsterdam.[54]

The acquisition of the Koenigs Collection led to a major shift in the museum's acquisitions policy after the war. A great deal of what was appearing on the market was now superfluous, and it would have been not only premature to buy early German drawings, given the chance that those originally in the collection would be returned, but also virtually impossible, since the supply was so limited that prices rocketed. However, the museum was not entirely inactive, for in 1955 it found the courage (and the money, thanks to the Lucas van Leyden Foundation) to buy two expensive drawings by Dürer (including cat. no. 7) from the collection of Prince Lubomirski in Lvov, Poland.[55]

The general policy was to look out for drawings that illustrated an aspect of an artist's work that was inadequately represented in the collection. This was what dictated the purchase of Adriaen van Ostade's *Interior with Peasants* (cat. no. 30), for although the museum had plenty of sheets by the "sophisticated" Van Ostade, it lacked such a rare, unrefined drawing from his early period. Using very much the same argument the museum was able to purchase the amusing caricature by Giandomenico Tiepolo (cat. no. 75) in 1955, and two years later a monumental Piranesi, described as "a magnificent evocation of imaginary classical architecture."[56] For Koenigs, the Flemish School was more or less synonymous with Rubens, Van Dyck and Jordaens, which is why it occasionally pays to buy a first-class sheet by a lesser master that can hold its own in such august company, such as Lucas van Uden's *Three Birches*, which was acquired for £95 in 1953, when prices were still moderate.

As to the French nineteenth century, Koenigs had concentrated mainly on a few superior draftsmen, without concerning himself overmuch with the breadth

of the collection. He evidently had little taste for the Neo-Impressionists, and was content with just a single sheet by Gauguin, so it was fortunate that the museum was able to find a way of adding a few more works by this group. Before the war, when the artist was still alive, the museum had been presented with a reed-pen drawing of a harbor scene by Paul Signac, followed in 1951 by a deep black chalk drawing by Seurat and a study sheet by the Symbolist Odilon Redon. The latter was part of the modest set of drawings put together by J.C.J. Bierens de Haan (1867–1951), which he had left to the museum together with his famous collection of prints. This transformed the department of Old Master prints, making it the second printroom in the Netherlands after the Rijksprentenkabinet.[57] Bierens de Haan also left part of his fortune to the city, to be administered by the Lucas van Leyden Foundation, which has made it possible to sustain the high standard of the print collection with new acquisitions.[58] The printroom secured other major works at this time, thanks to the alertness of J.C. Ebbinge Wubben, director of the museum from 1950 to 1978, who bought a series of colored lithographs by the Nabis and a large group of prints by Picasso.

In 1950 E. Haverkamp Begemann was appointed keeper in the departments of paintings and drawings, and became the driving force behind a number of important exhibitions which were held in the museum in the 1950s: *Olieverfschetsen van Rubens* (Oil Sketches by Rubens; 1953), *Rembrandt. Tekeningen* (Rembrandt Drawings; 1956, 350 years after the artist's birth) and *Hendrick Goltzius als tekenaar* (Hendrick Goltzius as a Draftsman; 1958). In fact, the museum appeared to have been preparing for years for the latter exhibition, to which it contributed no fewer than eleven sheets, three of which were bought between 1953 and 1956: *Venus and Cupid*, the miniature *Banquet under a Pergola* and *Arithmetica* (cat. no. 21). Another Goltzius drawing, *The Four Evangelists*, had been acquired in 1948 by exchange with the Fries Genootschap (Frisian Society) in Leeuwarden. Finally, in the year of the exhibition, the museum enlisted the aid of the Rembrandt Society to buy the artist's portrait drawings of his parents-in-law, Jan Baertsen and Elizabeth Waterland.[59]

The previous year the director had also approached the Rembrandt Society for a very appropriate purchase. A London auction house was selling a previously unknown album of landscape drawings by Fra Bartolommeo. In the eighteenth century they had been bound into an album by Cavaliere Gabburri, who had also put together the Rotterdam albums of figure studies by Fra Bartolommeo. The auctioneers were selling the sheets off individually, so every self-respecting cabinet of drawings was able to buy at least one. The Boymans Museum was clearly going to be among the bidders, as was the Rijksprentenkabinet in Amsterdam, which managed to buy a landscape, again with the assistance of the Rembrandt Society. One of the most powerful and beautiful sheets (cat. no. 57) went to Rotterdam for more than Dfl. 44,000.

The year 1958 was one of the most important in the museum's history. The city authorities had decided to buy the collection of D.G. van Beuningen, and this also resulted in the museum getting a new name. The most dramatic change was to the department of Old Master paintings, which suddenly found itself the owner of such works as Van Eyck's *Three Marys at the Tomb*, Pieter Bruegel's *Tower of Babel*, and Titian's *Portrait of a Boy with a Dog*. The collection of drawings also profited greatly.[60] To start with, there were two watercolors by Dürer, *Sea Crab* and *Linden Tree on a Bastion* (fig. 16), and the artist's *Study of Two Feet* (cat. no. 6) for the *Heller Altarpiece*, all three of which Van Beuningen had bought in 1939 from the collection of the Comtesse de Béhague in Paris.[61] Then there were the two early silverpoint drawings associated with the name of Jan van Eyck (cat. no. 11), Van Dyck's dramatic *Crucifixion* (cat. no. 50), and two sheets by Rembrandt: *View of Diemen* and *Ruth and Naomi*.[62] A further two drawings that had once belonged to Koenigs now also entered the museum: the Grünewald (cat. no. 9) and *The Doge Andrea Vendramin*, a famous colored miniature on vellum attributed to Gentile Bellini.

A year later the collection of sixteenth-century drawings was expanded with the purchase of three preparatory studies by Maerten van Heemskerck for his print series of the story of Job, and from I.Q. van Regteren Altena the museum bought a design for a standing musketeer in the *Wapenhandelinghe* (Exercise of Arms) of 1607 by Jacques de Gheyn.[63] From the collection of another art historian, M.J. Friedländer, whose estate was auctioned in 1959, the museum acquired three studies and a letter by Adolf Menzel (fig. 17), and a *Girl Writing at a Table* by Max Liebermann.[64] Friedländer, who fled to Amsterdam from Germany in 1936, had collected these works when he was working as a curator in Berlin, at roughly the same time as Domela Nieuwenhuys was buying his drawings. Friedländer knew both Menzel and Liebermann personally, and this purchase supplemented the collection of German drawings with works by artists who were missing from the Domela Nieuwenhuys Collection.

This period of perceptive and lively expansion in the 1950s was followed in the next decade by a downturn in the department's fortunes. The focus of the museum's policy shifted almost entirely to modern art, and for a long time not a single Old Master drawing was added to the collection. To make matters worse, at the end of the 1970s the printroom was robbed of half its academic staff, which severely affected the administration and cataloguing of the collection, quite apart from crippling the exhibition program. Before then, fortunately, catalogues had been published of various parts of the drawings collection: the eighteenth and nineteenth-century German sheets in 1964 and the French nineteenth-century in 1968, both compiled by H.R. Hoetink, and in 1974 the early German drawings by A.W.F.M. Meij.

18. Jan Toorop, *Aurore*, pastel, 1892

19. Edgar Degas, *Dancer*

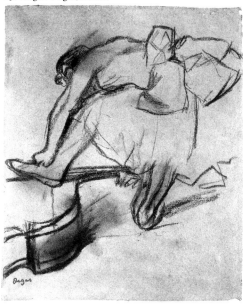

20. Johan Barthold Jongkind, *View of the Haringvliet Docks*, watercolor, 1868

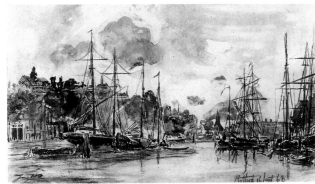

13

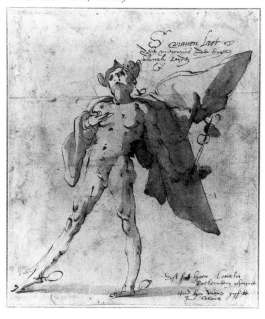

21. Gerrit Pietersz, *Mercury*

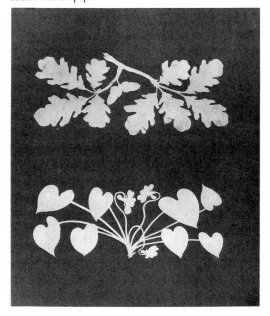

22. Philipp Otto Runge, *Violets and an Oak Twig*, scissor-cut on paper

Study of the drawings by Rembrandt and his school identified a number of weak areas, which were partly filled by figure studies on blue paper by Govert Flinck and Jacob Backer, executed in the period when Rembrandt's influence on their style was beginning to loosen.[65] During the preparations for the catalogue of this group of drawings, which appeared only in 1988, all the sheets were given new passepartouts and many of the old mounts were removed, which produced one or two surprises. On the verso of *Ruth and Naomi* from the Van Beuningen Collection, for instance, there was a bonus in the form of a red chalk sketch of an unusual type for Rembrandt, which is related to his 1638 etching of *Joseph Telling His Dreams*.[66] Even more important, though, was the purchase, just before the catalogue was published, of a study sheet executed with a broad pen which shows Rembrandt at the height of his virtuosity. There was no other drawing of its kind in the collection, which it immediately enhanced by fitting effortlessly between *Saskia at a Window* (cat. no. 33) and the *Study of a Recumbent Lion* (cat. no. 34), which is the reason for its inclusion in the present selection (cat. no. 35).

Various bodies, led by the Rembrandt Society, helped the Boymans Museum Foundation with this expensive purchase, and it was also the Rembrandt Society that came to the museum's aid in 1978 when it set its sights on Jan Toorop's large Symbolist pastel of 1892, *Aurore*, which was made as a wedding present for the painter Floris Verster (fig. 18).[67] It is a milestone in the master's *œuvre*, and a highlight of the Rotterdam Toorop collection, the foundations of which had been laid back at the beginning of the century. It was added to again in 1989, thanks to financial support from the Lucas van Leyden Foundation, with the purchase of a varied group of sketches and colored drawings from the collection of A.J.M. van Moorsel, who had been a friend of the artist in the 1920s. Van Moorsel also had a number of rare impressions of Toorop's graphic work, some printed in red or hand-colored, which were purchased at the same time.[68]

The last major donation to the museum was the bequest of Vitale Bloch (1900–75), an art dealer with a very individual taste, who had supplied museums all over the world with some of their most beautiful paintings. Three of the drawings in this catalogue are from his collection: the Giovanni Benedetto Castiglione, Jongkind and Corot (cat. nos. 71, 98 and 99), but the bequest also included sheets by Renoir, Bonnard and Degas (fig. 19), as well as carefully selected paintings by Guercino, Pier Francesco Mola and Cavallino, the gem-like *Still Life with a Tulip in a Vase* by Dirck van Delen, and works by Corot, Redon and Vuillard.[69] Another donation brought the museum its first Vuillard drawing, a watercolor design for a program for the 1890-91 season at the Théâtre Libre in Paris.[70]

In addition to Jongkind's watercolor of Marseilles (cat. no. 98), the Bloch bequest also contained a *View of the Schie* which the artist drew on a visit to Holland in September 1867. He returned again a year later, this time producing a watercolor *View of the Haringvliet Docks* in Rotterdam (fig. 20).[71] This brushed impression, which the museum bought in 1977, formed the basis for Jongkind's painting of 1881, *Haringvliet by Moonlight*, which is now in the Rijksmuseum in Amsterdam. The Boymans-van Beuningen Museum is very fortunate in having Jongkind as a portraitist of Rotterdam. A municipal museum has a duty to keep its collection of townscapes up to the highest possible standard, but that becomes embarrassing if the city itself has only attracted middle-ranking artists. In 1907, prompted by admiration for the work of his Jongkind, about whom he wrote a book, Paul Signac paid a visit to Rotterdam that resulted in a series of Pointillist drawings and paintings depicting the bustle on the River Maas. In 1952 the Boymans Museum received one of those paintings as a gift from D. Hannema, and in 1987 it was complemented with a related large drawing, which is executed with a broad brush in gray ink.

It will be clear from this introduction that the museum's collection of drawings has developed over quite a broad front in the past century and a half, leaving certain gaps that needed filling. This has been the focus of the acquisitions policy in recent years. Several fine specimens of Dutch Mannerist draftsmanship were purchased, among them the early, rapid drawing of *Mercury* by Gerrit Pietersz (fig. 21), the anonymous *Battle of the Gods and the Giants* (cat. no. 19), which is based entirely on drawings by Hans Speckaert, and the *modello* for Abraham Bloemaert's *Theagenes and Chariclea after the Shipwreck* of 1625, which was commissioned by Prince Frederik Hendrik, in which the faint echoes of Mannerism still reverberate.[72] The group of Italianate landscapes, which had been completely neglected since the nineteenth century, gained a broad panorama by Bartholomeus Breenbergh, and a *View of San Stefano Rotondo in Rome* from a group of drawings inscribed *C. du Jardin*.[73]

A few years ago it was the turn of Neo-Classicism, and artists such as John Flaxman, Henry Singleton, Dominique Vivant Denon and Bartolommeo Pinelli made their first appearance in the collection. Some were actually replacements for sheets acquired by Boijmans directly from the artists of this generation, but which had perished in the fire.

Likewise, landscapes were purchased by Dutch draftsmen of this period who were relatively under-represented in the collection, such as Hendrik Voogd and Abraham Teerlinck. Among the last acquisitions is a scissor-cut with floral motifs executed by the German Romantic artist Philipp Otto Runge around 1800 (fig. 22). This is one of his deft cut-out creations with floral shapes stylized in the manner characteristic of his graphic and painted *œuvre*.[74]

Recently, attention has turned to seventeenth-century Italian artists, who made only a sporadic showing in the Koenigs Collection. Purchases have included a drawing by Cavalier d'Arpino for a fresco in the Villa

Aldobrandini in Frascati (1602), and several figure studies in red chalk by Carlo Cignani and other Bolognese draftsmen. In the French School, attempts have been made to surround Watteau, Fragonard and Boucher with the better efforts by lesser-known artists such as Charles Natoire and Charles Parrocel (fig. 23),[75] thus giving a fuller picture of the art of drawing of that period. A meager budget and the meteoric rise in prices for Old Master drawings have necessarily made these acquisitions no more than footnotes to a great collection although it is still a challenge to find that one sheet that will "not merely augment, but also enrich the collection."

Ger Luijten

1. See F. Haskell, *Rediscoveries in Art: Some Aspects of Taste, Fashion and Collecting in England and France*, Ithaca, N.Y. 1976, p. 128, and for the catalogue of the paintings, W.H.J. Weale and J.P. Richter, *A Descriptive Catalogue of Pictures Belonging to the Earl of Northbrook*, London 1889, Appendix I.
2. See F. Lugt, *Les Marques de collections de dessins & d'estampes*, Amsterdam 1921, no. 2490. His collection of graphic art included the print *œuvre* by Dürer which the geographer Abraham Ortelius had put together in the sixteenth century, and which later passed into the collections of Pierre-Jean Mariette and Count Moriz von Fries.
3. For Boijmans see A.J. van der Aa, *Biographisch woordenboek der Nederlanden*, vol. I, Haarlem 1852, pp. 347-48, and the extremely malicious comments in the otherwise well documented book by P. Haverkorn van Rijsewijk, *Het Museum Boijmans te Rotterdam*, The Hague, Amsterdam n.d. [1910], pp. 27-59.
4. J.W.C. van Kampen, "Waarom het Museum Boijmans niet te Utrecht is gesticht," *Maandblad van Oud-Utrecht* X, 1935, p. 44: "*niemand heeft het ooit gezien dan alleen een paar kamers aan de straat [die] met schilderyen behangen [waren]... juist van dat middelmatig goed en daarnaar werd begrepen, dat hetwelk boven in kamers gepakt stonde, natuurlijk nog van minder aloij zullen zijn.*"
5. Ibid., pp. 41-44, 55-58: "*alwaar ik zo menigmaal in dat pakhuis van kunst hem bezocht heb,*" and "*Hij was onverzadelijk om alles machtig te worden en daar hij zeer eenvoudig met ééne meid leefde, was zijn huishouden van weinig betekenis, zoo dat al zijn geld in kunstwaarde belandde.*" For a much earlier assessment of the Boijmans Collection, by Cornelis Apostool (1762-1844), whom King Louis Napoleon appointed curator of the Royal Museum, see Haverkorn van Rijsewijk, op. cit. (note 3), pp. 37-38.
6. Lugt, op. cit. (note 2), p. 340, under nos. 1857-58.
7. G.D.J. Schotel, *Leven van den zeeschilder J.C. Schotel*, Haarlem 1840, pp. 37, 94: "*...mijn vader [was] meestal niet vrij in de keuze zijner onderwerpen. Hoe zou hij anders eene stoomboot hebben kunnen afmalen.*" See G. Jansen, *Nederlandse schilderkunst 1800-1850: een keuze uit de eigen collectie I*, Rotterdam, Museum Boymans-van Beuningen, 1987-88, p. 4, and A. Hoogenboom, "Een succesvol zeeschilder en zijn klantenkring," in exhib. cat. *J.C. Schotel 1787-1838: een onsterfelijk zeeschilder*, Dordrecht, Dordrechts Museum, 1989, p. 75, also pp. 97-98 and 86, fig. 54.
8. See exhib. cat. *Utrechtsche Kunst 1800-1850*, Utrecht, Centraal Museum, 1942, pp. 15-17, and L. van Tilborgh and A. Hoogenboom, *Tekenen destijds: Utrechts tekenonderwijs in de 18e en 19e eeuw*, Utrecht, Antwerp 1982, pp. 19-26.
9. Van Kampen, op. cit. (note 4), p. 44: "*...voet [had] bij der eerste der stad, vooral als de dames de kunst beoeffenden, die hij steeds van goede modellen [voorzag] en met raad enz. bijstond,*"

hetwelk niet algemeen als uit kunsthulp beschouwd werd."
10. Haverkorn van Rijsewijk, op. cit. (note 3), pp. 53-54; see also A. Hallema, "De schakel tusschen kunst en jeugdgevangenis," *Nieuwe Rotterdamsche Courant*, May 18 1939. I owe this reference to Peter Hoogstrate, librarian at the Museum Boymans-van Beuningen who also shared his extensive knowledge of the history of the museum.
11. Lugt, op. cit. (note 2), pp. 110-20.
12. *Catalogue d'un magnifique Cabinet de Tableaux... rassemblé par Monsieur F.J.O. Boymans*, Utrecht (G. Klanck) 1811, p. IV. Boijmans explains in the foreword that he was being forced to sell his drawings in order to pay his son the inheritance left to him by his mother.
13. Haverkorn van Rijsewijk, op. cit. (note 3), p. 63.
14. *Catalogus van Teekeningen in het Museum te Rotterdam gesticht door Mr. F.J.O. Boymans*, Rotterdam 1852.
15. Haverkorn van Rijsewijk, op. cit. (note 3), p. 57.
16. See the manuscript annual report for 1864 in the Rotterdam City Archives, and M. Robinson and R. Weber, *The Willem van de Velde Drawings in the Boymans-van Beuningen Museum*, vol. I, Rotterdam 1979, p. 10. Some works also survived of seventeenth-century artists from V to Z.
17. See G. Glück and F.M. Haberditzl, *Die Handzeichnungen von Peter Paul Rubens*, Berlin 1928, no. 140, and J. Held, *Rubens: Selected Drawings*, Oxford 1986, bij no. 91.
18. See Haverkorn van Rijsewijk, op. cit. (note 3), pp. 215-34.
19. It was a quite superb print collection. Vis Blokhuyzen was an expert on Dutch and Flemish graphics of the sixteenth and seventeenth centuries, and compiled a catalogue of the prints of Dirk de Bray which was published posthumously by Lamme: D. Vis Blokhuyzen, *Description des estampes qui forment l'œuvre gravé de Dirk de Bray*, Rotterdam 1870.
20. P.T.A. Swillens, exhib. cat. *Pieter Jansz Saenredam*, Utrecht, Centraal Museum, 1961, no. 80, fig. 84; G. Schwartz and M.J. Bok, *Pieter Saenredam: de schilder in zijn tijd*, Maarssen, The Hague 1989, pp. 220, figs. 230 and 264, no. 80.
21. See exhib. cat. *Van Gogh in Brabant: schilderijen en tekeningen uit Etten en Nuenen*, 's-Hertogenbosch, Noordbrabants Museum, 1987, no. 89.
22. B. Spaanstra-Polak in exhib. cat. *De grafiek van Jan Toorop 1858/1928*, Amsterdam, Rijksprentenkabinet, 1969, p. 7.
23. "*Om slechts datgene aan te kopen wat de verzameling niet alleen uitbreidt, maar ook verrijkt.*" See G. Luijten, "De veelheid en de eelheid': een Rijksmuseum Schmidt-Degener," *Het Rijksmuseum: opstellen over de geschiedenis van een nationale instelling; Nederlands Kunsthistorisch Jaarboek* XXXV, 1984, pp. 351-429.
24. Ibid., pp. 355-59 and 415-17, Appendix B: "Lijst van onder Schmidt-Degener verworven schilderijen voor Museum Boymans."
25. This drawing was recently published for the first time in exhib. cat. *Jacques Louis David 1748-1825*, Paris, Musée du Louvre, Versailles, Musée National du Château, 1989-90, no. 46.
26. D. von Hadeln, *Handzeichnungen von G.B. Tiepolo*, vol. I, Florence, Munich 1927, p. 24 and pl. 88.
27. For these collectors see Lugt, op. cit. (note 2), under nos. 381-82 and 1012. For Domela Nieuwenhuys, ibid., *Supplément*, The Hague 1956, no. 356b; H.R. Hoetink, *Duitse tekeningen uit de 18e en 19e eeuw: catalogus van de verzameling in het Museum Boymans-van Beuningen*, Rotterdam 1964, pp. 5-6; and J. Schaeps, *Duitse tekeningen uit de negentiende eeuw: de verzameling Domela Nieuwenhuys*, Rotterdam 1987.
28. Hoetink, op. cit. (note 27), pp. 50-52, nos. 79-82.
29. Examples include the dynamic study for the painting of *St Ambrose on a Horse* by Giovan Ambrogio Figino (ca. 1548-1608) in the Castello Sforzesco in Milan, inv. DN 114/11, see A. Perissa Torrini, *Disegni del Figino*,

23. Charles Parrocel,
Soldier Leaning on a Drum

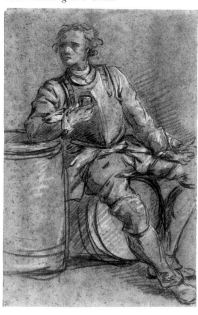

Gallerie dell'Accademia di Venezia, Milan 1987, p. 197, fig. 122, under nos. 122-35, and the *Rape of Europa*, inv. DN 179/76, then attributed to Gaspard Dughet, but recently published as a work by the seventeenth-century Flemish artist, Valentin Lefèvre, see U. Ruggeri, "Drawings by Valentin Lefèvre," *Master Drawings* XXVI, 1988, p. 349, no. 70, and pls. 36-37. The album of landscapes ascribed to Guercino in the Domela Nieuwenhuis Collection, inv. DN 142/39, is the work of his cleverest eighteenth-century imitator, Carlo Gennari (1712-90), see P. Bagni, *Il Guercino e il suo falsario: i disegni di paesaggio*, Bologna 1985, nos. 195-97.

30. For De Gheyn see exhib. cat. *Jacques de Gheyn II als tekenaar 1565-1629/ Jacques de Gheyn II: Drawings*, Rotterdam, Museum Boymans-van Beuningen, Washington, National Gallery of Art, 1985-86, no. 43, and for Delacroix, H.R. Hoetink, *Franse tekeningen uit de 19e eeuw: catalogus van de verzameling in het Museum Boymans-van Beuningen*, Rotterdam 1968, no. 94.

31. *Catalogus van aquarellen en teekeningen uit het legaat Montauban van Swijndregt*, Rotterdam 1944.

32. See J.-B. de la Faille, *The Works of Vincent van Gogh*, Amsterdam 1970, nos. 842, 1472a and 1025.

33. The *View of Scheveningen* in exhib. cat. *Willem Buytewech 1591-1624*, Rotterdam, Museum Boymans-van Beuningen, Paris, Institut Néerlandais, 1974-75, no. 106, pl. 112. In 1932 the museum also acquired an *Elegant Couple in a Landscape*, one of the rare red chalk drawings by this Rotterdam artist, see ibid., no. 71, pl. 60.

34. F.J. Duparc, exhib. cat. *Landscape in Perspective: Drawings by Rembrandt and his Contemporaries*, Cambridge, Mass., A.M. Sackler Museum, Montreal, Montreal Museum of Fine Arts, 1988, no. 104.

35. See J. Giltaij, *De tekeningen van Rembrandt en zijn school in het Museum Boymans-van Beuningen*, Rotterdam 1988, nos. 74 (Flinck), 92 (Koninck), 109 (Lievens). For Pieter Stevens see A. Zwollo in exhib. cat. *Prag um 1600: Kunst und Kultur am Hofe Rudolfs II.*, Essen, Villa Hügel, 1988, no. 272; and for Vinckboons, W. Wegner and H. Pée, "Die Zeichnungen des David Vinckboons," *Münchner Jahrbuch der Bildenden Kunst* XXXI, 1980, pp. 72-73, no. 29.

36. The Bruegel drawing, L. Münz, *Bruegel: the Drawings*, London 1961, no. 42, is from a group which was convincingly reassigned to Jacques Saverij recently by H. Mielke, "Review of K.G. Boon, *L'Époque de Lucas de Leyde et Pierre Bruegel: dessins des anciens Pays-Bas, collection Frits Lugt*," in *Master Drawings* XXXIII-XXXIV, 1985-86, pp. 76-81. For the drawing by Claes Jansz Visscher see M. Simon, *Claes Jansz. Visscher*, diss. Freiburg im Breisgau 1958, nos. 70-71.

37. For the history of the museum in these years see D. Hannema, *Flitsen uit mijn leven als verzamelaar en museumdirecteur*, Rotterdam 1973.

38. See Lugt, op. cit. (note 27), p. 150, under no. 1023a: "*Hij was bereid elke prijs te betalen, mits het om een uitzonderlijk blad ging en zijn oog, zijn flair en de snelheid waarmee hij beslissingen nam, verbaasden allen die hem gekend hebben.*"

39. For Koenigs see, in addition to Lugt, J.C. Ebbinge Wubben, "Van Museum Boymans tot Museum Boymans-van Beuningen: herinneringen aan enkele verzamelaars," *Essays in Northern European Art Presented to Egbert Haverkamp Begemann on his Sixtieth Birthday*, Doornspijk 1983, pp. 77-78; A.W.F.M. Meij, "Introduction," in exhib. cat. *Nineteenth-Century French Drawings from the Museum Boymans-van Beuningen*, Baltimore, Baltimore Museum of Art, Los Angeles, Los Angeles County Museum of Art, Fort Worth, Kimbell Art Museum, 1986-87, pp. 9-11; and A.J. Elen, *Missing Old Master Drawings from the Franz Koenigs Collection Claimed by the State of the Netherlands*, The Hague 1989, pp. 9-13.

40. For the Millet drawings see Hoetink, op. cit. (note 30), nos. 193-94.

41. New information on Willem II's collection will be found in E. Hinterding and F. Horsch, "A Note on Willem II's Collection of Drawings," in "'A Small but Choice Collection': the Art Gallery of King Willem II of the Netherlands (1792-1849)," *Simiolus* XIX, 1989, pp. 46-54.

42. On the provenance of Koenigs's drawings see Elen, op. cit. (note 39), pp. 10-12.

43. Written communication from Carlos van Hasselt, director of the Fondation Custodia, Paris, December 19 1989.

44. Philips Koninck's *River Landscape* is discussed in Giltaij, op. cit. (note 35), no. 93, and the Rembrandt school drawings in ibid., no. 168. For the *Head of a Young Cleric* attributed to Signorelli see exhib. cat. *Italiaanse tekeningen in Nederlands bezit*, Paris, Institut Néerlandais, Rotterdam, Museum Boymans-van Beuningen, Haarlem, Teylers Museum, 1962, no. 41, pl. XXXIV, and for the drawing which Lugt bought as a Theodoor van Thulden at the E. Wauters sale in 1926 (inv. V 103), J. van Tatenhove, "Enkele tekeningen en monotypieën van Anthonis Sallaert (ca. 1590-1650)," *Art in Denmark 1600-1650; Leids Kunsthistorisch Jaarboek* II, 1983, p. 246, note 14. Bruegel's *Fortitude* is Münz, op. cit. (note 36), no. 147. One of the few occasions when a drawing passed from Koenigs to Lugt was in 1929, an *Interior with Dancing Couples and Musicians* by Willem Buytewech, inv. 4103, which Koenigs had bought from the Grand-Ducal collection in Weimar; see exhib. cat. Rotterdam, Paris, cit. (note 33), no. 29, pl. 55.

45. See Table B in Elen, op. cit. (note 39), p. 11. For the French nineteenth-century drawings collected by Koenigs see Hoetink, op. cit. (note 30).

46. See for the "Maganza group," J. Byam Shaw, *The Italian Drawings of the Frits Lugt Collection*, vol. I, Paris 1983, nos. 252-57, and B.W. Meijer in exhib. cat. *Disegni Veneti di Collezioni Olandesi*, Venice, Fondazione Giorgio Cini, Florence, Istituto Universitario Olandese di Storia dell'Arte, 1985, nos. 51-52.

47. Giltaij, op. cit. (note 35).

48. Hannema, op. cit. (note 37), pp. 101-02.

49. Elen, op. cit. (note 39), pp. 14-25.

50. See the passage from the letter quoted in the entry to cat. no. 55, note 9.

51. For the missing drawings see the catalogue in Elen, op. cit. (note 39), and for the Titian in particular, H.E. Wethey, *Titian and His Drawings with Reference to Giorgione and Some Close Contemporaries*, Princeton 1987, pp. 138-39, no. 12.

52. M. Hirst, *Sebastiano del Piombo*, Oxford 1981, p. 79, pl. 111.

53. A.W.F.M. Meij, folder *Duitse tekeningen uit de verzameling Koenigs terug in Nederland*, Rotterdam, Museum Boymans-van Beuningen, 1987.

54. For the Dürer see A.W.F.M. Meij, *Duitse tekeningen 1400-1700: catalogus van de verzameling in het Museum Boymans-van Beuningen*, Rotterdam 1974, no. 23; for Mannheimer's French eighteenth-century drawings, K.G. Boon, *Gids voor het Rijksprentenkabinet*, Amsterdam 1964, p. 29, and exhib. cat. *Franse tekenkunst van de 18de eeuw uit Nederlandse verzamelingen*, Amsterdam, Rijksprentenkabinet, 1974.

55. The other Dürer is a study of a horse, see Meij, op. cit. (note 53), no. 24.

56. For the Piranesi see exhib. cat. 1962, cit. (note 44), no. 201, pl. CXLIII.

57. J.C. Ebbinge Wubben, "Dr. J.C.J. Bierens de Haan: zijn leven en zijn verzameling," *Bulletin Museum Boymans Rotterdam* III, 1952, pp. 22-52.

58. The Lucas Van Leyden Foundation has also financed the purchase of a number of drawings, such as Dürer's sheet of sketches, cat. no. 7.

59. On these acquisitions see E.K.J. Reznicek, *Die Zeichnungen van Hendrick Goltzius*, vol. I, Utrecht 1961, nos. 121, 179, 159, 71, 260, 352.

60. D. Hannema, *Meesterwerken uit de verzameling D.G. van Beuningen*, Rotterdam 1949.

61. Meij, op. cit. (note 54), nos. 21-22.

62. Giltaij, op. cit. (note 35), nos. 19 and 13.

63. Exhib. cat. Rotterdam, Washington 1985-86, cit. (note 30), no. 18.

64. Hoetink, op. cit. (note 27), nos. 83, 95, 96, 98.

65. Giltaij, op. cit. (note 35), nos. 73 and 39.

66. See ibid., no. 13, and J. Giltaij, "Een onbekende schets van Rembrandt," *Kroniek van het Rembrandthuis* XXIX, 1977, pp. 1-9.

67. J. Giltaij, "Aurore, 1892, Jan Theodoor Toorop (1858-1928)," *Jaarverslag Vereniging Rembrandt Nationaal Fonds Kunstbehoud* 1978, pp. 61-62.

68. Several rarities from Van Moorsel's collection were shown at the 1969 exhibition in the Rijksprentenkabinet in Amsterdam (see note 22).

69. A.W.F.M. Meij, *Legaat Vitale Bloch*, Rotterdam 1978.

70. Exhib. cat. Baltimore, Los Angeles, Fort Worth 1986-87 (see note 39), no. 48.

71. A.W.F.M. Meij, "Een landschap in de omgeving van Rotterdam door J.B. Jongkind," *Boymans bijdragen: opstellen van medewerkers en oud-medewerkers van het Museum Boymans-van Beuningen voor J.C. Ebbinge Wubben*, Rotterdam 1978, pp. 171-73.

72. For the drawing by Gerrit Pietersz see P.J.J. van Thiel, "Gerrit Pietersz.: addenda en corrigenda," in *Was getekend... tekenkunst door de eeuwen heen. Liber amicorum E.K.J. Reznicek; Nederlands Kunsthistorisch Jaarboek* XXXVIII, 1987, pp. 356-59; and for the Bloemaert, B. Broos, "Abraham Bloemaert en de Vader van de Schilderkunst," in ibid., pp. 66-67, fig. 5.

73. G. Luijten in *Italianisanten en bamboccianten: het italianiserend landschap en genre door Nederlandse kunstenaars uit de zeventiende eeuw*, Rotterdam, Museum Boymans-van Beuningen, 1988, nos. 45 and 53, and the color pls. on pp. 28-29.

74. C. Richter, *Philipp Otto Runge, Ich weiss eine schöne Blume. Werkverzeichnis der Scherenschnitte*, Munich 1981, no. 185.

75. After the Parrocel was purchased it was discovered that it is related to his painting, *The Mounted Grenadiers of the French Royal Guard and Their Commander at the Siege of Philippsburg* (1737), which was commissioned by Louis XV for Fontainebleau (Paris, Musée du Louvre, inv. 7123). There is a drawing in the Rijksprentenkabinet in Amsterdam of the man being addressed by the officer in the painting, who is based on the Rotterdam study; see J.W. Niemeijer, "Een studiekop van Charles Parrocel," *Bulletin van het Rijksmuseum* XV, 1967, pp. 135-38.

NOTE TO THE CATALOGUE

The titles of publications cited only once or twice in the catalogue are given in full. Abbreviated references in the notes followed by a date in brackets are to titles in the *Literature* section at the head of the entry. For all other short-form references see the Bibliography at the back of the book, which also contains the full titles of exhibition catalogues.

The entries were written by Ger Luijten (GL) and A.W.F.M. Meij (AM).

About the catalogue

The principle underlying the selection in this catalogue is that the drawings not only had to be beautiful, but that in concert they should provide an introduction to the art of drawing in the five centuries separating Pisanello from Cézanne. The names in our title were chosen to illustrate the catholic taste of Franz Koenigs, whose drawings make up the core of this book. Yet even this diversity is not really able to do justice to the scope of the museum's present collection. We are also well aware that this approach makes for a fairly conventional picture of the art of drawing, but we decided it would be better to go for depth rather than breadth, grouping drawings together in order to produce a more tightly woven fabric. As a result, some parts of the collection are underexposed, or even absent. There are no sheets by eighteenth- or nineteenth-century Dutch artists, the German nineteenth century is missing, as are the non-Venetian masters of the eighteenth century and the nineteenth-century Italian School, while Claude Lorrain is the sole representative of eighteenth-century France and Goya of the Spanish School, albeit with two sheets each.

It was decided that the greatest artists of all, upon whose drawings the fame of the Koenigs Collection rests, should be given correspondingly greater space – seven drawings in the case of Dürer and five each for Rembrandt, Rubens and Watteau. Nor could we resist including the unique group of four early Flemish silverpoints (cat. nos. 11-13), despite the complex problems of attribution surrounding such works. Hendrick Goltzius is represented with three rather different drawings. His *Dune Landscape with a Farmhouse* (cat. no. 23) opens the Dutch seventeenth century, and here too we opted for a fine focus. It introduces a series of early Haarlem landscapes, followed by Ruisdael, a Rembrandt and a colored panorama by Philips Koninck. This, unfortunately, left no room for the Italianate landscape. A second core group within the Dutch seventeenth century is composed of figure studies in various techniques, which highlight another aspect of drawing. For the sake of variety we also added Saenredam's *Interior of St Janskerk in Utrecht* (cat. no. 41) and a sheet of *Nine Exotic Insects* by Herman Henstenburgh (cat. no. 42), a minor master who has here surpassed himself, and who is included out of respect for all those seventeenth-century draftsmen who lavished so much time and patience on loving depictions of insects and flowers. To be honest, some choices were also dictated by the fact that the book was to be printed in full color.

Within the Italian School we have omitted the sheets by Michelangelo and Raphael, which are not really representative of their work. For obvious reasons, though, the selection does include three drawings by Fra Bartolommeo. It is now possible, for the first time since the eighteenth century, to exhibit his drawings from the Gabburri albums, which were recently dismembered. The sheets have been restored and are now kept in boxes in their original order.

Half of the finest Italian drawings in the collection are from Venice – a bias that reflects Koenigs's passion for artists of that school. Among the most famous sheets in the group are the Giorgione and Tiepolo's rooftop panorama, the precise locations of which have only very recently been discovered (cat. nos. 56, 73). The comparative illustrations reproduced with these two entries serve to confirm the accuracy of this identification.

Because the drawings in this book are also being exhibited in three American museums, some sheets have been withheld that are really essential to a survey of this kind, but whose condition or technique makes it impossible for them to travel. They include Dürer's large *Linden Tree on a Bastion* (fig. 16), which is in watercolor and bodycolor on parchment, Buytewech's *Anatomy Lesson* (fig. 4), and a very fine colored sheet by Jacob Jordaens (fig. 24), which has been laid down on panel and is thus very vulnerable to damage. Van Gogh's *Bank of the Rhône* (fig. 10) is missing because 1990 is the Van Gogh centennial, and it had already been promised for the major retrospective of his work, while Leonardo da Vinci's *Leda and the Swan* has been exhibited several times in the past few years and now deserves a rest.

The forerunner of this catalogue was E. Haverkamp Begemann's *Vijf eeuwen tekenkunst* (Five Centuries of Drawing) of 1957, a most elegant publication in black and white which for many was their introduction to the collection of drawings in Rotterdam. Like him, we wanted to produce a book that would grace more than coffee tables, and we have done our best to satisfy the scholar by providing the fullest possible documentation of the drawings and by not shirking on the bibliography. At the same time, though, we have catered to the interests of the general reader by not cluttering the entries with the names of authorities or discussion of outdated opinions. That is the main reason why there are so many footnotes; it is there that the references to the literature will be found. We left room for comparative illustrations in order to smooth the reader's path and to back up our arguments, and hope that we have succeeded in creating attractive visual combinations. The colored drawings have been reproduced actual size wherever possible, and in order to accommodate the oblong format of the landscapes without either reducing them or forcing the reader to turn the book through 90 degrees, it was decided that the book should have a square format, which would give all the drawings equal weight.

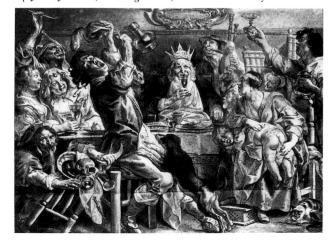

24. Jacob Jordaens, *The King Drinks*, watercolor and bodycolor

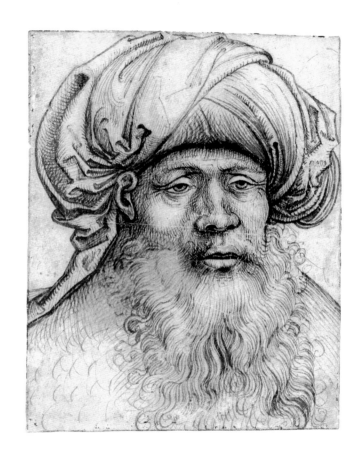

German School

I

Martin Schongauer
Colmar c. 1450–1491 Breisach
HEAD OF A TURBANNED MOOR

Pen and brown ink; 111 × 84 mm.
No watermark
Inv. MB 245

Provenance: F.J.O. Boijmans, bequest of 1847 (L. 1857).

Not previously exhibited

Literature: cat. Rotterdam 1852, no. 241 (A. Dürer);
cat. Rotterdam 1869, no. 105 (A. Dürer); M. Lehrs,
"Schongauer-Zeichnungen in Dresden," *Mitteilungen aus
der Sächsischen Kunstsammlungen* V, 1914, p. 13, no. 22;
J. Rosenberg, *Martin Schongauer Handzeichnungen*,
Munich 1923, p. 20, fig. 14; J. Baum, *Martin Schongauer*,
Vienna 1948, p. 46, fig. 128; E. Flechsig, *Martin
Schongauer*, Strasbourg 1951, p. 332; F. Winzinger,
Die Zeichnungen Martin Schongauers, Berlin 1962, no. 17
(ill.); Meij 1974, no. 13 (ill.); F. Winzinger, "Altdeutsche
Meisterzeichnungen aus sowjetrussischen Sammlungen,"
Pantheon XXIV, 1976, p. 104; M. Bernhard, *Martin
Schongauer und sein Kreis*, Munich 1980, p. 157 (ill.).

No fewer than nine of Schongauer's fifty-five extant
drawings are of Moorish heads, and the theoretical total
rises to at least sixteen if one adds the copies and
imitations of lost drawings.[1] Similar Moorish types also
appear frequently in his engravings, such as the *Large
Crucifixion* (fig. a).[2]

It is believed that shortly after settling in Colmar in
1469, Schongauer set out on a journey that took him as
far as Southern Spain, which at the time was ruled by
Mohammedans from North Africa, known as Moors.
Support for this theory is provided by the accurate
depiction of a dragon-tree (*Dracaena draco*) on the left of
the engraving of the *Flight into Egypt* (fig. b).[3] This tree
was only introduced into continental Europe from the
Canary Islands in the fifteenth century, and was at first
restricted to Southern Spain,[4] which is where
Schongauer must have seen it. During his travels, he
evidently made silverpoint studies of the people, flora
and fauna he encountered – a practice later followed by
Dürer and Hans Baldung Grien.[5] Back in Colmar,
Schongauer used those silverpoint sheets as the basis for
pen drawings like the one in Rotterdam.

This is a characteristic example of Schongauer's
distinctive drawing style, which was first described by
Winzinger.[6] He first drew the contours and the basic
details with very fine lines, some of which are still
visible (above the man's left shoulder, in this case), and
then went over them with a broader pen. Schongauer's
was the leading workshop on the Upper Rhine in the
second half of the fifteenth century, and was visited by
the young Dürer shortly after the master's death.

1. Winzinger (1962), nos. 15, 21, 29, and Winzinger (1976),
p. 104; copies etc.: Winzinger (1962), nos. 53, 57-59, 63,
68-69.
2. See Bernhard (1980), p. 49.
3. Ibid., p. 45.
4. H. Schenck, "Martin Schongauers Drachenbaum,"
Naturwissenschaftliche Wochenschrift N.F. XIX, 1920, no. 49,
p. 776.
5. Winkler 1936-39, vol. IV, nos. 761-87 (ill.); K. Martin,
Skizzenbuch des Hans Baldung Grien, Basel 1950.
6. Winzinger (1962), p. 13.

AM

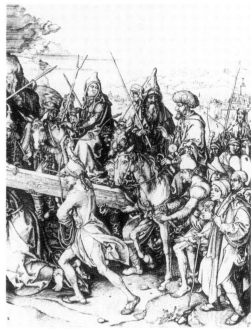

fig. a

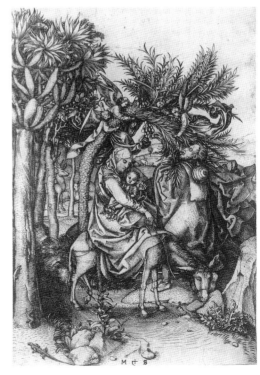

fig. b

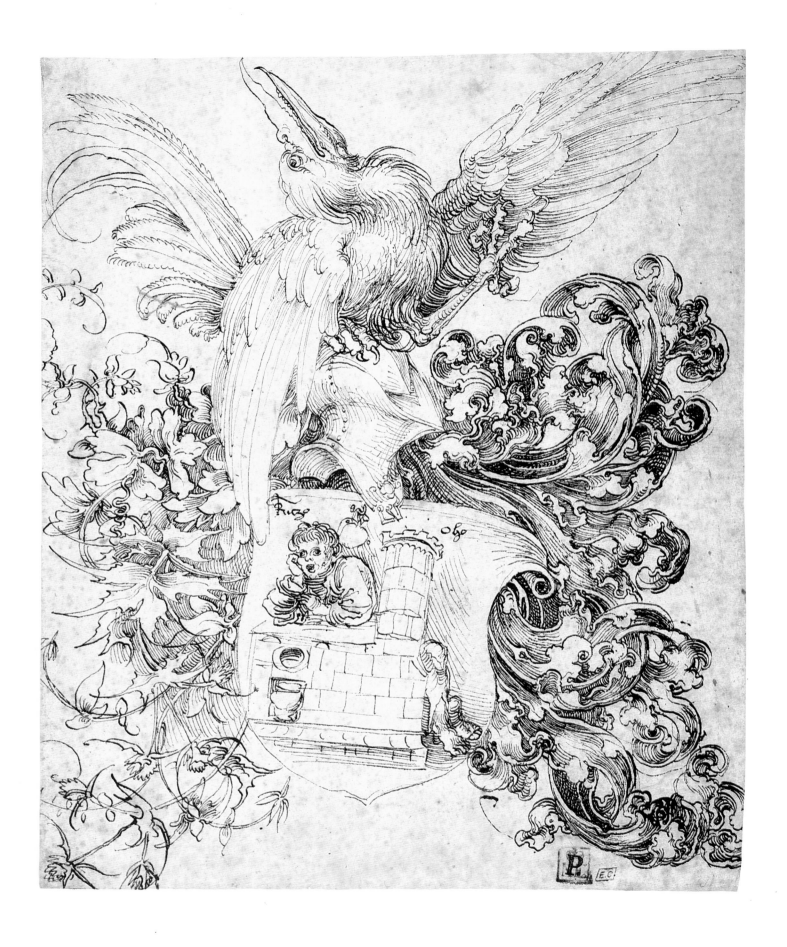

2

Albrecht Dürer
Nuremberg 1471–1528 Nuremberg
COAT OF ARMS

Pen and brown ink; 231 × 187 mm.
Inscribed in pen and brown ink: *Hitze Oho*
Verso: *Study of a Kneeling Woman*, pen and brown ink
No watermark
Inv. MB 1987/T29

Provenance: P. von Praun, Nuremberg; his sale,
Nuremberg, early February 1802, no. 198; N. Esterhazy,
Vienna (L. 1965); M. Pacetti, Rome (L. 2057);
E. Calando, Paris (L. 837); his sale, Paris (Godefroy
Huteau), March 17-18 1927, no. 64; F. Koenigs,
Haarlem (L. 1023a), acquired in 1927 (inv. D I 135);
D.G. van Beuningen, Rotterdam, acquired in 1940; in
1941 acquired for the Hitler Museum, Linz, and
removed to Dresden; returned to the Netherlands by
East Germany in 1987; on loan from the Rijksdienst
Beeldende Kunst (Netherlands Office for Fine Arts),
The Hague (inv. NK 3549).

Exhibitions: Nuremberg 1928-I, no. 234; Amsterdam
1929, no. 194 (ill.); Rotterdam 1938, no. 260; Dresden
1986, no. 1, fig. 8; Rotterdam 1987, no. 8.

Literature: Heller 1827, p. 86, no. 4; Flechsig 1931,
no. 338; Winkler 1936-39, vol. I, nos. 41, 43 (ill.);
G.F. Hartlaub, "Albrecht Dürers Aberglaube," *Zeitschrift
aus Deutschen Vereins für Kunstwissenschaft* VII, 1940,
p. 178, fig. 7; Winkler 1957, p. 38, fig. 11; Hütt 1970,
pp. 60, 62 (ill.); Strauss 1974, vol. I, nos. 1493/22-23
(ill.); Anzelewsky 1983, p. 134; H. Bashir-Hecht, *Der
Mensch als Pilger*, Stuttgart 1985, p. 87, fig. 33; Elen
1989, no. 144.

Within the shield is a shabbily dressed man leaning on
a tiled stove, with a pair of bellows on the wall behind
him (the object just to the right is the helmet buckle).
He appears to be uttering the words in the inscription,
Hitze oho (Ah, warmth). The shield is framed on the
right by stylized acanthus leaves, and on the left by
naturalistic vegetation, including sea holly (*Eryngium
maritimum*) at lower left. Surmounting the coat of arms
is a bird resembling a pelican.[1]

In the spring of 1490, after his four year-
apprenticeship to the painter, engraver and draftsman
Michael Wolgemut (1434–1519), Dürer left on a
journey which was to take him to the Upper Rhine
region before his return to Nuremberg in 1494. During
his *Wanderjahre*, Dürer visited the workshop of Martin
Schongauer (*c.* 1450–91) in Colmar, only to learn that
the master had died at Breisach, where he had been
working on the monastery frescoes. This was a great
blow to the younger artist, who had been hoping to
study with Schongauer. His friend Christoph Scheurl
(1481–1542), the Nuremberg jurist and humanist, later
recorded that Dürer had often told him that "not only
did I never study with 'schon Merten,' but I never even
met him his whole life long, much as I desired to do
so".[2] Dürer was nevertheless warmly welcomed by
Schongauer's brothers, Caspar, Paulus and Ludwig,
and this may have been the occasion when he acquired
material from Martin's studio. He is certainly known
to have owned several Schongauer drawings.[3] From
Colmar, Dürer traveled to Basel, where he collaborated
on the woodcut illustrations for Sebastian Brant's
Narrenschiff, which was published in 1494.

This *Coat of Arms* dates from the same period,
when Dürer was drawing in a style very similar to
Schongauer's. He would start by making a very delicate
design drawing in pen and brown ink (occasional traces
of which can still be seen), which he then went over
with a heavier pen before working it up into the
finished drawing. Dürer, though, handled the pen far
more freely than Schongauer, as shown here by the
vegetation to the left of the shield and the figure of
the man leaning on the stove.

The scene in the shield does not necessarily have a
deeper meaning, as is the case with some other Dürer
coats of arms.[4] However, it is possible that the
combination of a beggar and a pelican, the latter being
a symbol of charity, may contain an allusion to a
passage in Brant's *Narrenschiff*:

> "Many a man begs for years,
> Although quite able to work,
> For he's young, strong and healthy."[5]

This barb is aimed at those who pretend to be poor in the
hope of receiving alms or hospitality. Dürer had worked
on the *Narrenschiff*, so he presumably knew it well. In
1515 he drew a scene similar to this one, but with a far
clearer meaning, in Emperor Maximilian's *Gebetbuch*.[6]

The study of a kneeling woman on the verso (fig. a),
which is really more a study of the drapery than the
figure, is a sketch for a kneeling Virgin of the
Annunciation.

1. For similar birds which are quite clearly meant to be
pelicans, see Winkler 1936-39, vol. III, nos. 728, 743.
2. Rupprich 1956-69, vol. I, p. 295: "... *von ihm den Schon
Merten, hab er nit allein nit gelernet, sonder auch inen all sein
leben lang nie gesehen (jedoch zusehen hochlich begert.*"
3. See, for example, J.K. Rowlands, *The Age of Dürer and
Holbein*, London 1988, no. 25 (ill.).
4. Cf. Anzelewsky 1983, p. 78, fig. 44.
5. Sebastian Brant, *Das Narrenschiff* Basel 1509, p. LXVIIIr:
"*Mancher dut bättlen by der joren/ So er wol wercken möcht und
kundt/ Und er jung, starck ist und gesundt.*"
6. See H.C. von Tavel, "Die Randzeichnungen Albrecht
Dürers zum Gebetbuch Kaiser Maximilians," *Münchener
Jahrbuch der bildenden Kunst* XVI, 1965, p. 100, fig. 27.

AM

fig. a

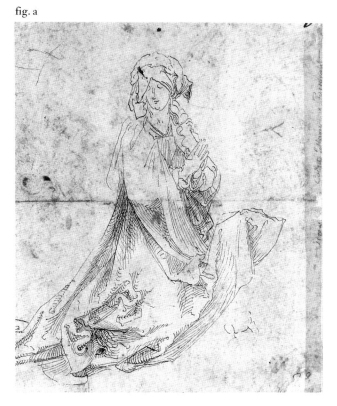

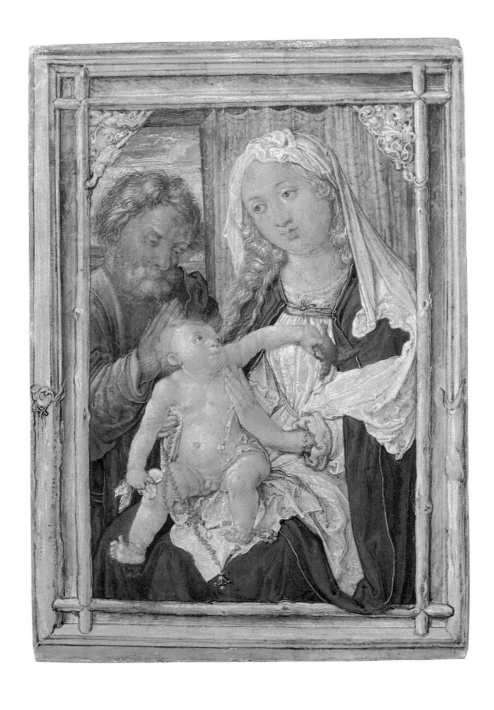

3

Albrecht Dürer
Nuremberg 1471–1528 Nuremberg
THE HOLY FAMILY

Gouache, heightened with gold, on vellum laid down on panel; 170 × 116 mm.
Signed with the brush in brown: *AD*
No watermark
Inv. MB 1987/T 30

Provenance: B. Lucanus, Halberstadt, before 1875; J. Hübner, Dresden; F. Koenigs, Haarlem (L. 1023a), acquired in 1928 (inv. D I 182); D.G. van Beuningen, Rotterdam, acquired in 1940; in 1941 acquired for the Hitler Museum, Linz, and removed to Dresden; in 1946 donated by the Soviet administration to the Museum der Bildenden Künste, Leipzig (L. 1669d); returned to the Netherlands by East Germany in 1987; on loan from the Rijksdienst Beeldende Kunst (Netherlands Office for Fine Arts), The Hague (inv. NK 3550).

Exhibitions: East Berlin 1983, no. B 65, fig. p. 128; Dresden 1986, no. 3, fig. 2; Rotterdam 1987, no. 9 (ill.).

Literature: Tietze 1937, no. 113A (ill.); Winkler 1936-39, vol. III, p. 105; Panofsky 1945, no. 726; Winkler 1957, p. 168; O. Benesch, *La Peinture allemande: de Dürer à Holbein*, Geneva 1966, p. 19; Ottino 1969, no. 38 (ill.); F. Anzelewsky, *Albrecht Dürer: das malerische Werk*, Berlin 1971, p. 25, cat. no. 18, fig. 25; K.H. Mehnert, *Altdeutsche Zeichnungen*, Leipzig, Museum der Bildenden Künste, 1974, no. 23 (ill.); Strauss 1974, vol. I, no. 1494/31 (ill.); F. Anzelewsky, *Dürer: Wirk und Wirkung*, Freiburg, Stuttgart 1980, p. 78, fig. p. 79; Anzelewsky 1983, p. 88, fig. 47; Elen 1989, no. 145.

In the spring of 1495 Dürer returned to Nuremberg after six months in Venice – his first visit to Italy. The influence of North Italian Renaissance art on the twenty-four-year-old German was slight, amounting to no more than the adoption of motifs from Venetian paintings and frescoes.

When he revisited Venice in 1506, local artists criticized his work as being "unclassical," and he also discovered that the work which he had admired eleven years before no longer appealed to him.[1] That first stay, however, sowed the seed of Dürer's lifelong, intense interest in perspective, geometry, and the principles of human proportion.

The work that Dürer produced in Nuremberg in the years following his first Italian journey is a blend of stylistic elements drawn from late Gothic and Venetian art. This gouache of the *Holy Family* can be dated to that period. The framing of the scene in rough wooden staves is a typically late Gothic touch, but the composition itself is highly reminiscent of the work produced in the 1480s and 1490s by Giovanni Bellini (1431/32–1516) and his Venice workshop, and of Cima da Conegliano (c. 1460–c. 1518), who worked there in the last decade of the century.[2]

The motif of the Christ Child playing with a bird also features in several Dürer prints of 1497/98, such as the engraving of the *Virgin and Child with a Guenon* (fig. a). In Christian iconography, the bird is a symbol of man's soul, which was liberated at Christ's coming.[3]

Vellum was a fairly expensive support for a drawing, so this gouache may have been made for a specific purpose.

1. Letter from Dürer to Willibald Pirckheimer of February 1506. It is not known what the "work" might have been, Dürer himself merely speaks of "*daz ding*"; Rupprich 1956-69, vol. I, p. 44.
2. See for instance F. Heinemann, *Giovanni Bellini e i Belliniani*, Venice 1959, no. 37, fig. 67, and no. 59, fig. 105; and L. Coletti, *Cima da Conegliano*, Venice 1959.
3. Cf. Anzelewsky 1983, p. 88.

AM

fig. a

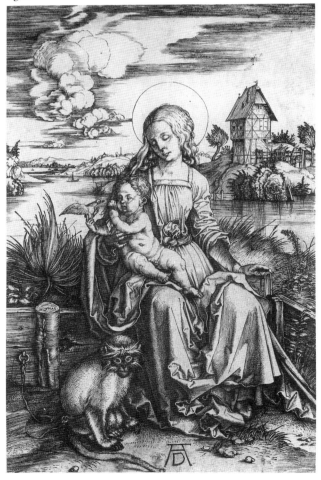

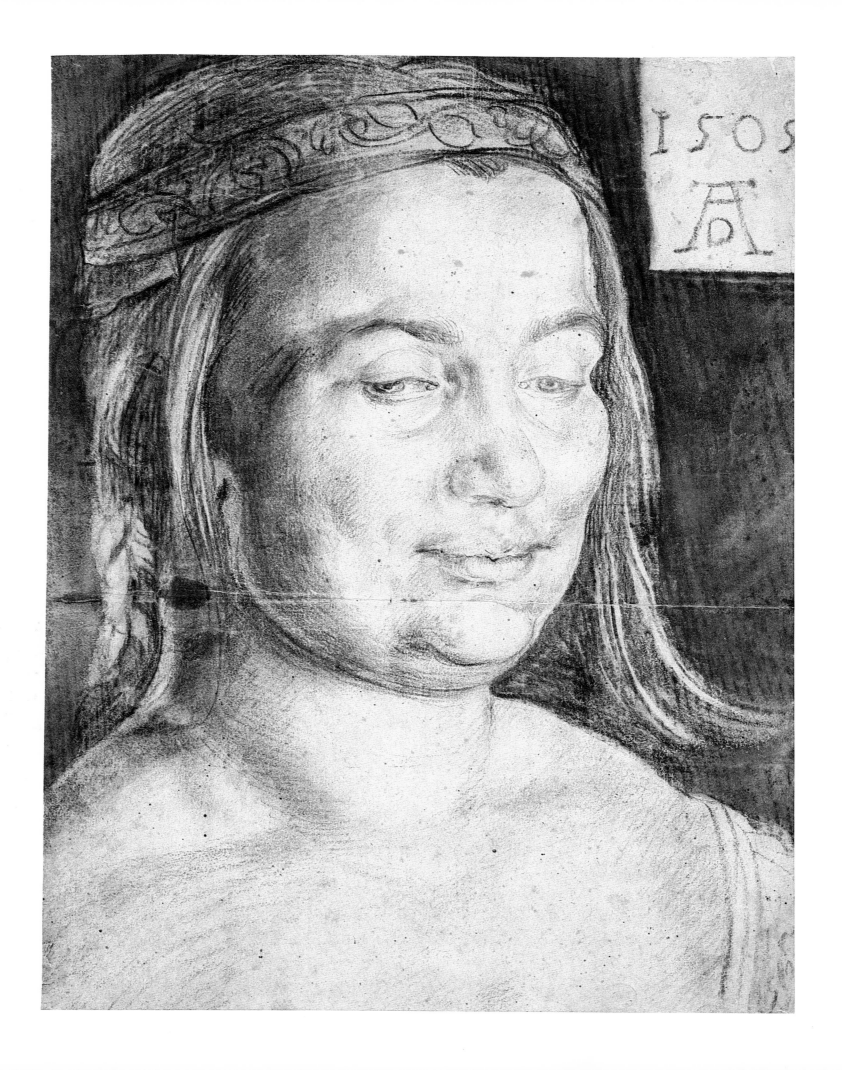

4

Albrecht Dürer
Nuremberg 1471–1528 Nuremberg
PORTRAIT OF A YOUNG WOMAN

Black chalk, the background of dark green watercolor
added later; 350 × 266 mm.
Signed and dated in black chalk: *AD 1505*
Watermark: scales in a circle, with a star, cf. Briquet
nos. 2575-99
Inv. MB 1947/T 17

Provenance: H.W. Campe, Leipzig (L. 1391); Luise
Vieweg, Campe's daughter, Braunschweig; G. Eissler,
Vienna[1]; F. Koenigs, Haarlem (L. 1023a), acquired in
1928 (inv. D I 161); D.G. van Beuningen, Rotterdam,
acquired in 1940; donated to the Boymans Museum
Foundation in 1947.

Exhibitions: Nuremberg 1928-II, no. 318; Rotterdam
1938, no. 261 (ill.); New York etc. 1939-40; Paris
1952-II, no. 58 (ill.); Rotterdam 1952, no. 27;
Nuremberg 1971, no. 530, fig. p. 284; Hamburg 1983,
no. 51 (ill.); East Berlin 1983, no. D 28, fig. p. 243.

Literature: Ephrussi 1882, p. 84; J. Springer, *Fünfzig
Bildniszeichnungen von Albrecht Dürer*, Berlin 1914, fig. II;
G. Glück, "Dürers Bildnis einer Venezianerin aus den
Jahre 1505," *Jahrbuch der Kunsthistorischen Sammlungen
in Wien* XXXVI, 1923-25, p. 117, fig. 6; Flechsig 1931,
pp. 312, 566, no. 455; Winkler 1936-39, vol. II, no. 371
(ill.); Tietze 1937, p. 21, no. 288 (ill.); Panofsky 1945,
no. 1107; E. Schilling, *Albrecht Dürer: Zeichnungen und
Aquarelle*, Basel 1948, no. 22 (ill.); H. Tietze, *Dürer als
Zeichner und Aquarellist*, Vienna 1951, pp. 38, 48;
Musper 1952, p. 156; Haverkamp Begemann 1955,
p. 82; Winkler 1957, p. 190, fig. 91; Haverkamp
Begemann 1957, no. 6 (ill.); K. Ginhart, "Albrecht Dürer
war in Kärnten," *Festschrift G. Moro*, Klagenfurt 1962,
p. 129, fig. 2; Hütt 1970, p. 426 (ill.); Meij 1974, no. 25
(ill.); Strauss 1974, vol. II, no. 1505/28 (ill.); Pignatti
1981, p. 164 (ill.); P. Strieder, *Dürer*, Königstein im
Taunus 1981, p. 113.

Early in the fall of 1505, Dürer set out on his second
journey to Venice. Unlike the first, this visit is fairly
well documented in the surviving copies of ten letters
which he wrote to his friend, the humanist Willibald
Pirckheimer (1470–1530).[2] In January 1506 he reported
that he had been commissioned to paint an altarpiece
for the Germans in Venice. He was to be paid 110
Rhineland guilders for the work, and trusted that there
would be enough left over to pay off his debt to
Pirckheimer. The Germans were merchants and
bankers, some from Nuremberg, who had their own
establishment in Venice, the Fondaco dei Tedeschi,
or the Fondaco d'Alemano, as it is called on the large
aerial map of the city made by Jacopo de' Barbari
(c. 1445–1516) in 1500.[3] The altarpiece is the so-called
Feast of the Rose Garlands, which was painted for San
Bartolomeo, the Fondaco church. It is now in Prague
in a pitiable condition.[4]

Dürer made numerous preparatory studies for the
painting on blue Venetian paper, using the brush in
gray ink and white bodycolor, following the practice of
Venetian artists like Vittore Carpaccio (after 1460–before
1525) and the workshop of the Bellini brothers.
Twenty of these studies for the *Feast of the Rose Garlands*
have survived.[5] Dürer followed the same method for
other paintings which he executed in Italy, and
continued to do so when he was back in Nuremberg.

On a drawing with a comparable portrait of a young
woman, also dated 1505, Dürer wrote: "*una vilana
windisch*," a Slovenian peasant woman (fig. a),[6] and it is
assumed that this sheet is of a similar subject. Slovenes
were the Slavonic-speaking population of Southern
Carinthia (also called the Slovenian Marches),[7] which
lay in the present-day North Italian province of Friuli,
opposite Venice. It is not known precisely what route
Dürer took to Venice, or whether he passed through
Carinthia, but it is perfectly possible that he saw and
drew these women in Venice. In a letter of January
1506, he told Pirckheimer that he had been unable to
make many purchases for him, because large numbers of
Germans had scoured the "*Riv*," buying up everything
in sight. The *Riv* is the Riva degli Schiavone, named
after the Slavonic merchants who sold their wares on
the quayside. The watermark on this sheet was
extremely common in the Venice region, so the most
likely explanation is that Dürer saw his subject there.[8]

1. Cf. L. 805b.
2. Rupprich 1956-69, vol. I, pp. 39-60.
3. See the detail from De' Barbari's map in Strauss 1974,
vol. II, p. 840. The building burned down in early 1505,
a new one rising on the same spot over the next few years.
4. See Strieder (1981), ill. 138.
5. Strauss 1974, vol. II, nos. 1505/9-30.
6. London, British Museum; Strauss 1974, vol. II, no. 1505/27.
7. *Brockhaus Enzyklopaedie*, vol. XX, Wiesbaden 1974, s.v.
"Windische"; "Windische Mark."
8. Briquet 1907, vol. I, p. 178, says of this watermark:
"Il est devenu banal dans les États de Venise."

AM

fig. a

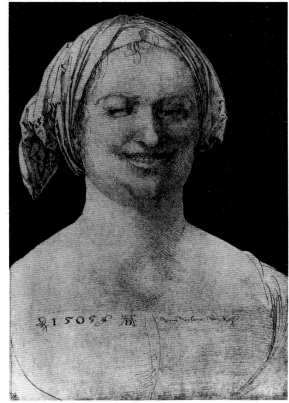

5

Albrecht Dürer
Nuremberg 1471–1528 Nuremberg
THE PIRCKHEIMER COAT OF ARMS; A LARGE AND SMALL
CAPITAL OMEGA

Watercolor and bodycolor, over pen and brown ink,
heightened with gold and white (the white oxidized);
46 × 134 mm. (image)
Watermark: scales, cf. Briquet nos. 2537 (Venice 1489),
2538 (Venice 1495)
Inv. MB 1940/B 3

Provenance: Willibald Pirckheimer; Felicitas Imhoff,
née Pirckheimer, or Barbara Straub, née Pirckheimer;
Willibald Imhoff (Pirckheimer's grandson); Hans Imhoff
Jr; Hans Hieronymus Imhoff (all of Nuremberg);
Thomas Howard, Earl of Arundel, acquired in 1636;
Henry Howard, Duke of Norfolk, received as a bequest
in 1646; transferred in 1677 to the Royal Society,
London; sale London, May 4 1925, no. 8; F. Koenigs,
Haarlem, acquired in 1925; D.G. van Beuningen,
Rotterdam, acquired in 1940 and donated to the
Boymans Museum Foundation.

Not previously exhibited

Literature: E. Rosenthal, "Dürers Buchmalereien für
Pirckheimers Bibliothek," *Jahrbuch der Preussischen
Kunstsammlungen* XLIX, 1928, pp. 17ff., fig. 13;
Tietze 1937, no. W54 (ill.); Panofsky 1945, no. 1717;
V. Thorlacius Ussing, "Den kunstneriske Udsmykning af
Willibald Pirckheimers Boger," *Fund og Forskning* V-VI,
1958-59, pp. 122ff.; Ottino 1968, no. 103j (ill.); Meij
1974, no. 31 (ill.); Strauss 1974, vol. II, no. 1504/48 (ill.);
N. Holzberg, *Willibald Pirckheimer*, Munich 1981, pp. 88,
105; W. Eckert and C. von Imhoff, *Willibald
Pirckheimer: Dürers Freund im Spiegel seines Lebens*,
Cologne 1982, p. 87.

Dürer decorated this first page of Aristophanes' comedy, *Ploutos*, with the coat of arms of his friend Willibald Pirckheimer, which takes the form of a stylized birch tree set within two cornucopias held by two putti.[1] He also colored the large printed omega at the start of the commentary and the ornament at the head of the page.

Pirckheimer was one of the leading German humanists of the first quarter of the sixteenth century. He studied law at Pavia and Padua between 1489 and 1495, and while at the latter university (the only one in Europe with a chair in Greek) he briefly studied Greek language and literature. As a student he began collecting the classical authors, showing a marked preference for the Greek editions published by Aldus Manutius of Venice in the 1490s.

Pirckheimer returned to Germany in 1495 and settled in Nuremberg, where he married Creszentia Rieter. In order to build up his library he relied on friends and acquaintances who were visiting Italy, among them Albrecht Dürer. In 1506, during his second sojourn in Venice, Dürer wrote to Pirckheimer: "Nowhere have I been able to find anything new being printed in Greek."[2]

This edition was published by Manutius in 1498. It contains nine of Aristophanes' eleven comedies, together with detailed commentaries printed in a typeface smaller than the main text. As can be seen from several inked annotations, it is also the copy that Pirckheimer used for his word-for-word Latin translation of *Ploutos*, on which he was working in 1501–03 and later.[3] On fol.ii recto he corrected a printing error, turning a *mu* into a *rho* with pen and brown ink.

Until the seventeenth century, Pirckheimer's library remained in the possession of the descendants of Hans Imhoff, the husband of Pirckheimer's daughter Felicitas. In 1634, financial necessity forced Hans Hieronymus Imhoff, Hans's great-grandson, to sell fourteen books from the library to a Dutchman from Leiden called Matheus Overbeck. According to Imhoff in his *Geheimbuchlein*, Overbeck chose those particular books because "in each one, below the title, there was a painting by Albrecht Dürer."[4]

In 1636 Imhoff sold the remainder of the library to Thomas Howard, Earl of Arundel.[5] Those books, too, contained miniatures by Dürer, some with just the Pirckheimer coat of arms, others with the Rieter coat as well. In 1677, Arundel's library passed to the Royal Society in London, which sold off volumes piecemeal over the next 250 years. In 1925 the residue was sent for auction in London. Pirckheimer's collection is thus scattered among numerous libraries, museums and private collections. The Aristophanes in the Boymans-van Beuningen Museum is from the Arundel Collection.

Although the date and attribution of the miniatures in Pirckheimer's books have been the subject of much controversy over the years, there can be no doubt that the miniatures with both the Pirckheimer and Rieter coats of arms must have been executed between 1495, when the couple married, and 1504, when Creszentia

Rieter died. Those with the Pirckheimer bearings alone were accordingly dated before 1495 or after 1504, depending on their style. It is now known that Dürer and Pirckheimer did not become acquainted before 1495,[6] so all the miniatures with just the Pirckheimer coat of arms can be dated after 1504. That creates no problem in the case of this edition of Aristophanes, which was only published in 1498, so the miniature must post-date 1504. But would it not be better to place most of the miniatures with the solo Pirckheimer coat after Dürer's second visit to Venice, i.e. in the period 1507–10, or perhaps even 1515? The two putti on this page could be the brothers of the three music-making putti in the drawing of the *Holy Family* of *c*. 1510.[7] That would locate these miniatures closer in time to other of Dürer's decorative works of that period, which culminated in the crowning achievement of the 1515 woodcut of Emperor Maximilian's triumphal arch.

Another argument that can be advanced for a late dating is the short span of only fifteen months between Creszentia's death in May 1504 and Dürer's departure for Italy in September 1505. It is doubtful, to say the least, whether he could have found the time amidst all his other work to create miniatures for so many of Pirckheimer's books.

Many have questioned whether all those miniatures are indeed by Dürer, but given the close ties between the two men there is good reason to believe that most of them are. There are only two, in fact, which are so amateurish that they could not possibly be from his hand.[8] Nor is it likely that they originated in his studio, for it is almost inconceivable that he would have passed off such shoddy work on his friend. The miniature in Pirckheimer's copy of Appian certainly seems to have been overpainted at a much later date.

Illumination had traditionally been restricted to manuscripts, but in the second half of the fifteenth century the Venetians also began ornamenting printed books with miniatures, decorative borders and illuminated initials.[9] In many cases, space was expressly left for the miniaturist by omitting the capital letter at the start of a new chapter.[10]

It is safe to assume that Dürer was familiar with books of this kind from his two journeys to Italy. His formal vocabulary in these miniatures is certainly a close match with the *stile all'antica* of the Venetian illuminators, as represented by the miniature by a Veneto-Ferraran artist with the arms of Bishop Zeno of Padua in a 1472 edition of Dante's *Commedia* (fig. a).[11] This retrograde style, which was introduced in Northern Italy around the middle of the century by Andreas Mantegna (1431–1506) and was brought to Venice by the Bellini brothers, employs decorative motifs from classical monuments.

1. In the Nuremberg dialect a *b* was often written as a *p*, turning *Birke* into *Pirke*.
2. Rupprich 1956-69, vol. I, p. 59: "... *ich kan nirgends erfaren, daz man ettwass neus Krichisch getruckt hett.*"
3. Cf. Holzberg (1981), pp. 104ff.
4. Rosenthal (1928), p. 50: "... *in iedwederes under dem titul des buchs Alb. Durer etwas mitt aigenen Haenden gemahlt [hat].*"
5. Ibid., pp. 51ff.
6. Cf. Rupprich 1956-69, vol. I, p. 65f.
7. Basel, Öffentliche Kunsthalle; Strauss 1974, vol. II, no. 1509/4 (ill.).
8. Flavius Josephus, *Opera...*, Verona 1480, Strauss 1974, vol. II, no. 1504/49 (ill.), Berlin, private collection; Appianus, *Historia Romana...*, Venice 1477, Strauss 1974, vol. II, no. 1504/51 (ill.), Rotterdam, Boymans, Van Beuningen Museum.
9. Cf. L. Armstrong, *Renaissance Miniature Painters and Classical Imagery*, London 1981, ch. 1; C. de Hamel, *A History of Illuminated Manuscripts*, Oxford 1986, p. 244.
10. An example is the 1488 edition of Homer in Pirckheimer's library, now in the Boymans-Van Beuningen Museum, containing three capitals drawn and painted by Dürer. The miniature which was originally in the book was later removed.
11. Dante Alighieri, *La Divina Commedia*, Mantua 1472, fol. 1a, Padua, Biblioteca Capitolare, Inc. n.12; cf. C. Mariani Canova, *La Miniatura Veneta del Rinascimento*, Venice 1969, cat. no. 58, fig. 72.

AM

fig. a

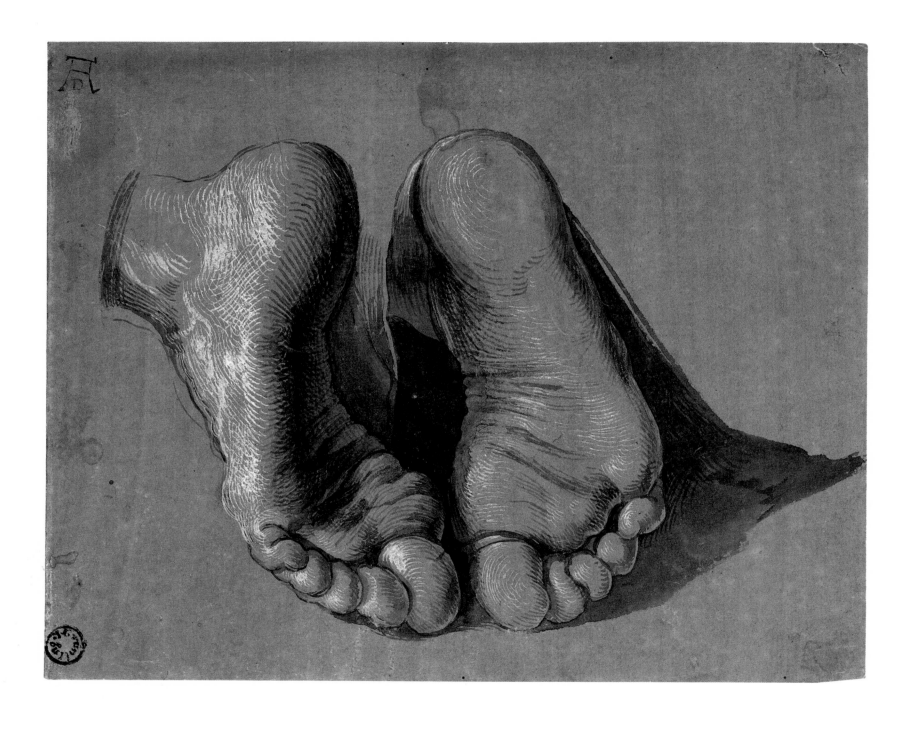

28

6

Albrecht Dürer
Nuremberg 1471–1528 Nuremberg
STUDY OF TWO FEET

Brush and gray ink, gray wash, heightened with white,
on green prepared paper; 176 × 216 mm.
Annotated in pen and black ink: *AD*
Watermark: tall crown, cf. Piccard 1961, no. XII, 5
(1506–14)
Inv. MB 1958/T 24

Provenance: J. Grünling, Vienna (L. 1107); A. Ritter von
Franck, Graz (L. 947); E. Habich, Kassel; his sale,
Stuttgart, April 27 1899, no. 235; Comtesse de Béhague,
Paris; D.G. van Beuningen, Rotterdam, acquired in
1939; acquired by the museum in 1958 with the Van
Beuningen Collection.

Exhibitions: Boston 1888-89, no. 279; New York 1889,
no. 4; Rotterdam 1949, no. 163; Paris 1952-II, no. 204
(ill.).

Literature: Heller 1827, p. 125, no. 26; M. Thausing,
"Der Hellersche Altar von Dürer und seine berreste zu
Frankfurt a/d M.," *Zeitschrift für Bildende Kunst* VI,
1871, p. 98; C. Ephrussi, *Étude sur le triptyque d'Albert
Dürer dit le tableau de Heller*, Paris 1876, pp. 11, 16 (ill.);
C. Ephrussi, "Les Dessins d'Albert Dürer," *Gazette des
Beaux-Arts* XVI, no. 2, 1877, p. 540 (ill.); Ephrussi 1882,
p. 152; M. Thausing, *Dürer*, Leipzig 1884, p. 18;
A. Wölfflin, *Albrecht Dürer Handzeichnungen*, Munich
1923, p. 15 (ill.); H. Weiszäcker, *Die Kunstschätze des
ehem. Dominikanerklosters in Frankfurt*, Munich 1923,
pp. 199, 205; K.T. Parker, *Drawings of the Early German
Schools*, London 1926, no. 26; Flechsig 1931, pp. 310,
572, no. 562; Tietze 1937, p. 47, no. 380 (ill.); Winkler
1936-39, vol. II, no. 464 (ill.); Panofsky 1945, no. 496;
Hannema 1949, no. 163 (ill.); Musper 1952, p. 180 (ill.);
Winkler 1957, p. 204; Rupprich 1956-69, vol. II, p. 321;
Hütt 1970, p. 523 (ill.); C. White, *Dürer: the Artist and
His Drawings*, London 1971, p. 124, fig. 48; W. Stechow,
Dürer in America, Washington 1971, p. VII; Meij 1974,
no. 26 (ill.); Strauss 1974, vol. II, no. 1508/12 (ill.).

It was probably in the summer of 1507, six months after
Dürer's return to Nuremberg from his second visit to
Venice, that Jakob Heller (*c.* 1460–1522), a wealthy cloth
merchant of Frankfurt, asked him to paint an altarpiece
for the city's Dominican church. In August, Dürer
wrote to tell Heller that he had not yet started work,
because he had to finish another assignment first. In
March 1508, he informed Heller that he would begin
on the altarpiece in a fortnight, and promised "to paint
the central panel myself, and shall take great pains with
it."[1] At the end of August he announced that the
preparatory work on the central panel had reached the
point where he was ready to begin the underpainting,
and added: "For some time I have been working
diligently on the designs for the central panel."[2] The
altarpiece was finally completed in August 1509, and
was carefully packaged and sent to Frankfurt. Patron
and painter kept in touch after the work was finished,
and in 1520 they met in Frankfurt, as Dürer was about
to embark for the Netherlands. "Also, Jakob Heller
bought me wine at the inn," Dürer noted in his diary.[3]

The altarpiece, and above all the central panel which
was the subject of this correspondence, is the so-called
Heller Altarpiece, a triptych with Dürer's *Assumption and
Coronation of the Virgin* flanked by wings painted on
both sides by studio assistants.[4]

The *Heller Altarpiece* remained in the Dominican
church until 1614, when Elector Maximilian I of
Bavaria (1573–1651), an avid collector of Dürer's
paintings, bought the main panel and installed it in his
Munich residence. In 1729 it was destroyed by fire, and
today it is only known from a painted copy by Jobst
Harrich (1580–1617). This was executed as a
replacement shortly before the original was taken to
Munich (fig. a),[5] and so is presumably a faithful copy. At
the top, the Virgin is being crowned by God the Father
and Christ, while on earth the twelve apostles either
stand or kneel in an extensive landscape around her
empty tomb. Dürer himself can be seen in the left
background.

In the summer of 1508, when Dürer told Heller that
he was about to start on the underpainting, he also
mentioned that he had been working on the design.
This is probably a reference to the detailed preliminary
studies, of which twenty still exist, some signed and
dated 1508.[6] This drawing of two feet is one of that
group. It is a study for the feet of the kneeling apostle
seen from the back, just to the right of the tomb, who
is traditionally identified as St Peter. A study for his left
hand also survives.[7] Dürer made these drawings on large
sheets of paper measuring approximately 40 × 30 cm,
with several studies to each sheet. Most of them were
later cut into smaller fragments.

All these detailed preliminary drawings were executed
in the same technique: brush in gray ink, heightened
with the brush in white, on green or, in two cases, blue
prepared paper. It was a method which Dürer had
adopted during his second stay in Venice (1505–07)

fig. a

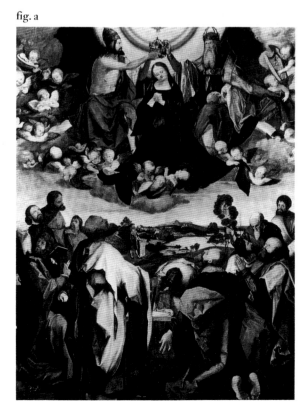

from such Venetian painters as Vittore Carpaccio (after 1460–before 1525).[8] The Venetians, however, used blue paper known as *carta azurra* or *carta turca*, which was introduced from Byzantium.[9] Dürer used that paper for his design drawings while in Venice,[10] but since it was unavailable in Northern Europe he later had to make do with white paper, to which he added a green or blue ground.

It was probably in Italy that he also saw the motif of the heavily foreshortened feet of the kneeling apostle. In a *Resurrection* of *c.* 1465 by Andrea Mantegna (1431–1506), which formerly hung in the ducal palace at Mantua, there is a kneeling, barefoot apostle seen from the rear (fig. b).[11] The feet in Mantegna's painting are so similar to those of Dürer's apostle as to virtually rule out coincidence. It is impossible to say for certain whether Dürer ever visited Mantua. There is no mention of it in his letters to Pirckheimer, but against that there is the story told by Dürer's younger contemporary, Joachim Camerarius (1500–74), the philologist and, from 1526, teacher of Greek at the gymnasium in Nuremberg. In the introduction which he wrote for Dürer's manual on human proportion in 1532, Camerarius relates that when the ailing Mantegna heard that Dürer was in Italy, he asked if they could meet. Dürer immediately abandoned the work he was doing and went to Mantua, only to find that Mantegna had died.[12]

Dürer's rendering of the apostle's feet in the *Heller Altarpiece* was famous in the sixteenth, seventeenth and eighteenth centuries. Karel van Mander (1548–1606), for instance, mentioned the motif in his biography of the artist. "Among other things admired and highly esteemed by the people is the heel and sole of a foot of a kneeling apostle, and it is said that much money was offered to have it removed."[13] This was a perfectly serious, literal proposal that the feet should be sawn out of the panel. The same story is found in a document in the Heller archives in Frankfurt, which records that an Italian was prepared to pay 100 crowns for the feet alone.[14] Dürer later repeated them in other works, such as his 1510 woodcut of the *Coronation of the Virgin* (fig. c).

The fact that this sheet was once owned by Joseph Grünling (1785–1845), a Viennese collector and art dealer, suggests that it came from the collection of Dürer drawings belonging to Duke Albert of Saxony (1739–1822), which today forms the core of the Graphische Sammlung Albertina in Vienna. In the first quarter of the nineteenth century, during the curatorship of François Lefèbvre (1762–1835), several hundred Dürer drawings disappeared from the duke's collection.[15]

In 1888/89 this study was in the United States, along with seven other drawings by Dürer, six of which were certainly autograph. They were first exhibited in the Museum of Fine Arts in Boston before being offered for sale in a New York gallery, but to the great disappointment of the dealers, not a single sheet was sold.[16] Only one drawing from the group was acquired by an American museum, but that was only eighty years later, when the Cleveland Museum of Art bought the large sheet with Eve's arm, which was executed in 1507.[17]

1. Rupprich 1956-69, vol. I, p. 65: "... *das mitler blat mit meiner aignen hand fleisig [zu] mallen.*" All that remains of the correspondence between Heller and Dürer are copies of nine of the latter's letters to his patron. The location of the originals is unknown.
2. Ibid., p. 66, "... *das corpus hab ich mit gar groszem fleiss entworfen mit laenger zeut.*"
3. Ibid., p. 149: "*Auch schenket mir heer Jakob Heller den wein in die herberg.*"
4. The latter are now in the Historisches Museum, Frankfurt. It is generally believed that the wings were painted by Dürer's brother Hans. In Frankfurt a few years later, Heller had a further two wings added by Grünewald. For a reconstruction of the entire altarpiece see W. Lücking, *Mathis: Nachforschungen über Grünewald*, Berlin 1983, pp. 38ff.
5. Rupprich 1956-69, vol. I, p. 63; Anzelewsky 1980, fig. 129.
6. Strauss 1974, vol. II, nos. 1508/1-19 (ill.).
7. Vienna, Graphische Sammlung Albertina; see W. Koschatzky and A. Strobl, *Die Dürer Zeichnungen der Albertina*, Salzburg 1971, cat. 71 (ill.).
8. An example is no. 55 in the present catalogue.
9. J. Meder, *The Mastery of Drawing*, ed. W. Ames, vol. I, New York 1978, pp. 140ff.
10. See, for example, the twenty or so extant preliminary studies for the *Feast of the Rose Garlands*; Strauss 1974, vol. II, nos. 1506/9-30.
11. Now in the Uffizi, Florence; cf. R. Lightbown, *Mantegna*, Oxford 1986, cat. no. 16, fig. 51.
12. See H. Lüdecke and S. Heiland, *Dürer und die Nachwelt*, East Berlin 1955, p. 53.
13. Van Mander 1604, fol. 209r: "*Daer is onder ander onder den volcke in verwonderen, en groot achten, eenen voet, hiele en plant, eens knielenden Apostels, daer men seght veel geldt voor is gheboden, om den selven te moghen uytnemen.*" The standard Dutch dictionary, *Woordenboek der Nederlandsche Taal*, does not give the word *uytnemen* (to remove or take out) in the sense of copying, which is how it is sometimes interpreted. Van Mander undoubtedly saw the *Heller Altarpiece* in Frankfurt on his way home from Prague. In 1577 he was in Nuremberg, where he examined paintings by Dürer, and he would certainly have continued his journey back to Holland by way of Frankfurt; cf. Van Mander, op. cit. fol. 209b.
14. Rupprich 1956-69, vol. II, p. 321.
15. See Koschatzky and Strobl, op. cit. (note 7), pp. 64-74.
16. Cf. Stechow (1971), p. VII: "...one is appalled at the thought of what this country could have gained then and there if somebody with a combination of enthusiasm, courage and money had taken hold of them."
17. Strauss 1974, vol. II, no. 1507/1 (ill.).

AM

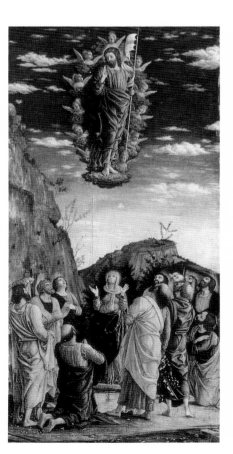

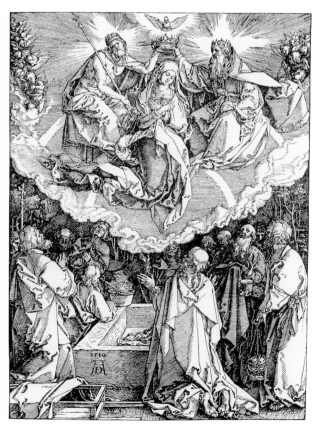

figs. b & c

7

Albrecht Dürer
Nuremberg 1471–1528 Nuremberg
STUDY SHEET WITH A SEATED WOMAN AND A MAN'S HEAD

Pen and brown ink; 246 × 136 mm.
Annotated in pen and brown ink: *AD*
Verso: *Two Construction Drawings for an Octagon*, pen
and brown ink
Annotated in pen and brown ink: *1...8 and a...b*
No watermark
Inv. MB 1955/T 2

Provenance: H. Lubomirski, Vienna; Lubomirskimuseum,
Lemberg (Lvov); acquired by the museum in 1955.

Not previously exhibited

Literature: H.S. Reitlinger, "An Unknown Collection of
Dürer Drawings," *Burlington Magazine* I, 1927, p. 159,
fig. IIIb; F. Winkler, "The Unknown Collection of
Dürer Drawings at Lemberg," *Old Master Drawings* II,
1927-28, p. 17; Tietze 1928, vol. I, no. A 107 (ill.);
M. Gebarowicz and H. Tietze, *Albrecht Dürers
Zeichnungen im Lubomirski Museum in Lemberg*, Vienna
1929, no. 18, fig. XX; Flechsig 1931, no. 834; Tietze
1937, no. 471 (ill.); Winkler 1936-39, vol. III, no. 550
(ill.); Panofsky 1945, no. 1474; Haverkamp Begemann
1955, p. 85, figs. 8, 9; Hütt 1970, p. 618 (ill.); Meij
1974, no. 28 (ill.); Strauss 1974, vol. III, no. 1514/12
(ill.); A. Dürer, *The Painter's Manual*, ed. W.L. Strauss,
New York 1977, p. 145, fig. p. 447.

In 1511, and again in 1514, Dürer made no fewer than
ten drawings in pen and brown ink of the Virgin and
Child, some also containing secondary figures like
Joseph, St Anne, angels and other saints.[1] All these
drawings display a very spontaneous, sketch-like style of
drawing, with special emphasis on the folds of the
Virgin's garment and the effect of light and shadow.
The seated female figure in this sheet (the bench on
which she sits is indicated with a few cursory lines) is a
study for one of these groups. It is uncertain whether it
dates from 1511 or 1514.

On the verso Dürer made two construction drawings
for an octagon (fig. a), using a ruler and compasses, the
puncture marks of which are still visible. His fascination
with geometry, which he considered "the very
foundation... of all painting,"[2] is shown by his purchase

figs. a & b

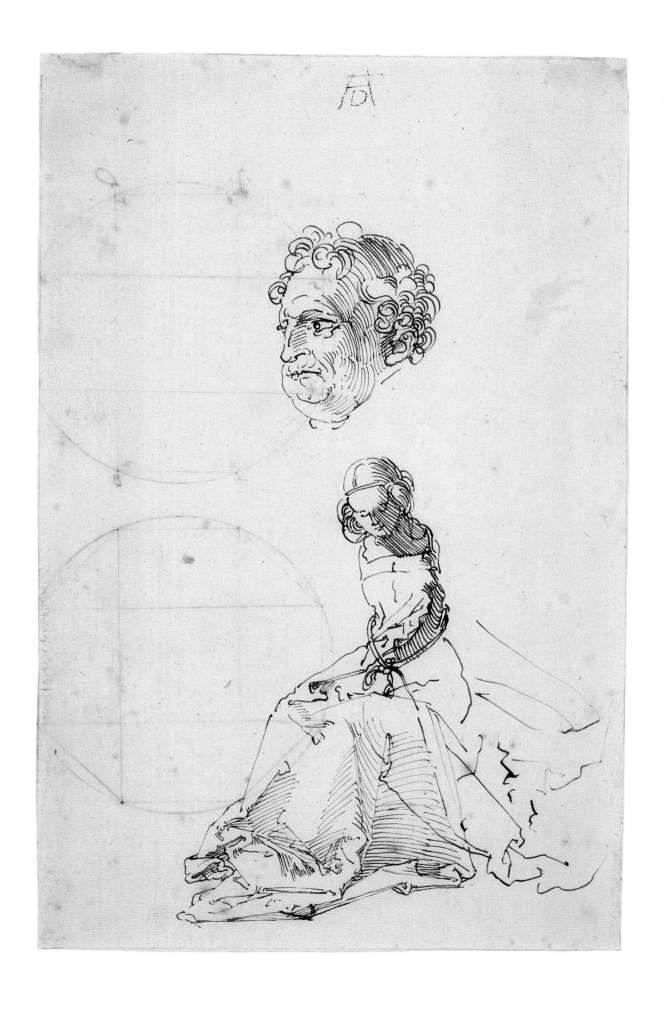

of Euclid's *Opera*, published in Venice in 1505, which he bought there in 1507 for one ducat.[3] In 1525 he published his *Underweyssung der Messung*, which had been twenty years in the writing. The surviving drawings for that book include a construction for an octagon, but it is very different from the one on the verso of the Rotterdam sheet.[4]

Dürer set out to construct two octagons, one above the other, both with a horizontal side at the top. He started by placing a ruler on the piece of paper and selecting two points, through which he established vertical and horizontal axes. Those axes cannot be seen on the sheet, but raking light reveals six indentations left by a hard object, possibly an etching needle. The other two were on the piece of paper which was cut from the left of the sheet. The points thus found are the vertices of two squares. Dürer drew circles through those points, which he divided into eight and then sixteen with compasses and a rectangle, giving him the vertices of a sixteen-sided figure. By linking those vertices with straight lines he finally found an octagon with a horizontal side at the top. The compass construction lines were on the piece of paper which has been cut from the sheet. It is not clear why Dürer drew the diagonals of the octagon but deliberately omitted the diameters of the circles.[5]

This is one of the twenty-five Dürer drawings which were discovered in 1927 in the Ossolinski Institute in Lemberg (present-day Lvov), which housed the Lubomirski Museum.[6] It is believed that, like the previous sheet, they were originally in the collection of Albert of Saxony, and that they came to Prince Heinrich Lubomirski (1777-1850) via Lefebvre.[7]

1. Strauss 1974, vol. III, nos. 1511/1, 3, 6-13; 1514/2, 3, 4, 6-10, 12-13.
2. From the introduction to A. Dürer, *Underweyssung der Messung*, Nuremberg 1525, fol. 1r: "... *die recht grundt... aller malerey.*"
3. Cf. Dürer, ed. Strauss (1977), p. 13, fig. 2.
4. Ibid., p. 144.
5. There may be some connection with Dürer's construction of a cube, cf. ibid., p. 322.
6. Reitlinger (1927), p. 153.
7. Cf. W. Koschatzky and A. Strobl, *Die Dürer Zeichnungen der Albertina*, Salzburg 1971, p. 82.

AM

Vn schickt es sich am negsten ein 8 eck zů machen/dem thůe also/ Nym den obgemachtenn zirckelriß/vnd behalt darinn die seiten.b.d.vnd teil die zirckellini darzwischen in zwey teyl/ in disen puncten setz ein.f.Darnach reiß.f.d.gerad zůsamen/ diß wirdet ein seiten eins achten eckes im zirckel herum/Nun begibt sich ein.16.eck. so du die zirckellini.f.d.mit eim punckt.g. entzwey teylst/vnd.g.d.zůsamen reist/die ist ein seyten eins.16.ecks/das im zirckel herumb langt/wie ich das in disen dreyen figuren hie vnden hab aufgeryssen.

fig. a

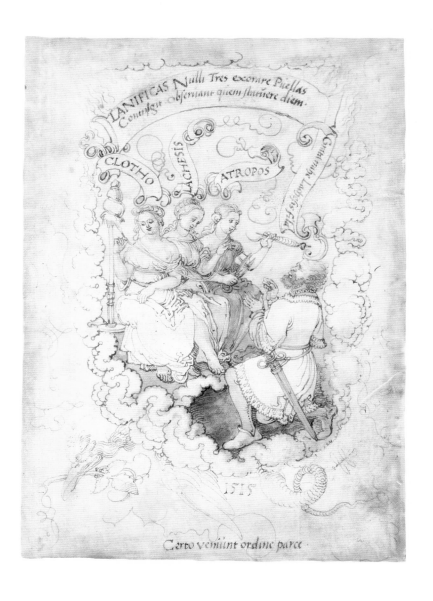

8

Albrecht Dürer
Nuremberg 1471–1528 Nuremberg
THE THREE FATES

Pen and brown ink, watercolor, on vellum;
144 × 102 mm.
Dated in pen and brown ink: *1515*
Annotated in pen and brown ink:
LANIFICAS Nulli Tres exorare Puellas
Contingit obseruant quem statuere diem.
CLOTHO LACHESIS ATROPOS
Grata trahe Lachesi fila
Certo vernunt ordine parce
Inv. MB 1987/T 34

Provenance: J.G. von Quandt, Leipzig and Dresden; his sale, Dresden, October 1 1860, no. 43; F. Koenigs, Haarlem (L. 1023a), acquired in 1925 (inv. D I 21); D.G. van Beuningen, Rotterdam, acquired in 1940; in 1941 acquired for the Hitler Museum, Linz, and removed to Dresden; returned to the Netherlands by East Germany in 1987; on loan from the Rijksdienst Beeldende Kunst (Netherlands Office for Fine Arts), The Hague (inv. NK 3554).

Exhibitions: Nuremberg 1928-II, no. 313; Dresden 1986, no. 6, fig. 10; Rotterdam 1987, no. 17 (ill.).

Literature: A. von Zahn, "Eine Zeichnung von Albrecht Dürer," *Archiv für Zeichnende Künste* X, 1864, pp. 286-87; F. Winkler, "Eine Pergamentmalerei Dürers," *Festschrift der internationalen Dürerforschung*, Leipzig, Berlin 1928, pp. 42ff., fig. 1; Winkler 1936-39, vol. III, no. 705 (ill.); Flechsig 1931, p. 462; Tietze 1938, no. A 315 (ill.); Panofsky 1945, no. 943; Rupprich 1956-69, vol. I, p. 74; Winkler 1957, p. 290, fig. 142; Hütt 1970, p. 846; Strauss 1974, vol. III, no. 1515/63 (ill.); Elen 1989, no. 154.

Seated in the clouds and borne on the back of a flying dragon are the three Fates, the arbiters of man's destiny and his daily existence. Clotho spins the thread of life, which Lachesis passes to Atropos, who snips it in two with a pair of shears. The banderole above them proclaims that "No one has ever swayed the three wool-spinners with entreaties. They observe the appointed day." Kneeling before the Fates is one such vain supplicant: "O Lachesis," he implores, "for my joy and gratitude, draw out the thread." But beneath the scene is the warning, "The Fates work to an immutable law," and the thread of life is severed.

The drawing is related to four others which Dürer executed on vellum.[1] One, the pendant of this sheet, originally showed a satyr playing the pan-pipes and a young woman holding a dice shaker and a pair of scales. Now, however, it is so faded that all that remains is the coat of arms, which was done in gouache. The subject is known only from the engraving which Ludwig Friedrich (1827–1916) made of it in 1864 (fig. a). It is not clear whether there was ever a sixth sheet, which would have completed a series of three pairs. One of each surviving pendant pair is set on earth, its companion in a "celestial" sphere framed by clouds. The Rotterdam and Vienna sheets are linked by the subject of life's transience and the uncertainty of human existence. The drawings in London (figs. b, c) depict a "heavenly" and earthly Carrying of the Cross. The fifth sheet, in Weimar, shows a man kneeling at a lectern in prayer (fig. d), but the subject of its presumed pendant can only be surmised. Judging by the inscription, it might have been an archangel, Michael perhaps.[2]

fig. a

fig. b

fig. c

fig. d

The coat of arms on each of the earthly pendants is that of Lorenz Spengler (1479–1534), the humanist and long-serving secretary to the Nuremberg city government. Dürer and Spengler were close friends, and it can be assumed that the latter wrote the Latin texts for this sheet. The drawings were very probably pasted into an album, the pagination of which might have been as follows. Page 2: the man praying, page 3: the missing drawing, page 4: the three Fates, page 5: the faded drawing in Vienna, and on pages 6 and 7 the two drawings of the Carrying of the Cross in London.

The Rotterdam and Vienna drawings are both dated 1515, and given the iconographic relationship between all five, this seems the likely date for the other three sheets as well.[3] At that time, Dürer and other artists were working on an important commission for Emperor Maximilian – providing the border decoration for his personal prayer-book, which had been printed at Augsburg in 1514. Dürer decorated the margins in pen and ink of various colors with an assortment of religious, allegorical and genre-like scenes framed by elaborate ornaments.[4] He was also working on other projects for Maximilian, among them the woodcuts of the emperor's triumphal arch and triumph.

These works, and their style of execution, exerted a particularly strong influence on German artists in the first half of the nineteenth century, especially on Peter Cornelius (1783–1867) and Ludwig Richter (1803–84), who deliberately sought to emulate the style Dürer was employing around 1515.[5] They were undoubtedly stimulated in their efforts by the lithographs after the drawings in Maximilian's prayer-book, which Alois Senefelder (1771–1834) published in Munich in 1808. It emerges from a letter which Cornelius wrote to Goethe in 1811 that he had Dürer's *Randzeichnungen* in his studio (the lithographs, of course).[6] In 1809, a friend of Cornelius wrote saying that he was very curious to discover what was meant by "*Dürerischer Art*," which was the direction that Cornelius wished to explore.[7] Three of the five drawings in this cycle for Spengler may also have played a part in this development, for at the time the Rotterdam and Vienna sheets belonged to J.G. von Quandt (1787–1859) of Dresden, which was where Richter also lived and worked. Quandt was an art historian and a collector of prints and drawings, and he is known to have associated with artists.[8] There can be no doubt that someone like Richter, who was a professor at the Dresden art academy from 1835, would have seen these original drawings.

1. They are *Christ Carrying the Cross* and *A Man Carrying the Cross*, London, British Museum, Strauss 1974, vol. IV, nos. 1525/7-8 (ill.); a *Kneeling Man*, Weimar, Schlossmuseum, ibid., no. 1525/6 (ill.); and a *Young Woman and a Satyr*, Vienna, Albertina, ibid., vol. III, no. 1515/62 (ill.).
2. Winkler has suggested that the copy of a Dürer drawing of *Christ as the Man of Sorrows* in Erlangen, Universitäts-bibliothek, could be after the missing sheet; cf. Winkler 1936-39, vol. IV, p. 95, note 2, ill. in ibid., vol. III, Anhang Tafel XI.
3. See ibid., vol. III, pp. 103ff., and vol. IV, p. 95. Until 1822 the drawing now in Weimar was in the Von Leyser Collection, also in Dresden. Winkler dated the London and Weimar sheets after 1520, but J.K. Rowlands, *The Age of Dürer and Holbein*, London 1988, nos. 66 a, b (ill.), puts them around 1515.
4. Strauss 1974, vol. III, nos. 1515/1-45 (ill.).
5. On Dürer and Richter see K.-H. Weidner, *Richter und Dürer*, Frankfurt 1983.
6. [A. Kuhn], *Goethes Faust*, Eltville 1976, p. XV.
7. Cf. H. Lüdecke and S. Heiland, *Dürer und die Nachwelt*, East Berlin 1948, p. 164.
8. Cf. Winkler 1936-39, vol. III, p. 104.

AM

9

Mathaeus Grünewald
Mathis Gothart Nithart (?)
c. 1470/80–1528 Halle [1]
VIRGIN AND CHILD IN THE CLOUDS

Black chalk, the entire sheet washed with gray,
watercolor and bodycolor; 322 × 268 mm.
Upper right, in pen and brown ink: *menz*; lower left,
in pencil: *N: 176.*
Verso, in red chalk: *135*
Watermark: coat of arms with a crowned R between
two fleurs-de-lys, cf. Briquet nos. 8992-94
Inv. MB 1958/T 29

Provenance: F.K. von Savigny; F. Koenigs, Haarlem
(L. 1023a), acquired in 1925 (inv. D I 42); D.G. van
Beuningen, acquired in 1940; acquired by the museum
in 1958 with the Van Beuningen Collection.

Exhibitions: Haarlem 1926, no. 26 (ill.); Rotterdam 1938,
no. 284 (ill.); Amsterdam 1939, no. 3; New York etc.
1939-40; Rotterdam 1949, no. 167 (ill.); Delft 1949,
no. 128; Paris 1952-II, no. 208 (ill.).

Literature: M.J. Friedländer, *Die Grünewaldzeichnungen
der Sammlung von Savigny*, Berlin 1926, pp. 11, 9, no. 7
(ill.); C. Glaser, "Die Grünewald-Zeichnungen der
Sammlung von Savigny," *Kunst und Künstler* XXIV,
1925-26, p. 290; M.J. Friedländer, *Die Zeichnungen von
Matthias Grünewald*, Berlin 1927, no. 17; M. Escherich,
"Bildnisse von Grünewald," *Zeitschrift für Bildende Kunst*,
1928-29, p. 118, fig. p. 119; H. Feurstein, *Matthias
Grünewald*, Bonn 1930, p. 142, fig. 78; F. Knapp,
Grünewald, Bielefeld, Leipzig 1935, pp. 38, 46, fig. 43;
W. Fraenger, *Matthias Grünewald in seinen Werken*,
Berlin 1936, fig. p. 144; A. Burkhard, *Matthias
Grünewald*, n.p. 1936, p. 70, fig. 84; W.K. Zülch,
Der historische Grünewald, New York 1938, no. 34 (ill.);
A. Behne, *Alte deutsche Zeichnungen*, Berlin 1942, fig. 179;
G. Schoenberger, *The Drawings of Mathis Gothart called
Grünewald*, New York 1948, pp. 14, 16, 38, fig. 29;
K.G. Boon, "Tekeningen uit de Elzas," *Maandblad voor
Beeldende Kunsten* XXV, 1949, p. 123, fig. p. 112;
Hannema 1949, no. 167, fig. 205; Friedländer 1949,
p. 152; O. Fischer, *Geschichte der deutschen Zeichnung und
Graphik*, Munich 1951, pp. 269ff.; F. Winkler, *Die
grossen Zeichner*, Berlin 1951, p. 43, fig. 25; idem, "Die
Mischtechnik der Zeichnungen Grünewalds," *Berliner
Museen* N.F. II, 1952, pp. 34ff.; K. Dittmann, *Die Farbe
bei Grünewald*, diss. Munich 1955, p. 131; L. Behling,
*Die Handzeichnungen des Mathis Gothart Nithart, genannt
Grünewald*, Weimar 1955, pp. 53ff., 76, no. 26,
fig. XXIV; G. Jacobi, *Kritische Studien zu den
Handzeichnungen von Matthias Grünewald*, diss. Cologne
1956, pp. 92ff.; N. Pevsner, M. Meier, *Grünewald*, New
York 1958, no. 34 (ill.); A. Weixelgärtner, *Grünewald*,
Munich 1962, pp. 99, 119, fig. 53; W. Brücker, "Mathis

Gothart Neithardt genannt Grünewald in der neueren
Forschung," *Kunst in Hessen und am Mittelrhein* III,
1963, p. 58, no. 25 (ill.); W. Hütt, *Mathis
Gothardt-Neithardt genannt "Grünewald"*, Leipzig 1968,
p. 143, fig. 98; L. Behling, *Matthias Grünewald*,
Königstein im Taunus 1969, p. 20, fig. 86; E. Ruhmer,
Grünewald Drawings, London 1970, p. 23, fig. 37,
no. XXXI; F. Baumgart, *Grünewald: tutti i disegni*,
Florence 1974, no. XXI (ill.); Meij 1974, no. 36, (ill.);
H.J. Rieckenberg, *Matthias Grünewald*, Ammersee 1976,
no. 11a, fig. 14b; W. Lücking, *Mathis: Nachforschungen
über Grünewald*, Berlin 1983, pp. 172ff., fig. 128;
W. Fraenger, *Matthias Grünewald*, Dresden 1983, p. 294,
fig. 138.

The title of this drawing is taken from Jakob von
Sandrart's *Teutsche Academie* of 1675. In his biography of
Grünewald, the painter, sculptor and architect, he gives
a quite lengthy description of three paintings which had
hung in Mainz Cathedral until the early 1630s.
Speaking of the picture with which this drawing is
generally associated, he says: "Our Lady with the Christ
Child in the clouds, while below, many saints wait
gracefully, among them Sts Catherine, Cecilia,
Elizabeth, Apollonia and Ursula, all so nobly, naturally,
charmingly and truly drawn, and in such beautiful
colors, that they appear to be in heaven rather than on
earth." [2] According to Sandrart, all three paintings were
looted by Swedish troops in 1632 or 1633, and went
down with the ship carrying them to Sweden.

The inscription *menz* (the local dialect word for
Mainz) by a late sixteenth-century hand, indicates that
this sheet was very probably a preliminary study for the
Mainz picture. The writer was evidently well-acquainted
with Grünewald's *œuvre*, for on a preliminary study for
the *Isenheim Altarpiece* he wrote "*Isenaw*", and he
annotated a drawing for a lost altarpiece from the
Dominican church in Frankfurt with the word
"*frankfürt*". [3] The date of the Rotterdam drawing is
uncertain, but it probably originates from around 1520.
That, at least, is the date on a copy of the second
Mainz painting described by Sandrart. It too is now
lost, but in the nineteenth century it was seen and
described by the German connoisseur and collector,
Sulpiz Boisserée. [4]

There are two other drawings which can be linked
with the *Altarpiece of the Virgin* in Mainz. Occupying the
recto and verso of a single sheet, one shows
St Catherine, who has her feet firmly planted on earth,
the other an unidentified female saint (figs. a, b). [5]

The Rotterdam drawing is generally considered to
represent the Virgin as the Woman of the Apocalypse
described in the book of Revelation. [6] That, though,
would require her to be standing on a crescent moon. If
the drawing is seen instead in the light of Sandrart's
description of the painting, it becomes more likely that
she is depicted in her role as Queen of Heaven or
Queen of All Saints. [7] There is an interesting passage
from a sermon by Bernard of Clairvaux which reads:

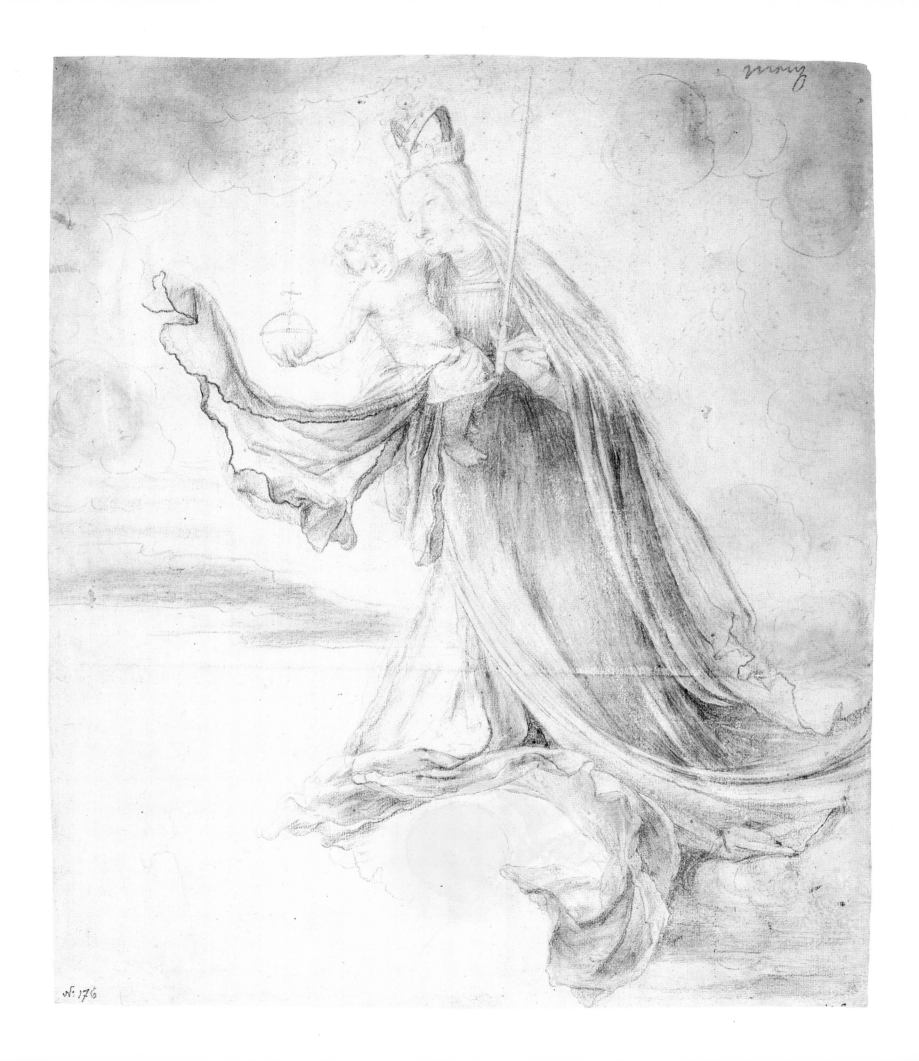

"You vest Him with your flesh and He vests you with the glory of His majesty. You vest the sun with a cloud, and you are vested by the sun."[8]

There are some thirty extant drawings by Grünewald, all executed in black chalk, and some with a sparing use of color. For this sheet he used a hard variety of natural chalk, the roughness of which accounts for the scratches in the Virgin's robe. It can also be seen that he originally placed the Child's hand lower down.

The Rotterdam drawing comes from a *Klebe-Band* (an album with a large number of drawings by different artists) belonging to the German jurist Von Savigny (1779–1861). In 1926 it was published by Friedländer together with six other Grünewald drawings from the same source.[9]

1. The name Grünewald first appears on the spine of an album of 1637 containing woodcuts signed MG, now in the British Museum, London; cf. J.K. Rowlands, *The Age of Dürer and Holbein*, London 1988, p. 149. Later, in 1675, Sandrart gave the name of the painter of the *Isenheim Altarpiece* and other works as Mathaeus Grünewald. Zülch identified this Grünewald with Mathis Gothart Nithart, a painter known only from archive sources. This was followed by Rieckeberg, who equated him with another archive figure, Mathis Grün, but that was in turn contested by W. Hütt and others. See Fraenger (1983), pp. 330ff., and W. Deyhle, "Zu Mathis Grün und Mathis Nithart oder Gothart," *Zeitschrift des Deutschen Vereins für Kunstwissenschaft* XXXIII, 1979, pp. 29ff.

2. J. von Sandrart, *Teutsche Academie...*, vol. II, pt. 3, Nuremberg 1675, fol. 236: "*... unsere liebe Frau mit dem christkindlein in der Wolke, unten warten viele Heiligen in sonderbarer Zierlichkeit auf, als S. Catharina, Caecilia, Elisabetha, Apollonia und Ursula/alle dermassen adelich/natürlich/holdselig und correct gezeichnet/ auch so wol colorirt/dass sie mehr im Himmel als auf Erden zu seyn schienen.*"

3. Lücking (1983), p. 175.

4. E. Firmenich-Richartz, *Die Brüder Boisserée*, vol. I, Jena 1916, p. 496.

5. Ruhmer (1970), nos. XXXII and XXXIII; Kupferstichkabinett, Berlin-Dahlem.

6. Revelation 12:1.

7. See E. Guldan, *Eva und Maria*, Graz, Cologne 1966, pp. 82, 103; Kirschbaum 1968-76, vol. III, col. 192.

8. Cf. Fraenger (1983), p. 299, note 52.

9. Now in the Kupferstichkabinett, Berlin-Dahlem.

AM

fig. a

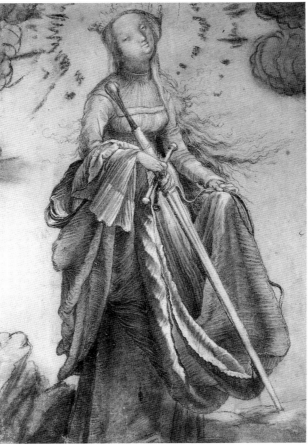

fig. b

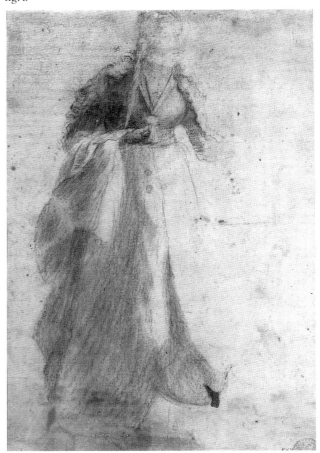

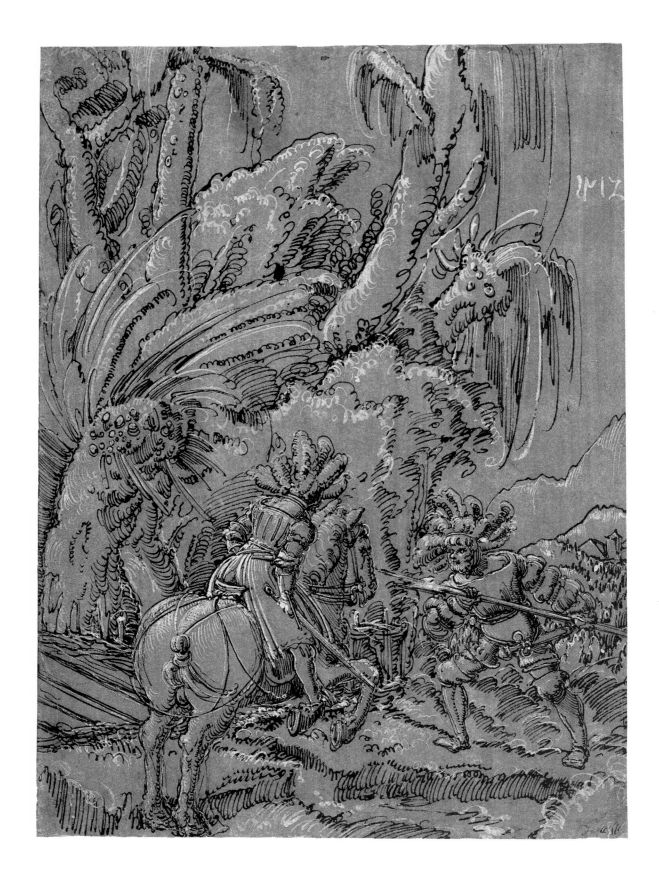

40

10

Albrecht Altdorfer
Regensburg c. 1480–1538 Regensburg
COMBAT BETWEEN A MOUNTED KNIGHT AND A
LANDSKNECHT

Pen and black ink, heightened with white, on greenish
brown prepared paper; 219 × 157 mm.
Dated with the brush in white bodycolor: *1512*
Watermark: anchor in a circle (partly visible)
Inv. MB 248

Provenance: F.J.O. Boijmans, bequest of 1847 (L. 1857).

Exhibitions: Munich 1938, no. 99; Paris 1984, cat. no. 9,
fig. 24; Berlin, Regensburg 1988, no. 61 (ill.).

Literature: cat. Rotterdam 1852, no. 406 (H. Hopfer);
cat. Rotterdam 1869, no. 284 (H. Hopfer);
M.J. Friedländer, *A. Altdorfer*, Berlin 1923, p. 64;
H. Tietze, *Albrecht Altdorfer*, Leipzig 1923, p. 86;
H.L. Becker, *Die Handzeichnungen Albrecht Altdorfers*,
Munich 1938, no. 58; L. Baldass, "Albrecht Altdorfers
künstlerische Herkunft und Wirkung," *Jahrbuch der
Kunsthistorischen Sammlungen in Wien* N.F. XII, 1938,
p. 149, note 59; F. Winzinger, *Albrecht Altdorfer
Zeichnungen*, Munich 1952, cat. no. 30 (ill.); O. Benesch
and E.M. Auer, *Die Historia Friderici et Maximiliani*,
Berlin 1957, cat. no. 24, p. 131; K. Oettinger, *Datum und
Signatur bei Wolf Huber und Albrecht Altdorfer*, Erlangen
1957, pp. 20, 60; K. Arndt, "Karl Oettinger, Datum und
Signatur bei Wolf Huber und Albrecht Altdorfer,
Erlangen 1957," *Kunstchronik*, 1958, p. 227;
K. Oettinger, *Altdorfer Studien*, Nuremberg 1959, p. 110,
fig. 35; K. Oettinger, "Ein Altdorfer Schüler: Der
Zeichner der Pariser Landsknechts," *Festschrift
F. Winkler*, Berlin 1959, p. 201, fig. 1; Meij 1974, no. 19
(ill.).

With Wolf Huber (*c.* 1485–1553), Altdorfer is the most
important representative of what is rather arbitrarily
classed as the Danube School.[1] The great majority of
his extant drawings are on paper with a colored
preparation – sometimes dark brown or olive,
sometimes red or blue. The drawing was applied with a
pen and black ink, and was then heightened with the
brush in white. It can be seen at lower left that
Altdorfer had second thoughts about the position of the
horse's legs. It was not unusual to make drawings on a
colored ground in Altdorfer's day, but it was certainly
exceptional for an artist to use this technique for almost
his entire drawn *œuvre*.[2]

It seems that sheets of this kind, which Altdorfer
produced in large quantities between 1511 and 1513,
were conceived and sold as finished works. None of the
landscapes in which his scenes are set was drawn from
life; all are from a strange, eerie world which is given
extra resonance by the colored ground.

Although doubts have been expressed as to the
authorship of this drawing,[3] it is accepted as authentic
in the recent literature, one of the main arguments
being the *pentimento* in the horse's legs.[4]

1. This was not so much a school as the definition of a
locality, although even that is loosely applied, for an artist like
Hans Leu in Switzerland was working in a related style.
2. For the technique of drawing on paper with a colored
preparation see H. Mielke in exhib. cat. Berlin, Regensburg,
1988, pp. 18-19.
3. Oettinger (1957), for instance.
4. See cat. Berlin, Regensburg, 1988, no. 61.

AM

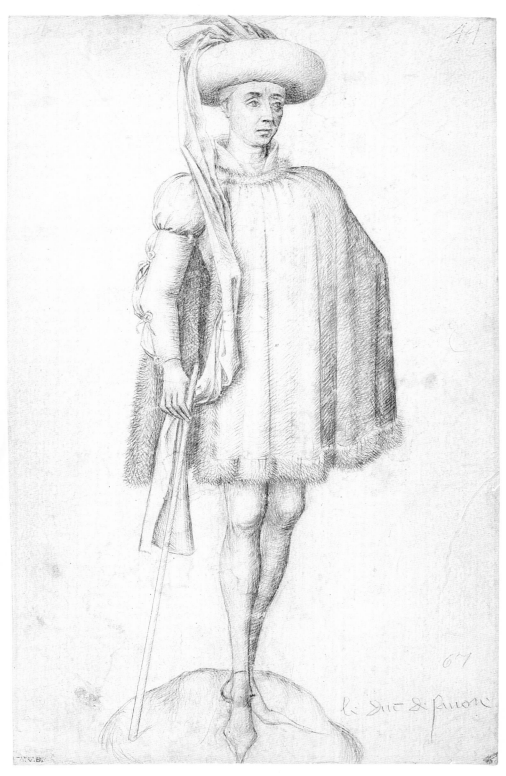

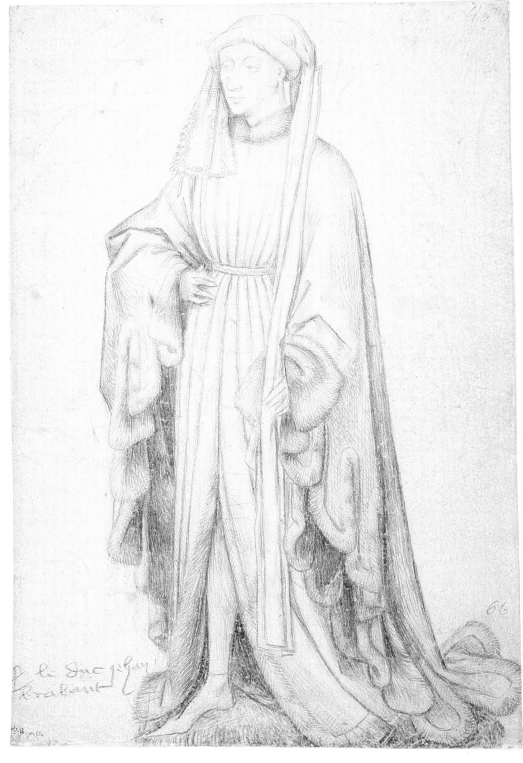

Early Netherlandish School

I I

Anonymous Southern Netherlandish artist, third quarter of the fifteenth century
LOUIS, DUKE OF SAVOY (1402–65)
JOHN IV, DUKE OF BRABANT (1403–26)

Silverpoint on prepared paper; each 204 × 128 mm.
Lower right in silverpoint: *le duc de savoie*; upper right in brown ink: *44*; lower right in pencil: *67*
Lower left in silverpoint: *le duc jehan de brabant*; upper right in brown ink: *46*; lower right in pencil: *66*
Inv. MB 1958/T 20-21

Provenance: titled Polish family; A. Goudstikker Gallery, Amsterdam; D.G. van Beuningen, Rotterdam (L. 758), acquired in 1936; acquired by the museum in 1958 with the Van Beuningen Collection.

Exhibitions: Rotterdam 1936, pp. 58-59, nos. 2a-b; Maastricht 1939, nos. 2-3; The Hague 1945, nos. 122-23; Paris 1947, nos. 40-41; Rotterdam 1948-49, nos. 36-37; Brussels, Paris 1949, nos. 1-2; Prague 1966, no. 2.

Literature: Anon., "Dutch Primitives in a Large Rotterdam Show," *Art News*, July 18 1936, p. 13; L. von Baldass, "Die Zeichnung im Schaffen des Hieronymus Bosch und der Frühholländer," *Die Graphischen Künste*, N.F. II, 1937-38, p. 19; M.J. Friedländer, *Die altniederländische Malerei*, vol. XIV, *Pieter Bruegel und Nachträge zu den früheren Bänden*, Leiden 1937, p. 78; P. Wescher, "Beiträge zu einigen Werken des Kupferstichkabinetts," *Berliner Museen* LIX, 1938, pp. 50-54; C. de Tolnay, *Le Maître de Flémalle et les frères Van Eyck*, Brussels 1939, p. 72, nos. 1-2, figs. 119-20; C.M.A.A. Lindeman, "De datering, herkomst en identificatie der 'Gravenbeeldjes' van Jacques de Gérines," *Oud Holland* LVIII, 1941, pp. 161-68; B. Degenhart, *Europäische Handzeichnungen aus fünf Jahrhunderten*, Berlin, Zürich 1943, p. 12, no. 15; H. Gerson, "Overzicht van de litteratuur betreffende Nederlandsche kunst, II. Schilderkunst, 15de en 16de eeuw," *Oud Holland* LXIII, 1948, pp. 135-36; D. Hannema, *Catalogue of the D.G. van Beuningen Collection*, Rotterdam 1949, nos. 164-65; A. Scharf, "An Exhibition of Flemish Drawings," *Burlington Magazine* XCI, 1949, p. 138; J. Leeuwenberg, "De tien bronzen 'Plorannen' in het Rijksmuseum te Amsterdam, hun herkomst en de voorbeelden waaraan zij zijn ontleend," *Gentse Bijdragen tot de Kunstgeschiedenis* XIII, 1951, pp. 14, 19-20, 24-25; L. Baldass, *Jan van Eyck*, Cologne 1952, p. 270; Panofsky 1953, vol. I, pp. 291, 438, note 200[3], 475-77, note 291[4]; O. Benesch, "Die grossen flämischen Maler als Zeichner," *Jahrbuch der Kunsthistorischen Sammlungen in Wien* LIII, 1957, pp. 9-11; R. van Luttervelt, "Bijdragen tot de iconografie van de graven van Holland naar aanleiding van de beelden uit de Amsterdamsche Vierschaar II," *Oud Holland* LXXII, 1957, pp. 143-44; A.-M. Cetto, *Der Berner Traian- und Herkinbald-Teppich*, Bern 1966, pp. 164-65; G. Troescher, "Die Pilgerfahrt des Robert Campin: altniederländische und südwestdeutsche Maler in Südostfrankreich," *Jahrbuch der Berliner Museen* IX, 1967, pp. 118-19; Friedländer 1967-76, vol. I, p. 103; Sonkes 1969, pp. 242-48, nos. E 15-16; J. Leeuwenberg, *Beeldhouwkunst in het Rijksmuseum*, The Hague, Amsterdam 1973, p. 45, under no. 10; M. Scott, *The History of Dress Series: Late Gothic Europe 1400-1500*, London, Sydney, Toronto 1980, p. 105; K.L. Belkin, *The Costume Book* (Corpus Rubenianum Ludwig Burchard XXIV), Brussels 1980, pp. 114-16, under no. 19; O. Pächt, U. Jenni and D. Thoss, *Die illuminierten Handschriften und Inkunabeln der Österreichischen Nationalbibliothek Flämische Schule I*, vol. I, Vienna 1983, p. 73, figs. 37, 86.

Connoisseurs were ecstatic in 1935, when four silverpoint drawings of Burgundian dukes and counts belonging to a titled Polish family suddenly appeared on the art market (no. 11 and figs. a and b). It was immediately apparent that they were connected with the tomb that Duke Philip the Good erected in Lille *c.* 1455 to the memory of Louis de Mâle, his wife Margaretha of Brabant and daughter Margaretha of Flanders, and since Jan van Eyck had worked at the Burgundian court, the drawings were immediately attributed to him and hailed as designs for the bronze statuettes on the monument.[1] At last, it was thought, we would be able to get a clearer idea of Van Eyck the draftsman. The sheets were taken as confirmation of Schmidt-Degener's theory that the ten statuettes of counts in the Rijksmuseum in Amsterdam had been cast to a design by Van Eyck.[2] This sent the price of the drawings soaring, and they were finally sold for staggering sums to the Dutch collectors D.G. van Beuningen and F. Mannheimer.[3]

In all the excitement, though, the Burgundian dress and appearance of the figures had been far too hastily associated with Van Eyck, only a few of whose drawings survive. The style and technique of the silverpoints certainly suggest a date around the middle of the fifteenth century, and the inscriptions, too, are of the period, but it is a great leap from there to assume that they are designs.[4] An important source of information on fifteenth-century funerary monuments in the Southern Netherlands is the illustrated *Memoriën* by Anthonio de Succa (*c.* 1567–1620), which was commissioned by Archduke Albert and his wife Isabella.[5] Among De Succa's drawings are pen sketches of the Lille tomb (which was destroyed in the French Revolution), in which the *pleurants* are all seen from exactly the same angle, as they are in later copies drawn after the monument. De Succa's depiction of Louis of Savoy, for instance, shows the left heel protruding just behind the right foot, as it is in the Rotterdam drawing.[6] The statuettes stood in niches in the monument, so they could only be drawn from one

angle. This proves that the silverpoints were also done from the bronzes, and that is borne out by the fact that all four include the circular pieces of terrain on which the figures stood, and which in turn were attached to hexagonal pedestals on the tomb itself.

Similar little patches of ground support the Rijksmuseum bronzes, which are reversed copies of the figures on the Lille monument, and come from the tomb of Isabella of Bourbon, which was built in Antwerp in 1476.[7] By comparison, the figures in the drawings are highly stylized. Their spidery legs, slender hands with pointed fingers, and elongated torsoes are composed of angular elements, as opposed to the more rounded forms of the shapelier statuettes. There is little or no suggestion of textures in the bronzes, so that is something that was added by the anonymous draftsman, who used hatching to differentiate between fur and other fabrics. This lends the figures a certain air of individuality. The *Duke of Savoy* displays a more vigorous handling of the silverpoint, but it is unlikely that two or even three artists were involved, as has been suggested.[8]

The inscriptions proved crucial for identifying the figures on the tomb. It seems that the twenty-four bronzes were removed in the sixteenth century to safeguard them from the Iconoclasts, and were then replaced incorrectly. Some of De Succa's names differ from those on the silverpoints, and these errors were perpetuated by Rubens, who used De Succa's sketches of *c.* 1602 for his *Costume Book*.[9]

The detail in the Rotterdam drawings makes them valuable documents for the history of Burgundian dress. Louis, Duke of Savoy, who only died in 1465, and thus lived to see the tomb completed, wears the kind of close-fitting costume which was in vogue around the mid-fifteenth century. It consists of a doublet with standing collar and puffed sleeves, a cape trimmed with fur down the front and around the bottom, and a bonnet with a liripipe.[10] John IV of Burgundy, Duke of Brabant (1403–26), is wearing a full-skirted houppelande, also edged with fur, which is caught high up, just under the ribs, which was the fashion in the 1420s. The tippet in his left hand, which hangs to below the knee, was first folded in four and then attached to his chaperon.[11]

The significance of the numbers on the drawings is unclear precisely. It is possible that these intriguing sheets come from a larger but very early collection of portrait drawings similar to the Arras *Receuil*, which was begun in the mid-sixteenth century.[12]

1. Hannema in exhib. cat. Rotterdam 1936, pp. 58-59, nos. 2a-b.
2. Friedländer (1937), p. 78; F. Schmidt-Degener, "De 'Zeven Deugden' van Johannes van Eyck in het Nederlandsch Museum te Amsterdam," *Onze Kunst* XI, 1907, pp. 18-32.
3. The two drawings bought by Mannheimer (figs. a and b; Sonkes 1969, nos. E 17-18) disappeared in the Second World War. For the history of this collection see M.D. Haga, "Mannheimer, de onbekende verzamelaar," *Bulletin van het Rijksmuseum* XXII, 1974, pp. 87-95.
4. Leeuwenberg (1951), pp. 24-25.
5. M. Comblen-Sonkes and C. van den Bergen-Pantens, *Memoriën van Anthonio de Succa* (Bijdragen tot de Studie van de Vlaamse Primitieven VII), 2 vols., Brussels 1977, esp. vol. I, pp. 166-71, vol. II, fols. 54v-58v.
6. Leeuwenberg (1951), pp. 25, 44-45, figs. IIIa-g.
7. Leeuwenberg (1973), pp. 40-45, no. 10.
8. Sonkes 1969, pp. 246, 248.
9. Comblen-Sonkes and Van den Bergen-Pantens, op. cit. (note 5), vol. I, pp. 46-47, and Belkin (1980), pp. 114-16, no. 19.
10. M. Beaulieu and J. Baylé, *Le costume en Bourgogne de Philippe le Hardi à Charles le Téméraire, 1364-1477*, Paris 1956, pp. 44-55; Belkin (1980), p. 114.
11. Scott (1980), pp. 105-06; see also M. Scott, *A Visual History of Costume: the 14th and 15th Centuries*, London 1986, pp. 68-69, no. 65 (ill.).
12. Sonkes 1969, p. 248; see L. Quarré-Reybourbon, "Trois recueils de portraits aux crayons ou à la plume représentant des souverains et des personnages de la France et des Pays-Bas," *Bulletin de la Commission Historique du Département du Nord* XXIII, 1900, pp. 1-127.

GL

fig. a

fig. b

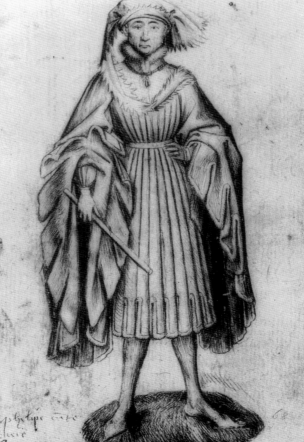

12

Petrus Christus
*probably born in Baerle-Hertog, Brabant, active in Bruges
1444–1472/73*
PORTRAIT OF A YOUNG WOMAN

Silverpoint on gray prepared paper; 132 × 89 mm.
No watermark
Inv. MB 328

Provenance: F.J.O. Boijmans, bequest of 1847 (L. 1857).

Exhibitions: Paris 1935, no. 191; Rotterdam 1936, p. 58,
no. 1; The Hague 1945, no. 125; Rotterdam 1948-49,
no. 39; Brussels, Paris 1949, no. 4; Rotterdam 1952,
no. 1; Prague 1966, no. 3.

Literature: cat. Rotterdam 1852, no. 395; cat. Rotterdam
1869, no. 273 (attributed to Hans Holbein);
P. Haverkorn van Rijsewijk, *Jaarverslag Museum
Boymans*, 1903, pp. 11-12; Schmidt-Degener 1911,
pp. 256, 261; F. Winkler, *Der Meister von Flémalle und
Rogier van der Weyden*, Strasbourg 1913, p. 54, note 3;
S. de Ricci, "A Flemish Triptych for Melbourne II,"
Burlington Magazine XL, 1922, pp. 163, 166;
M.J. Friedländer, *Die altniederländische Malerei*, vol. I,
Die Van Eyck, Petrus Christus, Berlin 1924, p. 127;
A.E. Popham, *Drawings of the Early Flemish School*,
London 1926, p. 21; cat. Rotterdam 1927, no. 558;
F. Winkler, "Skizzenbücher eines unbekannten
rheinischen Meisters um 1500," *Wallraf-Richartz Jahrbuch*
N.F. I, 1930, p. 124; J. Dupont, "Quelques dessins
flamands," *Arts et Métiers Graphiques* IX, 1936, no. 51,
p. 20; Tolnay 1939, p. 74, no. 5; A. Leclerc, *Flemish
Drawings: XV-XVI Centuries*, London, Paris, New York
1950, p. 26; J. Besançon, *Les dessins flamands du XVe au
XVIe siècle*, Paris 1951, p. 26; Baldass 1952, pp. 78,
note 1, and 291, no. 85; Panofsky 1953, vol. I, pp. 200,
438, note 200[3], 310, 489, note 310[7]; Haverkamp
Begemann 1957, no. 1; Friedländer 1967-76, vol. I, p. 74,
pl. 71c; Sonkes 1969, pp. 28, 258-60, E 24, pl. LXVIIa;
P. Schabacker, *Petrus Christus*, Utrecht 1974, pp. 127-28,
no. 26, fig. 54; U. Panhans-Bühler, *Eklektizismus und
Originalität im Werk des Petrus Christus*, Vienna 1978,
pp. 105-06, note 220; A. Tzeutschler Lurie, "A Newly
Discovered Eyckian St. John the Baptist in a
Landscape," *Bulletin of the Cleveland Museum of Art*
LXVIII, 1981, pp. 95-97, fig. 23.

Bearing an attribution to Hans Holbein, this drawing led an unremarked existence in the nineteenth century until, in the wake of the Bruges exhibition of 1902 and the resultant upsurge of interest in the Flemish primitives, it was re-ascribed to Rogier van der Weyden.[1] Soon afterwards the obvious connection was made with Jan van Eyck's painted portrait of his wife Margaretha in the Groeningemuseum in Bruges (1439), which is certainly close to the drawing in the positioning of the figure.[2] The woman fills almost the entire picture surface, is depicted three-quarter face and bust-length, but with the arms and hands included. It is a type of portrait which, although not created by Van Eyck, is very definitely associated with his name. Others, apart from his wife, whom he depicted in this pose in the 1430s were Baudouin de Lannoy and Giovanni Arnolfini (West Berlin, Staatliche Museen), the goldsmith Jan de Leeuw (Vienna, Kunsthistorisches Museum, and the young man in the 1432 *"leal sovvenir"* (London, National Gallery).[3]

Despite all these parallels, it is difficult to fit the Rotterdam sheet convincingly within Van Eyck's *œuvre*. The main imitator of this portrait type was Petrus Christus, who is believed to have worked for a time in Van Eyck's studio in Bruges. Moreover, as Panofsky has pointed out, the drawing is closer in some respects to Christus's painted portraits.[4] Van Eyck's sitters are always fully lit, whereas here there is subtle shading in the face and neck. Van Eyck's portraits are also more individual than this face, which, although not truly idealized, does have a certain stylization. What makes it so appealing is the blend of modesty and self-assurance in the sitter's gaze.

The simplified rendering of the forms is a particular characteristic of Petrus Christus, and in this respect a comparison can be made with a number of his paintings. In addition to the *Portrait of a Carthusian Monk* (New York, Metropolitan Museum), there is above all the *Portrait of Edward Grymestone* (fig. a; Gorhambury, Earl of Verulam Collection, on loan to the National Gallery, London), both of 1446.[5] The direction of the gaze in both pictures is the same as in this drawing, and the distribution of light and shadow is equally important for modeling the head. The portrait from the Earl of Verulam's collection shows a comparable stylization, and Grymestone's hand is painted in the same position, with the rather rigid fingers curled inward and upward. The woman's foreshortened left hand is very similar to that of St Eloi in a picture by Christus dated 1449, also in New York (fig. b).[6] As in the drawing, the drapery folds are angular and decidedly schematic. The head of the woman to the left of the saint is in exactly the same position as that in the drawing, the only difference being that she is looking downward.

The strongest correspondence, however, with the idiosyncratic type created by Petrus Christus is the round face and sharply receding chin of the woman in Rotterdam. Christus used this facial type for both male and female biblical figures and saints, and it was such an ingrained part of his repertoire that in portraits it tends to rob some of his female sitters of their individuality. Perhaps the donatrix on an altarpiece wing in Washington (fig. c), which is dated *c.* 1455, provides the best comparison with the Rotterdam drawing.[7]

However, this does not shed any light on the purpose of the sheet. We do not know whether Petrus Christus made such a highly detailed silverpoint in preparation for a painted portrait, or whether it was intended as a work of art in its own right. It might even be an autograph copy of one of his own painted portraits.[8] The scantiness of our knowledge of the drawings of the Flemish primitives reflects the paucity of material. This female portrait is one of the rare, authentic drawings from the fifteenth century which, together with a few portraits by Rogier van der Weyden and Van Eyck's preliminary study of Cardinal Albergati in Dresden, shows us the high standard attained by these artists in their portrait drawings.[9]

1. Haverkorn van Rijsewijk (1903), pp. 11-12.
2. Schmidt-Degener 1911; the portrait of Margaretha van Eyck discussed in A. Janssens de Bisthoven, *et al.*, *De Vlaamse Primitieven*, vol. I, *Corpus van de vijftiende-eeuwse schilderkunst in de Zuidelijke Nederlanden: Stedelijke Musea Brugge I*, Brussels 1981, pp. 175-93.
3. K. Bauch, "Bildnisse des Jan van Eyck," *Sitzungsberichte der Heidelberger Akademie der Wissenschaften*, 1961-62, Heidelberg 1963, pp. 96-142, and D. Jansen, *Similitudo: Untersuchungen zu den Bildnissen Jan van Eycks*, Cologne, Vienna 1988.
4. Panofsky 1953, pp. 310 and 489, note 310[7].
5. See Schabacker (1974), pp. 81-85, nos. 3-4.
6. Ibid., pp. 86-91, no. 6, and G. Bauman, *Early Flemish Portraits 1425-1525*, New York, The Metropolitan Museum of Art, 1986, pp. 10-12.
7. J.O. Hand and M. Wolff, *Early Netherlandish Paintings. The Collections of the National Gallery of Art Systematic Catalogue*, Washington 1986, pp. 49-55.
8. Schabacker (1974), pp. 126-27.
9. For a general discussion of this whole question, see Sonkes 1969, pp. 1-5.

GL

fig. c

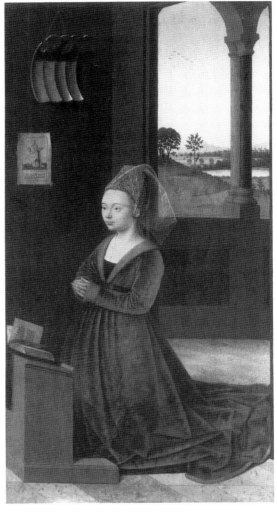

fig. b

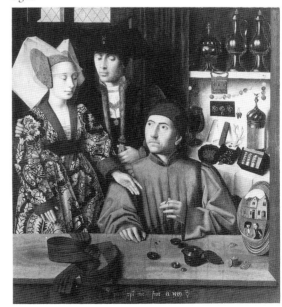

fig. a

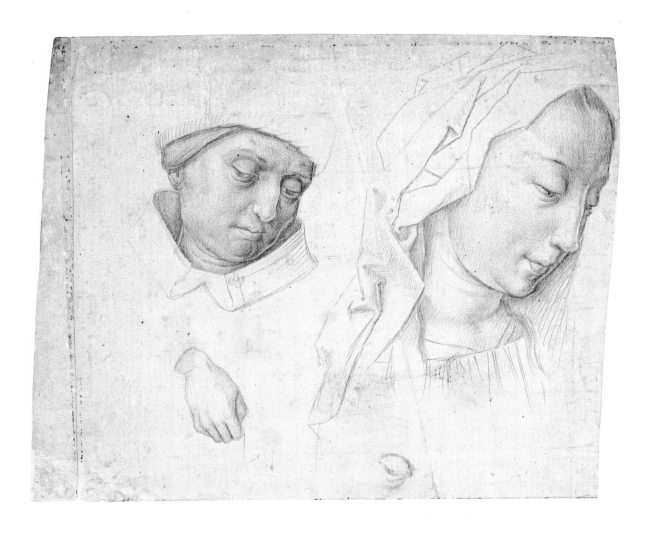

13

Attributed to the Master of the Legend of St Lucy
active in Bruges c. 1480–c. 1510
STUDIES OF A MAN'S HEAD, A WOMAN'S HEAD, AND A HAND

Silverpoint on prepared paper; 134 × 156/158 mm.
No watermark
Inv. MB 329

Provenance: F.J.O. Boijmans, bequest of 1847 (L. 288).

Exhibitions: The Hague 1945, no. 130; Paris 1947,
no. 48; Rotterdam 1948-49, no. 48; Brussels, Paris 1949,
no. 18, no. 20.

Literature: cat. 1852, no. 239; cat. 1869, no. 103;
Schmidt-Degener 1911, p. 255; J. Destrée, *Hugo van der
Goes*, Brussels, Paris 1914, pp. 75-76; W. Schöne, *Dieric
Bouts und seine Schule*, Berlin 1938, p. 171, no. 56;
O. Pächt, "The Master of Mary of Burgundy,"
Burlington Magazine LXXXIV-LXXXV, 1944, p. 300,
note 26; P. Wescher, "Sanders and Simon Bening and
Gerard Horenbout," *Art Quarterly* IX, 1946, p. 193;
O. Pächt, *The Master of Mary of Burgundy*, London 1948,
p. 61; K.G. Boon, "Naar aanleiding van tekeningen van
Hugo van der Goes en zijn school," *Nederlands
Kunsthistorisch Jaarboek* 1950-51, pp. 87-88; F. Winkler,
Das Werk des Hugo van der Goes, Berlin 1964, p. 273;
Boon 1978, vol. I, pp. 2-3, under no. 2; A.M. Roberts,
"Silverpoints by the Master of the Legend of Saint
Lucy," *Oud Holland* XCVIII, 1984, pp. 237-45.

fig. a

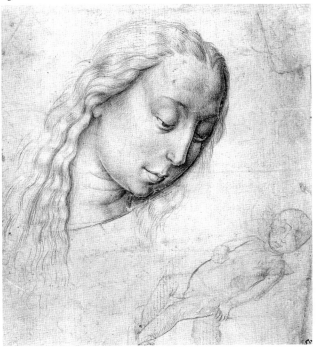

There can be no doubt that this small, highly sensitive
study sheet is by the same artist who made a
comparable drawing of the Virgin's head and a sketch
of the Christ Child now in the Rijksprentenkabinet in
Amsterdam (fig. a).[1] Both sheets are executed in
silverpoint on similar, prepared paper, and are close
in style. The isolated heads are minutely detailed, with
a great feeling for the rendering of space, but the
clothing and other accessories are merely suggested.
The contours of the heads and noses are firmly defined,
but elsewhere the faces are built up with thin, extremely
regular hatching. Some of the lines curve with the shape
of the forehead or eye socket, but generally they are
carefully laid down in a regular pattern, with only
occasional cross-hatching.

Because the female heads are so reminiscent of the
work of Hugo van der Goes, the drawings were
associated at an early date with his *Portinari Altarpiece*
in the Uffizi in Florence.[2] But however striking the
correspondence with the female figures in that work,
the drawings were certainly not preliminary studies.
Moreover, the head of the man in the Rotterdam sheet,
who has been identified as one of the Magi on the
strength of the insignia on his collar, is far harder to
associate with a painting by Van der Goes. He is much
closer to the somewhat contorted types painted by
Dieric Bouts, and a link has been noted with one of the
figures in the latter's *St Hippolytus Altarpiece* of *c.* 1479 in
the Church of Christ the Savior in Bruges.[3] It is by no
means a faithful copy of that figure, but a variant,
although of course it is always possible that the drawing
was made after a lost painting by Bouts.

The affinity with the work of Van der Goes led to
the two drawings being attributed to followers like the
Master of Mary of Burgundy and the Master of the
Hortulus Animae.[4] However, given the fact that the
drawings contain studies after both Bouts and Van der
Goes, it has recently been suggested that they might be
the work of an eclectic artist like the Master of the
Legend of St Lucy, who was working in Bruges between
c. 1480 and 1510.[5]

Apart from a certain Spanish influence in his late
period, this master's works betray a close study of
leading Flemish artists like Hans Memling, Jan van
Eyck, Hugo van der Goes, Dieric Bouts and Rogier van
der Weyden.[6] In addition, there are remarkable
parallels, to say the least, between the two drawings and
some pictures by the St Lucy Master.[7]

His finest work, the *Virgin with Female Saints* in the
Musées Royaux des Beaux-Arts in Brussels, contains
several female figures which closely resemble the drawn
studies (fig. b).[8] The position of the head of St Ursula,
the second figure from the left in the painting, is
virtually identical to that of the female head in the
Rotterdam sheet, which, reversed left for right, is again
close to the third saint from the right, St Margaret,
who is also reading from a book. The Brussels painting
is known to have been installed in 1489 in the Church
of Our Lady in Bruges, on the altar endowed by the
"Three Female Saints" chamber of rhetoric, which gives

a lead as to its date, and possibly to that of the drawing as well. However, the man's head corresponds, again in reverse, with that of St Lucy's suitor in the picture from which the master takes his name, *The Legend of St Lucy* in the Church of St James in Bruges, which is dated 1480 (fig. c).[9] One possible explanation for this spread in dates is that the artist later added the woman to a sheet which already bore the man's head. By the time he came to paint the Brussels altarpiece, which is the finer of the two, he seems to have studied the work of Hugo van der Goes, making copies of the figures on sheets like those in Rotterdam and Amsterdam. It is possible that he had not yet seen Van der Goes's work nine years previously, for the stiff, highly stylized female figures in the *Legend of St Lucy* are far weaker than those of his more mature period. However, Van der Goes is not the only influence discernible in the *Virgin with Female Saints*; there is a clear debt to Rogier van der Weyden in the figure of the Virgin herself, and in the Magdalen seen three-quarters from the back.[10]

Since most of the surviving Netherlandish drawings of the fifteenth century are copies after paintings or drawings by other artists, it is difficult to give them a firm attribution. Most were intended as reference material, and rarely have the personal imprint of the draftsman. In some cases, indeed, it is only possible to identify the model. If we are correct in this tentative reconstruction of the working method of the anonymous St Lucy Master based on the two silverpoint drawings, it once again demonstrates the key role of drawings in shaping the style of fifteenth-century artists.

1. Boon 1978, vol. I, pp. 2-3, no. 2. It is by no means certain, as Boon suggests, that the drawing with a woman's head which he mentions under no. 3 is by the same hand, despite the common provenance of the Amsterdam sheets.
2. Schmidt-Degener 1911, p. 255.
3. Schöne (1938), p. 171, no. 56.
4. Pächt (1944), p. 300, note 26, and Pächt (1948), p. 61.
5. Roberts (1984), pp. 237-45, in an article based on her dissertation, *The Master of the Legend of Saint Lucy: a Catalogue and Critical Essay*, University of Pennsylvania 1982.
6. See exhib. cat. *Anonieme Vlaamse Primitieven*, Bruges, Groeningemuseum, 1969, pp. 47-48; N. Veronee-Verhaegen in Friedländer 1967-76, vol. VIb, pp. 123-24; D. de Vos, "Nieuwe toeschrijvingen aan de Meester van de Lucialegende, alias de Meester van de Rotterdamse Johannes op Patmos," *Oud Holland* XC, 1976, pp. 137-61; and the excellent account of the artist in J.O. Hand and M. Wolff, *Early Netherlandish Paintings. The Collections of the National Gallery of Art Systematic Catalogue*, Washington 1986, pp. 177-83.
7. The following is largely based on Roberts (1984).
8. For that painting see exhib. cat. Bruges 1969, cit. (note 6), pp. 53-54, no. 15.
9. Ibid., pp. 48-49, no. 12.
10. See M.J. Friedländer, "A Drawing by Rogier van der Weyden," *Old Master Drawings* I, 1926, pp. 29-32, who believes that the St Lucy Master used Rogier's drawing of the Virgin and the Christ Child giving the blessing in the Boymans-van Beuningen Museum (Sonkes 1969, pp. 29-33, no. A 4) for the Brussels painting. See also B. Dunbar, "The Source of a Figure Motif in the Art of the Lucy Master," *Oud Holland* XCIV, 1980, pp. 65-70, who stresses the importance of a sheet of studies after Rogier van der Weyden for another painting by the Master of the Legend of St Lucy.

GL

fig. b

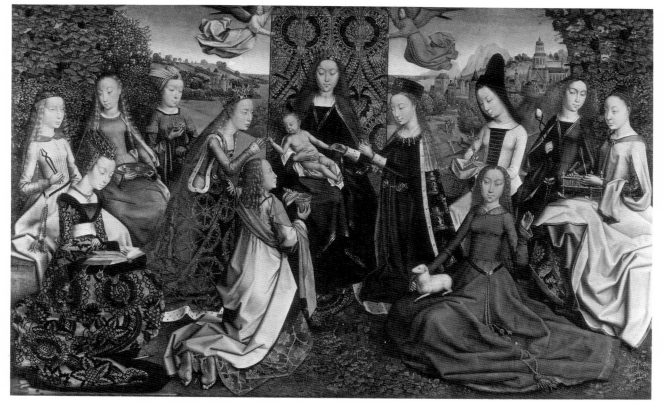

fig. c

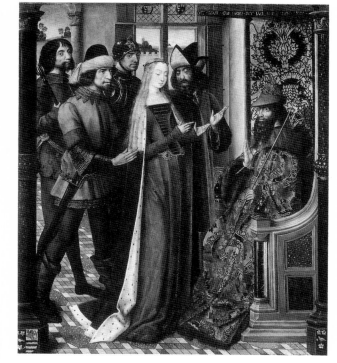

14

Hieronymus Bosch
's-Hertogenbosch c. 1450–1516 's-Hertogenbosch
THE OWL'S NEST

Pen and brown ink, laid down; 140 × 196 mm.
Verso (visible through the mount): *Construction Sketch
for a Gallows with a Wheel*, pen and brown ink
Watermark: not visible
Inv. N 175

Provenance: F. Koenigs, Haarlem (L. 1023a), acquired in
1930; D.G. van Beuningen, Rotterdam, acquired in 1940
and donated to the Boymans Museum Foundation.

Exhibitions: Rotterdam 1934, no. 2; Rotterdam 1936,
p. 62, no. 13; Brussels 1937-38, no. 4; Rotterdam 1938,
no. 233; Rotterdam 1948-49, no. 6; Brussels, Paris 1949,
no. 26, no. 28; Dijon 1950, no. 43; Rotterdam 1952,
no. 6; Paris 1952, no. 40; Prague 1966, no. 9; Rome
1972-73, no. 27; Berlin 1975, no. 16; Washington, New
York 1986-87, no. 16.

fig. a

Literature: N. Beets, "Zestiende-eeuwsche kunstenaars.
IV. Lucas Corneliszoon de Kock. 2. Teekeningen van
Lucas Cornelisz en Pieter Cornelisz," *Oud Holland* LII,
1935, p. 225; Von Baldass 1937, p. 22; O. Benesch,
"Der Wald, der sieht und hört: zur Erklärung einer
Zeichnung von Bosch," *Jahrbuch der Preussischen
Kunstsammlungen* LVIII, 1937, pp. 260-61; C. de Tolnay,
Hieronymus Bosch, Basel 1937, pp. 49, 111, no. 8;
J. Rosenberg, "Hieronymus Bosch: the Heads of Two
Pharisees(?) – Adam and Eve," *Old Master Drawings*
XIII, 1938-39, p. 62; J.G. van Gelder, "Teekeningen van
Jeroen Bosch," *Beeldende Kunst* XXVII, 1940-41, p. 63;
L. von Baldass, *Hieronymus Bosch*, Vienna 1943, pp. 77,
84-85, 88, 255; Tolnay 1943, pp. 58, 131, no. 156;
J. Combe, *Jérôme Bosch*, Paris 1946, p. 97; D. Bax,
Ontcijfering van Jeroen Bosch, The Hague 1949, pp. 159,
162, notes 14-15; N. Beets, "Nog eens 'Jan Wellens de
Cock' en de zonen van Cornelis Engebrechtsz: Pieter
Cornelisz Kunst, Cornelis Cornelisz Kunst, Lucas
Cornelisz de Kock," *Oud Holland* LXVII, 1952, p. 29;
Haverkamp Begemann 1957, no. 4; L. Baldass,
Hieronymus Bosch, New York 1960, pp. 66, 68, 239;
Münz 1961, p. 12, fig. 1; J. Rosenberg, "On the Meaning
of a Bosch Drawing," *De Artibus Opuscula XL: Essays in
Honor of Erwin Panofsky*, New York 1961, pp. 422-26;
Haverkamp Begemann, in Benesch *et al.* 1962, no. 475;
C. de Tolnay, *Hieronymus Bosch*, Baden-Baden 1965,
p. 389, no. 8; P. Reuterswärd, *Hieronymus Bosch* (Acta
Universitatis Upsaliensis, Figura, N.S. VII), Stockholm
1970, p. 274, no. 36; J.P. Filedt Kok, "Underdrawing
and Drawing in the Work of Hieronymus Bosch:
a Provisional Survey in Connection with the Paintings
by Him in Rotterdam," *Simiolus* VI, 1972-73, pp. 155,
159; C. van Beuningen, *The Complete Drawings of
Hieronymus Bosch*, London, New York 1973, p. 30;
H. Holländer, *Hieronymus Bosch*, Cologne 1975,
pp. 110-11; D. Bax, *Hieronymus Bosch, His Picture-Writing
Deciphered*, Rotterdam 1979, p. 209, note 14;
G. Unverfehrt, *Hieronymus Bosch: die Rezeption seiner
Kunst im frühen 16. Jahrhundert*, Berlin 1980, pp. 40, 43,
227; P. Vandenbroeck, "Bubo Significans: die Eule als
Sinnbild von Schlechtigkeit und Torheit, vor allem in
der niederländischen und deutschen Bilddarstellung und
bei Jheronimus Bosch I," *Jaarboek van het Koninklijk
Museum voor Schone Kunsten* 1985, p. 22; R. Marijnissen,
Hiëronymus Bosch: het volledig œuvre, Antwerp 1987,
p. 461 (ill.).

This sublime *Owl's Nest*, like *The Field Has Eyes, The
Forest Has Ears* in Berlin (fig. a) and *The Tree-Man* in
the Albertina in Vienna, is one of the few drawings by
Hieronymus Bosch which is unquestionably autograph.[1]
All three are clearly related in subject, style and
allegorical content, and given the careful composition
and meticulous technique, they were obviously
conceived as independent works and not as preparatory
studies. They are generally dated to Bosch's later
period, that is to say between *c.* 1505 and 1516.
Examination of the underdrawing in the painting of

The Vagabond in the Boymans-van Beuningen Museum has revealed that details which were planned but never executed, including birds and leaves, are directly related to *The Owl's Nest* in both form and style (fig. b).[2]

A young owl peers out of a hole in a gnarled tree, while two others of its kind are perched on the trunk nearby. The large one in the center has spread its wings and is looking down into the nest. Elsewhere in the tree are various day diurnal birds, probably magpies, hunting for insects. On the right, between the bare, forked branch of the tree is a web with two spiders, which a magpie is eyeing hungrily. Flying by at the top is a bird with open beak which appears to be scolding the third owl. At lower left are the silhouette of a faraway town and a group of horsemen riding through the countryside. Up against the left edge of the sheet is a wheel on a post. To the right of the tree there is a cross by the wayside. Here the landscape is hillier, and is dominated by a tall, slender tree in which another bird is perched. Bosch modified his hatching to increase the sense of depth, and also used a thinner ink for the background. The large tree is firmly drawn with broad pen-strokes, and details like the bark and the large owl's quill-feathers are clearly indicated. The distant view is built up of thin lines, while the trees are done with short, curved strokes.

The Owl's Nest has been compared to a movie close-up, and it certainly has a very modern look, with the main subject occupying such a prominent position.[3] In fact, the sheet has probably been trimmed on all sides, with a particularly heavy loss at the bottom. Its original format was probably roughly the same as that of the drawings in Berlin and Vienna, both of which are vertical.[4] This makes it even harder to penetrate the meaning of the work, which is difficult enough anyway in Bosch's case.

Owls have been regarded as symbols of evil since time immemorial, and given Bosch's subject matter it is no surprise that they occur so frequently in his paintings and drawings.[5] The motif of the owl surrounded by other birds, which is also common in his *œuvre* (fig. a, for instance), has been linked with the symbolism of sin. The owl, as a night bird, stands for those who shun the light, for the sin that cannot face the light of day, and the other birds, which are active in the daytime, serve to underline that meaning. Since Bosch also included a place of execution, which is a reminder that sin does not go unpunished, the drawing might well be a warning against vice and wickedness.[6]

This interpretation is consistent with a passage in the mid-fourteenth century *Dialogus creaturarum*, which Gerard Leeu published in a Dutch translation at Gouda in 1481.[7] It is illustrated with a woodcut of an owl being attacked by other birds (fig. c).[8] Bosch's *Owl's Nest* is less aggressive than many other images of the type, so it has been suggested that he introduced a shift in emphasis, analogous to a Dürer woodcut of the period with the inscription "*Der Eulen seyndt alle Vogel neydig und gram*."[9] There, the accompanying verses reproach the smaller birds for their hatred and envy of the owl,

and reverse the tradition by portraying them, rather than the owl, in a bad light. If that is the sense of this drawing, Bosch might have been illustrating the wickedness of all creatures by showing the magpies' greediness.

Since it is not known what important details were lost when the drawing was cropped, it is difficult to know how to interpret the scene. The Berlin sheet illustrates a proverb,[10] and the Rotterdam drawing has also been associated with the saying "*Het is een regt uilenest*" (This is a real owl's nest), meaning somewhere dark and moldering.[11] Even that interpretation cannot be entirely ruled out, although it in no way robs the drawing of its allegorical significance. The wheel in the distance could be a warning to avoid the owl's nest and never to imitate the bird's behavior. Interestingly, the maxim in the passage on the long-eared owl in the *Dyalogus dat is Twispraec der creaturen* tells us that "A fall awaits those who exalt themselves, and death comes at last to the treacherous."[12]

1. Von Baldass 1937, pp. 18-26; see also G. Lemmens, E. Taverne, "Hieronymus Bosch: naar aanleiding van de expositie in 's-Hertogenbosch," *Simiolus* II, 1967-68, pp. 78-89.
2. Filedt Kok (1972-73), pp. 155-57, figs. 18-20.
3. Tolnay (1937), p. 49.
4. Rosenberg (1961), p. 423 and fig. 2.
5. Vandenbroeck (1985), pp. 19-135, with an extensive bibliography on the owl in literature and the visual arts.
6. Bax (1949), p. 159, Vandenbroeck (1985), pp. 60-78.
7. The passage "*Van die ransuyle*" from the *Dyalogus dat is Twispraec der creaturen*, Gouda (G. Leeu) 1481, fols. 81v-82r, is included in R.H. Marijnissen, *Laatmiddeleeuwse symboliek en de beeldentaal van Hiëronymus Bosch* (Mededelingen van de Koninklijke Academie voor Wetenschappen, Letteren en Schone Kunsten van België. Klasse der Schone Kunsten XXXIX, no. 1) Brussels 1977, p. 21; see also pp. 16-17 for the iconography of the owl.
8. Rosenberg (1961), p. 424 and fig. 5.
9. Ibid., p. 425 and fig. 7; also C. Talbot in exhib. cat. *From a Mighty Fortress: Prints, Drawings, and Books in the Age of Luther 1483-1546*, Detroit, Institute of Arts, Ottawa, National Gallery of Art, Coburg, Kunstsammlungen der Veste Coburg, 1981-82, pp. 291-93, no. 162.
10. The most recent commentary on that drawing is by J.O. Hand in exhib. cat. Washington, New York 1986-87, no. 17.
11. P.J. Harrebomée, *Spreekwoordenboek der Nederlandsche taal, of verzameling van Nederlandsche spreekwoorden en spreekwoordelijke uitdrukkingen*, Utrecht 1858-70, vol. II, p. 350.
12. Marijnissen, op. cit. (note 7), p. 21: "*Hi valt die hem seluen maeckt groot. ende dye verraet doet coemt int eynde ter doot.*"

GL

fig. b

fig. c

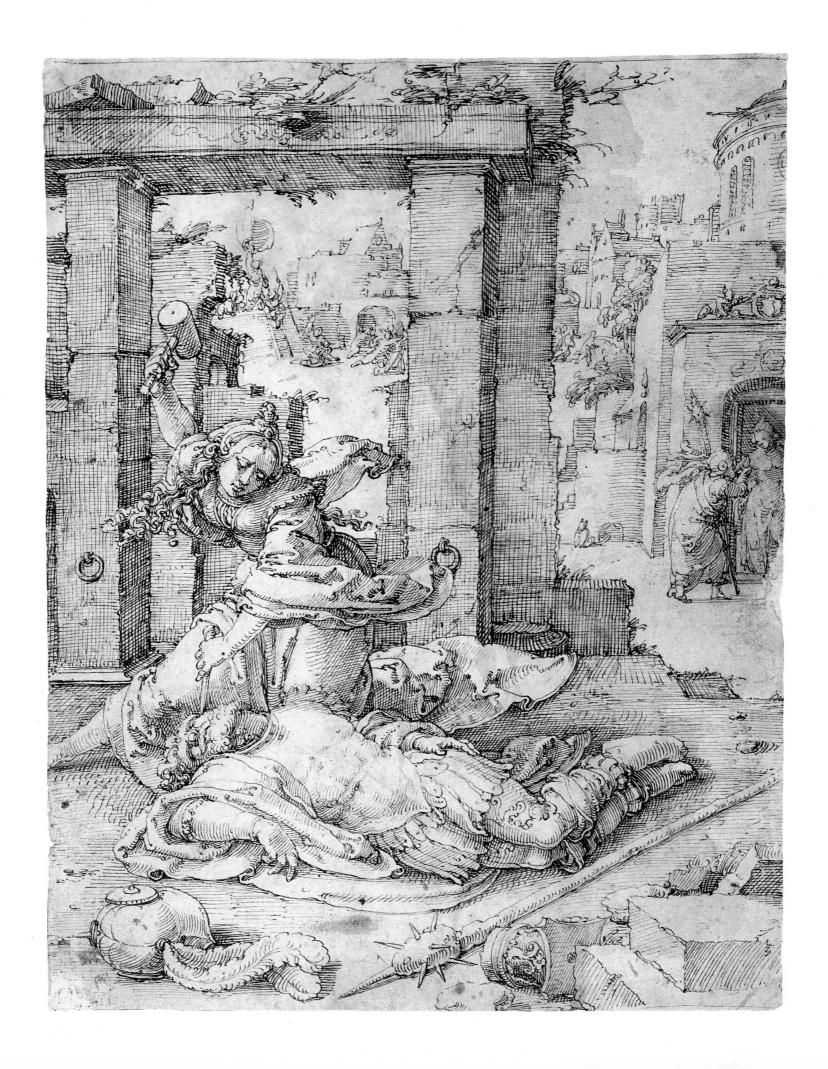

15

Lucas van Leyden
Leiden in or before 1494–1533 Leiden
JAEL KILLING SISERA

Pen and brown ink, framing line at the top;
271 × 203 mm.
A Dürer monogram erased in the lower left corner
Watermark: a Gothic *P* below a four-petaled flower[1]
Inv. N 13

Provenance: Sir Thomas Lawrence, London (L. 2445);
F. Koenigs, Haarlem (L. 1023a); D.G. van Beuningen,
Rotterdam, acquired in 1940 and donated to the
Boymans Museum Foundation.

Exhibitions: Rotterdam 1934, no. 23; Rotterdam 1936,
no. 55; Washington 1958-59, no. 14; Prague 1966,
no. 12; Leiden 1978, no. 19; Washington, New York
1986-87, no. 79.

Literature: P. Koomen, "Oud-Nederlandsche
Teekeningen," *Maandblad voor Beeldende Kunsten* XI,
1934, p. 306; G.J. Hoogewerff, *De Noord-Nederlandsche
schilderkunst*, vol. III, The Hague 1939, p. 288, fig. 151;
M. Friedländer, *Lucas van Leyden*, ed. F. Winkler, Berlin
1963, p. 77, no. 33; W. Kloek, "The drawings of Lucas
van Leyden," *Lucas van Leyden Studies; Nederlands
Kunsthistorisch Jaarboek* XXIX, 1978, pp. 428, 432,
444-45, 454, no. 10; R. Vos, *Lucas van Leyden*, Bentveld,
Maarssen 1978, p. 196, no. 237; J.P. Filedt Kok, exhib.
cat. *Lucas van Leyden: grafiek*, Amsterdam,
Rijksprentenkabinet, 1978, pp. 58-59; Boon 1978, vol. I,
p. 122, under no. 339; K. Renger, C. Syre, exhib. cat.
*Graphik der Niederlande 1508-1617: Kupferstiche und
Radierungen von Lucas van Leyden bis Hendrik Goltzius*,
Munich, Staatliche Graphische Sammlung, 1979, pp. 63,
73, note 106; C. Dittrich in exhib. cat. *Lucas van Leyden:
das graphische Werk im Kupferstich-Kabinett zu Dresden*,
Dresden, Staatliche Kunstsammlungen, 1983, p. 77
under no. 186; W. T. Kloek, J.P. Filedt Kok, "'De
Opstanding van Christus', getekend door Lucas van
Leyden," *Bulletin van het Rijksmuseum* XXXI, 1983,
p. 16; J. Maldague, "La part de Michel-Ange dans
l'aboutissement de l'art de Lucas van Leyden," *Revue des
Archéologues et Historiens d'Art de Louvain* XVII, 1984,
pp. 150-51, fig. 5.

After twenty years of oppression by Sisera, the
Canaanite war-leader, the Israelites rose in revolt.
Spurred on by the prophetess Deborah, their
commander Barak raised an army of 10,000 men and
defeated the Canaanites with God's assistance. Sisera
fled from the battlefield and sought refuge in the tent
of an ally, whose wife Jael bade him welcome and
attended to his needs. She brought him drink but when
he fell asleep, worn out by the battle, she "took a nail
of the tent, and took an hammer in her hand, and went
softly unto him, and smote the nail into his temples,
and fastened it into the ground" (Judges 4).

This grisly tale was very popular in the sixteenth
and seventeenth centuries, and was often depicted in art.[2]
In the medieval *Speculum humanae salvationis*, Jael,
together with Judith and Tomyris, was regarded as a
prefiguration of the Virgin's triumph over evil. Jael
also had a permanent place in later pantheons of Old
Testament heroines,[3] as well as in series illustrating
women's wiles.[4]

Lucas van Leyden produced two woodcut series on
the cunning acts of women – one in approximately
1514, the other in 1517. The story of Jael and Sisera
features in the latter (fig. a).[5]

The drawing in Rotterdam probably dates from the
early 1520s, at a time when Lucas's drawing style was
visibly influenced by the modernism of the Antwerp
Mannerists. In the distance, under the walls of a
sketchily drawn town, the Israelites are battling with
Sisera's army. On close inspection it can be seen that

fig. a

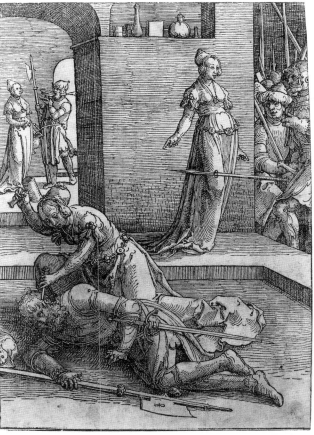

one side has sounded the retreat, while an Israelite raises a flag on the wall in the left background. One of Lucas's favorite devices was to combine different moments from the same story in a single composition. Here, for instance, the fugitive Sisera is given a drink on the right, while simultaneously meeting his fate in the foreground. The action does not take place in a tent, as described in the Bible, but amidst the ruins of a classical building. Parts of the drawing differ from the earlier woodcut, which also shows Jael displaying Sisera's corpse, nailed to the ground, to Barak and his men. The Canaanite's halberd has also been replaced with a distinctly unwieldy mace, which Lucas had earlier depicted in the same position as the attribute of a sleeping Samson.[6] It is remarkable how often he placed a supine figure horizontally in the foreground of a composition, from his earliest dated print, *Mohammed and the Monk Sergius* of 1508, by way of *Christ on the Mount of Olives* from the circular Passion series, to *Adam and Eve Mourning the Dead Abel* of 1529.

The pendant to this drawing is the *Judith and Holofernes* in the British Museum, London, the composition of which is virtually identical.[7] Both were engraved by Jan Saenredam in 1600 (figs. b, c), when, according to the inscriptions beneath the prints, the sheets were still in Leiden, where they were copied by an anonymous artist.[8] A third engraving by Saenredam after Lucas, the *Triumph of David*, has the same dimensions and is also dated 1600 (fig. d).[9] The drawing

for that print is lost, but it is possible that all three were once part of a series depicting the deeds of biblical heroes and heroines. The meticulous technique of the Rotterdam and London sheets might indicate that they were intended as designs, possibly for small stained glass windows. Karel van Mander mentions that Hendrick Goltzius owned one such window "of the women dancing out to meet David,... very finely drawn and excellently engraved by Jan van Saenredam."[10] This is surely a reference to the latter's *Triumph of David*, which, with the other two prints, must be seen in the light of the Lucas van Leyden renaissance set in train by Goltzius. Traces of that revival are also apparent in the work of Hendrick Hondius and Nicolaes de Bruyn, as well as in Van Mander's biography of Lucas, which is one of the most engaging in the entire *Schilder-boeck*.[11]

1. For this watermark in paper with prints by Lucas van Leyden, see Hollstein, *Dutch and Flemish*, vol. X, p. 236, under no. 26, and p. 239 (prints, dated 1508, 1509, 1525, 1527, 1529, 1530); exhib. cat. Amsterdam 1978, pp. 170-71, nos. 21-30, and M. van Berge-Gerbaud, exhib. cat. *Lucas de Leyde (1489/94-1533): gravures de la Fondation Custodia, Collection Frits Lugt*, Paris, Institut Néerlandais, 1983, p. 55.
2. A. Pigler, *Barockthemen*, vol. I, Budapest 1974, pp. 114-18.
3. *De spiegel der menschelicker behoudenesse*, ed. L.M.F. Daniëls, Tielt 1949, pp. 68-69, and J. Paul, "Jael und Sisara," in E. Kirschbaum (ed.), *Lexikon der christlichen Ikonographie*, vol. II, Rome etc. 1970, cols. 360-62.

4. See S.L. Smith, *"To Women's Wiles I Fell:" the Power of Women "Topos" and the Development of Medieval Secular Arts*, diss. University of Pennsylvania 1978, and exhib. cat. *Tussen heks en heilige: het vrouwbeeld op de drempel van de moderne tijd, 15de/16de eeuw*, Nijmegen, Commanderie van Sint-Jan, 1985, nos. 17-18.
5. Exhib. cat. Amsterdam 1978, pp. 49-60; for Jael and Sisera see ibid., cat. no. 67, and exhib. cat. Washington, Boston 1983, nos. 61-62.
6. Exhib. cat. Amsterdam 1978, no. 66.
7. Kloek (1978), p. 445, no. 11; a good reproduction in Hoogewerff (1939), p. 287, fig. 152.
8. Saenredam's prints in Hollstein, *Dutch and Flemish*, vol. XXIII, p. 19, no. 18, and p. 21, no. 20. The drawn copies, all probably by the same artist, are in Braunschweig, Herzog Anton Ulrich-Museum (Kloek (1978), under no. 11), and Amsterdam, Rijksprentenkabinet, Boon 1978, vol. I, p. 122, no. 339, illustrated in Schapelhouman 1987, Appendix, p. 218.
9. Hollstein, *Dutch and Flemish*, vol. XXIII, p. 13, no. 11.
10. Van Mander 1604, fol. 214r: *"... van den vrouwen dans David tegemoet komende,... dat wonder fraey is ghehandelt en comt oock in print seer wel ghesneden door Ian van Sanredam."* See also R. Vos, "The Life of Lucas van Leyden by Karel van Mander," *Lucas van Leyden Studies; Nederlands Kunsthistorisch Jaarboek* XXIX, 1978, pp. 474-75, and 503-04, notes 117-18.
11. See ibid., pp. 459-507; Reznicek 1961, pp. 113-15, 126, for Goltzius's high opinion of Lucas van Leyden; and Hollstein, *Dutch and Flemish*, vol. X, pp. 240-44, nos. 1-102, for the prints after Lucas.

GL

fig. b

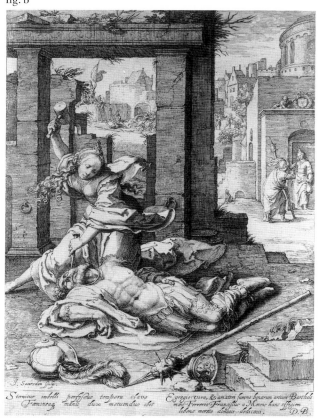

fig. c

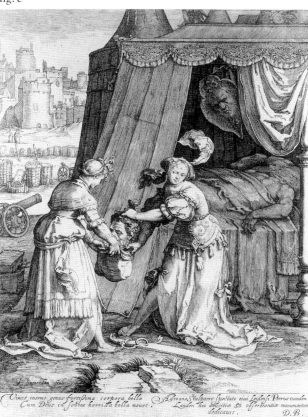

fig. d

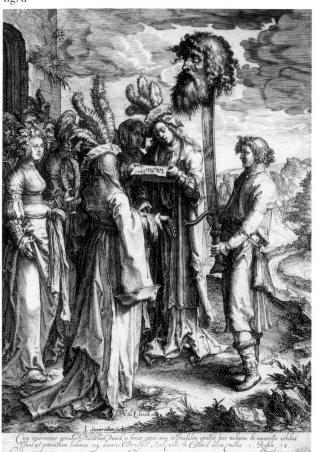

16

Pieter Coecke van Aelst
Aelst 1502–1550 Brussels
GENRE SCENE WITH A PEASANT IN AN INN

Pen and brown ink, brown wash, heightened with white, laid down; 201 × 161 mm.
Signed on the left: *Petrus van Aelst. inu & F*:
Verso annotated in brown ink by Ploos van Amstel:
Petrus Koeke van Aelst f 1529 geb 1496 te Aelst.
Discipel van Bern. van Orley geb. te Brussel 1484
Discipel van Rafael Urbinus
No watermark
Inv. MB 330

Provenance: C. Ploos van Amstel, Amsterdam; Diederick, Baron van Leyden; sale Amsterdam (P. van der Schley and Spaan), 13 May 1811, portfolio M, no. 11 (*Verkeerbordspelers*); D. Vis Blokhuyzen, Rotterdam; sale Rotterdam, 23 October 1871, no. 1; acquired by the museum.

Exhibitions: Antwerp 1930, no. 387; Brussels 1963, no. 283; Berlin 1975, no. 144; Washington, New York 1986-87, no. 35.

Literature: M. J. Friedländer, "Pieter Coecke van Alost," *Jahrbuch der Preussischen Kunstsammlungen* XXXVIII, 1917, p. 85; T. Muchall-Viebrook, "Ein neuer Gobelinentwurf von Pieter Coecke van Aelst," *Münchner Jahrbuch der Bildenden Kunst* N.F. V, 1928, p. 205; Benesch 1928, p. 9; J. G. van Gelder, "Een nieuw werk van Pieter Coecke van Aelst," *Onze Kunst* XLVI, 1929, p. 135; A. J. J. Delen, *Teekeningen van Vlaamsche Meesters*, Antwerp etc. 1944, pp. 63-64, pl. XXII; G. Marlier, *La Renaissance flamande: Pierre Coeck d'Alost*, Brussels 1966, pp. 88-90, fig. 27; E. de Jongh, "Erotica in vogelperspectief: de dubbelzinnigheid van een reeks 17de eeuwse genrevoorstellingen," *Simiolus* III, 1968-69, p. 45, note 50; Judson 1970, p. 56, fig. 120; D. Shubert, "Recension K. Renger, Lockere Gesellschaft," *Kunstchronik* XXVI, 1973, p. 217; Friedländer 1967-76, vol. XII, pp. 34-35, no. 1; W. S. Gibson, "Some Flemish Popular Prints from Hieronymus Cock and His Contemporaries," *Art Bulletin* LX, 1978, p. 679; H. G. Wayment, "The Stained Glass in the Chapel of the Vyne," *National Trust Studies* XLIV, 1980, p. 44, fig. 13; H.-J. Raupp, *Bauernsatiren: Entstehung und Entwicklung des bäuerlichen Genres in der deutschen und niederländischen Kunst ca. 1470-1570*, Niederzier 1986, pp. 209-10, fig. 190; J. Müller Hofstede, "Artificial Light in Honthorst and Terbrugghen: Form and Iconography," in R. Klessmann (ed.), *Hendrick ter Brugghen und die Nachfolger Caravaggios in Holland* (Symposium 1987), Braunschweig, Herzog Anton Ulrich-Museum, 1988, p. 22, fig. 18.

Pieter Coecke van Aelst, an artist renowned for his versatility, was a pupil of Barent van Orley in Brussels. In 1525 he was living in Antwerp, where he very probably continued his apprenticeship with the painter Jan van Dornicke. Two years later he was admitted to the city's Guild of St Luke, and went on to make his name as a painter of altarpieces and designer of tapestries and stained glass windows. In 1533 he embarked on a journey to Constantinople, which resulted in the remarkable series of woodcuts, *Mœurs et fachon de faire du Turcz*. As court painter to Charles V, he held a key position in the world of sixteenth-century art, and made a fundamental contribution to the dissemination of the Renaissance style. He also worked as an architect, and in 1539 published a translation of Serlio's treatise on architecture.[1]

This drawing, the only one signed by the artist,[2] was attached to a mount in the eighteenth century, the back of which is inscribed with the date 1529 by the former owner, Cornelis Ploos van Amstel (1726–98). It is not known what he based this information on, but stylistically the sheet is closer to Van Aelst's work of around 1540. *The Money-Changer*, another of his interiors, is in the Albertina in Vienna (fig. a). It is an earlier work, and as such offers several interesting points of comparison with the Rotterdam sheet.[3] In overall conception and specific details it is still reminiscent of fifteenth-century models, whereas the Rotterdam inn scene conforms more to Renaissance ideals. The chimney-breast, with its frieze of dancing putti, contains traces of the modern style, and a knowledge of the work of Italian Renaissance artists is also evident in the appearance of the female companions of the down-at-heels customer.

For a long time the scene was interpreted as the Prodigal Son in the brothel, but although it contains various elements from that story, the man's dress makes that theory untenable.[4] He is a peasant, on his way to market with a basket of chickens, who is squandering his money and merchandise on drink and gambling. The woman on the right is pointing to his debt on the slate, while the outstretched hand of his gaming companion shows that he is losing at tric-trac, and must pay with his wares. It is a theme that owed its popularity to the attitude of sixteenth-century urban society toward country bumpkins, who were regarded as uncouth simpletons. The same iconography is found in other examples from the period.

The prototype is a small engraving by Cornelis Matsys of two peasants losing their possessions to some well-organized tavern wenches.[5] Closely related to the Rotterdam drawing is a painting of *c.* 1530, which shows an equally tatterdemalion peasant risking everything on the fall of the dice (fig. b).[6] There are several versions of this anonymous painting, and also a print by Remigius Hogenberg with almost exactly the same scene.[7] The victim's panic is expressed in the inscription: "My luck is out, I've lost all my money, so I scratch my hat; I've gambled away my eggs, my corn is all gone, if my wife heard of this she'd murder me."[8] In both the painting

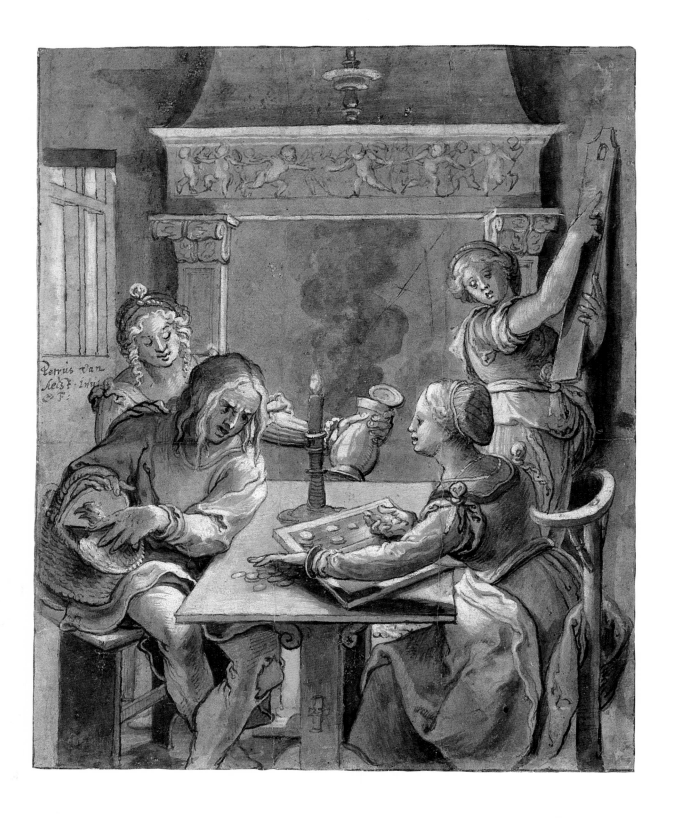

and Hogenberg's print, the peasant is carrying a basket of eggs, but Pieter Coecke gives him a chicken, an equally ambiguous attribute, and certainly as apt an allusion to his sexual longings.[9]

The anonymous painting is regarded as one of the earliest nocturnes, along with works by Aertgen van Leyden and Jan van Amstel, and is an obvious precursor of the night-time genre scenes which the Caravaggisti painted at the beginning of the seventeenth century.[10] However, the drawing too had some influence on later developments. It is one of the first in Netherlandish art in which the draftsman places so much emphasis on the chiaroscuro effect, and in this he was doubtless inspired by the woodcuts of Ugo da Carpi and other Italian artists. Pieter Coecke has carefully depicted the reflection of the candlelight on the faces of the people around the table. The second source of light is the flickering fire, which illuminates the chimney-piece and casts strong shadows, heightening the dramatic impact of the scene. It is possible that he wanted to emphasize the deceptive nature of night as the realm of vice and self-delusion, as was later done by artists like Joos van Winghe.[11] It was atmospheric drawings of this kind that inspired Frans Floris and Dirck Barendsz to master the technique of chiaroscuro.[12]

1. See Marlier (1966).
2. Cf. the receipt written by Pieter Coecke in the Koninklijke Bibliotheek in Brussels, reproduced in Marlier (1966), p. 43, fig. 7.
3. Inv. 7852; see O. Benesch, *Meisterzeichnungen der Albertina*, Salzburg 1964, p. 352, no. 132, and Marlier (1966), p. 295, fig. 236.
4. For the iconography see K. Renger, *Lockere Gesellschaft*, Berlin 1970, pp. 23-70.
5. Hollstein, *Dutch and Flemish*, vol. XI, no. 130; J. van der Stock, exhib. cat. *Cornelis Matsys 1510/11-1556/57: grafisch Werk*, Brussels, Koninklijke Bibliotheek Albert I, 1985, no. 27.
6. Gibson (1978), pp. 679-81 and fig. 9. The best version, formerly in the Figdor Collection, was last auctioned in 1937 in Munich (J. Böhler), no. 688; see Raupp (1986), p. 209, under 5b, and W. Kloek, "The Caravaggisti and the Netherlandish Tradition," in R. Klessmann (ed.), *Hendrick ter Brugghen und die Nachfolger Caravaggios in Holland* (Symposium 1987), Braunschweig, Herzog Anton Ulrich-Museum, 1988, p. 52, fig. 51 and note 12.
7. Gibson (1978), pp. 679-80 and fig. 8; Raupp (1986), p. 209.
8. "*Ick heb mijn kansse verkeecken/ mijn ghelt verloren/ dijes krauwick mijn hoet/ myn eyeren verspeelt ende oock mijn coren/ Wist myn wif sij sloech my doet.*"
9. See De Jongh (1968-69), and Raupp (1986), p. 210-11.
10. Kloek, op. cit. (note 6), and Müller Hofstede (1988), pp. 22-23.
11. K. Renger, "Joos van Winghes 'Nachtbancket met een Mascarade' und verwandte Darstellungen," *Jahrbuch der Berliner Museen* XIV, 1972, pp. 161-93.
12. Judson 1970, p. 56.

GL

fig. a

fig. b

17

Pieter Bruegel the Elder
Breda (?) c. 1525–1569 Brussels
VIEW OF REGGIO DI CALABRIA

Pen and brown ink, with a later (probably seventeenth-century) brown and gray wash; 154 × 241 mm.
Annotated on the verso in pen and brown ink: *Claude Lorrain*
No watermark
Inv. N 191

Provenance: C. Rolas du Rosey (L. 2237), Dresden; I.Q. van Regteren Altena, Amsterdam; F. Koenigs (L. 1023a), Haarlem; D.G. van Beuningen, Rotterdam, acquired in 1940 and donated to the Boymans Museum Foundation.

Exhibitions: Rotterdam 1934, no. 12; Rotterdam 1938, no. 245; Dijon 1950, no. 48; Paris 1952, no. 25; Rotterdam 1952, no. 16; Prague 1966, no. 20; Berlin 1975, no. 25, fig. 54; Brussels 1980, no. 13 (ill.).

Literature: Tolnay 1952, no. 5 (ill.); Grossmann 1954, p. 34, fig. 2; Haverkamp Begemann 1957, no. 9 (ill.); Münz 1961, no. 26, fig. 25; Menzel 1966, p. 28, fig. 3; F. Grossmann, *Bruegel: the Paintings*, London 1966, pp. 15, 194; H.A. Klein and M.C. Klein, *Peter Bruegel the Elder*, New York, 1968, p. 59, fig. 38; Lebeer 1969, under no. 40; Marijnissen 1969, no. 19; J. Müller Hofstede, "Zur Interpretation von Bruegels Landschaft," *Pieter Bruegel und seine Welt, Colloquium Berlin 1975*, Berlin 1979, pp. 96, 107, note 121; exhib. cat. *Das Dresdner Kupferstich-Kabinett und die Albertina*, Vienna, Graphische Sammlung Albertina, 1978, under no. 65; M. Gibson, *Bruegel*, Paris 1980, p. 90, fig. 91; E. Schutt-Kehm, *Pieter Bruegel d. Aeltere*, Stuttgart, Zürich 1983; Marijnissen *et al.* 1988, p. 59 (ill.).

fig. a

Fierce fires appear to be burning in Reggio di Calabria, which lies on the Strait of Messina opposite the Sicilian capital. The left and right foreground and the columns of smoke rising over the city were later washed with brown and gray ink, although without obscuring the original drawing. The name of Claude Lorrain (1600–82) on the verso has been taken as an indication that it was he who applied this wash.[1] Exactly the same view of Reggio in flames is found, reversed left for right, in the large engraving of 1561 by Frans Huys (c. 1522–62), on which Bruegel is credited as *inventor* (fig. a). The print shows a sea battle in the Strait of Messina between Turkish galleys and European men-of-war.

There is complete agreement on both the attribution to Pieter Bruegel the Elder and the identification of the city as Reggio, but there are differences of opinion as to when and where Bruegel made this drawing. The style suggests that it is from Bruegel's Italian journey of 1552-54,[2] in the course of which he is now believed to have visited Rome and Naples. It is also thought that he was in Calabria and Sicily, and that he witnessed the bombardment of Reggio by a Turkish fleet in 1552, which set the city ablaze.[3] This is by no means impossible, and it is also conceivable that Bruegel made drawings of the event and used them for his design for Huys's engraving eight years later. This drawing, though, is not admissible as evidence for that theory. The Strait of Messina in Huys's engraving is topographically accurate. The view is from north to south, with Messina on the right and Reggio on the left. Here Bruegel has deliberately placed Reggio on the right so that it would be in the correct position when reversed for a print. However, the idea that he made a drawing from life with an eye to an engraving which was only cut many years later is highly implausible.[4] He did, though, make allowance for the printing process by employing reversal in his designs for *The Seven Virtues*, and for other prints as well.[5] The fact that the print and the drawing agree down to the smallest details shows that Huys did indeed use this sheet for his engraving. That becomes even clearer when one compares the architectural details in the print with those later covered with the wash. Moreover, and perhaps even more telling, the distance from the church spire in the center of the city to the solitary tree on the spit of land in the foreground is exactly 83 mm. in both drawing and print, while the horizontal and vertical measurements of the view of Reggio correspond precisely to those in the engraving. Huys's print was published in 1561, so the drawing would have been made in 1560, after Bruegel had completed the series of the Seven Virtues that same year.

Working on the assumption that the Rotterdam sheet was Huys's direct model, it can be assumed that Bruegel also produced designs for the other parts of the composition, such as the view of Messina, and the ships and galleys in the foreground. The large warship in the left foreground is sufficiently close to one of the vessels which Huys engraved after Bruegel in his ship series to

suggest that both had a common origin in a Bruegel design (fig. b).

In this connection, there is an interesting comment by Joris Hoefnagel (1542–1600) on his own print of the Strait of Messina, which was published in 1617 in the final volume of Braun and Hogenberg's *Civitatis Orbis Terrarum*.[6] In the 1580s and 1590s, Hoefnagel made the designs for many of the prints in this book of townscapes, either from direct observation or from prints by other artists. In the cartouche at lower right he states that he composed his view of the strait with the aid of "*studia autographa*" by Pieter Bruegel which he had discovered (fig. c). "*Ab ipsomet delineatum*," he added superfluously. Might the Rotterdam drawing have been one of those autograph studies?

Huys's engraving after Bruegel was used by cartographers and illustrators until late in the seventeenth century. Joan Blaeu incorporated it in his *Theatrum civitatum nec non Admirandorum Neapolis et Sicili Regnorum*, which was published at Amsterdam in 1652 (fig. d).[7] It was also used for the background in an etching of 1680 by Jan Luyken (1649–1712), which shows the battle between the Dutch and French fleets off the coast of Sicily in 1676, which cost the life of Admiral Michiel de Ruyter (fig. e).[8]

1. This attribution was made by I.Q. van Regteren Altena on the old passepartout.
2. Cf. Grossmann (1966); K. Oberhuber in exhib. cat. Brussels 1980, p. 65; K. Oberhuber, "Bruegel's Early Landscape Drawings," *Master Drawings* XIX, 1981, p. 151.
3. Cf. Menzel 1966.
4. Cf. exhib. cat. Brussels 1980, under no. 13 (A.W.F.M. Meij).
5. See cat. no. 17.
6. Vol. VI, fol. 58.
7. *Freti Siculi*, fols. 73v and 74r.
8. Cf. P. van Eeghen, *Het werk van Jan en Caspar Luyken*, vol. I, Amsterdam 1905, p. 32, no. 202.

AM

fig. d

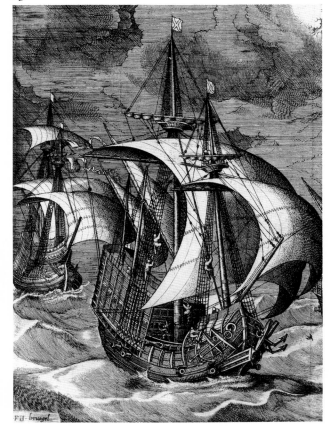

fig. b

fig. c

fig. e

18

Pieter Bruegel the Elder
Breda (?) c. 1525–1569 Brussels
TEMPERANCE

Pen and brown ink, indented; 221 × 294 mm.
Signed and dated in pen and brown ink: *1560*
Annotated in mirror writing in pen and brown ink:
Temporancia
Annotated along the lower margin in pen and brown
ink: *Vivendum ut nec voluptati dediti prodigi et Luxuriosi
appareamus nec avara tenacitati sordidi aut obscuri existamus*
(We must take care not to give ourselves over to vain
pleasures, debauchery and self-indulgence, but also that
avarice does not lead us into a life of ignorance and
sorrow)
Watermark: eagle with spread wings
Inv. MB 331

Provenance: P. Wouters; F.J.O. Boijmans; bequest of
1847 (L. 1875).

Exhibitions: Dijon 1950, no. 47; Paris 1952, no. 24;
Rotterdam 1952, no. 15; Prague 1966, no. 23; Berlin
1975, no. 74, fig. 104; Brussels 1980, no. 34 (ill.).

Literature: cat. Rotterdam 1852, no. 196 (P. Brueghel the
Younger); cat 1869, no. 55 (P. Brueghel the Younger);
R. van Bastelaer and G.H. de Loo, *Peter Bruegel l'Ancien*,
Brussels 1907, p. 196, no. 95; K. Tolnai, *Die Zeichnungen
Pieter Bruegels*, Munich 1925, p. 85, no. 44; O. Benesch,
"Bruegels Fortitudo," *Old Master Drawings* II, 1927,
p. 4; J.G. van Gelder and J. Borms, *Brueghels deugden en
hoofdzonden*, Amsterdam 1939, pp. 35-37, fig. XV;
D.T. Enklaar, *Uit Uilenspiegels kring*, Assen 1940, p. 87;
Delen 1943, p. 72, fig. 33; Tolnay 1952, no. 63;
Grossmann 1954, fig. 5; C.G. Stridbeck, *Bruegelstudien*,
Stockholm 1956, pp. 162ff., fig. 39; Marijnissen 1969,
no. 40; Münz 1961, no. 148, fig. 145; Menzel 1966,
p. 45, fig. 20; Lebeer 1969, under no. 37; W.S. Gibson,
Bruegel, London 1977, p. 22, fig. 4, p. 62, fig. 33;

E.K.J. Reznicek, "Bruegels Bedeutung für das
17. Jahrhunderts," *Pieter Bruegel und seine Welt*,
Colloquium Berlin 1975, Berlin 1979, pp. 159-64,
fig. p. 163, no. 1; M. Winner, "Zu Bruegels 'Alchimist'",
Pieter Bruegel und seine Welt, *Colloquium Berlin 1975*,
Berlin 1979, pp. 193-202, fig. p. 201, no. 9; W.S. Gibson,
"Artists and Rederijkers in the Age of Bruegel," *Art
Bulletin* LXIII, 1981, pp. 426ff., figs. 1, 2; I.M. Veldman,
De maat van kennis en wetenschap, Amsterdam 1985,
p. 24; Marijnissen *et al.* 1988, pp. 130ff. (ill.).

This drawing is one of fourteen designs for two print
series, of the Seven Deadly Sins and the Seven Virtues,
which Bruegel made in the second half of the 1550s
for the Antwerp publisher and printer, Hieronymus
Cock (*c*. 1510–70). The association with Cock began
immediately after Bruegel's return from Italy in
1554–55, when Cock added a religious scene to a
Bruegel drawing of 1554, which he then etched and
published.[1] From then until his departure for Brussels
in 1563, Bruegel supplied Cock with forty drawings on
a wide variety of subjects to be etched or engraved,
printed and published at Cock's Antwerp establishment,
"In de vier winden." The *Seven Virtues* series was issued
in 1560, and was probably engraved by Philips Galle
(1537–1612), who was employed by Cock. All Bruegel's
designs have survived, both for this series and for the
Seven Deadly Sins, which appeared in 1557.[2] The
drawings for the virtues set are all dated – five of them
1559 and two, including this *Temperance*, 1560.
Although Galle followed Bruegel's compositions closely,
he heightened the dramatic impact by introducing a
strong contrast between the light and dark passages
which is absent in the drawings (fig. a).

Bruegel used the same compositional program for
both series. In the center of each drawing there is a
female figure with various attributes. Around her are
scenes illustrating the virtue or vice she personifies.
In the *Seven Deadly Sins*, those vignettes are generally
bizarre or menacing, with demons, devils, deformed
creatures and monsters populating an imaginary and
often hellish landscape. The virtues, on the other hand,
are all surrounded by everyday scenes with the
exception of *Fortitude*, where the seven deadly sins
reappear in the guise of their attributes to do battle
with the virtuous.

All the prints and most of the drawings have a Latin
or Dutch inscription (not by Bruegel) which clarifies the
general meaning of the scene. The significance of many
of the details, though, remains obscure. It is not known
whether Bruegel took his inspiration for both series
from the same literary source, but there were certainly a
number from which he could have chosen.

He drew the designs for both sets in pen and brown
ink over a black chalk sketch, some traces of which can
still be seen. The engraver then placed the sheet on a
copper plate and indented the drawing with a stylus,
evidence of which is also occasionally visible. Bruegel
took account of the fact that his designs would be

fig. a

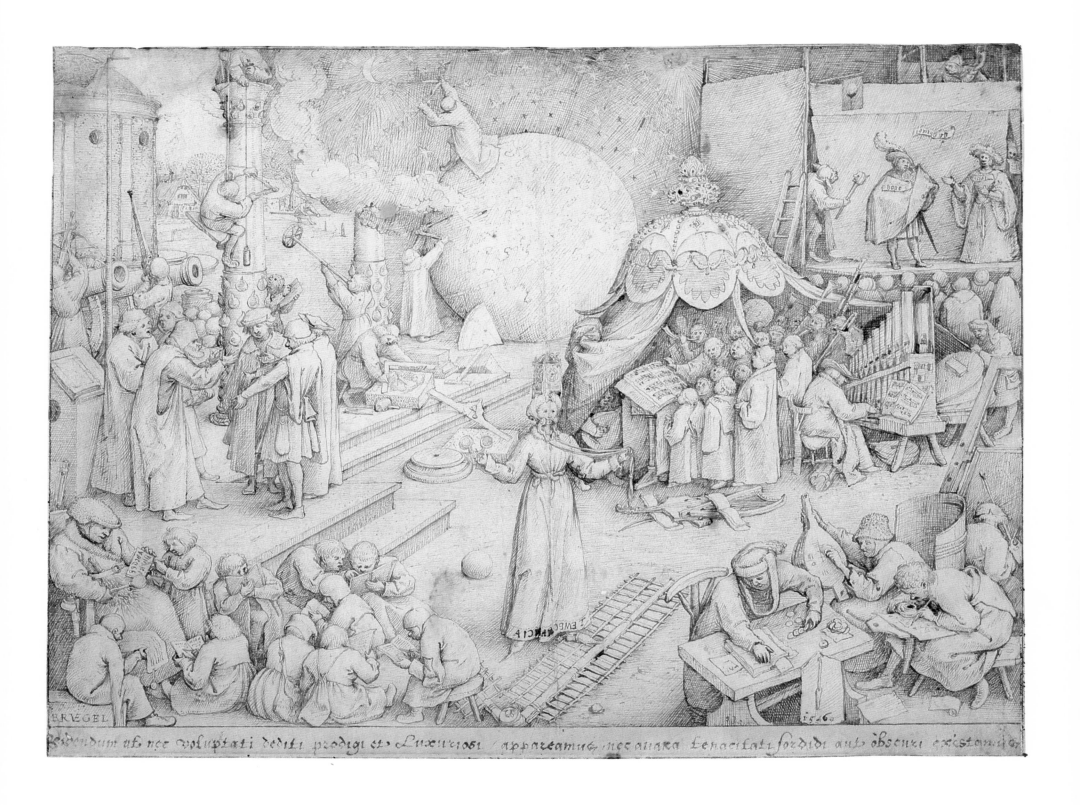

BRVEGEL 1556

fpbendum est nec voluptati dediti prodigi et Luxuriosi appareamus, nec auara tenacitati sordidi aut obscuri existamus

reversed, which explains why they contain so many left-handed people.

The central figure in this scene is Temperance, personified by a woman with a clock on her head, a bit in her mouth, the reins in her left hand, and in her right hand a pair of spectacles. She is also wearing spurs as she treads on the sails of a windmill. These are precisely the attributes which she has in two miniatures in two different French manuscripts, one from the last quarter of the fifteenth century, (fig. b)[3], the other of 1511 (fig. c).[4] The verse accompanying the miniature of *c.*1475 explains these accessories as follows. Those who keep their eye on the time conduct their affairs at the proper moment; those who control their tongues will speak no evil; those who put on spectacles will see more clearly, even objects which are close at hand; and the sails of a windmill always turn regularly. Of course it is unlikely that Bruegel ever saw either of these manuscripts, but the parallels do illustrate the generality of this kind of symbolism.

Grouped around Temperance are the Seven Liberal Arts, all of which are united by the themes of measurement or keeping time. In the left foreground is Grammar, represented by a village school with the teacher holding up a tablet from which one of the children is reading the letters of the alphabet (written back to front). The money-changers at lower right stand for Arithmetic. The two clerks busily taking down notes are doing so with their left hands. With his back towards us Bruegel included a painter behind an easel with which he possibly wanted to stress that painting should be considered part of the liberal arts as well. Behind him comes Music, with a choir, organist and wind ensemble performing in an ornate pavilion. The bare stage in the right background is the realm of Rhetoric. A man with the word *hope* emblazoned on his banderole is addressing a richly dressed woman. There is no way of telling what she is meant to represent, for her motto is unfortunately illegible, as is the inscription on the backdrop, which would have identified the play or allegorical mime. In the left middleground are three clerics and three laymen symbolizing Dialectics. They are having a heated discussion about the large volume on the lectern at the left and another book which one of the prelates is holding in his hand. Behind, representing Geometry, are various people industriously measuring a column with compasses and plumb line, while a surveyor goes about his work in the background. Half-hidden by the smoke is a second pillar, which suggests that this might be a reference to the device of Charles V: the pillars of Hercules with the arrogant motto *Plus ultra* – this far and further.[5] Finally, Astronomy is epitomized by two men attempting to measure the globe and the distance between the earth and the heavenly bodies with a pair of compasses.

It was unusual, not to say unconventional, in the sixteenth century to associate the Seven Liberal Arts so deliberately and directly with a single virtue like Temperance, and it is believed that Bruegel had some special reason for doing so.[6] His *Temperance* appears to

illustrate an attitude toward art and learning held by humanists in the mid-sixteenth century. Erasmus, at the beginning of the century, had written scathingly about scholars, lampooning grammarians and schoolmasters (*Grammatica*), poets and rhetoricians (*Rhetorica*), and theologians (*Dialectica*) in his *Praise of Folly*.[7] Many years after Bruegel made this drawing, Dirck Volckertsz Coornhert (1519–90), the Haarlem humanist, writer, and designer and engraver of prints, reiterated this idea. "But just as all things have their measure, so it is with the desire for knowledge.... For the craving to know too much is curiosity or idle inquisitiveness," he wrote in 1586.[8] In the second half of the sixteenth century Coornhert was in regular correspondence with Antwerp humanists like Ortelius (1527–98) and the printer and publisher Christopher Plantin (1520–89). All three were members of a semi-secret society called "The Family of Love" – a network of liberal European humanists. Hieronymus Cock, who commissioned work from Bruegel, very probably mixed in the same circles, and could easily have passed these ideas on to him. Coincidence or not, the year in which Bruegel made this drawing also saw the publication of the first Dutch edition of Erasmus's *Praise of Folly*.[9]

1. Cf. K. Arndt, "Unbekannte Zeichnungen von Pieter Bruegel d. Ae.," *Pantheon* XXIV, 1966, p. 206f.; exhib. cat. Brussels 1980, no. 11 (ill.).
2. For the drawings see Münz 1961, nos. 130-38, figs. 127-33, and nos. 142-48, figs. 139-45; for the engravings Lebeer 1969, nos. 18-24 (ill.).
3. Bibliothèque Nationale, Paris, Ms. franç. 9186, fol. 304r; cf. E. Mâle, *L'Art religieux de la fin du Moyen Age*, Paris 1931, p. 311, fig. 168. The manuscript was made for Jacques d'Armagnac, duc de Nemours, who was beheaded in 1477. See also J. O'Reilly, *Studies in the Iconography of the Virtues and Vices in the Middle Ages*, diss. 1972, New York, London 1988, p. 124, fig. 9.
4. Koninklijke Bibliotheek, The Hague, Ms. 76 E 13, fol. 8r. It is dated on fol. 22v, and was made on the death of Phillipe de Commines in 1511.
5. Cf. Winner (1979), p. 201.
6. Stridbeck (1956), pp. 165-66.
7. Desiderius Erasmus, *Lof der Zotheid*, ed. J.B. Kan, Amsterdam 1912, chs. 49, 50, 53.
8. D.V. Coornhert, *Zedekunst dat is wellevenskunste*, ed. B. Becker, Leiden 1942, p. 128: "*Maar zo alle dinghen huer mate hebben, zo heeftse oock de begheerte om te weten.... Want te vele te willen weten is curiositeyt of onnutte weetghierichheyd.*" See also Veldman (1985), p. 15, and for Coornhert and the Familists, A. Hamilton, *The Family of Love*, Cambridge 1981, pp. 102-07.
9. Desiderius Erasmus, *Dat constelijck ende costelijck Boecxken Moriae Encomion...*, Embden 1560.

AM

fig. b

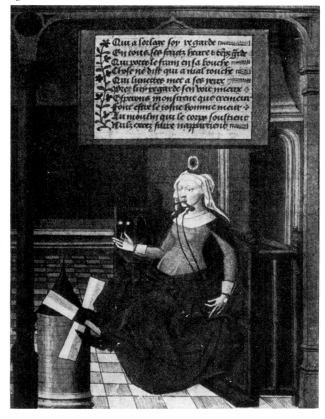

fig. c

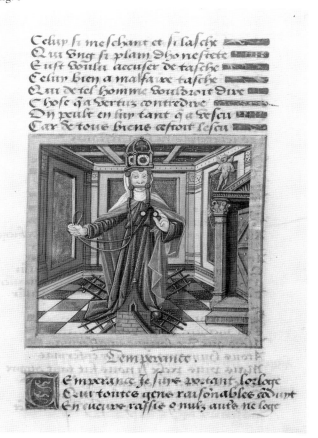

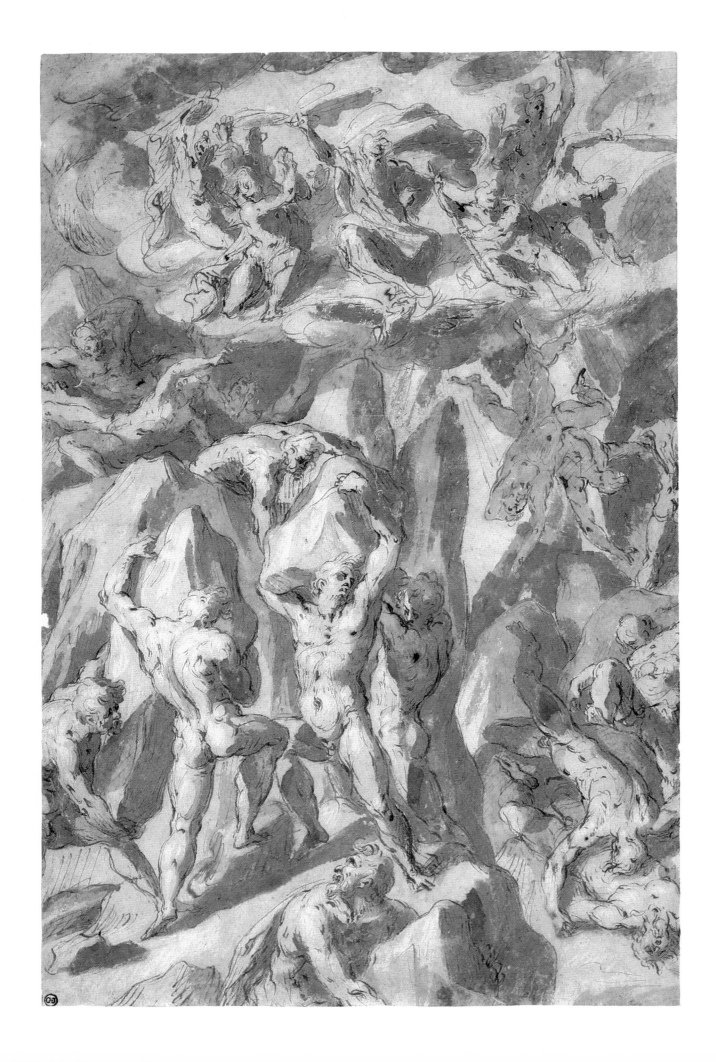

19

Anonymous Netherlandish Mannerist, c. 1575
THE BATTLE OF THE GODS AND GIANTS

Pen and brown ink on blue paper, brown wash,
heightened with the brush and white bodycolor;
415 × 269 mm.
No watermark
Inv. MB 1988/T 5

Provenance: Alphonse Daudet (1840–97); sale Amboise,
Château de Chargé, June 9 1947; Royan (dealer); C. de
Jong, Seychelles (?); sale Paris (Drouot) March 10 1986,
no. 3; Paris art market; acquired by the museum in
1988.

Not previously exhibited

Not previously published

fig. a

fig. b

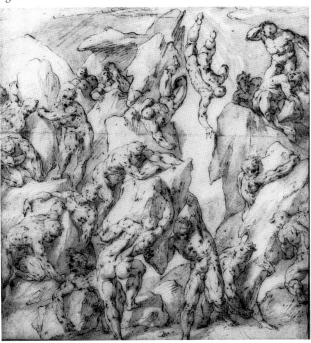

Hubris will be punished. Sixteenth and seventeenth-
century authors illustrated this moral by citing not
only Proverbs 16:18 ("Pride goeth before destruction,
and an haughty spirit before a fall"), but also the battle
of the gods and giants from the first book of the
Metamorphoses. There Ovid describes how the gods were
angered when the giants attempted to storm Olympus
by piling up boulders to make a staircase to the
heavens. The ensuing battle was won by the gods,
who then sent a great flood to punish mankind.[1]

This was also a popular subject with artists,
particularly in the Mannerist period, for it allowed them
to depict the human body in all sorts of histrionic
poses. It was an opportunity which the draftsman of this
sheet also seized with relish. On the left the giants are
hard at work building up the mountain from which to
launch their assault, while above the gods retaliate. Led
by Jupiter, seated on his eagle and hurling thunderbolts,
they fling down rocks and wield their traditional
weapons – lance, caduceus and trident. On the right the
defeated giants tumble into the abyss, where their
shattered bodies lie in an untidy heap.

The vault of the heavens opens up behind the gods,
allowing the artist to set up an interplay of light and
shade as the clouds cast shadows on the warring figures.
The dark brown washes, an intermediate ocher hue and
the numerous highlights combine with the blue paper to
heighten the drama. The uneven fall of light is
suggested by the occasional accent on a knee or
buttock. There is broad hatching throughout, and many
of the outlines have been drawn twice. The gods at the
top, elegantly composed in an imaginary oval, are more
freely rendered than the giants in the foreground.

This drawing belongs to quite a large group of
stylistically related sheets which were influenced by the
work of Hans Speckaert, an artist who was born in
Brussels but worked in Rome, where he died at an early
age in 1577.[2] Karel van Mander, who came to Rome in
1574 and met him there, describes him as "an excellent
young painter... who painted and drew most ably."[3]
From a document of April 3 1575 we know that
Speckaert, "formerly an outstanding painter" had been
struck down by paralysis.[4]

His *œuvre* is small, probably far smaller in fact than
has been assumed until now.[5] Nevertheless, his
remarkable drawing style held a great appeal for
Northern artists, and despite his early death he stood
with Bartholomeus Spranger (1546-1611) at the head of
the late Mannerist movement to which Goltzius also
belonged.[6] Speckaert's impact on Spranger is already
evident in 1572/73, and later Van Mander, Anthonie
van Blocklandt and above all Hans von Aachen
displayed their receptiveness to his work, along with
numerous other artists who visited Rome and whose
names are now lost.[7] Some of that influence was
transmitted through prints engraved to his designs by
Cornelis Cort, Pieter Perret and Aegidius Sadeler.[8]
Even more important, though, was the fact that for a
long time many artists in Rome had access to the
drawings he left on his death. One of his friends was

Anthonie van Santvoort, known as "Blue Anthony," who not only inherited Cornelis Cort's possessions in 1578, among them drawings by Speckaert, but who seems to have administered Speckaert's estate as well.[9] Van Santvoort died in Rome in 1600, so artists were able to inspect Speckaert's drawings for more than two decades after his death.[10] Even Goltzius may have seen them in Van Santvoort's workshop when he was in Rome in 1591.

Artists did not just copy Speckaert's drawings, they also produced series of their own inspired by his example. In the case of some subjects there are several versions with minor compositional and stylistic differences. One such is *The Battle of the Gods and Giants*, of which there are at least two other interpretations. The first is in the Uffizi in Florence (fig. a), but despite the affinities it is not certain that it is by the same hand as the Rotterdam drawing.[11] It was probably larger originally, and seems to have been trimmed at the top. The present whereabouts of another drawing (fig. b), which was once attributed to Jan Muller, a Goltzius follower, is not known.[12] To judge from the photograph, it could well be by the same artist as the Rotterdam sheet. Some of the poses have been reversed, while others display slight variations. It is not clear whether all three drawings derive from a single model by Speckaert, or whether he himself produced several versions of the subject. A number of the figures are obviously taken from Michelangelo's *Last Judgment* in the Sistine Chapel. Speckaert's eclecticism recalls that of Italian contemporaries like Rafaellino da Reggio and Taddeo Zuccaro. He was especially influenced by the latter,[13] who also made a drawing of *The Battle of the Gods and Giants* to which the above three sheets bear a certain resemblance.[14]

The subject became extremely popular with Netherlandish Mannerists after Speckaert. One drawing, by Anthonie van Blocklandt (fig. c), is virtually inconceivable without Speckaert's model.[15] Van Blocklandt's Jupiter is related to the figure to the left of the supreme god in the Rotterdam sheet, and the pose of the giant lying at the foot of the ladder also seems to come from the same source. But this was not the end of Speckaert's influence, for although the paintings by Joachim Wtewael and Cornelis van Haarlem (fig. d) are compositionally more remote from the prototype, they unmistakably belong to the same iconographic tradition.[16]

1. Ovid, *Metamorphoses*, I, 152-58.
2. E. Valentiner, "Hans Speckaert: ein Beitrag zur Kenntnis der Niederländer in Rom um 1575," *Städel-Jahrbuch* VII-VIII, 1932, pp. 163-71.
3. Van Mander 1604, fol. 230r: "... een fraey jongh schilder... die seer aerdigh schilderde, en teekende. ... Hy was van Brussel, en soon van een Borduerwercker." For the meaning of the terms "*fraey*" and "*aerdigh*," which Van Mander uses repeatedly, see H. Miedema, *Fraey en aerdigh, schoon en moy in Karel van Manders Schilder-Boeck*, Amsterdam, Kunsthistorisch Instituut van de Universiteit van Amsterdam, 1984.
4. G.J. Hoogewerff, *Bescheiden in Italië omtrent Nederlandsche kunstenaars en geleerden*, vol. II, The Hague 1913, p. 616: "*voorheen uitstekend schilder*."
5. T. Gerszi, "Unbekannte Zeichnungen von Jan Speckaert," *Oud Holland* LXXXIII, 1968, pp. 161-80; S. Béguin, "Pour Speckaert," *Album Amicorum J.G. van Gelder*, The Hague 1973, pp. 9-14; but see also W.T. Kloek, "Review of T. Gerszi, *Netherlandish Drawings in the Budapest Museum: Sixteenth-Century Drawings*," *Simiolus* VII, 1974, p. 108. The "Speckaert group" was considerably expanded recently by J. Zimmer, *Joseph Heintz der Altere: Zeichnungen und Dokumente*, Munich, Berlin 1988, pp. 54-55, note 170. The following remarks on Speckaert's influence on his followers, some of them anonymous, are based on conversations with W.T. Kloek, who

generously allowed me to examine his files on the artist. The key works for all further attributions are the drawings in Paris, Musée du Louvre, *The Crowning with Thorns* (F. Lugt, Musée du Louvre, *Inventaire général des dessins des écoles du nord. Maîtres des anciens Pays-Bas nés avant 1550*, Paris 1968, no. 686, pl. 196), Florence, Uffizi, *The Rape of Helen* (W.T. Kloek, *Beknopte catalogus van de Nederlandse tekeningen in het Prentenkabinet van de Uffizi te Florence*, Utrecht 1975, no. 184), Amsterdam, Rijksprentenkabinet, *Nude Warriors Fighting* (Schapelhouman 1987, no. 84), and Paris, private collection, *The Visitation* (exhib. cat. *Dessins des écoles du nord dans les collections privées françaises*, Paris, Galerie Aubry, no. 99, pl. 101).
6. K. Oberhuber, *Die stilistische Entwicklung im Werk Bartholomäus Sprangers*, diss. Vienna 1958, pp. 60-63.
7. For Van Mander see Reznicek 1961, vol. I, p. 161; for Van Blocklandt, Jost 1960, p. 45. Further: T. Gerszi in exhib. cat. *Prag um 1600: Kunst und Kultur am Hofe Rudolfs II*, Essen, Kulturstiftung Ruhr, 1988, pp. 308-09, fig. 6; T. da Costa Kaufmann, *The School of Prague: Painting at the Court of Rudolf II*, Chicago, London 1988, pp. 34, 38.
8. J.C.J. Bierens de Haan, *L'Oeuvre gravé de Cornelis Cort: graveur hollandais 1533-1578*, The Hague 1948, nos. 138, 146, 195; for Perret see Hollstein, *Dutch and Flemish*, vol. XVII, p. 48, nos. 32-33; for Sadeler, ibid., vol. XXI, pp. 25-26, nos. 81-86, and W. Stechow, "The 'Triumph of David' by Hans Speckaert," *Bulletin Allen Memorial Art Museum Oberlin* XIX, 1961-62, pp. 110-14.
9. According to Van Mander 1604, fol. 263v, Speckaert and Van Santvoort were also close friends of Aert Mijtens. Cort's inventory is given in Bierens de Haan, op. cit. (note 8), pp. 226-28. For the little that is known about Mijtens and Van Santvoort, see E. Fucikova, "Umen a umelci na dvore Rudolfa II.-Vztahy k Italii," *Umeni* XXXIV, 1986, pp. 119-28.
10. Joseph Heintz also stayed with Van Santvoort, see J. Zimmer, *Joseph Heintz der Altere als Maler*, Weissenhorn 1971, p. 14, and Zimmer, op. cit. (note 5), pp. 367-69.
11. Kloek, op. cit. (note 5), no. 181.
12. P.J.J. van Thiel, "Cornelis Cornelisz van Haarlem as a Draughtsman," *Master Drawings* III, 1965, p. 150, and exhib. cat. *Dutch Mannerism: Apogee and Epilogue*, Poughkeepsie, N.Y., Vassar College, 1970, no. 79 (still as Jan Muller). The drawing was later sold as "German School" in Paris (Palais Galliera), April 6 1976, no. 4.
13. F. Baumgart, "Zusammenhänge der niederländischen mit der italienischen Malerei in der zweiten Hälfte des 16. Jahrhunderts," *Marburger Jahrbuch für Kunstwissenschaft* XIII, 1944, pp. 187-250.
14. A.E. Popham and J. Wilde, *The Italian Drawings of the XV and XVI Centuries in the Collection of His Majesty the King at Windsor Castle*, London 1949, p. 275, no. 539, fig. 117, where the drawing is attributed to Lelio Orsi, but see E. Monducci et al., *Lelio Orsi*, Milan 1987, p. 261, no. 58.
15. Jost 1960, pp. 152-53, cat. no. II,5, and exhib. cat. *Kunst voor de beeldenstorm*, Amsterdam, Rijksmuseum, 1986, no. 312.
16. A. Lowenthal, *Joachim Wtewael and Dutch Mannerism*, Doornspijk 1986, pp. 102-04, cat. nos. A-23, 24; P.J.J. van Thiel, "Cornelis Cornelisz. van Haarlem – his first ten years as a painter," in G. Cavalli-Björkman (ed.), *Netherlandish Mannerism: Papers Given at a Symposium in the Nationalmuseum Stockholm, September 21-22, 1984*, Stockholm 1985, pp. 76-77, fig. 3. Another work which is firmly in the same tradition is the large chiaroscuro woodcut of 1647 by Bartolommeo Coriolano after Guido Reni; see Bartsch, vol. XII, p. 114, no. 12.

GL

fig. c

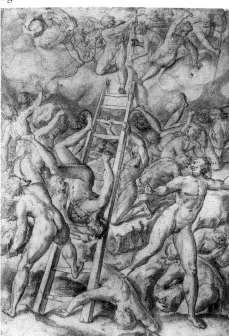

fig. d

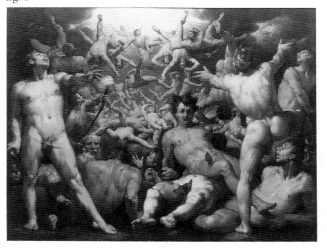

20

Jan van der Straet, called Stradanus
Bruges 1523–1605 Florence
ODYSSEUS ON THE ISLAND OF THE SUN-GOD

Pen and brush and brown ink, blue wash, heightened
with white bodycolor; 182 × 274 mm.
Signed in the lower left corner (barely visible):
IOA STRADA
No watermark
Inv. MB 332

Provenance: F.J.O. Boijmans, bequest of 1847 (L. 1857).

Not previously exhibited

Literature: cat. 1852, no. 953; cat. 1869, no. 817.

When Odysseus and his companions landed on the
island of the sun-god Helios, a fierce storm blew up
which prevented them from putting to sea again for a
full month. Ignoring the warning to keep away from
the "splendid broad-browed cattle" belonging to the
all-seeing Helios, Odysseus's men waited until he fell
asleep and then rounded up the finest cows and roasted
them to still their hunger. But disaster struck when they
finally left the island, and their ship sank in a storm,
drowning all but Odysseus.[1]

There is not a hint of impending doom in Stradanus's
interpretation of the crew's fatal act of disobedience,
which has more the air of a charming pastoral. The
hero is asleep beneath some trees in the foreground,
reclining in a pose which in the sixteenth century was
usually reserved for those overcome by melancholy. He
has unbuckled his sword, and his plumed helmet lies on
the ground beside him. In the middleground his men
are stealing the divine cattle, but in contrast to the
bloodthirstiness of some of Stradanus's hunting scenes,
the action here is almost balletic, with the cows as the
dancers. According to Homer, the men had no wine to
pour over the roasting meat, so they used water instead,
and this is emphasized by the smoke rising from the fire
in the background. The liberal use of white bodycolor,
combined with the bright blue wash, gives the sheet a
startling brilliance.

The drawing was probably executed in Florence,
where Stradanus spent the greater part of his life after
working as an assistant to Giorgio Vasari, with whom
he participated on several important decorative
programs. He also produced numerous designs for the
Florentine tapestry industry, and made preparatory
drawings for various Antwerp engravers, including
Johannes Collaert and Philips Galle, many of which
still survive.[2]

Odysseus on the Island of the Sun-God is one of a series
of drawings executed in the same technique and with
the same dimensions. Two of the others, also in the
Boymans-van Beuningen Museum, are *Odysseus in Hades*
and *Odysseus in the Cave of the Winds*. The third,
Odysseus and Circe, is in the Courtauld Institute,
London,[3] and there is an *Odysseus and Scylla* which was
last seen at an auction in 1937.[4] In an annotated
drawing for a title-page which is clearly associated with
the series (fig. a),[5] Odysseus appears in the same garb to
the left of a cartouche. On the other side, with lyre and
pen, is Homer, who is under the tutelage of Apollo and
takes his inspiration from the Muse below him.

fig. a

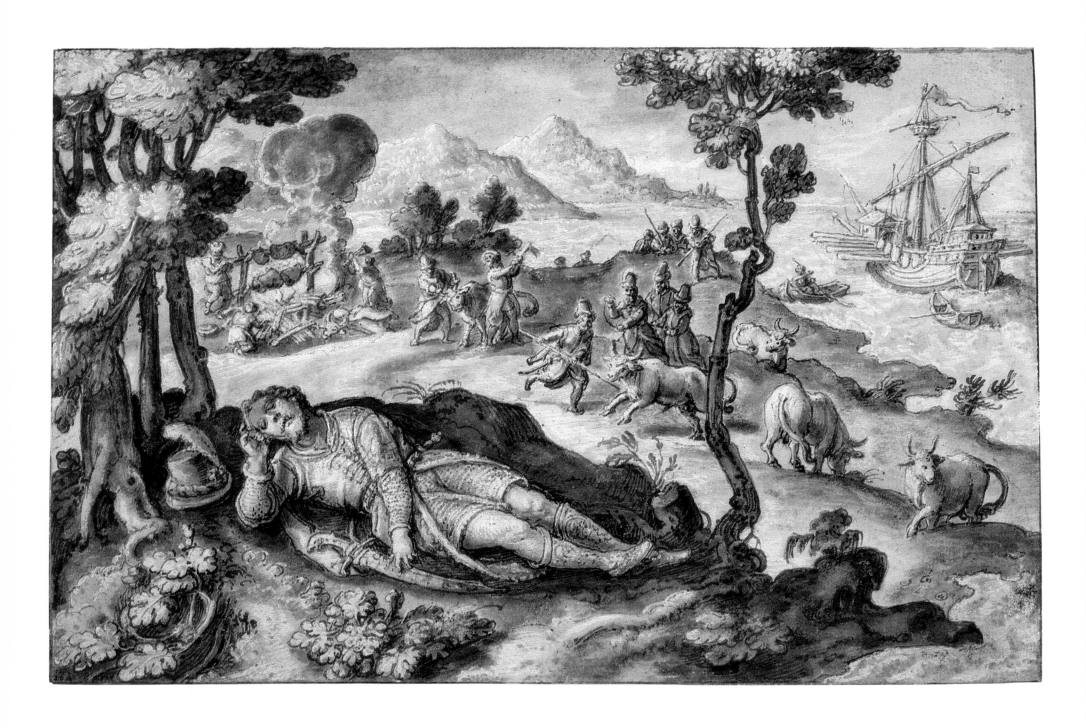

Odysseus's patroness is Minerva, who also comes to his aid in the *Odyssey*, and at his feet is a suit of armor. Penelope and her maidservants are weaving in the oval at the top, and at the bottom, while Troy burns in the background, Odysseus takes his revenge on her suitors after his return to Ithaca.

Stradanus often made a small composition sketch before starting work on his drawings.[6] Several for the *Odyssey* series have been preserved, and show that he planned, or indeed made, more illustrations than the six now known in their finished state.[7] The sketches have every appearance of being jotted down while Stradanus was actually reading the *Odyssey*. In a few cases he changed the final composition, but the sketch for *Odysseus on the Island of the Sun God* retains all the elements found in the drawing, and also has the same structure (fig. b).[8] It is difficult to put a date on this sheet. From around 1580, after his Mannerist period with Vasari, Stradanus developed a uniform style which remained virtually unchanged until his death in 1605, and this is the idiom of all the *Odyssey* sheets.

Although none of the drawings are indented for transfer to a copper plate, it can be assumed that they are designs for a series of prints or book illustrations.[9] It is possible that they were the fruit of Stradanus's collaboration with the writer Luigi Alamanni (1558–1603), who was a member of the Accademia degli Alterati in Florence.[10] Their relationship is documented from 1587-88, when Stradanus supplied designs for a series of unexecuted engravings for Alamanni's study of Dante's *Inferno*.[11] Stradanus later dedicated various prints to Alamanni, who in turn provided verse inscriptions for his prints and instructed him in the finer points of iconography.[12] Several of Stradanus's drawings have explanatory notes by Alamanni, and it was probably he who inserted the names of the characters on the sketches for the *Odyssey* illustrations. In the eulogy composed on his death in 1603, Alamanni is praised as an editor of classical texts. There is also mention of a proposed edition of Homer which had been brought to nothing by his death.[13] If Stradanus's drawings really were intended for that project, they can be located late in his long career, around 1600 or thereabouts.

fig. b

1. Homer, *Odyssey*, bk. XII.
2. For Stradanus see G. Thiem, "Studien zu Jan van der Straet, genannt Stradanus," *Mitteilungen des Kunsthistorischen Institutes in Florenz* VIII, 1957-59, pp. 88-111; W. Bok-van Kammen, *Stradanus and the Hunt*, diss. Baltimore, Maryland, 1977; D. van Sasse van Ysselt, "Il Cardinale Alessandro de'Medici commitente dello Stradano," *Mitteilungen des Kunsthistorischen Institutes in Florenz* XXIV, 1980, pp. 201-36.
3. *Handlist of the Robert Witt Collection*, London 1956, p. 131, no. 2395. This drawing has a Dutch inscription from Stradanus's hand.
4. From the collection of Baron R. Portalis; see sale Amsterdam (Frederik Muller) July 5 1927, no. 306, and sale A.W.M. Mensing, Amsterdam (Frederik Muller) April 27 1937, no. 692.
5. San Francisco, Achenbach Foundation for Graphic Arts; exhib. cat. *Master Drawings from Californian Collections*, Berkeley, University of California Art Museum, 1968, pp. 73-74, no. 72, fig. 158.
6. See Thiem, op. cit. (note 2).
7. Most of the sketches (all measuring approximately 70 × 110 mm.) are in the Cooper Hewitt Museum in New York, which has an extensive collection of Stradanus drawings; see M.N. Benisovich, "The Drawings of Stradanus (Jan van der Straeten) in the Cooper Union Museum for the Arts of Decoration, New York," *Art Bulletin* XXXVIII, 1956, pp. 249-51. The subjects are the figure of Homer, inv. 1901-39-141, study for the title-page in San Francisco (note 5); *Odysseus and Circe*, inv. 1901-39-161v, study for the London drawing (note 3); *Odysseus in Hades*, inv. 1901-39-2657v, study for the Rotterdam drawing, inv. J.S. 1; *Odysseus in the Cave of the Winds*, inv. 1901-39-146v, study for the Rotterdam drawing, inv. J.S. 2; *Odysseus and the Laestrygonians*, inv. 1901-39-161r; *Odysseus and Polyphemus*, inv. 1901-39-146r; and *Odysseus and the Sirens*, inv. 1901-39-2657r. The Pierpont Morgan Library in New York recently acquired the sketch of *Odysseus and Calypso*, inv. 1979.14:6, from the Janos Scholz Collection.
8. New York, Cooper Hewitt Museum, inv. 1901-39-115.
9. Prints to designs by Stradanus are not listed in I. Krueger, *Illustrierte Ausgaben von Homers Ilias und Odyssee vom 16. bis ins 20. Jahrhundert*, diss. Tübingen 1970, Ulm 1971.
10. *Dizionario biografico degli italiani*, vol. I, Rome 1960, p. 571.
11. M. Sellink, "Lucifer," *Bulletin van het Rijksmuseum* XXXV, 1987, pp. 91-104. An annotation on the verso of a design in the Cooper Hewitt Museum, inv. 1901-39-2635v, confirms that Alamanni commissioned drawings from Stradanus for the *Inferno*, see ibid., p. 103, note 26.
12. Among the prints which Stradanus dedicated to Alamanni was the *Nova Reperta* series, which was engraved by Hans Collaert and Theodor Galle; see Hollstein, *Dutch and Flemish*, vol. VII, p. 87, nos. 410-30.
13. Jacopo Soldani, "Orazione Sesta" (September 25 1603) in *Prose Fiorentine*, Venice 1751, vol. I, pt. 4, pp. 46-52, esp. p. 48. I would like to thank D. van Sasse van Ysselt of the Netherlands Institute for Art History in The Hague for her generosity in allowing me to examine her material on Stradanus, and also for drawing attention to the part played by Alamanni in the illustrations.

GL

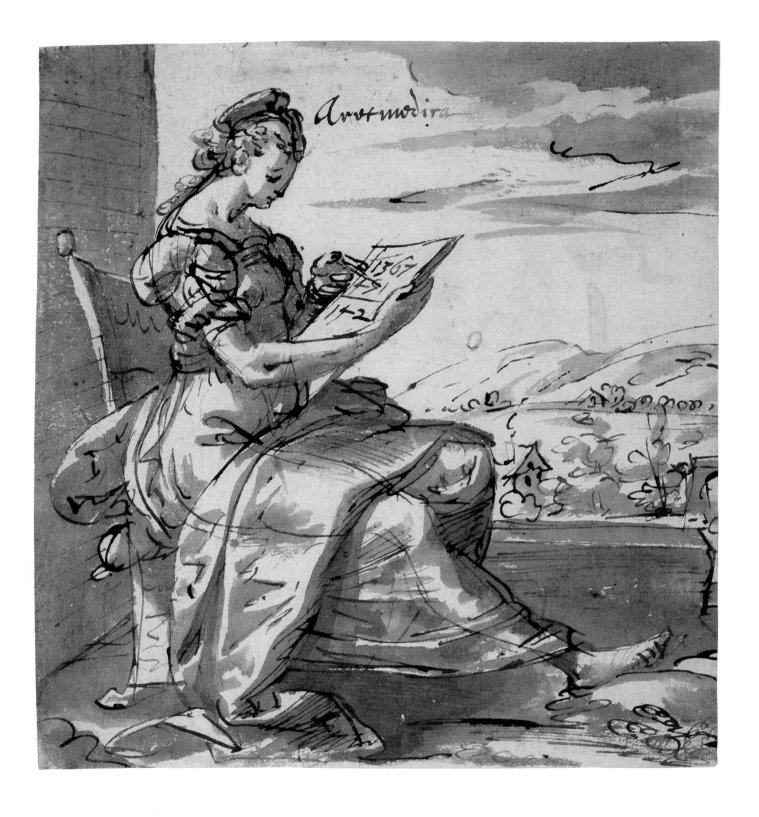

21

Hendrick Goltzius
Mühlbracht near Venlo 1558–1617 Haarlem
ARITHMETICA

Pen and brown ink, red wash; 198 × 179 mm.
Upper center: *Aritmedica*, and in the book, from top to
bottom: *1367, 451* and *142*
Verso, by a seventeenth-century hand: *hendrick goltzus*,
and by a modern hand: *36* and *Coreggio Wilton House
Colln (Lot 410) Strong's catalogue*
No watermark
Inv. MB 1956/T 7

Provenance: Wilton House Collection; sale London
(Sotheby's), October 5, 6 and 9 1917, probably part of
lot 410; K.E. Maison, London; K. Meissner (art dealer),
Zürich; acquired by the museum in 1956.

Exhibitions: Rotterdam, Haarlem 1958, no. 36.

Literature: Reznicek 1961, vol. I, p. 301, K 159, vol. II,
A 13.

In Goltzius's early years as an artist, when he was
working almost entirely as an engraver of other people's
designs, his drawn *œuvre* consisted chiefly of small
portraits. Many were of leading citizens of Haarlem,
to which he had moved in 1577 with his master, Dirck
Volckertsz Coornhert (1519–90). Only a few figure
drawings survive from the period up to 1583, when,
according to Van Mander, he was introduced to the
work of Bartholomeus Spranger.[1]

This swiftly executed personification of Arithmetic is
one such sheet. When it was in the collection at Wilton
House, its earliest known location, it was attributed
(not very perceptively) to Correggio, but by the time it
entered the museum in 1956 it had already been
identified as a Goltzius.[2] In style it is closely related to
the Munich drawing, monogrammed *HG*, of a *Standing
Soldier*, whose pose is derived from Lucas van Leyden's
Standard-Bearer.[3] Also from around 1580 are two
drawings in Braunschweig with scenes from the story of
Lucretia, which Goltzius used for his four-print suite of
the same subject.[4] The female figure in Rotterdam is
repeated almost identically, but reversed, on the right
of the drawing of Lucretia and her maidservants
spinning (fig. a).

A similarity has been noted between those works and
the drawing style of Frans Floris and his followers,
which was the most important influence on Goltzius
before his exposure to Spranger. The print series of the
Story of Lucretia was published by Philips Galle
(1537–1612), and it would have been through him that
Goltzius became acquainted with drawings by Floris and
prints to his design. Reznicek believes that the
Rotterdam *Arithmetica*, like the *Standing Soldier* in
Munich, is derived from a print – in this case Cornelis
Cort's 1565 engraving of the same subject after Frans
Floris, which was published by Hieronymus Cock
(fig. b).[5] Although that engraving may have been the
iconographic model, there is a more direct source for
the composition in one of Philips Galle's prints after
Anthonie van Blocklandt, an artist whom Goltzius
greatly admired. It was not for nothing that Goltzius
embarked on his career as a print publisher in 1582
with an engraving of *Lot's Escape from Sodom* after Van
Blocklandt, or that he followed the master's example by
introducing the female nude in his work at the same
time.[6]

The print in question is *The Delphic Sibyl* from the set
dedicated to Benito Arius Montano, which Galle himself
published in Antwerp in 1575 (fig. c).[7] Not only is there
a close correspondence in the composition and the
placement of the figure, but there are also clear
similarities in details such as the positions of the legs
and the right foot, the hanging drapery, and the dark
bulk of the building on the left.

Goltzius must have had that print in front of him as
he swiftly jotted down the basic forms. He wasted no
time on the details, and at first did not realize that the
woman's dress would have to cover her right thigh.

The highly schematic background also testifies to the
rapidity of the sketch. Goltzius exhibited this urge for
virtuosity from very early on, and when he later
undertook exercises of this sort "from the imagination"
it helped secure his reputation. Here, though, he was
working from a print, and he continued to do so even
after he had exchanged the pen for the brush in order
to apply the garish red wash, for the drawing has an
almost identical distribution of light and shadow, both
in the face and body of the figure and in the landscape.
Even in the sky at upper right there is an area of wash
corresponding to the hatching in the engraving.

This sheet was probably one of a set of seven
drawings of the liberal arts, for which Goltzius may also
have used other prints from Galle's series – with
appropriate modifications to the attributes. He later
published a print series of the *Seven Liberal Arts* to his
own design, which was engraved by his nephew, the
scientist Cornelis Drebbel (1572–1633).[8]

1. Reznicek 1961, vol. I, pp. 47-62.
2. See the advertisement reproducing the drawing in *Die
Weltkunst* XXV, 1955, no. 24, p. 25.
3. Reznicek 1961, vol. I, p. 456, K 441, vol. II, A 14.
4. Ibid., vol. I, pp. 292-94, K 140-41, vol. II, A 15-16. Van
Mander greatly admired this early series, which he says was
made before his own arrival in Haarlem; see ibid., p. 293, and
exhib. cat. *Das gestochene Bild: von der Zeichnung zum
Kupferstich*, Braunschweig, Herzog Anton Ulrich-Museum,
1987, pp. 71-76, nos. 62-65.
5. J.C.J. Bierens de Haan, *L'Oeuvre gravé de Cornelis Cort,
graveur hollandais 1533-1578*, The Hague 1948, p. 209, no. 225,
and C. van de Velde, *Frans Floris (1519/20-1570): leven en
werken*, Brussels 1975, vol. I, p. 427, no. 118, vol. II, fig. 271.
6. Reznicek 1961, vol. I, pp. 61-62, and esp. pp. 144-45.
7. Hollstein, *Dutch and Flemish*, vol. VII, p. 78, no. 277; Jost
1960, pp. 169-70, no. III.8; *The Illustrated Bartsch: Netherlandish
Artists*, vol. LVI, New York 1987, p. 233, no. 066:3.
8. Hollstein, *Dutch and Flemish*, vol. VI, p. 2, nos. 4-10.

GL

fig. a

fig. b

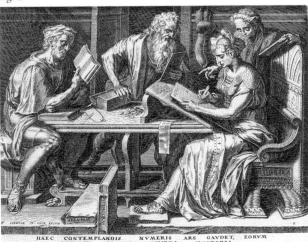

HAEC CONTEMPLANDIS NVMERIS ARS GAVDET, EORVM
OCCVLTA SOLLERS ERVENS MYSTERIA.

fig. c

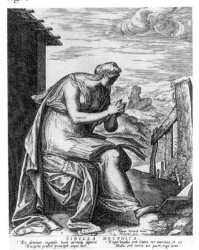

SIBYLLA DELPHICA

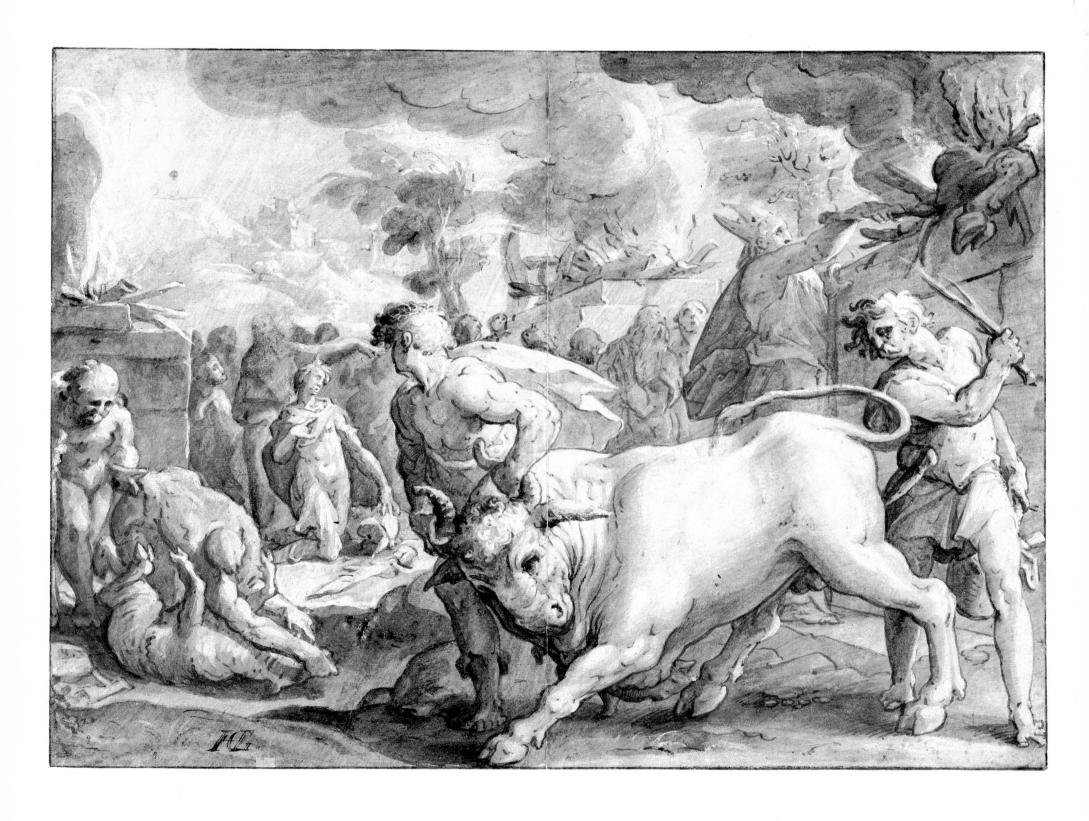

22

Hendrick Goltzius
Mühlbracht near Venlo 1558–1617 Haarlem
SACRIFICIAL SCENE

Pen and gray ink, gray wash, heightened with white, on
green prepared paper; 308 × 411 mm.
Signed at lower left with monogram: HG
Verso: black chalk study of *A Nude Man Falling
Backward*
Watermark: not visible
Inv. MB 333

Provenance: F.J.O. Boijmans, bequest of 1847 (L. 1857).

Not previously exhibited

Literature: cat. 1852, no. 319; cat. 1869, no. 189;
Reznicek 1961, vol. I, p. 240, K 14, vol. II, A 67; Judson
1970, p. 92, fig. 150.

Goltzius's interest in chiaroscuro effects is evident in a
number of his drawings, this one among them. In it he
constructed complete shapes and figures using no more
than the brush and white bodycolor which also served
for the occasional highlight. There are very few contour
lines, and the prepared paper is treated almost like a
first tone block. In this respect the drawing is akin to
the equally painterly *Rest on the Flight in Egypt* in the
Teyler Museum in Haarlem, which is dated 1589 and is
from the same period as the Rotterdam sheet.[1] Neither
work is really conceivable without the example of Dirck
Barendsz (1534–92) and his drawings. In 1584 Goltzius

made an engraving of Barendsz's *Venetian Wedding*, and
was evidently much attracted by the latter's highly
unusual style, which owed much to Venetian art.
Goltzius's introduction to Barendsz's work undoubtedly
fired his curiosity about Italy, which he eventually
visited in 1590.[2] There are close parallels, stylistic and
even figural, between this *Sacrificial Scene* and Barendsz's
drawing of *David Playing the Harp* in the Rijksprenten-
kabinet in Amsterdam.[3]

As on other occasions (cf. cat. no. 21), Goltzius
consulted various prints for the figures in this sheet.
The composition as a whole recalls scenes of sacrifice
by Etienne Delaune and Antonio Fantuzzi after Rosso
Fiorentino.[4] The massive sacrificial animal, set
prominently in profile in the foreground, is based on a
print by Gian Giacopo Caraglio after one of Rosso's
1524 series of the *Labors of Hercules* (fig. a).[5] Goltzius
must have been particularly impressed by that series, for
he used another of the prints, *Hercules Battling Cerberus*
(fig. b), for one of his most spectacular creations, the
chiaroscuro woodcut of *Hercules and Cacus* (fig. c).[6]

It had previously escaped notice that the verso of this
Sacrificial Scene has a cursory chalk sketch which is
unquestionably from Goltzius's hand (fig. d). It is a
rather faded study of a nude man falling backward –
a variation on the famous series of four falling *Titans*
engraved by Goltzius after Cornelis van Haarlem and
dated 1588.[7] It has been shown that the series is based
on paintings by Cornelis, one of which, *Ixion*, was
acquired by the Boymans-van Beuningen Museum a few
years ago.[8] The most obvious assumption is that the
sketch on the verso of this sheet originated in the same
period, which supports the dating of the *Sacrificial Scene*
to the late 1580s.

1. Reznicek 1961, vol. I, K 27, vol. II, A 108.
2. Judson 1970, p. 92, and M. Royalton-Kisch, "Dirck
Barendsz. and Hendrick Goltzius," *Bulletin van het Rijksmuseum*
XXXVII, 1989, pp. 14-26.
3. See W. Kloek in exhib. cat. *Kunst voor de beeldenstorm:
Noordnederlandse kunst 1525-1580*, Amsterdam, Rijksmuseum,
1986, p. 412, no. 302.
4. See E.A. Carroll, exhib. cat. *Rosso Fiorentino: Drawings,
Prints, and Decorative Arts*, Washington, National Gallery of
Art, 1987-88, pp. 276-81, nos. 87-88.
5. Bartsch, vol. XV, no. 49, and Carroll, op. cit. (note 4),
pp. 86-87, no. 14.
6. Bartsch, vol. XV, no. 44, and Carroll, op. cit. (note 4),
pp. 76-77, no. 9. To the best of my knowledge this borrowing
has never been noticed, although Friedrich Antal did stress the
importance of Caraglio's prints for Northern Netherlandish
Mannerists in general, see "Zum Problem des Niederländischen
Manierismus," *Kritische Berichte* II, 1928-29, p. 215, note 1.
Kloek recently published another borrowing by Goltzius in his
Hercules and Cacus, this time from Dirck Barendsz's *Fall of the
Rebel Angels*, see Kloek, op. cit. (note 3), p. 372, under no. 250.
7. Hollstein, *Dutch and Flemish*, vol. VIII, p. 103, nos. 306-09;
W.L. Strauss, *Hendrik Goltzius 1558-1617: the Complete
Engravings and Woodcuts*, New York 1977, nos. 257-60.
8. A. Walther Lowenthal, "The Disgracers: Four Sinners in
One Act," *Essays in Northern European Art Presented to Egbert
Haverkamp-Begemann*, Doornspijk 1983, pp. 148-53.

GL

fig. a

fig. b

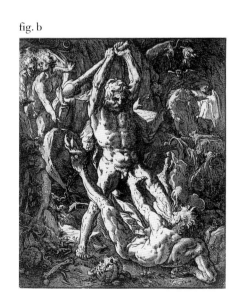

fig. c

fig. d

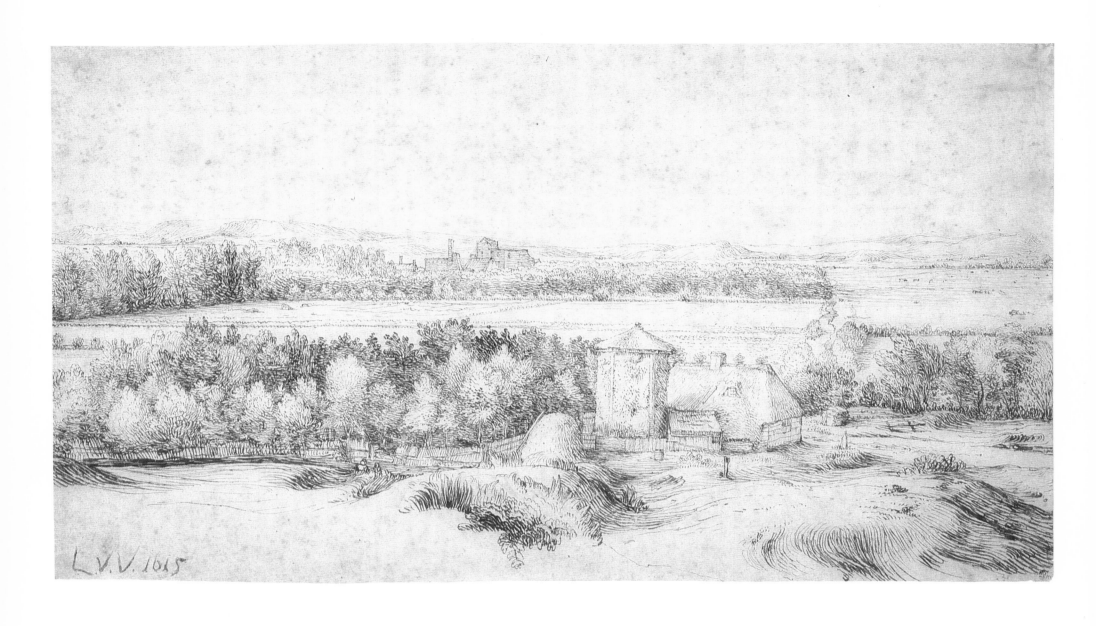

L.V.V. 1615

Dutch School: Seventeenth Century

23

Hendrick Goltzius
Mühlbracht near Venlo 1558–1617 Haarlem
DUNE LANDSCAPE WITH A FARMHOUSE

Pen and brown ink; 160 × 287 mm.
Lower left, by a later hand: *L.V.V. 1615*
Verso, by a later hand: *H. Goltzius Possessor, Lucas v. Uden*, and an alpha
No watermark
Inv. DN 199/96

Provenance: possibly S. Feitama; sale Amsterdam, October 16 1758, Kunstboek L, no. 57 (H. Goltzius: A view near Haarlem, with the pen; 6 × 12 inches); B. Jolles, Dresden and Vienna (L. 381); sale Munich, October 28-31 1895, no. 625, (ill.); A.J. Domela Nieuwenhuis, Munich (L. 356b); presented by him to the Boymans Museum in 1923.

Exhibitions: Rotterdam, Haarlem 1958, no. 92; Washington 1958-59, no. 31; Prague 1966, no. 32.

Literature: Van Gelder 1933, p. 52, fig. 28; E. Haverkamp Begemann, "Twee tekeningen van Goltzius," *Bulletin Museum Boymans* IV, 1953, pp. 67-72 (fig. 5); J.G. van Gelder, "Jan van de Velde 1593-1641, teekenaar-schilder, Addenda I," *Oud Holland* LXX, 1955, p. 24; Haverkamp Begemann 1959, p. 38; Reznicek 1961, vol. I, K 405, vol. II, A 351; W. Stechow, *Dutch Landscape Painting of the Seventeenth Century*, London, New York 1966, pp. 17-18, fig. 54; C. van Hasselt in exhib. cat. Brussels etc. 1968-69, pp. 65-66, under no. 90; C.O. Baer, *Landscape Drawings*, New York 1973, pp. 188-89, no. 77; G.S. Keyes, *Esaias van den Velde 1587-1630*, Doornspijk 1984, pp. 31-32, note 5, p. 45, note 9; E.K.J. Reznicek, "Hendrick Goltzius and his conception of landscape," in exhib. cat. *Dutch Landscape: the Early Years. Haarlem and Amsterdam 1590-1650*, London, National Gallery, 1986, p. 61, fig. 5; Schapelhouman and Schatborn 1987, p. V, and p. VII, note 13; F.J. Duparc in exhib. cat. Cambridge, Mass., Montreal 1988, p. 111, under no. 34.

This panoramic dune landscape, together with two other sheets by Goltzius (fig. a), are among the earliest evidence of the fascination for the natural countryside in Northern Netherlandish art.[1] In the Mannerist period, landscape drawings were dominated by fantastic and exotically shaped crags and mountains, but around 1600 a change took place, as artists turned to a more realistic depiction of their surroundings, showing village streets, waterways, a bridge, a dilapidated town gate, and farmhouses with meadows – scenery which was described as "pleasant" both to wander round in and look at.[2] Goltzius's drawings played a crucial role in this awakening, and heralded a stylistic development that was coupled with the rediscovery of the drawn and printed landscapes of Pieter Bruegel the Elder and the Master of the Small Landscapes. This new genre flourished in Haarlem and Amsterdam, led by artists like Willem Buytewech, Claes Jansz Visscher, and Esaias and Jan van de Velde (see cat. nos. 25-27).[3] The importance of prints for disseminating their style cannot be overstated, and it is notable that all of them, without exception, also worked as etchers or engravers.[4]

Goltzius's innovative landscape drawings, which were undoubtedly made *en plein air*, have been related to a passage in Van Mander, who says that the consumptive artist went on long walks in the Kennemerland district to rid himself of the disease. The drawings are supposedly the result of those "constitutionals."[5]

The slight difference in style between this *Dune Landscape* and the other two has prompted the suggestion that it was made a little earlier.[6] It has even been attributed, somewhat diffidently, to Goltzius's stepson, Jacob Matham.[7] The broad parallel hatching and whiplash lines in the foreground of this sheet contrast with the far more delicate hatching technique used for the distance. This handling of the foreground recalls the landscapes in the Venetian manner which Goltzius was producing in the 1590s.

It remains to be seen, though, whether the sheet should be dated earlier on that account. The technique of working in a darker shade in the foreground so as to enhance the effect of recession into depth was part of a tradition dating back to the early sixteenth century, and Goltzius continued to use wavy hatching to accentuate the foreground in later works. It is also prominent in prints by Simon Frisius and Gerrit Gouw after lost drawings by Goltzius, which appear faithful to the linear treatment of the originals (figs. b, c).[8] It is probably incorrect to regard the topographical landscapes as the final phase in Goltzius's development. Frisius's prints, which are a reversion to the fantasy landscape, have the seemingly authentic signature *HG in* at the top, and the date *Ao 1608*. This merely goes to show that Goltzius worked "from the imagination" or "from life" as the fancy took him, and that this was considered perfectly compatible with the discovery of the true Dutch landscape.

1. The other two sheets are in Paris, Fondation Custodia, Frits Lugt Collection, and Rotterdam, Boymans-van Beuningen Museum (fig. a); see Reznicek 1961, vol. I, K 400 and K 404, and vol. II, A 380-81.
2. Van Gelder 1933, pp. 14-34; Schapelhouman, Schatborn 1987, pp. IV-VII.
3. Van Gelder 1933, pp. 35-46.
4. D. Freedberg, *Dutch Landscape Prints of the Seventeenth Century*, London, British Museum, 1980, pp. 25-38, figs. 20-36.
5. Van Mander 1604, fol. 284r; see Reznicek 1961, vol. I, p. 428, under K 400.
6. Reznicek 1961, vol. I, p. 431.
7. Van Gelder (1955), p. 24, and recently Keyes (1984), p. 45, note 9. Landscape drawings by Matham are in West Berlin (Van Gelder 1933, pl. III, fig. 6) and Paris, École des Beaux-Arts (F. Lugt, *Inventaire général des dessins des écoles du nord I. École hollandaise*, Paris 1950, p. 88, no. 713, pl. XCII, as "Manière de Claes Jansz Visscher").
8. Simon Frisius, Hollstein, *Dutch and Flemish*, vol. VII, p. 29, nos. 105-06 (ill.); Gerrit Adriaensz Gouw, Hollstein, *Dutch and Flemish*, vol. VIII, p. 159, no. 1. Numbers 2-4 in the same series were undoubtedly made by Gouw as well, but they are wrongly given to Jacob Matham in Hollstein, *Dutch and Flemish*, vol. XI, p. 234, nos. 357-59 (ill.).

GL

fig. a

fig. b

Symons Frizius fecit. *Robbertus de Baudous Excudebat.*

fig. c

Symon Frizius fecit. *Robbertus de Baudous, Excudebat.*

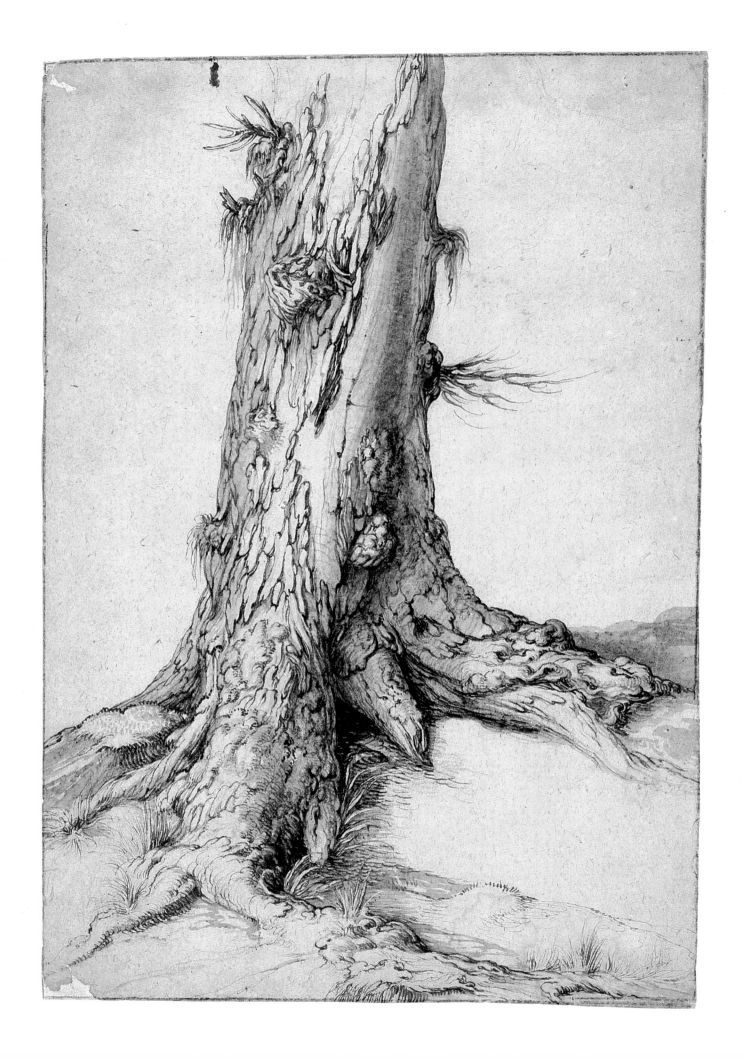

24

Jacques de Gheyn II
Antwerp 1565–1629 The Hague
STUDY OF THE TRUNK OF AN OLD OAK

Pen and brown ink over a sketch in black chalk,
brown and gray wash; 356 × 210 mm.
No watermark
Inv. MB 1976/T 41

Provenance: Arnhem, art market, *c*. 1950; The Hague,
private collection; purchased by the museum in 1976.

Exhibitions: Rotterdam, Washington 1985-86, no. 87.

Literature: I.Q. van Regteren Altena, *Jacques de Gheyn:
Three Generations*, The Hague, Boston, London 1983,
vol. II, p. 152, no. 1002, vol. III, pl. 303; exhib. cat.
Washington, New York 1986-87, under no. 51.

In addition to flowers, plants and animals, of which he
made numerous studies, Jacques de Gheyn was
fascinated by the fantastic shapes and structures of
majestic trees like this old oak. His tree studies lie
midway between drawings from life and stylized,
imaginary subjects, although the use of black chalk for
the underdrawing in some of the sheets suggests that
they may well have been direct observation which were
later worked up in the studio with pen and brush.

It is possible that this sheet originally showed rather
more of the tree and was later trimmed, although on
balance that does not seem very likely. Not only is it
still a considerable size, but there are other De Gheyn
drawings of just a tree-trunk with its roots writhing
outward over the ground. They are in the
Rijksprentenkabinet in Amsterdam, the collection of the
heirs of I.Q. van Regteren Altena, and the Leiden
University Printroom (fig. a), the latter depicting two
trunks similarly framed.[1] The series also includes the
Stump of a Sawn-Off Oak in the Ambrosiana in Milan
(fig. b), which is done in pen only, and a sheet drawn
on both sides in the Rijksprentenkabinet in Amsterdam
(fig. c).[2] The latter is a rear view of a caped figure
seated rather awkwardly among the roots of a tree,
emphasizing its colossal scale. Judging by his pose,
he could be a draftsman making a study of the tree.[3]

There were a number of artists at the beginning of
the seventeenth century who realized the graphic
potential of ancient, gnarled trees, although it was
Pieter Bruegel who had made the subject popular with
his landscape drawings.[4] They exerted a particular
fascination over Roelant Savery, and there are also
several tree studies by Abraham Bloemaert.[5] The latter
two occasionally made such drawings for use in a
painting, but De Gheyn's are finished works in which
he appears to be exploring the graphic effect of pen and
ink. The hatching is extremely varied, and the rhythmic
interplay of lines sets up decorative patterns which have

been compared to the auricular ornamentation which
was so popular in his day.[6] His trees seem to weep,
and occasionally it is as if the bark is dripping from the
trunk like molten wax.

From time to time De Gheyn used his studies in
other drawings, and it is possible that one of them was
the model for the large oak in the left background of
The Fortune-Teller in the Herzog Anton Ulrich-Museum
in Braunschweig. Another of his studies may also have
served for the tree in the left foreground of the large,
carefully worked-up drawing of the *Preparations for the
Witches' Sabbath* in Stuttgart.[7] Both of those sheets can
be dated around 1608 on stylistic grounds, which would
also place the tree studies in the first decade of the
century. They must have impressed a number of later
artists, for their influence can still be detected in the
drawings of Govert Flinck and Jan Lievens.[8]

1. Van Regteren Altena (1983), vol. II, p. 152, nos. 1001, 1000
and 999, vol. III, pls. 283-85.
2. Ibid., vol. II, p. 152, nos. 1003 and 998, vol. III, pls. 303-05.
3. A drawing of a related subject attributed to Cornelis
Saftleven, showing a standing man sketching a tree-stump, is
in the collection of the University of Göttingen, see exhib. cat.
*Niederländische Gemälde und Zeichnungen des 17. Jahrhunderts aus
der Kunstsammlung der Universität Göttingen*, Dortmund,
Museum für Kunst und Kulturgeschichte, 1984, p. 22 (ill.).
Another figure engrossed in the same subject is the draftsman
in a drawing attributed to Roelant Savery in Paris, Fondation
Custodia, Frits Lugt Collection; see exhib. cat. Brussels etc.
1968-69, no. 140, pl. 4.
4. See, for instance, the drawing by Pieter Bruegel the Elder
in the Ambrosiana in Milan, exhib. cat. Berlin 1975, p. 35,
no. 27, fig. 61, and the drawings of trees by his followers,
among them Jan Bruegel, ibid., pp. 44-49, nos. 42-50,
figs. 72-80.
5. See the sheets in the collection of the heirs of I.Q. van
Regteren Altena, exhib. cat. *Kabinet van tekeningen: 16e en 17e
eeuwse Hollandse en Vlaamse tekeningen uit een Amsterdamse
verzameling*, Rotterdam, Boymans-van Beuningen Museum,
Paris, Institut Néerlandais, Brussels, Koninklijke Bibliotheek
Albert I, 1976-77, no. 20, pl. 30 (Bloemaert), and no. 120, pl. 31
(Savery). Also N. Walch, "Remarques sur la gravure maniériste
aux Pays-Bas vers 1600: aspects particuliers du motif de
l'arbre," in *Liber Amicorum Herman Liebaers*, Brussels 1984,
pp. 585-607.
6. By E.K.J. Reznicek in exhib. cat. Rotterdam, Washington
1985-86, p. 16.
7. See, respectively, Van Regteren Altena (1983), vol. II,
nos. 534 and 519, vol. III, pls. 301, 337-39, and exhib. cat.
Rotterdam, Washington 1985-86, nos. 63 and 68.
8. For Flinck see Giltaij 1988, p. 164, no. 74, and the color
illustration on p. 192; also R. Judson, *The Drawings of Jacob de
Gheyn II*, New York 1973, pp. 26-27.

GL

fig. a

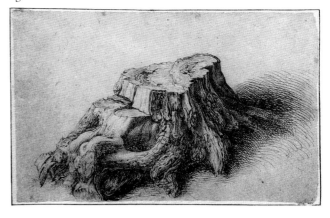

fig. b

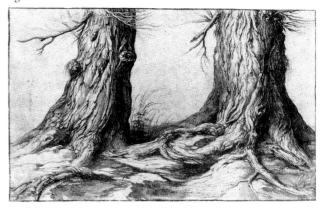

fig. c

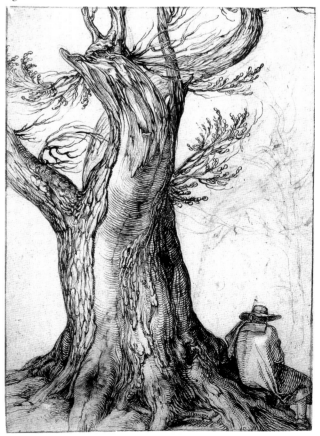

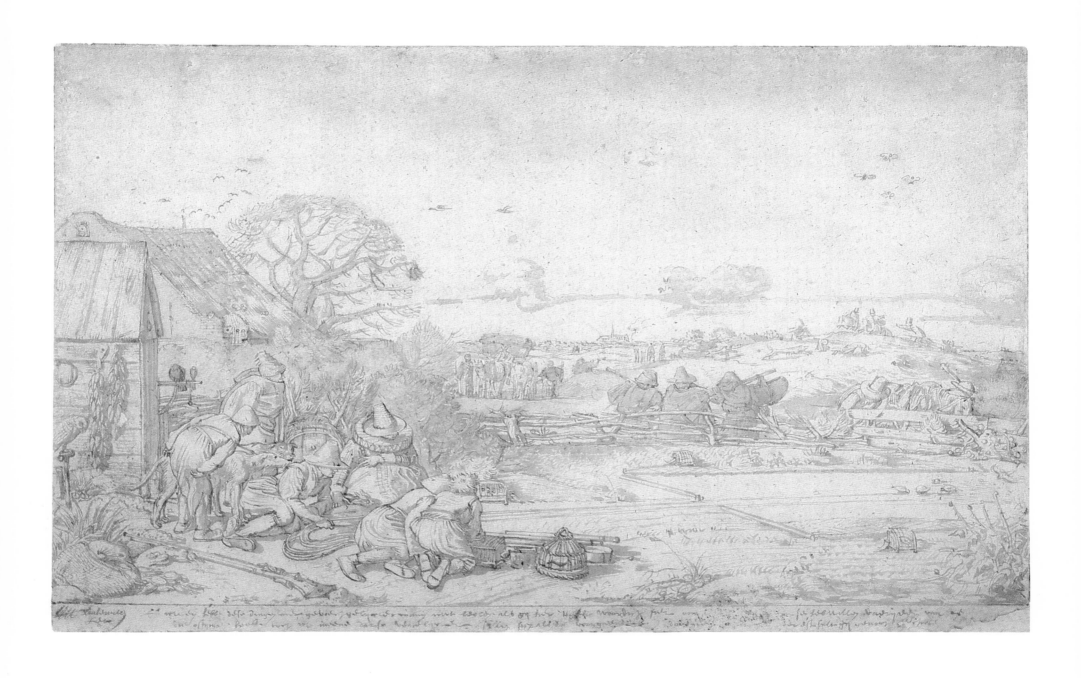

25

Willem Pietersz Buytewech
Rotterdam 1591/92–1624 Rotterdam
THE FINCHERY ("AIR")

Pen and brown ink, with scattered traces of black chalk, brown wash, indented; 185 × 293 mm.
Signed at lower left in pen and brown ink:
W. buytewech fec.
Inscribed in the lower margin:
En ick en hebbe dese dingen niet gevoech[.]elycker connen wit beelden als gy hier tegen woordich siet om [...] dat ick se heb willen vaerye(r)en van de/ die ostyr[.]en hoort doch ick meene datse ventelycker sullen syn als de voorgaenden doeden [...] derest sult gy genoch [.]e[.]schieten.
Watermark: flowers in a jug
Inv. MB 334

Provenance: sale Amsterdam (Frederik Muller), June 11 1912, no. 51, (ill.); C. Hofstede de Groot, The Hague (L. 561); sale Leipzig (Boerner), November 4 1931, no. 38; acquired by the Boymans Museum.

Exhibitions: The Hague 1930, no. 27; Dijon 1950, no. 53; Paris 1950, no. 112; Rotterdam 1952, no. 38; Prague 1966, no. 58; New York, Boston, Chicago 1972, no. 25; Rotterdam, Paris 1974-75, no. 22.

Literature: F. Becker, *Handzeichnungen Holländischer Meister aus der Sammlung C. Hofstede de Groot im Haag*, Leipzig 1923, pl. X; O. Hirschmann, "Die Handzeichnungen-Sammlung Dr. Hofstede de Groot im Haag. I," *Der Cicerone* VIII, 1916, p. 406; J.G. van Gelder, "De etsen van Willem Buytewech," *Oud Holland* XLVIII, 1931, p. 61; M.D. Henkel, *Le dessin hollandais*, Paris 1931, p. 47; Haverkamp Begemann 1957, p. 94, no. 24; J.S. Kunstreich, *Der "geistreiche Willem": Studien zu Willem Buytewech (1591-1624)*, Kiel 1959, pp. 9, 93, 131, note 18, and p. 41, no. 115; Bernt 1957-58, vol. I, no. 139; Haverkamp Begemann 1959, pp. 16, 18, 44, 54, 93, 107, 111, 144-45, 200, and pp. 94-95, no. 24, fig. 133; K. Renger, "Verhältnis von Text und Bild in der Graphik (Beobachtungen zu Missverhältnissen)," in H. Vekeman and J. Müller Hofstede (eds.), *Wort und Bild in der Niederländischen Kunst und Literatur des 16. und 17. Jahrhunderts*, Erftstadt 1984, pp. 157-59, and p. 161, note 43.

With the new emphasis on realism at the beginning of the seventeenth century, artists began depicting the Four Elements not as allegorical figures, as the Mannerists had done, but as genre scenes with subjects taken from everyday life. In an earlier print series which he designed for Jan van de Velde, Buytewech portrayed Earth as a cattle market, Water as a group of fishermen, Fire as cannoneers discharging their guns, and Air as a company out hawking (fig. a).[1]

This drawing, too, symbolizes Air, and in 1622 Van de Velde translated it unaltered into an engraving for another series of the Four Elements (fig. b).[2] The scene is set outside Haarlem, with the Church of St Bavo on the skyline. The traditional title, *The Finchery* is not strictly correct, for the fowlers have set a double clap-net, which was used for catching small birds of every kind.[3] Around the fenced-off field are cages with decoy birds, and at the extreme left is an owl on a perch, which also served the same purpose. The artist has succeeded brilliantly in capturing the engrossment of the fowlers in their prospective bag – a handful of birds pecking at the bait in the field. The youth leaning on one elbow is working the net, on which all eyes are fastened (apart from one of the dogs, which is looking out of the drawing as if warning the viewer to keep quiet). In the distance is a group of hawkers, one of whose birds is stooping on a heron above their heads. Approaching over the dunes is a coach drawn by two horses which is very similar to the one in Buytewech's earlier depiction of Air (fig. a). On the right some men are beating for game, probably rabbits.

The entire scene is rendered with great attention to detail. The subtle use of wash is particularly effective in the bulging breeches of the boys kneeling on the left and in the fashionable dress of the crouching woman. The brushwork is a little broader here and there, while the delicate accents in the background give the scene an attractive atmospheric perspective. The clouds are more conspicuous in earlier reproductions of the drawing, and it seems that they suffered when the sheet was treated to correct the severe oxidation of the paper.

Below the scene is a fascinating inscription, although unfortunately a few key words cannot be deciphered. It was undoubtedly written by Buytewech himself, and is addressed to the engraver and publisher, Jan van de Velde, who must have received the designs in Haarlem in or shortly before 1622, when Buytewech had moved back to Rotterdam.[4] It is a letter, or part of one, in which Buytewech explains: "I have been unable to depict these subjects any more pleasingly than you see here, for I wished them to be different from [...]; yet I believe that they will sell more readily than the previous [...]." The final words may be a reference to the other series of Four Elements, which had been etched and published by Van de Velde.

Comparing the two series, it is very difficult to see how one is more "pleasing" than the other, although the suggestion that Buytewech was referring to the composition is certainly plausible.[5] It is completely reworked in this second version of *Air*, which has a

scenic (and recognizable) landscape in the background, greater detail and more action, instead of just a large, central group of figures.

The artists were evidently satisfied with the rather generalized inscriptions on the first print series, for they repeated them on the second. Air is described as follows: "Now comes air, the fount of life, without which nothing on earth can live. In constant motion, it makes the earth fruitful by ceaseless fertilization. Here the winds rule, they and the feathered flocks."[6]

1. For this print series see D. Franken Dz. and J.P. van der Kellen, *L'Oeuvre de Jan van de Velde, graveur hollandais*, Amsterdam 1883, nos. 134-37; Hollstein, *Dutch and Flemish*, vols. XXXIII-XXXIV, pp. 16-17, nos. 22-25; exhib. cat. Rotterdam, Paris 1974-75, nos. 177-80.
2. Franken and Van der Kellen, op. cit. (note 1), nos. 138-41; Hollstein, *Dutch and Flemish*, vols. XXXIII-XXXIV, pp. 14-16, nos. 18-21; exhib. cat. Rotterdam, Paris 1974-75, nos. 181-84.
3. P. Schatborn in exhib. cat. New York, Boston, Chicago 1972, no. 25.
4. Buytewech had joined the Haarlem Guild of St Luke in 1612, but in 1617 he is recorded back in his native Rotterdam, where he bought a house in 1618; see exhib. cat. Rotterdam, Paris 1974-75, pp. XXI-XXII.
5. Ibid., p. 22.
6. Ibid., p. 145, no. 180.

GL

fig. a

fig. b

26

Claes Jansz Visscher
Amsterdam 1587–1652 Amsterdam
A WINDMILL
A SKATER

Pen and brown ink, blue wash, the outlines indented;
75 × 60 mm. and 75 × 59 mm.
No watermark
Inv. H 190, H 191

Provenance: sale A. Mos and J. Nieuwenhuis Kruseman, Amsterdam (R.W.P. de Vries), November 7-8 1928, nos. 659-60; F. Koenigs, Haarlem (L. 1023a), acquired in 1929; D.G. van Beuningen, Rotterdam, acquired in 1940 and donated to the Boymans Museum Foundation.

Not previously exhibited

Literature: Van Gelder 1933, p. 28; M. Simon, *Claes Jansz. Visscher*, diss. Freiburg 1958, pp. 231-43 and nos. 72-73; exhib. cat. Brussels etc. 1968-69, pp. 173-74, under no. 169.

In 1614 in Amsterdam, Willem Jansz Blaeu published Roemer Visscher's *Sinnepoppen*, a work of such elegance in its design and etchings that it has seldom been rivaled in Dutch emblem literature. In keeping with the tradition of impenetrability, the illustrations do not immediately yield up their meaning, for an emblem is an indivisible trinity of icon, motto and epigram, and only when they are combined can its sense be divined.[1] Roemer Visscher stresses this in his preface, in which he relates how the anthology came into being.

He had asked an artist to draw some illustrations upon which, in his friends' company, he could extemporise a motto and an epigram (one author has likened this to the games of wit we play today).[2] By his own account, he was then urged to write down his creations, of which the *Sinnepoppen* was the result. Even if this is no more than an ingenious form of modest disclaimer, the assertion that it was Roemer Visscher himself who commissioned the drawings is certainly credible: "I had this work counterfeited or drawn on some sheets of paper, but without any exposition or gloss, that I might use them to divert my mind."[3] He must have given the artist a list of subjects, some of which were taken from the established emblematic tradition, but they would have to have been sufficiently neutral to allow Visscher to improvise freely. He probably also supplied him with copies of earlier collections of emblems by such authors as Gabriël Rollenhagen, Hadrianus Junius and Eduard de Dene, for they clearly inspired many of the illustrations in his own book.[4] Some of the animal icons, in fact, were copied straight from De Dene's *De warachtighe fabulen der dieren* of 1567.[5]

Roemer Visscher does not mention the artist's name in his preface, but the illustrations are of such a high caliber that there was no dissent when it was suggested in 1899 that they might well be the work of Claes Jansz Visscher – a draftsman, etcher and print publisher of Amsterdam.[6] Soon afterward there was a chance to verify that attribution when four preparatory drawings appeared at auction. These are two of them; the other two later re-emerged in a salesroom before vanishing again.[7] They certainly correspond very closely with other work by Visscher. He was primarily a landscape draftsman, and the stylized trees, the small church and the ragged clouds are very similar to his known sheets. The skater in his baggy breeches is stylistically akin to Visscher's 1641 design for the title-print of *Playsante landschappen* (fig. a), a print series by Jan van de Velde which was published posthumously.[8] The props in that drawing – a fishing net, fishing rods, a box and a large hourglass – also show that Visscher was fluent in drawing such objects, which recur frequently in the *Sinnepoppen*.

The windmill also fits neatly into his drawn *œuvre*, and if there was less wash in the sails it could almost have been taken from the superb sheet of *Windmills in a Landscape* in Paris (Fondation Custodia, Frits Lugt Collection; fig. b).[9] It is a smock-mill, which evolved from the old post-mill type. Smock-mills were mainly used for pumping away excess groundwater, and that function also lies at the heart of Roemer Visscher's emblem "*Ut emergant*", which he translated as "That they may flourish," namely "those lands which, without their aid, would remain inundated and quite barren." The motto accompanying his self-assured skater is "*Gheoeffent derf*" (The skilled dare), with the timeless reminder "that one should learn betimes in order to use the knowledge in one's maturity".[10]

1. See K. Porteman, *Inleiding tot de Nederlandse emblemataliteratuur*, Groningen 1977.
2. L. Brummel in the introduction to the reissue of *Sinnepoppen*, The Hague 1949, p. XXI.
3. Roemer Visscher, *Sinnepoppen*, Amsterdam 1614, "Voor-reden", p. IV: "*Dit werck had ick doen conterfeyten of malen in sekere pampieren bladen, doch sonder eenighe uytlegginge oft glose, om tot vermaeckelijcheyt van mijn sinnen te gebruycken.*"
4. Porteman, op. cit. (note 1), p. 125, and A. Henkel and A. Schöne, *Handbuch zur Sinnbildkunst des XVI. und XVII. Jahrhunderts*, Stuttgart 1967 ("Bildregister").
5. Most of the animals are featured in Roemer Visscher's "Tweede schock" (second group of sixty). Illustrations which have been copied from Marcus Gheeraerdts's etchings are II,21 (the ass from "*Noch luy, noch lecker*"), II,28 (the deer gazing at its own reflection in a pool of water in "*Schadelijck, nimmer schoon*") and II,34 (the peacock from "*Laet duncken*"). Jan van de Velde also copied three of Gheeraerdts's prints; see Hollstein, *Dutch and Flemish*, vols. XXXIII-XXXIV, p. 146, nos. 460-62.
6. A.G.C. de Vries, *De Nederlandsche emblemata: geschiedenis en bibliographie tot de 18de eeuw*, Amsterdam 1899, pp. XXXV-XXXVI, no. 53.
7. For the other two drawings, *Woman Playing a Lute* and *The Mounted Falconer*, see sale A.I. van Huffel, Utrecht, March 22-24 1932, no. 119, and Simon (1958), nos. 77-78. No fewer than eighty-four designs were recently discovered in an album in Glasgow University Library, shelf-mark SM 1891A; see H.M. Black and D. Weston, *A Short Title Catalogue of the Emblem Books and Related Works in the Stirling Maxwell Collection of Glasgow University Library (1499-1917)*, Aldershot, Hants 1988, p. 101, Appendix, no. 16. Jochen Becker of the University of Utrecht is preparing a study of these drawings under the title "'Elck heeft de zijn,' neue Zeichnungen von Claes Jansz Visscher: ihre Bedeutung für Roemer Visschers Sinnepoppen und die Deutung des niederländischen Realismus."
8. Simon (1958), no. 12; Schapelhouman and Schatborn 1987, no. 7; see also Hollstein, *Dutch and Flemish*, vols. XXXIII-XXXIV, p. 105, under nos. 333-67. The style of the drawing also corresponds to that of a sheet with a panoramic view of a harbor with peasants on the foreshore, which was the design for the *View of Amsterdam* based on Pieter Bast; see Simon (1958), no. 74, and P. Bjurström, exhib. cat. *Tekeningen uit het Nationalmuseum te Stockholm*, Paris, Musée du Louvre, Brussels, Koninklijke Bibliotheek Albert I, Amsterdam, Rijksprentenkabinet. 1970-71, no. 84 (ill.). The print is illustrated in I. de Groot and R. Vorstman, *Sailing Ships: Prints by the Dutch Masters from the Sixteenth to the Nineteenth Century*, Maarssen 1980, no. 20.
9. C. van Hasselt, exhib. cat. Brussels etc. 1968-69, no. 169.
10. Roemer Visscher, op. cit. (note 3), I,40: "*... op datse op komen, ... de landen die sonder behulp van dien, onder water souden blyven gantsch vruchteloos ligghen,*" and III,7: "*... dat hy hem in tijts moet begheven tot leeren om in zyn ouderdom te ghebruycken.*"

GL

fig. a

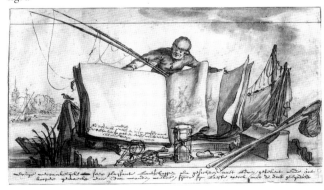

fig. b

fig. b

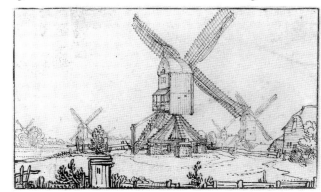

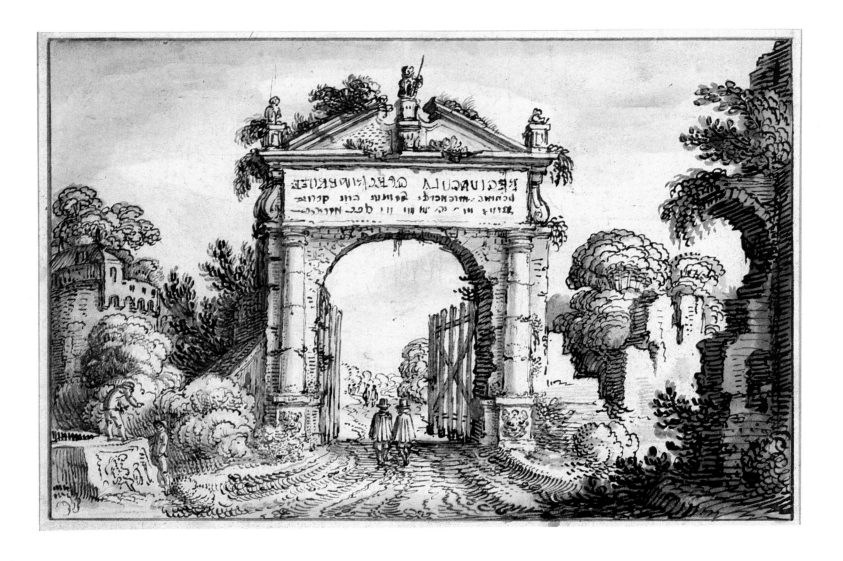

Jan van de Velde II
Rotterdam or Delft 1593–1641 Enkhuizen
LANDSCAPE WITH RUINS AND A MONUMENTAL GATEWAY

Pen and brown ink, blue and brown wash, traces
of black chalk, framing lines in pen and brown ink,
laid down, the outlines indented; 132 × 195 mm.
Watermark: not visible
Inv. H 175

Provenance: T. Straus-Negbaur, Berlin (L. 2459a); sale
Berlin (P. Cassirer and H. Helbing), November 25-26
1930, no. 101; F. Koenigs, Haarlem (L. 1023a); D.G. van
Beuningen, Rotterdam, acquired in 1940 and donated to
the Boymans Museum Foundation.

Exhibitions: Rotterdam 1938, no. 369; Braunschweig
1948, no. 47; Dijon 1950, no. 103; Rotterdam 1952,
no. 40.

Literature: Van Gelder 1933, p. 54, no. 53, pl. XVIII,
fig. 32; J.G. van Gelder, "Drawings by Jan van de
Velde," *Master Drawings* V, 1967, p. 39.

Jan van de Velde II was a cousin of the landscapist
Esaias van de Velde and the son of the famous
calligrapher Jan van de Velde the Elder (1568–1623).
He grew up in Rotterdam, but his family originally
came from Flanders. Like so many others, they left the
Southern Netherlands after the fall of Antwerp in 1588
to seek their fortune in the north. Jan's father had
planned to apprentice him to the etcher Simon Frisius
in Haarlem, but it is known from a letter of 1613 that
the young artist was then living in Jacob Matham's
house.[1] It was a stimulating environment in which to
work, for Goltzius was still active, as was Willem
Buytewech of Rotterdam (see cat. no. 25), who became
a friend of Van de Velde's. In 1614 Jan enrolled in the
Guild of St Luke as a master engraver.

Van de Velde went on to specialize in the Dutch
landscape, to which most of his 500 prints are devoted,
along with a few biblical scenes, some genre pieces and
a series of portraits.[2] Influenced by Claes Jansz
Visscher, Willem Buytewech and his cousin Esaias,
he developed a workmanlike but attractive style that
enabled him to compose a landscape using rapid
hatching, short strokes of the pen, stipples and the
occasional wash. There is usually a dark tree or part of
a building up against the edge of the drawing to
increase the sense of depth. Almost all his landscapes
contain figures – people strolling through meadows or
along a woodland path, or companies enjoying
themselves on the water.

At first Jan van de Velde worked after his own
designs, but later he concentrated on etching and
engraving after drawings by other artists, among them
Willem Buytewech and Pieter de Molijn. A reasonable
number of his drawings have survived, but only a few
were ever made into prints. It is possible that his
manner of working allowed him to draw directly onto
the etching ground without first preparing a design.

The outlines of these overgrown ruins have, however,
been indented with a sharp implement for transfer to
the plate. The resultant etching is very faithful to the
original (fig. a).[3] The pen-strokes have been followed
closely, and the light hatching precisely matches the
areas of blue wash. The lines drawn with the pen,
though, are considerably thicker than those made with
the etching needle. The grotesque heads on the bases of
the half-columns are more detailed in the print, partly
because Van de Velde would have been unable to
reproduce their sketchy appearance with the sharper
implement. The drawing was not done directly with the
pen, for beneath the arch of the gateway are traces of
the initial construction lines in black chalk. There is a
superb, deep brown wash, and the bright blue is also
well preserved.

This is an early sheet, from in or before 1616, which
is the date on the open-topped pediment over the gate
in the first state of the print. The etching was used as
the frontispiece for a series of landscapes titled
Amenissimae aliquot regiunculae, for which the subject of
a gate was eminently suitable. In the sixteenth and
seventeenth centuries, a gateway was a standard

iconographic motif on title-pages, symbolizing the
entrance to the world contained in the book.[4] Print
series were often sold as albums or sewn together, and
in this case the gateway could have stood for the portal
to the twenty-six different landscapes in the first state of
the set.[5] Even after the plates had been sold to Claes
Jansz Visscher, who published the second state, this
print retained its original function as the frontispiece to
an enlarged suite of sixty landscapes.

1. See Van Gelder 1933, pp. 1-13.
2. D. Franken Dz. and J.P. van der Kellen, *L'Oeuvre de Jan van
de Velde, graveur hollandais*, Amsterdam 1883, and the fully
illustrated catalogue in Hollstein, *Dutch and Flemish*, vols.
XXXIII-XXXIV.
3. Hollstein, *Dutch and Flemish*, vol. XXXIII, p. 75, no. 232.
4. M. Corbett and R. Lightbown, *The Comely Frontispiece:
the Emblematic Title-Page in England 1550-1660*, London,
Boston 1979, pp. 6-9, and J. Becker, "From Mythology to
Merchandise: an Interpretation of the Engraved Title of Van
Mander's *Wtlegghingh*," *Quaerendo* XIV, 1984, pp. 20-22, and
note 7.
5. This was only discovered very recently from two print
albums in the Stadtbibliothek in Trier, which have made it
possible to reconstruct the original suite of prints which
Franken and Van der Kellen, op. cit. (note 2), nos. 271-330,
were obliged to describe from the second state; see K. Koppe,
"Zwei Graphikbände des 17. Jahrhunderts aus dem Trierer
Jesuitenkolleg," *Kurtrierisches Jahrbuch* XXVIII, 1988,
pp. 247-52, and Hollstein *Dutch and Flemish*, vols.
XXXIII-XXXIV, pp. 74-95, nos. 232-91.

GL

fig. a

28

Jacob van Ruisdael
Haarlem 1628/29–1682 Haarlem
A TREE GROWING OVER A STREAM

Black chalk, gray wash, heightened with white, framing
lines in pen and gray ink; 156 × 236 mm.
Signed at lower left (possibly by a later hand): *vRuisdaël*
No watermark
Inv. MB 335

Provenance: C. Josi, Amsterdam and London
(L. 2925bis); sale London (Christie's), March 18 1829,
no. 132; Baron J.G. Verstolk van Soelen, The Hague;
sale Amsterdam (De Vries), March 22 1847, no. 81;
G. Leembruggen Jz., Hillegom; sale Amsterdam (Roos),
March 5-8 1866, no. 540; acquired by A.J. Lamme for
the Boymans Museum (L. 1857).

Exhibitions: Brussels 1937-38, no. 133; Dijon 1950,
no. 92; Vancouver 1958, no. 67; Brussels, Hamburg
1961, no. 122; Prague 1966, no. 116; Paris, Leningrad
1974, no. 106; The Hague, Cambridge, Mass. 1981-82,
no. 73; Cambridge, Mass., Montreal 1988, no. 78.

Literature: cat. Rotterdam 1869, no. 714; J. Rosenberg,
Jacob van Ruisdael, Berlin 1928, no. Z68; K.E. Simon,
Jacob van Ruisdael: eine Darstellung seiner Entwicklung,
Berlin 1930, pp. 68, 84; C.O. Baer, *Landscape Drawings*,
New York 1973, pp. 232-33, no. 99; S. Slive, "Notes on
three drawings by Jacob van Ruisdael," in *Album
amicorum J.G. van Gelder*, The Hague 1973, pp. 274-75,
(ill.); J. Giltaij, "De tekeningen van Jacob van Ruisdael,"
Oud Holland XCIV, 1980, pp. 155, 200, no. 96.

It is in beautifully organized drawings like this one that
Ruisdael fully displays his ability to keep a composition
clear and uncluttered. The tree stands in precisely the
right position to show off its sturdy solidity to the best
effect. The middleground, with a shepherd leading some
sheep across a field, has been left transparent, and runs
down to the area glimpsed beneath the arching spur of
the tree. The transition to the distant view of
mountains is bridged by a forest of conifers which the
artist evidently felt was a little overdone, for he then
toned it down with brush and white bodycolor.
Although Ruisdael probably never saw a mountain in his
life (if one excepts the hills around Bentheim), they do
feature in several of his paintings and drawings. That is
not unusual, for other seventeenth-century landscapists
also combined imaginary landscapes with features
observed directly from nature.

The drawing has been worked up with great care.
The gray washes are precisely positioned and vary in
tone, with a smooth and natural progression from light
gray to near-black. The white passage in the center,
beneath the tree, is perhaps a touch too prominent, and
gives the impression that this part of the landscape is a
little overlit. Ruisdael's rendering of water is as
convincing in his drawings as in his paintings. Curls of
chalk describe the water tumbling over the small
cascade under the tree, while further to the left long
brushstrokes evoke the calmer flow of the stream.

The prominence given to this oddly shaped tree is
typical of Ruisdael, whose passion for portraying gnarled
trees was probably inspired by the paintings and
drawings of Roelant Savery. A massive and equally
sinuous tree by the side of a pond or stream is also the
subject of one of Ruisdael's etchings (fig. a).[1]

The Rotterdam sheet, which was later given a rather
over-elaborate signature, is generally dated to the early
1650s, when Ruisdael was reaching maturity as an
artist.[2] Its careful finish suggests that it was made
directly for the market, although Ruisdael did repeat the
tree in a painting now in a private collection which
probably dates from the same period (fig. b).[3] There it is
seen from slightly further off, and several modifications
have been made to the landscape. The background
peaks have gone, and greater care has been lavished on
the sky with its fine banks of clouds.

Ruisdael modeled other paintings on meticulously
worked-up drawings which appear to have been made
for the collectors' market, so it is difficult to assess the
original purpose of each sheet. A further complication is
that there was also a market for rather sketchy drawings
which have the look of preparatory studies for
paintings.[4] It was only later, in the eighteenth century,
that the demand for detailed, finished drawings led to
the practice of working up seventeenth-century sheets.
In the process, many an original Ruisdael acquired
figures, or a wash in the sky.[5]

1. Hollstein, *Dutch and Flemish*, vol. XX, p. 169, no. 2; S. Slive
in exhib. cat. The Hague, Cambridge, Mass. 1981-82,
pp. 254-56, no. 106.
2. Giltaij (1980), p. 155.
3. See Slive (1973), pp. 274-75, and F.J. Duparc in exhib. cat.
Cambridge, Mass., Montreal 1988, pp. 187-88, who states that
the painting is in a Dutch collection.
4. Giltaij (1980), p. 183.
5. See B. Broos, "Improving and Finishing Old Master
Drawings: an Art in Itself," *Hoogsteder-Naumann Mercury* VIII,
1989, pp. 34-55.

GL

fig. a

fig. b

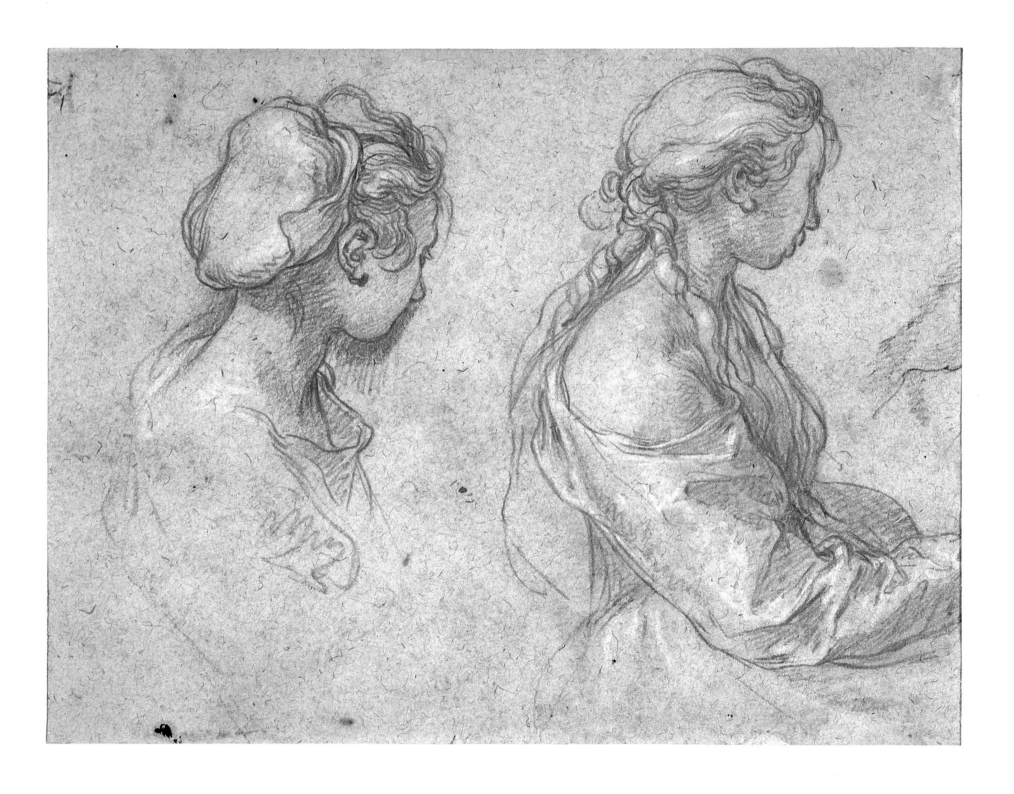

29

Abraham Bloemaert
Gorinchem 1564–1651 Utrecht
TWO STUDIES OF A GIRL

Red and black chalk, heightened with white, on light
brown paper; 200 × 247 mm.
Verso: *various studies of legs and torsos*
Recto and verso, by a later hand: *Bloemaert*
Recto, at upper left: *254* (?), and written across it at
right angles: *15*
No watermark
Inv. MB 336

Provenance: anonymous donation to the museum in
1925.

Exhibitions: Rotterdam 1952, no. 33; Brussels, Hamburg
1961, no. 6; Prague 1966, no. 34.

Not otherwise published

These studies are probably not exercises, but sketches
for a specific painting, although the work has not so far
been identified. Bloemaert left a mass of such study
sheets, many done in two colors of chalk, and some
with a crowded *mise-en-page*.[1] Bloemaert was first and
foremost a painter of history pieces with numerous
figures, and this demanded careful preparation. After he
had drawn an initial sketch or *modello* and had decided
on the composition, he turned to the question of details
like limbs, heads and poses, such as those on the verso
of this sheet (fig. a).[2]

Although Bloemaert occasionally chose an unusual
subject with no long iconographic tradition, his
repertoire was really quite limited. Among his favorite
subjects were the Adoration of the Shepherds and the
Preaching of John the Baptist.[3] The latter provided him
with the opportunity of depicting idealized figures in
graceful poses, of bringing together people of different
ages, dress and appearance, and of experimenting with
landscape. He had a weakness for boldly painted,
colorful groups in an arcadian setting whose lushness
occasionally approaches a bilious green.

The nature of these studies might indicate that they
were intended for an Adoration of the Shepherds, as has
indeed been suggested.[4] However, if they were all made
for a single work, a more likely candidate is the Baptism
of Christ. A painting of that subject in a private
collection would have required just such detail studies
(fig. b).[5] As ever, there is a seated woman in the
foreground, seen three-quarters from the back, over
whose shoulder the viewer watches the proceedings.
Bloemaert could well have prepared for such a figure
with the studies of the girl, with her characteristic,
full-cheeked profile, her hair bound up in a kerchief
in one case, and in the other hanging loose over her
shoulder. The remaining sketches also have parallels in
the painting. On the right there is a group of people

undressing in order to be baptized, and the study of the
leg with the stocking pushed down to the ankle could
belong to one of them. The boy with his hands clasped
in the study sheet could also be awaiting baptism. It is
possible, too, that the bent left leg and the bare lower
leg and foot belong to the man with crossed legs on the
right, who has the same function as the repoussoir
group on the left. The torso, which betrays Bloemaert's
Mannerist past, could have been drawn for the figure of
Christ. When reversed, the pose with the head turned
slightly away under the stream of falling water is very
similar to that in the canvas. Bloemaert dated the
painting 1646, and if the above theory is correct that
would place the studies late in his long career. Against
that it should be said that Bloemaert had been producing
this kind of picture since the mid-1620s, after a period
of influence by Caravaggism, and he never really
changed his style from then on.

The recto of the sheet, which suggests close
observation despite the rapid ribbon hatching, has an
Italian look, and recalls studies by Bernardino Poccetti
and Ludovico Cigoli. Bloemaert's son Frederik
borrowed part of the righthand study in a composite
sheet of female heads which is now in the Fitzwilliam
Museum in Cambridge (fig. c). That collage served as
the model for an illustration in the *Artis Apellae Liber*, a
book of drawing models based on Abraham Bloemaert's
work and first published around 1650.[6]

fig. a

fig. b

fig. c

1. Examples include the drawings in the Rijksprentenkabinet in
Amsterdam, inv. A 686 (Boon 1978, vol. I, no. 55, P. Schatborn
in exhib. cat. Amsterdam, Washington 1981-82, no. 20 and
p. 38), and inv. 1984:1 (Schapelhouman 1987, no. 3). A large
group of such drawings from an old French collection was
auctioned with the A. Giroux Collection in Paris on April
18-19 1904, no. 175, and subsequently dispersed. All those
sheets have a number written in pen in the upper right corner.
See, for instance, those in Paris, Fondation Custodia, Frits
Lugt Collection, Darmstadt and Malibu: exhib. cat. New York,
Paris 1977-78, no. 11, G. Bergsträsser, *Niederländische
Zeichnungen des 16. Jahrhundert im Hessischen Landesmuseum
Darmstadt*, Darmstadt 1979, no. 5, and Goldner 1988, no. 102.
The history of the Rotterdam sheet is unknown prior to 1925.
2. For Bloemaert's working method see P. Schatborn in exhib.
cat. Amsterdam, Washington 1981-82, pp. 38-39, and B. Broos,
"Abraham Bloemaert en de Vader van de Schilderkunst,"
*Was getekend... tekenkunst door de eeuwen heen: liber amicorum
E.K.J. Reznicek, Nederlands Kunsthistorisch Jaarboek* XXXVIII,
1987, pp. 62-72, with further references to the literature.
3. Examples being the paintings in Nancy, Musée des Beaux
Arts, exhib. cat. *Le siècle de Rembrandt: tableaux hollandais des
collections publiques françaises*, Paris, Musée du Petit Palais,
1970-71, no. 16, and Braunschweig, Herzog Anton
Ulrich-Museum, R. Klessmann, *Die holländischen Gemälde:
kritische Verzeichnis*, Braunschweig 1983, no. 172.
4. Exhib. cat. Brussels, Hamburg 1961, p. 7.
5. See exhib. cat. *A Selection of Important Paintings by Old and
Modern Masters from our 1980 Collection*, London, Robert
Noortman Gallery, 1980, no. 2.
6. J. Bolten, *Method and Practice: Dutch and Flemish Drawing
Books 1600-1750*, Landau 1985, pp. 50-67.

GL

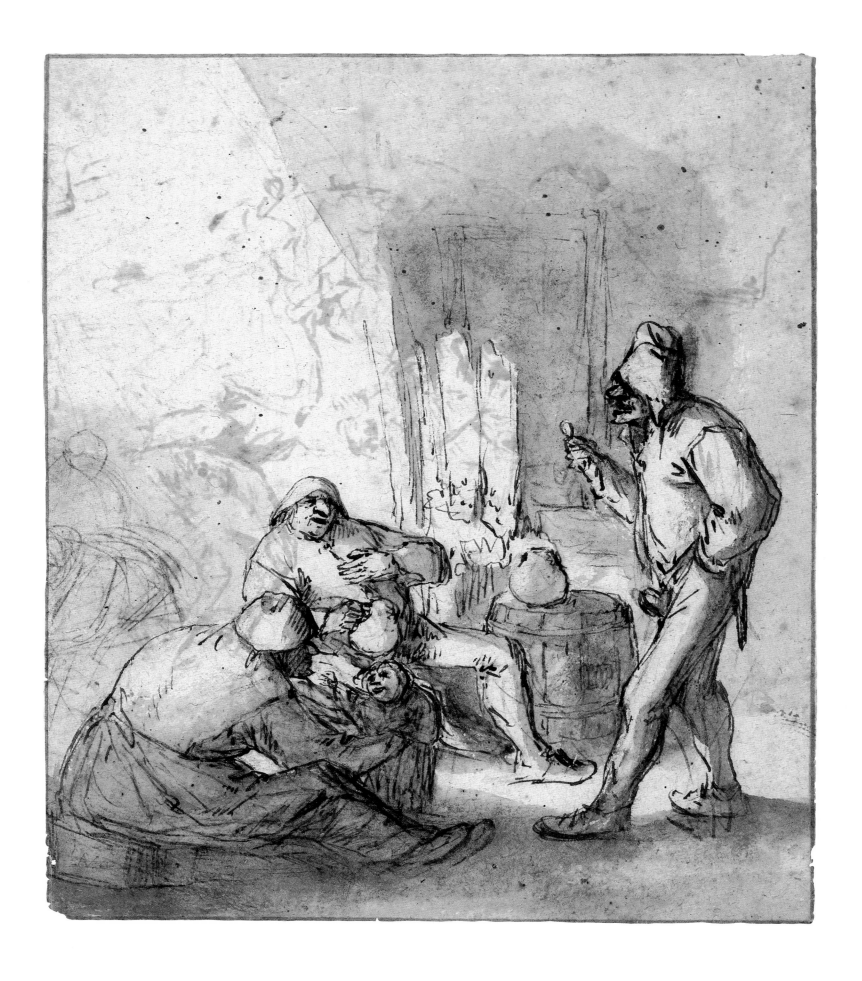

30

Adriaen van Ostade
Haarlem 1610–1685 Haarlem
INTERIOR WITH PEASANTS

Pen and brown ink over a leadpoint sketch, brown and
gray wash; 239 × 205 mm.
Signed in pen and brown ink with monogram on the
box at lower left: *AVO*
Verso: *Brawling Peasants*, pen and brown ink over a
leadpoint sketch
No watermark
Inv. MB 1948/T 2

Provenance: France, private collection; M.J.Schretlen
(dealer), Amsterdam; acquired by the museum in 1948.

Exhibitions: Brussels, Hamburg 1961, no.83, fig.XII;
Prague 1966, no.100.

Literature: E.Haverkamp Begemann, "Een vroege
tekening van Adriaen van Ostade," *Bulletin Museum
Boymans Rotterdam* II, 1951, pp.7-11; E.Trautscholdt,
"Über Adriaen van Ostade als Zeichner," *Festschrift
Friedrich Winkler*, Berlin 1959, p.284; Schnackenburg
1981, vol.I, pp.37, 39, 47, and p.79, no.3, vol.II, pls.2,
15.

Adriaen van Ostade was the supreme seventeenth-
century chronicler of Dutch peasant life. He gave the
subject an abiding popularity, as evidenced by his
many followers. His work was in such demand that
Cornelis Dusart, one of his pupils (see cat. no. 32),
devoted his life to making the most perfect imitations of
his paintings.[1] Van Ostade remained equally popular in
the eighteenth century, largely due to his idealized,
sympathetic watercolors – a medium which was
eminently suited to his subjects. There are scores of
small watercolor pictures and drawings of spectacle-
sellers and knife-grinders arriving in peasant hamlets,
where the inhabitants are seen dozing on benches,
quaffing from tankards, or saying a pious prayer at table.
These countryfolk are all of the same amiable type,
with oversized heads and somewhat oafish expressions
– typical Van Ostade figures who, as Martin once put it,
all seem to belong to one vast extended family.[2]

But there is also the very different Van Ostade of the
1630s and 1640s, who followed Adriaen Brouwer
(1605/06–38) and depicted the coarser side of peasant
life in a style quite unlike that of his later career.[3] This
is an important sheet from that early period, for it
shows his unpolished style of drawing, the strokes broad
and rapid, and contains figures which are not far
removed from the gross and loutish caricatures created
by Brouwer.[4]

In a room whose outlines are only vaguely perceived,
several figures are relaxing with large jars of ale within

easy reach. The standing peasant, who is shown in
profile, is beautifully observed. He holds his pipe in a
peculiar grip, right up against the bowl, his cap is pulled
halfway over his eyes, and his codpiece juts out against
the background. The knife at his belt had been a
standard attribute of drinking peasants since the days of
Brouwer. On the verso it is brought into play, as a
group of people set about each other in a drunken
brawl (fig. b).[5]

Van Ostade began with a very free, linear sketch in
leadpoint which he then went over with the pen, but
without adhering rigidly to the initial sketch. The figure
in the left background has not been worked up, and
other details have been modified. The right leg of the
standing peasant, for instance, is now set further back.
Shadows are indicated with wash, but some of the
darker accents are rendered with rapid hatching.

The drawing also exhibits the influence of David
Vinckeboons (1576–1632) in the figure of the seated
woman and the standing child reaching out to her. This
is one of the "tiny adult" types which are so frequently
found in paintings and drawings by Vinckeboons, an
adherent to the Bruegelian tradition who was partly
responsible for introducing the peasant genre in the
Northern Netherlands. The verso has certain echoes of
the style employed by Andries Both (1611/12–41) in the
1630s – a correspondence which is made even more
striking by the fact that Both too had a weakness for
peasant and low-life types.[6] Further study is needed to
discover the precise nature of interaction between these
two artists (Both was a pupil of Abraham Bloemaert,
and worked in Utrecht before his departure for Italy).

The verso with the brawling peasants, which is
perhaps datable a little later than the recto, was used
by Adriaen's younger brother Isack (1621–49) for a
painting titled *Peasants Fighting at the Annual Fair*.[7]
The preparatory drawing for that picture in the
Prentenkabinet in Leiden shows that Isack borrowed
the figure wielding the stool and the woman who is
trying to restrain him (fig. a).[8]

1. B. Haak, *The Golden Age: Dutch Painters of the Seventeenth
Century*, New York 1984, pp. 389-90.
2. W. Martin, *De Hollandsche schilderkunst in de zeventiende eeuw.
I: Frans Hals en zijn tijd*, Amsterdam 1935, p. 390.
3. Ibid., pp. 389-90, and B. Schnackenburg, "Die Anfänge des
Bauerninterieurs bei Adriaen van Ostade," *Oud Holland*
LXXXV, 1970, pp. 158-69, who also cites Rembrandt as one of
the young Van Ostade's models.
4. For Van Ostade's early drawings see Schnackenburg 1981,
vol. I, pp. 36-40.
5. K. Renger, exhib. cat. *Adriaen Brouwer und das niederländische
Bauerngenre 1600-1660*, Munich, Alte Pinakothek, 1986, *passim*,
but esp. pp. 65-67 for Brouwer's influence on the Van Ostade
brothers.
6. See, for example, the drawing in Rotterdam, inv. H 229:
G. Jansen and G. Luijten, *Italianisanten en bamboccianten: het
italianiserend landschap en genre door Nederlandse kunstenaars uit
de zeventiende eeuw*, Rotterdam. Boymans-van Beuningen
Museum, 1988, pp. 76-77, no. 41 (ill.).
7. Formerly in the Linnartz Collection, sale Berlin (Lepke),
March 23 1926, no. 146 (as Adriaen van Ostade); see
C. Hofstede de Groot, *Beschreibendes und kritisches Verzeichnis
der Werke der hervorragendsten holländischen Maler*, vol. III,
Stuttgart 1910, no. 246l (as Isack van Ostade).
8. Leiden, Prentenkabinet der Rijksuniversiteit, inv. 1714,
Schnackenburg 1981, vol. I, no. 411.

GL

fig. a

fig. b

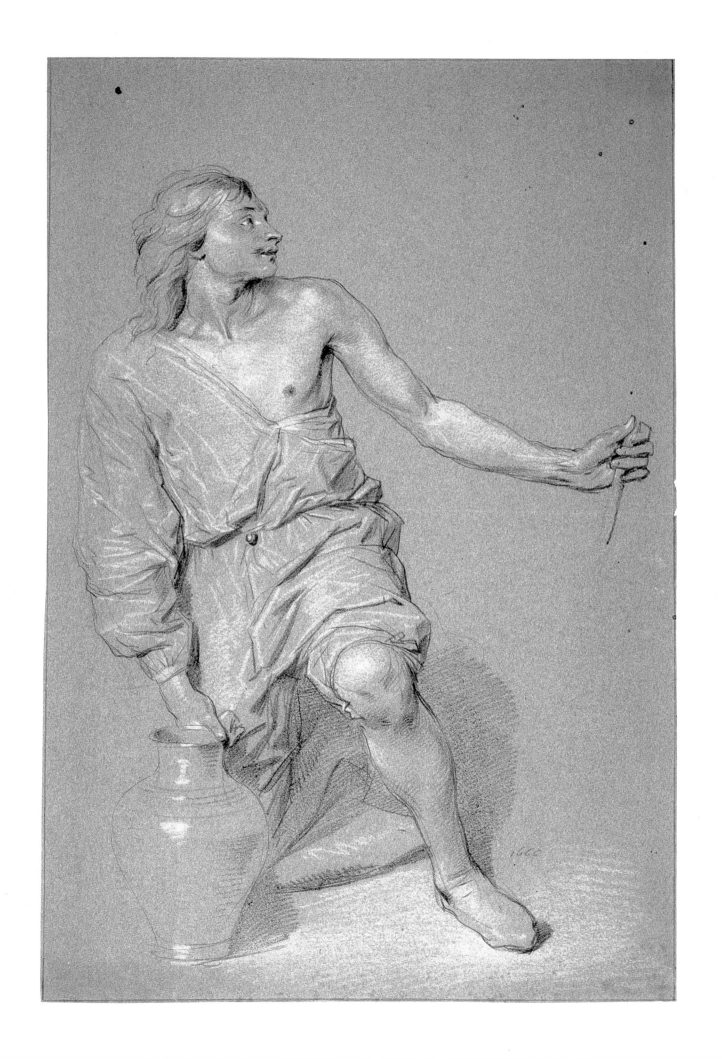

31

Leendert van der Cooghen
Haarlem 1632–1681 Haarlem
KNEELING YOUTH WITH A PITCHER

Black and white chalk on blue paper;
433 × 276/284 mm.
Dated at lower right: *1666*
No watermark
Inv. MB 337

Provenance: unknown, acquired by the museum between
1871 and 1910 (L. 288).

Exhibitions: Amsterdam, Washington 1981-82,
pp. 102-03 (ill.), and p. 133, no. 33.

Not otherwise published

fig. a

In his biography of Leendert van der Cooghen, Arnold
Houbraken not only treats the reader to a long,
humorous anecdote about the Haarlem artist, whose
confirmed bachelorhood earned him the affectionate
nickname of "Uncle Leendert," but he also supplies
seemingly reliable information about him. He says that
Van der Cooghen studied with Jacob Jordaens in
Antwerp but did not need to paint for a living, since he
came from a wealthy family.[1] He was apparently a good
friend of the artist Cornelis Bega (1620–64), whose
portrait he drew several times.[2] Houbraken's statement
that he made very few paintings seems to be borne out
by the fact that only two are now known: a *Doubting
Thomas* of 1654 in the Mauritshuis in The Hague, and
an *Adoration of the Shepherds* (1656) in the Frans Hals
Museum in Haarlem.[3] Although Van der Cooghen was
more of an amateur than a professional, he nevertheless
enrolled as "painter and born burgess" in the Haarlem
Guild of St Luke in 1652, of which he became warden
in 1668. His status as wealthy dilettante is reflected in a
statement entered in the guild books after his death,
where he is referred to as "Signeur van der Coge."[4]

Van der Cooghen owes his reputation to his drawings
and prints. His fourteen etchings, all of a remarkably
high standard and wide range,[5] are dated between 1664
and 1666, the year of this supremely self-assured figure
study. Several of the etchings are copies after Salvator
Rosa (Houbraken compares his etching style to
Carracci's),[6] and this sheet too shows a familiarity with
Italian drawing which he may have gained during his
time with Jordaens in Antwerp, or later, when he had
access to Abraham van Lennep's collection. The latter
had acquired many of the famed drawings that had
belonged to Thomas Howard, Earl of Arundel, and on
his death in 1675 he left them to his stepfather, Dirck
van der Cooghen, who was a cousin and lifelong friend
of Leendert's.[7]

Van der Cooghen's drawings can be divided into
several categories. Two girls' heads in red chalk of 1653
and 1654 were clearly drawn under Flemish influence.[8]
Then there is a large group of portraits of various dates,
some almost lifesize, and a series of figure studies of
1653, all executed on blue paper and with the same old
man as the model.[9] There is just one extant landscape,
which is done with the pen, as is the design for the
etching of *St Bavo in a Landscape*.[10]

This *Kneeling Youth with a Pitcher* is closely related to
two figure studies in the same technique which were
also drawn from the live model – one in the British
Museum in London (fig. a), the other in the West
Berlin printroom (fig. b).[11] It is not immediately
apparent from the London drawing, but when van der
Cooghen asked the model to take up the pose on the
cushion he must already have had an idea of the slightly
modified etching he was to make of *Christ on the Cold
Stone* (fig. c). The Berlin sheet is from the same model,
but with accessories identifying the subject as *St
Sebastian*. The function of the Rotterdam drawing is not
known, but it may have been an autonomous work,
which was not unusual among the group of Haarlem

93

artists to which Van der Cooghen belonged.

In addition to drawing with Cornelis Bega, as mentioned by Houbraken, he would also have worked with Jan de Bray (1627–97), who tended to date his sheets in the same way with the day, month and year. Some of their drawings are deceptively similar, with the same dry handling of the chalk, evenly spaced, taut hatching, and an unusual lighting of the model. They probably used candlelight to create hard shadows and slightly simplify the shape of the figure. The same effect is found in the drawings of Dirck Helmbreker which, like Jan de Bray's, are quite often mistaken for Van der Cooghen's. That confusion is characteristic of the Haarlem School of the second half of the seventeenth century, especially since the figure studies of Cornelis Bega and Gerrit Berckheyde also resemble each other so closely. A recent approach which has had some success is to identify figures in paintings which are clearly based on known studies, and this could lead to the reconstruction of the drawn *œuvres* of each of these artists.[12]

1. Houbraken 1718-21, vol. I, pp. 350-54. See further H. van Hall, "Biografische aantekeningen," *Oud Holland* LXXI, 1956, pp. 171-72, supplemented by C.A. van Hees, "Nadere gegevens omtrent de Haarlemse vrienden Leendert van der Cooghen en Cornelis Bega," *Oud Holland* LXXI, 1956, pp. 243-44.
2. A. van der Willigen, *Les artistes de Harlem*, Haarlem, The Hague 1870, p. 198, mentions two portrait drawings of Bega by Van der Cooghen in the collection of Bodel Nijenhuis in Leiden. There is a portrait in the Boymans-van Beuningen Museum, inv. L.v.d.C. 5, and another in the British Museum, London, Hind 1915-31, vol. III, p. 129, no. 3, which was used for the print in Houbraken 1718-21, vol. I, pl. O.
3. The *Adoration of the Shepherds* is reproduced in W.R. Valentiner, "Ein Familienbild des Leendert van der Cooghen," *Pantheon* X, 1932, pp. 212-16, fig. 5. The *Family Portrait* in the National Gallery, London, inv. 1699, which Valentiner attributes to Van der Cooghen, is definitely not his work; see also N. McLaren, *The Dutch School. National Gallery Catalogues*, London 1960, pp. 275-76 (as possibly by Michiel Nouts). The Van der Cooghen painting listed in the P. van Spijk sale, Leiden, April 23 1781, no. 71, as "Zenobia, Queen of Palmyra," is possibly identical with a "Queen of Sheba" which was auctioned with a pendant in Munich, December 16 1908, no. 62.
4. H. Miedema, *De archiefbescheiden van het St. Lukasgilde te Haarlem*, vol. II, Alphen aan den Rijn 1980, pp. 622, 673, 692.
5. The etchings in Hollstein, *Dutch and Flemish*, vol. IV, pp. 223-24, and C.S. Ackley in exhib. cat. *Printmaking in the Age of Rembrandt*, Boston, Museum of Fine Arts, St Louis, St Louis Art Museum, 1980-81, p. 254, no. 174.
6. Van der Cooghen was not the only seventeenth-century Dutch artist to copy prints by Salvator Rosa. The Boymans-van Beuningen Museum recently acquired a series of unknown, relatively early copies after the *Figurine*, by Cornelis Danckerts. These need to be added to the list in R. Wallace, *The Etchings of Salvator Rosa*, Princeton 1979, pp. 330-32, nos. 131-41.
7. See S.A.C. Dudok van Heel, "De kunstverzamelingen Van Lennep met de Arundeltekeningen," *Jaarboek Amstelodamum* LXVII, 1975, pp. 137-48, B. Broos, "Antoni Waterlo f(ecit) in Maarsseveen," *Jaarboekje Nifterlake* 1984, p. 36 and for his portrait by Caspar Netscher: P. Hecht, exhib. cat. *De Hollandse Fijnschilders. Van Gerard Dou tot Adriaen van der Werff*, Amsterdam, Rijksmuseum, 1989-90, no. 35.
8. Amsterdam, Rijksprentenkabinet; see I.Q. van Regteren Altena and L.C.J. Frerichs, *Keuze van tekeningen bewaard in het Rijksprentenkabinet, Amsterdam*, Amsterdam 1963, p. 13, reproduced on the cover; and Rotterdam, Boymans-van Beuningen Museum, inv. L.v.d.C. 4, P. Schatborn in exhib. cat. Amsterdam, Washington 1981-82, p. 133, no. 31 and p. 102, fig. 1.
9. The series comprises drawings in Rotterdam (inv. L.v.d.C. 1 and 2), Edinburgh (inv. D. 1954; K. Andrews, *Catalogue of Netherlandish Drawings in the National Gallery of Scotland*, Edinburgh 1985, p. 19, fig. 125), Paris (inv. RF 38381; E. Starcky, *Inventaire général des dessins des écoles du nord, supplément*, Paris 1988, p. 155, no. 217), Cambridge, Mass., Fogg Art Museum (exhib. cat. *Van Clouet tot Matisse: Franse tekeningen uit Amerikaanse collecties*, Rotterdam, Boymans Museum, 1958, no. 12, fig. 17, as Anonymous, French), and sale New York (Sotheby's Parke Bernet), November 21 1980, no. 51 (ill.).
10. For the landscape see exhib. cat. *Oude tekeningen: een keuze uit de verzameling P. en N. de Boer*, Laren, Singer Museum, 1966, no. 58, fig. 15.
11. Hind 1915-31, vol. III, p. 129, no. 5, and E. Bock and J. Rosenberg, *Die Zeichnungen niederländischer Meister im Kupferstichkabinett zu Berlin*, Berlin 1930, p. 109, no. 2878.
12. See P. Schatborn in exhib. cat. Amsterdam, Washington 1981-82, pp. 99-109.

GL

fig. b

fig. c

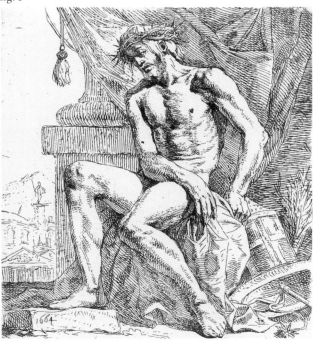

32

Cornelis Dusart
Haarlem 1660–1704 Haarlem
A SEATED MAN

Black and red chalk, framing lines in pen and brown
ink; 310 × 210 mm.
Watermark: *MGMD* in monogram
Inv. MB 338

Provenance: F.J.O. Boijmans, bequest of 1847 (L. 1857).

Not previously exhibited

Literature: cat. 1852, no. 248; cat. 1869, no. 112;
T. Gerszi, *Zwei Jahrhunderte niederländischen Zeichenkunst*,
Budapest 1976, under no. 60 (ill.); idem in exhib. cat.
Leonardo to Van Gogh: Master Drawings from Budapest,
Washington, National Gallery of Art, Chicago, The Art
Institute, Los Angeles, County Museum of Art, 1985,
p. 190, under no. 87.

Apart from stating that Cornelis Dusart "followed close
on the heels" of his teacher Adriaen van Ostade
in depicting peasant life (see also cat. no. 30), the
biographer Johan van Gool relates that Dusart's
drawings, "in black and red chalk, or watercolor... [are]
esteemed and valued by art-lovers."[1] Dusart is very akin
to Van Ostade as both painter and draftsman.[2] On the
latter's death in 1685, Dusart inherited the contents of
his studio, which included hundreds of drawings. He
cherished them all his life and used them as models,
and when his own death inventory was drawn up in
1708 his "paper art" included portfolios full of Van
Ostade drawings.[3]

Although Dusart relied heavily on Van Ostade as a
draftsman, it is nevertheless difficult to attribute the
appearance and style of a sheet like this one entirely to
the master. The technique – a combination of red and
black chalk – was certainly used by Van Ostade, but
mainly for study heads and rarely for full-length
figures.[4] The rendering of textures and the disciplined
hatching to suggest drapery folds and shadows tell us
that another master is at work in these figure studies.
Moreover, Dusart's chalk drawings are more highly
finished or, as one author recently put it: "In this
manner Dusart developed from Van Ostade's figures,
which were only preliminary studies, elegant drawings
which were made as individual works of art for
connoisseurs."[5] In this respect Dusart is sometimes
regarded as a precursor of Watteau.[6] However, more
plausible sources for figure studies of this type are to be
found in the work of such Haarlem artists as Jan de
Bray, Cornelis Bega and Gerrit Berckheyde. It is known
from the inventory of Dusart's estate that an album of
"artistic drawings" included sheets by all these masters.[7]
It also contained work by Dusart himself, but further on
in the inventory there is separate mention of various
"art books." Number 15, for instance, lists "Men done
from life by Dusart, 251 items." Although we know that
he sold his drawings as finished works (some, for
example, are done on vellum), the fact that he still
possessed a large number on his death suggests that he
may also have used them as reference material. Their
quantity gives an idea of his productivity, while the
extant sheets reveal something of his working method.

Dusart had only a limited number of models, almost
all of them men, whom he drew in different costumes

fig. a

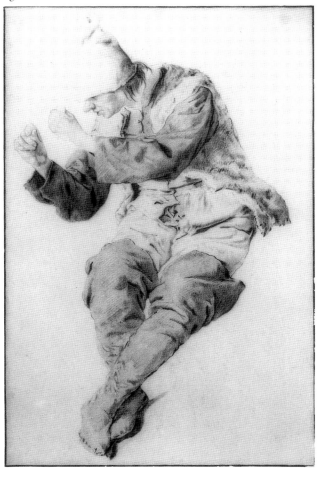

and poses. Most of the figures are seated. The boy seen here in a fur jacket must have been an extremely patient sitter, for Dusart drew him on many occasions. He is recognizable by his strawlike hair, which is sometimes long, sometimes short, by his nose resembling that of a garden gnome, and by his thick lips, dark eyebrows and his general air of quiet amusement. In some of the drawings he has a flat cap, in others a large, broad-brimmed beret,[8] and in some this tall cap. It has a split at one side and is drawn down over the head to just above the eyes, like a skater's cap.[9] There are whole groups of studies in which the same model is seen from different angles, rather as if they had been made during a drawing lesson, the difference being that they are all by the same artist. One sheet in the Metropolitan Museum in New York shows the boy from the back (fig. b),[10] while in another, in Budapest, he is seen from the left in the act of writing (fig. c).[11] In a drawing formerly in Bremen (fig. a),[12] he is also turned to the left, as in the Rotterdam sheet, and is wearing the same top boots, which suggests that both were made during a single sitting.

1. Van Gool 1750-51, vol. II, pp. 457-58: "... *kort op de hielen gevolgt is in 't verbeelden van 't Boereleven,*" and "... *zyne Tekeningen, met zwart en root kryt, of met waterverwen, ... by de Liefhebbers in achting [zyn] en van hen na waerde [worden] geschat.*"
2. E. Trautscholdt, "Beiträge zu Cornelis Dusart," *Nederlands Kunsthistorisch Jaarboek* XVII, 1966, pp. 171-200; Schnackenburg 1981, vol. I, pp. 60-63.
3. A. Bredius, *Künstler-Inventare*, vol. I, The Hague 1915, pp. 63-66.
4. Schnackenburg 1981, vol. I, pp. 103-04, nos. 112-16, vol. II, pls. 58-59.
5. P. Schatborn in exhib. cat. Amsterdam, Washington 1981-82, pp. 110-111.
6. F. Fox Hofrichter, exhib. cat. *Haarlem: the Seventeenth Century*, Rutgers, N.J., The Jane Voorhees Zimmerli Art Museum, 1983, p. 76, under no. 34.
7. Bredius, op. cit. (note 3), p. 63, no. 3.
8. See the drawing in the R. Goldschmidt Collection, Berlin, sale Frankfurt (Prestel), October 4-5 1917, no. 179, pl. 70.
9. There are also sheets in London (Hind 1915-31, vol. III, p. 80, no. 8, pl. XLIII) and Turin (dated 1686, see G.C. Sciolla, *I disegni di maestri stranieri della Bibliotheca Reale di Torino*, Turin 1974, p. 39, no. 41, ill.).
10. H. Bobritzky Mules, *Dutch Drawings of the Seventeenth Century in the Metropolitan Museum of Art*, New York 1985, pp. 24-25 (ill.).
11. Gerszi (1985), p. 190, (ill.).
12. That drawing, inv. 09/712, has been untraceable since the Second World War, but is reproduced in G. Pauli, *Zeichnungen alter Meister in der Kunsthalle zu Bremen*, Frankfurt 1916, p. 10, no. I 16.

GL

figs. b & c

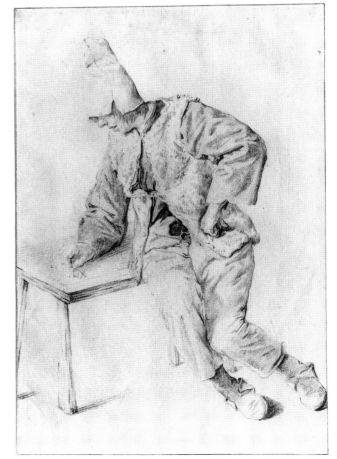

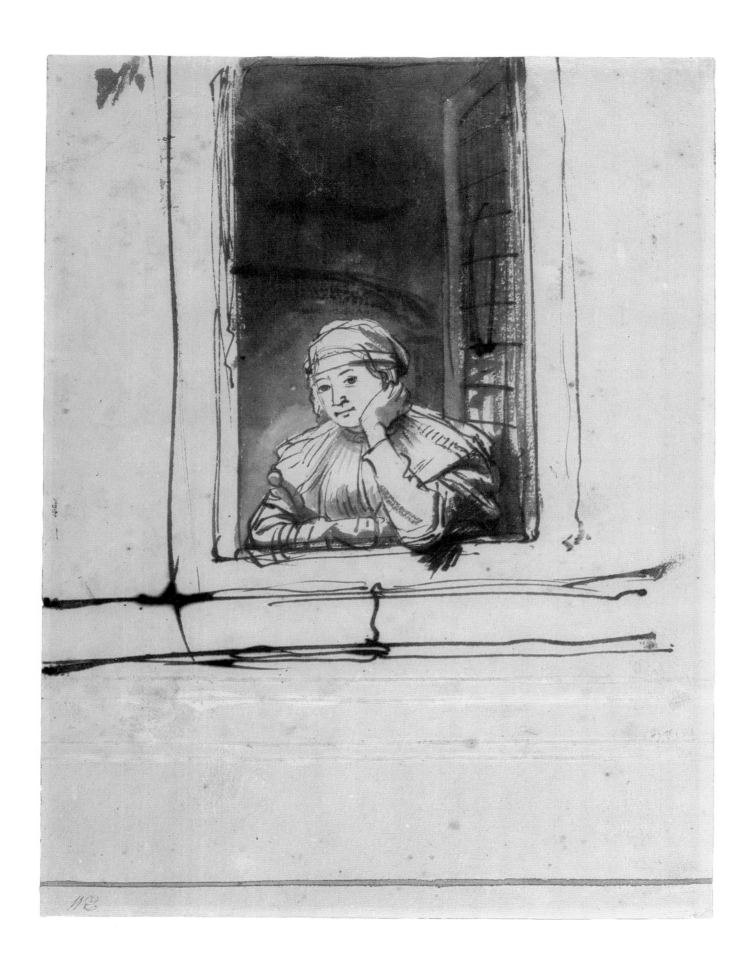

33

Rembrandt Harmensz van Rijn
Leiden 1606–1669 Amsterdam
SASKIA AT A WINDOW

Pen and brown ink, brown wash, corrected with white,
on tinted paper; 236 × 178 mm.
Verso: *5 xyz* in pencil, and *from the coll of the Marquis
Vinde* in the handwriting of W. Esdaile
No watermark
Inv. R 131

Provenance: Paignon-Dijonval;[1] C.G. vicomte Morel de
Vindé, Paris; S. Woodburn, London; T. Dimsdale,
London (L. 2426); Sir Thomas Lawrence, London
(L. 2445); W. Esdaile, London (L. 2617); sale London
(Christie's), June 17 1840, no. 89; C.S. Bale, London
(L. 640); sale London (Christie's), June 1 1881,
no. 2420; J.P. Heseltine, London (L. 1507); M.J. Bonn,
London; sale London (Sotheby's), February 15 1922,
no. 46; H.E. ten Cate, Almelo (L. 533b); F. Lugt,
Maartensdijk, acquired in 1930; F. Koenigs, Haarlem
(L. 1023a), acquired in 1930; D.G. van Beuningen,
Rotterdam, acquired in 1940 and donated to the
Boymans Museum Foundation.

Exhibitions: London 1835, no. 74; London 1899,
no. 129; Paris 1908, no. 403; London 1929, no. 639;
Amsterdam 1932, no. 274; Rotterdam 1934, no. 83;
Brussels 1937-38, no. 66; Rotterdam 1938, no. 314;
Dijon 1950, no. 81; Rotterdam 1952, no. 41; Paris 1952,
no. 45; Stockholm 1956, no. 76; Rotterdam, Amsterdam
1956, no. 23; Vienna 1956, no. 12; Washington
1958-59, no. 58; Brussels, Hamburg 1961, no. 48;
Prague 1966, no. 87; Amsterdam 1969, no. 35; Paris
1974, no. 74; Leningrad, Moscow, Kiev 1974, no. 82.

Literature: M. de Bénard, *Cabinet de M. Paignon Dijonval*,
Paris 1810, no. 1963; Lippmann and Hofstede de Groot
1888-1911, vol. I, no. 185; Michel 1893, pp. 472, 583;
W. von Seidlitz, "Rembrandt's Zeichnungen,"
Repertorium für Kunstwissenschaft XVII, 1894, p. 122;
Hofstede de Groot 1906, no. 1016; *Original Drawings by
Rembrandt in the Collection of J.P. Heseltine*, London 1907,
no. 69; R.R. Tatlock, "Auctions," *Burlington Magazine*
XL, 1922, pp. 49-50; *Commemorative catalogue London*
1930, p. 214; Hell 1930, p. 104, note 1; Hind 1932,
p. 50; M. Freeman, *Rembrandt van Rijn* (Master
Draughtsmen 4), London 1933, no. 8; Valentiner,
vol. II, 1934, no. 676; Benesch 1935, p. 16; *Verslag
Stichting Museum Boymans* 1939-41, p. 7; J. Rosenberg,
Rembrandt, vol. I, Cambridge, Mass., 1948, p. 148;
Benesch 1954-57, vol. II, no. 250; Baard 1956, no. 36;
Haverkamp Begemann 1957, no. 20; E. Haverkamp
Begemann, "Otto Benesch, The Drawings of
Rembrandt," *Kunstchronik* XIV, 1961, p. 24; O. Benesch,
"Neuentdeckte Zeichnungen von Rembrandt," *Jahrbuch
der Berliner Museen* VI, 1964, p. 112; J. Rosenberg,
Rembrandt: Life and Work, London 1964, p. 240;
S. Slive, *Drawings of Rembrandt*, vol. I, New York 1965,
no. 198; P. Descargues, *Rembrandt et Saskia à Amsterdam*,
Lausanne 1965, p. 110; G. Arpino, *L'opera pittorica
completa di Rembrandt*, Milan 1969, p. 134; Hoetink
1969, p. 21, no. 10; Benesch 1970, p. 251; exhib. cat.
*Rembrandt et son temps: dessins des collections publiques et
privées conservées en France*, Paris, Musée du Louvre,
1970, p. 68, under no. 151; E. Haverkamp Begemann,
"The Present State of Rembrandt Studies," *Art Bulletin*
LIII, 1971, p. 88; Benesch 1973, vol. II, no. 250; Haak
1976, pp. 20, 26; Bernhard 1976, p. 81; exhib. cat. New
York, Paris 1977-78, under no. 87; Pignatti 1981,
p. 223; Schatborn 1985, under no. 14; Giltaij 1988, no. 8.

Rembrandt Harmensz van Rijn and Saskia Uylenburgh
were betrothed on June 5 1633, and married a little
over a year later in the Parish of St Anne in the
northern province of Friesland.[2] Saskia was the daughter
of Rombout Uylenburgh, a lawyer who served as
pensionary (legal adviser to the town council) and
burgomaster of Leeuwarden, and his wife Sjoukje
Ozinga.[3] Rembrandt met his future bride at the house
of her uncle, the art dealer Hendrick Uylenburgh, who
was his partner and in whose house he had lived when
he first arrived in Amsterdam.[4] Saskia bore Rembrandt
four children, three of which died in infancy; only Titus
survived to maturity. Saskia herself died in 1642 after a
long illness, aged thirty.

Rembrandt used his wife as a model on numerous
occasions. He painted her portrait several times,
included her in various historical and biblical scenes,
made etchings of her, and drew her in a variety of
domestic settings – at her toilet, in childbed, and as a
young mother with a newborn baby in her arms. The
series of drawings probably begins with the intimate
silverpoint in Berlin, which has an inscription recording
that "this is my wife's likeness, taken when she was
twenty-one years old, the third day after we plighted
our troth, June 8 1633" (fig. a).[5]

fig. a

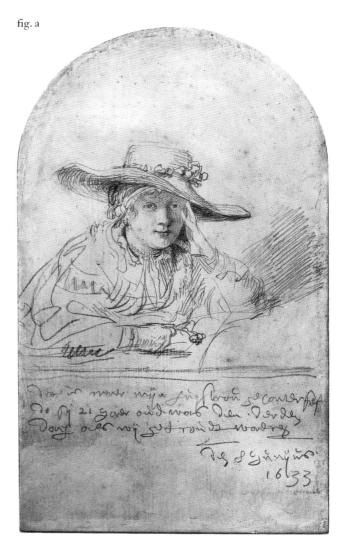

There too she rests her head on her hand, which gives her a rather dreamy expression that seems to have appealed to Rembrandt, for it recurs in several etchings.[6] Her pensive gaze is generally fixed on a point outside the frame, but in the Rotterdam drawing we are under the illusion that our eyes meet hers, which gives the sheet its special charm. The pen-strokes are broad and precise, with a jagged blotch to suggest the shadow which Saskia's left arm casts on the wall. The heavy washes used for the interior of the room are also spirited, but the brush was used rather more carefully for the dark passages in the headdress and clothing. The position of the open window in the middle of the sheet shows that Rembrandt did indeed give some thought to the overall composition, as does his correction of the initial horizontal lines below the window.

There are several other drawings of Saskia at a window, but this is the only view from the outside. An equally powerful sheet in the Lugt Collection in Paris, which also shows her supporting her head with her hand (fig. b),[7] is so similar in spirit that both appear to have been executed in a single sitting. A third drawing, in the Rijksprentenkabinet in Amsterdam (fig. c), is done with a calmer pen and has a more transparent wash, but is nevertheless closely related to the other two. In addition to being figure studies, all three are exercises in the effect of light and shadow, which is why the model is always by a window. The drawings in Rotterdam and Paris are dated between 1633 and 1636, but the slightly later date of *c.* 1638 has recently been proposed for the one in Amsterdam.[8]

1. De Bénard (1810), no. 1963.
2. H.F. Wijnman, "Rembrandt en Saskia wisselen trouwbeloften," *Amstelodamum* LVI, 1969, p. 156.
3. C. Hofstede de Groot, *Die Urkunde über Rembrandt*, The Hague 1906, p. 37, no. 37.
4. See H.F. Wijnman, "Rembrandt als huisgenoot van Hendrick Uylenburgh te Amsterdam (1631-1635)," in idem, *Uit de kring van Rembrandt en Vondel*, Amsterdam 1959, pp. 1-18, and Schwartz 1984, pp. 139-42.
5. Berlin, Staatliche Museen; Benesch 1954-57, vol. II, no. 427, fig. 483. The inscription reads: *"dit is naer mijn huijsvrou geconterfeijt/ do sij 21 jaer oud was de derden/ dach als wij getroudt waren/ den 8 junijus/1633."*
6. Hollstein, *Dutch and Flemish*, vol. XVIII, nos. B 365, B 367.
7. Paris, Fondation Custodia, F. Lugt Collection, inv. 288; Benesch 1954-57, vol. II, no. 253; exhib. cat. New York, Paris 1977-78, no. 87.
8. Amsterdam, Rijksprentenkabinet, inv. 1930:51; Schatborn 1985, no. 14.

GL

fig. b

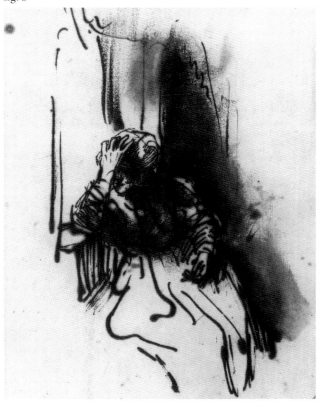

fig. c

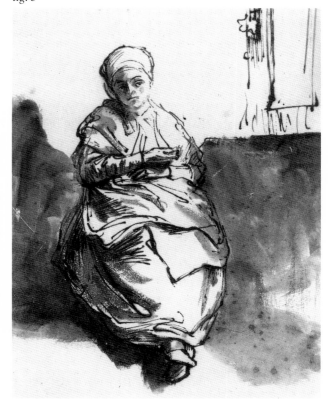

34

Rembrandt Harmensz van Rijn
Leiden 1606–1669 Amsterdam
RECUMBENT LION

Pen and brown ink, brown wash, corrected with white,
indented, laid down; 140 × 203 mm.
Verso: the date *1835* and *WE* in pen and brown ink,
3xyz in pencil. Two old annotations are visible through
the mount: *No 5.a* in pen and brown ink, *f 6, -/van
remb. na 't leven* in red chalk.
No watermark
Inv. R 12

Provenance: Baron D. Vivant-Denon, Paris (L. 779);
probably sale Paris (Pérignon), May 1-19 1826, no. 656
(455 francs); Sir Thomas Lawrence, London (L. 2445);
W. Esdaile, London (L. 2617); sale London (Christie's),
June 17 1840, no. 106 (£8 10s.); S. Woodburn, London;
Sir J. Knowles, London; sale London (Christie's), May
27-29 1908, no. 99 (£135); P. Mathey, Paris; E. Wauters,
Paris (L. 911); sale Amsterdam (Frederik Muller), June
15-16 1926, no. 144 (Dfl. 22,000); F. Koenigs, Haarlem
(L. 1023a); D.G. van Beuningen, Rotterdam, acquired in
1940 and donated to the Boymans Museum Foundation.

Exhibitions: London 1835, no. 53; London 1899,
no. 159; London 1929, no. 626; Berlin 1930, no. 332;
Amsterdam 1932, no. 255; Rotterdam 1934, no. 91;
Amsterdam 1936, no. 197; Rotterdam 1938, no. 318;
Dijon 1950, no. 87; Rotterdam 1952, no. 43; Paris 1952,
no. 47; Rotterdam, Amsterdam 1956, no. 181; Brussels,
Hamburg 1961, no. 62; Prague 1966, no. 92;
Amsterdam 1969, no. 106.

Literature: Hofstede de Groot 1906, no. 1070;
Lippmann and Hofstede de Groot 1888-1911, vol. IV,
no. 46; Lees 1913, p. 119; *Commemorative catalogue
London* 1930, p. 211; M.D. Henkel, *Le dessin hollandais
des origines au XVIIe siècle*, Paris 1931, pp. 74, 123; Lugt
1933, p. 64, under no. 1330; Benesch 1935, p. 43;
Henkel 1942, p. 52, under nos. 105 and 107; *Verslag
Stichting Museum Boymans* 1939-41, p. 7; Benesch 1947,
p. 38, under no. 183; Benesch 1954-57, vol. V, no. 1211;
Haverkamp Begemann 1957, no. 21; Slive 1965, vol. II,
no. 491; Haak 1968, p. 231; Hoetink 1969, p. 29, no. 41;
Wegner 1973, p. 169, under no. 1165; Benesch 1973,
vol. V, no. 1211; J.G. van Gelder, "Frühe Rembrandt-
Sammlungen," *Neue Beiträge zur Rembrandt-Forschung*,
Berlin 1973, p. 200, note 51; Haak 1976, p. 20;
P. Schatborn, "Beesten nae 't leven," *Kroniek van het
Rembrandthuis* XXIX, 1977, no. 28; Broos 1981, p. 149,
under no. 40; P. Schatborn, "Van Rembrandt tot
Crozat: vroege verzamelingen met tekeningen van
Rembrandt," *Nederlands Kunsthistorisch Jaarboek* XXXII,
1981, pp. 25-27; P. Schatborn, "B. Broos, Rembrandt en
tekenaars uit zijn omgeving," *Oud Holland* XCVI, 1982,
p. 251; Schatborn 1985, p. 218, under no. 109; Giltaij
1988, no. 23.

Among the many albums of prints and drawings listed
as being in the "Art Chamber" in the 1656 inventory of
Rembrandt's possessions was: "One ditto, filled with
drawings by Rembrandt of animals done from life."[1]
These were *aides-mémoire* for Rembrandt's history
paintings, but he would also have drawn and collected
sheets of the more exotic species out of sheer curiosity.
The latter probably include his studies of lions, which
are among the high points in his drawn *œuvre*. This
beautiful drawing is in fact not so much a study as a
masterpiece in its own right.[2]

Rembrandt succeeded brilliantly in capturing the
mixture of repose and vigilance that typifies a lion at
rest, noting such details as the twitching tail and the
wiry mane. The hind feet are both visible on one side
of the lion's body, the viewpoint being directly opposite
the claws of the right paw. The lifelike impression is
heightened by the light brown ochreous color of the
ink, which approaches that of a real lion's pelt. The
wash and touches are extremely effective in describing
the beast's anatomy, while the use of an almost dry
brush gives the drawing a painterly look. There are
indications that Rembrandt started with a thinner brush,
for more precisely drawn lines can be seen here and
there among the quite bold, broad contours. One or
two passages have been corrected with white, the
position of the left hind paw is redrawn, and the
forepaw has been shortened a little.

The lions which Rembrandt drew have been
identified as Berber lions from the Atlas Mountains in
North Africa. These heavily built animals have a light
brown skin, a belly mane and a square head.[3]
Rembrandt may have seen a specimen in a menagerie
like the one kept by Prince Frederik Hendrik at
Honselaarsdijk near The Hague, which was among the
very first zoos in Europe. Seamen, though, also brought
back wild animals to be put on display as novelties at
carnivals and fairs, and the Dutch East India Company
even built stables to house them.[4]

It is not known who acquired the album with
"animals done from life" at the sale of Rembrandt's
belongings in 1656. However, the catalogue of the art
cabinet of Jan Pietersz Zomer (1641–1724), which was

fig. a

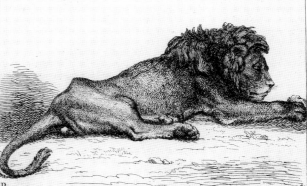

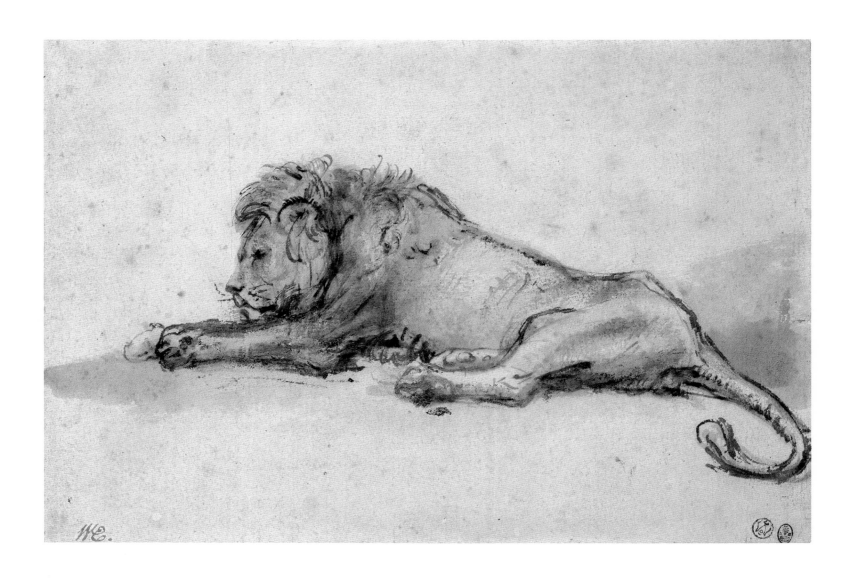

compiled at the end of his life, lists a book, "oblong, no. 38, with a horn binding and gilt bands," containing "19 lions most artfully done from life by Rembrandt," as well as other works.[5] One of them might possibly have been this lion in Rotterdam, which was reproduced shortly afterward in a print by Bernard Picart (1673–1733) in his *Receuil des lions* of 1729 (fig. a). Picart occasionally made his own copy of a drawing, resulting in minor differences in the dimensions between drawing and print, but his etching of this particular lion is exactly the same size as the original, which accounts for its indented outlines.[6]

Most of Rembrandt's lion studies, including this one, are generally dated to the 1650s on stylistic grounds.[7] The *terminus post quem* is 1634, the date on the etching of *St Jerome Reading* (fig. b), where the lion was quite definitely not observed from nature, but was taken from another print.[8] Opinions differ as to whether Rembrandt had already made drawn studies by the time he came to paint the lion in his *Concord of the State* in the early 1640s,[9] but it is possible that some of the lion studies date from around then.

This *Recumbent Lion* used to belong to Franz Koenigs, who bought it at the important sale of Emile Wauters's collection in 1926. Three years later he acquired a second Rembrandt lion (fig. c),[10] this one seen from the right and with its head turned more toward the viewer. In the Second World War that drawing was acquired by the Germans for the planned Hitler Museum in Linz, and has since vanished.

fig. b

fig. c

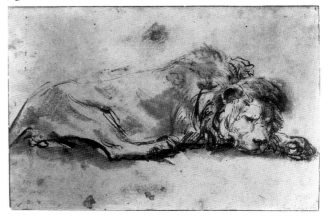

1. W. Strauss, M. van der Meulen *et al.*, *The Rembrandt Documents*, New York 1979, p. 375, 1656/12, no. 249: *"Een dito, vol teeckeninge van Rembrandt, bestaende in beesten nae 't leven."*
2. Schatborn (1977), pp. 5, 24-31. Two drawn copies of the Rotterdam sheet are known: Paris, Musée du Louvre (Lugt 1933, no. 1330, pl. CIII), and Munich, Staatliche Graphische Sammlung (Wegner 1973, p. 169, no. 1165).
3. Schatborn (1977), p. 24.
4. Schatborn 1985, p. 116, under no. 53.
5. S.A.C. Dudok van Heel, "Jan Pietersz Zomer (1641-1724): makelaar in schilderijen (1690-1724)," *Jaarboek Amstelodamum* LXIX, 1977, p. 106: *"over dwars No. 38 met een hoorne band en gouden streepjes... zeer konstig van Rembrandt, 19 Leeuwen na 't leven getekent"*; see also Schatborn (1981), pp. 21-24.
6. Van Gelder (1973), p. 200; Schatborn (1981), pp. 25-28.
7. Benesch 1954-57, vol. V, no. 1211 and others.: *c.* 1650-52. Lugt 1933, p. 31, under no. 1190, dated the lion studies shortly after 1640.
8. Hollstein, *Dutch and Flemish*, vol. XVIII-XIX, p. 55, no. B 100; L. Münz, *A Critical Catalogue of Rembrandt's Etchings*, vol. II, London 1952, p. 111, no. 245, suggested that this lion was copied after Albrecht Altdorfer.
9. O. Kurz, "Rembrandt van Rijn (1606-1669) – Study of a Lion," *Old Master Drawings* XI, 1936-37, p. 52; see also Broos 1981, pp. 147-49, esp. note 1.
10. Acquired with the J. Böhler Collection in 1929; see Benesch 1954-57, vol. IV, 1954, no. 782, fig. 977, and Elen 1989, no. 501.

GL

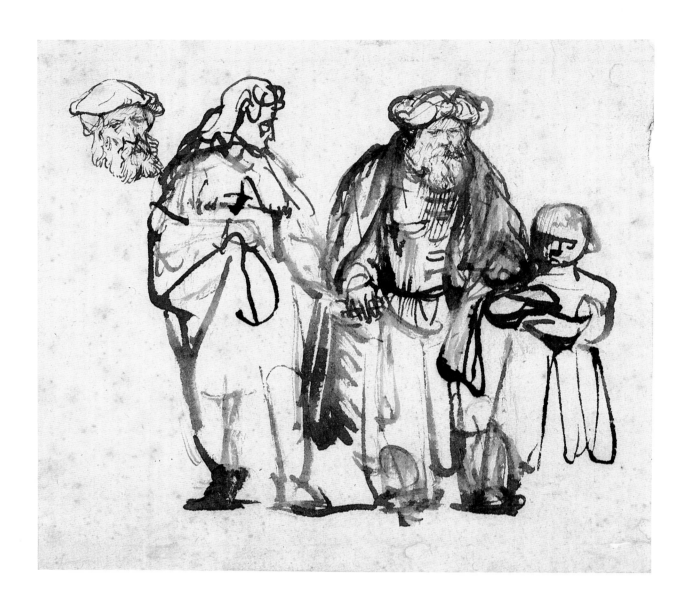

35

Rembrandt Harmensz van Rijn
Leiden 1606–1669 Amsterdam
BIBLICAL SCENE

Pen (and possibly brush) and brown ink, corrected with
white; 149 × 164 mm.
Verso: *6, Rembrandt van Rijn, 3-113, 40* and *I 5248* in
pencil
Watermark: shield with bishop's crosier (the arms of
Basel)
Inv. MB 1988/T 6

Provenance: A.P.E. Gasc, Paris (L. 1131); sale Paris
(Drouot), January 11-12 1861, no. 210; J. Mathey, Paris;
F. Lugt, Paris, acquired in 1937; C.R. Rudolf, London,
acquired in 1938; sale London (Sotheby's), May 21
1963, no. 39; acquired by A. Pringuer for £ 33,600;
N.G. Stogdon Gallery, New York, 1986; purchased in
1988 by the Boymans Museum Foundation with the aid
of the Rembrandt Society, the J.E. Jurriaanse
Foundation, the "Bevordering van Volkskracht"
Foundation and the Erasmus Foundation.

Exhibitions: London, Birmingham, Leeds 1962, no. 122;
New York 1986, no. 9.

Literature: R. Hamann, "Hagars Abschied bei
Rembrandt und im Rembrandt-Kreise," *Marburger
Jahrbuch für Kunstwissenschaft* VIII-IX, 1936, pp. 42-43;
Benesch 1954-57, vol. I, no. 190; W. Sumowski,
"Bemerkungen zu Otto Beneschs Corpus der
Rembrandt-Zeichnungen I," *Wissenschaftliche Zeitschrift
der Humboldt-Universität zu Berlin* VI, 1956-57, p. 257;
Weltkunst May 1 1963, p. 5; C. Tümpel, "Iconografische
verklaring van de voorstelling op twee tekeningen van
Rembrandt," *Kroniek van het Rembrandthuis* XXVI, 1972,
pp. 68-70; Benesch 1973, vol. I, no. 190; Giltaij 1988,
no. 16.

The studies of biblical, mythological and historical
subjects which Rembrandt produced with such regularity
throughout his life constitute the largest single group
within his drawn *œuvre*. They are not preparatory
studies, for they rarely have any demonstrable
connection with a painting. They were probably made
principally as exercises in the grouping of figures, but
they may also have helped stimulate Rembrandt's
imagination. The extremes of emotion depicted in many
of them would have enabled him to penetrate to the
very heart of a story. The act of drawing was also an
exploration of the different visual facets of the narrative,
and Rembrandt often produced several variations on a
single theme. He must have passed on this practice of
making exercise studies to his pupils, for they too left a
remarkably large number of similar sketches.[1]

In the course of the 1640s, Rembrandt increasingly
pared down his narrative drawings to the bare essentials.
Details are omitted, and the settings are vague or
non-existent, directing the viewer's attention to the
relationship between the figures, and to their poses and
expressions. The main focus in this sheet, which appears
to date from around 1642, is on the pensive old man,
who is wearing a flat bonnet or turban and has a long
cloak draped over his shoulders. His features are
carefully delineated with a fine pen. Rembrandt
probably started with the head at upper left but was
evidently dissatisfied with its expression, and began
again 10 centimeters to the right with the second head,
which he then worked up. It is now that he displays his
great virtuosity, for the further he moves away from the
head the broader the pen-strokes and the more fluid the
handling of line. The boy on whom the old man is
leaning is rendered with just a few bravura pen lines,
and the figure on the left is also executed with great
rapidity and deftness. It is not clear whether the broad
lines were applied with the brush, but the smears in the
old man's cloak may have been done with the finger.

"Largement traité," reads the description in the Paris
sale catalogue of 1861, and one can well imagine how
attractive this sheet must have been at a time when

Delacroix's career was drawing to its close. The study
had already attracted attention earlier in the century.
It was translated into an etching (fig. a) by Chevalier
Ignace-Joseph de Claussin (1795–1844), who added the
inscription "3 Mars 1814 à Amsterdam," from which it
can be concluded that the drawing was in an Amsterdam
collection at the time. Claussin omitted the head at
upper left, transferring it instead to a print after a sheet
of study heads by Rembrandt which is now in the
Barber Institute in Birmingham.[2]

There have been various interpretations of the
Rotterdam drawing, which the museum only acquired
very recently. Richard Hamann identified it as Abraham
banishing Hagar and Ishmael (Genesis 21:14) in his
essay on the iconography of that theme, but he had
only seen Claussin's print, not the original drawing.[3]
Moreover, the composition is very different from
Rembrandt's 1637 etching of the same subject.[4] It was
later pointed out that the lefthand figure is probably a
man, and so could hardly be Hagar.[5] After going under
the title of *Zacharias Led by Servants* for some time, it
was suggested by Christian Tümpel in 1972 that it
actually showed Jacob sending his sons to Egypt without
Benjamin.[6] This brought the wheel more or less full
circle, albeit unwittingly, for in the 1861 sale catalogue
of the Gasc Collection the subject is described as
"Épisode de l'histoire de Joseph."

The story comes from Genesis 42:4. After being
appointed Pharaoh's chief administrator, Joseph stored
up grain against the impending famine, and only sold it
when other countries ran short. Jacob sent his sons to
Egypt to buy corn, but kept back Benjamin, his favorite,
whose mother, Rachel, had died in childbirth. However,
it seems that Rembrandt chose not this but a later
episode in the story. Joseph sold his brothers corn when
they arrived in Egypt, but demanded that they return
with their youngest brother. When they got home they
appealed to Jacob to let Benjamin to go with them, and
after much soul-searching he eventually agreed. This
drawing could very well depict the moment when either
Reuben or Judah beg their father to allow Benjamin to

fig. a

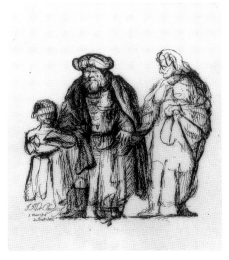

fig. b

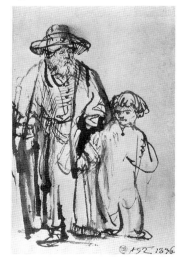

fig. c

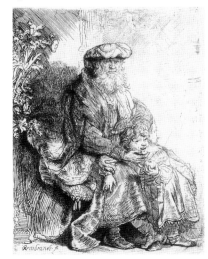

accompany them. This would fit the relationship between the three figures: the anxious, expectant look of the figure on the left and, above all, the bond between the old man and the boy.

This is probably also the subject of a Rembrandt drawing in Stockholm (fig. b), which has clear similarities to the Rotterdam sheet, despite being trimmed on the left,[7] where traces remain of a third figure. Rembrandt probably borrowed the motif of an old man leaning on a boy from a print by Maarten van Heemskerck, who was his source of inspiration on more than one occasion.[8] He also employed it in his painting of the *Visitation* in 1640 (Detroit, Detroit Institute of Arts; fig. d), where the aged Zacharias descends a flight of steps leaning on a boy's shoulder.[9] The relationship between the old man and the boy is more intimate in the two drawings than in the painting, where the child is a servant. In that respect the drawings are closer to the etching traditionally known as *Abraham Caressing Isaac* (fig. c), but which may equally well represent *Jacob Caressing Benjamin*, in which the old man bears more than a passing resemblance to the one in the Rotterdam drawing.[10]

1. W.W. Robinson, "Rembrandt's Sketches of Historical Subjects," in W. Strauss and T. Felker (eds.), *Drawings Defined*, New York 1987, pp. 241-58.
2. Benesch 1954-57, vol. II, no. 340; H. Miles and P. Spencer-Longhurst, *Master Drawings in the Barber Institute*, Birmingham 1986, no. 12. The print is reproduced in Giltaij 1988, no. 16, fig. c.
3. Hamann (1936), p. 42.
4. For Rembrandt's drawings of Hagar and Ishmael see Schatborn 1985, no. 40, and for the etching, Hollstein, *Dutch and Flemish*, vols. XVIII-XIX, p. 14, B 30. The subject enjoyed something of a vogue among Rembrandt's pupils, see Hamann (1936), and P. Schatborn in exhib. cat. *Bij Rembrandt in de leer*, Amsterdam, Museum het Rembrandthuis, 1984-85, pp. 84-91, nos. 68-75.
5. Benesch 1954-57, vol. I, no. 190.
6. Tümpel (1972), pp. 67-75.
7. Benesch 1954-57, vol. I, no. 189.
8. Tümpel (1972), pp. 71-72, fig. 5; B.P.J. Broos, *Index to the Formal Sources of Rembrandt's Art*, Maarssen 1977, and idem, exhib. cat. *Rembrandt en zijn voorbeelden*, Amsterdam, Museum het Rembrandthuis, 1985-86.
9. An elderly person being led by a boy was of course a common sight in the seventeenth century. A study sheet by Rembrandt with an old blind woman and a boy (Berlin, Staatliche Museen; Benesch 1954-57, vol. II, no. 223r, fig. 242) may very well have been drawn from life. See also K. Jones Hellerstedt, "The blind man and his guide in Netherlandish painting," *Simiolus* XIII, 1983, pp. 163-81.
10. Hollstein, *Dutch and Flemish*, vols. XVIII-XIX, pp. 14-15, no. B 33. See for the revised interpretation C. Tümpel, exhib. cat. *Rembrandt legt die Bibel aus*, Berlin, Kupferstichkabinett, Staatliche Museen, 1970, no. 20.

GL

fig. d

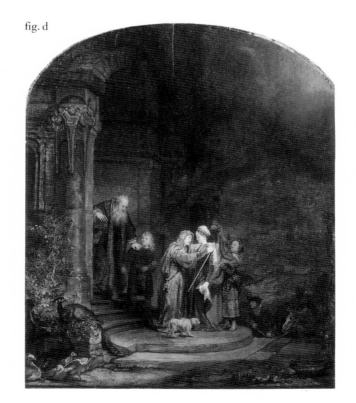

36

Rembrandt Harmensz van Rijn
Leiden 1606–1669 Amsterdam
STANDING MAN, STUDY FOR ONE OF THE SYNDICS

Pen and brush and brown ink, brown wash, corrected
with white and heightened, on paper taken from a cash
ledger, laid down; 225 × 175 mm.
At left and right a vertical line of the cashbook paper
Verso, visible through the lining: a column of figures,
and *Rembrand* in pen
No watermark
Inv. R 133

Provenance: Marquess of Lansdowne; sale London
(Sotheby's), March 25 1920, no. 56; H.E. ten Cate,
Almelo (L. 533b); F. Lugt, Maartensdijk, acquired in
1930; F. Koenigs, Haarlem (L. 1023a), acquired in 1930;
D.G. van Beuningen, Rotterdam, acquired in 1940 and
donated to the Boymans Museum Foundation.

Exhibitions: Amsterdam 1925, no. 613; London 1929,
no. 631; Amsterdam 1932, no. 341; Rotterdam 1934,
no. 108; Brussels 1937-38, no. 75; Rotterdam 1938,
no. 335; Dijon 1950, no. 91; Paris 1952, no. 54;
Rotterdam 1952, no. 56; Stockholm 1956, no. 184;
Rotterdam, Amsterdam 1956, no. 255; Vienna 1956,
no. 144; Munich 1957, no. 38; Prague 1966, no. 96;
Amsterdam 1969, no. 137.

Literature: J.H.J. Mellaart, *Dutch Drawings of the
Seventeenth Century*, London 1926, p. 6, no. 7;
W. Weisbach, *Rembrandt*, Berlin, Leipzig 1926, p. 588;
Hell 1930, p. 126; O. Benesch, "Rembrandts spätestes
gezeichnetes Selbstbildnis," *Mitteilungen der Gesellschaft
für vervielfältigende Kunst: Die Graphischen Künste* LV,
1932, p. 31; Hind 1932, p. 144; Lugt 1933, p. 20, under
no. 1153; Valentiner, vol. II, 1934, no. 746; Benesch
1935, p. 67; A. Bredius, *Rembrandt schilderijen*, Utrecht
1935, under no. 415; *Verslag Stichting Museum Boymans*
1939-41, p. 7; Henkel 1942, p. 18, under no. 41, p. 20,
under no. 44; De Tolnay 1943, p. 32; J. Poortenaar,
Rembrandt teekeningen, Naarden [1944], p. 34, no. 11;
T. Borenius, *Rembrandt, peintures choisies*, Paris 1946,
p. 36, under no. 95; Benesch 1947, no. 282; H.E. van
Gelder, *Rembrandt, schilder van de Nachtwacht*
(Paletserie), Amsterdam [1948], p. 58; J.G. van Gelder,
"The Drawings of Rembrandt," *Burlington Magazine*
XCI, 1949, p. 207; Benesch 1954-57, vol. V, no. 1180;
exhib. cat. Rotterdam, Amsterdam 1956, pp. 178, 180;
A. van Schendel, "De schimmen van de Staalmeesters,"
Oud Holland LXXI, 1956, pp. 2-5; Baard 1956, no. 114;
H. Kauffmann, "Die Staalmeesters," *Kunstchronik* X,
1957, pp. 125-26; Haverkamp Begemann 1957, no. 26;
E. Trautscholdt, "Zeichnungen und Radierungen von
Rembrandt, Ausstellung der Staatlichen Graphischen
Sammlung München," *Kunstchronik* X, 1957, p. 161;
J. Rosenberg, "Otto Benesch, The Drawings of
Rembrandt," *Art Bulletin* XLI, 1959, p. 110, note 3;
O. Benesch, *Rembrandt as a Draughtsman*, London 1960,
p. 31, no. 102; K. Clark, *Rembrandt and the Italian
Renaissance*, London 1966, pp. 62-63; K. Bauch,
Rembrandt: Gemälde, Berlin 1966, p. 27, under no. 540;
Haak 1968, p. 310; A. Bredius, *Rembrandt: the Complete
Edition of the Paintings*, revised by H. Gerson, London
1969, p. 585, under no. 415; Hoetink 1969, p. 37, no. 67;
Benesch 1970, p. 113; Benesch 1973, vol. V, no. 1180;
Haak 1976, pp. 17, 22; Bernhard 1976, p. 569; K. Clark,
An Introduction to Rembrandt, London 1978, p. 111;
P. Schatborn in exhib. cat. Amsterdam, Washington
1981-82, p. 58, and p. 142 under no. 86; Schatborn
1985, under no. 56; Giltaij 1988, no. 36.

This is one of three extant studies for Rembrandt's
painting of *The Syndics* (1662), now in the Rijksmuseum,
Amsterdam (fig. a), which shows the five wardens of the
Drapers' Guild with, as Jan Wagenaar records in his
history of Amsterdam, "standing, the servant of the
Syndics' Hall."[1] The wardens, or sampling officials,
were responsible for ensuring that the color of the cloth
produced in the city matched that of the official sample,
and for attaching a lead seal to the cloth as a guarantee
of its quality.

Since the sixteenth century it had been customary to
immortalize the boards of such corporations in group
portraits. Regents, regentesses and officials were
portrayed (often lifesize) in paintings which adorned
committee rooms and guildhalls. The development
of this type of collective portrait corresponded to the
rise of the urban burgess class, who filled the main
administrative posts in a city. The paintings were
designed to flatter the vanity of these worthy sitters
by commemorating their service with a particular
organization. The officials' probity was usually
symbolized by depicting them as they carefully
inspected the accounts or counted money.[2]

The Syndics fits squarely within that tradition.[3]
Rembrandt shows the gentlemen in full session, with
books on the table. He also made a symbolic allusion to
their dedication in the overmantel painting above the
head of the syndic on the right. It contains an emblem
of a watch-tower with a fire burning on top. The
beacon was a token of civic virtue in the seventeenth
century, and in one of Jacob Cats's emblems it has the
motto "Luceat lux vestra coram hominibus" (Let your
light shine for the benefit of all mankind).[4] That the
syndics had to radiate an aura of dignity and honor is
also evident in the preparatory drawing. Rembrandt
made provision for the fact that the picture would be
hung high up (it was probably intended as an
overmantel) by depicting the man from a low vantage
point.

The figure in the painting is stooped further forward
than in the drawing, as if caught halfway between
sitting and rising, which has given rise to a certain
amount of misunderstanding.[5] X-ray photographs show
that Rembrandt originally portrayed him in the
near-upright posture he has in the drawing (fig. b), and
that is also how he appears in a composition study in
Berlin (fig. c), which incorporates a sketchy repetition of
the Rotterdam sheet.[6] It is not known whether
Rembrandt's clients were dissatisfied with that pose or
whether he changed it himself for compositional
reasons. The X-ray also shows that the third man from
the left was moved a little to the right in the finished
version.[7]

The preliminary studies demonstrate how Rembrandt
fashioned his group portrait from the individual figures.
When he executed the Rotterdam drawing he was
already making allowance for the fact that the syndic
would be partly overlapped by his neighbor sitting in an
armchair on the extreme left, for whom he reserved the
lower left corner. Even more than in the Amsterdam

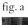
fig. a

study for that seated figure, with its more delicate hatching (fig. d),[8] it is clear that this broadly brushed drawing is by an artist who has already started painting in his mind. It is a highly worked sheet, with lines corrected with white and then redrawn, to such an extent that the paper is actually damaged in a few places. Both the Rotterdam and Amsterdam drawings are on paper from a cashbook. This is immediately visible on the verso, but on the recto too there are vertical lines dividing the paper into columns. Rembrandt used a similar sheet of paper in 1661-62 for a study of a seated female nude (Amsterdam, Rijksprentenkabinet).[9]

Archive research has turned up the names of the "wardens of the cloth" of 1661-62 who very probably sat for Rembrandt.[10] The syndic in the Rotterdam drawing has been identified as Volckert Jansz (1605/10-81), a Mennonite cloth merchant who was elected to the board for the second time on Good Friday 1661. He had a large art and natural history collection which had been started by his father and was much admired by the German, Christian Knorr van Rosenroth, on a visit to Amsterdam in 1663.[11] It is tempting to speculate that it was the connoisseur Volckert Jansz who was responsible for the choice of Rembrandt as the artist to immortalize the syndics, but there is nothing to support this theory.[12]

fig. a

fig. b

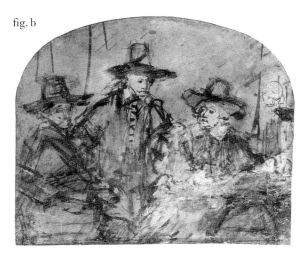

fig. c

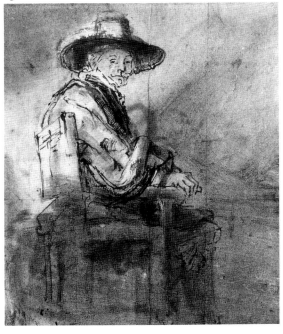

1. J. Wagenaar, *Amsterdam in zijne opkomst, aanwas, geschiedenissen, voorregten, koophandel, gebouwen, kerkenstaat, schoolen, schutterije, gilden en regeeringe*, vol. II, Amsterdam 1765, p. 42. On the painting see van Schendel (1956), pp. 1-23.
2. B. Haak, *Regenten en regentessen, overlieden en chirurgijns: Amsterdamse groepsportretten van 1600 tot 1835*, Amsterdam, Amsterdams Historisch Museum, 1972.
3. H. van de Waal, "The Syndics and Their Legend" [1956], in *Steps towards Rembrandt: Collected Articles 1937-1972*, Amsterdam, London 1974, pp. 247-92.
4. Ibid., pp. 269 and 290, and E. de Jongh, *Zinne- en minnebeelden in de schilderkunst van de zeventiende eeuw*, Amsterdam 1967, pp. 63-64, figs. 47-48.
5. Van de Waal, op. cit. (note 3), *passim*.
6. For the drawing in the Staatliche Museen in Berlin see Benesch 1954-57, vol. V, no. 1178.
7. Haak 1968, p. 309.
8. Benesch 1954-57, vol. V, no. 1179; Schatborn 1985, no. 56.
9. Benesch 1954-57, vol. V, no. 1142; Schatborn 1985, no. 55.
10. J. Six, "De namen der staalmeesters," *Oud Holland* XIV, 1896, pp. 65-67; I.H. van Eeghen, "De Staalmeesters," *Jaarboek Amstelodamum* XLIX, 1957, pp. 65-80, and idem, "De Staalmeesters," *Oud Holland* LXXIII, 1958, pp. 80-84.
11. "Aus dem Itinerarium des Christian Knorr von Rosenroth," *Jaarboek Amstelodamum* XIV, 1916, pp. 211-19.
12. Schwartz 1984, p. 336. The syndics of 1661-62 were installed in office by the same burgomasters who, in October 1661, had commissioned Rembrandt to paint *The Conspiracy of Claudius Civilis* for Amsterdam's new Town Hall; see ibid., pp. 318-20.

GL

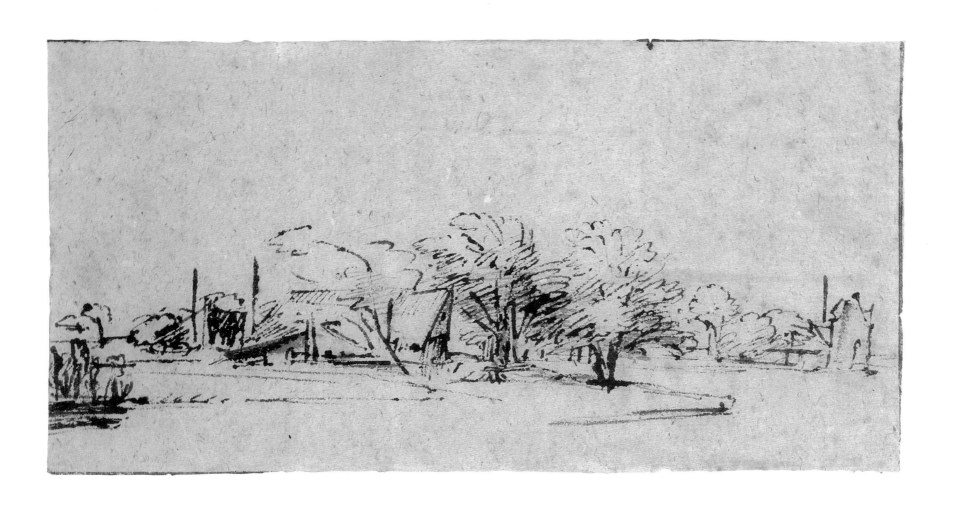

37

Rembrandt Harmensz van Rijn
Leiden 1606–1669 Amsterdam
FARMHOUSE BY A WATERWAY

Pen and brown ink on brown cartridge paper, framing
lines in pen and brown ink, laid down; 120 × 226 mm.
No watermark
Inv. R 114

Provenance: J.P. Heseltine, London (L. 1507);
J.W. Böhler, Lucerne; F. Koenigs, Haarlem (L. 1023a),
acquired in 1929; D.G. van Beuningen, Rotterdam,
acquired in 1940 and donated to the Boymans Museum
Foundation.

Exhibitions: Berlin 1930, p. 63; Rotterdam 1934, no. 88;
Rotterdam 1938, no. 322; Dijon 1950, no. 86;
Rotterdam, Amsterdam 1956, no. 199; Vienna 1956,
no. 104; Brussels, Hamburg 1961, no. 66; Prague 1966,
no. 93; Tokyo, Kyoto 1968-69, no. 109.

Literature: Michel 1893, p. 583; Lippmann and Hofstede
de Groot 1888-1911, vol. II, no. 30B; Hofstede de
Groot 1906, no. 1046; *Original Drawings by Rembrandt
in the Collection of J.P. Heseltine*, London 1907, no. 74;
O. Benesch, "Rembrandt-Relicta aus der Münchener
Graphischen Sammlung," *Mitteilungen der Gesellschaft für
vervielfältigende Kunst: Die Graphischen Künste* XLVIII,
1925, p. 32; G. Wimmer, *Rembrandts
Landschafts-zeichnungen*, diss. Frankfurt 1935, pp. 60, 68;
Benesch 1935, p. 57; *Verslag Stichting Museum Boymans
1939-41*, p. 7; J.G. van Gelder, "Landschapstekeningen
van Rembrandt," *Beeldende Kunst* XXVIII, 1942, p. 7;
Benesch 1947, p. 43, under nos. 221-22; Benesch
1954-57, vol. VI, no. 1324; C. Müller Hofstede,
"Rembrandt as a Draughtsman," *The Connoisseur*
CXXXVIII, 1956, p. 38; Slive 1965, vol. I, no. 250;
Hoetink 1969, p. 31, no. 47; Benesch 1970, p. 90;
Benesch 1973, vol. VI, no. 1324; Giltaij 1988, no. 27.

Rembrandt occasionally used coarse brown paper for his
drawings of landscapes and other subjects. The rough
surface of the paper of this drawing absorbed the ink
more freely, which added an atmospheric touch,
particularly when done with a broad pen. This kind of
paper is also ideal for rapid work, with detail kept to a
minimum.

The farmhouse with its leaning gable and the
surrounding trees have been given a brisk, summary
treatment. The stretch of water in the foreground
curves around at the right of the sheet, where a second
farmhouse can be seen. Rembrandt was some distance
from the central building, probably on the far bank of
the waterway. However, it was evidently possible to get
nearer, for a drawing in the Frick Collection in New
York shows a closer view of the farmhouse from the
same angle (fig. a).[1] Some of the details are more
distinct in the New York sheet. For example, the two
circles on the left prove to be the wheels of a cart, and
the triangular shape is the top of a hayrick set between
four upright posts. The water in the foreground is now
no wider than a drainage ditch, and looks too narrow to
be called a river, so the suggestion that it is the Amstel
is probably incorrect.[2] The location appears very similar
to that in the drawing of *Farmhouses on St Anthony's
Dike* in the British Museum (fig. b).[3] Rembrandt would
not have had far to walk from his house in Sint
Anthoniebreestraat, through St Anthony's Gate, to the
dike, which was part of the old sea defenses and had an
inner dike running beside it.[4] The farm in the
Rotterdam drawing, which is also surrounded by
ditches, may have lain further along the dike.

Doubts are sometimes raised as to whether
Rembrandt really drew all his landscapes out in the
open, and whether some were not in fact done in his
studio. In several cases this is a fair question, although
it does seem that the Rotterdam and New York sheets
were executed outdoors. It is likely that Rembrandt was
indeed standing further away when he made the
Rotterdam drawing, and it was only when he
approached that he realized that the righthand tree near
the building actually stood further back, which is where
he placed it in the New York sheet. That "close-up" is
drawn on white paper, which gives it a far brighter
effect. Although it is just as sketchy, the wash and
greater attention to detail make it less impressionistic.

Leaving aside the central motif, the Rotterdam
drawing is remarkable for its emptiness – a feature
which it shares with some of Rembrandt's late landscape
etchings, such as the *Clump of Trees with a Vista* of 1652
(fig. c).[5] That sublime drypoint has the same distribution
of light and shade, as well as an empty foreground and
sky. Both works also have a similar, rhythmic interplay
of line. The trees have comparable feathery outlines
with the occasional bold accent. The Rotterdam
drawing is dated *c.* 1653, along with several other
landscapes to which it is stylistically related.[6]

1. Benesch 1954-57, vol. VI, no. 1325.
2. See Giltaij 1988, no. 27.
3. Benesch 1954-57, vol. IV, no. 832 (*c.* 1648). A second
drawing of this subject, seen from a closer vantage point, is in
Providence, Rhode Island, Benesch 1954-57, vol. IV, no. 831;
see F.W. Robinson in D.J. Johnson (ed.), exhib. cat. *Old Master
Drawings from the Museum of Art, Rhode Island School of Design*,
Providence, Rhode Island, 1983, no. 61.
4. See F. Lugt, *Mit Rembrandt in Amsterdam*, Berlin 1920,
pp. 139-42, and exhib. cat. Amsterdam 1969, no. 78.
5. Hollstein, *Dutch and Flemish*, vols. XVIII-XIX, pp. 106-07, B.
222. The farmhouse in the etching also appears in drawings in
Cambridge, Fitzwilliam Museum (Benesch 1954-57, vol. VI,
no. 1274), and Rotterdam, Boymans-van Beuningen Museum
(Benesch 1954-57, vol. VI, no. 1272, and Giltaij 1988, no. 25).
6. Benesch 1954-57, vol. VI, nos. 1315-31.

GL

fig. a

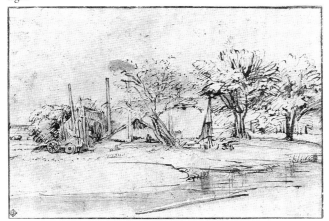

fig. b

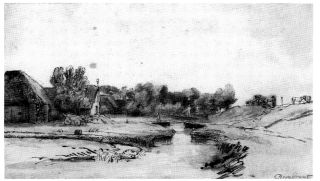

fig. c

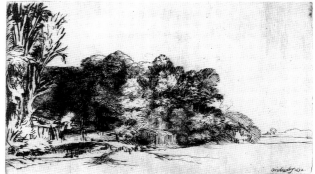

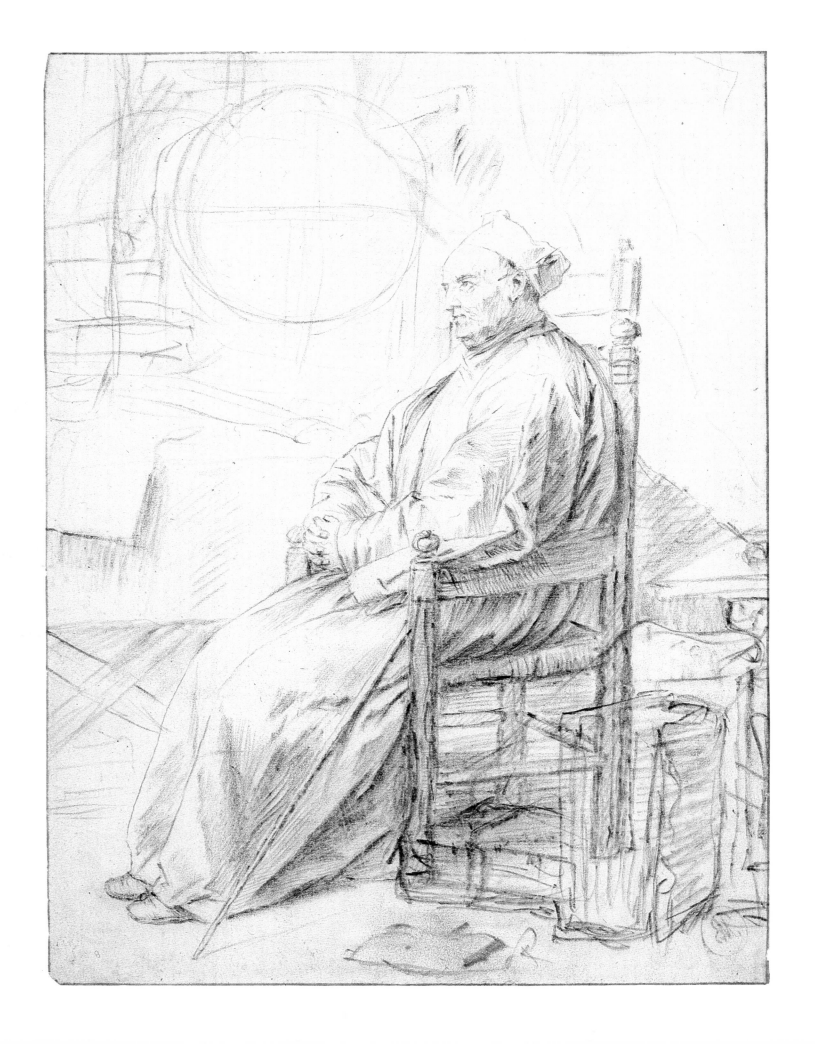

38

Jan Lievens
Leiden 1607–1674 Amsterdam
PORTRAIT OF A SCHOLAR

Black chalk, with some corrections in white, framing
lines in pen and brown ink, the outlines of the figure
and the chair partly incised; 255 × 192 mm.
No watermark
Inv. MB 197

Provenance: F.J.O. Boijmans, bequest of 1847 (L. 1857).

Exhibitions: Oberlin 1962, p. 146; Chicago, Minneapolis,
Detroit 1969-70, no. 193; Braunschweig 1979, no. 57.

Literature: cat. 1852, no. 750; cat. 1869, no. 629;
Kleinmann 1894-99, vol. VI, no. 47; Von Wurzbach
1906-11, vol. II, pp. 47, 49; A.M. Hind, "The Woodcut
Portraits of Jan Lievens and Dirk de Bray," *The Imprint*
I, 1913, p. 237; H. Schneider, *Jan Lievens, sein Leben und
seine Werke*, Haarlem 1932, pp. 85, 192, Z 42;
C.E. Köhne, *Studien zur Graphik von Ferdinand Bol und
Jan Lievens*, diss. Bonn 1932, p. 61; Hollstein, *Dutch and
Flemish*, vol. XI, p. 73, under no. 102; E. Trautscholdt,
"Walter Bernt, die niederländischen Zeichner des 17.
Jahrhunderts," *Kunstchronik* XIV, 1961, p. 330; Hoetink
1969, p. 57, no. 121; H. Schneider, *Jan Lievens, sein
Leben und seine Werke* (with supplement by
R.E.O. Ekkart), Amsterdam 1973, pp. 85, 192, 360,
Z 42; C.S. Ackley, exhib. cat. *Printmaking in the Age of
Rembrandt*, Boston, Museum of Fine Arts, St Louis, St
Louis Art Museum, 1980-81, under no. 90; Sumowski
1979-85, vol. VII, no. 1596; Giltaij 1988, no. 102;
E. Ornstein-van Slooten in exhib. cat. *Jan Lievens:
prenten & tekeningen*, Amsterdam, Museum het
Rembrandthuis, 1988-89, under no. 39.

fig. a

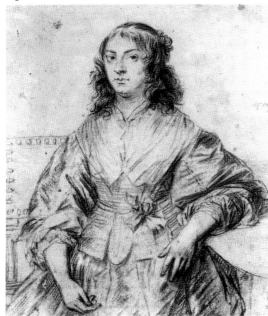

In 1619, after an apprenticeship with the painter Joris
van Schooten (1587–1652/53), Jan Lievens left Leiden
for Amsterdam to continue his training under Pieter
Lastman (1583–1633), who also taught Rembrandt.
In 1621 Lievens returned to his birthplace, where he
shared a studio with Rembrandt from 1625 to 1631.
At first it was Lievens who was the dominant influence,
but gradually the roles were reversed.[1] In 1632, after
Rembrandt had settled in Amsterdam, Lievens moved to
England. From 1635 to 1644 he was active in Antwerp,
and from then until his death in 1674 he worked chiefly
in Amsterdam. His last years were clouded by financial
hardship.[2]

As a draftsman, Lievens is known mainly for his
landscapes and woodland scenes, but he also drew a
series of striking portraits.[3] These were strongly
influenced by Anthony Van Dyck, whom Lievens met
in England and with whom he later struck up a
friendship in Antwerp. Many of Lievens's portraits have
a Van Dyckian elegance, although some are less
flattering to the model. They all vary widely in pose
and characterization, and many are finished works
executed in chalk and signed with the monogram *IL*.

This portrait of a scholar is exceptional in Lievens's
œuvre, not only in being a full-length (most of the
others are heads or half-lengths) but also because of the
numerous attributes. Behind the seated figure is a large
globe, and several large tomes are within arm's reach on
the floor. The man is evidently at work, for he has a
quill pen stuck behind his ear. It is a decidedly
sketch-like drawing: the globe was gone over twice,
the chair originally had a higher back, and some of the
objects are merely outlined. All in all, it resembles
nothing so much as a design for a painting. The style is
freer than is generally the case with Lievens, and in this
respect the sheet is a close relative of the *Portrait of a
Woman* in Düsseldorf, which is also brightly lit (fig. a).[4]
The type of armchair portrait was derived from Van
Dyck, and recalls his *Portrait of Cardinal Bentivoglio* in
the Palazzo Pitti in Florence (fig. b).[5]

Parts of the *Portrait of a Scholar* have been indented
with a stylus for a woodcut that bears Lievens's
monogram (fig. c).[6] The dozen known woodcuts by
Lievens are superb seventeenth-century examples of the
technique. They were probably inspired by Christoffel
Jegher's woodcuts after Rubens, which Lievens may
have seen in Antwerp. It is not known whether Lievens
cut the blocks himself, although it is not entirely out of
the question. An impression of another woodcut in the
British Museum in London bears the inscription *Joannes
Lievens pinxit/Francisc. du Sart sculp*, so the cutter may
have been François Dusart, who is otherwise known
only as a sculptor.[7] Whoever it was, he was certainly a
very accomplished master of the technique, as can be
seen from the subtle and highly evocative rendering of
the gleaming, velvety texture of the short cloak worn
over the sitter's long robes, which is the main
innovation relative to the drawing.

1. The relationship between Rembrandt and Lievens during
their Leiden period is discussed by P. Schatborn in exhib. cat.
Amsterdam 1988-89.
2. For Lievens's biography see Schneider (1973), and exhib.
cat. Braunschweig 1979, pp. 36-38.
3. See Sumowski 1979-85, vol. VII, pp. 3544-3933.
4. Exhib. cat. Braunschweig 1979, no. 59; Sumowski 1979-85,
vol. VII, no. 1654x. That drawing is one of only two female
portraits which are generally accepted as being by Lievens.
The other is in the Städelsches Kunstinstitut in Frankfurt,
Sumowski 1979-85, vol. VII, no. 1606.
5. Larsen 1988, vol. I, pp. 211-12, vol. II, no. 332.
6. Hollstein, *Dutch and Flemish*, vol. XI, p. 73, no. 102; Ackley
(1980-81), no. 90.
7. Hind (1913), pp. 233-34.

GL

fig. b

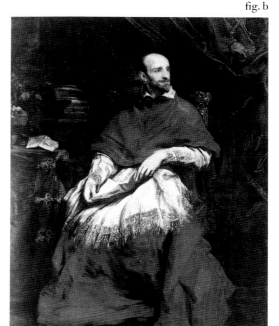

fig. c

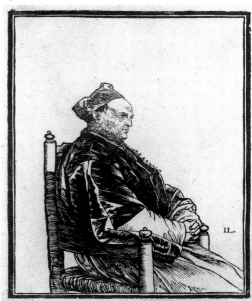

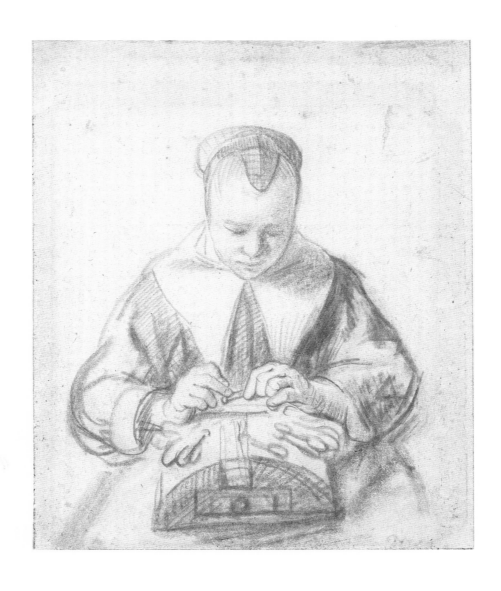

39

Nicolaes Maes
Dordrecht 1634–1693 Amsterdam
A LACEMAKER

Red chalk, framing lines in pencil; 141 × 118 mm.
At lower right by a later hand, the signature *Maes*
Verso: *11 xyz* and *21* in pencil
Watermark: fool's cap
Inv. MB 199

Provenance: F.J.O. Boijmans, bequest of 1847 (L. 1857).

Exhibitions: London 1929, no. 670; Dordrecht 1934,
no. 8; Brussels 1937-38, no. 111; Dijon 1950, no. 69;
Washington 1958-59, no. 82.

Literature: cat. 1852, no. 560; cat. 1869, no. 439;
Kleinmann 1894-99, vol. VI, no. 14; Von Wurzbach
1906-11, p. 90; W.R. Valentiner, *Nicolaes Maes*,
Stuttgart, Berlin, Leipzig 1924, p. 46; vol. II, J.C. van
Dyke, *The Rembrandt Drawings and Etchings*, New York
etc. 1927, p. 112; *Commemorative catalogue London* 1930,
p. 224; L. Gowing, *Vermeer*, London 1952, p. 144;
exhib. cat. *Rembrandt als leermeester*, Leiden, Stedelijk
Museum De Lakenhal, 1956, p. 43, under no. 70;
R.H. Hubbard, *The National Gallery of Canada. Catalogue
of Paintings and Sculpture I*, Ottawa, Toronto 1957,
p. 86; Hoetink 1969, p. 58, no. 126; G. Sciolla, "Disegni
rembrandtiana a Torino," *Critica d'Arte* XIX, no. 126,
1972, p. 76, note 14; F. Stampfle in exhib. cat. Paris etc.
1979-80, under no. 121; P. Schatborn in exhib. cat.
Amsterdam, Washington 1981-82, p. 84, and p. 140
under no. 69; W. Sumowski, *Gemälde der
Rembrandt-Schüler*, vol. III, Landau 1983, under
no. 1342; Sumowski 1979-85, vol. VIII, no. 1776; Giltaij
1988, no. 114.

fig. a

Houbraken says that when Nicolaes Maes entered
Rembrandt's studio in 1648 as a fourteen-year-old
apprentice he had already learned the basic principles of
drawing from "a common master" in his native
Dordrecht.[1] Perhaps it was there that he was taught to
draw schematic figures and heads similar to those found
in model books. There is certainly a fairly unusual study
sheet by Maes of heads composed with the aid of
construction lines,[2] and there is nothing to indicate that
Rembrandt ever taught his pupils this method.

Maes remained with Rembrandt until 1653, when he
returned to Dordrecht and set up as an independent
master. He painted religious and mythological subjects
and genre pieces, all in a very personal style, with the
palette as the main testimony to his period with
Rembrandt. In the 1660s he traveled to Antwerp,
where, according to Houbraken, he visited Jordaens's
studio. In 1673 he returned to Amsterdam and devoted
himself exclusively to portraiture in the fashionable,
French manner. As Houbraken explains, "the young
ladies, in particular, delighted more in the white than
the brown."[3]

Maes was in the habit of making preparatory
composition sketches, not only for his histories but also
for genre paintings. He experimented with various poses
for the girls who act as eavesdroppers in his interiors,
and occasionally made a more detailed drawing before
he started painting, as with his *Hurdy-Gurdy Player* in
the Dordrecht Museum.[4] For his figure studies he used
either brown ink or red chalk, and some of the latter
are worked up with the brush and brown ink, giving
them a painterly effect and a tonality which also informs
his early pictures.

Maes used this study of a lacemaker for a painting
which is now in the National Gallery in Ottawa (fig. a).[5]
The young woman, who is totally absorbed in her work,
is laid down with broad chalk lines which serve mainly
to define her pose. Details like the bobbin lace
implements and the pillow are only cursory, but even so
the drawing provided Maes with a firm basis for the
painting, which is dated *1655 Martius 9* on the calendar
on the wall at the right. He followed the sketch very
closely indeed, even down to the fall of light on the
woman's wide, pointed collar and the distribution of
light and shadow on her face. It has been suggested that
the model was Maes's wife, Adriana Brouwers, whom he
married in Dordrecht on January 31 1654.[6] That is
certainly not impossible, given the number of times this
woman, with her distinctive, slightly round head,
appears in his domestic genre pictures – almost invariably
in the role of the ideal wife as defined by Jacob Cats:
an industrious helpmeet and devoted mother. She also
features in other drawings by Maes. In a red chalk study
with a brown wash in the Lugt Collection she is seen
working at her embroidery,[7] and in a sheet in the
Rijksprentenkabinet in Amsterdam she holds her head in
exactly the same position, although here the lighting is
different.[8]

In Berlin there is a small composition sketch for the
Ottawa painting which Maes followed fairly faithfully

(fig. b).[9] It is difficult to say whether that sketch
preceded the figure study. In the latter the woman does
not appear to be sitting at a table, for Maes also gives
the outlines of her skirt, but the fact that he did not
draw her full length might mean that he already knew
that she would be hidden from the waist down. Both
drawings must date from shortly before the painting of
1655.

1. Houbraken 1718-21, vol. II, pp. 273-74.
2. P. Schatborn in exhib. cat. Amsterdam, Washington
1981-82, pp. 13-14, fig. 1. The study sheet is now in Toronto,
Gabor Kekkö Collection, see Sumowski 1979-85, vol. VIII,
no. 1783.
3. Houbraken 1718-21, vol. II, p. 273: "*inzonderheit de jonge
Juffrouwen meer behagen namen in het wit dan in 't bruin.*"
4. London, British Museum, inv. 1895-9-15-1342, see
Sumowski 1979-85, vol. VIII, no. 1768, with the painting
reproduced as fig. 103.
4. Valentiner (1924), p. 30, fig. 34; Sumowski (1983), no. 1342.
6. Valentiner (1924), pp. 42-43; Sumowski 1979-85, vol. VIII,
under no. 1817x.
7. Paris, Fondation Custodia, F. Lugt Collection, inv. 420;
Sumowski 1979-85, vol. VIII, no. 1807x.
8. From the F. Mannheimer Collection, Amsterdam; now
Amsterdam, Rijksprentenkabinet, inv. 1953:220; Valentiner
(1924), p. 29, fig. 33; Sumowski 1979-85, vol. VIII, no. 1817x.
9. Berlin, Staatliche Museen, inv. 16523; Sumowski 1979-85,
vol. VIII, no. 1775.

GL

fig. b

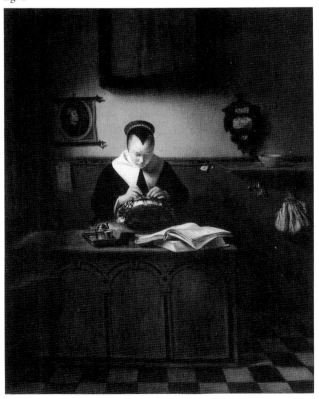

40

Philips Koninck
Amsterdam 1619–1688 Amsterdam
LANDSCAPE WITH A CORNFIELD

Pen and brown ink, watercolor in brown, yellow and red, heightened with white, framing lines in pen and brown ink; 135 × 191 mm.
Watermark (partly visible): shield with the Strasbourg fleur-de-lys and the letters *RR*
Inv. R 75

Provenance: Lord Brownlow; sale London (Sotheby's), June 29 1926, no. 18; acquired by F. Koenigs, Haarlem (L. 1023a); D.G. van Beuningen, Rotterdam, acquired in 1940 and donated to the Boymans Museum Foundation.

Exhibitions: Rotterdam 1934, no. 113; Dijon 1950, no. 65.

Literature: H. Gerson, *Philips Koninck*, Berlin 1936, p. 66, Z 42; Hoetink 1969, p. 54, no. 112; W. Schulz in exhib. cat. *Die holländische Landschaftszeichnung 1600-1740*, Berlin, Kupferstichkabinett Staatliche Museen, 1974, p. 50, under no. 108; Sumowski 1979-85, vol. VI, no. 1483x; Giltaij 1988, no. 95.

Philips Koninck was born into an artistic family. His father was the Amsterdam goldsmith Aert Koninck, and there is documentary evidence that he trained for some time with his elder brother, the painter Jacob Koninck, who lived in Rotterdam. It was there, in 1640, that Philips married Cornelia Furnerius, sister of the artist Abraham Furnerius. Two years later he returned to Amsterdam,[1] but it is not known whether he was really Rembrandt's pupil, as Houbraken maintains,[2] although the two were certainly friends in the 1650s.[3]

Philips Koninck's fame rests on his panoramic landscape paintings with their great swathes of clouds, which owe much to both Rembrandt and Hercules Segers.[4] He also had aspirations to be a figure painter, despite a notable lack of ability. His endless series of figure studies are excruciatingly bad, while his drawn biblical and genre scenes are grotesque and devoid of the slightest sense of *mise-en-scène*.[5] Yet as a landscape draftsman his talent was formidable.

This Dutch river scene, with its light coating of watercolor, is a dazzling display of his skill. It is astonishing to see how he conjures up the sense of an infinite distance with such an economy of means. Like Rembrandt, he adopted a slightly elevated viewpoint and a horizon well below the middle of the image plane. This recessive effect is accentuated by the pronounced horizontality of the foreground, combined with the winding skein of the river meandering off to the far horizon, drawing the viewer's eye with it as it goes.

The expanses of water are not suggested by the shade of paper, as in other drawings by Koninck, but by white bodycolor. This imparts a shimmer and smoothness to the surface of the water that conjures up memories of a river glimpsed on a quiet summer's day, with the result that the seemingly exaggerated reflection of the trees appears absolutely convincing. Here and there a white accent lends an extra sparkle to a boat's sail or a farmhouse wall. Koninck evidently had second thoughts about the atmospheric perspective, for with a broad stroke of the brush or a smear of the finger he toned down the distant view with more white bodycolor. This afterthought is exposed by the thickness of the paint, and by the fact that it is slightly discolored at the edges. Koninck interrupted the white at the nearest windmill, allowing it to stand out starkly against the skyline.

The composition is closed on the left by a farmhouse with a step gable, and on the right by a truncated clump of trees. The staffage also contributes to the suggestion of depth. The figures strolling on the far side of the cornfield are several times smaller than those in the foreground, one of whom is up to his neck in the corn. The crop is ready to be harvested, so the scene must be set in August, as it is in a very closely related sheet in the Teyler Museum in Haarlem, where reaping has already started (fig. a).[6] That drawing too is finished with watercolor, and since the practice of making lightly colored drawings was more common toward the end of the seventeenth century, both sheets, which are part of a larger group, are often placed late in Koninck's career.[7] However, the lack of dated works makes it difficult to reconstruct the chronology of Koninck's drawn *œuvre*. There is even something to be said for allocating these drawings, with their attractively naive look, to the late 1640s, when Koninck was under the influence of Furnerius.[8]

1. See Gerson (1936), pp. 82-98. For the drawings by Jacob Koninck, some of which are deceptively similar to those by Philips, see Sumowski 1979-85, vol. VI, pp. 2883-2943, nos. 1289-1316xx.
2. Houbraken 1718-21, vol. II, p. 53.
3. Gerson (1936), pp. 10, 88.
4. Ibid., pp. 15-43; P.J.J. van Thiel, "Philips Konincks Vergezicht met hutten aan de weg," *Bulletin van het Rijksmuseum* XV, 1967, pp. 109-15; P.C. Sutton in exhib. cat. *Masters of 17th-Century Dutch Landscape Painting*, Amsterdam, Rijksmuseum, Boston, Museum of Fine Arts, Philadelphia, Philadelphia Museum of Art, 1987-88, pp. 366-70.
5. Sumowski 1979-85, vol. VI, pp. 2945-3403.
6. Inv. P. 28; Gerson (1936), p. 66, Z 38; Sumowski 1979-85, vol. VI, no. 1480x.
7. Gerson (1936), p. 66; Giltaij 1988, no. 95 (*c.* 1670).
8. Schulz (1974), p. 50, under no. 108; Sumowski 1979-85, vol. VI, nos. 1479x-1486x.

GL

fig. a

St Jans kerck. Binnen vtrecht.

P. Saenredam
fsijt deijck

41

Pieter Jansz Saenredam
Assendelft 1597–1665 Amsterdam
INTERIOR OF ST JANSKERK IN UTRECHT

Black and white chalk, pen and brown ink, on blue
paper, heightened with white; 277 × 414 mm.
On the step, in pen and brown ink: *St Jans kerck.*
Binnen Utrecht.
Lower right corner: *Pr. Saenredam geteijckent*, and on
the memorial plaque above: *int Jaer 1636. den 6. october.*
No watermark
Inv. H 183

Provenance: Six Collection, Amsterdam; sale Amsterdam
(Frederik Muller), October 16-18 1928, no. 452;
acquired by F. Koenigs, Haarlem (L. 1023a); D.G. van
Beuningen, Rotterdam, acquired in 1940 and donated to
the Boymans Museum Foundation.

Exhibitions: Rotterdam 1934, no. 64, pl. XXIII;
Rotterdam, Amsterdam 1937-38, no. 76; Dijon 1950,
no. 97; Utrecht 1961, no. 142, fig. 143; Prague 1966,
no. 75; Paris 1970, no. 47; Utrecht 1988, no. 84.

Literature: C. Hofstede de Groot, *Teekeningen en
schilderijen in Utrechtse kerken door P. Saenredam*, Haarlem
1899, no. 11; P.T.A. Swillens, *Pieter Jansz. Saenredam*,
Amsterdam 1935, no. 129, fig. 163; G. Schwartz and
M.J. Bok, *Pieter Saenredam: de schilder in zijn tijd*,
Maarssen, The Hague 1989, pp. 162, 167, 202, 204, 278,
cat. no. 142 and fig. 185.

In 1609, after the death of the engraver Jan Saenredam
(1565–1607), his widow moved to Haarlem with her
young son, Pieter. In 1623, after a ten-year
apprenticeship with Frans Pietersz de Grebber, he
enrolled as a member of the Guild of St Luke, which
he later served in several official capacities.[1] In 1628 he
made a decision "finally to devote himself entirely to
painting perspectives of churches, halls, galleries,
buildings and other edifices from life, viewing them
from without and from within," as his biographer
Cornelis de Bie, writing in 1662, described it.[2]

He did indeed paint the churches and town hall of
Haarlem on the spot, but in order to do other works
"from life" he took to making short field trips to Den
Bosch (1632), his native Assendelft (1633, 1634 and
1654), Amsterdam (1641), Rhenen (1644) and Alkmaar
(1661).[3] His longest period away from Haarlem was in
Utrecht in 1636, where, in De Bie's words, "he spent a
period of twenty weeks, working diligently to complete
this art there."[4] He made drawings of seven Utrecht
churches, and later used no fewer than nineteen of
them as the basis for a painting, sometimes after an

interval of many years. For example, it was only
twenty-six years later that he completed his magnificent
Mariakerk and Mariaplaats, Utrecht (Rotterdam,
Boymans-van Beuningen Museum), the drawing for
which was executed "in the year 1636, on the 18th of
September," as Saenredam's inscription records
(Haarlem, Teyler Museum).[5]

The present drawing of the interior of the Janskerk
was executed over a fortnight later, and was used for
the painting of 1645 in the Centraal Museum in
Utrecht (fig. a). It is a view of the Chapel of St
Anthony, off the north aisle of the church, which had
been endowed by Dirk van Wassenaar (d. 1465), dean of
the chapter. Glimpsed through the two arches on the
right, which are supported by plain pillars, are part of
the north aisle and the nave. At the top is the end of
the barrel vault over the chapel, and on the left is the
north wall of the church, with the light entering
through the tall pointed windows. At the far end of the
chapel stands a simple altar, with a late Gothic funerary
tablet set into the wall on the left, and two hatchments
on the right. The bell high up on the right wall is
omitted in the painting, as is the chest up against the
north wall. Also missing is the memorial plaque for a
canon at top right, which is of the same type as a
surviving fifteenth-century fragment from the Mariakerk
in Utrecht (fig. b).[6] Saenredam inserted the date of the
drawing in the space at the bottom of the plaque which
was usually reserved for the name and dates of the
deceased.

In the painting Saenredam extended the field of view
to include more of the barrel vault. It is possible,
though, that the drawing has been trimmed at the top,
for Saenredam followed most of his other interior
drawings fairly faithfully in the finished painting. For
instance, the view in a second painting of St Janskerk in
the Boymans-van Beuningen Museum is identical to
that in the preparatory drawing (Hamburg, Kunsthalle).[7]
Both show the nave and lofty Gothic choir of the
church (1508–39) from west to east, with a glance into
St Anthony's Chapel on the left. Here too Saenredam
made the interior more austere by omitting the chest
against the north wall.

The Hamburg drawing, which is dated September 15
1636, was done with the pen, and has yellow, blue, pink
and light brown watercolor accents and gray washes.
The strong chiaroscuro was achieved by leaving the
paper white at various points, such as the chapel
window. In the Rotterdam sheet, Saenredam remedied
the lack of contrast between the blue paper and black
chalk by adding a number of white highlights. Some
of the pen lines were drawn with the aid of a ruler,
but the paved floor and the outlines of the tomb slabs
are composed of short, quite free strokes of the pen.
The all-important vanishing point is circled on the wall
to the left of the altar. The cool fall of light is very
studied. The effect gained by lightly rendering the
shadowed passages with chalk rather than hatching is
best appreciated when the drawing is viewed from a
distance.

1. Schwartz and Bok (1989), pp. 101-05 and 171-74.
2. C. de Bie, *Het Gulden Cabinet vande edel vry Schilder const...*,
Antwerp 1662, p. 246: "*ende begaf hem eyndelijck [...] geheel tot
schilderen van perspectiven kercken saelen galderijen ghebouwen en
andere dinghen soo van buyten als van binnen soo naer het leven
doende.*"
3. P.T.A. Swillens in exhib. cat. Utrecht 1961, p. 29, and
Schwartz and Bok (1989).
4. De Bie, op. cit. (note 2), p. 246: "*den tijdt van twintigh
weecken met grooten yver besteedt heeft om dese Const aldaer te
voltrecken.*"
5. See the survey in Schwartz and Bok (1989), pp. 273-83, cat.
nos. 115-75, and G. Jansen, *Pieter Saenredam: gezicht op de
Mariaplaats en de Mariakerk te Utrecht*, Rotterdam, Museum
Boymans-van Beuningen, 1987.
6. Utrecht, Centraal Museum, inv. no. HC 1928, no. 1387; see
exhib. cat. Utrecht 1988, pp. 77-78, no. 83, with further
references to the literature.
7. Exhib. cat. Utrecht 1961, nos. 138-39. A third drawing of
the interior of the same church, of which there is no known
painted version, is in Utrecht City Archives; see ibid., no. 140.

GL

fig. a

fig. b

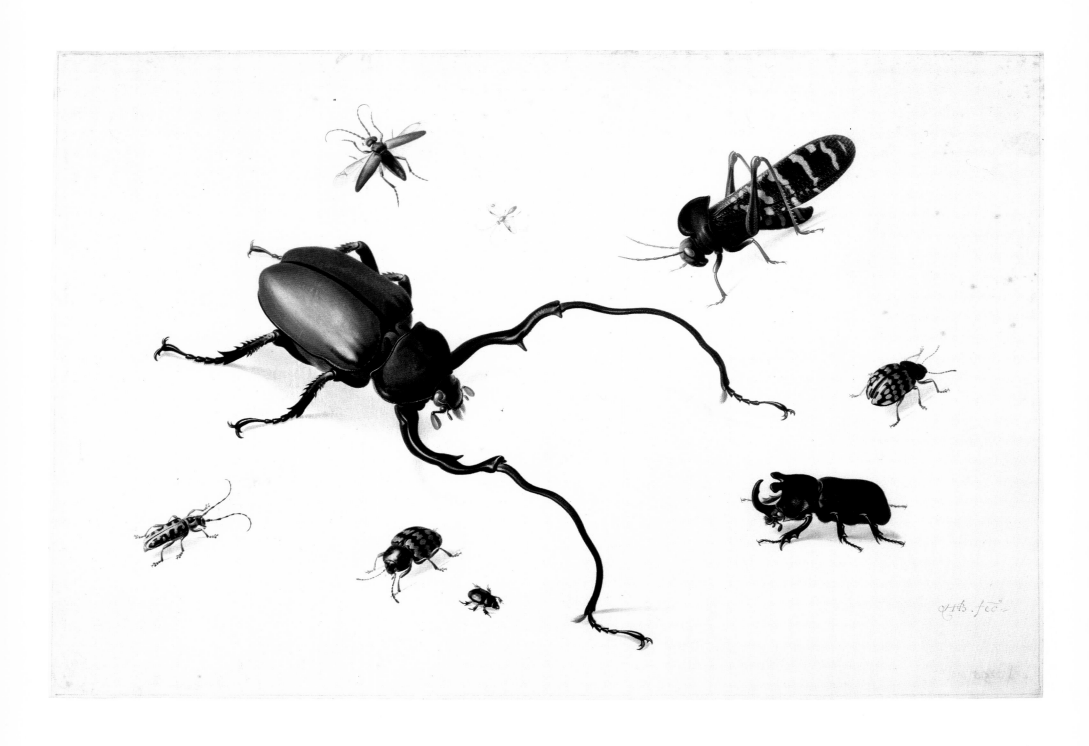

42

Herman Henstenburgh
Hoorn 1667–1726 Hoorn
NINE EXOTIC INSECTS

Watercolor and bodycolor on vellum; 231 × 342 mm.
Signed at lower right with monogram: *HHB. fec=*
Inv. MB 339

Provenance: G. Leembruggen Jz, Hillegom; sale
Amsterdam, March 5 1866, no. 302; acquired at the sale
by A.J. Lamme for the Boymans Museum, together with
a similar sheet (inv. H.H. 4).

Exhibitions: Dordrecht, Amsterdam 1959-60, no. 35,
fig. 4; Ingelheim am Rhein 1964, no. 40; Prague 1966,
no. 121.

Literature: L.J. Bol, *Bekoring van het kleine*, n.p.,
Stichting Openbaar Kunstbezit, 1963, no. 25.

Now long forgotten, Herman Henstenburgh of Hoorn
was a pastrycook by trade, like his teacher and fellow
townsman, Johannes Bronkhorst (1648–1727). According
to the biographer Johan van Gool, Henstenburgh
perfected his drawing technique by copying prints,
and later became familiar with the watercolors of Pieter
Hollstein.[1] He decided to specialize in watercolors of
plants and animals – a genre that had been popularized
by artists such as Maria Sybille Merian, Pieter Withoos
and Willem de Heer.[2]

Henstenburgh became highly skilled in the
illusionistic depiction of birds, lizards and insects,
conducting experiments with pigments that led to a
recipe which Van Gool says "could bear the test of
comparison with oil paint in many respects." Most of
his drawings are done in a combination of watercolor
and bodycolor on vellum, plain or prepared, and many
of them display a remarkably bold palette.

That applies to this collection of insects, which is a
perfect illustration of Van Gool's reference to "forceful,
radiant colors." The wing-case of the large *Enchirus
longimanus* is especially lifelike, but the other insects are
also amazingly realistic. The long-armed beetle, one of
the few members of the *Enchirinae* subfamily, comes
from the island of Amboina in Indonesia, and is an
example of Henstenburgh's eclecticism – happily
grouping exotic insects from different parts of the world
on a single sheet. Hoorn was a port used by the ships
of the Dutch East India Company, which may explain
why Henstenburgh was acquainted with so many
different and widely dispersed species. The other insects
in this drawing are a South American rhinoceros beetle
(*Coelosis biloba*), the *Saperda scalaris* at lower left and the
Aromia moschata at upper left (both longhorn beetles
found in the Netherlands), a hister beetle (*Histeridae
spec.*), and two fungus beetles of the large *Erotylidae*
family from South America. The grasshopper

(*Orthoptera spec.*) at upper right possibly came from
tropical regions, while the tiny ichneumon fly beside it
(*Ichneumonidae spec.*) may have been of Dutch origin.[3]
The subtle gray washes used for the shadows serve to
set the insects even more firmly on their feet.

This is probably not a late work of Henstenburgh's.
Van Gool says that around 1695 he began concentrating
more on flowers and fruit, and this is borne out by his
dated drawings. He specialized in only a few types of
still life: flower and plant pieces with *vanitas* overtones,
and straightforward compositions of fruit and flowers
arranged on and around a marble slab which is often
truncated, as in the work of Adriaan Coorte.[4]
Henstenburgh also produced a few large sheets of
sculpted busts surrounded by garlands of flowers and
foliage, which can almost be regarded as paintings.
In those works he exploited the contrast between the
snowy-white marble and the colorful blooms, adding
snails and insects to heighten the *trompe l'œil* effect.[5]
Some of the drawings have very garish colors, a
masterly example being the exuberant watercolor of
1701 with a bouquet of flowers hanging from a nail
(fig. a; Haarlem, Teyler Museum).[6]

Despite his virtuosity, Henstenburgh was unable to
make a living from art. As Van Gool relates: "There
he sat in his native town, with all his works of art about
him, as if in oblivion, for rarely did he receive a visit
from an art-lover." It was only after his death that his
drawings caught the eye of collectors, and many of
them disappeared to England. Henstenburgh's
reputation must have been firmly established by 1750,
for Van Gool relates that he once saw the Rotterdam
collectors Jan and Pieter Bisschop pay the princely sum
of 105 guilders for a watercolor at an Amsterdam
auction, "yet it contained but three peaches and a bunch
of grapes." His fame continued to grow, and he was
particularly well represented in early nineteenth-century
collections like the one formed by F.J.O. Boijmans, the
founder of the museum.[7] Nevertheless, A.J. Lamme,
director of the museum, was so taken by the qualities of
this sheet when it came up for auction in 1866 that he
wanted to add it to the group already in the collection.
He only had to pay 16,50 guilders for it and another
drawing (fig. b) at the Leenbruggen sale.

1. Van Gool 1750-51, vol. I, pp. 248-56.
2. Bol (1963).
3. I am grateful to Bernhard J. van Vondel, curator of the
Natural History Museum in Rotterdam, for identifying the
insects.
4. Drawings by Henstenburgh with *vanitas* symbols can be
found in Hoorn, Westfries Museum, and in the Pierpont
Morgan Library, New York, inv. 1982.95 (as Gerard van
Spaendonck). See further sale Stockholm (Bukowski), April 23
1975, no. 168, pl. 54, and sale London (Sotheby's), July 4 1977,
no. 181, fig. on p. 31 (as Gerard van Spaendonck).
5. For instance, Boymans-van Beuningen Museum, Rotterdam,
inv. H.H. 3, sale Amsterdam (Mak van Waay), September 26

1972, no. 338 (ill.), and the Broughton Collection, Cambridge,
Fitzwilliam Museum, see D. Scrase, exhib. cat. *Flowers of Three
Centuries: One Hundred Drawings & Watercolors from the
Broughton Collection*, Washington etc. 1983-84, no. 43 (color
frontispiece).
6. Exhib. cat. *Boeket in Willet: Nederlandse bloemstillevens in de
achttiende en de eerste helft van de negentiende eeuw*, Amsterdam,
Museum Willet Holthuysen, 1970, no. 47.
7. F.J.O. Boijmans had four colored drawings by
Henstenburgh. The reason why the museum bought so much
in the late 1860s, and at such high prices, was to make good
the losses in the calamitous fire of 1864, using the money paid
out by the insurers.

GL

fig. a

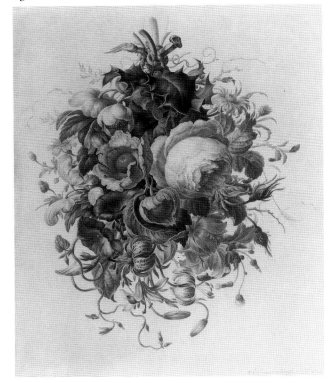

fig. b

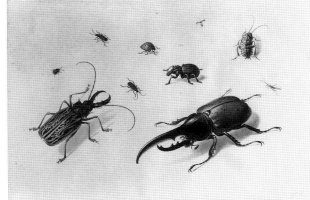

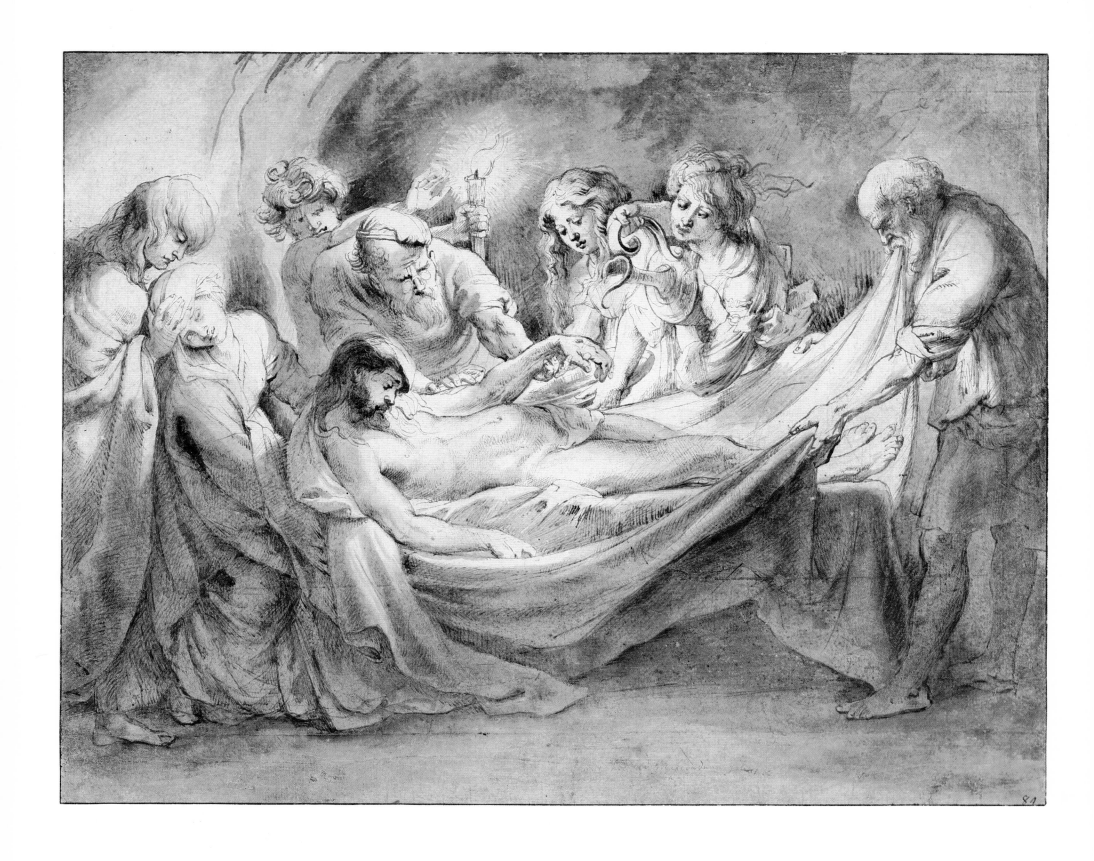

Flemish School: Seventeenth Century

43

Peter Paul Rubens
Siegen 1577–1640 Antwerp
THE ENTOMBMENT

Pen and brush and brown and gray ink over a sketch in black chalk, brown and gray wash, corrected with white bodycolor, laid down; 324 × 409 mm.
In the lower right corner, in pen and brown ink: *84*
Slightly to the left, in pen and brown ink, the remains of a Latin inscription: *...focus hic ad miscendum et mirram et aloen...*
Watermark: not visible
Inv. MB 340

Provenance: F.J.O. Boijmans, bequest of 1847 (L. 1857).

Exhibitions: Antwerp 1956, no. 31; Paris 1974, no. 92; Leningrad, Moscow, Kiev 1974, no. 92; Antwerp 1977, no. 133; Cologne 1977, no. 22.

Literature: cat. 1852, no. 261; cat. 1869, no. 128 (as School of Anthony van Dyck); I.Q. van Regteren Altena, "Rubens as a Draughtsman. I. Relation to Italian Art," *Burlington Magazine* LXXVI, 1940, p. 199; Held 1959, no. 4; Burchard and d'Hulst 1963, no. 36; J. Müller Hofstede, "Some Early Drawings by Rubens," *Master Drawings* II, 1964, p. 6; M. Jaffé, "Rubens as a Collector of Drawings, Part Three," *Master Drawings* IV, 1966, p. 129; Müller Hofstede 1966, p. 442; J. Müller Hofstede, "Rubens in Rom, 1601-1602," *Jahrbuch der Berliner Museen* XII, 1970, p. 63; Kuznetsov 1974, no. 21; Bernhard 1977, p. 215; M. Jaffé, *Rubens and Italy*, Oxford 1977, pp. 29, 31, 62; Held 1980, under nos. 360-61, 365; Held 1986, no. 12.

This sheet, which was associated with Anthony van Dyck in the nineteenth-century catalogues of the Boymans-van Beuningen Museum, is undoubtedly from the hand of the young Rubens. It is closely related to the drawings which he made at the beginning of his period in Italy, for which he set out on May 9 1600 at the age of twenty-three.[1] It compares well with the *Descent from the Cross* in the Hermitage in Leningrad (fig. a),[2] which is also built up with delicate, scattered hatching with considerable variation in the direction of the lines. There is also some cross hatching, and the initial design reflects Rubens's thorough grounding in the methods used in the graphic arts to invest forms with volume. The brushwork imparts a strong chiaroscuro to both drawings, intensifying the dramatic impact. In the Rotterdam sheet Rubens was particularly concerned with the effects of the light from the torch, which he rendered by leaving parts of the paper white and by working in gradations from white to almost unthinned dark brown.

There are also similarities between the figures in the two drawings. The Italian-looking woman with the luxuriant, flowing hair appears in both, and the man halfway up the ladder in the Leningrad sheet is the twin of the bespectacled disciple in the *Entombment*, who is lifting up the dead Christ's hand so that it can be oiled.[3] Rubens was evidently fascinated by the motif of the man gripping one end of the shroud between his teeth. He features not only in these two drawings, but also in the later painting of the *Descent from the Cross* in Antwerp Cathedral, which is based on the Leningrad sheet.[4] This motif originated in Italy, one of the first artists to use it being Lorenzo Lotto in his *Entombment* of 1512, now in the Pinacoteca Civica in Jesi.[5] Rubens may have known it from an engraving (fig. b) by Giovanni Battista Franco (*c.* 1498-1561), which he

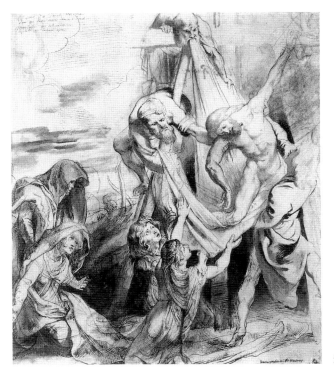

fig. a

fig. b

loosely followed in the Rotterdam drawing.[6] It should be noted, though, that the motif had already reached Flanders in the sixteenth century, possibly by way of Franco's print, where it was used in 1573 in an engraving to a design by Gerard van Groeningen (fig. c).[7]

The appearance of Christ in the Rotterdam *Entombment* is similar to that in one of the three altarpieces that Rubens painted for Archduke Albert in Rome in 1602.[8] That *Mocking of Christ* is a nocturnal scene, and is lit very much like the Rotterdam drawing, possibly in imitation of Venetian artists such as Tintoretto, or of Caravaggio. Rubens certainly knew the latter's *Calling of Matthew*, which was installed along with the other St Matthew paintings in San Luigi dei Francesi in December 1600, and it may have given him the idea of providing spectacles for the old man, who is probably Joseph of Arimathaea.[9]

Another reason for dating this drawing in Rubens's Roman period, and specifically to 1601-02, is that in the summer of 1601 he traveled from Mantua, where he was working at the Gonzaga court, to Rome. His route may have taken him through Perugia, where Raphael's famous *Entombment* (1507; Rome, Galleria Borghese) was hanging in the Capella Baglioni in the Church of San Francesco. That painting is the probable source for the figures of the swooning Virgin and the bystander supporting her with a hand to her forehead (fig. d).[10]

There is no known painting based on the Rotterdam drawing, although the body of Christ does appear in a roughly similar pose in an oil sketch of *c*. 1610 in Berlin.[11] This makes it difficult to determine the function of the drawing, although it is tempting to think that, like the *Descent from the Cross* (fig. a) and stylistically related sheets in Chatsworth and Malibu, it was intended to interest a patron in a painted version.[12]

1. Jaffé (1977), p. 7, and *passim*.
2. Held 1986, no. 15.
3. This action of lifting up the hand of the deceased to apply the oil is identical to that in a drawing of the *Death of Creusa* in the Musée Bonnat in Bayonne; see Held 1986, no. 59, fig. 46.
4. Oldenbourg 1921, p. 52. Rubens also used this motif in an oil sketch in the Courtauld Institute in London (Held 1980, no. 365), and in a drawing in Rennes (Burchard and d'Hulst 1963, no. 71).
5. B. Berenson, *Lorenzo Lotto*, Milan 1955, p. 45 (ill.).
6. Bartsch vol. XVI, no. 22.
7. From the suite after Gerard van Groeningen, *Christi Iesu vitae*, Antwerp 1573, no. 49; see Held 1986, p. 79, and H. Mielke, *Hans Vredeman de Vries: Verzeichnis der Stichwerke und Beschreibung seiner Stils sowie Beiträge zum Werk Gerard Groenings*, diss. Berlin 1967, p. 179. The print series is in Antwerp, Plantijn Moretus Museum, inv. A 1836.
8. They are now in Grasse, Hôpital de Petit-Paris; see Oldenbourg 1921, p. 2, Jaffé (1977), p. 10, fig. 182, and H. Vlieghe, *De schilder Rubens*, Utrecht, Antwerp 1977, pp. 62-65, fig. 26.
9. See W. Friedländer, *Caravaggio Studies*, Princeton 1955, p. 177. J. Held identified a borrowing from Caravaggio's *Calling of Matthew* in a sheet of *Studies for a Last Supper*, then at Chatsworth and now in Malibu, J. Paul Getty Museum; see J. S. Held, "Rubens' Pen Drawings," *Magazine of Art* XLIV, 1951, p. 288, and Goldner 1988, no. 90.
10. Müller Hofstede in exhib. cat. Cologne 1977, no. 133.
11. Staatliche Museen, inv. 798 K, Held 1980, no. 361, pl. 356.
12. Jaffé (1977), p. 62. See Held 1986, no. 18, for the sheet at Chatsworth, Duke of Devonshire Collection.

GL

fig. c

fig. d

44

Peter Paul Rubens
Siegen 1577–1640 Antwerp
KNEELING MAN SEEN FROM THE BACK

Black chalk, heightened with white, made up on the left
with an insertion near the arm; 520 × 390 mm.
Verso, in pen and brown ink: *18*
Watermark: posthorn
Inv. V 52

Provenance: P.H. Lankrink, London (L. 2090);
Bellingham Smith; sale Amsterdam (Frederik Muller),
July 5 1927, no. 111; F. Koenigs, Haarlem (L. 1023a);
D.G. van Beuningen, Rotterdam, acquired in 1940 and
donated to the Boymans Museum Foundation.

Exhibitions: London 1927, no. 580; Antwerp 1927,
no. 14; Amsterdam 1933, no. 70; Rotterdam 1938,
no. 339; Brussels 1938-39, no. 30; Rotterdam 1939,
no. 29; Rotterdam 1948-49, no. 114; Brussels, Paris
1949, no. 84, no. 87; London 1950, no. 53; Rotterdam
1952, no. 64; Paris 1952, no. 30; Helsinki 1952-53,
no. 43; Brussels 1953, no. 43; London 1953-54, no. 527;
Antwerp 1956, no. 60; Prague 1966, no. 41; Paris 1974,
no. 93; Leningrad, Moscow, Kiev 1974, no. 93; Antwerp
1977, no. 147.

Literature: C. Dodgson in *Catalogue of the Loan
Exhibition of Flemish and Belgian Art, a Memorial Volume*,
London 1927, no. 580; L. Burchard, "Peter Paul
Rubens, Study of Nude Male Figure," *Old Master
Drawings* II, 1927, pp. 39-40; Glück and Haberditzl
1928, no. 60; F. Lugt, *Musée du Louvre. Inventaire général
des dessins des écoles du nord, école flamande*, vol. II, Paris
1949, under no. 1030; Delen 1949, pp. 100-01;
C. Norris, "Rubens in Retrospect," *Burlington Magazine*
XCIII, 1951, p. 7; E. Haverkamp Begemann in exhib.
cat. *Olieverfschetsen van Rubens*, Rotterdam, Boymans
Museum, 1953, under no. 4; Haverkamp Begemann
1957, no. 29; Held 1959, no. 75; Burchard and d'Hulst
1963, no. 92; J. Müller Hofstede, "Beiträge zum
Zeichnerischen Werk von Rubens," *Wallraf-Richartz
Jahrbuch* XXVII, 1965, pp. 298-300; Müller Hofstede
1966, p. 450; Haverkamp Begemann 1967, p. 43;
Kuznetsov 1974, no. 69; Bernhard 1977, p. 201; Roberts
1977, no. 70; exhib. cat. *Rubens, ses maîtres, ses élèves.
Dessins du musée du Louvre*, Paris, Musée du Louvre,
1978, under no. 16; J. Rupert Martin and G. Feigenbaum
in exhib. cat. Princeton 1979, under no. 13; Held 1980,
under no. 325; Held 1986, no. 54; R.-A. d'Hulst and
M. Vanderven, *Rubens: the Old Testament* (Corpus
Rubenianum Ludwig Burchard III), London, New York
1989, p. 74, under no. 17.

Barely had he returned to Antwerp after his years in
Italy (1600–08) than Rubens received a commission
from the Antwerp city government in 1609 to paint an
Adoration of the Magi as an overmantel for the States'
Chamber of the town hall (fig. a) – the room chosen for
the negotiations for the Twelve Years' Truce between
Spain and the young Dutch Republic. This superb
canvas only hung there until 1612, when the city
authorities presented it to the Spanish envoy, Rodrigo
de Calderon, Count of Oliva. On his death in 1623 it
passed to King Philip IV and, as if it was not already
large enough, Rubens was asked to enlarge it. This he
did on his visit to Madrid in 1628–29, giving it the
imposing dimensions of 346 × 488 cm.[1] Its original
appearance is known from a painted copy and from
Rubens's own pulsating preparatory oil sketch (fig b;
Groningen, Groninger Museum).[2]

The Rotterdam study of a kneeling man is for one of
the magi's bearers, so it is not surprising that Rubens
placed so much emphasis on the musculature. The
broad lines are drawn with great assurance, although
here and there one can see him searching for the right
contour. The white highlights are essential for
reinforcing the volume of the figure, but the white
chalk was also used occasionally to tone down a
misplaced line. Discovering that the right foot would
not fit onto the sheet, Rubens started again a little to
the left, paying particular attention to the creases in the
sole.

The foot of the bearer in the Madrid painting is
identical, and Rubens also carefully repeated the figure's
pose, which deviates only slightly from that of the
model in the sketch. It has accordingly been suggested
that the drawing is later than the oil sketch, and
credence is lent to this by the fact that the musculature
of the figure in the painting follows that in the drawing.
After the painting had been enlarged in 1628–29, the
different stages in which the gifts carried by the bearers
are lowered to the ground follows a diagonal starting at
upper right with the head of the camel. The figure
from the Rotterdam drawing goes down on his knees,
completing the progression.[3]

fig. a

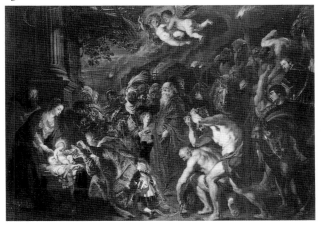

fig. b

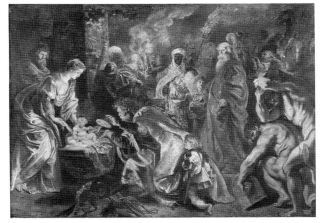

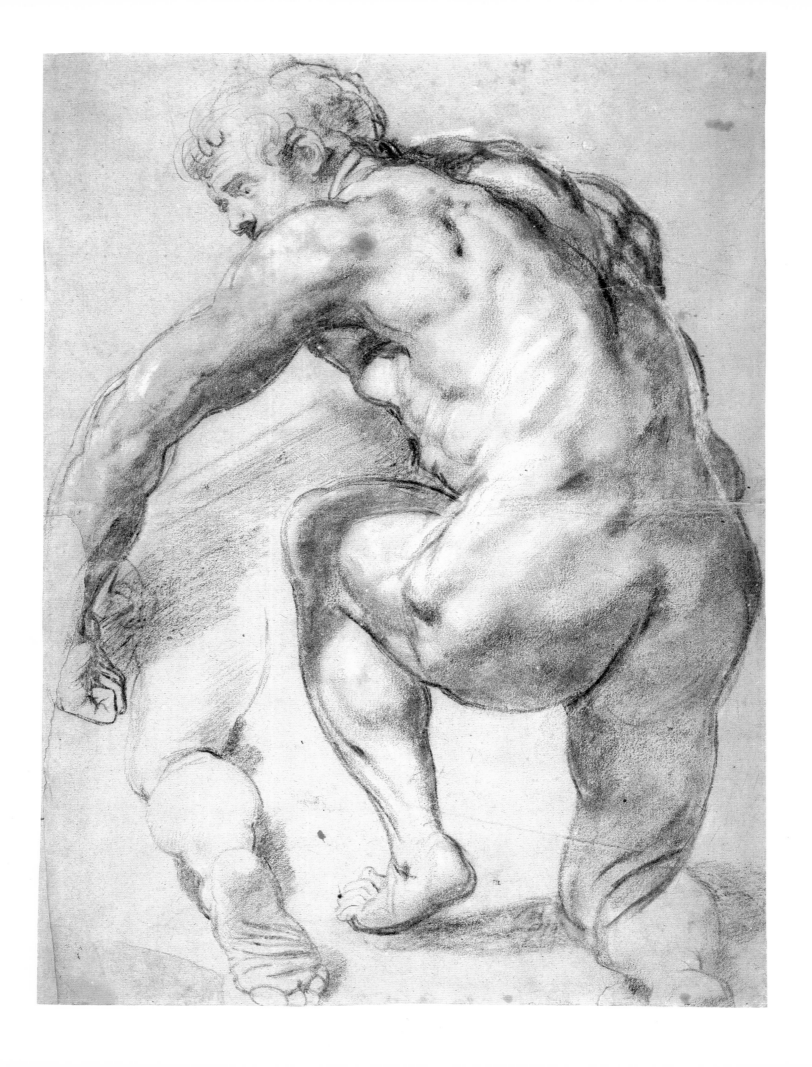

In the Louvre there is a second drawing from the same model (fig. c) which Rubens may also have made with the *Adoration of the Magi* in mind.[4] There the man is crouched even closer to the ground. Although the Rotterdam sheet is always proposed as the source for the bearer in another of Rubens's paintings, *The Meeting of Abraham and Melchizedek* of *c.* 1615 (fig. d; Caen, Musée des Beaux-Arts),[5] that giant's pose appears closer to that of the man in the Louvre study. This is also suggested by the empty space between the legs and the ground, which is darker in the drawing. Stylistically, though, both sheets are so intimately related that it is impossible to make out whether there might be a period of six years between them. In fact, they are very akin to Rubens's drawings of around 1610.[6] As was his practice, Rubens could very well have used an earlier drawing from his study portfolio for the Caen picture, just as he repeated the standing bearer with a basket of bread from the Madrid canvas. Rubens's resourcefulness in varying and reusing poses is shown by the reappearance of the Rotterdam figure in the guise of a goat-legged satyr in the foreground of the *Allegory of Nature* in Glasgow (fig. e), which is dated 1613–14.[7]

1. C. Norris, "Rubens' Adoration of the Kings of 1609," *Nederlands Kunsthistorisch Jaarboek* XIV, 1963, pp. 129-36; Dìaz Padròn 1975, vol. I, pp. 226-29, no. 1638.
2. Held 1980, no. 325; J. Giltaij in exhib. cat. *Schilderkunst uit de eerste hand: olieverfschetsen van Tintoretto tot Goya*, Rotterdam, Boymans-van Beuningen Museum, Braunschweig, Herzog Anton Ulrich-Museum, 1983-84, no. 3.
3. This way of illustrating a series of actions in a single painting resembles Rembrandt's exposition of musketry in the *Night Watch*, which he depicts in three stages based on Jacques de Gheyn's *Wapenhandelinge*; see E. Haverkamp Begemann, *Rembrandt: The Nightwatch*, Princeton 1982, pp. 86-88.
4. Lugt (1949), no. 1030; Burchard and d'Hulst 1963, no. 91; exhib. cat. Paris (1978), no. 16.
5. Exhib. cat. *Le siècle de Rubens dans les collections publiques françaises*, Paris, Grand Palais, 1977-78, no. 120, and d'Hulst and Vanderven (1989), no. 17.
6. See Held 1986, no. 54.
7. Oldenbourg 1921, no. 61; the resemblance was noted by Burchard and d'Hulst 1963, no. 92.

GL

fig. c

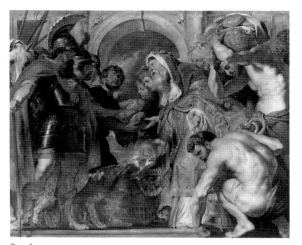

fig. d

fig. e

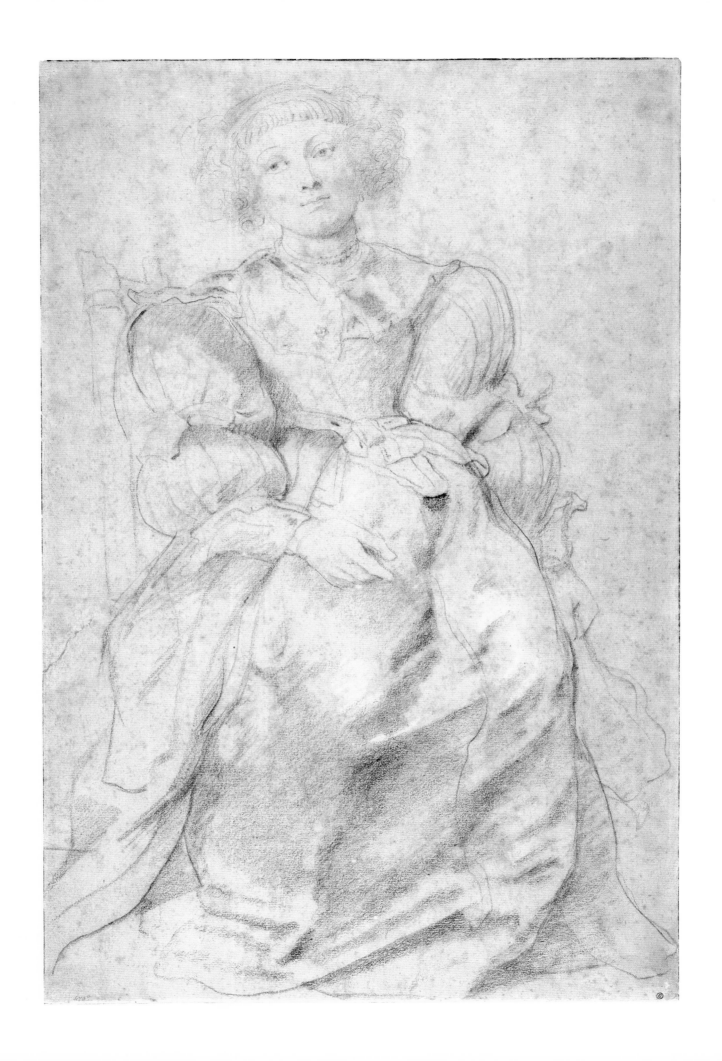

45

Peter Paul Rubens
Siegen 1577–1640 Antwerp
PORTRAIT OF HÉLÈNE FOURMENT

Black and red chalk, heightened with white, laid down;
488 × 320 mm.
Watermark: not visible
Inv. V 45

Provenance: G. Huquier, Paris (L. 1285); Count Moriz
von Fries, Vienna (L. 2903); Sir Thomas Lawrence,
London (L. 2445); H. Wellesley, Oxford; sale London
(Sotheby's), June 25 1866, no. 2392; J.P. Heseltine,
London (L. 1507); F. Koenigs, Haarlem (L. 1023a);
D.G. van Beuningen, Rotterdam, acquired in 1940 and
donated to the Boymans Museum Foundation.

Exhibitions: London 1835, no. 38; London 1879-80,
no. 443; Antwerp 1927, no. 3; Amsterdam 1933,
no. 121; Brussels 1938-39, no. 17; Rotterdam 1938,
no. 348; Rotterdam 1939, no. 20; Rotterdam 1948-49,
no. 131; Brussels, Paris 1949, no. 100, no. 104;
Rotterdam 1952, no. 69; Paris 1952, no. 33; Prague
1966, no. 47; Paris 1974, no. 100; Leningrad, Moscow,
Kiev 1974, no. 100.

Literature: M. Rooses in *Bulletin-Rubens* V, 1900-05,
pp. 196, 329, no. 1505; Glück and Haberditzl 1928,
no. 193; Degenhart 1942, p. 181; H.G. Evers, *Peter Paul
Rubens*, Munich 1942, note 460; Delen 1943,
no. LXXIII; Held 1959, no. 115; Haverkamp Begemann
1967, p. 43; Bernhard 1977, p. 397; Held 1980, under
no. 74; Tijs 1983, p. 127; Held 1986, no. 201; Vlieghe
1987, no. 96a.

On December 6 1630, four years after the death of
Isabella Brant, his first wife, Rubens remarried. He was
fifty-three at the time, and his bride Hélène Fourment,
daughter of the Antwerp tapestry merchant Daniël
Fourment, only sixteen. Rubens explained his choice as
follows: "I made up my mind to marry again, since I
was not yet inclined to live the abstinent life of the
celibate, thinking that, if we must give the first place to
continence, we may enjoy licit pleasures with
thankfulness. I have taken a young wife of honest but
middle-class family, although everyone tried to persuade
me to make a court marriage. But I feared pride, that
inherent vice of the nobility, particularly in that sex, and
that is why I chose one who would not blush to see me
take my brushes in hand."[1] Hélène proved not in the
least haughty about her husband's profession; she
became his favorite model in history paintings, and he
also drew and painted her portrait several times.

This is a preliminary drawing for the panel in the
Alte Pinakothek in Munich (fig. a), where Hélène is
depicted full-length, seated in an armchair.[2] It is
deemed to be one of Rubens's earliest portraits of his
wife, and her opulent dress and somewhat regal array
have given rise to the theory that it was painted to
celebrate their marriage. However, it is probably not
official bridal attire she is wearing, and there are also no
obvious marriage symbols. She does have a sprig of
orange blossom in her hair, but that is not an attribute
exclusive to marriage. It was a more general symbol of
love, and could also allude to both purity and fertility.[3]
That latter meaning has been cited in connection with
Hélène's noticeably rounded form to suggest that she is
pregnant. There are no children present, so this would
be her first pregnancy, which resulted in the birth of
the couple's daughter Clara-Johanna on January 18
1632.

If this is true, it would mean that the drawing
originated in the latter half of 1631, and not on the
occasion of their marriage. The drawing lacks all the
elements that give the painting such a stately air. There
are no jewels or ornaments, no décolleté, and her gown
is simple. The everyday collar lies flat on Hélène's
shoulders, although the white highlights do show that
the dress was of a shiny material, as it is in the painting.
The coiffure, with the short fringe and the thick masses
of small curls framing the face, is one that Hélène
evidently wore for years, for it recurs constantly in her
portraits. Her left hand, in which she holds a feather
fan, is hanging loosely by her side, whereas in the
painting it rests on the arm of the chair. Her pose in
the drawing is a little stiffer, but on closer inspection
one sees that she is posed on a low chair without any
armrests.

One is constantly struck by the dreaminess of this
drawing. In part that may well be due to the slight
blurring of the chalk lines over the years, but the air of
intimacy probably owes as much to the fact that artist
and model were husband and wife. In addition, Hélène
has a pensive, almost introspective look, and this is
accentuated by her gaze, which is focused on something

beyond the borders of the sheet. It can be deduced
from various portraits that Hélène Fourment must have
had a slight squint, and in the Rotterdam drawing, too,
her right and left eyes look in different directions. In
1639 she was described by the Cardinal-Infante
Ferdinand in a letter to his brother, Philip IV of Spain,
as "without doubt the most beautiful woman to be
found in Flanders."[4] Perhaps, as so often with feminine
beauty, it was that small imperfection that made her so
attractive.

1. Letter of December 18 1634 to his friend Nicolas-Claude
Fabri de Peiresc; see *The Letters of Peter Paul Rubens*, ed.
R. Saunders Magurn, Cambridge, Mass. 1955, p. 393, no. 235.
2. For the painting see Vlieghe 1987, pp. 88-91, no. 96. There
used to be a second portrait drawing in the Koenigs Collection
(Inv. V 25) which was likewise believed to be of Hélène
Fourment and was also associated with the Munich picture.
However, the sitter's frail build has little in common with that
of Rubens's second wife, and her features are different; see
Held 1986, no. 202, pl. 197. Rubens used that second drawing
for an oil sketch, Held 1980, no. 334, pl. 332. The drawing
disappeared to Germany in 1940, see Elen 1989, no. 523.
3. M. Levi d'Ancona, *The Garden of the Renaissance: Botanical
Symbolism in Italian Painting*, Florence 1977, pp. 272-75, and
E. de Jongh, exhib. cat. *Portretten van echt en trouw*, Haarlem,
Frans Halsmuseum, 1986, no. 56.
4. Letter of February 27 1639 from Brussels, see M. Rooses
and C. Ruelens, *Correspondance de Rubens et documents épistolaires
concernant sa vie et ses œuvres*, vol. VI, Antwerp 1909, pp. 228-29,
no. DCCCXVI.

GL

fig. a

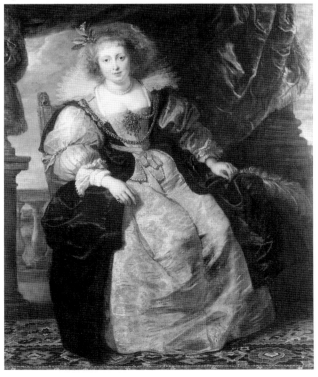

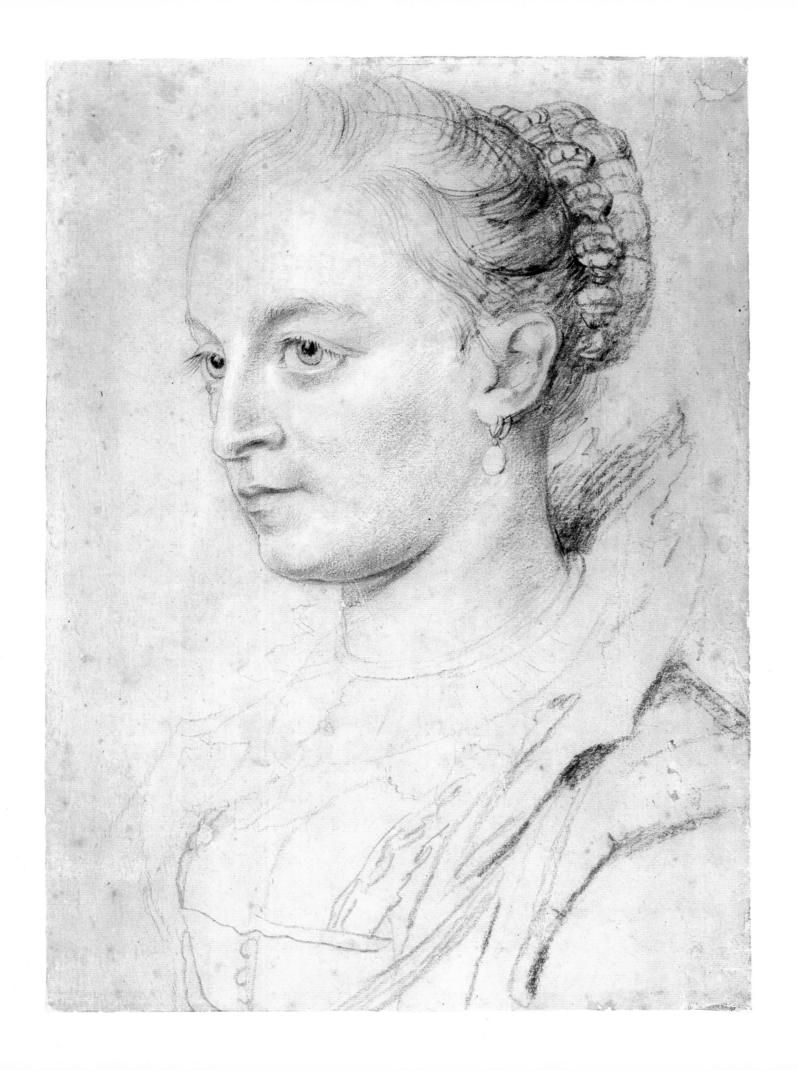

46

Peter Paul Rubens
Siegen 1577–1640 Antwerp
PORTRAIT OF A SISTER OF HÉLÈNE FOURMENT

Black and white chalk, heightened with white, laid
down; 388 × 280 mm.
The old mount had the inscription: *Mademoiselle forment
sœur de la seconde femme de Rubbens. P.P. Rubens fecit.*
Watermark: not visible
Inv. V 58

Provenance: Mrs. L.M. Bancroft, Manchester; sale
London (Sotheby's), May 16 1928, no. 51; F. Koenigs,
Haarlem (L. 1023a); D.G. van Beuningen, Rotterdam,
acquired in 1940 and donated to the Boymans Museum
Foundation.

Exhibitions: Düsseldorf 1929, no. 87; Amsterdam 1933,
no. 123; Rotterdam 1938, no. 346; Brussels 1938-39,
no. 19; Rotterdam 1939, no. 21; Rotterdam 1948-49,
no. 126; Brussels, Paris 1949, no. 97, no. 101; Rotterdam
1952, no. 68; Paris 1952, no. 32; Antwerp 1956, no. 101;
Prague 1966, no. 46; Paris 1974, no. 98; Leningrad,
Moscow, Kiev 1974, no. 98.

Literature: A.M. Hind in *Vasari Society*, second series,
vol. VIII, 1927, no. 10; Glück and Haberditzl 1928,
no. 161; T. Borenius, *Pantheon* I, 1928, pp. 167-68;
Glück 1933, pp. 136-38; Delen 1943, p. 111; Delen
1950, no. 6; Haverkamp Begemann 1957, no. 31; Held
1959, no. 104; Burchard and d'Hulst 1963, no. 136;
G. Martin, *The Flemish School circa 1600-circa 1900.
National Gallery Catalogues*, London 1970, pp. 178-79,
under no. 852; Kuznetsov 1974, no. 117; Bernhard 1977,
p. 349; Mitsch 1977, under no. 43; H. Vlieghe, "Une
grande collection anversoise du dix-septième siécle: le
cabinet d'Arnold Lunden, beau-frère de Rubens,"
Jahrbuch der Berliner Museen XIX, 1977, p. 191, note 78;
Held 1986, no. 161; Vlieghe 1987, no. 104a.

Rubens left a number of large portrait drawings, such as
this appealing study of a woman, which were executed
in the *trois crayons* technique.[1] It is not clear whose
example he was following. Leaving aside the few heads
by Jan Vermeyen (1500–59), the only other real source
for such large portrait sheets is Hendrick Goltzius,
although in contrast to Rubens he generally depicted
men. Several of Rubens's extremely powerful chalk
drawings are related to paintings, although in the
seventeenth century they would undoubtedly have been
valued as autonomous works of art as well. Notably, the
majority of the sitters whom Rubens immortalized in
this way were members of his immediate family:
Isabella Brant (his first wife), his children (often from a
very early age), and later, on numerous occasions,
Hélène Fourment (see cat. no. 45).

The reason why this drawing has always been taken
as the likeness of Suzanne Fourment, quite apart from
the old inscription cited above, lies in a certain
resemblance to the drawn and painted portraits which
are known to be of Hélène's elder sister.[2] On balance,
though, the similarities are not really close enough to
support this identification. The woman in the
Rotterdam sheet has a more rounded face, her lips have
a different shape, and the general resemblance (based on
the sharp nose and set of the eyes) could equally well
apply to one of the other Fourment sisters.[3] That would
also accord with the inscription, which disappeared with
the old mount but is clearly legible in a reproduction of
1928.[4] To dismiss such an annotation out of hand
would be overly rigorous.

No fewer than eleven children, including several
daughters, were born of the marriage between the
tapestry and silk merchant Daniël Fourment and Clara
Stappaerts. Rubens was a friend of the Fourment family
long before he married Hélène, for he knew Suzanne
when his future wife was still a little girl. In 1622
Suzanne Fourment married for the second time, and her
husband, Arnold Lunden, was a close friend of Rubens.[5]
His portraits of her, which are also listed in
seventeenth-century inventories, must predate his
second marriage in December 1630, for it has recently
been discovered that Suzanne died on July 31 1628, far
earlier than was previously thought.[6] A daughter from
her first marriage, to Raymond del Monte, became the
wife of Rubens's son Albert in 1641, shortly after
Rubens's death.[7]

The young woman in the Rotterdam drawing appears
in profile in a painting now in the Louvre, which is
suspected to be a copy of a lost original by Rubens
(fig. a).[8] Her remarkably large eyes, razor-sharp nose
and round chin are seen there to good effect. In the
Madrid *Garden of Love*, Rubens gave the same profile to
the woman on the extreme right with her fan raised in
the air as she enters the garden on the arm of her
companion, who is clad in a dashing and brilliant red
(fig. b).[9]

1. See Held 1986.
2. For these portraits see Vlieghe 1987, pp. 103-10. For the
"chapeau de paille" in London, ibid., no. 102, and for the
drawing in the Albertina in Vienna, Mitsch 1977, no. 43, and
Vlieghe 1987, no. 102a.
3. The traditional identification is questioned by G. Martin
(1970), pp. 178-79, note 26.
4. See the reproduction in the auction catalogue, London
(Sotheby's), May 16 1928. The first to associate the drawing
with the other portraits were Glück and Haberditzl in 1928.
5. Vlieghe (1977), pp. 172-204.
6. This was brought to light by C. van de Velde, who
discovered her date of death in the 1628 Requestboek
(Petitions Register) in Antwerp City Archives, PK. 727,
fol. 149r; see Vlieghe 1987, p. 105, note 1. Ever since
P. Génard, *P.P. Rubens: aanteekeningen over den grooten meester
en zijn bloedverwanten*, Antwerp 1877, p. 411, she was believed
to have died on December 11 1643.
7. Génard, op. cit. (note 6), p. 411, and Vlieghe 1987,
pp. 103-05.
8. A. Brejon de Lavergnée, J. Foucart and N. Reynaud, *Écoles
flamande et hollandaise. Catalogue sommaire illustré des peintures
du Musée du Louvre*, Paris 1979, p. 122, inv. R.F. 2122; Vlieghe
1987, no. 104.
9. Oldenbourg 1921, p. 348; Dìaz Padròn 1975, vol. I,
pp. 280-82, no. 1690. The resemblance between the figures in
the Rotterdam drawing and the *Garden of Love* was pointed out
by Martin (1970), p. 179, note 26. Much earlier, in 1920,
G. Glück had demonstrated that many of the figures in the
Garden of Love were relatives of Rubens, which serves to
confirm the identification; see "Rubens' Liebesgarten", in
G. Glück, *Rubens, Van Dyck und ihr Kreis: Gesammelte Aufsätze*,
Vienna 1933, pp. 82-153, esp. pp. 136-44.

GL

fig. b

fig. a

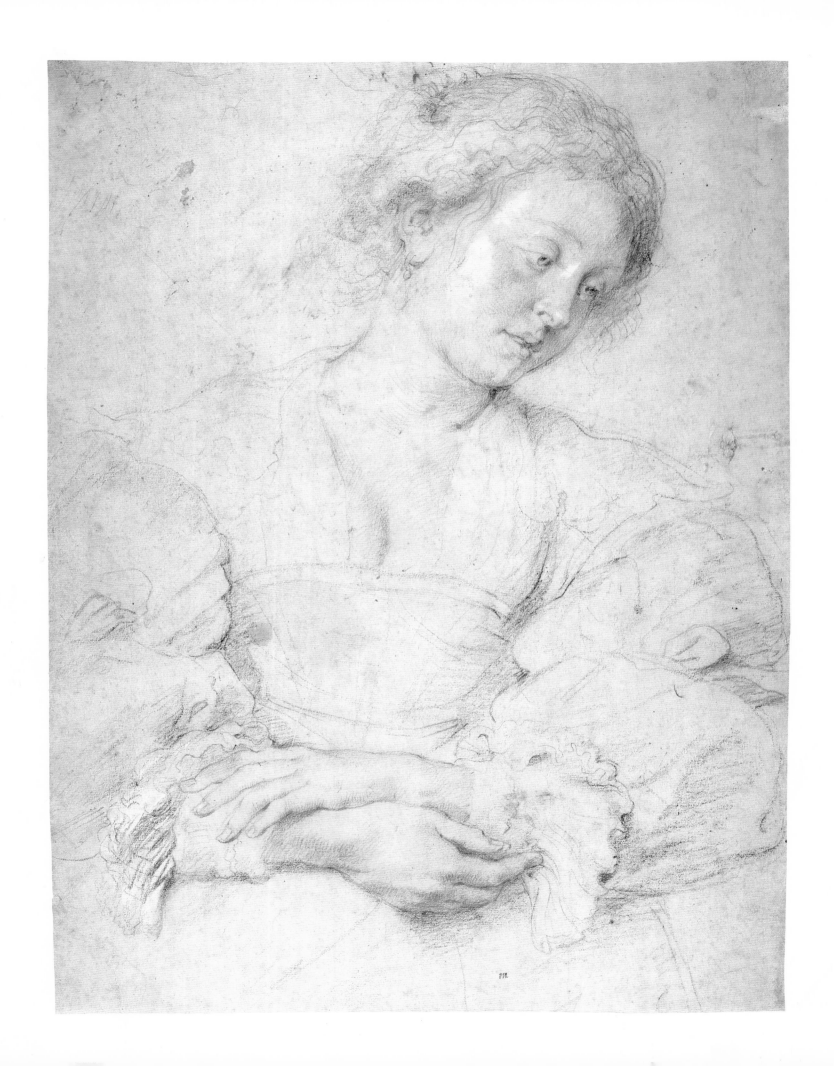

47

Peter Paul Rubens
Siegen 1577–1640 Antwerp
YOUNG WOMAN WITH FOLDED HANDS

Red and black chalk, heightened with white;
473 × 354 mm.
Verso: the inscriptions *no 14ff*, *R.46*, and *faustina
Rubbens Doghter*
Watermark: coat of arms with a lion and three roundels
Inv. V 81

Provenance: P.H. Lankrink, London (L. 2090);
J.W. Böhler, Lucerne; F. Koenigs, Haarlem (L. 1023a),
acquired in 1929; D.G. van Beuningen, Rotterdam,
acquired in 1940 and donated to the Boymans Museum
Foundation.

Exhibitions: Amsterdam 1933, no. 124; Rotterdam 1938,
no. 349; Brussels 1938-39, no. 18; Rotterdam 1939,
no. 22; Rotterdam 1948-49, no. 132; Brussels, Paris
1949, no. 105; Rotterdam 1952, no. 70; Paris 1952,
no. 34; Prague 1966, no. 105; Antwerp 1977, no. 167.

Literature: Glück and Haberditzl 1928, no. 207; Delen
1943, p. 120; Degenhart 1943, p. 181; Delen 1949,
p. 19; Haverkamp Begemann 1957, no. 30; Held 1959,
no. 110; J. Jacob, "A Holy Family and Other Related
Pictures by P.P. Rubens," *Jaarboek Koninklijk Museum
voor Schone Kunsten Antwerpen* 1959-60, pp. 15-16;
Haverkamp Begemann in Benesch, *et al.* 1962, no. 537;
Burchard and d'Hulst 1963, no. 174; C.T. Eisler,
Drawings of the Masters: Flemish and Dutch Drawings,
New York 1963, pl. 33; Haverkamp Begemann 1967,
p. 43; R.-A. d'Hulst, exhib. cat. *Flemish Drawings of the
17th Century from the Collection of Frits Lugt, Institut
Néerlandais, Paris*, London, Victoria and Albert Museum,
etc. 1972, no. 83, note 6; Kuznetsov 1974, no. 132;
Bernhard 1977, p. 412; Roberts 1977, no. 96; Mitsch
1977, under no. 49; Tijs 1983, p. 129; Held 1986,
no. 192.

fig. b

This is one of the most tender and sensitive of all
Rubens's studies of women, and yet the verve and
fluency with which he sketched the broad lines of the
figure and her dress show that his virtuosity was no
obstacle when it came to capturing such sweetness and
charm. Nowhere is the handling of line hesitant or stiff,
and one can imagine how loosely he must have held the
chalk when drawing the puffed sleeves, the ribbons, and
the curly hair. He used red chalk not only for the flesh
tones – face, neck and hands – but also for the hair, as
if the model really was a redhead. The white chalk has
been used sparingly; only in the face are there a few
smudged, white highlights.

Unlike the previous drawing (cat. no. 46), this sheet
was not intended as a portrait, as can be seen from the
way Rubens used it in his painted *œuvre*. In 1630 the
Infanta Isabella commissioned a triptych from him for
the chapel of the Sodality of St Ildefonsus in the court
church of St Jacob op den Coudenberg in Brussels.[1] For
the central panel with the legend of St Ildefonsus
(606–667), Rubens painted female onlookers witnessing
the Virgin's appearance to the Spanish saint in his
cathedral at Toledo. She is presenting him with an
embroidered chasuble for his fierce defense of the
doctrine of the Immaculate Conception, for which he
was assailed by heretics. This theme came to the fore
again in Rubens's day as a result of the controversy
between Catholics and Protestants over the role of the
Virgin.

The captivating model from the Rotterdam drawing
appears in the painting (fig. a; Vienna, Kunsthistorisches
Museum) amid the other virgins, who are all gazing
down at the saint as he kneels before the Virgin.[2]
Rubens has given her a veil, altered the position of her
hands, which are loosely folded in the drawing, and
modeled her on the famous classical statue of *Pudicitia*,
the goddess of chastity (fig. b; Rome, Musei Vaticani).[3]
The sculpture had been excavated at the end of the
sixteenth century on the estate of the Roman Mattei
family, and was a great attraction at the time when
Rubens was living in Rome.[4] It can be assumed that he
visited the Villa Mattei and sketched the statue, for the
earliest known engraving of *Pudicitia* only dates from
1704.[5] His incorporation of a full-length incarnation of
that sculpture in his *Ildefonsus Altarpiece* was a
particularly astute quotation in a picture relating to the
Immaculate Conception, although hardly surprising in
an artist who knew his classics.

Rubens was evidently pleased with the silhouette in
the Rotterdam drawing, for in another commission of
the same period, the *Coronation of St Catherine* for the
Augustinian church in Mechelen (Malines), he repeated
the pose in the figure of the enthroned Virgin looking
down at the saint (now Toledo, Ohio, Toledo Museum
of Art).[6] The position of the Virgin's right hand is also
copied almost literally from the drawing.

1. Vlieghe 1973, no. 117.
2. The figure had not yet been included in the oil sketch
(Leningrad, Hermitage) for this huge altarpiece; see
M. Varshavskaya, *Rubens' Paintings in the Hermitage Museum*,
Leningrad 1975, no. 31; Held 1980, vol. I, no. 412, vol. II,
pl. 401. Studies for the other women in the painting, which
were also executed in different colors of chalk but were later
trimmed closely around the heads, are in the Albertina in
Vienna; see Mitsch 1977, nos. 49-51.
3. E. Kieser, "Antikes im Werke des Rubens," *Münchener
Jahrbuch der Bildenden Kunst*, N.F., XI, 1933, p. 132;
W. Helbig, *Führer durch die öffentlichen Sammlungen klassischer
Altertümer in Rom*, Tübingen 1963-74, vol. I, pp. 321-22. This
was not the first time that Rubens borrowed the statue's pose
for a painting. See, for instance, his *Three Marys at the Tomb* of
c. 1614, formerly in the Czernin Collection and now in the
Norton Simon Museum, Pasadena, California; Oldenbourg
1921, p. 79.
4. For the fame and later whereabouts of the statue see
F. Haskell and N. Penny, *Taste and the Antique: the Lure of
Classical Sculpture 1500-1900*, New Haven, London 1981,
pp. 300-01, no. 74.
5. Ibid. See also P.A. Maffei, *Raccolta di statue antiche e moderne,
data in luce... da Domenico de Rossi*, Rome 1704, pl. CVII.
6. Oldenbourg 1921, p. 343; *European Paintings. The Toledo
Museum of Art*, Toledo, Ohio 1976, pp. 146-47, inv. 50.272.

GL

fig. a

48

Anthony van Dyck
Antwerp 1599–1641 London
KNEELING MAN SEEN FROM THE BACK

Black and red chalk, traces of very light yellow chalk,
heightened with white; 463 × 270 mm.
Watermark: crown, cf. Briquet, vol. II, no. 5097 (?)
Inv. MB 341

Provenance: F.J.O. Boijmans, bequest of 1847 (L. 1875).

Exhibitions: Antwerp, Rotterdam 1960, no. 37, fig. XXI;
Paris 1974, no. 23, fig. 91; Princeton 1979, no. 13 (ill.);
Ottawa 1980, no. 31 (ill.).

Literature: cat. Rotterdam 1852, no. 260; cat. Rotterdam
1869, no. 124; F. Lugt, *Les dessins des écoles du nord de la
collection Dutuit au Musée des Beaux-Arts de la ville de
Paris (Petit Palais)*, Paris 1927, under no. 27; M. Delacre,
"Le dessin dans l'œuvre de Van Dyck," *Mémoires de
l'Académie Royale de Belgique. Classe des Beaux-Arts*, vol. II,
no. 3, Brussels 1934, p. 55, fig. 29; F. Lugt, *Musée du
Louvre. Inventaire général des dessins des écoles du nord,
école flamande*, vol. I, Paris 1949, p. 52; Vey 1956, p. 49,
fig. 13; H. Vey, *Van Dyck Studien*, diss. Cologne 1958,
p. 115; Vey 1962, p. 143, no. 75, fig. 101; Dìaz Padròn
1975, p. 98; H. Mielke and M. Winner, *Pieter Paul
Rubens. Kritischer Katalog der Zeichnungen*, Berlin,
Staatliche Museen Preussischer Kulturbesitz, 1977,
under no. 43Kr.; M. Schapelhouman, *Oude tekeningen in
het bezit van de Gemeentemusea van Amsterdam waaronder
de collectie Fodor. Deel 2: Tekeningen van Noord- en
Zuidnederlandse kunstenaars geboren voor 1600*, Amsterdam
1979, under no. 15; A. McNairn, "Dessins de jeunesse
de Van Dyck," *L'Oeil*, no. 300-01, 1980, p. 27, fig. 9;
C. Brown, *Van Dyck*, Oxford 1982, p. 36; Larsen 1988,
vol. I, p. 174.

After five years as a pupil of the Antwerp painter
Hendrik van Balen (1575–1632), Van Dyck set up as an
independent artist at the youthful age of fifteen. Three
years later he was admitted to the artists' guild. This
was the beginning of his first Antwerp period, which
ended with his departure for Italy at the end of 1621.
Flemish painting was dominated at the time by Rubens
and his large studio, and before long the two artists
were working closely together. An important moment
in their association came with the commission for
thirty-nine ceiling paintings for the Jesuit Church in
Antwerp. In the contract of March 1620 between
Rubens and the Jesuits, which survives in a transcript,
it was agreed that Rubens would make the designs for
the thirty-nine paintings himself and that they would be
executed by Van Dyck and "some other disciples," after
which Rubens "shall, with his own hand, finish therein
that which is deemed to be imperfect."[1] It hardly needs
emphasizing that Rubens had an enormous influence on
the work of his younger colleague.

The drawing is undoubtedly a study from a male
model who posed for Van Dyck in the studio. The
man's torso as far as the neck is repeated very sketchily
at upper right. The right arm and hand with the spread
fingers is drastically foreshortened. In the man's head
one can see the profile of a first version, which Van
Dyck may himself have corrected with white. The red
chalk in the second rendering of the face is by a later
hand. Working from the live model was standard
practice in the studios of both Rubens and Van Dyck,
and the resulting drawings, generally in black and white
chalk on large sheets of paper,[2] were later used in the
planning of painted works, often in a modified form.
Van Dyck first prepared these compositions with pen
drawings in brown ink over black chalk on paper.

Van Dyck used the Rotterdam study for the third in a
series of four composition sketches, all done in pen and
brown ink over black chalk (fig. a),[3] in preparation for a
painting of the *Crowning with Thorns*, of which there
were three autograph variants (fig. b).[4] The man from

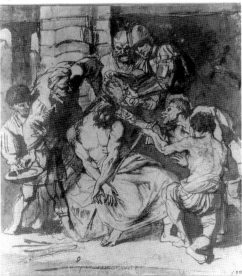

fig. a

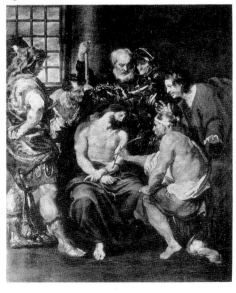

fig. b

the Rotterdam drawing is the tormentor who offers Christ a reed as a scepter. This figure can also be seen in the two preceding composition sketches, one of which is in Amsterdam (fig. c),[5] but in a completely different pose and position. One of the new elements in the third sketch is the man on the right, who is sticking out his tongue at Christ and ridiculing him with the crude gesture for *cornuto*, or wearer of horns.

Van Dyck eventually decided not to use the Rotterdam study for the *Crowning with Thorns*, and in the fourth composition sketch, which can be regarded as the final one on the grounds that it is virtually identical to the painted variant formerly in Berlin, he based this soldier on a study from the live model which Rubens had made in 1608–09 (see cat. no. 44). That figure appears with minor alterations in all three paintings of the *Crowning with Thorns*. Van Dyck may have seen this study of a kneeling man in Rubens's studio. Rubens is known to have reused it in another painting (see cat. no. 44, fig. d), so he had evidently preserved it.

Despite all the similarities between the two nude studies by Rubens and Van Dyck, there are also some obvious differences. Rubens placed great, even exaggerated emphasis on the musculature, whereas Van Dyck was more interested in the contours, with the result that his is the more realistic and convincing effort.

It is worth noting, incidentally, that the high drama of the scene, and the caricature nature of the soldiers tormenting Christ in the first three composition sketches, have been toned down considerably in the fourth sketch and in the three painted versions.

The motif of a soldier offering Christ a scepter in the form of a reed is part of the traditional iconography of the Crowning with Thorns.[6] What is remarkable in Van Dyck is the pronounced foreshortening of this figure. The Titianesque nature of Van Dyck's three paintings of the *Crowning with Thorns* has already been noted, and the motif of the kneeling man seen from the back likewise appears to derive from the Venetian master. A similar figure is found in his painting of the same subject of *c.* 1545–50, now in the Louvre, which was executed for a church in Milan (fig. d).[7] It is not likely that Van Dyck knew this painting before he went to Italy, but the mediator could well have been Rubens, who himself profited from Titian's influence, notably in his own *Crowning with Thorns* of 1601–02 for St Helena's Chapel in the church of S. Croce in Geruselemme in Rome.[8] Van Dyck may have seen the composition sketch for that work, which Rubens had kept (fig. e),[9] or possibly the *modello*.[10]

It is assumed that the lost version of the painting was made for the Bridgettine nunnery in Hoboken, near Antwerp.[11] This is certainly not inconsistent with the subject, for St Bridget of Sweden, the fourteenth-century mystic and founder of the order, had some influence on the iconography of the Passion through her *Revelations*.[12]

Prints were later made of Van Dyck's *Crowning with Thorns* by Schelte A. Bolswert (*c.* 1586-1659) and Jeremias Falck (*c.* 1619–67).[13]

1. J.R. Martin, *The Ceiling Paintings for the Jesuit Church in Antwerp* (Corpus Rubenianum Ludwig Burchard I), Brussels 1969, p. 214: "*met syn Eygen handt in de selve volmaken sal 't gene men bevinden sal daer aen te gebreken.*"
2. There are at least two other black chalk studies from the live model which have the same dimensions as the Rotterdam sheet, see Vey 1962, no. 14, fig. 19 and the sheet in Berlin, Mielke and Winner (1977), no. 43Kr (ill.).
3. Dutuit Collection, Paris, Petit Palais; Vey 1962, nos. 72-74, figs. 98-100, and no. 78, fig. 105.
4. This version was formerly in the Kaiser Friedrich Museum, Berlin, but was destroyed in the Second World War. The other two variants are in the Prado, Madrid, and in a private collection in Basel; see Larsen 1988, vol. II, nos. 271-73 (ill.).
5. Fodor Collection, Amsterdam Historical Museum, Schapelhouman (1979), no. 15.
6. L. Réau, *Iconographie de l'art chrétien*, vol. II, pt. 2, Parijs 1957, p. 457.
7. See H.E. Wethey, *The Paintings of Titian*, vol. I, London 1969, no. 26, fig. 132.
8. See Vlieghe 1973, no. 111, fig. 34. The painting is now in Grasse.
9. Ibid., no. 111a, fig. 33.
10. The *modello* for this altarpiece has survived; see J. Müller Hofstede, "Rubens in Rom, 1601-1602", *Jahrbuch der Berliner Museen* XII, 1970, p. 67, fig. 3.
11. See Larsen 1988, vol. I, p. 170.
12. See J. Hall, *Dictionary of Subjects and Symbols in Art*, London 1974, pp. 53, "Bridget of Sweden" and 80, "Crowning with Thorns."
13. Hollstein, *Dutch and Flemish*, vol. III, no. 18; ibid., vol. VI, no. 17.

AM

fig. c

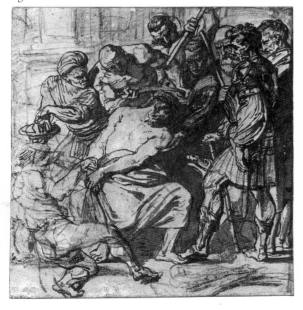

fig. d

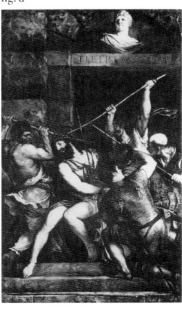

fig. e

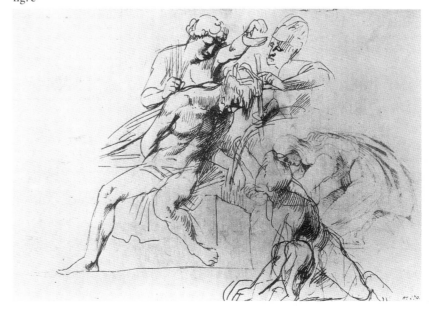

49

Anthony van Dyck
Antwerp 1599–1641 London
PORTRAIT OF FRANS FRANCKEN THE YOUNGER

Black chalk; 237 × 183 mm.
Watermark: hunting horn
Inv. V 15

Provenance: J. Barnard, London; Sir Thomas Lawrence,
London (L. 2445); F. Koenigs, Haarlem (L. 1023a);
D.G. van Beuningen, Rotterdam, acquired in 1940 and
donated to the Boymans Museum Foundation.

Exhibitions: London 1835-36, no. 4; Antwerp 1927,
no. 40; Antwerp 1949, no. 95; Prague 1966, no. 81 (ill.);
Paris 1974, no. 28, fig. 99.

Literature: J. Smith, *A Catalogue Raisonné of the Works of
the Most Eminent Dutch, Flemish and French Painters*,
vol. III, London 1831, no. 762; M. Delacre, "Recherches
sur le rôle du dessin dans l'iconographie de Van Dyck,"
Mémoires de l'Académie Royale de Belgique II, no. 4, 1932,
p. 86; idem, III, no. 1, 1934, pp. 8, 19-20; A.J.J. Delen,
Antoon van Dyck: een keuze van 29 tekeningen, Antwerp
1943, no. 17 (ill.); Vey 1956, p. 191; Vey 1962, no. 252,
fig. 311; U. Härting, *Frans Francken der Jüngere
(1581-1642): die Gemälde mit kritischem Oeuvrekatalog*,
Freren 1989, p. 22, fig. 21.

Van Dyck's *Iconography* is a collection of some 200
portrait prints made after his drawings or paintings.
Most are engravings by many different artists, and in
the course of 150 years the anthology went through
numerous editions.[1] The project began modestly
enough. In Antwerp, in the late 1620s and the first half
of the 1630s, Van Dyck made a series of eighteen
etchings of people of his day, mainly artists, whom he
had evidently asked to pose for him. The majority were
done from his own drawings, the remainder from
paintings or other sources, either because the subject
had died or because Van Dyck had never met him.
That, for example, was the case with Frans Francken
the Elder (1542–1616), whose portrait he took from a
painting of *c.* 1615 by Rubens.[2] That this is indeed
Frans the Elder and not his son, as is sometimes
assumed,[3] is apparent from Van Dyck's autograph
annotation, *Franciscus Vranx Senior*, in pen and brown
ink on a second state of the etching in the Boymans-van
Beuningen Museum (fig. a).

It is not known whether it was the idea at this stage
to publish the series of eighteen etchings as an album;
it is possible that they were sold separately. It was
probably on the initiative of the Antwerp publisher
Martinus van den Ende (active 1630–54), who also
issued some of the first eighteen etchings, that Van
Dyck made drawings in the same period for a further
eighty portraits of his contemporaries. These were made
into prints by various engravers and published by Van
den Ende between 1636 and 1641,[4] but without the
initial eighteen etchings. This first publication of the
Iconography (it was not actually given that title until
later) contains the portraits of fifty-two artists and art
lovers, as well as generals and noblemen, statesmen and
scientists. A few years later the plates of both the
etchings and the engravings came into the hands of
another Antwerp publisher, Gillis Hendricx (member of
the Antwerp artists' guild 1643/44–77). He added fifteen
of the original eighteen etchings to the eighty prints of
the first edition, and commissioned more engravings
after portrait paintings by Van Dyck, who was now
dead. This second edition contained 100 portraits, and
appeared in 1645–46 with a title page by Hendricx.
This was followed in the seventeenth and eighteenth
centuries by several other editions of the *Iconography*,
each from a different publisher, with the number of
portraits growing each time. The copper plates were
bought by the Louvre in 1851.

The drawings which Van Dyck made for Van den
Ende's first edition, of which more than forty survive,
are all done in black chalk, occasionally with a brown or
gray wash.[5] In many cases Van Dyck drew just the head
and bust of the sitter, leaving the background and
attributes to the engraver. The drawings and prints
show the pains Van Dyck took to bring as much variety
to the portraits as possible. The positions of the head,
body and hands are always different, and the artists all
have a look of fierce concentration. The result is a
series of eloquent and striking likenesses.[6]

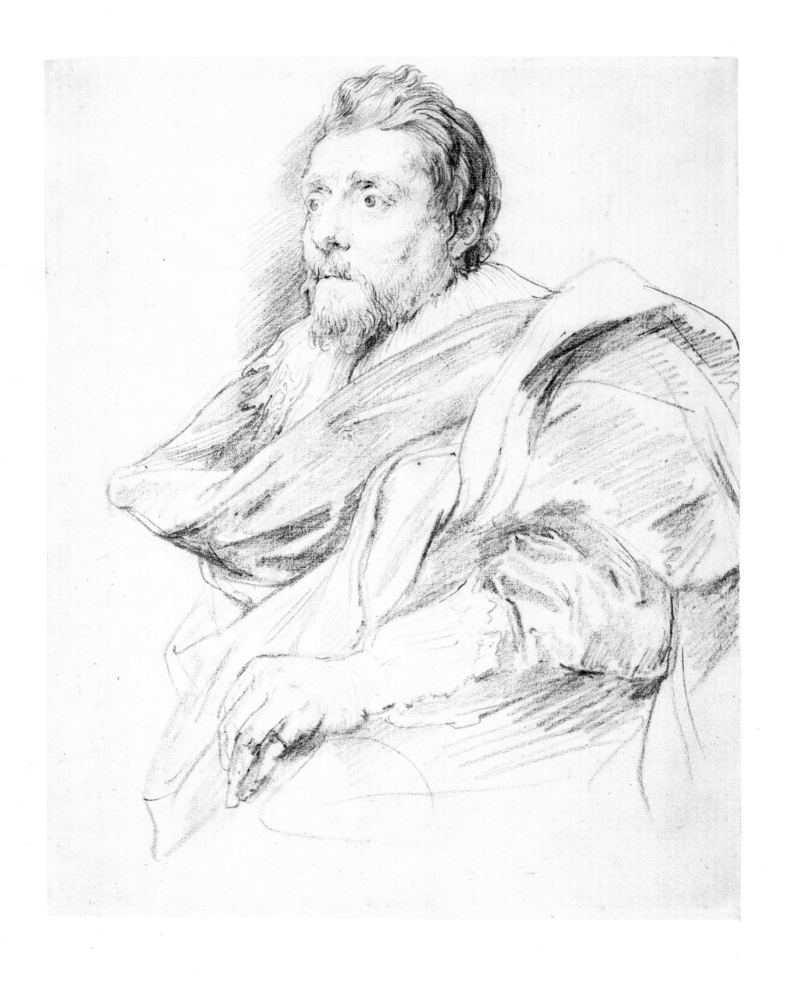

This Rotterdam sheet is the preliminary study for the portrait of Frans Francken the Younger (1581–1642), which was engraved in the same direction (fig. b) by Pieter de Jode (1606–after 1674), whose name appears on the fourth state. Francken, like his father, specialized in cabinet pictures – small paintings specifically intended for the art cabinets of private collectors. Francken's vast output embraced mythological, genre and religious subjects.

All the engravings in Van den Ende's edition of the *Iconography* have the legend *Ant. van Dyck pinxit*, which led to the belief that they were all executed after paintings by Van Dyck,[7] for which the surviving drawings were thought to be the preliminary studies. A more likely explanation, however, is that Van Dyck made the drawings while the subject posed for him, so "pinxit" should be interpreted here as "depicted."

Comparison of the drawing and engraving of Frans Francken the Younger shows that Van Dyck drew his hand in a slightly different position. It is a little more arched than in the engraving, as if he is grasping the armrest of his chair, and suggests that he is seated. In the engraving, however, his forearm is raised at a slightly steeper angle, and his hand rests on a fragment of classical masonry which was added by the engraver, with the result that he appears to be standing.

1. See M. Mauquoy-Hendrickx, *L'iconographie d'Antoine van Dyck*, Brussels 1956.
2. Vlieghe 1987, no. 105, figs. 116, 118.
3. Mauquoy-Hendrickx, op. cit. (note 1), p. 15, and on the painting, Larsen 1988, vol. II, under no. A 19 (ill.).
4. Ibid., p. 51.
5. Vey 1962, nos. 245-81, figs. 294-333; J. Spicer, "Unrecognised Studies for Van Dyck's Iconography in the Hermitage," *Master Drawings* XXIII-XXIV, 1985-86, pp. 537-44.
6. See, for instance, H.-J. Raupp, *Untersuchungen zu Künstlerbildnisse und Künstlerdarstellungen in den Niederländen im 17. Jahrhundert*, Hildesheim etc. 1984, pp. 133ff.
7. Härting (1989), p. 22.

AM

fig. b

FRANCISCVS VRANX SENIOR PICTOR

fig. c

FRANCISCVS FRANCK IVNIOR

Ant. van Dyck pinxit *Mart. vanden Enden excudit Cum privilegio*

fig. a

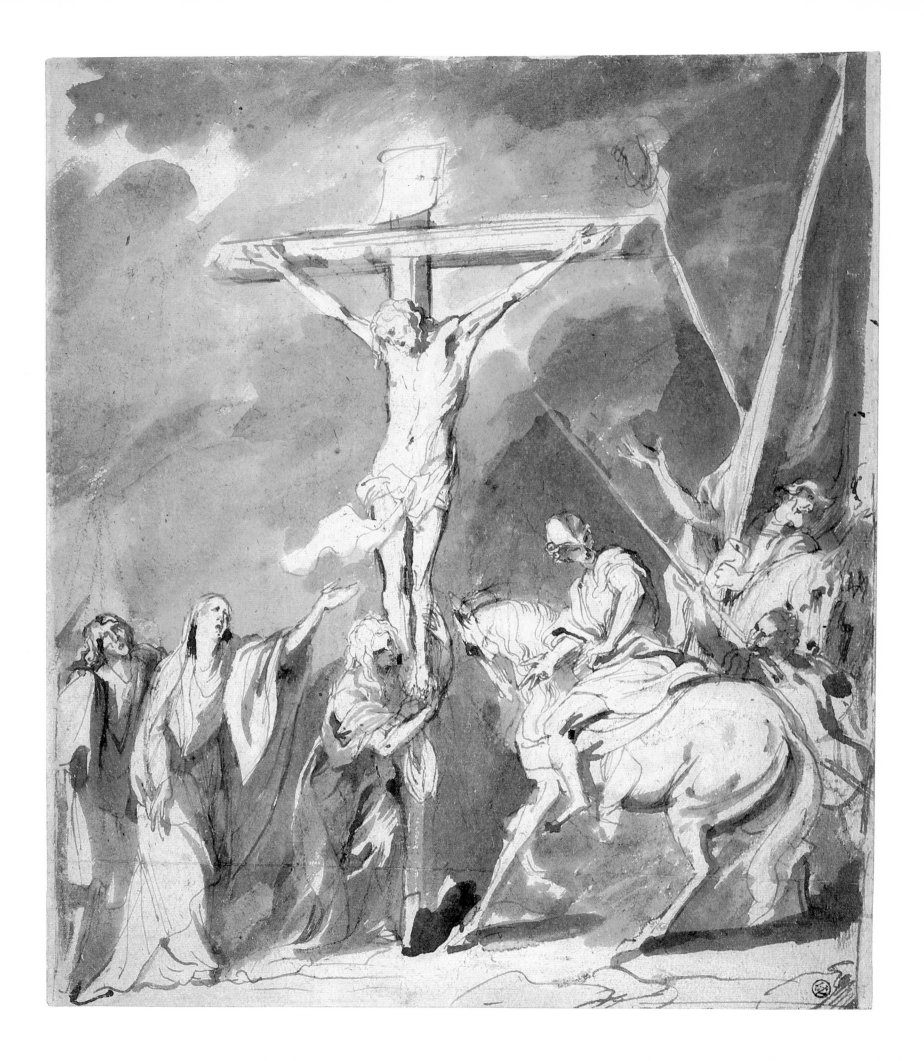

50

Anthony van Dyck
Antwerp 1599–1641 London
THE CRUCIFIXION

Pen and brown ink, brown wash, over black chalk,
corrected with white, laid down; 300 × 253 mm.
Watermark: not visible
Inv. MB 1958/T 25

Provenance: Cabinet de M. Telusson, Paris (?);[1] Vasal de
Saint-Hubert, Paris; his sale, Paris, March 29-April 13
1779, no. 26; W. Russell, London (L. 2648; stamped
twice); J.H. Cremer, Amsterdam; his sale, Amsterdam,
June 15 1886, no. 82; E. Habich, Kassel (L. 862); his
sale, Stuttgart, April 27 1899, no. 244; E. Wauters, Paris
(L. 911); his sale, Amsterdam, June 15-16 1926, no. 62;
D.G. van Beuningen, Rotterdam (L. 758), acquired in
1926; acquired by the museum with the Van Beuningen
collection in 1958.

Exhibitions: London 1877-78, no. 1127; Brussels 1910,
no. 28; Antwerp, Rotterdam 1960, no. 71, fig. 45; Prague
1966, no. 82; Paris 1974, no. 30, fig. 97; Princeton 1979,
no. 44 (ill.).

Literature: O. Eisenmann, *Ausgewählte Handzeichnungen
ältere Meister aus der Sammlung Edward Habich zu Cassel*,
Lübeck 1890, no. 17; Lees 1913, p. 107; Hannema
1949, no. 159, fig. 209; H. Vey, "Een belangrijke
toevoeging aan de verzameling van Dyck tekeningen,"
Bulletin Museum Boymans-van Beuningen Rotterdam X,
1959, pp. 2-22, fig. 1; Vey 1962, p. 192, no. 125, fig. 162;
Larsen 1988, vol. I, p. 252, fig. 219; vol. II, under
no. 712.

On the last Sunday of January 1628, "Father Bauters
assigns to Paul Rubens of Antwerp the task of making
and painting the altarpiece in the Chapel of the Holy
Cross, thirteen feet in height, and in width
commensurate with the height and requirements of the
work, for the sum of 800 guilders."[2] Bauters was the
parish priest of St Michael's in Ghent. Attached to the
church was the influential Sodality of the Holy Cross,
whose members included Archduke Albert and his wife
Isabella. It owed its prestige chiefly to the fact that in
its chapel in the north transept of the church it had
three fragments of the True Cross, the last of which
had been presented by Albert and Isabella in 1617. In
the years that followed, the chapel was enriched with
several works of art, including a silver cross in which to
keep the fragments, as well as a number of paintings.

The task of painting the altarpiece fell to Rubens, for
whom 1628 was to prove an exceptionally busy year.
His correspondence tells us that in January he had also
started work on his designs for the gallery of King
Henri IV of France, who had died in 1610.[3] This large
cycle of paintings for the Palais de Luxembourg in Paris
was to depict the life and deeds of the dead king, and
Rubens had accepted the contract for it back in 1622
from Maria de' Medici, Henri's widow, who ruled
France as regent. In the same letter Rubens wrote that
he was convinced it would be more successful than his
previous project (the Medici cycle of 1622-25), and that
he hoped he would surpass himself in the execution of
the new gallery. At the end of August he left for
Madrid to prepare for a diplomatic mission to London,
and only returned to Antwerp in the spring of 1630.
It is fair to ask whether he had not taken on too much
when he agreed to paint the huge canvas for the
Sodality of the Holy Cross in Ghent.[4] Or had he not
expected to spend so long abroad? Whatever the
answer, the financial accounts of the Church of
St Michael for the years 1629/30 show that the
commission eventually went to Van Dyck: "Item, paid
to Anthony van Dyck for the painting standing on the
altar of the Holy Cross, the sum of 133 pounds, 6
shillings and 8 groats."[5] The painting is still in the
church today.

This sheet is Van Dyck's composition drawing for
that altarpiece (fig. a). It is a dramatic interpretation of
the moment of Christ's death as described in
St Matthew's gospel: the world was covered in darkness,
the earth shook, and the rocks split asunder. This could
explain the odd posture of the centurion's horse. Van
Dyck appears to have drawn cracks in the earth in the
foreground, and it is as if the animal is trying to keep
its footing as the ground shakes. On the right, in
accordance with the gospel account, a soldier rushes
forward with the vinegar-soaked sponge on a long stave.

From this drawing Van Dyck then made a *modello*,
which differs from it at several points (fig. b).[6] It is also
less turbulent, and in this respect the composition of the
painting in Ghent is closer to the *modello*. As Vey
remarked, it is more a devotional work than a dramatic
rendering of the Bible story.

Vey also came up with the attractive suggestion that a
Rubens *modello* for a *Crucifixion* in the Rockox House in
Antwerp may have been his initial design for the
altarpiece.[7] There are certainly points of correspondence
between the two works. The figures are similarly
positioned, Christ has no crown of thorns, and in
Rubens's sketch he appears to be addressing the Virgin
and St John. The motif of the Magdalen embracing the
Cross and kissing Christ's feet is also common to both.
However, a certain weakness in some of the details
makes it doubtful that this oil sketch is entirely by
Rubens. Might it not be that it was begun by him,
finished by a studio assistant after he left for Spain, only
to be rejected by the patron?

A print of Van Dyck's *Crucifixion* was later made by
Schelte A. Bolswert (*c.* 1586–1659).[8]

1. See sale catalogue Vasal de Saint-Hubert, Paris, March 29-
April 13 1779, p. 8.
2. *Liber Sodalitatis Stae Crucis*; here quoted from Vey (1959),
p. 9, notes 14ff: "*pasteur Bauters besteet aan Sr Pauwel Ruebens
tot Antwerpen het maecken ende schilderen van de aultaer tafel in
de Capelle van 't h. Cruyse totter hoochde van XIII voeten ende
breedt naer proportie ende heesch van twerck voor de somme van
acht hondert gulden.*"
3. See *The Letters of Peter Paul Rubens*, ed. R. Saunders Magurn,
Cambridge, Mass. 1955, p. 234. On the Henri IV cycle see
I. Jost, "Bemerkungen zur Heinrichsgalerie des P.P. Rubens,"
Nederlands Kunsthistorisch Jaarboek XV, 1964, pp. 175-228.
4. One Antwerp rod = 20 Antwerp feet or 5.75 m.; 13
Antwerp feet = 3.70 m.
5. Vey (1959), p. 10: "*Item betaelt aen Sr. Anthonio van Dycke
voor de schilderye staende op den autaer van het h. Cruys de somme
van lcXXXIII lib. VI sch. VIII gr.*"
6. Brussels, Musées Royaux des Beaux-Arts; Larsen (1988),
vol. II, no. 713, fig. 220.
7. Formerly in the Bührle Collection, Zurich; Held 1980, cat.
no. 353, fig. 348. Rubens's *modello* was engraved by Jacob Neefs
(1610–after 1660), Hollstein, *Dutch and Flemish*, vol. XIV, no. 7.
8. Hollstein, *Dutch and Flemish*, vol. III, no. 22.

AM

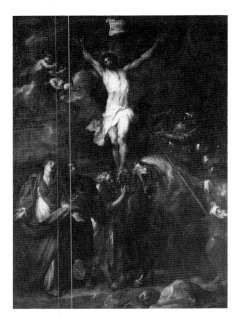

fig. a

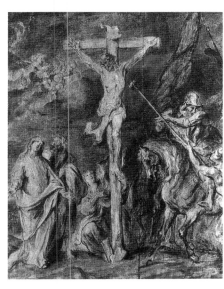

fig. b

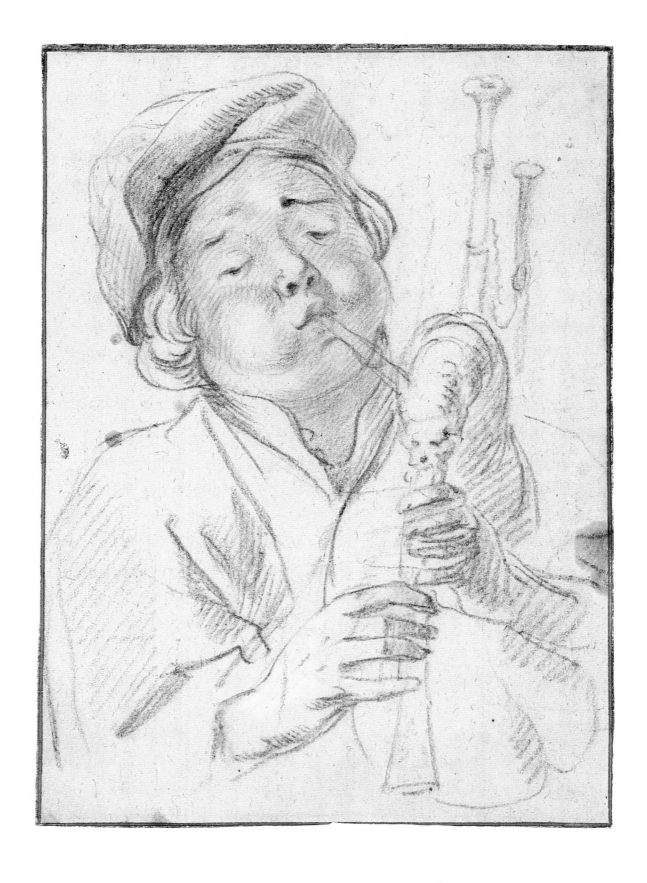

51

Jacob Jordaens
Antwerp 1593–1678 Antwerp
BAGPIPER

Black and red chalk, heightened with white;
216 × 152 mm.
Verso: *Woman pouring a glass of wine* (fig. a)
Black chalk, cropped at the top
Watermark: Gothic P
Inv. V 21

Provenance: F. Koenigs, Haarlem (L. 1023a), acquired in 1923; D.G. van Beuningen, Rotterdam, acquired in 1940 and donated to the Boymans Museum Foundation.

Exhibitions: Prague 1966, no. 64; Antwerp, Rotterdam 1966-67, no. 58; Ottawa 1968-69, no. 196 (ill.); Paris 1974, no. 56, fig. 112; Antwerp 1978, no. 29 (ill.).

Literature: R.-A. d'Hulst, "De tekeningen van Jacob Jordaens in het Museum Boymans," *Bulletin Museum Boymans Rotterdam* IV, 1953, p. 54, fig. 20; R.-A. d'Hulst, *De tekeningen van Jacob Jordaens*, Brussels 1956, no. 74, fig. 122; A.P. de Mirimonde "Les sujets de musique chez Jacob Jordaens," *Jaarboek van het Koninklijk Museum voor Schone Kunsten*, 1969, p. 222, fig. 18; R.-A. d'Hulst in exhib. cat. *Flemish Drawings of the 17th Century from the Collection of Frits Lugt, Institut Néerlandais, Paris, London, Victoria and Albert Museum, etc.* 1972, under no. 40; R.-A. d'Hulst, *Jordaens Drawings*, vol. I, Brussels 1974, no. A 127, figs. 139-40; exhib. cat. *Jordaens in Belgisch bezit*, Antwerp, Koninklijk Museum voor Schone Kunsten, 1978, under no. 27; R.-A. d'Hulst, *Jacob Jordaens*, Antwerp 1982, p. 312, fig. 136; Tijs 1983, p. 326 (ill.).

Jordaens, like Rubens, was an extraordinarily prolific draftsman. There was a great need for drawings in their studios, especially for figure studies. This was due to the nature of the commissions they received – mainly large pictures with numerous figures, which they could not have produced without the help of apprentices and assistants,[1] who worked from the drawings and *modelli* supplied by the master. Jordaens's *modelli* are in bodycolor and watercolor on paper, in contrast to Rubens, who used oil on panel. After the latter's death in 1640 it was Jordaens who received most of the major commissions from churches and monasteries, civic bodies and private citizens.

Jordaens used the drawings on both the recto and verso of this sheet for the painting in Munich of a merry company seated at a table (fig. b),[2] the central portion of which was executed in the 1630s. The bagpiper from the Rotterdam drawing is in the center background of the painting, while the study of the hand pouring a glass of wine from a jug was employed for the young woman seated on the left of the table by the open window. This study of a bagpiper, which was undoubtedly done from life, was also used for a picture of 1638 in Antwerp (fig. c).[3] There, though, Jordaens altered the tilt of the head, after first making another preparatory drawing (fig. d).[4] The position of the hands on the instrument remained unchanged. From this one can perhaps conclude that the Munich painting originated slightly earlier or around the same time as the one in Antwerp.

Jordaens inscribed the latter work "*Soo d'ovde songen soo pepen de ionge*" (As the old sing, so twitter the young). Both pictures illustrate the Netherlandish saying that children ape their parents' behavior – in this case with a negative connotation. The verb *pepen* is a variant of both *piepen* (twitter) and *pijpen* (pipe), the latter in the sense of playing a wind instrument.[5] This proverb, needless to say, appears in Jacob Cats's anthology,[6] but that was not necessarily Jordaens's source. Elsewhere in Cats the proverb is rendered as "*Siet alderhande jongen die pijpen even soo gelijck de moeders songen*" (Look around you at the young, pipe they will as their mothers have sung).[7] In addition to the old man, almost all Jordaens's depictions of this subject contain two or three women of different ages.

Jordaens was evidently much attached to the themes of "As the old sing" and "The king drinks," the latter being a depiction of the Twelfth Night festivities, when the person receiving the piece of bread with a bean in it became king for a day. There are more than ten paintings of the two subjects in his own *œuvre* or that of his studio.[8] The general treatment of both themes is very similar: a boisterous group of people, young and old, overindulging in food and drink and singing lustily. In many cases only a minor detail distinguishes the two subjects, such as a crown on the head of the old man. It is even possible that the Munich merry company was originally a Twelfth Night scene, for recent X-ray examination has revealed a picture with a close resemblance to *The King Drinks* in Kassel.[9] Paintings of that subject often include a bagpiper as well, and there his puffed cheeks and the swollen bladder of his instrument may echo the Flemish saying, "You sing better on a well-filled belly."[10]

1. See d'Hulst (1974), p. 58.
2. Alte Pinakothek.
3. Museum voor Schone Kunsten.
4. Amsterdam, collection of the heirs of I.Q. van Regteren Altena. A third study of a bagpiper in yet another pose is in Paris, Institut Néerlandais, Fondation Custodia (coll. F. Lugt); d'Hulst (1974), no. A 129, fig. 142.
5. *Woordenboek der Nederlandsche Taal*, vol. XII, pt. 1, col. 1148.
6. J. Cats, *Spiegel van den Ouden en den Nieuwen Tijd*, vol. II, The Hague 1632, p. 13.
7. Ibid., vol. I, p. 65.
8. See Tijs 1983, pp. 325-26.
9. K. Renger, "Wie die Alten sungen, ...," *Kunst & Antiquitäten* IV, 1989, fig. 1.
10. De Mirimonde (1969), p. 222.

AM

fig. a

fig. b

fig. c

fig. d

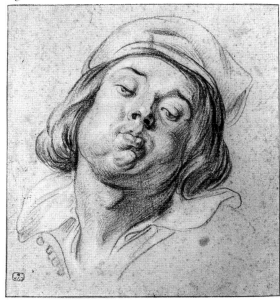

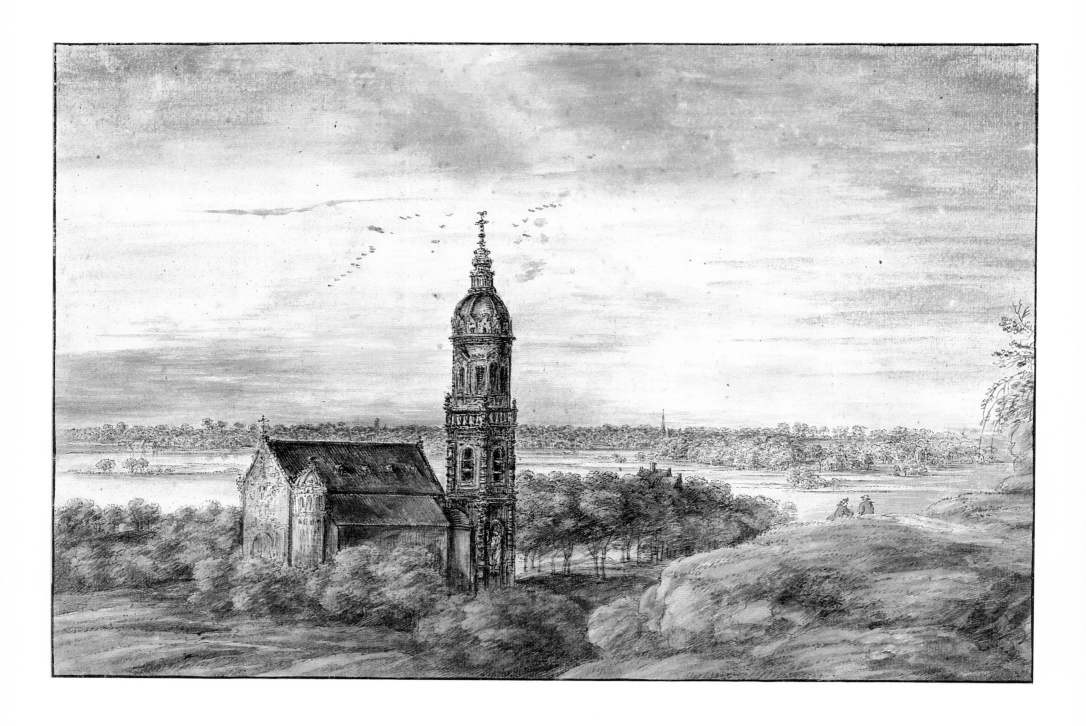

Lucas van Uden
Antwerp 1595–1672/73 Antwerp
LANDSCAPE WITH A CHURCH IN THE FOREGROUND

Watercolor over pen and brown ink; 204 × 304 mm.
Annotated in pencil on the verso in a
seventeenth-century (?) hand: *V Vden*
No watermark
Inv. V 99

Provenance: R. Peltzer, Cologne (L. 2231); his sale,
Stuttgart, May 13-14 1914, no. 425 (ill.);
T. Straus-Negbaur, Berlin (L. 2459a); her sale, Berlin,
November 25-26 1930, no. 98, fig. XXIII; F. Koenigs,
Haarlem (L. 1023a), acquired in 1930; D.G. van
Beuningen, Rotterdam, acquired in 1940 and donated to
the Boymans Museum Foundation.

Not previously exhibited

Literature: Bernt 1957-58, vol. II, no. 574 (ill.).

Van Uden's younger contemporary, Cornelis de Bie
(1627–c. 1715), a notary of Lier near Antwerp, and also
a playwright and biographer of artists, described his
paintings as "meltingly and sweetly executed," by which
he probably meant that Van Uden understood the art of
gradation, or allowing one color to merge smoothly
with the next.[1] One could say the same of his
watercolors, of which this is one.

Van Uden's reputation has always rested not so much
on his paintings as on his watercolors of the Flemish
landscape, all of which were executed over a pen
drawing in brown ink. In Van Dyck's *Iconography*, for
instance, in which only a few of the artists have an
attribute alluding to their profession, Van Uden is
holding such a sheet with a landscape scene (fig. a),
while the inscription describes him as a painter of
"*ruralium prospectus*," or rural views.

Van Uden made several copies after landscapes by
Rubens, which has given rise to the theory that he and
Jan Wildens painted the landscape backgrounds for the
master's paintings.[2] Although that is far from certain,[3]
the copies certainly indicate that he must have been
on a personal footing with Rubens.[4]

This watercolor shows an extensive landscape with a
river winding through it. On a hill in the foreground
stands a church with an ornate tower, which turns out
to be Carolus Borromeus, the great Baroque church of
the Jesuits on Hendrik Conscience Square in the heart
of Antwerp, which was built between 1615 and 1621 by
Pieter Huyssens (1577–1637), a Jesuit priest. Clearly
identifiable in the drawing are the tower, with its
distinctive rounded top, its constituent elements, the
semicircular choir at its foot, and one of the two corner
towers up against the facade (figs. b, c).[5] What is
missing is the majestic main front of the church.

Rubens was also involved in the building of the
Carolus Borromeus, making designs for the decoration
of the main front,[6] and of course executing the famous
ceiling paintings, which were destroyed by fire in the
eighteenth century. It has been discovered that he also
had a hand in the decorative elements of the tower.[7] As
Rubens himself wrote in 1622, the Carolus Borromeus
was one of the first churches north of the Alps to break
with the prevailing late Gothic style, returning instead
to the rules of Greek and Roman architecture.[8] The
design of the tower also betrays a deep knowledge of
the Italian Baroque, which could hardly have come from
Huyssens, since he had not yet visited Italy. Rubens,
though, had spent many years there.

We can only conjecture why Van Uden plucked the
church of Carolus Borromeus from the center of
Antwerp and set it down in the middle of this stretch of
countryside. Other seventeenth-century artists, however,
also placed a real church or secular building in an
imaginary setting. A comparable instance is found in a
painting by Anthonie van Beerstraten (active 1660–71),
who transported the Church of St Mary in Utrecht to
the quayside of a bustling port.[9]

1. Cornelis de Bie, *Het Gulden Cabinet vande edel vrij schilder
const...*, Antwerp 1662, p. 240: "*dommelachtigh en soet van
handelinghe*"; cf. *Woordenboek der Nederlandsche Taal*, vol. III,
pt. 2, s.v. *dommelen*.
2. Most recently by E. Larsen, *Seventeenth Century Flemish
Painting*, Freren 1985, p. 280.
3. W. Adler, *Jan Wildens: der Landschaftsmitarbeiter Rubens*,
Fridingen 1980, p. 11.
4. Ibid., figs. 290-95.
5. Fig. c shows the church as it is today; fig. c is a detail from
an engraving by Jacob Neefs (1610–after 1660), Hollstein,
Dutch and Flemish, vol. XIV, no. 32.
6. Held 1986, nos. 125-26, figs. 106-07, 125.
7. F. Baudouin, "De toren van de Sint-Carolus-Borromeuskerk
te Antwerpen," *Academiae Analecta. Mededelingen van de
Koninklijke Academie voor Wetenschappen, Letteren en Schone
Kunsten van België*, Klasse der Schone Kunsten, XLIV, 1983,
no. 3, pp. 15-56.
8. Rubens makes this observation in the introduction to his
Palazzi di Genova, Antwerp 1622; see further J.R. Martin, *The
Ceiling Paintings for the Jesuit Church in Antwerp* (Corpus
Rubenianum Ludwig Burchard I), Brussels 1969, p. 25, note 6.
9. See *Catalogus der schilderijen*, Utrecht, Centraal Museum,
1952, no. 1035, fig. 166.

AM

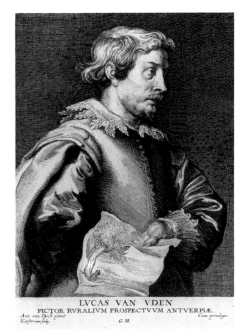

LVCAS VAN VDEN
PICTOR RVRALIVM PROSPECTVVM ANTVERPIÆ.
Ant. van Dyck pinxit. *Cum privilegio*
V conforman fecit. *G. H.*

figs. a, b, c

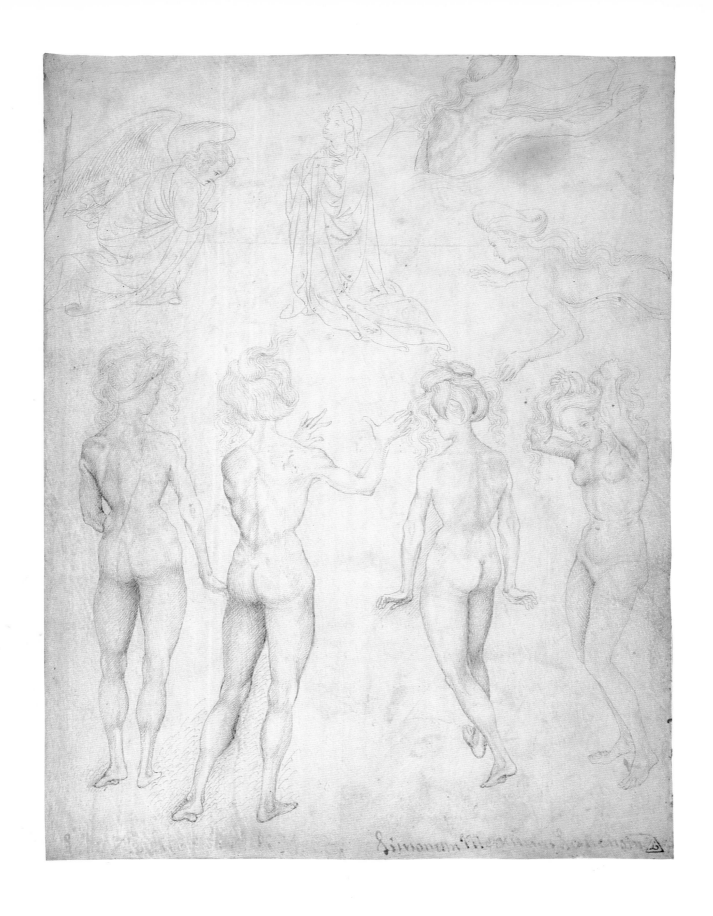

Italian School

53

Vittorio or Antonio di Puccio (Pisano), called Pisanello
Pisa c. 1395–1455 Rome (?)
FOUR STUDIES OF A FEMALE NUDE, AN ANNUNCIATION, AND
TWO STUDIES OF A WOMAN SWIMMING

Pen and brown ink on vellum; 223 × 167 mm.
At lower right: *Simonum Memius Senensim* in pen and
brown ink
Verso: *Warriors Fighting over the Body of an Amazon;
Two Seated Amazons*, pen and brown ink, brown wash
Inv. I 520

Provenance: Count Moriz von Fries, Vienna (L. 2903);
J.B.F.G. de Meyran, Marquis de Lagoy, Aix-en-Provence
(L. 1710); probably sale Paris (Bénard), April 17 1834;
F. Koenigs, Haarlem (L. 1023a), acquired in 1930; D.G.
van Beuningen, Rotterdam, acquired in 1940 and
donated to the Boymans Museum Foundation.

Exhibitions: Düsseldorf 1929, no. 17; Paris 1932, no. 90;
Amsterdam 1934, no. 611; Paris 1935-II, no. 646; Paris
1952, no. 1; Rotterdam 1952, no. 76; Paris, Rotterdam,
Haarlem 1962, no. 8; Venice, Florence 1985, no. 7;
Rome 1988, no. 45 (verso).

Literature: A. de Hevesy, "Zur Pariser Pisanello
Ausstellung," *Pantheon* IX, 1932, p. 148; A. van
Schendel, "De tentoonstelling Italiaansche kunst in het
Stedelijk Museum," *Maandblad voor Beeldende Kunst* XI,
1934, p. 243; L. Venturi, "Nell'esposizione d'arte italiana
ad Amsterdam," *L'Arte* XXXVII, 1934, p. 494;
B. Degenhart, *Antonio Pisanello*, Vienna 1941, pp. 24, 27,
50, 65; B. Degenhart, *Pisanello*, Turin 1945, pp. 21, 30,
49, 72; B. Degenhart, "Le quattro tavole delle leggenda
di S. Benedetto: opere giovanili del Pisanello," *Arte
Veneta* III, 1949, p. 16; W.R. Deusch, *Die Aktzeichnung
in der Europaeischen Kunst 1400-1950*, Berlin 1950,
pp. 12, 42; Haverkamp Begemann 1957, no. 33;
L. Magagnato in exhib. cat. *Da Altichiero a Pisanello*,
Venice, Fondazione Giorgio Cini, 1958, p. 90;
J. Rosenberg, *Great Draughtsmen from Pisanello to Picasso*,
Cambridge, Mass. 1959, p. 7; J. Bean, *Les dessins italiens
de la collection Bonnat* (Inventaire général des dessins des
Musées de Province 4), Paris 1960, under no. 223;
B. Degenhart and A. Schmitt, "Gentile da Fabriano in
Rom und die Anfänge des Antikenstudiums," *Münchner
Jahrbuch der Bildenden Kunst* IX, 1960, pp. 67, 112,
120-21, note 5, 129, note 20, 127, note 30; E. Sindona,
Pisanello, Milan 1961, pp. 59, 127; M. Fossi Todorow,
"Un taccuino di viaggi del Pisanello e della sua
bottega," *Scritti di Storia dell'Arte in onore di Mario
Salmi*, vol. II, Rome 1963, pp. 135, 138-39; K. Edschmid,
Aktzeichnungen grosser Meister, Vienna 1963, p. 149;
M. Fossi Todorow, *I disegni del Pisanello e della sua
cerchia*, Florence 1966, pp. 19, 20, 57-58, no. 2; Byam
Shaw 1967, p. 45; M. Baxandall, *Painting and Experience
in Fifteenth Century Italy*, London, Oxford, New York
1972, p. 78; R. Chiarelli, *L'opera completa del Pisanello*,

Milan 1972, no. 15; F. Anzelewsky, "Handzeichnungen
und Druckgraphik in Spätmittelalter und beginnende
Neuzeit," *Propyläen Kunstgeschichte* VII, Berlin 1972,
p. 251, no. 157; G. Paccagnini, *Pisanello e il ciclo
cavalleresco di Mantova*, Milan 1973, p. 148; J. Byam
Shaw, *Maestri veneti del Quattrocento* (Biblioteca di
Disegni, vol. III), Florence 1978, no. 7; J. Meder and
W. Ames, *The Mastery of Drawing*, New York 1978,
p. 15, fig. 12; Pignatti 1981, pp. 72-73.

This extremely delicate drawing is most often assigned
to Pisanello's early career, the mid-1420s, because of
the truly remarkable resemblance of the facial features
and the position of the head of the figure on the far
right, who is binding up her tresses, to the Virgin in
the *Annunciation* in the Basilica of San Fermo Maggiore,
Verona (fig. a).[1]

On the sheet – one of the most extraordinary nude
drawings of the early Renaissance – a standing female
model is studied in four different poses. In the upper
right corner two nude female figures are seen
swimming. The profile of the one at the top, who is
making her way along a summarily indicated
embankment, is identical to that of the standing figure
at bottom left, while that of the swimmer just below
her corresponds to the second woman from the right.
Pisanello may have been attempting to represent figures
in action using the ones he had previously drawn from
life, for no model seems to have been used in the case
of the swimmers.

In the more elaborated foreground studies, the artist
concentrated chiefly on an accurate rendering of the
anatomy. It is impressive to see how he modeled the
bodies with subtle hatching while tending at the same
time to such details as the light on an ankle, the
foreshortening of a foot or the form of a shoulder
blade. Here and there broader hatching is applied
around the figures, and there are rhythmic strokes
around the legs of the second from the left. Pisanello
also took liberties with the women's hair, treating it
almost like decoration in the manner of Stefano da
Verona (*c.* 1375–after 1438), his presumed teacher.

What the artist was planning to do with these studies
is not altogether clear. The nudes, seen three-quarters
from behind, are reminiscent of the three Graces,[2]
but Pisanello could just as easily have been thinking of
Venus. Medieval representations of Venus-Luxuria
swimming do exist, sometimes – as in illustrations of
the *Ovide moralisé* – with nude female bathers looking
on.[3] Worth noting in this connection is another
drawing by Pisanello of the personification of Luxuria
(fig. b). Preserved in the Albertina, Vienna, it dates from
the same period and is closely related in style to the
drawing under discussion.[4] Pisanello may well have been
inspired by French and Flemish paintings of the subject
and by miniatures. He could have become familiar with
the latter during his sojourn at the court of the
Gonzaga in Mantua between 1424 and 1426, exactly the
period in which the drawing was made.[5]

As to the *Annunciation* at upper left, the suggestion
has been made that it was added by a student close to
Pisanello, but this is by no means certain.[6] Admittedly
the two figures are little more than outlines, but then
this is not unusual for the artist. This part of the sheet
may not have been drawn at the same time as the rest,
which could explain the slight deviation. However, on
closer examination both the style and the contours of
the figures are not significantly different from the
rendering of the swimmer on the right. The scene

fig. a

fig. b

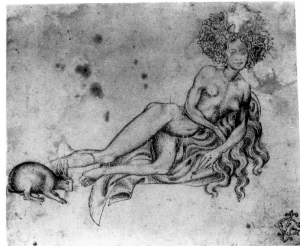

could well be a copy after a painting, but if the sheet is contemporaneous with Pisanello's superb *Annunciation* in San Fermo, it is hardly surprising that the subject would have been on his mind.

A different artist was doubtless responsible for the drawing on the verso. The subject – a struggle between warriors around a fallen Amazon, together with studies of separate figures – and the style are so different from those on the recto that they cannot possibly be attributed to Pisanello (fig. c). One of his students probably copied them after sheets of sketches either by the master or by Gentile da Fabriano (*c.* 1370–1427), who was one of the first artists to draw fragments of classical sculpture.[7] Both the group in the center and the two seated Amazons at the top of the sheet are copies after the so-called *Sarcophagus of the Amazons*, which stood in the front courtyard of the Roman church of SS Cosma e Damiano in Pisanello's day. In the mid-sixteenth century the sarcophagus was dismantled, and its various parts scattered. The sculpted lid on which the two captured Amazons appear seated is now in the British Museum, London, while the left side (fig. d) has been erected in the Cortile del Belvedere of the Vatican.[8]

The drawing is one of the few made after classical sculpture during the early Renaissance in which subjects are represented in a group, just as they appear in the original. Artists were generally interested only in isolated figures, and ignored the rest of the composition, paying no attention to the myth or the iconographical context.[9] The origin of the man at the very bottom of the sheet is not entirely clear. A similar figure is found on the far left of the sarcophagus fragment, partly overlapped by the shield with which he is defending himself against the attacking horseman (fig. c). It could be that the draftsman copied this figure, completing it according to his own imagination. In any event, he seems to have had difficulty with the sculptor's ingenious method of suggesting depth, for he placed the warrior facing left at the center of the image in front of, rather than behind, the fallen Amazon.

The inscription on the recto, "*Simonum Memius Senensim*", has been attributed to the seventeenth century biographer Carlo Ridolfi on the basis of the handwriting. The same hand inscribed a large group of related drawings by Pisanello, Gentile da Fabriano and others. Like the exhibited sheet, most of this material was intended for study. In the early nineteenth century the majority of the drawings were divided between Count Moriz von Fries (1777–1826) and Marquis de Lagoy (1764–1829), only to be scattered over various collections after 1834. No less than ten of the sheets were acquired by Franz Koenigs in about 1930.[10]

1. Degenhart (1945), and Fossi Todorow (1966), pp. 57-58, no. 2. For Pisanello's *Annunciation* see Chiarelli (1972), no. 17, pls. VIII-IX.
2. Cf. E. Wind, *Pagan Mysteries in the Renaissance*, New York 1968, pp. 26-35, figs. 9-19.
3. E. Panofsky, "Blind Cupid," *Studies in Iconology: Humanistic Themes in the Art of the Renaissance*, New York 1962, pl. XLVIII, figs. 86-87, and J. Seznec, *The Survival of the Pagan Gods*, Princeton 1972, p. 107, fig. 31.
4. Fossi Todorow (1966), p. 57, no. 1.
5. Paccagnini (1973), p. 148.
6. Fossi Todorow (1966), p. 58, and Anzelewsky (1972), no. 157.
7. Degenhart and Schmitt (1960), pp. 59-151.
8. Ibid., pp. 112-13 and 116-17, figs. 86-88, and exhib. cat. Rome 1988, no. 45.
9. Exhib. cat. Rome 1988, pp. 147-60.
10. Degenhart and Schmitt (1960), pp. 67-68; R.W. Scheller, *A Survey of Medieval Model Books*, Haarlem 1963, pp. 171-75, cat. no. 25; and B. Degenhart and A. Schmitt, *Corpus der italienische Zeichnungen 1300-1450, Teil I. Süd und Mittelitalien*, Berlin 1968, vol. I, pt. 1, pp. 236-37, under no. 127, vol. II, Exkurs II. For the drawings from this group collected by Koenigs see Degenhart and Schmitt (1960), p. 137, under Rotterdam.

GL

fig. c

fig. d

54

Workshop of Benozzo Gozzoli
Florence 1420–1497 Pistoia
SHEET WITH STUDIES OF ST JOHN THE BAPTIST
AND A STANDING AND A RECLINING FIGURE
SHEET WITH SEATED AND RECLINING FIGURES

Silverpoint, pen, brush and brown ink on violet
prepared paper, heightened with white;
each 229 × 160 mm.
On no. 54b: the number 57 (or 51) crossed out
and replaced by *49*
Inv. I 561, fol. 9B-10

Provenance: Prince Don Carlo (?) Trivulzio, Milan, as
part of the Biblioteca Trivulziana, Codex 2145;
F. Koenigs, Haarlem (L. 1023a), acquired in the late
1920s; D.G. van Beuningen, Rotterdam, acquired in
1940 and donated to the Boymans Museum Foundation.

Exhibitions: London 1930, no. 429; Amsterdam 1934,
no. 456; Rotterdam 1952, no. 83; Paris, Rotterdam,
Haarlem 1962, no. 17.

Literature: C. Amoretti, *Memorie storiche per la vita, gli
studi e le opere di Leonardo da Vinci*, Milan 1804, p. 45;
G. Porro, *Catalogo dei codici mss. della Trivulziana*, Turin
1886, p. 369, no. 2145; A.E. Popham, "A Book of
Drawings of the School of Benozzo Gozzoli," *Old
Master Drawings* IV, 1929-30, pp. 53-58; M. Salmi, "Un
libro di disegni fiorentino del secolo XV," *Rivista d'arte*
XII, 1930, pp. 87-95; K. Clark, "Italian Drawings at
Burlington House," *Burlington Magazine* LVI, 1930,
p. 175; Popham 1931, no. 26; Berenson 1938, vol. II,
pp. 43-53, no. 558B; Juynboll 1938, pp. 18-19;
A. Mongan, *One Hundred Master Drawings*, Cambridge,
Mass. 1949, p. 18; A.E. Popham and P. Pouncey, *Italian
Drawings in the Department of Prints and Drawings in the
British Museum. The Fourteenth and Fifteenth Centuries*,
London 1950, under nos. 87, 90 and 91; Berenson 1961,
vol. II, no. 559G-I; M. Muraro, exhib. cat. *Venetian
Drawings from the Collection Janos Scholz*, Venice,
Fondazione Giorgio Cini, 1957, under no. 2;
R.W. Scheller, *A Survey of Medieval Model Books*,
Haarlem 1963, pp. 207-11, cat. no. 30; B. Degenhart and
A. Schmitt, *Corpus der Italienischen Zeichnungen
1300-1450. I. Süd- und Mittelitalien*, Berlin 1968, vol. I,
pp. 478-90, nos. 434-69, vol. II, pls. 327-38; M. Baxandall,
Painting and Experience in Fifteenth Century Italy,
London, Oxford, New York 1972, pp. 61-62; C. Marks,
From the Sketchbooks of the Great Artists, New York 1972,
pp. 34-36; C.L. Ragghianti and G. dalla Regoli, *Firenze
1470-1480: disegni dal modello*, Pisa 1975, p. 30; F. Ames
Lewis, *Drawing in Early Renaissance Italy*, New Haven,
London 1981, pp. 79-81; L. Fusco, "The Use of
Sculptural Models by Painters in Fifteenth-Century
Italy," *Art Bulletin* LXIV, 1982, p. 175; F. Ames Lewis
and J. Wright, exhib. cat. *Drawing in the Italian*

Renaissance Workshop, Nottingham, University Art
Gallery, London, Victoria and Albert Museum, 1983,
under no. 64; S. Pasti in exhib. cat. Rome 1988,
pp. 135-41, and A. Nesselrath in idem, under no. 83
(the album in each case).

For cat. no. 54a: Popham (1929-30), p. 55, fol. 9B;
Salmi (1930), p. 95; Degenhart and Schmitt (1968),
vol. I, p. 484, no. 448; cat. no. 54b: Popham (1929-30),
p. 55, fol. 10; Salmi (1930), p. 90; Popham and Pouncey
(1950), under no. 91; Berenson 1961, vol. II, p. 102;
Degenhart and Schmitt (1968), vol. I, p. 485, no. 452;
Ames-Lewis (1981), pp. 80-81.

These two sheets form folios 9 verso and 10 of a small
album from the studio of Benozzo Gozzoli. Comprising
a total of thirty-three pages of diverse studies and
bound in parchment with the rather absurd inscription
"*di leon da Vinci*" on the spine, the album is one of the
most famous rarities collected by Fritz Koenigs. It is a
rich source of information about artistic practices in the
Quattrocento, and about the importance of drawings in
the dissemination of figures and motifs.

The series of drawings in the album is not complete,
as evidenced by the incoherent numbering system and
by the comparable numbers inscribed on loose sheets
now in Stockholm, London, Venice and Paris that must
have originally been bound with them.[1] There has been
speculation that several other single drawings were
removed from the album as well; its original size can be
deduced from an inscription on one of the drawings in
Rotterdam: "*carte 85*".[2]

The sheet that now serves as the album's title page
bears a remarkable quotation which was adopted as a
motto by visual artists who sought to emancipate
themselves by likening painting to poetry. The
quotation comes from a passage in Horace's *Ars poetica*
that was crucial to the "*ut pictura poesis*" theory, and

reads: "*Pictoribus atque poetis semper fuit et erit equa
potestas*," meaning "Painters and poets have always had
an equal right in hazarding anything."[3]

Given the great differences between the drawings as
regards style and the materials used, they cannot
possibly have all been executed by the same hand,
although the parallels between them and works by
Gozzoli are such that they probably all originated in his
workshop. Berenson attempted to assign individual
sheets to artists closely associated with the Tuscan
master, such as Domenico di Michelino, the "Alunno
di Benozzo" and Giovanni Boccati da Camerino – a
hazardous undertaking in this case, since most of the
drawings are copies after other sheets.[4]

The album contains studies of, or copies after, a rich
variety of subjects: architectural elements, floral subjects
and decorative scrolls, figures painted by both Fra
Angelico and Gozzoli, the bronze horse from the
equestrian statue of Marcus Aurelius on the Capitoline,
animals such as a pair of oxen drawn by Pisanello and
a camel from Gozzoli's fresco in the Palazzo
Medici-Riccardi, Florence, fourteen different hand
positions, a cast of a sculpted foot, and various figures
on brightly colored, prepared paper such as these two
sheets.

It is not difficult to imagine the kind of frescoes and
paintings for which such a range of studies was deemed
necessary. Indeed there are works not only by Gozzoli
but also by other Florentine painters of the second half
of the fifteenth century that seem like a visual
summation of such a collection.

In his *Libro dell'arte* of *c*. 1390, Cennino Cennini had
advised studio apprentices to copy above all else the
drawings of good artists. Judging from the Rotterdam
album, which most closely resembles a medieval model
book, Gozzoli's drawings must have circulated among
his students.[5] This is not to say that all the drawings
were made directly after originals by the master; some
were copied after copies by others, and thus gradually

fig. a

fig. b

fig. c

strayed further from the model. At times students would misunderstand particular forms, or lack the technique necessary to achieve credible results. The process can be compared to a game of "pass it on," in which the third player in the circle passes on a totally different word from the one with which the game started. The drawings were not always copied in their entirety, moreover, and elements from various sheets were often combined.

The first of the two sheets exhibited here includes a half-length John the Baptist and two studies of the same nude male model lying as though asleep, and standing with a cane in hand, looking over his shoulder. Judging from Gozzoli's paintings, the latter pose was one of his favorites. The reclining figure was presumably borrowed from another sheet in the album where he appears full length (fig. a).[6] Of the two draftsmen involved, the one responsible for the latter was obviously the more accomplished: the placement of the figure on the surface of the sheet is well considered, the right hand fitting perfectly into the upper left corner, and the left foot is beautifully foreshortened. Yet another draftsman copied the man seated below the reclining figure, but had little understanding of anatomy. This separate, rather stiff drawing is likewise in Rotterdam (fig. b).[7]

The seated man in the second exhibited drawing was also repeated (fig. c). The number "26" at lower left on that sheet, which is now in the British Museum, indicates that it once belonged to the album as well, though there is evidence that it had already been removed by the seventeenth century.[8] The far from faultless anatomy of the Rotterdam drawing is even less plausible in the London copy, which is not to deny that the struggle to represent the human figure produced drawings with a certain naive charm. It is remarkable that the artist of the London copy repeated not only the empty space between the arm and body, which is filled in with the brush, but also the shadow along the left side of the figure, executed with pen and brush. Moreover, in the upper right corner is a very

Gozzoli-like profile in silverpoint that corresponds exactly with a profile sketch in the same corner of a sheet in the Rotterdam album (fig. a).

The study of the foreshortened, reclining man in the second of the Rotterdam sheets – probably the same model who posed for the seated figure, going by the shape of the head and the burly physique – has been used to date both of them.[9] One finds an identical pose in the foreground of Gozzoli's fresco, *The Destruction of Sodom*, in the Campo Santo in Pisa, which is dated 1474 (fig. d).[10] It has been assumed that the drawing postdates the fresco, but this was not necessarily the case. It was customary for artists to maintain a collection of models to which they would return repeatedly over a long period of time. The reclining figure in the fresco could thus easily be based on an earlier drawing by Gozzoli, from which the man in the Rotterdam drawing could have been copied, like so many of the studies in our album.

A strongly foreshortened pose such as this was common in the Renaissance, especially for scenes of combat. Fallen warriors lie in just such an attitude in the foreground of many painted battle scenes, if only to demonstrate the artist's mastery of perspective. It is not surprising that, when printed books of models superseded gatherings such as the Rotterdam album in the course of the sixteenth century, they contained figures in similar poses (fig. e).[11]

As a possible date for these drawings, 1474 is rather late. Most of them can be linked to works painted by Gozzoli in the 1450s, just as the flower watermark found in some of the sheets corresponds to paper produced during that decade.[12]

1. Degenhart and Schmitt (1968), vol. I, pp. 478-79, and pp. 481-87, nos. 438-40, 443-44, 451, 458 (with the old numbering), pp. 487-90, nos. 461-69 (numbers trimmed off).
2. Degenhart and Schmitt (1968), vol. I, no. 434, vol. II, pl. 327a.

3. Ibid., vol. I, no. 441, vol. II, pl. 328e. For the quotation see Horace, *Satires, Epistles and Ars Poetica*, ed. H. Rushton Fairclough, London etc. 1936, p. 451 and A. Chastel, "Le dictum Horatii quidlibet potestas et les artistes (XIIIe-XVIe siècle)," in *Fables, formes, figures*, vol. I, Paris 1978, pp. 363-76, esp. "Appendice," pp. 376 and 365, fig. 163.
4. Cf. Berenson 1938, vol. II, under no. 558B. The attribution of fol. 3, *Bust of a Man*, to Giovanni Boccatis in Berenson 1961, vol. II, p. 101, nos. 559G-I, was supported by P. Pouncey, who cited a Boccatis drawing in the Louvre which Berenson, vol. II, no. 559C, was still ascribing to Gozzoli; see "Review Bernard Berenson, I Disegni dei pittori fiorentini," *Master Drawings* II, 1964, p. 283 and pl. 31.
5. Cennino d'Andrea Cennini, *The Craftsman's Handbook. The Italian "Il Libro dell'arte"*, translated by D.V. Thompson Jr., New York 1960, ch. XXVII, pp. 14-15. See for the modelbook tradition U. Jenni, "The phenomena of change in the modelbook tradition around 1400," in W. Strauss, T. Felker eds., *Drawings defined*, New York 1987, pp. 35-47.
6. Degenhart and Schmitt (1968), vol. I, no. 449. This reclining figure also recurs in a rather ghostly form on the verso of a sheet in Rome, Gabinetto Nazionale delle Stampe, inv. 128283/84, with the head of a bishop, regarded as an original Gozzoli by Degenhart and Schmitt (1968), vol. I, no. 410, vol. II, pl. 318), and probably once part of the same sketchbook. That sketch would have been added to Gozzoli's drawing by a pupil.
7. Degenhart and Schmitt (1968), vol. I, no. 436, who follow Popham (1929-30), p. 54, fol. 12, in suspecting that it was executed later, when the album had already been bound.
8. Popham and Pouncey (1950), p. 54, no. 91; Degenhart and Schmitt (1968), vol. I, no. 440. As shown by the number "g.7", this drawing was in the possession of Padre Sebastiano Resta in the seventeenth century (see also cat. no. 56).
9. Popham (1929-30), p. 57.
10. M. Bucci and L. Bertolini, *Camposanto Monumentale di Pisa: affreschi e sinopie*, Pisa 1960, pp. 125-26 and fig. p. 126.
11. Erhard Schön, woodcut in *Unnderweisung der Proporzion...*, Nuremburg 1538, reproduced in *The Illustrated Bartsch*, vol. XIII, New York 1986, p. 152, no. 34n.
12. The watermark is Briquet 6654-55, which occurred in Rome 1452-53, Perugia 1456-58 and Pisa 1464-69; see Degenhart and Schmitt (1968), vol. I, p. 479 and under nos. 435 and 450, also pp. 653 and 658, WZ 68.

GL

figs. d & e

55

Vittore Carpaccio
Venice 1455 or later–1525/26 Venice
HEAD OF AN OLD MAN

Black chalk, brush and brown ink on brown paper,
heightened with white; 128 × 123 mm.
No watermark
Inv. MB 1940/T 8

Provenance: S. Bonfiglioli, Bologna; B. Bonfiglioli,
Bologna and Venice; Z. Sagredo, Venice, acquired from
the Bonfiglioli estate between 1728 and 1734; J. Udney,
consul at Venice, acquired from the Sagredo estate in
1763; Earls van Sunderland; G.C. Spencer Churchill,
Duke of Marlborough, Blenheim Palace, Woodstock;
sale London (Christie's), June 15 1883, probably lot
114, to Thibeaudeau;[1] J.P. Heseltine, London (L. 1507);
P.&.D. Colnaghi and Obach, London, 1912;
H. Oppenheimer, London; sale London (Christie's), July
10-14 1936, no. 55; F. Lugt, The Hague; F. Koenigs,
Haarlem, acquired in 1936; donated by Koenigs to the
Boymans Museum Foundation in 1940.

Exhibitions: Rotterdam 1952, no. 87; Amsterdam 1953,
no. T 16; Paris, Rotterdam, Haarlem 1962, no. 35;
Venice 1963, p. 291, no. 1; Venice, Florence 1985,
no. 12.

Literature: S. Colvin, "Uber einige Zeichnungen des
Carpaccio in England," *Jahrbuch der Königliche
Preussischen Kunstsammlungen* XVIII, 1897, pp. 203-04;
J.P. Heseltine, *Original Drawings by Old Masters of the
Schools of North Italy*, London 1906; D. von Hadeln,
Venezianische Zeichnungen des Quattrocento, Berlin 1925,
p. 58, no. 25; K.T. Parker, *North Italian Drawings of the
Quattrocento*, London 1927, p. 32, pl. 52; K.T. Parker,
*Catalogue of the Famous Collection of Old Master Drawings
Formed by the Late Henry Oppenheimer, Esq., F.S.A.*,
London 1936, no. 55; C.L. Ragghianti, "Due disegni del
Carpaccio," *Critica dell'Arte* I, 1936, p. 279; G. Fiocco,
Carpaccio, Milan 1942, pp. 78, 80; Tietze 1944, no. 621;
C.L. Ragghianti, "Carpaccio e i suoi disegni," *Miscellanea
di Critica d'Arte*, Bari 1946, pp. 119-20; G. Fiocco,
Carpaccio, Novara 1958, p. 31; J. Lauts, *Carpaccio:
Paintings and Drawings*, London 1962, pp. 253, 276,
no. 48; T. Pignatti, "Review of Jan Lauts, Carpaccio:
Paintings and Drawings," *Master Drawings* I, no. 4,
1963, p. 50; M. Muraro, *Carpaccio*, Florence 1966, pp. 76,
110; Byam Shaw 1967, p. 45; G. Perocco, *L'Opera
completa di Carpaccio*, Milan 1967, pp. 86-87; M. Muraro,
I disegni di Vittore Carpaccio (Corpus graphicum II),
Florence 1977, p. 76.

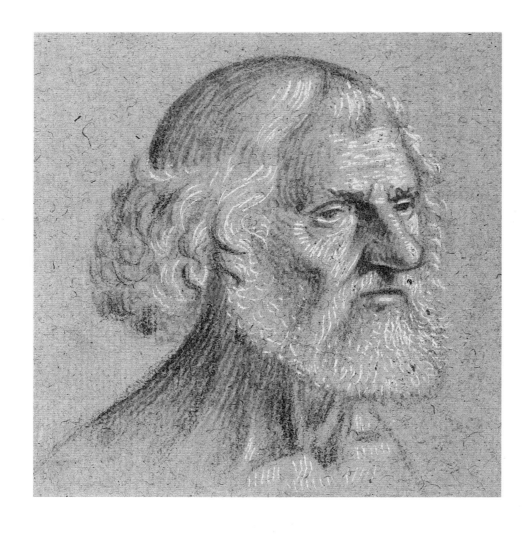

Whether or not Vittore Carpaccio was a student of Gentile Bellini, as many believe, he certainly shared that artist's tendency to crowd his paintings with figures. To this end he made numerous studies of figures and heads, many of which survive and serve to reconstruct his working method to some extent.

Before starting work on a painting, Carpaccio would make at least one composition sketch with pen or brush on white paper, indicating the figures and other compositional elements only cursorily. Then, on blue or brown paper, he would work out each figure separately, paying close attention to the lighting, the position of the arms and hands, and the face. This method, which was also practiced by other fifteenth and sixteenth-century Venetian artists, must have appealed to Albrecht Dürer, for he too started making detail studies on colored or prepared paper shortly after he had been in Italy (see cat. no. 6, for instance).

Whenever Carpaccio was especially satisfied with his rendering of a head or a figure, he would often use it again at some later date, reversing or otherwise adapting it if need be. He was a master at handling groups, and certainly in the great cycles he painted, such as in the Scuola di Sant'Orsola in Venice, that talent served him well. In his famous cycle of the legend of St George in the Scuola di San Giorgio degli Schiavoni, for instance, we can see how he used the group of Turkish musicians, with the intent drummer and the foreshortened brass player, in two different ways. In one scene they have been placed prominently in the foreground, while in the previous scene exactly the same figures, greatly reduced in size, appear in the princess's entourage.[2]

Carpaccio also used the Rotterdam drawing of a bearded man's head in at least two paintings, both of them altarpieces: the first time for St Peter in the now badly damaged polyptych in the Cathedral of Zara, Yugoslavia (fig. a),[3] and later for one of the apostles at the deathbed of the Virgin, in a painting dated 1508 and now preserved in the Pinacoteca of Ferrara (fig. b).[4] The exact date of the painting in Zara is a matter of dispute.[5] Judging from its style it must have been painted prior to the Ferrara *Death of the Virgin*, probably towards the end of the fifteenth century. This would mean that at least ten years passed before Carpaccio returned to the same drawing for the head of the apostle in Ferrara.

That painting offers further evidence that the artist consulted his stock of drawings. In 1502, for instance, he had already used the drawing for the apostle with the long white beard (fig. c; Paris, Fondation Custodia, coll. F Lugt)[6] in *The Calling of St Matthew* in the Scuola di San Giorgio degli Schiavoni (Venice).[7] The two sheets share the same remarkable provenance, seem to have been drawn from life, and resemble one another as regards technique, even if the hatching on the back of the head and neck of the Rotterdam figure is somewhat heavier than that of the one in Paris. It has been suggested that Carpaccio retouched those parts of the head somewhat in order to enhance the chiaroscuro.[8] In the Ferrara painting, as in the drawing, he sought to describe the neck muscles as realistically as possible.

This drawing was not among the collection loaned to the Boymans Museum by Franz Koenigs in 1935. He gave it to the museum in 1940, together with another splendid study by Carpaccio which he had bought at the Oppenheimer sale, as a token of his gratitude for the fact that, thanks to the intervention of D.G. van Beuningen, his collection had been secured for the museum.[9]

1. For the earliest provenance see J. Byam Shaw, *The Italian Drawings of the Frits Lugt Collection*, vol. I, Paris 1983, p. 226, under no. 223.
2. See the illustrations in Perocco (1967), pls. XLIII, XLV, XLVI.
3. Lauts (1962), pp. 253-54, no. 93, pl. 74.
4. Ibid., p. 241, no. 46.
5. See Perocco (1967), pp. 86-87, no. 6.
6. Byam Shaw, op. cit. (note 1), vol. I, pp. 226-27, no. 223, vol. III, pls. 253, 252.
7. Perocco (1967), p. 97, no. 33A.
8. Byam Shaw 1967, p. 45, no. 3.
9. See the letter of April 17 1940 from Franz Koenigs to D.H. Hannema, director of the Museum Boymans: "*Ons verheugt het, dat de collectie in Holland is gebleven en wij zien haar natuurlijk het liefst in Museum Boymans. Om aan deze gevoelens uiting te geven, heb ik U... twee teekeningen van Carpaccio uit de collectie Oppenheimer voor het Museum toegezonden. Zij kunnen wellicht eene steeds door mij gevoelde leemte in de opeenvolging der Venetiaansche teekeningen eenigszins aanvullen.*" (We are glad that the collection has remained in Holland, and of course prefer to see it in the Boymans Museum. In order to give expression to these sentiments I have sent you, for the museum, ... two drawings by Carpaccio from the Oppenheimer Collection. Perhaps they may to some extent fill a gap that I have always felt existed in the sequence of Venetian drawings. [Archives of the Boymans-van Beuningen Museum]). The second Carpaccio drawing donated by Koenigs is a study for one of the monks kneeling around the body of St Jerome in one of the scenes in the Scuola di San Giorgio Degli Schiavoni; see Muraro (1977), p. 75, no. 1-3, fig. 19.

GL

fig. a

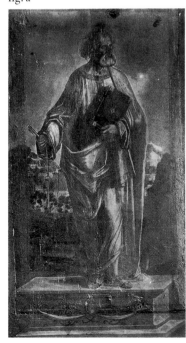

fig. b

fig. c

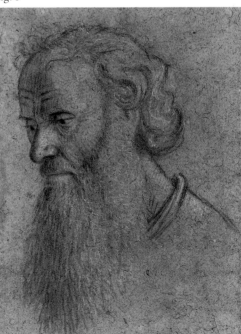

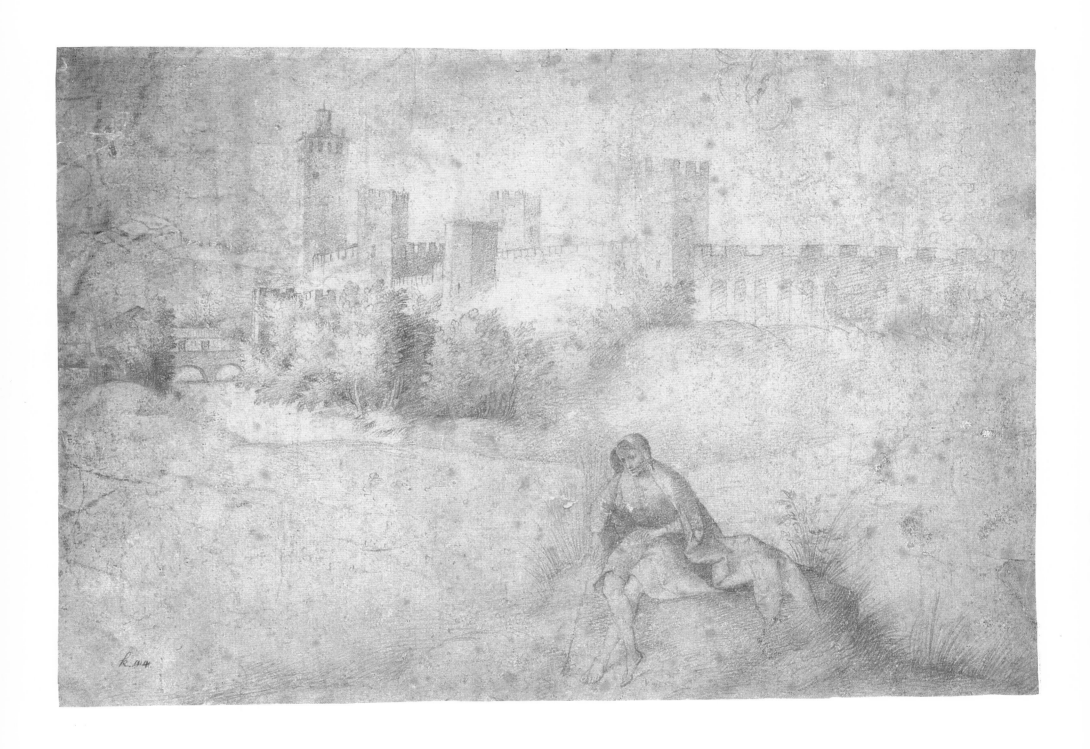

56

Giorgio da Castelfranco, called Giorgione
Castelfranco Veneto 1478–1510 Venice
VIEW OF CASTEL SAN ZENO, MONTAGNANA,
WITH A SEATED FIGURE IN THE FOREGROUND

Red chalk, laid down; 203 × 290 mm.
In the lower left corner, in the hand of Padre
Sebastiano Resta: *k.44.* in pen and brown ink
No watermark
Inv. I 485

Provenance: Padre S. Resta, Milan (L. 2992);
G.M. Marchetti, Bishop of Arezzo; Chevalier Marchetti,
Pistoia (cf. L. 2911), acquired in 1704; John Lord
Somers, Worcester and London (cf. L. 2981), acquired
in 1710; C. Rogers, London, acquired in 1759; probably
sale London (T. Philipe) April 15 1799; Sir
J.C. Robinson, London (cf. L. 1433); L. Böhler, Munich;
J.W. Böhler, Lucerne; F. Koenigs, Haarlem (L. 1023a),
acquired in 1929; D.G. van Beuningen, Rotterdam,
acquired in 1940 and donated to the Boymans Museum
Foundation.

Exhibitions: London 1930, no. 700; Amsterdam 1934,
no. 554; Paris 1935, no. 553; Amsterdam 1953, no. T18;
Venice 1955, Disegni 1; Paris, Rotterdam, Haarlem
1962, no. 72; Venice, Florence 1985, no. 15;
Washington 1988-89, no. 4.

Literature: F. Becker, *Handzeichnungen alter Meister in
Privatsammlungen*, Leipzig 1922, p. 12, no. 36; D. von
Hadeln, *Venezianische Zeichnungen der Hoch-Renaissance*,
Berlin 1925, p. 32, no. 3; H. Leporini, *Die Stilentwicklung
der Handzeichnung: XIV. bis XVIII. Jahrhunderts*, Vienna,
Leipzig 1925, no. 107; L. Justi, *Giorgione*, vol. II, Berlin
1926, p. 300; A. Venturi, *Storia dell'arte italiana*, Milan
1901-40, vol. IX, pt. 3, p. 22; A.E. Popham, *Italian
Drawings Exhibited at the Royal Academy, Burlington
House, London 1930*, London 1931, p. 70; *Commemorative
Catalogue of the Exhibition of Italian Art Held in the
Galleries of the Royal Academy, Burlington House, London*,
Oxford, London 1931, no. 855; D. von Hadeln,
*Meisterzeichnungen aus der Sammlung F. Koenigs,
Venezianische Meister*, Frankfurt 1933, no. 4; L. Venturi,
"Nell'esposizione d'arte italiana ad Amsterdam," *L'Arte*
XXXVII, 1934, p. 496; L. Justi, *Giorgione*, vol. II, Berlin
1936, p. 300; A.E. Popham, "Sebastiano Resta and his
Collections," *Old Master Drawings* IX, 1936, pp. 9, 19;
G.M. Richter, *Giorgione de Castelfranco called Giorgione*,
Chicago 1937, p. 425, no. 34; H. Tietze and
E. Tietze-Conrat, "Contributo critico allo studio
organico dei disegni veneziani del Cinquecento," *Critica
d'Arte* II, 1937, pp. 81-82; Juynboll 1938, p. 21;
G. Fiocco, *Giorgione*, Bergamo 1941, p. 33; A. Morassi,

Giorgione, Milan 1942, pp. 118-19, 175; Tolnay 1943,
no. 128; Tietze 1944, no. 709; L. Venturi, *Giorgione*,
Rome 1953, pp. 45, 167; L. Coletti, *Tutta la pittura di
Giorgione*, Milan 1955, no. 92; P. della Pergola,
Giorgione, Milan 1955, pl. 98; T. Pignatti, *Giorgione*,
Milan 1955, p. 139; L. Grassi, *Il disegno italiano dal
Trecento al Seicento*, Rome 1956, p. 96; Haverkamp
Begemann 1957, no. 38; L. Baldass, G. Heinz, *Giorgione*,
Munich 1964, pp. 130-31; O. Benesch,
Meisterzeichnungen der Albertina, Salzburg 1964, p. 323,
under no. 16; P. Zampetti, *L'opera completa del Giorgione*,
Milan 1968, no. 19; T. Pignatti, *Giorgione*, Milan 1969,
pp. 101-02, no. 14; L. Magagnato, *Introduzione a
Giorgione e alla pittura veneziana del Rinascimento*, Milan
1970, p. 159; T. Pignatti, *La Scuola Veneta* (I Disegni dei
Maestri), Milan 1970, p. 82, pl. VIII; exhib. cat. Rome
1972-73, under no. 6; K. Oberhuber in exhib. cat. *Early
Italian Engravings from the National Gallery of Art*,
Washington 1973, pp. 399, 402, 410-11; G. Pochat,
Figur und Landschaft, Berlin 1973, pp. 393, 448;
G. Tschmelitsch, *Zorzo genannt Giorgione: der Genius und
sein Umkreis*, Vienna 1975, pp. 110, 114, 243, 284;
J. Byam Shaw, *Drawings by Old Masters at Christ Church*,
Oxford 1976, under no. 715; exhib. cat. *Fifty Old Master
Drawings*, London, Baskett and Day, 1976, under no. 5;
K. Oberhuber in exhib. cat. *Disegni di Tiziano e della sua
cerchia*, Venice 1976, p. 52; M. Roskill, *What is Art
History?*, London 1976, p. 82; W.R. Rearick, *Maestri
veneti del Cinquecento* (Biblioteca di Disegni V), Florence
1976, pp. 7, 8, no. 1; S. Carazzolo *et al.*, *Castel San Zeno
di Montagnana in un disegno di Giorgione* (Centro Studi
Castelli Montagnana Quaderno X), Montagnana 1978;
S. Carazzolo, *et al.*, "Castel S. Zeno di Montagnana in
un disegno attribuito a Giorgione," *Antichità Viva* XVII,
1978, no. 4-5, pp. 40-52; R. Maschio in *Giorgione e il
Veneto*, Venice 1978, p. 50; B.W. Meijer, "Due proposte
iconografiche per il 'Pastorello' di Rotterdam,"
*Giorgione. Atti del Convegno internazionale di studi,
Castelfranco Veneto 1978*, Castelfranco Veneto 1979,
pp. 53-56; T. Pignatti, *Giorgione*, Milan 1978, no. 15;
D. Sutton, "The enigma of Giorgione," *Apollo* CVIII,
1978, no. 198, p. 95; A. Ballarin, "Tiziano prima del
Fondaco dei Tedeschi," *Tiziano e Venezia. Convegno
internazionale di studi, Venezia 1976*, Venice 1980, p. 484,
note 3; T. Pignatti, *Disegni antichi del Museo Correr di
Venezia*, vol. I, Venice 1980, p. 17; T. Pignatti, "Il
'Corpus' pittorico di Giorgione," in R. Pallucchini (ed.),
Giorgione e l'umanesimo veneziano (Civiltà Veneziana
Saggi 27) vol. I, Florence 1981, p. 141; Pignatti 1981,
p. 130; J. Byam Shaw, "Drawing in Venice," in exhib.
cat. *The Genius of Venice 1500-1600*, London, Royal
Academy of Arts, 1983-84, p. 243; T. Pignatti and
G.D. Romanelli, *Drawings from Venice: Masterpieces from
the Museo Correr*, Venice, London 1985, p. 14; Wethey
1987, pp. 71-72; 173-74, no. 64.

"Then, about 1507, came Giorgione da Castelfranco...
whose exquisite style enabled him to give his work a
greater softness and depth. He used to paint living,
natural subjects, and to render them in oil colors as
faithfully as possible, in strong and soft shades just as
they occur in nature. He drew nothing beforehand,
since he firmly believed that painting alone with the
colors themselves, without studying anything on paper,
was the true and best method."[1] With these words
Vasari introduced Giorgione in his biography of the
latter's pupil, Titian. The passage is one of many that
could be cited to illustrate Vasari's prejudice against
the Venetian School: for painters belonging to what he
believed to be the superior Florentine School, drawing
was a crucial step in the creative process. Admittedly
Vasari's view may not be entirely unfounded: while a
few of the paintings Giorgione produced during his
short life have come down to us, he is entirely unknown
as a draftsman. This could indicate that, as Vasari says,
he produced hardly any drawings at all.

This sheet, the fame of which contrasts sharply with
its poor condition, is indeed the only drawing whose
attribution to Giorgione is largely accepted today.
Without any point of comparison it is difficult to build
any argument in favor of the attribution, yet this
delicately drawn, poetic landscape comes closest to how
we would visualize Giorgione's drawings from the
evidence of his paintings.[2] And though the present
drawing is not directly related to any of them, it
broadly corresponds with the *Tempesta* in the Accademia
in Venice (fig. a), and with other works by the artist in
which a castle or fortified city appears in the
background.

What also links the drawing to Giorgione is the
similarity of its style to that of engravings and drawings
executed by his followers, and above all to the engraved

fig. a

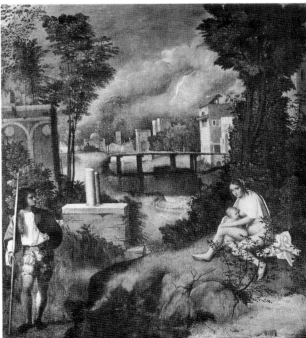

landscapes by Giulio Campagnola (*c.* 1482–after 1515).³ In his *St Jerome* of *c.* 1503-04 (fig. b), for instance, Campagnola renders the rolling landscape just as Giorgione would have done, with hills ranged one behind the other. The parallels between the manner in which the two artists handled vegetation are equally striking: sharp blades of grass invariably emerge from behind a hillock or a rock; hatching is used to suggest clumps of trees, the trunks of which reflect the light. Even Campagnola's use of the saint as a *repoussoir* in the foreground of his engraving resembles Giorgione's method of achieving a sense of depth in the Rotterdam drawing.⁴ Though Campagnola's prints seem hard when compared to a red chalk drawing such as the one under discussion, he was sometimes known to use very fine stippling techniques, the effect of which was not unlike stipple engravings. One can well imagine that he did so partly in order to approximate the mood of a red chalk drawing such as this one.⁵

The attribution of the Rotterdam landscape to Giorgione dates back at least as far as the Italian collector Padre Sebastiano Resta (1635–1714), who described it in an inventory as a "View of Castelfranco drawn by Giorgione." It was he who wrote "k.44" on the sheet in pen and brown ink, corresponding to the numbering in one of the albums he assembled for the Bishop of Arezzo, Monsignor Giovanni Matteo Marchetti. Album K bore the title *Tomo Secondo Secolo d'oro*. According to an explanatory note written by Padre Resta himself, he washed the sheet with warm water, apparently in an attempt to remove the grime from the paper. Needless to say, this did little for the drawing's legibility.

Besides attributing the present work to Giorgione, Resta also claimed the artist was responsible for number 43 in the same album, supposedly another version of the same landscape drawing. According to the cleric, the artist portrayed himself in the foreground, "as either a shepherd with his flock or as a man in the act of drawing in the sand."⁶

This romantic tale is a little too good to be true. The traditional identification of the buildings in the background of our drawing with Giorgione's native Castelfranco, long accepted in the literature, has proven just as fanciful. The Centro Studi Castelli of Montagnana has been able to show that the fortifications belong not to Castelfranco, but to the Castel San Zeno, at Montagnana, near Este, in the Veneto.⁷ Unusually precise, the drawing makes it possible to determine the artist's position exactly: he was seated on a higher elevation in the northeastern outskirts of Montagnana, along the road to Vicenza. He drew the broadly crenellated town walls together with their towers, both large and small, the more narrowly crenellated walls and finally the twelfth-century Castel San Zeno (fig. c). The towers, one of which has since collapsed, are depicted at exactly the right spot. The double-arched bridge on the left leads into Montagnana through the Porta Padova, spanning a small river that encircles the town.

There are various altarpieces by artists close to Giovanni Bellini in which an existing city is depicted in the background. These views must have been based on studies such as the present one, few of which have been preserved. The Castello di San Salvatore in the town of Collalto, for instance, is faithfully represented in the *Madonna dell'arancio* by Cima da Conegliano (1459/60–1517/18). Montagnana itself features in a painting by Giovanni Buonconsiglio, called Marescalco (active 1495/97–1535/37), not with the Castel San Zeno as in the present drawing, but with the Rocca degli Alberi.⁸

It is quite inconceivable that, during a trip away from home, Giorgione drew this landscape for possible use in a painting. And yet the sheet is more than simply a personal reminder. If only because Giorgione added the seated figure in the foreground – according to the Tietzes "an insect rather than a man" – the drawing is not merely a portrait of Montagnana, even if its exact subject remains elusive.⁹ Whatever the artist's motives may have been, the sheet is an excellent demonstration of the evocative use of chalk. Vasari wrote that Giorgione had a lively interest in the renowned *sfumato* of Leonardo da Vinci – the "smudged" outlines, without sharp transitions, so that the forms appear to dissolve – and sought to imitate it.¹⁰ In the early 1500s Leonardo was probably one of the few draftsmen from whom Giorgione could have learned to handle red chalk so suggestively.¹¹

1. Vasari 1878-85, vol. VII, p. 427: "*Ma venuto poi, l'anno circa 1507, Giorgione da Castelfranco... cominció a dare alle sue opere più morbidezza e maggiore rilievo con bella manièra; usando nondimeno di cacciarsi avanti le cose vive e naturali, e di contrafarle quanto sapeva il meglio con i colori, e macchiarle con le tinte crude e dolci, secondo che il vivo mostrava, senza far disegno; tenendo per fermo che il dipingere solo con i colori stessi, senz'altro studio di disegnare in carta, fusse il vero e meglior modo di fare ed il vero disegno.*"
2. Rearick (1977), pp. 7-8.
3. Oberhuber (1973), pp. 390-401.
4. A.M. Hind, *Early Italian Engraving*, London 1938-48, vol. V, p. 197, no. 7; see Oberhuber (1973), pp. 397-99.
5. Oberhuber (1973), no. 149, although the surviving preliminary drawing for that print was executed in ink. See also G.F. Hartlaub, "Giorgione im graphischen Nachbild," *Pantheon* XVIII, 1960, pp. 76-85.
6. See Popham (1936), *passim*, but esp. p. 19.
7. Carazzolo *et al.* (1978).
8. For Cima's painting see P. Humpfrey, *Cima da Conegliano*, Cambridge, etc. 1983, no. 145, pl. 59. In various of his altarpieces Cima included a view of the castello in his birthplace, Conegliano, ibid., p. 30. See further F. Gibbons, "Giovanni Bellini's topographical landscapes," in I. Lavin and J. Plummer (eds.), *Studies in Late Medieval and Renaissance Painting in Honor of Millard Meiss*, New York 1977, pp. 176-84, and for Buonconsiglio's *Madonna with John the Baptist and St Catherine* (Padua, Cassa di Risparmio), R. Pallucchini, "Una nuova opera del Marescalco," *Arte Veneta* XXVI, 1972, pp. 31-38, and Carazzolo *et al.* (1978)-I, pp. 25-27.
9. Tietze 1944, no. 709. Meijer (1979) gives a not very convincing interpretation of the subject.
10. Rearick (1977), pp. 7-8. For Vasari's remarks on Leonardo's influence on Giorgione see Vasari 1878-85, vol. IV, p. 92.
11. See B.W. Meijer in exhib. cat. Venice, Florence 1985, no. 15. As far as landscapes are concerned, one could cite the drawing of the *Copse of Trees* from the Leoni album in the English royal collection (inv. 12431); see C. Pedretti, *Landscapes, Plants and Water Studies in the Collection of Her Majesty the Queen at Windsor Castle*, London, New York 1982, no. 8.

GL

fig. b

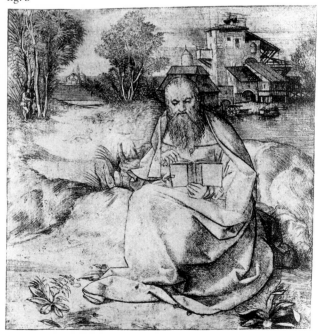

fig. c

57

Baccio della Porta, called Fra Bartolommeo
Florence 1472–1517 Florence
ROCKY LANDSCAPE WITH A RUINOUS GATE, SOME BUILDINGS
AND FIGURES IN THE DISTANCE

Pen and brown ink; 202 × 284 mm.
Watermark: part of a tulip (cf. Briquet 6664, Florence
1508)
Inv. MB 1958/T 1

Provenance: from a large group of drawings bequeathed
by Fra Bartolommeo to Fra Paolino da Pistoia,
Florence; Suora Plautilla Nelli, Florence, before 1547;
nunnery of St Catharine of Siena, Florence, Piazza San
Marco, probably acquired on the death of Suora
Plautilla Nelli in 1588; Cavaliere F.M.N. Gabburri,
Florence, acquired *c.* 1725; W. Kent, Rome,[1] acquired in
1742; private collection, Eire; private collection, Great
Britain, acquired in 1925; sale London (Sotheby's),
November 20 1957, no. 34; acquired by the museum
with the aid of the Rembrandt Society.

Exhibitions: Paris, Rotterdam, Haarlem 1962, no. 60;
Rome 1972-73, no. 4; Florence 1980, no. 87.

Literature: C. Gronau, *Catalogue of Drawings of
Landscapes and Trees by Fra Bartolommeo*, London
(Sotheby's), November 20 1957, pp. ii-iv and no. 34;
J.C. Ebbinge Wubben in *Vereeniging Rembrandt. Verslag
over de jaren 1956 en 1957*, unpaginated; F. Junghans,
"Neuerwerbung des Museum Boymans," *Alte und neue
Kunst*, 1959, p. 121; L.S. Malke, *Italienische Zeichnungen
des 15. und 16. Jahrhunderts aus eigenem Beständen*,
Frankfurt, Städelsches Kunstinstitut und Städtische
Galerie, 1980, under no. 49.

fig. a

Although "106 sheets with landscapes in pen and ink"
are mentioned in the inventory of Fra Bartolommeo's
possessions drawn up in 1517 by the painter Lorenzo di
Credi, he remained virtually unknown as a draftsman of
landscapes until 1957.[2] That year an album containing
forty-one landscape drawings and tree studies by Fra
Bartolommeo was taken apart and sold at auction. The
drawings subsequently found their way into various
collections scattered over Europe and the United
States.[3]

The Boymans-van Beuningen Museum acquired this
splendid *Rocky Landscape*, one of the most beautiful
sheets of the entire group, as a supplement to the large
collection of drawings by the artist already in the
museum. In 1940, two albums containing approximately
500 studies in red and black chalk by Fra Bartolommeo
entered the collection. Until the eighteenth century all
three albums shared the same provenance (see also cat.
nos. 57 and 58). The drawings were originally mounted
in the albums in about 1730 by Cavaliere Francesco
Maria Niccoló Gabburri (1675–1742), whose coat of
arms decorated the frontispiece of the one that was
dismembered. However, according to the title page,
drawn by Rinaldo Botti, Gabburri believed that the
landscapes were the work of Andrea del Sarto (fig. a).[4]
Gabburri was responsible for the conservation of Del
Sarto's frescoes in the cloister of the Santissima
Annunziata in Florence. His intimate knowledge of
those works, in which landscapes figure so prominently,
together with the inscription on one of the drawings
("*Di mano dell' Frate Anzi d'Andrea*"), may have
prompted his attribution.

The purpose of the landscape drawings has not been
established, though the painter is known to have used a
few of them in the background of his paintings. The
panorama in *The Rape of Dina* in the Kunsthistorisches
Museum, Vienna – unfinished at the time of Fra
Bartolommeo's death and then completed by Giuliano
Bugiardini in about 1530 – is unmistakably based on the
landscape drawing in the Seilern Collection at the
Courtauld Institute, London.[5] Such an application of
the Rotterdam drawing has not come to light, nor has
the exact location of this rocky landscape been
established, as has been the case with various other
landscape drawings by the artist. These are mostly
Tuscan views drawn by Fra Bartolommeo while staying
in Dominican monasteries during his travels. The
monastery of Santa Maria Maddalena in the Mugnone
Valley is depicted in one of the drawings, for instance,
and that of Santa Maria del Sasso in Bibiena in
another.[6]

As with other landscapes by the artist, the Rotterdam
sheet was certainly drawn from life. A more sketchlike
version in the Städelsches Kunstinstitut in Frankfurt
contains the same ruinous gate (fig. b). Judging from
this last sheet, it would appear that the draftsman took
some liberties with the arrangement of the trees and
with their proportions.[7] Though he made some tree
studies with chalk, in this case Fra Bartolommeo worked
directly with the pen. First he indicated the shape of all

the larger forms with curving lines, and then filled in the remainder with a very varied and lively pen. His handling of line is rather restless and not free from a certain acerbity, so that the landscape almost seems to vibrate. While a few bushes and the leaves of the trees are described in a rather scratchy manner, the contours of the tall trees in the background are loose and curly. In the middleground he decided to use stippling; crosshatching occurs only in the foreground, where short, broad lines are drawn over long, thin parallel hatching. Most of Fra Bartolommeo's landscapes are enlivened with travelers on foot; here two figures, indicated summarily, are seen moving in the direction of the gate.

Because the character of these landscape drawings is so unique, it is difficult to specify by whom Fra Bartolommeo could have been influenced. There may have been comparable drawings by Andrea del Sarto, with both artists being influenced by Piero di Cosimo.[8] Another possibility is that the Florentine artist took his example from German or Dutch landscapes. The background of one of the drawings, copied after Dürer's engraving of *Hercules at the Crossroads* of *c.*1498-99, shows that he was familiar with the latter's prints.[9] Moreover some of Fra Bartolommeo's tree studies (fig. c) have certain stylistic affinities with the early landscape drawings of Wolf Huber (*c.*1503-05) and other draftsmen of the Danube School, which are of approximately the same date.[10] The use of brown ink in the landscapes, the stylistic resemblance to other early drawings by Fra Bartolommeo, and the watermark all indicate that the drawings were executed in or before 1508.[11]

1. See J. Fleming, "Mr. Kent, Art Dealer, and the Fra Bartolommeo Drawings," *Connoisseur* CXLI, 1958, p. 227.
2. The inventory entries read: "*106 fogli di paesi non coloriti cioè tochi di penna*," "*4 ruotoli di tela di paesi coloriti cioè tochi di penna*" and "*6 quadretti di paesi in tela coloriti*"; see F. Knapp, *Fra Bartolommeo della Porta und die Schule von San Marco*, Halle 1903, pp. 275-76.
3. See Gronau (1957).
4. Ibid., p. ii, pls. 4-5, and C. Fischer, "Fra Bartolommeo's Landscape Drawings," *Mitteilungen des Kunsthistorischen Institutes in Florenz* XXXIII, 1989 (forthcoming). The two drawings by Rinaldo Botti later came up for auction again in New York (Sotheby's), January 16 1986, no. 219, when they were acquired by the Fondation Custodia in Paris.
5. A drawing in Cleveland provided the background for the painting of *God the Father with the Magdalen and St Catharine of Siena* (1509) in the Villa Guinigi in Lucca, as well as for a picture from the school of Fra Bartolommeo in the Rijksmuseum in Amsterdam. See M.M. Johnson, exhib. cat. *Idea to Image: Preparatory Studies from the Renaissance to Impressionism*, Cleveland, The Cleveland Museum of Art, 1980, pp. 39-41, figs. 42-44. For the painting completed by Bugiardini see I. Härth, "Landschaftszeichnungen Fra Bartolommeos und seines Kreizes," *Mitteilungen des Kunsthistorischen Institutes in Florenz* IX, 1959-60, pp. 125-30, and L. Pagnotta, *Giuliano Bugiardini*, Turin 1987, p. 218, no. 61.
6. See R.W. Kennedy, "A Landscape Drawing by Fra Bartolommeo," *Smith College Museum of Art Bulletin* XXXIX, 1959, pp. 1-13, and Fischer, op. cit. (note 4), *passim*.
7. Malke (1980), no. 49.
8. C. Fischer, "Andrea del Sarto Revived," *Kunstchronik* XL, 1987, pp. 557-58, and Fischer, op. cit. (note 4), note 13.
9. Fischer, op. cit. (note 4); see the drawing in Paris, Musée du Louvre, inv. R.F. 5565. The influence of the same engraving can be seen in a sheet from the album now in New York, Metropolitan Museum of Art; see J. Bean and F. Stampfle, *Drawings from New York Collections. I. The Italian Renaissance*, New York, The Metropolitan Museum of Art, 1965, no. 31.
10. Fig. c was no. 29 in the sale of 20 November 1957, and was sold to Hallsborough. Its present location is unknown. For Wolf Huber's early drawings see H. Mielke in exhib. cat. Berlin, Regensburg 1988, pp. 316-17, nos. 203-04.
11. Fischer, op. cit. (note 4).

GL

fig. b

fig. c

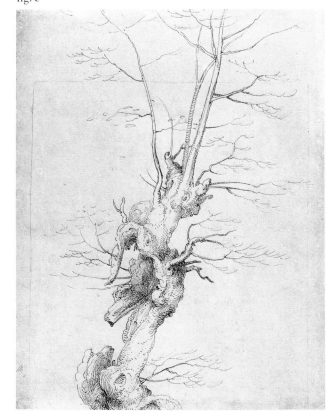

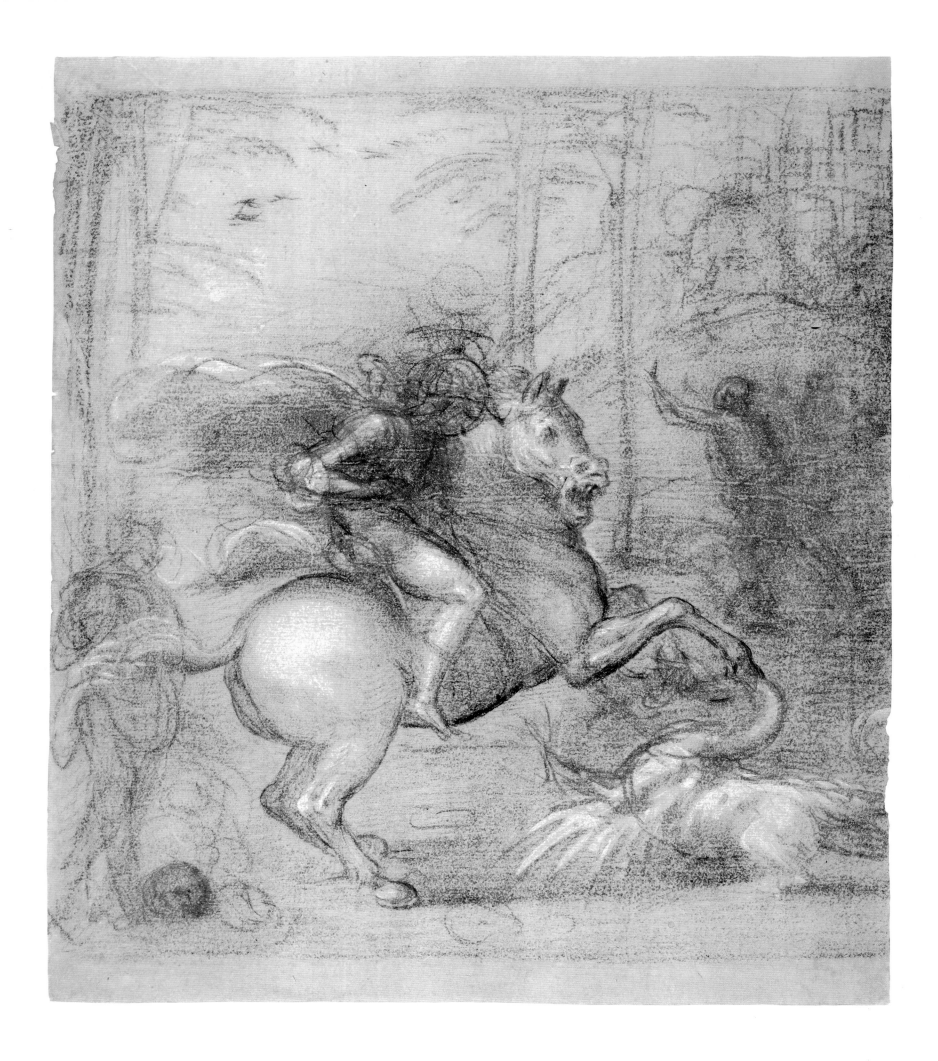

58

Baccio della Porta, called Fra Bartolommeo
Florence 1472–1517 Florence
ST GEORGE AND THE DRAGON

Black, white and yellowish chalk on gray prepared
paper; 317 × 272 mm.
No watermark
Inv. I 563/M88

Provenance: from a large group of Fra Bartolommeo
drawings bequeathed the artist to Fra Paolino da
Pistoia, Florence; Suora Plautilla Nelli, Florence,
before 1547; nunnery of St Catharine of Siena,
Florence, Piazza San Marco, probably acquired on the
death of Suora Plautilla Nelli in 1588; Cavaliere
F.M.N. Gabburri, Florence, acquired in 1727 and
assembled by him into two albums of 391 sheets with
505 drawings in or shortly before 1729; W. Kent,
Rome, acquired in 1742; B. West, London; Sir Thomas
Lawrence, London, acquired in 1820; S. Woodburn,
London, acquired in 1830; Willem II, later King of the
Netherlands, The Hague, acquired *c.* 1838; sale The
Hague, August 12 1850, no. 281, bought in; Sophie,
Grand Duchess of Saxe-Weimar, Weimar; Wilhelm
Ernst, Grand Duke of Saxe-Weimar; F. Koenigs,
Haarlem, acquired *c.* 1923; D.G. van Beuningen,
Rotterdam, acquired in 1940 and donated to the
Boymans Museum Foundation.

Exhibitions: London 1836, both albums described in the
foreword; Haarlem 1931, no. 199; Amsterdam 1934,
no. 479; Rotterdam 1952, no. 91; Paris, Rotterdam,
Haarlem 1962, no. 56 (the albums in each case).

Literature: S. Woodburn in exhib. cat. *The Lawrence
Gallery. The Seventh Exhibition*, London 1836, p. 20;
Von Zahn 1870, pp. 174-201; Von der Gabelentz 1922,
vols. I-II, *passim*, esp. vol. II, pp. 178-298; Berenson
1938, vol. II, no. 309D; Haverkamp Begemann 1957,
pp. 40-43, no. 42; Berenson 1961, vol. II, p. 85,
no. 506A; Fischer 1986, *passim* (the albums in each
case).

For cat. no. 58 specifically: Von Zahn 1870, p. 186,
no. 88; Knapp 1903, p. 303; Von der Gabelentz 1922,
vol. II, no. 548; W. Suida, *Leonardo und sein Kreis*,
Munich 1929, pp. 70, 244; A. Schug, "Zur Chronologie
von Raffaels Werken der Vorrömischen Zeit," *Pantheon*
XXV, 1967, p. 476; D.A. Brown in exhib. cat. *Raphael
and America*, Washington, National Gallery of Art,
1983, p. 195, note 124; Fischer 1986, p. 91, under
no. 46.

This swiftly drawn *St George and the Dragon* is part of a series of preparatory studies on that theme commonly linked to a painting by Fra Bartolommeo formerly in the palazzo of the Florentine merchant and art collector Francesco del Pugliese (1458–1519). Vasari tells us that the artist executed the oil painting in grisaille – according to the biographer, one of his favorite techniques ("*che si dilettó assai*") – in a niche located on the stairway landing of the palazzo.[1] The work was apparently still *in situ* in 1677, but was later lost, presumably in the course of the reconstruction carried out in about 1778, when the palazzo in Via de'Serragli became the property of Marchese Giuseppe Ferroni.[2]

Despite the loss of the painting, this and the other surviving preparatory studies enable us to reconstruct its appearance to some extent, and to retrace the various stages of the composition's development.

The artist's point of departure was the small, framed sketch of St George facing left on the verso of the drawn *Self-Portrait* in Munich.[3] Starting with the next stage of development (fig. a),[4] Fra Bartolommeo consistently drew the saint in the opposite direction. In that first study of St George facing right, the rearing horse is reminiscent of drawings by Leonardo da Vinci (fig. b).[5] Equine anatomy fascinated Leonardo, and rearing horses in particular feature not only in his designs for equestrian statues but also in his drawings of knights slaying dragons, whether the figure was meant to be St George or not.[6]

Fra Bartolommeo eventually decided not to have the saint's horse rear so violently. He tried out the final, slightly lower position for the first time in the Rotterdam drawing, where he filled the background with a landscape and the skyline of the city which, according to legend, the monster harassed. Here we also see the princess fleeing, her arms outstretched in horror. The legend has it that the dragon was overwhelmed with the lance and then killed with the sword. The drawing focuses on the moment when St George thrusts the lance home, his mantle billowing behind him. Thanks to the white chalk heightenings, the monster with its spread, forked wings may remind the viewer more of a swan taking flight than of a dragon. The obligatory skull on the left notwithstanding, the mood is decidedly less gruesome than paintings of the same subject by the Frate's Venetian contemporary Carpaccio, who littered his compositions with half-dismembered bodies and carcasses. The role of the observer standing on the left is not clear; there are witnesses in other depictions of the story, to be sure, but always at a safer distance from the scene of action.

Once he had worked out the composition, Fra Bartolommeo began, as always, to elaborate the various elements. On the same sheet in Munich mentioned earlier, a vague sketch of the fleeing princess can already be seen, but individual studies of this figure followed.[7] He took the greatest pains with the rider and

the horse, as evidenced by a fragment of a drawing in the Uffizi in Florence and other sheets in Rotterdam. The sequence of these studies, which have all been squared for transfer, is more difficult to determine.[8] In one drawing the artist accentuates the horse a bit more and examines the silhouette of its neck and forelegs (fig. c),[9] while in another the position of the rider is emphasized (fig. d).[10] The bulk of the animal's hind legs and the form of the hoof fluctuated for a long time. In the final (and not very attractive) study in the series, the horse's head assumed what was probably its definitive position (fig. e).[11]

The exact date of the lost *St George and the Dragon* has not been established. Given the fact that one source speaks of an "unfinished" work,[12] it could be very late, though the author may have mistaken the grisaille technique for *non finito*. The recto of the Munich sheet bears a self-portrait of the type that Fra Bartolommeo twice incorporated, in idealized form, in paintings: in the Visconti Venosta tondo (Milan, Museo Poldi Pezzoli) and in the *Pala del Gran Consiglio* (Florence, Museo di San Marco), commissioned in 1510. The sheet in Rotterdam on which the Frate tried out the pose of the fleeing princess includes a study for the *Madonna del Santuario*. That work is dated 1509, but he presumably started working on it several years earlier.[13]

Another clue to the dating of the drawings for *St George and the Dragon* is provided by their striking similarity to Raphael's small panel of the same subject

fig. a

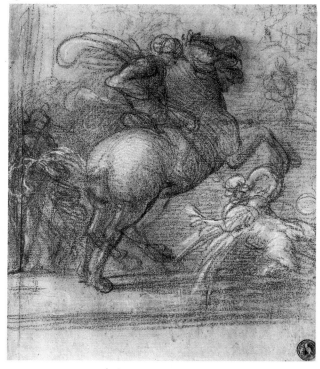

fig. b

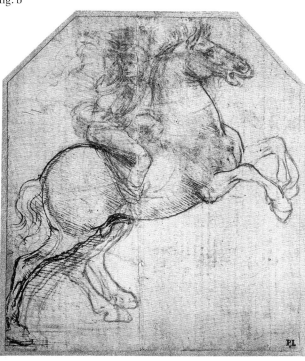

fig. c

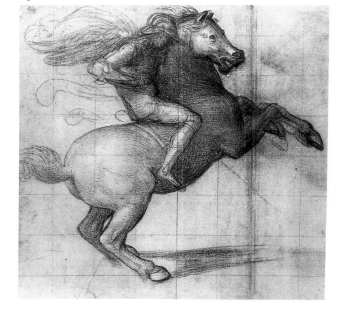

in the National Gallery of Art, Washington (fig. f).[14] Although the two artists represented the saint and his mount facing opposite directions, it is virtually inconceivable that they arrived at their respective interpretations independently. Raphael's *St George* is generally dated 1504-05, when he was active in Florence, and the Frate very probably painted his version not long thereafter.

The influence of Leonardo's equine studies on both Raphael and Fra Bartolommeo was considerable. In the case of Raphael, the marble relief by Donatello on Or San Michele in Florence has been cited as a likely model as well.[15] We may assume that Fra Bartolommeo was equally familiar with that strikingly vital Renaissance masterpiece (fig. g). The robes of Donatello's princess are distinctly classical; placed *in contrapposto* behind the saint, she folds her hands demurely on her breast. The relief may well have given Fra Bartolommeo the idea of placing the princess in the same pose in the foreground of his composition.

1. Vasari 1878-85, vol. IV, p. 194; for Francesco del Pugliese, Fischer 1986, pp. 92-93.
2. Fischer 1986, p. 93.
3. For the self-portrait see R. Harprath in exhib. cat. *Zeichnungen aus der Sammlung des Kurfürsten Carl Theodor*, Munich, Staatliche Graphische Sammlung, 1983-84, no. 5, pl. 7.
4. Rotterdam, Boymans-van Beuningen Museum, inv. I 563/M89; Von der Gabelentz 1922, vol. II, no. 549; Berenson 1938, vol. III, fig. 447. See also D.A. Brown in exhib. cat. Washington (1983), pp. 144, 195, note 124, and Fischer 1986, pp. 91, 94. It is not known who owned the collector's mark of a bird against a dark background visible in the lower right corner (L. 2818). It also appears on various other drawings in the Rotterdam group, and must have been applied before the sheets were bound into the album.
5. This Leonardo drawing is from the H. Oppenheimer Collection, and was later in Launceston, N. Colville Collection, see A.E. Popham, *The Drawings of Leonardo da Vinci*, London 1957, no. 64.
6. Ibid., nos. 54-102.
7. Rotterdam, Boymans-van Beuningen Museum, inv. I 563/N8 recto and verso; Von der Gabelentz 1922, vol. II, no. 669, and Fischer 1986, p. 91.
8. Fischer 1986, no. 46.
9. Inv. I 563/M91; Von der Gabelentz 1922, vol. II, no. 551, Fischer 1986, pp. 91, 93.
10. Inv. I 563/M90; Von der Gabelentz 1922, vol. II, no. 550, Fischer 1986, pp. 91, 93.
11. Inv. I 563/N7; Von der Gabelentz 1922, vol. II, no. 668, Fischer 1986, pp. 91, 93.
12. In the list of works by Fra Bartolommeo drawn up by Bernardo Cavalcanti, see Marchese 1879, vol. II, p. 182.
13. Fischer 1986, p. 93.
14. Schug (1967), p. 476; see D.A. Brown in exhib. cat. Washington (1983), pp. 135-57.
15. At an early date by W. Vöge, *Raffael und Donatello*, Strasbourg 1896, pp. 2-6; see D.A. Brown in exhib. cat. Washington (1983), pp. 140-41, 194, note 115.

GL

fig. g

fig. d

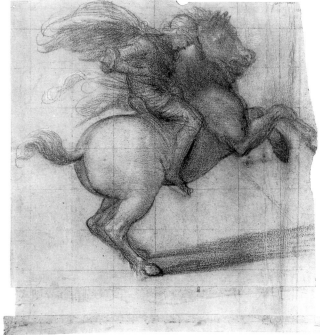

fig. e

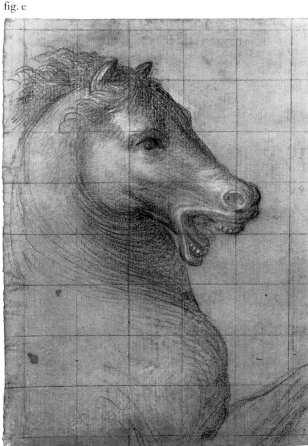

fig. f

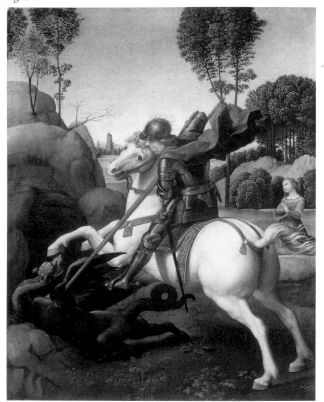

Baccio della Porta, called Fra Bartolommeo
Florence 1472–1517 Florence
SHEET WITH VARIOUS FIGURE STUDIES

Red chalk; 287 × 197 mm.
Verso: *Study of a Standing Man*, red chalk
Watermark: two-wheeled wagon (cf. Briquet 3541,
Florence 1529)
Inv. I 563 M3

Provenance: from a large group of Fra Bartolommeo
drawings bequeathed by the artist to Fra Paolino da
Pistoia, Florence; Suora Plautilla Nelli, Florence, before
1547; nunnery of St Catharine of Siena, Florence,
Piazza San Marco, probably acquired on the death of
Suora Plautilla Nelli in 1588; Cavaliere
F.M.N. Gabburri, Florence, acquired in 1727 and
assembled by him into two albums of 391 sheets with
505 drawings in or shortly before 1729; W. Kent,
Rome, acquired in 1742; B. West, London; Sir Thomas
Lawrence, London, acquired in 1820; S. Woodburn,
London, acquired in 1830; Willem II, later King of the
Netherlands, The Hague, acquired *c.* 1838; sale The
Hague, August 12 1850, no. 281, bought in; Sophie,
Grand Duchess of Saxe-Weimar, Weimar; Wilhelm
Ernst, Grand Duke of Saxe-Weimar; F. Koenigs,
Haarlem, acquired *c.* 1923; D.G. van Beuningen,
Rotterdam, acquired in 1940 and donated to the
Boymans Museum Foundation.

Exhibitions: London 1836, both albums described in the
foreword; Haarlem 1931, no. 199; Amsterdam 1934,
no. 479; Rotterdam 1952, no. 91; Paris, Rotterdam,
Haarlem 1962, no. 56 (the albums in each case).

Literature: S. Woodburn in exhib. cat. *The Lawrence
Gallery. The Seventh Exhibition*, London 1836, p. 20; Von
Zahn 1870, pp. 174-201; Von der Gabelentz 1922,
vols. I-II, *passim*, esp. vol. II, pp. 178-298; Berenson
1938, vol. II, no. 309D; Haverkamp Begemann 1957,
pp. 40-43, no. 42; Berenson 1961, vol. II, p. 85,
no. 506A; Fischer 1986, *passim* (the albums in each
case).

For cat. no. 59 specifically: Von Zahn 1870, p. 182,
no. 3; Knapp 1903, p. 300; Von der Gabelentz 1922,
vol. I, p. 172, vol. II, no. 463.

"For the Church of San Romano he painted a *Madonna
della Misericordia*, standing on a stone pedestal, with
some angels holding her mantle; she is flanked by a
throng of figures on a stairway – some of them
standing, others sitting and still others kneeling – all
of them beholding Christ who appears in the air above
them. ... In this work Fra Bartolommeo demonstrated
his ability to represent shadow, achieving an amazing
sense of depth, as well as his mastery of color, his skill
as a draftsman and his inventiveness, so that it is a work
as perfect as anything he made."[1]

Thus Giorgio Vasari acclaimed Fra Bartolommeo's
monumental *Madonna della Misericordia* (fig. a;
390 × 255 cm.) in his *Vite*. Painted for the Church of
San Romano in Lucca, the altarpiece was commissioned
by Fra Sebastiano Lombardi of Montecatini, prior of
the Dominican monastery in the town of Lopeglia.
Now in the Villa Guinigi in Lucca, it is signed and
dated 1515, that is, two years before the artist's death.
The Frate portrayed his patron kneeling in the right
foreground next to St Dominic, the founder of the
order he himself had joined fifteen years previously.[2]

There are about forty figures in the painting – men,
women and children – representing various segments of
the population. The effect is that of an overcrowded
Sacra Conversazione, and the crush would have been
even greater if the artist had not omitted the figure of
the monk beckoning to the beholder in the left
foreground of one of the preparatory drawings (fig. b).[3]
Fra Bartolommeo obviously studied the work Raphael
had just completed in the Vatican Stanze while he was
in Rome in 1513-14, for his canvas is patently based on
the younger artist's *Mass of Bolsena* in the Stanza di
Eliodoro.[4] The splendidly arranged group in the right

fig. a

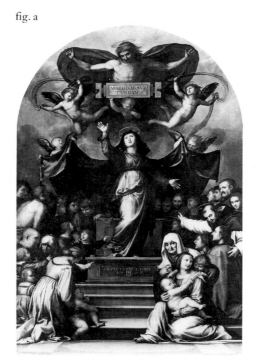

fig. b

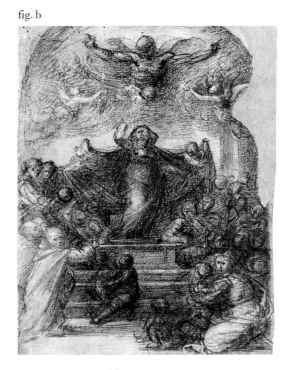

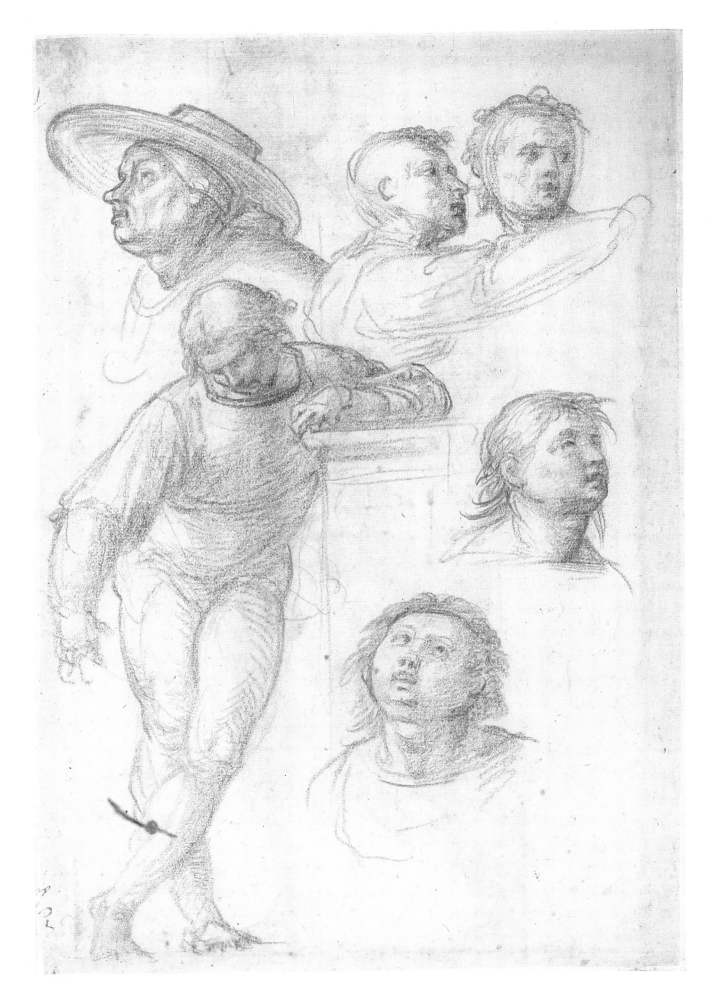

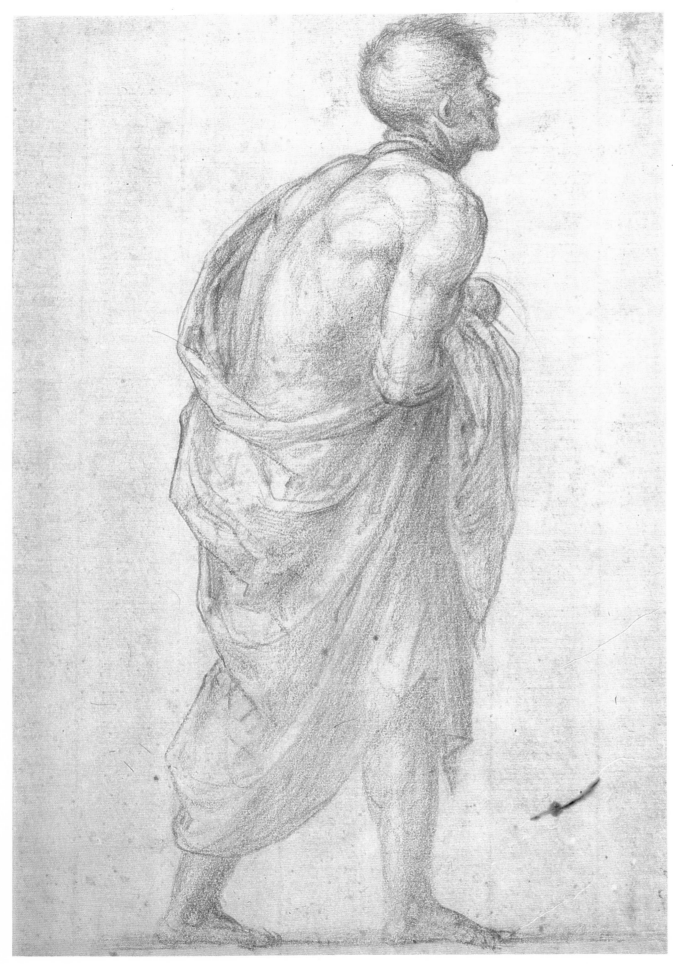

verso

foreground is a translation into everyday terms of a Raphaelesque Virgin and Child with St Anne and the infant John the Baptist (fig. c).[5]

Besides the composition study for the *Madonna della Misericordia*, the Boymans-van Beuningen Museum has some fifteen sheets of figure studies for the altarpiece, of which this is but one example. On the verso is a study for the half-naked man who, overlapped by various other onlookers, is only partly visible on the left of the painting. On the recto are studies of heads and a full-length figure of a standing youth, leaning placidly with his left arm on the Virgin's throne while tenderly regarding two children. Fra Bartolommeo used the other head studies as well; while they measure only a few centimeters on the sheet, they are virtually lifesize on the canvas. Possibly a model posed for some of these studies, though this can not be determined in every case. Vasari writes that the Frate would often start with studies from life and then use a mannequin to determine the position of the limbs, as can be seen in several of his drawings. Among the artist's personal effects at the time of his death were three different *manichini*, one of which came into the possession of Vasari, who kept it as a memento.[6]

The man with the broad-brimmed hat and the two youths in the Rotterdam drawing stand respectively to the right and left of the throne in the painting; the head just below the youths on the right of the sheet is a further elaboration of one of them. The artist turned the figure in the lower right corner of the drawing somewhat to the left and placed him behind St Dominic in the altarpiece. With the help of these and other studies, Fra Bartolommeo filled in one figure after another.

A sheet related to the one exhibited here bears studies of the curly-headed boy who reaches out to touch the Virgin in the painting, and of the two angels grasping billowing sashes (fig. d).[7] The head of the downward-looking angel appears a second time at the bottom. Although the various sketches are scattered across the surface of the sheet, it differs from ours in being squared with a view to enlarging the figures.

Like many other studies for the *Madonna della Misericordia*, Fra Bartolommeo executed this one in red chalk. This is a departure from his usual practice, since he drew almost all his other figure studies with black and white chalk on gray or brown prepared paper. Among the preparatory drawings for this altarpiece in Rotterdam are several that he started with a piece of hard chalk or a leadpoint, which left grooves in the paper. As Michelangelo was wont to do, he then went over these grooves with red chalk. The early composition sketch (fig. b) was done in black and white chalk. At a late stage in his preparation of the altarpiece, after completing all the individual studies, the Frate made the very loose red and black chalk study now in the Uffizi. This is probably a fragment of a similar composition sketch, which he completely reworked in pen and brown ink after finishing the detail studies.[8]

1. Vasari 1878-85, vol. IV, p. 191: "...*in San Romano fece una tavola... dentrovi una Nostra Donna della Misericordia, posta su un dado di pietra, ed alcuni Angeli che tengono il manto; e figuró con essa un popolo su certe scalee, che ritto, chi a sedere, chi inginocchioni, i quali risguardano un Cristo in alto... Certamente mostró Fra Bartolomeo in questa opera possedere molto il diminuire l'ombre della pittura e gli scuri di quella, con grandissimo rilievo operando, dove le difficoltà dell'arte mostró con rara ed eccellente maestria e colorito, disegno ed invenzione; opra tanto perfetta, quanto facesse mai.*"
2. Marchese 1879, vol. II, pp. 131-37, and Von der Gabelentz 1922, vol. I, pp. 170-72. At one time Koenigs also owned the very powerful study in black and red chalk (Berenson 1961, vol. II, no. 390B, vol. III, fig. 402) for the profile portrait of Fra Sebastiano Lombardi. In 1940, after its acquisition by D.G. van Beuningen, it was sold for inclusion in the Hitler Museum at Linz; see Elen 1989, no. 316 (ill.).
3. Inv. I 563/M197; Von der Gabelentz 1922, vol. II, no. 657.
4. D. Redig de Campos, *Raffaello nelle Stanze*, Milan 1973, pp. 43-48, pl. XV-XVI.
5. The pose of this nude child closely resembles that in Raphael's *Colonna Madonna* in the Staatliche Museen in Berlin, inv. 248; L. Dussler, *Raphael*, London 1971, p. 25. It is impossible to determine the precise path of the influence between the two artists, but it was certainly a reciprocal process, for Raphael made certain borrowings from the work of the older Fra Bartolommeo during his stay in Florence from *c.* 1504 to 1508.
6. Vasari 1878-85, vol. IV, pp. 195-96: "*Aveva openione Fra Bartolommeo, quando lavorava, tenere le cose vive innanzi; e per poter ritrar panni ed arme ed altre simil cose fece fare un modello di legno grande quanto il vivo, che si snodava nelle congenture, e quello vestiva con panni naturali... il quale modello, cos intarlato e guasto come è, è appresso di noi per memoria sua.*"
7. Inv. I 563/N116; Von der Gabelentz 1922, vol. II, no. 777, on paper with the same watermark as cat. no. 59.
8. Fischer 1986, pp. 135-38, no. 81.

GL

fig. c

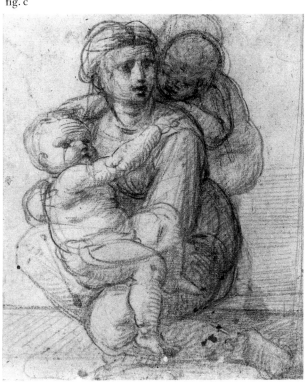

fig. d

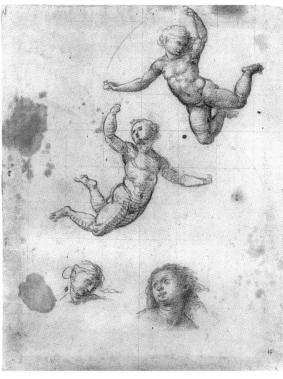

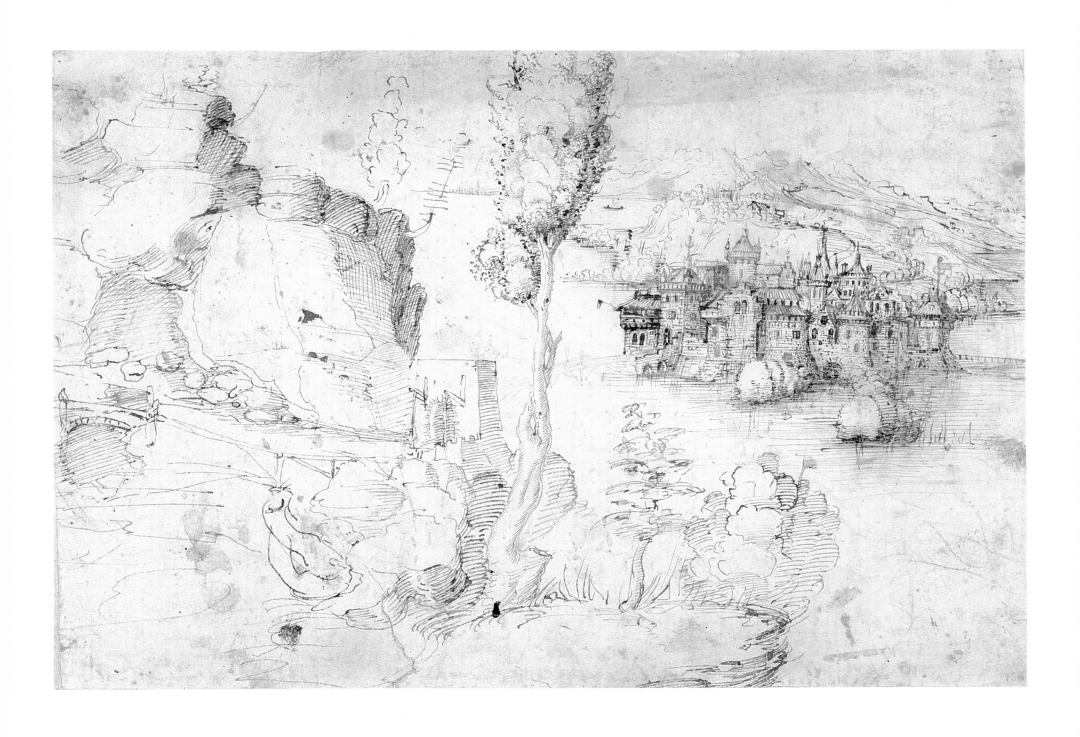

60

Attributed to Marco Basaiti
Venice or Friuli c. 1470–after 1530
ROCKY LANDSCAPE WITH HILLS AND A CITY ON A LAKE

Pen and brown ink, laid down; 205 × 304 mm.
Watermark: not visible
Inv. I 481

Provenance: F. Koenigs, Haarlem (L. 1023a), acquired in
1930; D.G. van Beuningen, Rotterdam, acquired in
1940 and donated to the Boymans Museum Foundation.

Exhibitions: Amsterdam 1934, no. 460; Venice, Florence
1985, no. 19.

Not otherwise published

fig. a

fig. b

Our knowledge of Marco Basaiti as a draftsman is far
from complete. There is only a single drawing by this
artist, who was of Greek origin but active in Venice,
that is directly related to a painting: the *Study for a
Dead Christ on a Sarcophagus* in the Uffizi, Florence,
which is related to the *Dead Christ and Two Angels* in
the Accademia, Venice.[1] That is hardly enough to form
a balanced impression of any draftsman's hand, which
explains the Tietzes' brief, tentative treatment of him in
their standard work on Renaissance Venetian drawing.[2]

Recently Bert Meijer took up the cause of this rocky
landscape, which until then had been designated simply
as "anonymous, Venetian, *c.* 1500."[3] A closely related
landscape in the Albertina in Vienna is undoubtedly by
the same hand, given the stylistic parallels between
them (fig. a).[4] Both drawings can be compared to the
backgrounds in paintings by Basaiti, where similar
landscapes serve as a decorative setting for a Sacra
Conversazione or for a hermit saying his prayers.
Most of the artist's painted landscapes consist of rocks,
bright green strips of mossy land, and stylized trees with
forked branches growing out of small stumps, exactly as
they do in both drawings. In particular, the landscape in
the *Virgin and Child, Saints and Patron* in the Fitzwilliam
Museum, Cambridge (fig. b), resembles the trees and
rocks in the foreground of the Rotterdam drawing.[5]

Basaiti would often place a scene high within a
landscape so as to enhance the sense of depth. He did
this, for instance, in the Cambridge picture, where a
lake is visible in the distance on the left, but it is
especially striking in one of his most famous paintings,
The Calling of the Sons of Zebedee (Accademia, Venice),
dated 1510 (fig. c).[6] Like that panel, this drawing has
the same, somewhat unbalanced division of the
composition into a foreground and a background,
suggesting that the artist may have had difficulty with
the relationships between the various elements. In the
case of the drawing, however, one could also draw the
conclusion that two separate landscapes are involved,
especially since the hatching of the city is so different
from the rest. The bridge connecting the foreground
with the background, reminiscent of the Venice
painting, is rendered, to be sure, with thin outlines,
but is not further elaborated.

The drawings attributed to Basaiti in Rotterdam and
Vienna, and a few related ones, [7] demonstrate once
again the impact of Dürer's prints on Italian art of the
early sixteenth century – an influence that only
intensified following the German artist's second visit to
Venice in 1506. Dürer's drawings provided his Italian
contemporaries not only with motifs, but also with
graphic solutions to the representation of trees and
other vegetation.[8] In the Rotterdam landscape,
for example, this is evident in the undulating lines and
in the varied directions of the hatching on the rocks.
The cityscape, too, seems German rather than Italian.
The drawing probably dates from the same period
that Fra Bartolommeo committed his own landscapes to
paper, which are no less free of German influence (see
cat. no. 57).

1. W.R. Rearick, *Tiziano e il disegno veneziano del suo tempo*,
Florence, Gabinetto Disegni e Stampe degli Uffizi, 1976,
no. 11.
2. Tietze 1944, pp. 42-43.
3. Exhib. cat. Venice, Florence 1985, no. 19.
4. Ibid., and O. Benesch, cat. tent. *Disegni veneti dell'Albertina
di Vienna*, Venice, Fondazione Giorgio Cini, 1961, no. 12.
5. F. Heinemann, *Giovanni Bellini e i Belliniani*, Venice 1959,
p. 293, fig. 438.
6. Ibid., p. 294, fig. 448.
7. See the *St Bernardino in a Landscape* in Boston, Museum
of Fine Arts; T. Pignatti, *Venetian Drawings from American
Collections*, Washington, National Gallery of Art, Fort Worth,
Kimbell Art Museum, St Louis, The St Louis Art Museum,
1974, no. 6, and H. Macandrew, *Italian Drawings in the Museum
of Fine Arts, Boston*, Boston 1983, no. 1. Slightly more remote
is a drawing in Vienna formerly attributed to Basaiti,
W. Koschatzky, K. Oberhuber and E. Knab, *I grandi disegni
italiani dell'Albertina di Vienne*, Milan 1972, pp. 34-35, fig. 12.
8. Cf., for example, engravings such as *The Holy Family with a
Butterfly*, Hollstein, *German*, VII, B. 42, and for the rocks, *St
John Chrysostom*, ibid., B. 54.

GL

fig. c

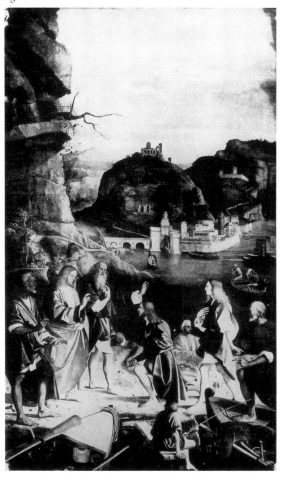

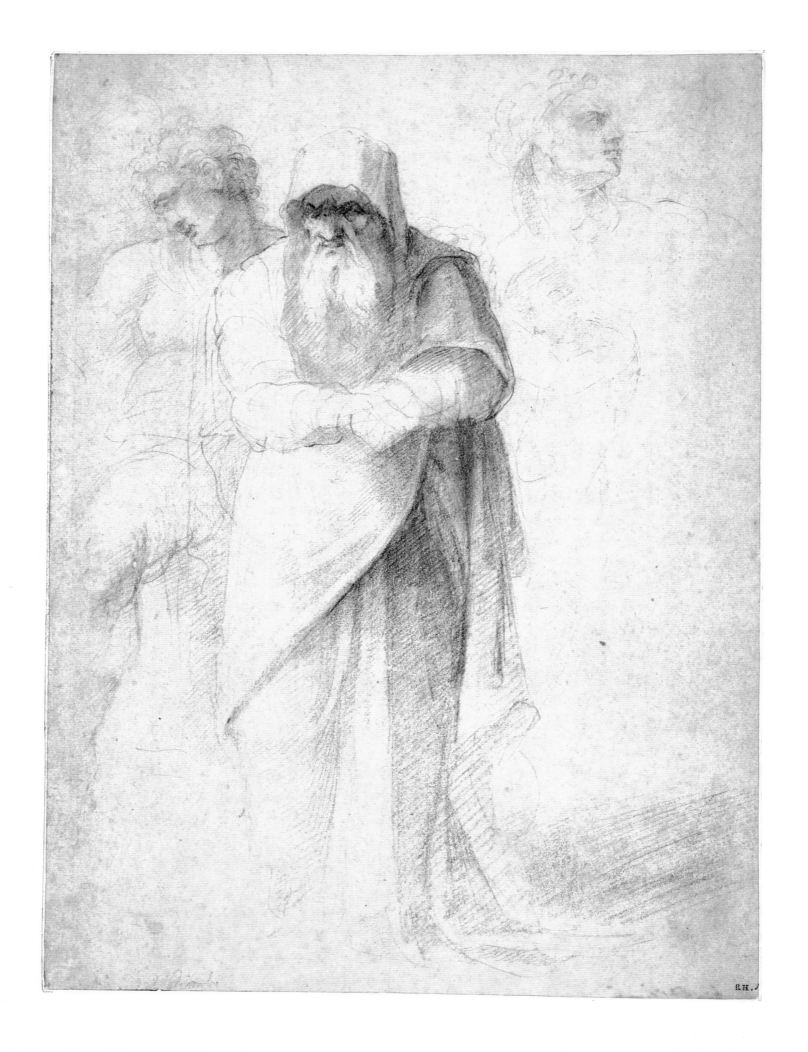

172

61

Sebastiano del Piombo
Venice 1485–1547 Rome
SHEET OF STUDIES WITH FOUR MALE FIGURES

Black chalk, laid down; 353 × 259 mm.
At lower left, in black chalk: *Piombo*
Watermark: not visible
Inv. I 378

Provenance: R. Houlditch, London (L. 2214); W. Russell, London (L. 2648); possibly sale London (Christie's), December 10-12 1884; J.W. Böhler, Lucerne; F. Koenigs, Haarlem (L. 1023a), acquired in 1929; D.G. van Beuningen, Rotterdam, acquired in 1940 and donated to the Boymans Museum Foundation.

Exhibitions: Amsterdam 1934, no. 608; Paris 1935-II, no. 689; Groningen 1949, no. 44; Paris, Rotterdam, Haarlem 1962, no. 89.

Literature: Berenson 1938, vol. II, no. 2506B; Juynboll 1938, p. 20; L. Dussler, *Sebastiano del Piombo*, Basel 1942, no. 247; M. Lucco, *L'Opera completa di Sebastiano del Piombo*, Milan 1980, pp. 125-26, no. 102A-1; P. Pouncey, "Review of Bernard Berenson, I Disegni dei Pittori Fiorentini," *Master Drawings* II, 1964, p. 291; M. Hirst, "A Late Work of Sebastiano del Piombo," *Burlington Magazine* CVII, 1965, p. 182 and notes 26-27; R. Bacou in exhib. cat. *Le XVIe Siècle Européen. Dessins du Louvre*, Paris, Musée du Louvre, 1965, under no. 101; exhib. cat. *Roman Drawings of the Sixteenth Century from the Musée du Louvre, Paris*, Chicago, The Art Institute, 1979-80, under no. 54; M. Hirst, *Sebastiano del Piombo*, Oxford 1981, p. 146.

More than twenty years after Sebastiano del Piombo had painted the *Visitation* that was presented to the Queen of France (fig. a; Paris, Louvre),[1] he executed a second, more monumental version as a fresco for the Church of Santa Maria della Pace in Rome. The fresco, then commissioned by Filippo Sergardi, former secretary of Agostino Chigi, originally belonged to a series that included a *Presentation of the Virgin* by Baldassare Peruzzi and an *Assumption of the Virgin* by Francesco Salviati. Peruzzi's is the only one of the series that remains in the church. Salviati's fresco is lost, and only fragments of Sebastiano del Piombo's, transferred to canvas, are preserved in the Duke of Northumberland's collection at Alnwick.[2] Though it is not possible to reconstruct the fresco completely on the basis of these fragments, an old painted copy in the Galleria Borghese in Rome and a print, attributed by Vasari to Hieronymus Cock (fig. b), give some idea of the original.[3] The fresco maintained the overall composition of the earlier painting – with Mary, Elizabeth and their handmaids in the foreground and the aged Zacharias, accompanied by male figures, on the second plane – but it was broadened considerably. The measurements of

the remnants in Alnwick point to a width of more than four meters.

As the print differs from the painted copy in certain details, it could have been based on a more developed study, or *modello*, that has since been lost, namely the "*quadro di chiaro oscuro*" listed in the collection of Fulvio Orsini.[4] The artist must have amalgamated his various studies in order to create that lost *modello*. Some have survived, and it is thought that the present sheet is one of them. The style and dignified monumentality of this drawing correspond to the late drawings of Del Piombo in both the Louvre and the British Museum, which were executed in preparation for the fresco.[5] However, the group of figures in the Rotterdam drawing is not represented in the same form in either the painted copy or the print.

The old man with the grave expression presumably represents Zacharias prominently situated in the background and flanked by male figures seen in profile. He is unmistakably Michelangelesque; his hood and powerful build recall the bearded man in the right foreground of the *Crucifixion of St Peter* in the Cappella Paolina in the Vatican, which dates from the same period as Sebastiano's *Visitation* in Santa Maria della Pace.[6] The pose of the two other figures in the drawing is also one typical of Michelangelo, with the heads attached to the bodies at a somewhat unnatural angle. It may well be that, even at this late date, Del Piombo still drew inspiration from the Florentine master, who had so often supplied him with drawings for paintings in his youth.[7]

Ultimately, the old man in the drawing more closely resembles the Zacharias in the Louvre's *Visitation* of 1521 (fig. a) than the one in the Duke of Northumberland's fresco. For the latter, Del Piombo chose a slightly more virile type, whom he depicted in a reflective pose without any head covering, based on a statue of an ancient philosopher. Though it seems most likely that the sheet was executed with the fresco in mind, it cannot be considered a preparatory drawing in the usual sense. It includes figures which the artist may have considered for the background but then abandoned after starting work on the painting.

In this drawing, Sebastiano began by outlining the shapes of the figures rather sketchily, then filled them in with fine, sometimes attenuated hatching which determines the lighting. All the hatching is in the same direction; there is no crosshatching. He then reinforced some of the central figure's contours, gave the face a dark accent here and there, and went over the hatching a second time for emphasis. The manner in which he left certain areas blank to suggest the fluffy texture of the beard and the light on the face below the cap is especially beautiful. The figures on the sheet are not connected, and the two secondary ones have not been finished. The foreshortened left leg does not belong to the torso above it, of which the right shoulder is depicted but not the corresponding arm. Barely discernible to the right of the old man is the sketchy profile of a fourth body, turned to the left.

1. Inv. 357, Hirst (1981), pp. 76-79, pl. 105.
2. Hirst (1965), pp. 177-85, and Hirst (1981), pp. 144-47, pls. 194-96, 203.
3. For the painted copy, which was probably once in the collection of the painter Cavalier d'Arpino, see P. della Pergola, *Galleria Borghese. I Dipinti*, vol. II, Rome 1959, pp. 134-35, no. 186, and Hirst (1981), p. 145 and pl. 202. For the print mentioned in Vasari 1878-85, vol. V, p. 424, see Hirst (1965), pp. 178-81. It is listed in T.A. Riggs, *Hieronymus Cock: Printmaker and Publisher*, New York, London 1977, Appendix, p. 391, no. a-32.
4. See Hirst (1981), p. 145, note 99, and p. 156, Appendix B-III, "Works by Sebastiano Owned by Fulvio Orsini": "*Quadro corniciato di noce, di chiaro oscuro, in tela, di mano di fra Bastiano, con la Visitatione d'Elisabetta.*"
5. Hirst (1981), p. 146 and pls. 197-99. See also P. Pouncey and J.A. Gere, *Raphael and his Circle: Italian Drawings in the Department of Prints and Drawings in the British Museum*, London 1962, vol. I, no. 280, vol. II, pl. 262, and exhib. cat. Chicago (1979-80), no. 54.
6. C. de Tolnay, *Michelangelo: Sculptor, Painter, Architect*, Princeton 1975, pp. 63-64, 66-68.
7. See J. Wilde, *Michelangelo and his Studio. Italian Drawings in the Department of Prints and Drawings in the British Museum*, London 1953, pp. 27-31, nos. 15-17, and Hirst (1981), pp. 41-48, and pp. 148-51, Appendix A, "The Drawing Styles of Michelangelo and Sebastiano."

GL

fig. a

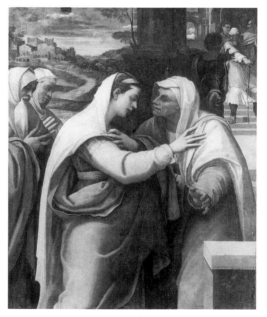

fig. b

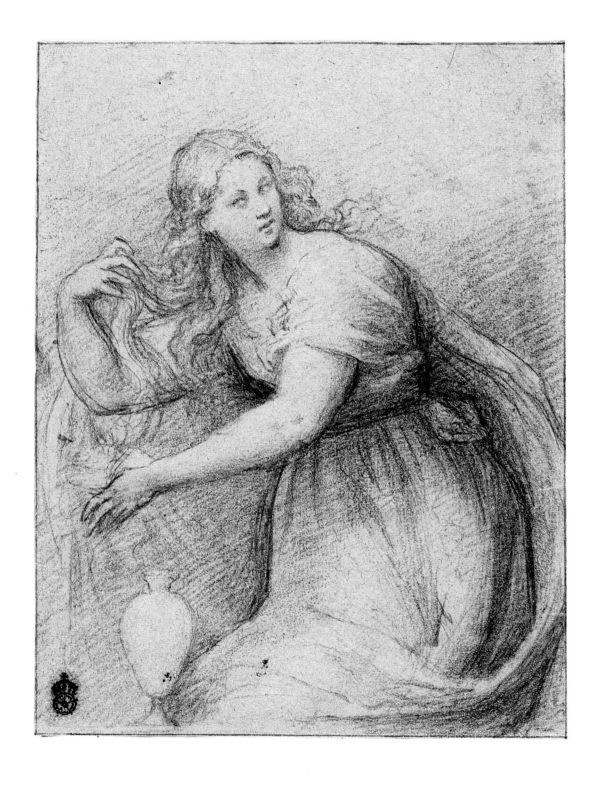

62

Giovanni Antonio de Sacchi, called Il Pordenone
Pordenone 1482/83–1539 Ferrara
MARY MAGDALEN

Black chalk on blue-gray paper, heightened with white,
framing line in pen and brown ink; 192 × 143 mm.
Verso, in pen and brown ink: *Pordonone*, and in red
chalk: *no. 525*
No watermark
Inv. I 292

Provenance: A.G.B. Russell, London and Swanage,
Lancaster Herald (L. 2770a); sale London (Sotheby's),
May 9 1929, no. 20; acquired for £44 by F. Koenigs,
Haarlem (L. 1023a); D.G. van Beuningen, Rotterdam,
acquired in 1940 and donated to the Boymans Museum
Foundation.

Exhibitions: Pordenone 1984, p. 227, no. 4.46

Literature: D. von Hadeln, *Venezianische Zeichnungen
der Hochrenaissance*, Berlin 1925, p. 36, pl. 49; G. Fiocco,
Il Pordenone, Udine 1939, pp. 104, 154; Tietze 1944,
no. 1324; Byam Shaw 1967, p. 46, fig. 4; M. Lucco,
"Pordenone a Venezia," *Paragone* CCCIX, 1975, p. 23;
C.E. Cohen, *The Drawings of Giovanni Antonio da
Pordenone* (Corpus graphicum III), Florence 1980,
pp. 122-23, 127; C. Furlan, *Il Pordenone*, Milan 1988,
pp. 293-94, no. D 57.

fig. a

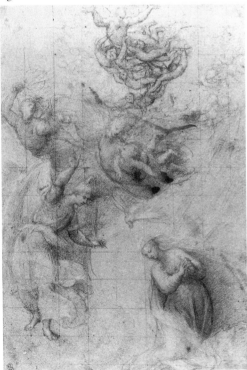

Most of Giovanni Antonio Pordenone's surviving
drawings were executed in red chalk. Some others were
done in pen and brown ink, but only a handful of black
chalk drawings have been attributed to him.[1] The most
striking of these is the splendid preparatory study at
Windsor Castle which the artist made for his *Annunciation*
in the monastery of Santa Maria degli Angeli, Murano,
in 1537-38 (fig. a).[2] Like the present drawing, the
Windsor study was drawn on blue paper. A striking
characteristic of both sheets is the fine hatching, within
which are the heavily delineated contours of the figures.
Pordenone's paintings and frescoes were strongly
influenced by Titian and Giorgione. His flowing, softly
modeled style of drawing shows just how thoroughly he
studied their graphic works as well. The Mannerist poses,
moreover, attest to his familiarity with the art of
Parmigianino and Correggio.

It was with chalk in hand that Pordenone did his
thinking – drawing and redrawing many lines in the
process. In this sheet, his corrections can be seen
around the right arm, whereas the form of the left
seems to have been defined partly by reserving the area
and highlighting it with white chalk, just as the artist
gave the angel Gabriel his right wing in the Windsor
Annunciation. The lighting in both drawings is diffuse,
and nowhere are there strong accents. The folds on
the left shoulder of the Magdalen are drawn over the
hatching with white chalk. Her powerful, almost
masculine arms and bound-up sleeves are characteristic
of Pordenone. This may have been appropriate for the
strapping young women in the *Birth of the Virgin* in
Piacenza (*c.* 1534-35), but here the arms seem unduly
large in proportion to the Magdalen's slim build.

In contrast to the squared drawing in Windsor Castle,
no one painting can be singled out for which the
Magdalen in Rotterdam was intended. She does resemble
various female figures in the Correggiesque frescoes of
1530-32 in the Church of Santa Maria di Campagna,
Piacenza.[3] It would seem that the gesticulating sibyls in
the pendentives, and St Catherine of Alexandria as she
appears in the various scenes illustrating her life, were
based on the same model.[4]

If the drawing was intended for a specific work,
then it was probably the frescoes in the Chapel of St
Catherine in the same Piacentine church. On the walls
of the drum Pordenone painted a series of very
animated female saints in niches, including the
Magdalen (fig. b).[5] Although her pose differs from that
in the drawing, there are nevertheless some striking
parallels between them: the long, billowing hair parted
in the middle, for example, the fluttering, draped cloak,
and the distinct form of the ointment jar which is
merely outlined in the drawing. The Magdalen in the
Rotterdam sheet is not necessarily seated.[6] Although the
jar stands at the bottom of the image, the drawing was
obviously trimmed along that edge and at the right, and
the framing line added later. As in the fresco, the
original figure was probably shown full length.

1. They include two drawings in the Uffizi in Florence:
the *Portrait of a Man with a Hat*, inv. 677E, Cohen (1980),
pp. 71-72, fig. 10 (the attribution of which has been questioned,
see Furlan [1988], p. 344, no. DA17), and the *Dancing Children*,
inv. 729E, Cohen (1980), pp. 75-76, fig. 75, Furlan (1988),
pp. 276-79, no. D42.
2. Inv. 6658, Cohen (1980), pp. 127-28, figs. 136-37, and
Furlan (1988), pp. 238-39, no. 102, and pp. 319-20, no. D94.
3. Furlan (1988), pp. 185-99, no. 72.
4. Ibid., pp. 199-203, figs. on pp. 202-03.
5. Cohen (1980), pp. 122-23, figs. 120-21, Furlan (1988),
pp. 199-200.
6. Cf. Cohen (1980), p. 122.

GL

fig. b

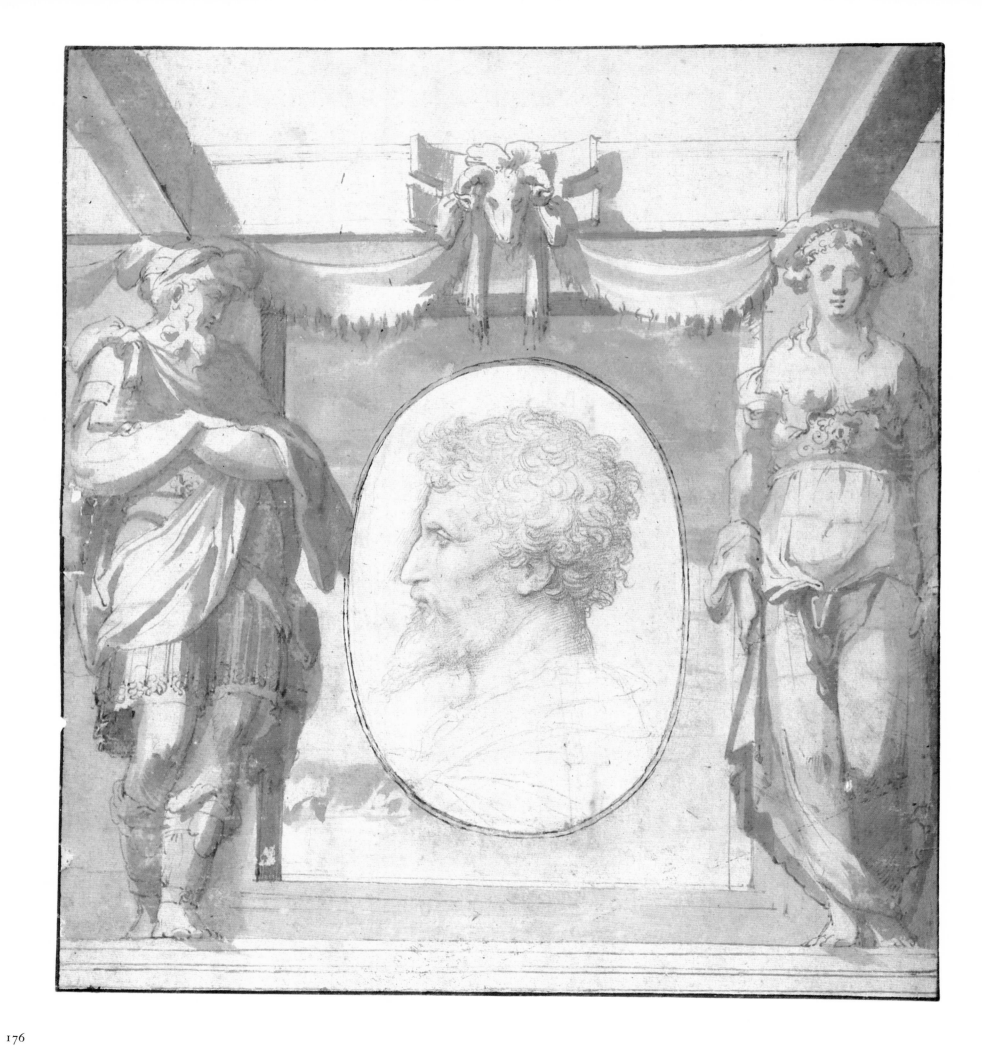

63

Girolamo Francesco Maria Mazzola,
called Parmigianino
Parma 1503–1540 Casalmaggiore
PORTRAIT OF VALERIO BELLI

Red chalk, oval; 158 × 127 mm.

and

Giorgio Vasari, or one of his assistants
Arezzo 1511–1574 Florence
CARTOUCHE WITH TWO CARYATIDS

Pen and brush and brown ink, brown wash;
273 × 246 mm.
Verso, in pen and brown ink: *Di Gio: Antonio Pordanone*
Watermark: an anchor in a circle surmounted by a star
(cf. Briquet 496)
Inv. I 392

figs. a, b, c

VALERIO ET ALTRI. 295

VALERIO VICENTINO
INTAGLIATORE.

*Vite di Valerio Vicentino, di Giouanni da castel Bo
lognese, di Matteo dal Nasaro Veronese, e dal
tri Ecc. intagliatori di Camei, & gioie.*

Provenance: G. Vasari, Arezzo and Florence;
A.J. Dezallier d'Argenville, Paris; Sir Thomas Lawrence,
London (L. 2445); S. Woodburn, London; Willem II,
later King of the Netherlands, acquired in 1838; sale
The Hague, August 12 1850, no. 164; Grand Duke Karl
Alexander of Saxe-Weimar, Weimar; J.W. Böhler,
Lucerne; F. Koenigs, Haarlem (L. 1023a), acquired in
1929; D.G. van Beuningen, Rotterdam, acquired in
1940 and donated to the Boymans Museum Foundation.

Exhibitions: London 1836 (Tenth Exhibition), no. 39.

Literature: Von Rigten 1865, pl. 26; R. Weigel, *Die
Werke der Maler in ihren Handzeichnungen: beschreibendes
Verzeichniss der in Kupfer gestochen, lithographierten und
photographierten Facsimiles von Originalzeichnungen grosser
Meister*, Leipzig 1865, no. 4939; E. Kris, *Meister und
Meisterwerke der Steinschneide-Kunst*, Vienna 1929, vol. I,
pp. 56, 165, vol. II, pl. 218; W. Suida, *Leonardo und sein
Kreis*, Munich 1929, p. 237; O. Kurz, "Giorgio Vasari's
'Libro de' disegni' (Conclusion)," *Old Master Drawings*
XII, 1937, p. 38, pl. 34; K. Oberhuber, exhib. cat.
*Parmigianino und sein Kreis: Zeichnungen und
Druckgraphik aus eigenem Besitz*, Vienna, Albertina, 1963,
p. 3, under no. 7; W. Prinz, *Vasari's Sammlung von
Künstlerbildnissen, Beiheft zu Mitteilungen der
Kunsthistorischen Institutes in Florenz* XII, 1968, p. 132,
no. 114; A.E. Popham, *Catalogue of the Drawings of
Parmigianino*, New Haven, London 1971, I, p. 178,
no. 569, III, pl. 430; L. Ragghianti Collobi, *Il Libro de'
Disegni del Vasari*, Florence 1974, vol. I, pp. 126, 183-84,
vol. II, p. 213, pl. 486; J.A. Gere and N. Turner, exhib.
cat. *Drawings by Raphael from the Royal Library, the
Ashmolean, the British Museum, Chatsworth and other
English Collections*, London, British Museum, 1983,
p. 174, under no. 142; B.W. Meijer and C. van Tuyll,
exhib. cat. *Disegni italiani del Teylers Museum Haarlem*,
Florence, Istituto Universitario Olandese di Storia
dell'Arte, Rome, Istituto Nazionale per la Grafica,
1983-84, under no. 24; C. Gardner von Teuffel,
"Raphael's Portrait of Valerio Belli: Some New
Evidence," *Burlington Magazine* CXXIX, 1987,
pp. 663-66.

The attributive history of this dignified profile portrait
of the famous gem cutter and medalist Valerio Belli,
also known as Vicentino (*c.* 1468–1546), is full of ups
and downs. When it belonged to Sir Thomas Lawrence
it was assigned to Michelangelo and was supposedly the
portrait of the poet Ariosto.[1] In fact, it was auctioned
as such in 1850, together with the rest of the collection
of King Willem II of the Netherlands: "*Michel-Ange -
un médaillon avec le portrait en profil de l'Arioste. Ce beau
dessin est en partie à la sanguine et en partie lavé au
bistre*."[2] Soon, however, cracks in this optimistic
attribution began to show and the drawing was demoted
variously to "School of Parmigianino," "Bernardino
Luini" and "Florentine School,"[3] until at last, in 1963,
Oberhuber gave it to Parmigianino, whose authorship
has not been seriously contested since then.

The drawing served as the model for the woodcut of
Belli's portrait in the second edition of Giorgio Vasari's
Vite in 1568 (fig. a), and was included in his *Libro de'
Disegni*, as the Mannerist, ornamental frame bears
witness. Valerio Belli himself used the drawing for a
lead medal which is now in the Samuel H. Kress
Collection at the National Gallery of Art, Washington
(fig. b).[4] The artist's appearance has also been recorded
in a marble relief – related to the drawing –in the
Victoria and Albert Museum, London,[5] and in a small
tondo portrait by Raphael, formerly owned by Lord
Clark (fig. c).[6]

The story goes that shortly before Raphael's death
in 1520, he made Belli godfather of his illegitimate
daughter. In Raphael's tondo, Belli appears somewhat
younger than in this drawing, which could mean it was
executed in the early 1520s. It does not necessarily have
to predate Parmigianino's departure for Rome (1524),
since the two men could have met there. Belli's
presence in the papal city is documented in the first
months of 1520.[7] Belli's admiration for Parmigianino is
evidenced among other things by the fact that, some
time after 1527, he acquired Parmigianino's self-portrait,
painted before a convex mirror, from Pietro Aretino.[8]

Apart from various self-portraits, all of which are rather stylized, Parmigianino has few drawn portraits to his name. Nevertheless, the obvious stylistic similarities between this drawing and other examples of his draftsmanship more than justify the attribution. Characteristic of Parmigianino are the soft, blurred lines and the careful hatching. In his *Libro de' Disegni*, Vasari sought to document the draftsmanship of the artists whose biographies he had recorded in the *Vite*. Although he acquired many drawings directly from relatives or students of the artists, not all of his attributions by any means have stood the test of time. The present sheet is a good example of this.

Vasari possibly believed that this oval, red chalk drawing of Belli was actually a self-portrait, despite his low opinion of Belli's *disegno*.[9] Perhaps he had another artist in mind, for when the drawing was recently removed from its old lining, not only the watermark but also a sixteenth-century inscription came to light on the verso. In a firm calligraphic hand the following can be read: *Di Gio: Antonio Pordanone*. This could well be Vasari's own attribution, and it must have been penned some time between the creation of the drawing and the addition of the ornamental setting, which is either by Vasari himself or an assistant like Cristofano Gherardi ("Il Doceno").[10] Mistaking Parmigianino for Pordenone (1482/83–1539) is not difficult to do, though of course the discovery of the inscription alone does not warrant taking the drawing away from Parmigianino. After all, his debt to Pordenone was recently pointed out yet again, and indeed it is evident in some of his drawings.[11]

1. S. Woodburn in exhib. cat. *The Lawrence Gallery. The Tenth Exhibition. A Catalogue of One Hundred Original Drawings by Michael Angelo*, London 1836, no. 39.
2. Sale cat. The Hague, August 12 1850, no. 164.
3. By Weigel (1865), no. 4939, Suida (1929), p. 237, and Kris (1929), p. 56 respectively. Oberhuber's attribution in exhib. cat. Vienna (1963), p. 3.
4. G. F. Hill, *Portrait Medals of Italian Artists of the Renaissance*, London 1923, p. 48, nos. 24 (25), pl. XXIII, and L. and G. Pollard, *Renaissance Medals: Complete Catalogue of the Samuel H. Kress Collection*, London 1967, pp. 72, 131.
5. J. Pope Hennessy, *Catalogue of Italian Sculpture in the Victoria and Albert Museum*, vol. II, London 1964, pp. 488–89.
6. See Gardner von Teuffel (1987). Paolo Giovio also had a portrait of Belli in his collection of "Uomini illustri," see L. Rovelli, *Paolo Giovio: il Museo dei Ritratti*, Como 1928, p. 193, no. 354.
7. G. Zorzi, "Alcuni rilievi sulla vita e le opere di Valerio Belli detto Vicentino," *L'Arte* XXIII, 1920, p. 184.
8. See Popham (1971), no. 569. The portrait subsequently belonged to the sculptor Alessandro Vittoria, who presented it to Emperor Rudolf II. See also T. von Frimmel, *Geschichte der Wiener Gemäldesammlungen*, vol. I, Leipzig 1899, p. 362, no. 58.
9. Vasari 1878-85, vol. V, p. 379.
10. Ragghianti Collobi (1974), pp. 183-84.
11. K. Oberhuber in exhib. cat. *The Age of Correggio and the Carracci: Emilian Painting of the Sixteenth and Seventeenth Centuries*, Washington, National Gallery of Art, New York, Metropolitan Museum of Art, Bologna, Pinacoteca Nazionale, 1986-87, p. 159.

GL

64

Jacopo Carucci, called Pontormo
Pontormo 1494–1557 Florence
TWO SEATED YOUTHS

Red chalk; 277 × 379 mm.
Verso, in black chalk, within a framing line:
Study of a Head with a Hat (image 125 × 114 mm.),
inscribed in pen and brown ink: *Puntorm*
No watermark
Inv. I 117

Provenance: J. Richardson Sr., London (L. 2183);
Earl Spencer, Althorp; E. Wauters, Paris (L. 911);
sale Amsterdam (Frederik Muller), June 15-16 1926,
probably one of nos. 253-338; acquired by F. Koenigs,
Haarlem (L. 1023a); D.G. van Beuningen, Rotterdam,
acquired in 1940 and donated to the Boymans Museum
Foundation.

Exhibitions: Amsterdam 1955, no. 235.

Literature: Juynboll 1938, pp. 19-20 (ill.); Berenson
1961, vol. III, no. 2368A-2; J. Cox Rearick, *The Drawings
of Pontormo*, Cambridge, Mass. 1964, vol. I, nos. 255-56,
vol. II, fig. 240.

Jacopo Pontormo was one of those Mannerist artists for whom Franz Koenigs had a particular affection. In this he was ahead of his time, for it was only after the Second World War that Pontormo became widely appreciated. Besides this genre study Koenigs also acquired a powerful study of the young John the Baptist for the altarpiece in the Church of San Michele in Visdomini, Florence, together with studies for the *Pietà* in Dublin on the verso and a portrait drawing of a seated magistrate. At the Oppenheimer sale in 1936 he was apparently also interested in the Tuscan artist's splendid preparatory study of *Two Standing Monks* for the *Supper at Emmaus* in the Uffizi, Florence, with an intriguing study of a nude on the verso.[1] He must have decided to leave that drawing to A.E. Popham, who bought it on behalf of the British Museum.[2]

It seems that Koenigs wished his collection to illustrate as many facets of Pontormo's draftsmanship as possible. In that respect the present sheet was of great importance, for the artist did not make many drawings of figures in contemporary dress. Its genre-like character is equally unusual, and makes it even more attractive. Two youths, thought by some to be studio apprentices, occupy much of the surface, the one on the right fitted into the lower right corner. His companion looks directly at him, and seems to be gesturing with his left hand, though some have suggested he is simply picking his nose. As if bored with their reading, each one uses a hand to mark his place. Andrea del Sarto was largely responsible for the popularity of this motif; in his altarpieces apostles and saints often appear with a finger in a book. Pontormo began studying with Del Sarto in 1512, and may well have seen his superb studies of hands and books done from life.

The subject and the contemporary dress recall *Four Singing Youths*, a drawing by Pontormo formerly in the Esterhazy Collection and now in the museum at Budapest (fig. a).[3] That sheet is generally dated to the period of Pontormo's fresco in Poggio a Caiano

(*c*. 1520-21). At that time his drawing style was somewhat angular, and the contours in the Budapest sheet are indeed sharp, and there is something rather menacing about the pointed tips of the fingers. The Rotterdam drawing is freer, the forms of the drapery are rounder, and the hatching, which does not fill the surface entirely, is broader and less compulsive. Even though the two sheets do not otherwise show much stylistic difference, the *Two Seated Youths* nevertheless probably belongs to a later period – the one in which the artist painted his *Supper at Emmaus*, for instance, or perhaps even after that. There is a striking similarity between the profile of the youth on the right and one of the men seated at the table in the Uffizi painting, while the style of the preparatory study for that figure in Munich is comparable to that of the Rotterdam sheet (fig. b).[4] Even the position of the left arm, with which the man in the painting holds a knife, corresponds to the same arm in this drawing.

Given Pontormo's functional approach to drawing, we should not assume that the present sheet is an independent work of art, though no direct relationship between it and any of the artist's paintings has been established. The only suggestion so far as to the drawing's original purpose has come from Berenson, and could also help date it. Vasari writes that in 1532, during his reign as Pope Clement VII, Giulio de' Medici tried to persuade Pontormo to complete the decoration of the Salone in his family villa at Poggio a Caiano. Pontormo is said to have prepared cartoons for the project, and in fact there is a washed pen and ink drawing in Florence that has been associated with that commission; it may be a study for the lunette opposite Pontormo's earlier masterpiece, *Vertumnus and Pomona*.[5] The precise subject of the drawing is not clear, but it seems to represent learned men in conversation, and it was intended for placement around the window (fig. c). One is playing music, another is using a compass, and a third, crowned with laurel, is speaking from an elevated

fig. a

fig. b

179

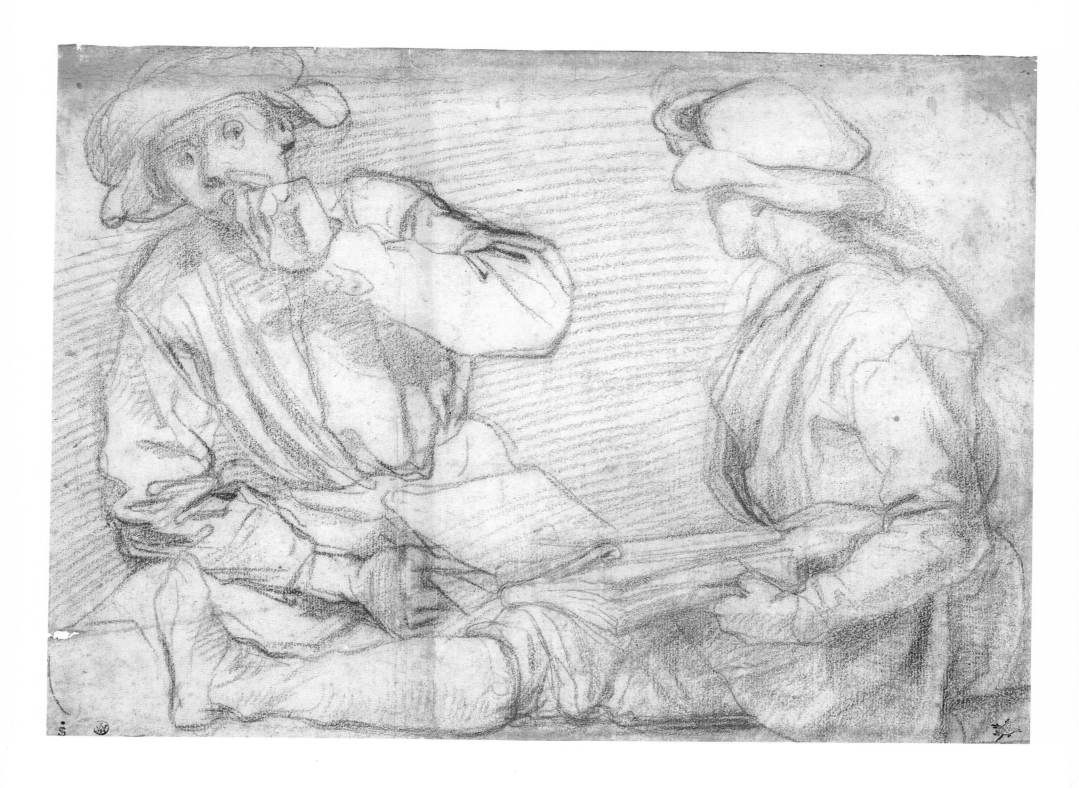

position. Berenson suggested that Pontormo used the Rotterdam sheet in order to work out his ideas for the figures in the lower right corner. This seems unlikely, however, even if it would explain why the leg of the young man on the right has been drawn parallel to the beholder, which is an unusual position.[6]

It was primarily Pontormo's informal drawings, such as this one, that attracted the Florentine draftsmen of the early Baroque. His influence on Bernardino Poccetti and Jacopo da Empoli, for instance, is obvious in their figure drawings.

The back of the sheet bears a small, characteristic chalk sketch of a head in profile wearing a broad-brimmed hat (fig. d). One can see that the artist first sketched the entire head, then gave it a hat, and finally filled in the face with chalk to indicate the area that would remain visible. The attitude of the head is identical to that of the boy with the wicker basket in Poggio a Caiano (fig. e), who at one stage was also planned with a hat, as evidenced by the preparatory studies.[7] It is not clear whether the small chalk sketch in Rotterdam was one of these studies or a later, more stylized treatment of the same subject.

1. See Cox Rearick (1964), vol. I, p. 128, no. 37, vol. II, fig. 44, and vol. I, pp. 141-42, no. 64, vol. II, fig. 68. The portrait of the magistrate, which disappeared to Germany in 1940 (inv. I 293, Elen 1989, no. 361, [ill.], Berenson 1938, vol. III, no. 2250A), also came from the Wauters Collection, and is now attributed to Cavalori by Cox Rearick (1964), vol. I, pp. 393-94, no. A203. The *Two Standing Monks* is listed in the literature with the inventory number I 149 (Berenson 1938, vol. III, no. 2250B, and Cox Rearick [1964], vol. I, nos. 215, 253), which it never had. In C. Gamba, *Contributo alle Conoscenza del Pontormo*, Florence 1956, pp. 11-12, it is incorrectly located in Haarlem, Koenigs Collection.
2. Inv. 1936-10-10-10. See also N. Turner, exhib. cat. *Florentine Drawings of the Sixteenth Century*, London, British Museum, 1986, no. 105. The verso, with a model pointing insistently at the viewer, is reproduced in Cox Rearick (1964), vol. II, fig. 241.
3. Cox Rearick (1964), vol. I, no. 172, vol. II, fig. 164; see also Loránd Zentai in exhib. cat. *Leonardo to Van Gogh: Master Drawings from Budapest*, Washington, National Gallery of Art, Chicago, Art Institute of Chicago, Los Angeles, Los Angeles County Museum of Art, 1985, no. 14.
4. For the painting see L. Berti, *L'Opera completa del Pontormo*, Milan 1973, no. 85, pl. XXXIX, and for the drawing Cox Rearick (1964), vol. I, no. 220, vol. II, fig. 214, and R. Harprath, exhib. cat. *Italienische Zeichnungen des 16. Jahrhunderts aus eigenem Besitz*, Munich, Staatliche Graphische Sammlung, 1977, no. 68.
5. Vasari 1878-85, vol. V, p. 196, and vol. VI, pp. 275-76. For the Uffizi drawing, inv. 455F, see Berenson 1961, vol. III, no. 1971, and Cox Rearick (1964), vol. I, no. 132. For the fresco: M. Winner, "Pontormos Fresko in Poggio a Caiano: Hinweise zu seiner Deutung," *Zeitschrift für Kunstgeschichte* XXXV, 1972, pp. 153-97.
6. Berenson 1961, vol. III, no. 2368A-2.
7. Florence, Uffizi, inv. 6514F verso, Cox Rearick (1964), vol. I, no. 140, vol. II, fig. 133, and inv. 452F verso, Cox Rearick (1964), vol. I, no. 141, vol. II, fig. 135.

GL

fig. c

fig. d

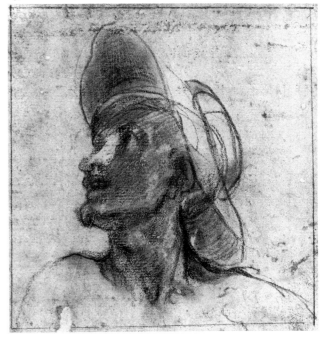

fig. e

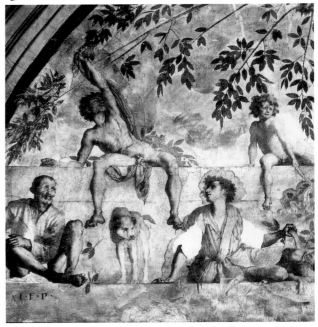

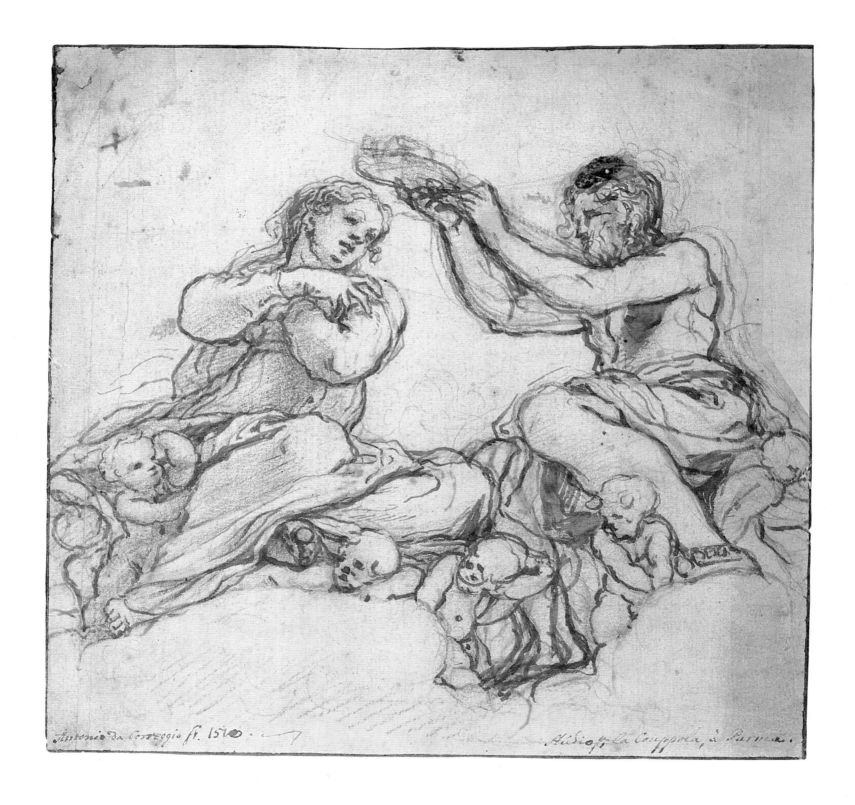

65

Antonio Allegri, called Correggio
Correggio (?) c. 1489/1494–1534 Correggio
CORONATION OF THE VIRGIN

Red chalk, pen and brush in brown and gray ink, traces
of black chalk, framing line in brown ink, laid down;
196 × 203 mm.
At lower left, in pen and brown ink: *Antonio da
Correggio ft. 1518*; at lower right: *Studio per la Couppola
a Parma*
Watermark: not visible
Inv. I 381

Provenance: D. Versteegh, Amsterdam (not identified
in sale Amsterdam, November 3 1823); Sir Thomas
Lawrence, London (L. 2445); Willem II, later King of
the Netherlands, The Hague, acquired in 1838; sale
The Hague, August 12 1850, no. 187; Grand Duke Karl
Alexander of Saxe-Weimar, Weimar; J.W. Böhler,
Lucerne; F. Koenigs, Haarlem (L. 1023a), acquired in
1929; D.G. van Beuningen, Rotterdam, acquired in
1940 and donated to the Boymans Museum Foundation.

Exhibitions: London 1835-36, no. 54; Amsterdam 1934,
no. 529; Paris, Rotterdam, Haarlem 1962, no. 100;
Washington, Parma 1984, pp. 84-85, no. 10.

Literature: Von Ritgen 1865, pl. 34; J. Meyer, *Correggio*,
Leipzig 1871, p. 413, no. 104; A. Venturi, *Storia dell' arte
Italiana*, vol. IX, Milan 1926, p. 532, fig. 428; A. Venturi,
Il Correggio, Rome 1926, p. 186, fig. 71; C. Ricci, *Antonio
Allegri da Correggio*, Rome 1930, p. 165, pl. CCLI;
A. Quintavalle, "Un disegno del Correggio scoperto
nello stacco dell'affresco dell'Incoronata," *Bolletino d'Arte*
XXXI, 1937, p. 80; A.E. Popham, *Correggio's Drawings*,
London 1957, pp. 42-43, 153, no. 22, pl. XXVIII;
I. Fenyö, "Some Newly-discovered Drawings by
Correggio," *Burlington Magazine* CI, 1959, p. 422;
A. Ghidiglia Quintavalle, *Gli Affreschi del Correggio in
S. Giovanni Evangelista a Parma*, Milan 1962, p. 24;
I. Fenyö, *North Italian Drawings from the Collection of the
Budapest Museum of Fine Arts*, New York 1965, p. 56;
C. Gould, *The Paintings of Correggio*, London 1976,
pp. 65, 247, pl. 42c; G. Ercole, *Arte e Fortuna del
Correggio*, Modena 1982, p. 134; L. Fornari Schianchi,
La Galleria Nazionale di Parma, Parma 1983, p. 80;
exhib. cat. *Leonardo to Van Gogh: Master Drawings from
Budapest, Museum of Fine Arts*, Washington, National
Gallery of Art, Chicago, The Art Institute of Chicago,
Los Angeles, Los Angeles County Museum of Art,
1985, pp. 36-37; M. di Giampaolo and A. Muzzi,
Correggio: i disegni, Turin 1989, no. 35 (ill.).

This is one of a series of studies Correggio made in
preparation for his fresco of the *Coronation of the Virgin*
in the apse of San Giovanni Evangelista in Parma,
which he painted between 1520 and 1522.[1]
Unfortunately the original fresco has not survived.
As early as 1587 it was heavily damaged while the church
was being enlarged, and was replaced with an exact copy
by Cesare Aretusi that remains there to this day.[2]
Only fragments of the original have come down to us,
including part of the *Coronation* in the center (fig a;
Parma, Galleria Nazionale), of which the *sinopia*, the
underdrawing on the rough plaster, has also survived
(Parma, Biblioteca Palatina).[3]

Aretusi's copy and the surviving fragment show that
Correggio did not follow the drawing in Rotterdam
precisely. The speed and dynamism that distinguish the
study have been weakened, for instance. The manner in
which the turning figure of Mary is handled in the
drawing is full of movement, whereas both she and
Christ are comparatively static in the fresco. The rather
massive appearance of the figures' lower halves in the
drawing was doubtless intended to compensate for the
distortion that inevitably occurs whenever paintings are
viewed from below. The artist's attempts to determine
the exact contours of the bodies are clearly visible – the
lines from the top of Christ's head down his back were
drawn at least three times, for instance – but later on
Correggio used the brush to strengthen certain lines
and delineate the forms more precisely.

Christ's pose evidently gave Correggio some
difficulty. The artist wanted (or was obliged) to give
him a scepter, but this would have been impossible if he
were meant to crown the Virgin with both hands, as in
the Rotterdam sheet. The scepter, barely discernible in
Christ's left hand, points back toward him – a solution
that Correggio explored further in a drawing of Christ
alone (Courtauld Institute, London).[4] In another sketch,
preserved in Poitiers, the artist tried raising the left arm
halfway, but was no more satisfied with this.[5] Thanks to
sheets in Oxford, Budapest, and Paris it is possible to
follow how Correggio finally determined Christ's
position in the fresco – wearing a cloak and holding the
scepter aloft with his raised left hand – even if he did
apparently rely on the early Rotterdam drawing for the
rest of the figure, which is painted virtually in profile.[6]

The Virgin underwent a similar, step-by-step
development, as can be seen from drawings in Paris and
Budapest, of which the latter most closely resembles the
fresco.[7] The position of the head and the crossed arms
with the bent fingers were not changed in the later
versions, but the lower body was swung round so as to
enhance the foreshortening.

The Rotterdam sheet, the only surviving study for
the apse in which Christ and the Virgin both appear,
delighted A.E. Popham, who went so far as to say
"The Rotterdam sketch may serve as the type *par
excellence* of Correggio's draftsmanship: the touch of the
underdrawing is tentative as the artist gropes his way to
the realization of a figure; as this becomes clear to his
mind's eye, he fixes it on the paper with swift and

emphatic strokes of the brush. We are fortunate in
possessing this authentic sketch for the central group of
one of the most remarkable achievements of the Italian
High Renaissance."[8]

Correggio's *Coronation of the Virgin* had a profound
influence on later painters, not the least of them
Annibale Carracci. Annibale's own treatment of the
motif, for which he borrowed Correggio's God the
Father almost exactly, for instance, could be considered
an eloquent tribute to his predecessor's monumental
interpretation.[9]

1. See Ghidiglia Quintavalle (1962), Gould (1976), pp. 60-66,
and D. DeGrazia in exhib. cat. Washington, Parma 1984,
pp. 84-85, no. 10.
2. Gould (1976), fig. 39A.
3. Popham (1957), pls. XXVII and XXIX; Gould (1976),
figs. 40A-B.
4. Not in Popham (1957); Gould (1976), fig. 42A, Giampaolo
and Muzzi (1989), no. 33.
5. Popham (1957), p. 153, no. 23, pl. XXXIb.
6. Ibid., p. 154, no. 24r, pl. XXXIIb (Oxford, Ashmolean
Museum), p. 154, no. 25, pl. XXXb (Paris, Louvre). For the
Budapest drawings: Fenyö (1959), pp. 421-25, figs. 1, 3 (Gould
[1976], figs. 41C-D).
7. Popham 1957, p. 154, no. 26 (Paris, Louvre), Fenyö (1959),
pp. 422-25, fig. 2 (Gould [1976], fig. 43C), and exhib. cat.
Washington, Chicago, Los Angeles (1985), pp. 36-37 for the
Budapest drawing.
8. Popham (1957), p. 43.
9. The Metropolitan Museum of Art in New York acquired
Annibale's painting from Sir Denis Mahon. See D. Posner,
*Annibale Carracci: a Study in the Reform of Italian Painting
around 1590*, vol. II, London 1971, p. 41, no. 94, and exhib. cat.
*The Age of Correggio and the Carracci: Emilian Painting of the
Sixteenth and Seventeenth Centuries*, Washington, National
Gallery of Art, New York, Metropolitan Museum of Art,
Bologna, Pinacoteca Nazionale 1986-87, pp. 286-87, no. 95.

GL

fig. a

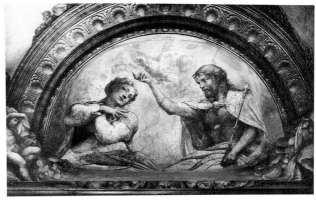

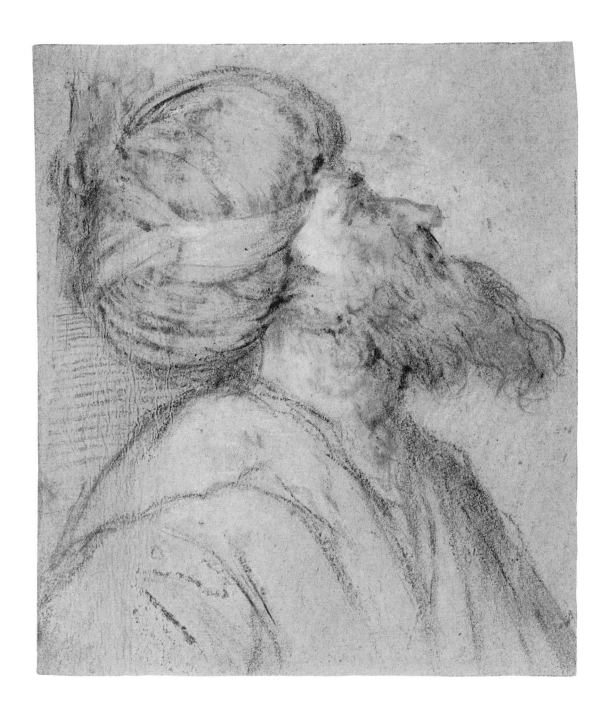

66

Jacopo Bassano, called Da Ponte
Bassano del Grappa 1510/15–1592 Bassano del Grappa
HEAD OF A BEARDED MAN WEARING A TURBAN

Black, red and colored chalks on blue paper, heightened
with white chalk, laid down; 174 × 143 mm.
Verso, in pen and brown ink: *BB n°: 45*
Watermark: not visible
Inv. I 516

Provenance: Z. Sagredo, Venice (?); "Borghese"
Collection; M. de Marignane, Paris; F. Koenigs,
Haarlem (L. 1023a), acquired in 1930; D.G. van
Beuningen, Rotterdam, acquired in 1940 and donated to
the Boymans Museum Foundation.

Exhibitions: Amsterdam 1929, no. 168; Venice, Florence
1985, no. 32.

Literature: Tietze 1944, no. 153; E. Arslan, *I Bassano*,
vol. I, Milan 1960, p. 176; A. Ballarin, "Introduzione ad
un catalogo dei disegni di Jacopo Bassano-II," *Scritti di
Storia dell'Arte in onore di Antonio Morassi*, Venice 1971,
p. 141, fig. 7; W.R. Rearick, "Tiziano e Jacopo Bassano,"
in *Tiziano e Venezia. Convegno Internazionale di Studi,
Venezia 1976*, Vicenza 1980, p. 373; W.R. Rearick,
*Jacopo a Ponte Bassanensis II (Disegni della Maturità
1549-1567)*, Bassano del Grappa (Vicenza) 1987,
no. II,3, pl. II-b.

This head, the style of which seems more akin to a
painting than to a drawing, was originally attributed to
Francesco Bassano, but in a note on the mount, James
Byam Shaw suggested that it was really by Francesco's
father Jacopo.[1] That attribution is convincing, especially
since the drawing corresponds with other studies of
heads executed in various colors of chalk by the elder
Bassano. The most closely related of these is a drawing
in the Albertina (Vienna) of a balding man who is also
looking up (fig. a).[2] That head, possibly a fragment of
a larger sheet, is a study for one of the apostles in the
Pentecost Altarpiece by Jacopo. Now preserved in the
Museo Civico of the artist's native Bassano, it can be
dated about 1558.[3]

The Rotterdam *Head of a Bearded Man Wearing a
Turban* probably dates from the same time, during the
period when Bassano reached artistic maturity under
the renewed influence of Titian. The Venetian master's
impact is especially evident in this sheet, since it is
based on the figure of King David in *The Triumph of
Christ*, the renowned woodcut after Titian's design of
1508 (fig. b).[4] Bassano himself probably owned a copy
of this monumental woodcut, for much earlier, in 1536,
he had already put motifs borrowed from the print to
good use in various paintings. Then, too, he adapted
the King David for murals in the Church of Santa
Lucia, in the village of Tezze sul Brenta near Bassano.[5]

In the drawing one can see how the artist
concentrated on the head, omitting the harp. Here and
there he repeated the lines and hatching of the woodcut
precisely, in order to suggest the curve of the turban,
for instance. The way in which chalk is used to model
the head makes the final result more fluid than the
hard, linear impression given by the print. Bassano
rendered the flesh tones in the face with an occasional
vivid red accent, and gave the sharp nose a hard, red
contour, as in the drawing in Vienna. The direction of
the gaze is virtually identical to that of his model.
Bassano may have considered using the sheet for a
bystander beholding the crucified Christ from below,
though there is no such figure in the Cartigliano
Crucifixion of 1575.[6]

As in the case of other Bassano drawings, this sheet
has a number on the verso, preceded by the initials *BB*.
This inscription dates from the time when the drawing
was part of the legendary collection of Zaccharia
Sagredo in Venice, and stands for "*bottega bassanese*,"
the workshop of the Bassano family. Sagredo probably
acquired from the Da Ponte estate an entire group of
drawings in which the various Bassano artists were no
longer distinguished. This confusion corresponds to
sixteenth-century practice which, in the case of the
Bassani, led to a family style rather than to a succession
of highly individual artistic personalities.

1. Arslan 1960, p. 176, could get no closer than "*Tra Jacopo
e Francesco*," somewhere between Jacopo and Francesco.
2. Rearick (1987), no. II,2, pl. II-a.
3. Arslan (1960), vol. I, p. 162, vol. II, pl. 122.
4. Pointed out by Rearick (1980), p. 373. For the woodcut see
M. Muraro and D. Rosand, *Tiziano e le silografia Veneziana del
Cinquecento*, Vicenza 1976, pp. 74-78, pl. 9.
5. Rearick (1987), no. II,3. See the remarks on the murals
by M. Muraro, "The Jacopo Bassano Exhibition," *Burlington
Magazine* XCIX, 1957, p. 291, and p. 293, fig. 3, although
without this fragment.
6. Ballarin (1971), pp. 141-42.

GL

fig. a

fig. b

67

Jacopo Tintoretto
Venice 1518–1594 Venice
STUDY AFTER AN ANTIQUE HEAD

Black chalk, heightened with white, on faded blue
paper; 340 × 230 mm.
Verso, in black and white chalk: the same head from
a slightly different angle
No watermark
Inv. I 205

Provenance: A. Simonetti, Rome (L. 2288bis); F. Koenigs,
Haarlem (L. 1023a), acquired in 1927; D.G. van
Beuningen, Rotterdam, acquired in 1940 and donated to
the Boymans Museum Foundation.

Exhibitions: Amsterdam 1934, no. 676; Rotterdam 1938,
no. 363; Paris 1952, no. 10; Rotterdam 1952, no. 95;
Amsterdam 1953, no. T 62; Paris, Rotterdam, Haarlem
1962, no. 115; Venice, Florence 1985, no. 35.

Literature: D.F. von Hadeln, *Zeichnungen des Giacomo
Tintoretto*, Berlin 1922, p. 24; Von Hadeln 1933, no. 8;
Tietze 1944, no. 1663; Haverkamp Begemann 1957,
no. 45; Jaffé 1962, p. 234; E.R. Meijer, "Bekende
gezichten," *Openbaar Kunstbezit* I, 1963, no. 3;
K. Andrews, *Catalogue of Italian Drawings. National
Gallery of Scotland, Edinburgh*, Cambridge 1968, I, p. 120,
under no. D 1854; P. Rossi, *I disegni di Jacopo Tintoretto*
(Corpus graphicum I), Florence 1975, p. 54, figs. 5 and I.

With no fewer than twenty drawings, Jacopo Tintoretto
was disproportionately represented in the collection of
Franz Koenigs. Since they were not bought *en bloc*, their
presence may well point to a conscious preference on
the part of the collector – one which was by no means
unique in the 1920s and 1930s. At that time many
artists and critics shared the conviction that Tintoretto
and El Greco were the precursors of modern art.
Following this lead, art collectors eagerly acquired the
work of both masters.[1] For Cézanne, the drawings of
Tintoretto were clearly a source of inspiration. In a
letter to Emile Bernard, he referred to Tintoretto as
"*le plus vaillant des Vénitiens.*" Prompted by his dealer,
Paul Cassirer, Koenigs may have wanted to illustrate in
his collection the French artist's admiration for the
Venetian, for he also owned no fewer than twenty-three
drawings by Cézanne.[2] Moreover, Frits Lugt, who did
not share Koenigs' appreciation for Tintoretto, is
known to have sold or passed on to him various
drawings by the artist.[3]
 The Tintorettos in the Koenigs Collection are
representative of the artist's draftsmanship. Besides the
well-known schematic figure studies for paintings,
Koenigs collected some of the drawn copies the artist
made of subjects sculpted by Michelangelo, as well as
early studies after classical models, including two after

antique portrait busts.[4] One of the latter is of a bust
given to the city of Venice in 1523 by Cardinal
Domenico Grimani (fig. a); in Tintoretto's time it was
believed to represent the emperor Vitellius.[5] The artist
himself owned a cast of the bust, later referred to as the
"*testo di Vitelo*" in the will of his son Domenico.[6] Each
time Tintoretto drew the head, he changed the lighting
and angle, circling his subject as a photographer would
nowadays. Tintoretto's unusually broad, rhythmic
hatching on blue paper demonstrates his preference
for dramatic lighting, which was probably achieved by
moving candles around the bust. The artist went over
each drawing thoroughly with white chalk to intensify
the chiaroscuro even further. Now and then he used the
"Vitellius" in a painting, such as the youthful *Supper in
the House of the Pharisee* of the 1550s (Nuevos Museos,
El Escorial), where the bust served as the model for one
of the figures at the table.[7]
 No such adaptation of this powerfully drawn head –
assumed to be an early work – has yet been identified.
Its similarity to the "Vitellius" drawings is obvious, and
Tintoretto probably made more than one study of this
model as well. The head is repeated on the verso, but
not elaborated to the same degree. Drawings by some
of Tintoretto's followers have been preserved which
obviously derive from the Rotterdam sheet and from
other drawings that have since been lost.[8] In the face,
Tintoretto made copious and effective use of white
chalk to suggest the wrinkles in the forehead, for
instance. He represented the drilled-out pupils of the
sculptural model with heavy black accents. As in his
drawings in Frankfurt and Oxford of the head of
Michelangelo's *Giuliano de' Medici*, Tintoretto also chose
to depict the subject slightly from above.
 It is difficult to identify Tintoretto's model in this
case, though the bald head, the deep wrinkles and the
sharp nose are reminiscent of Julius Caesar. In the
sixteenth century Jacopo Contarini owned a marble
portrait bust of Caesar which Tintoretto may have
known. This well-known bust was illustrated in *Delle
antiche statue greche e romane* by the Zanetti brothers in
1740.[9] It ended up in the Statuario Pubblico of Venice,
passed from there to the Ca d'Oro, and is now preserved
in the Archeological Museum of the same city (fig. b).

1. Among them being Marczell von Nemes; see H. von
Tschudi, "Vorwort," in *Katalog aus der Sammlung des kgl. Rates
Marczell von Nemes - Budapest*, Munich 1911.
2. The quotation from P. Cézanne, *Correspondance*, ed.
J. Rewald, Paris 1937, p. 268, in a letter of December 23 1904.
3. J. Byam Shaw, *The Italian Drawings of the Frits Lugt
Collection*, Paris 1983, p. xii.
4. See Tietze 1944, pp. 285-86, nos. 1655-A, 1677bis, and Rossi
(1975), pp. 53-57, 64-65.
5. Inv. I 341, Rossi (1975), pp. 56-57. That drawing
disappeared to Germany in 1941, see Elen 1989, no. 396.
For the series of drawings after the bust see also R. Harprath,
Italienische Zeichnungen des 16. Jahrhunderts aus eigenem Besitz,
Munich, Staatliche Graphische Sammlung, 1977, no. 92, pl. 12,
and Rossi (1975), pp. 46-47, for the various imitations of the
drawings. For the identification: A.N. Zadoks-Josephus Jitta,

"A Creative Misunderstanding," *Nederlands Kunsthistorisch
Jaarboek, opgedragen aan H. Gerson* XXIII, 1972, pp. 3-12.
6. R. Tozzi, "Notizie biografiche su Domenico Tintoretto,"
Rivista di Venezia XI-XII, 1933, p. 316, and Zadoks-Josephus
Jitta, op. cit. (note 5), p. 7, fig. 5.
7. Rossi (1975), p. 46; see R. Pallucchini and P. Rossi,
Tintoretto: le opere sacre e profane, Milan 1982, vol. I, pp. 152-53,
no. 120, vol. II, fig. 151.
8. For those derivations see, *inter alia*, Andrews (1968), vol. I,
p. 120, no. D 1854, vol. II, fig. 815, and A. Forlani, *Mostra di
disegni di Jacopo Tintoretto e delle sua scuola*, Florence, Gabinetto
Disegni e Stampe degli Uffizi, 1956, no. 71.
9. A. Girolamo and A. D'Alessandro Zanetti, *Delle antiche statue
greche e romane che nell'antisala della libreria di San Marco*, Venice
1740, pl. I. The print was engraved by Gian Antonio Faldoni.

GL

figs. a & b

187

68

Andrea Meldolla, called Schiavone
Zara c. 1510–1563 Venice
STANDING BELLONA

Brush and brown and white bodycolor on brown
prepared paper; 200 × 138 mm.
Inscribed at upper center in pen and brown ink: *Andrea
Schiavon*
Verso, in pen and brown ink: *S.L. no: 32*
No watermark
Inv. I 36

Provenance: F. Koenigs, Haarlem (L. 1023a), acquired in
1927; D.G. van Beuningen, Rotterdam, acquired in
1940 and donated to the Boymans Museum Foundation.

Not previously exhibited

Literature: Tietze 1944, p. 251, no. 1431;
F.L. Richardson, "Some Pen Drawings by Andrea
Schiavone," *Master Drawings* XIV, 1976, pp. 32-33,
figs. 1-2; F.L. Richardson, *Andrea Schiavone*, Oxford
1980, p. 115, no. 141, fig. 80.

Everything in this drawing points to the influence that
Parmigianino exercised on Schiavone, but whether the
latter actually studied with the Parmesan master is by
no means certain. From a remark made by Carlo Ridolfi
in his *Le Maraviglie d'arte* (1648), it can be deduced that
Schiavone owned a large group of Parmigianino's
drawings,[1] which would explain his familiarity with
them. When exactly Schiavone left Zara, the town on
the Dalmatian coast where he was born, for Venice,
where he spent most of his productive life, is still a
mystery. According to Vasari, he was living in Venice
by 1540, in which year the Tuscan artist asked him
to paint the battle between Charles V and Sultan
Barbarossa, a painting that Vasari would later present
to Ottaviano de' Medici in Florence.[2] Vasari was more
than satisfied with the work, which has since been lost,
but in his biography of Meldolla – known in Italy as
"Schiavone," the Slav, after the area where he was born
– he had little praise for the painter. Vasari's prejudices
against the Venetian manner (the poor sense of
anatomy, the endless *non finito* and the daubing of
paint) are clearly evident in the passage he devoted to
Schiavone in his *Vite*, where he opined that he produced
his best paintings purely by accident (*per disgrazia*).
What Vasari did respect in Schiavone was his ability to
absorb the style of the great masters. Parmigianino,
an artist whom Vasari greatly admired, is not mentioned
by name, but he is clearly one of those intended.

An indication of the nature and extent of
Parmigianino's influence on Schiavone is the fact that
the latter repeatedly used a small repertory of the
former's models, raising the arms in one case, turning a

head somewhat in another, or slightly altering the point
of view. This debt to Parmigianino is immediately
apparent in Bellona's elegant pose, with the gracefully
bent right leg, and her billowing veil.[3] Schiavone used
the same figure and even the same technique in at least
one other drawing, now in the Uffizi, of a woman with
a bird.[4] Like most of his female subjects, she grasps her
garment with one hand, her fingers spread, whereas the
arm in the Rotterdam drawing serves to keep the shield
upright. The triangular folds of the drapery at the lap
are also characteristic.

Schiavone experimented with etching and drypoint
quite freely by the standards of his day, and by the time
of his death he had produced a large number of prints.[5]
The Rotterdam sheet is one of nine surviving studies
for his etchings. The subject is Bellona, the goddess of
war, who appears in reverse in the printed version
(fig. a). Schiavone made two other etchings of Bellona:
one in profile, in which the goddess is captured in rapid
motion, the other a frontal view as she is about to hurl
her lance, raising her shield in readiness (fig. b). The
mood of these two prints is certainly more violent than
that of our drawing.[6] Given that the measurements of
the second print and its technique – primarily drypoint
– are identical to those of the print based on the
Rotterdam drawing, the two are presumably pendants.[7]
Even the presentation of the two subjects is similar. All
things considered we can probably conclude that
Schiavone sought to counterbalance the peaceful pose of
Bellona in the one print, where she rests on the deadly
tools of her trade, with the fearless warrior in the other.

The drawing for Bellona at rest certainly would not
appear to be intended for an etching, for it is not linear
in character, although in that respect it is no different
from the other preparatory drawings Schiavone
produced for his prints. The choice of materials and the
style are closely related to the Louvre's no less painterly
Christendom Triumphant over Heresy, formerly attributed
to Paolo Farinati.[8] The group of figures in that drawing
has been traced with a stylus in order to transfer it
precisely onto the plate. This is not the case with the
Rotterdam *Bellona*, and given the differences between
drawing and print, apparently the artist merely glanced
at it while drawing the image in the etching ground
with a needle. He evidently paid more attention to the
areas heightened with white in the drawing, which most
resembles a preparatory study for a clair-obscur
woodcut. The result is a print in which the chiaroscuro
is so charged that the goddess of war appears transfixed
by a supernatural radiance.

1. See A.E. Popham, *The Drawings of Parmigianino*, New York
1953, pp. 46-47.
2. Vasari 1878-85, vol. VI, pp. 596-97. This passage later
provided the framework for Schiavone's rehabilitation by
Giulio Cesare Gigli in his *La pittura trionfante* of 1615; see
D. Rosand, "The Crisis of the Venetian Renaissance," *L'Arte*
XI-XII, 1970, pp. 5-55.
3. A.E. Popham, *Catalogue of the Drawings of Parmigianino*,
New Haven, London 1971, vol. I, p. 261, no. O.R. 125, vol. III,
pl. 120 (detail).
4. W.R. Rearick, *Tiziano e il disegno Veneziano del suo tempo*,
Florence, Gabinetto Disegni e Stampe degli Uffizi, 1976,
pp. 148-50, no. 106, and Richardson 1980, p. 124, no. 170,
fig. 28 (as Persephone and Ascalaphus?).
5. D. Acton in exhib. cat. *Italian Etchers in the Renaissance &
Baroque*, Boston, Museum of Fine Arts, Cleveland, Cleveland
Museum of Art, Washington, National Gallery of Art, 1989,
pp. 22-26, nos. 13-14.
6. The standing *Bellona* is described by Bartsch in vol. XVI,
under no. 76; the other two etchings under nos. 68 and 77.
7. Drawings by Parmigianino to which this figure is related are
in Venice, Accademia, and Paris, Louvre; see Popham, op. cit.
(note 3), vol. I, pp. 157-58, no. 477, p. 185, no. 599 and vol. III,
pl. 393.
8. Richardson (1980), p. 115, no. 140, figs. 77-78.

GL

fig. a
fig. b

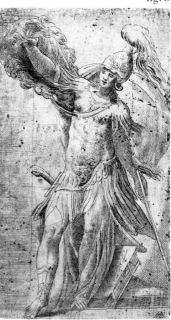

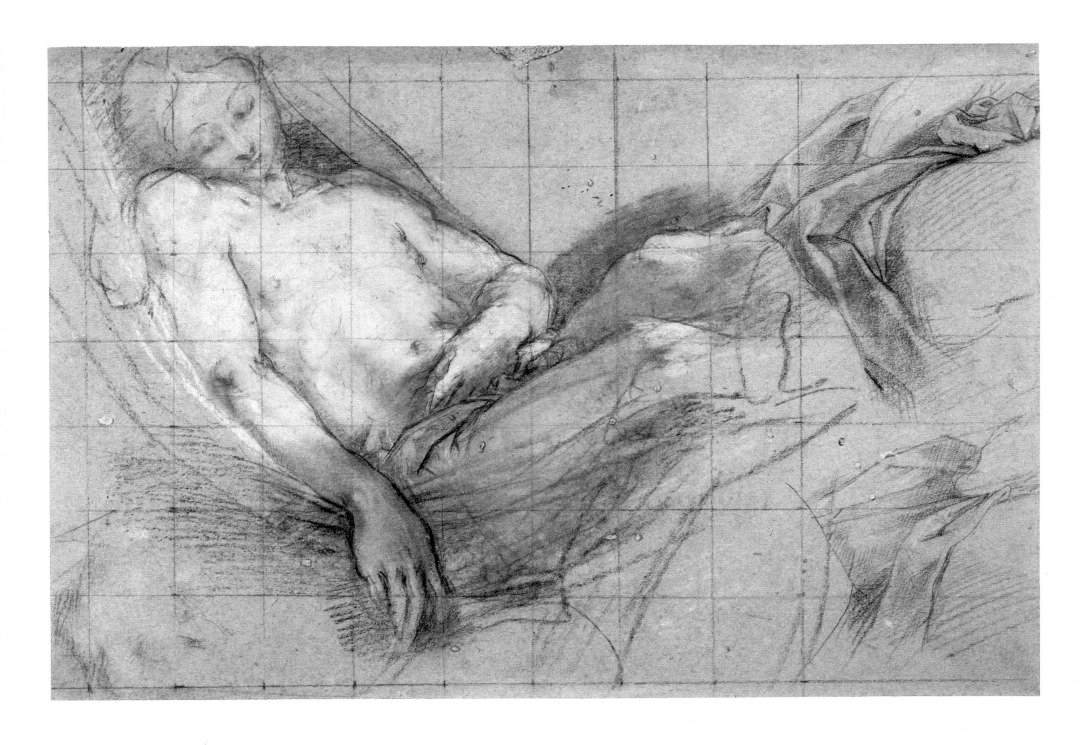

69

Federico Barocci
Urbino 1535–1612 Urbino
STUDY FOR A DEAD CHRIST

Black and white chalk on blue paper, squared in black
chalk, laid down; 257 × 373 mm.
Watermark: not visible
Inv. I 428

Provenance: J.W. Böhler, Lucerne; F. Koenigs, Haarlem
(L. 1023a), acquired in 1929; D.G. van Beuningen,
Rotterdam, acquired in 1940 and donated to the
Boymans Museum Foundation.

Exhibitions: Rotterdam 1938-39, no. 35; Groningen
1949, no. 13; Paris, Rotterdam, Haarlem 1962, no. 129;
Bologna 1975, no. 108.

Literature: H. Voss, *Zeichnungen der Italienischen
Spät-renaissance*, Munich 1928, p. 46, no. 18; H. Olsen,
"Federico Barocci: a Critical Study in Italian
Cinquecento Painting," *Figura* VI, 1955, pp. 10, 132,
134; H. Olsen, *Federico Barocci*, Copenhagen 1962,
p. 172, under no. 33; Jaffé 1962, p. 232; G.G. Bertelà,
exhib. cat. *Disegni di Federico Barocci*, Florence,
Gabinetto Disegni e Stampe degli Uffizi, 1975, p. 52,
under no. 43; E.P. Pillsbury and L. Richards, exhib. cat.
*The Graphic Art of Federico Barocci: Selected Drawings and
Prints*, Cleveland, Cleveland Museum of Art, New
Haven, Yale University Art Gallery, 1978, p. 65, under
no. 42; D. DeGrazia, "Refinement and Progression of
Barocci's Entombment: The Chicago Modello," *The Art
Institute of Chicago Museum Studies* XII, no. 1, 1985,
p. 40, note 12; A. Emiliani, *Federico Barocci*, vol. I,
Bologna 1985, p. 159, and p. 156, fig. 302.

On July 2 1579 Federico Barocci, "*pittor, omo ecelente in
tal arte de pitoria*" (in the words of the contract),
received a commission from the Confraternità della
Croce e Sagremento of Senigallia, a town located
between Pesaro and Ancona, to paint an altarpiece with
an Entombment of Christ. The painter, who was active
in Urbino, finished the canvas in 1582. One of his
undisputed masterpieces, it still stands on the high altar
of the Church of Santa Croce in Senigallia (fig. a).[1]

As he did for all his monumental works, Barocci
produced a long series of preparatory studies for the
Entombment. This earned him praise from his
biographer Giovanni Pietro Bellori, the well-known
admirer of Poussin and proponent of Classicist art
theory. So enthusiastic was Bellori, in fact, that he
recommended Barocci's methods to other artists.[2]

As his point of departure for the *Entombment*, Barocci
chose Raphael's celebrated treatment of the subject,
which now belongs to the Galleria Borghese in Rome
(see cat. no. 43, fig. d) but was then still in the Church
of San Francesco in Perugia, for which it was made.
Barocci would have become acquainted with the
Entombment while installing his *Deposition* on an altar in
Perugia's cathedral in 1569. The Senigallia commission
called for an upright format, and while he therefore had
to deviate from Raphael's example, the preparatory
studies show that he did not reverse the composition
until a late stage.

Several of Barocci's cartoons for the *Entombment* have
survived: a large charcoal sketch with white highlights,[3]
the "*cartone per i lumi*," loosely indicating lighting
contrasts in oil,[4] and an "*abbozzo per i colori*," or color
sketch, on canvas.[5] Besides these, a few composition
sketches have been identified, as well as numerous
studies for individual figures, draperies, hands, feet and
other details, illustrating the exceptional care Barocci
was wont to take. In addition to the Rotterdam study

fig. a

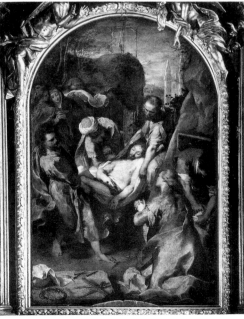

fig. b

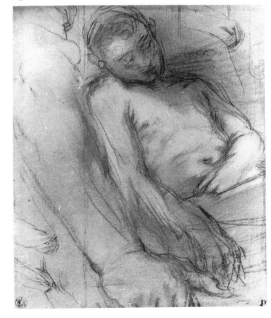

for the lifeless body of Christ, for which a recumbent model in a hammock was presumably used, there are others in Berlin (fig. b), Princeton and Florence. In Berlin there are also studies for the dangling arm and hands.[6]

Contrary to what is generally assumed, Barocci did not always construct a complete *modello* on the basis of detailed figure studies executed beforehand. At times he would work out the composition at the very beginning, in a larger format or a colored cartoon, and add details and determine positions only afterwards.[7] Yet the Rotterdam study for the dead Christ must have been executed at an early stage, since it is reversed with respect both to the surviving cartoons and to the painting. In the upper righthand corner of the sheet, part of the thigh and the loincloth draped over it have been further elaborated. It is not clear whether Barocci was already planning to highlight the knee, the arm and the white drapery in the painting while he was working on the drawing; it is altogether possible that he only added the white heightenings later. He was apparently capable of reversing such a figure at the moment of transition from drawing to painting without difficulty, for he did so frequently. At one time the study for John the Baptist on the left of the painting also belonged to Franz Koenigs, and that too was originally conceived in reverse (fig. c).[8] That sheet, which includes several drapery studies, is another example of Barocci's virtuosity, especially with white chalk.

The success of the *Entombment* was immediate. Philippe Thomassin made an engraving of it between 1585 and 1590, and there is also a print by Aegidius Sadeler.[9] The latter must have been executed at an early date, and in any case before 1603, since it was through Sadeler's engraving that Karel van Mander knew the work. Apart from Vasari and Borghini, Van Mander was one of the first authors to write about Barocci, and one of the few to do so during the artist's lifetime. It is interesting that Van Mander's remarks about the print in his *Schilder-boeck* implicitly relate to Barocci's thorough preparatory studies. In discussing the artist's treatment of drapery, for instance, Van Mander lauds the fact that the work is not "confused in folds and wrinkles" and comments favorably on the "most pleasingly composed *Entombment*, in which Christ is borne away, with a face gentle in death."[10] It is this face that presumably first received its gentle expression in our drawing.

1. P. Emilio Vecchioni, "La Chiesa della Croce e Sagramento in Senigallia e la Deposizione de Federico Barocci," *Rassegna Marchigiana* V, 1926-27, pp. 497-503; Emiliani (1985), vol. I, pp. 151-59.
2. E.P. Pillsbury in exhib. cat. Cleveland, New Haven (1978), pp. 7-24, and G.P. Bellori, *Le vite de'pittori, scultori e architetti moderni*, ed. E. Borea, Turin 1976, pp. 177-207.
3. Formerly in the Dutch royal collection, now in the Rijksprentenkabinet, Amsterdam; see Emiliani (1985), vol. I, p. 152, fig. 297; L.C.J. Frerichs, *Italiaanse Tekeningen II. De 15de en 16de eeuw, Rijksprentenkabinet/Rijksmuseum Amsterdam*, Amsterdam 1981, pp. 16-17, no. 24.
4. Formerly in the collection of the Duke of Devonshire, Chatsworth, now J. Paul Getty Museum, Malibu; see Emiliani (1985), vol. I, p. 154, fig. 300, exhib. cat. Cleveland, New Haven (1978), pp. 63-64, no. 41, and Goldner 1988, pp. 24-25, no. 3. The cartoon may be based on a related pen drawing which was recently acquired by the Art Institute of Chicago from the Calmann Collection, see exhib. cat. Cleveland, New Haven (1978), pp. 63-64, no. 40, and DeGrazia (1985), pp. 30-41.
5. Urbino, Galleria Nazionale delle Marche; Emiliani (1985), vol. I, p. 155, fig. 301.
6. Pacetti Collection (L. 2057); ibid., pp. 156-67, figs. 303-10, and J. Goldman, "An Unpublished Drawing by Federico Barocci for The Entombment," *Master Drawings* XXVI, 1988, pp. 249-52. A recent addition is a study for one of the three Marys from a private collection in Dordrecht, see exhib. cat. *Netherlandish and Italianate Old Master Drawings*, New York, Bob P. Haboldt & Co., 1990, no. 5.
7. See exhib. cat. Cleveland, New Haven (1978), and E. Pillsbury, "Review of A. Emiliani: Federico Barocci (Urbino 1535-1612)," *Master Drawings* XXV, 1987, pp. 286-87.
8. Inv. I 427, 388 × 274 mm. The drawing was exhibited in Amsterdam 1934, no. 477, and disappeared to Germany in 1940, see the introduction to the present catalogue, and Elen 1989, no. 315.
9. There are three different copies after Sadeler's print, see Hollstein, *Dutch and Flemish*, vol. XXI, p. 19, no. 55, and p. 192, no. 2.
10. Van Mander 1604, fols. 186v and 187r: "*confuys in vouwen en kreucken*," and "*seer aerdige wel gheordineerde Graflegginge daer Christus met een vriendelicke doode tronie wort gedragen.*" See H. Noë, *Carel van Mander en Italië*, The Hague 1954, pp. 165-70.

GL

fig. c

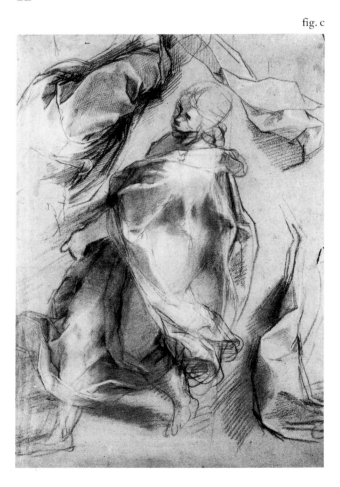

70

Andrea Lilli
Ancona c. 1555–after 1631 Ascoli Piceno
STUDY OF A MALE NUDE AND A HEAD

Black chalk, heightened with white, squared in black
chalk, on yellowish paper showing traces of fire
damage; 279 × 225 mm.
At lower center, in pen and brown ink: *allori* (?)
Verso: two studies of the same figure, black chalk
Watermark: coat of arms with a lion
Inv. I 188

Provenance: Sir Joshua Reynolds, London (L. 2364);
E. Wauters, Paris (L. 911); sale Amsterdam (Frederik
Muller), June 15-16 1926, no. 9; acquired by F. Koenigs,
Haarlem (L. 1023a); D.G. van Beuningen, Rotterdam,
acquired in 1940 and donated to the Boymans Museum
Foundation.

Exhibitions: Amsterdam 1934, no. 504; Paris 1935-II,
no. 528.

Literature: Lees 1913, p. 87, pl. 99; A.G.B. Russell,
"Some Drawings by Italian Painters of the Sixteenth
Century," *Burlington Magazine* XLV, 1924, p. 125;
Berenson 1938, vol. I, no. 604B; Berenson 1961, vol. I,
no. 605D-I.

It is not difficult to understand why this drawing was
long attributed to Bronzino, as it was by Bernard
Berenson in his *Drawings of the Florentine Masters*.
Figure type and, to a lesser degree, style do, in fact,
closely resemble Bronzino's study in the Louvre for
Marsyas in *The Contest between Apollo and Marsyas*
(Leningrad, Hermitage). The Rotterdam drawing has
been thought to be a study for one of the other nudes
in that painting.[1] That, though, was not unanimously
accepted, and the drawing was largely neglected by later
scholars.[2] In the 1961 Italian edition of Berenson's
standard work, it was still considered one of the few
drawings that could be securely attributed to the
Florentine master. However, a more plausible
identification of the subject was propounded, namely the
Christ in a lost *Pietà*. Meanwhile visitors to the
museum's printroom were, without exception, surprised
at the quality of the drawing. Only in the case of James
Byam Shaw did this positive assessment lead to an
alternative attribution: "Try Tanzio da Varallo," he
wrote on the mount in the 1960s, and anyone familiar
with the striking beauty of Tanzio's drawings will
realize that this was a compliment to the quality of the
sheet.[3]

The most fruitful suggestion, though, came from the
Danish art historian, Chris Fischer. While working on
his catalogue of the Willumsen Collection, he had
discovered a drawing by Andrea Lilli or Lilio that had
formerly been attributed to Correggio, and it reminded
him of the Rotterdam study.[4] Even more instructive is
the comparison with a sheet in the Teyler Museum,
Haarlem, formerly attributed to Lanfranco and to
Francesco Vanni, but recently published as Lilli (fig. b).[5]
This *Study of an Evangelist* may have been executed in
preparation for a lunette painting in the cloister of Sant'
Angelo Magno in Ascoli. If so, it would belong to the

fig. b

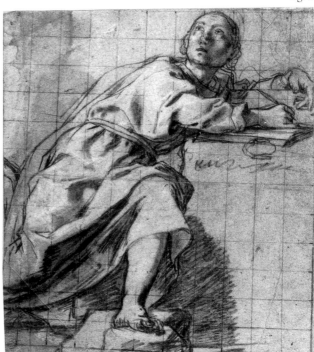

fig. a

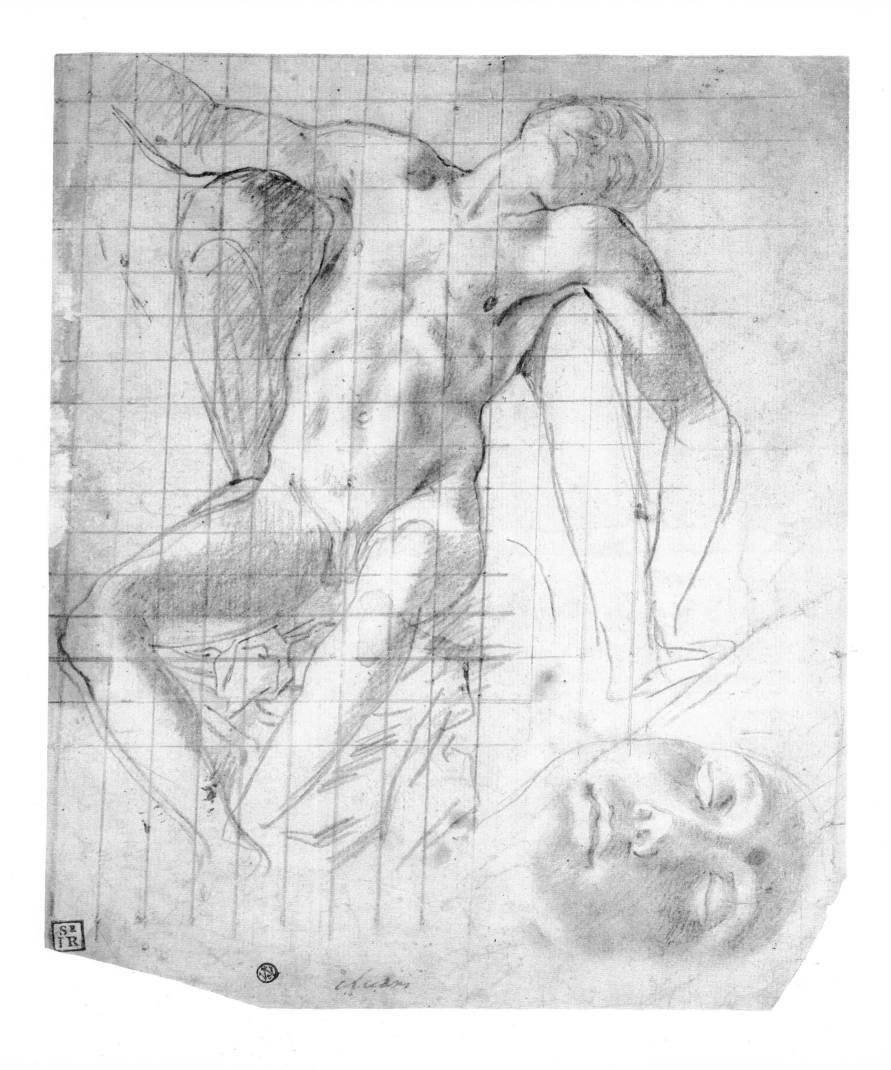

last period of the artist's career, and could be dated around 1631.[6] Broad zigzag hatching, softly modeled figures and garments, and a refined division of light and dark areas characterize the drawings in Haarlem and Rotterdam. Soft chalk was used in both cases, allowing the artist to capture separate parts of the figures with little more than a single stroke. Reinforced outlines also occur here and there in both. In order to determine the exact lighting of the Rotterdam head, the artist sketched another version of it at the bottom of the same sheet, carefully smudging the chalk so that the hatching becomes almost imperceptible.

The most conclusive evidence that Lilli is, in fact, responsible for the present drawing is the remarkable altarpiece for which it was a preparatory study. Only recently rediscovered in a former church in the town of Bagnacavallo (Emilia Romagna) and transferred to the Pinacoteca, this *Pietà* shows the dead Christ in the lap of the Virgin surrounded by six saints; it is signed and dated "*ANDREA LILLI 1596*" (fig. c).[7] The squaring of the drawing facilitated the transfer of the image to the canvas, but in the process the slack body of the inanimate Christ was inadvertently diminished with respect to the other figures. The position of the arms is unaltered, and the careful illumination of the head, corresponding exactly to the separate study at the bottom of the sheet, demonstrates how closely the artist adhered to this preparatory study.

For a long time the painting stood on the high altar in the Capuchin church in Imola. Lilli most probably executed the work in Rome, since he signed the new statutes of the Accademia di San Luca in 1596. He is known to have been active in the papal city for many years, and was already working in the Vatican in the 1580s, together with Ventura Salimbeni and Ferraù Fenzoni. Recorded in Rome for the last time in 1629, he must have returned to the Marches shortly afterwards.[8]

Though a number of Lilli's composition sketches have survived, only a few figure studies have been attributed to him apart from those in Haarlem and Frederikssund. One striking, detailed drawing marked "*del Lilli*" appeared not long ago at a sale in Munich (fig. d).[9] The composition is comparable to that of the altarpiece in Bagnacavallo, only this time it shows the wounded St Sebastian surrounded by other figures. The artist handled the lighting of the nocturnal scene expertly in both cases, using the man with the candle, like John the Baptist in the *Pietà*, to draw our attention to the suffering of the principal actors. The squaring shows that this drawing too is a study for a painting; the only question is whether the artist also produced such a *modello* for the canvas in Bagnacavallo, or whether he first made one rough composition sketch and then produced studies of details like those on the sheet in Rotterdam. If Lilli's working methods were anything like those of his compatriot Federico Barocci, he would have made composition studies, drawings of individual figures and elaborate *modelli* before commencing work on any painting (see cat. no. 69).

On the verso of the Rotterdam sheet are two further studies of the model on the recto, drawn in such a free style that they should have excluded any attribution to Bronzino long ago (fig. a). Here Lilli varied the position of the feet, having the model raise his right leg higher in one case and cross his legs in another. Since such poses are obviously difficult to maintain, the model's feet were generally supported by a bar, part of which can be seen in the sketch at the bottom of the verso.[10]

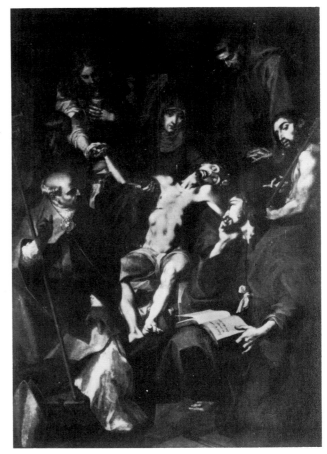

fig. c

1. Berenson 1938, vol. I, no. 604B, following Russell (1924), p. 125. For the Paris drawing see C. Monbeig-Goguel, *Vasari et son Temps. Inventaire Général des Dessins Italiens I. Maîtres toscans nés après 1500, morts avant 1600, Musée du Louvre*, Paris 1972, pp. 36-38, no. 9.
2. For example, it is not even mentioned in C. Hugh Smyth, *Bronzino as Draughtsman: an Introduction*, New York 1971, the only monograph devoted to the drawings of the Florentine master.
3. See exhib. cat. *Tanzio da Varallo*, Turin, Palazzo Madame, 1959-60, pp. 47-55, pls. 130-55, and the fine drawing in New York, Pierpont Morgan Library, *A Group of Soldiers with Lances*, J. Bean and F. Stampfle, exhib. cat. *Drawings from New York Collections II. The 17th Century in Italy*, New York, Metropolitan Museum of Art, Pierpont Morgan Library, 1967, no. 22, (ill.).
4. C. Fischer, *Italian Drawings in the J.F. Willumsen Collection II*, Frederikssund, The J.F. Willumsen Museum, 1988, no. 100, pl. 85.
5. B.W. Meijer and C. van Tuyll, exhib. cat. *Disegni italiani del Teylers Museum Haarlem*, Florence, Istituto Universitario Olandese di Storia dell'Arte, Rome, Istituto Nazionale per la Grafica, Gabinetto Nazionale delle Stampe, 1983-84, no. 20. Another stylistically related figure study is in the Ambrosiana in Milan, see G. Bora, *I disegni del Codice Resta*, Milan 1976, no. 164.
6. Observed by L. Arcangeli in exhib. cat. *Andrea Lilli nella pittura delle Marche tra Cinquecento e Seicento*, Ancona, Pinacoteca Civica Francesco Podesti, 1985, no. 29; the lunette is reproduced as pl. IX.
7. Ibid., no. 3. The painting was published by A. Corbara, "Note e schede per la pittura in Romagna. 1. Un capolavoro di Andrea Lilio a Bagnacavallo," *Romagna Arte e Storia* I, 1981, pp. 28-31.
8. For Lilli's biography and archive records relating to his Roman period see op. cit. (note 6), pp. 223-37. For his last years: F. Rangoni, "Precisazione cronologica sull'estrema attività del Lilli," *Ricerche di Storia dell'Arte* XVIII, 1982, p. 86.
9. That sheet once belonged to Hermann Voss, Wiesbaden; see C. von Prybram-Gladona, *Unbekannte Zeichnungen alter Meister aus europäischem Privatbesitz*, Munich 1969, no. 60. It was sold in Munich (Karl & Faber), November 26-27 1981, no. 148.
10. Another example of a figure study from the same period showing a leg rest is by Denys Calvaert (c. 1564-1619); see *Colnaghi. Master Drawings*, London, P. & D. Colnaghi & Co., 1988, no. 18 (ill.).

GL

fig. d

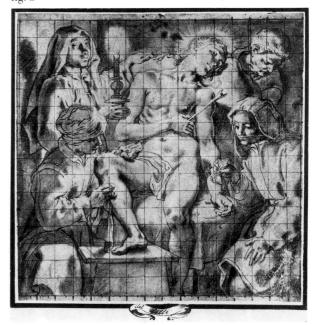

71

Giovanni Benedetto Castiglione, called Il Grecchetto
Genoa 1609–between 1663 and 1665 Mantua[1]
REST ON THE FLIGHT INTO EGYPT

Brush and brown, gray and blue bodycolor;
371 × 271 mm.
Annotated at lower left in pencil: *Castiglione*
No watermark
Inv. MB 1976/T 15

Provenance: L.P.M. Norblin de Lagourdaine; sale Paris
(Guichardot), February 5-9 1855, no. 60; A. Mouriau,
Brussels (L. 1853, verso L. 1829); sale Paris (Vignère),
March 11-12 1858, no. 72; A. Marmontel, Paris; sale
Paris, March 28-29 1898, no. 16; A. Beurdeley, Paris
(L. 421); sale Paris, June 8-10 1920, no. 87; H. Brame;
V. Bloch, The Hague and Paris; bequeathed by him to
the Boymans-van Beuningen Museum in 1976.

Exhibitions: Philadelphia 1971, no. 87.

Literature: M. Santifaller, "Giambattista Tiepolos
Radierung 'Die Anbetung der Könige'," *Pantheon* XXX,
1972, pp. 484-92; cat. 1978, no. 6.

fig. a

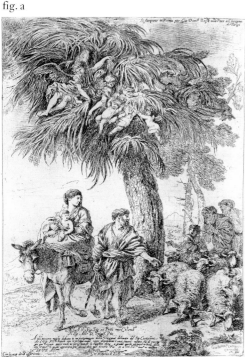

The Genoese artist Giovanni Benedetto Castiglione is
famous for his large-scale animal pictures, but he also
painted allegorical, mythological and religious subjects.
According to the earliest sources, he studied with
Sinibaldo Scorza (1589–1631) and Giovanni Battista
Paggi (1554–1627) among others,[2] though their
influence on him is difficult to determine, unless the
interest in the "*mondo animalistico*" that he shared with
Scorza can be counted as such. Castiglione seems to
have been more attracted to the work of older
contemporaries such as Gioacchino Assereto (1600–49)
and Bernardo Strozzi (1581–1644), the leader of the
Genoese School. Judging from the manner in which
he incorporated the influence not only of Anthony van
Dyck but also of the Bassani and later, during his
travels, of Poussin, the Neapolitan School and Dutch
landscape painters active in Italy, Castiglione was an
eclectic. His prints show that Rembrandt's etchings also
had an impact in Italy. Castiglione was a very
well-traveled artist: besides Genoa he was also active
in Venice, Rome, Naples and Mantua where, in 1651,
he found employment at the court of the Gonzaga.

Just as the daring color contrasts, bold brushwork
and compositional feats of Castiglione's paintings never
cease to amaze, so, too, the extraordinary virtuosity of
his drawings can leave one speechless.[3] Nor did
Castiglione hesitate to experiment with technique. He is
known as the inventor of the monotype, which he used
expressively (fig. b), and he also tried out various etching
grounds.[4] As a result of his free application of these
techniques, his works on paper often have a very
modern look.

Because many of his drawings, including this *Rest on
the Flight into Egypt*, were done with oil and brush, they
most closely resemble the oil sketches that Rubens and
Van Dyck made on small, lightly grounded panels as a
first idea for a larger composition. Sometimes
Castiglione forgot that he was working on paper and
used too much oil, which was immediately absorbed by
the paper, with the result that several of his drawings
are stained. Often allowing himself no time to dip his
brush, he would keep on working even when it was
almost dry, as can be seen in some parts of this
drawing. The brushwork is restless, sometimes angular,
almost too rough for the small surface, but at times
extremely suggestive. Just a few strokes suffice for the
cherubs cavorting in the air above Joseph and Mary,
whose tender concern for the Christ Child is rendered
with an astonishing economy. The small amount of blue
pigment, which the artist applied as though he were
painting, contrasts beautifully with the dominant brown,
thus giving the landscape atmospheric depth.

The drawing, acquired by the museum in 1976 as
part of the Vitale Bloch bequest, reveals parallels with
various other works by Castiglione. The hovering *putti*
also feature in his etching of the *Flight into Egypt*, which
presumably dates from about 1648, during his second
stay in Rome (fig. a),[5] and there is a related drawing of
the same subject in the Lugt Collection in the
Fondation Custodia, Paris.[6] Castiglione repeated the

position of Mary with the Christ Child, in reverse and
somewhat modified, in two monotypes of the *Nativity*
in the Albertina, Vienna, and in the royal collection at
Windsor Castle (fig. b).[7]

The donkey, depicted virtually in profile behind the
Holy Family, deserves special mention. Placing the
animal so prominently on the sheet is a motif frequently
adopted by Giambattista Tiepolo, in his etching of the
Adoration of the Magi, for instance, and one that
subsequently gained a certain popularity among other
Baroque painters. The assumption that Tiepolo
borrowed it from Castiglione is doubtless correct.[8]

1. The year of Castiglione's birth was recently discovered by
P.L. Alfonso, see M. Newcome, "A Castiglione-Leone
Problem," *Master Drawings* XIV, 1978, p. 171, note 36.
2. He is mentioned as Paggi's pupil on the latter's death in
1627, see V. Belloni, *Pittura Genovesi del Seicento*, Genoa 1974,
vol. II, pp. 65 and 72.
3. See A. Blunt, "The Drawings of Giovanni Benedetto
Castiglione," *Journal of the Warburg and Courtauld Institutes*
vol. VIII, 1945, pp. 161-74; idem, *The Drawings of
G.B. Castiglione and Stefano della Bella in the Collection of Her
Majesty the Queen at Windsor Castle*, London 1954, pp. 3-26.
4. A. Percy in exhib. cat. Philadelphia 1971, pp. 150-56, and
exhib. cat. *The Painterly Print: Monotypes from the Seventeenth
to the Twentieth Century*, New York, Metropolitan Museum of
Art, Boston, Museum of Fine Arts, 1980-81, pp. 68-83,
nos. 5-15.
5. Bartsch, vol. XXI, no. 16, exhib. cat. Philadelphia 1971,
pp. 144, 146, no. E17.
6. J. Byam Shaw, *The Italian Drawings of the Frits Lugt
Collection*, Paris 1983, vol. I, p. 415, no. 416, vol. II, pl. 467.
7. Exhib. cat. Philadelphia 1971, pp. 152-53, under nos. M6
(ill.) and M8; exhib. cat. New York, Boston 1980-81 (note 4),
pp. 74, 77, no. 11.
8. Santifaller (1972), pp. 484-92. For Tiepolo and Castiglione,
see also Blunt 1954, op. cit. (note 3), p. 23.

GL

fig. b

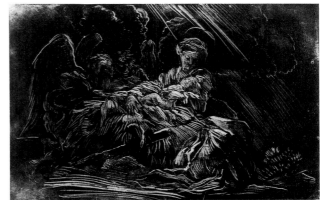

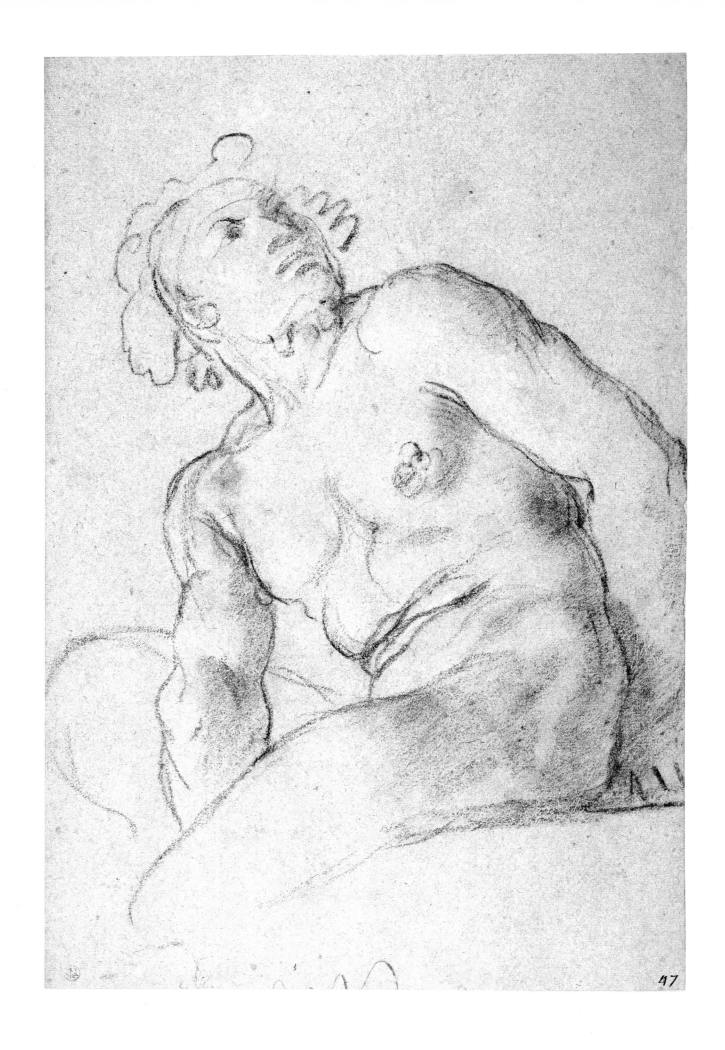

47

72

Annibale Carracci
Bologna 1560–1609 Rome
SEATED MALE NUDE

Black chalk, heightened with white, on blue paper,
laid down; 336 × 221 mm.
At lower right, in pen and brown ink: *47*
No watermark
Inv. I 183

Provenance: F. Angeloni, Rome (1641);[1] P. Mignard,
Paris; P. Crozat, Paris; P.J. Mariette, Paris (?); sale
Paris, November 15 1775–January 30 1776, p. 50;
E. Wauters, Paris (L. 911); sale Amsterdam (Frederik
Muller), June 15-16 1926, no. 40; acquired by
F. Koenigs, Haarlem (L. 1023a); D.G. van Beuningen,
Rotterdam, acquired in 1940 and donated to the
Boymans Museum Foundation.

Exhibitions: Amsterdam 1934, no. 518; Bologna 1956,
no. 184; Paris, Rotterdam, Haarlem 1962, no. 142.

Literature: R. Wittkower, *Drawings of the Carracci in the
Collection of Her Majesty the Queen at Windsor Castle*,
London 1952, p. 138, under no. 303; R. Bacou, exhib.
cat. *Dessins des Carrache*, Paris, Musée du Louvre, 1961,
under no. 77; J.R. Martin, *The Farnese Gallery*, Princeton
1965, no. 124, fig. 238; exhib. cat. *Le dessin à Rome au
XVIIe siècle*, Paris, Musée du Louvre, 1988, under no. 38.

In late 1594, Cardinal Odoardo Farnese called the
brothers Agostino and Annibale Carracci from Bologna
to Rome in order to decorate the interior of the Palazzo
Farnese. The construction of the Palazzo had lasted for
generations, finally being completed in 1589, according
to an inscription in the loggia. Such a prestigious edifice
required a monumental decorative program. It is not
clear how much was known in Rome about the ability
of the Carracci to carry out such a commission, but
their reputation must have been considerable. According
to his biographer Giovanni Pietro Bellori, Annibale had
previously worked for the Farnese in Parma, while
Annibale, Agostino (1557–1602) and their cousin
Lodovico Carracci (1555–1619) had already completed
frescoes in the Palazzo Fava and Palazzo Magnani in
Bologna (1584 and 1588-91 respectively).[2]

In the Palazzo Farnese, Annibale was expected to
paint both the Sala Grande, where the military exploits
of Prince Alessandro (1545–1592) were to be portrayed,
and the so-called Camerino Farnese, the cardinal's
study. A Mannerist design for one of the walls of the
Galleria Farnese, the large rectangular room on the
west side of the building, has been preserved. Attributed
to Cherubino Alberti (1553–1615), it was never
executed. Annibale painted the Camerino first. After it
was finished, the commencement of work on the Sala
Grande had to be further delayed, and the Bolognese
master started painting the Galleria instead, though
originally the commission was probably not intended for
him.[3] The result is a superb decoration in the tradition
of Raphael's Stanze in the Vatican, the Farnesina, and
Michelangelo's Sistine Chapel.

fig. a

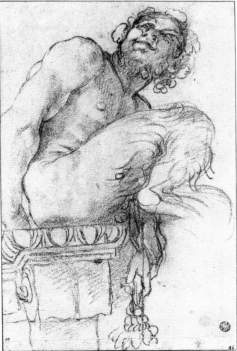

fig. b

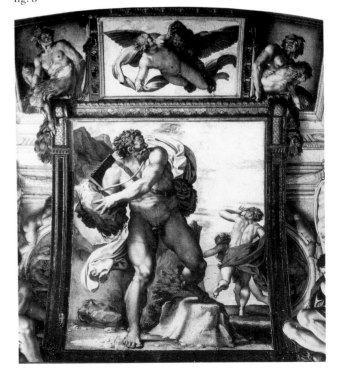

The Galleria is surmounted by a barrel vault stretching the entire length of the room, which Carracci divided into compartments and decorated with mythological figures, with the famous *Triumph of Bacchus and Ariadne* as the centerpiece. On the walls at either end of the room are two scenes from the myth of Polyphemus and Galathea, based on Ovid's *Metamorphoses*. Many *ignudi*, that is nude or scantily clad youths, are arranged about the narrative scenes, overlapping the painted borders at many points, thus creating, together with their painted shadows, a most effective *trompe l'œil*. "One's first impression on entering is that the decoration is sculpted," remarked one early visitor to the Galleria.[4]

Carracci made preparatory studies, many of which have survived, for virtually every figure in the Galleria.[5] Although he would sometimes work out the composition of the narrative scenes with pen and ink, he almost invariably drew chalk studies for single figures (such as our satyr) on paper of the same size and format. The satyr in the fresco is seated on the frame of *Polyphemus and Acis* (fig. a); the study for his companion is in the Louvre (fig. b).[6] Together they flank *The Rape of Ganymede*, and are mirrored on the opposite side of the gallery by two satyrs above *Polyphemus and Galathea*. It is worth noting that Annibale borrowed the manner in which all four satyrs raise one of their goat-like legs from the classical statue *Pan and Apollo*, a version of which belonged to the Farnese (fig. c).[7]

Although it is not clear whether the artist drew these studies from life, it is obvious that he knew exactly what the position of the figures in the Galleria would be. The lighting in the Louvre drawing corresponds to that

of the painting, and the model has hairy goat's legs.[8] The Rotterdam sheet does not include this portion of his anatomy, but he is wearing the beard normally associated with satyrs. Nor is the right hand visible, whereas in the painted version it grasps the left knee. The artist encircled the head with curling chalk lines, thus suggesting hair. That Annibale, who was initially influenced by the sensuous aesthetic of Correggio, was attracted to Michelangelo's figurative vocabulary in Rome becomes clear when one compares a figure such as this with those in the Sistine Chapel. The position of the satyr's head, for instance, closely resembles that of Michelangelo's prophet Jonah, and there is an obvious relationship between the *ignudi* in the chapel (fig. d) and subjects such as the one studied in this drawing.[9]

1. For the peregrinations of the drawings related to the Galleria Farnese in the seventeenth and eighteenth centuries, see Martin (1965), pp. 170-73. We know from the number on the Rotterdam drawing it was once part of the group from the Angeloni Collection which was brought to France by the painter Pierre Mignard.
2. See Martin (1965), pp. 10-20: "The Carracci in the Service of the Farnese," and for the frescoes in Bologna, exhib. cat. *Bologna 1584. Gli esordi dei Carracci e gli affreschi di Palazzo Fava*, Bologna, Pinacoteca Nazionale 1984, pp. 85-150.
3. For the chronology of the frescoes see D. Mahon in exhib. cat. Paris 1961, pp. 57-61, and esp. Martin (1965), pp. 21-48 and 51-68. For the drawing attributed to Cherubino Alberti, ibid., p. 8, and W. Vitzthum, "A Drawing for the Walls of the Farnese Gallery and a Comment on Annibale Carracci's 'Sale Grande'," *Burlington Magazine* CV, 1963, pp. 445-46.

4. Zdenek Waldstein, a Moravian nobleman, in his diary for October 26 1610: "*ut in introïtu primo sculpturas esse diceres*," quoted in Martin (1965), p. 54, note 10.
5. The largest groups are in the Louvre, Paris, and in the collection of Queen Elizabeth II at Windsor Castle, see Martin (1965), pp. 169-277.
6. Martin (1965), p. 270, no. 123.
7. F. Haskell and N. Penny, *Taste and the Antique: the Lure of Classical Sculpture 1500-1900*, New Haven, London 1981, pp. 286-88, no. 70. For the drawings of the other satyrs in the Galleria Farnese, see Martin (1965), pp. 227-28 and pp. 269-70, nos. 121-22.
8. For Carracci's ability to draw figures from memory see C. Goldstein, *Visual Fact over Verbal Fiction: a Study of the Carracci and the Criticism, Theory and Practice of Art in Renaissance and Baroque Italy*, Cambridge etc. 1988, pp. 106-19.
9. For Michelangelo's influence on Carracci's *ignudi*, see Martin (1965), pp. 76-77, and Goldstein, op. cit. (note 8), pp. 183-85.

GL

fig. c

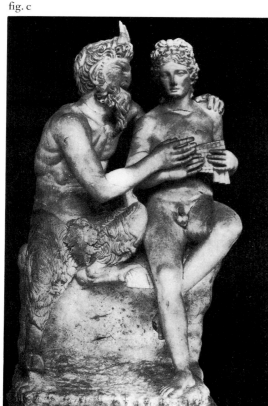

fig. d

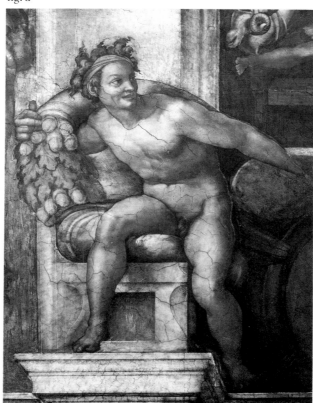

73

Giovanni Battista Tiepolo
Venice 1696–1770 Madrid
VIEW FROM TIEPOLO'S HOUSE IN VENICE, WITH THE
CHURCH OF SAN FELICE

Pen and brown ink, brown wash on white prepared
paper; 153 × 283 mm.
Inscribed at lower left in pen and brown ink by
Giandomenico Tiepolo: *Tiepolo f*
Verso: *View of the Castello in Brescia*, pen and brush
and brown ink
Watermark: fleur de lis with the letters *CB*
Inv. I 217

Provenance: presumably from the albums in the
collection of Col. E. Cheney, Badger Hall, Shropshire,
acquired in 1842; Col. A. Chapel Cure, Blake Hall,
Ongar, Essex; sale London (Sotheby's), April 28 1885,
from lot 1024; E. Parsons and Sons, London;
G. Bellingham Smith, London; sale Amsterdam, July 5-6
1927, no. 119; acquired by F. Koenigs, Haarlem
(L. 1023a); D.G. van Beuningen, Rotterdam, acquired in
1940 and donated to the Boymans Museum Foundation.

Exhibitions: Amsterdam 1934, no. 660; Rotterdam 1938,
no. 361; Paris 1952, no. 14; Rotterdam 1952, no. 111;
Munich 1958, no. 342; Paris, Rotterdam, Haarlem 1962,
no. 185; Brussels 1983, no. 27.

Literature: D. von Hadeln, *Handzeichnungen von G.B.
Tiepolo*, Florence, Munich 1927, vol. I, p. 23, vol. II,
pl. 114; K.T. Parker, "Some Observations on Guardi
and Tiepolo," *Old Master Drawings* XIII, 1938-39, p. 60,
note 2; A. Morassi, *Tiepolo*, Bergamo, Milan, Rome
1943, p. 41, 49; Haverkamp Begemann 1957, pp. 47-48,
no. 49; Vigni 1959, p. 57; G. Knox, *Un quaderno di
vedute di Giambattista e Domenico Tiepolo*, Milan 1974,
pp. 54-55, no. 43; A. Rizzi, exhib. cat. *Giambattista
Tiepolo: disegni dai Civici Musei di Storia e Arte di Trieste*,
Trieste, Civico Museo Sartorio, Milan 1988, p. 34;
W. Kranendonk, "La vista dalla casa veneziana di
Giambattista Tiepolo," *Arte Veneta* XLII, 1988
(forthcoming).

For the sake of variety while working on monumental
commissions, Giovanni Battista Tiepolo would make
unpretentious landscape drawings that are a real feast
for the eye.[1] Like his figure studies with pen and brush,
Tiepolo's landscapes show that he was a master at
simplifying forms and suggesting strong light effects.
He was capable of representing a corner of a barnyard
or a building as if seen through squinted eyes, to which
end he made extremely effective use of the white of his
paper. No one else has captured as economically as
Tiepolo the mood of a summer afternoon in the
Veneto, the silence broken only by the sound of crickets
(figs. a, b).[2]

Tiepolo was in the habit of depicting a subject from
various points of view, looking at it through the arch of
a gate on one occasion, from nearby the next, and
sometimes *di sotto in sù* – that is, somewhat
exaggeratedly from below – presumably because he was
seated on the ground while he was drawing. Among his
drawings, however, there are also various views of a villa
or of part of a city that include only the tops of the
buildings, as architecture appears to someone on an
upper storey or a roof terrace. This is the case with a
view of the Duomo in Udine which the artist drew
from a vantage point somewhere on the Church of the
Purità (Cambridge, Fitzwilliam Museum),[3] and with this
drawing, executed on white prepared paper so that the
light appears even stronger than usual. Rows of roof
tiles are indicated with rapid zigzag hatching, and lines
scratched by the artist's pen can be seen under the
heavy washes in the right foreground. On the verso
(fig. d) we get an idea of how such a cityscape looked
before it was elaborated with washes; since no details
have yet been added it looks as though there is no
sunlight.

Apart from the Cambridge drawing, the artist's
location has only been identified in the case of a few
views of the Villa Valmarana in Vicenza. For a while, in

fig. a

fig. b

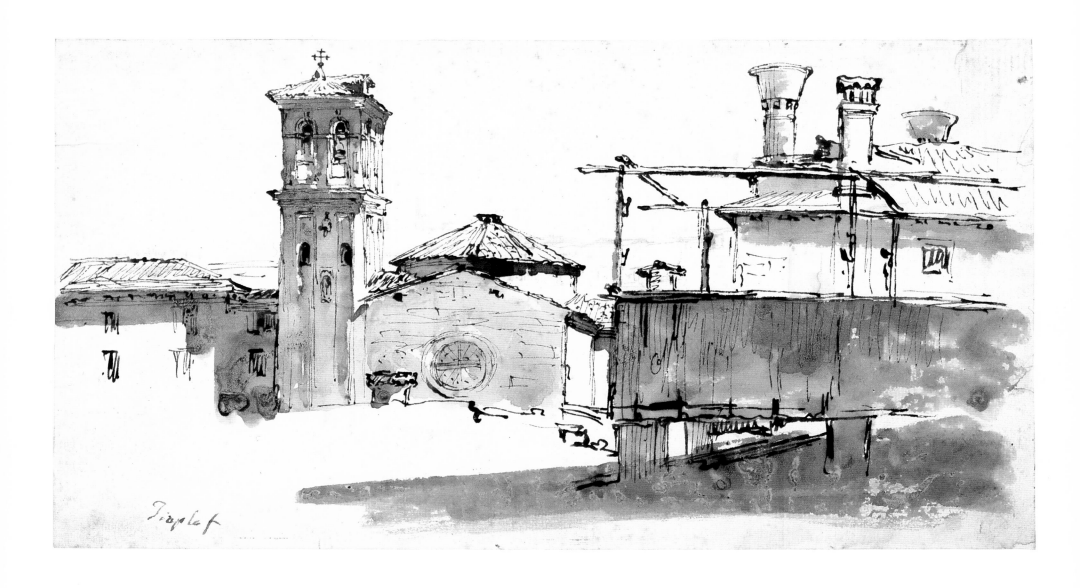

Diaphot

fact, it was believed that the Rotterdam drawing was made in Udine – that is until the church and its tower were recently identified, and with surprising results.[4] It is the Church of San Felice in Venice (fig. c), which makes this the only drawing the artist is known to have made of his native city. What is more, it must have been drawn from one of the upper floors of the house in the neighborhood of Santa Fosca where Tiepolo lived from 1747.[5] That year he rented a house from one Michiel Grimani, located (according to the record in the Venetian registry) "*Al ponte di Noal vicino a Ca' Curti et al Tentor.*" After eliminating other houses and palazzi in that vicinity whose inhabitants are known, the only house near the Calle del Minio (then known as Ca' Gussoni) that matches this description looks directly onto San Felice.[6]

We can assume that the drawing dates from the mid-1750s, shortly after Tiepolo's return from Würzburg in 1753. Giandomenico, who often used his father's supply of drawings, depicted the church in the background of his painting *The Tooth-Puller* of 1754 (Paris, Louvre),[7] but with the church so close at hand, we now know that he could also have drawn it himself. It was, however, Giandomenico who wrote "*Tiepolo f*" on the drawing, and he may also be responsible for the purely linear sketch on the verso (fig. d).[8] In any case, the verso can be linked to one of his paintings in the presbytery of the Church of SS Faustina e Giovita in Brescia, on which Giandomenico also started working in 1754.[9] The drawing includes the outline of the medieval castello, the fortress on the hill above Brescia which, viewed from the same angle, forms the background for the fresco *The Intervention of Sts Faustina and Giovita during the Defense of Brescia* (fig. e).[10]

1. Knox (1974).
2. Boymans-van Beuningen Museum, Rotterdam, inv. I 45 and I 436, Knox (1974), nos. 42 and 41 respectively.
3. G. Knox, exhib. cat. *Tiepolo. A bicentenary exhibition 1770-1970*, Cambridge, Mass., Fogg Art Museum, 1970, under no. 82, and p. 228, figs. 17-18, and Knox (1974), no. 50. Giambattista and Domenico Tiepolo were working in the Church of the Purità in August and September 1759.
4. Kranendonk (1988), *passim*.
5. P.L. Sohm, "A New Document on Giambattista's Santa Fosca Residence," *Arte Veneta* XL, 1986, p. 239.
6. Kranendonk (1988).
7. Mariuz 1971, pp. 131-32, fig. 85.
8. For the inscription see J. Byam Shaw in Parker (1938-39), p. 60, note 2. The style of the verso and the device of omitting the hill on which the buildings stand is comparable to Giandomenico's *View of Udine* in a London private collection; see A. Rizzi, exhib. cat. *Disegni del Tiepolo*, Udine, Loggia del Lionello, 1965, under no. 102, Knox (1974), no. 54, (ill.), and J. Stock in exhib. cat. *Disegni veneti di collezioni inglesi*, Venice, Fondazione Giorgio Cini, 1980, no. 100.
9. Knox (1974), no. 43, where the verso is compared with a drawing on blue paper once in the Wendland Collection; see Von Hadeln (1927), vol. II, no. 190, and Byam Shaw 1962, p. 27, note 6.
10. Mariuz 1971, pp. 114-15, fig. 74.

GL

fig. c

fig. d

fig. e

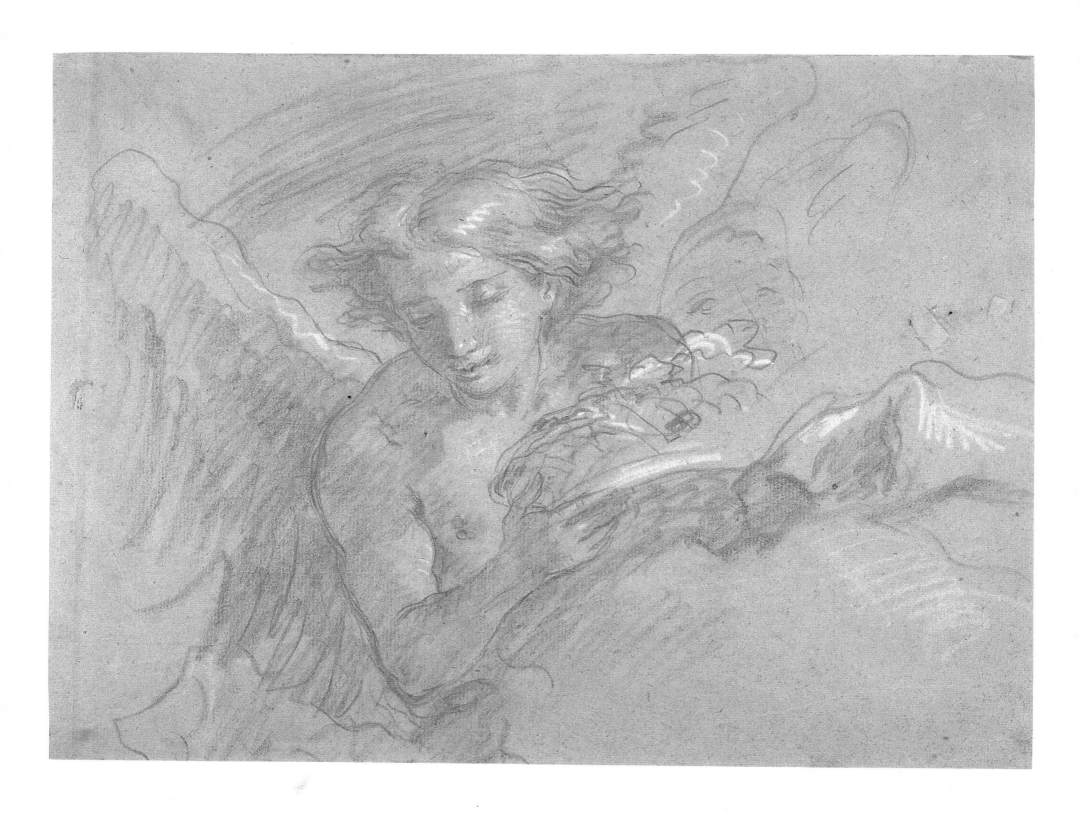

74

Giovanni Battista Tiepolo
Venice 1696–1770 Madrid
STUDY OF AN ANGEL WITH A BASKET OF FLOWERS

Red chalk on blue paper, heightened with white,
laid down; 272 × 363 mm.
Watermark: not visible
Inv. I 165

Provenance: A.L. de Mestral de Saint-Saphorin (?);
A.S. Drey, Munich; F. Koenigs, Haarlem (L. 1023a),
acquired in 1927; D.G. van Beuningen, Rotterdam,
acquired in 1940 and donated to the Boymans Museum
Foundation.

Exhibitions: Amsterdam 1934, no. 670; Venice, Florence
1985, p. 100, no. 89.

Literature: Vigni 1959, pp. 62-64, fig. 21; Byam Shaw
1967, p. 49, no. 10; G. Knox, "Drawings from the
Saint-Saphorin Collection," in *Atti del Congresso
Internazionale di Studi sul Tiepolo*, Udine 1970, p. 62,
fig. 21; G. Knox, *Giambattista and Domenico Tiepolo, a
Study and Catalogue Raisonné of the Chalk Drawings*,
Oxford 1980, vol. I, p. 242, no. M.248, vol. II, fig. 262.

During the last years of his life, that is from 1762 until
his death in 1770, Giovanni Battista Tiepolo was
working in Spain, where he had gone at the request of
Charles III. The king commissioned Tiepolo, at that
time the most celebrated artist in all of Europe, to
decorate the Royal Palace in Madrid. It was in the
throne room of the Palace that the master displayed his
virtuosity once again.[1] After completing these frescoes,
Tiepolo received another important commission from
the king: no fewer than seven large altarpieces for St
Pascual Baylon, a monastic church in Aranjuez, south
of Madrid, which was under construction at the time.[2]

No sooner were Tiepolo's paintings installed in the
church in 1770 than they were replaced by the paintings
of Anton Rafael Mengs and two mediocre Spanish
painters, namely Bayeu and Maella, protégés of Joaquin
de Eleta, the king's confessor and confidant. No one
knows exactly why the Venetian's altarpieces were
replaced, but perhaps the emerging Neo-Classical style
had already gained the upper hand at court. The
paintings by Mengs, Bayeu and Maella vanished in the
1930s during the Spanish Civil War, and only fragments
of Tiepolo's paintings have survived.[3] Five painted
modelli are preserved in the collection of the Courtauld
Institute, London.[4] One of them, intended for the
altarpiece in the second chapel on the left of the
church, shows St Joseph and the Christ Child seated on
a cloud – a not terribly successful, rather static
composition. The sketch was presumably rejected, for
the final painting was very different and much less
severe. That canvas was cut into fragments at some

point, but its original design can be reconstructed on
the basis of a pen and ink drawing of the composition
by Tiepolo's son, Giandomenico, in the Musée Jenisch
at Vevey, Switzerland (fig. a),[5] while some idea of the
painting's final appearance can be gained from a
fragment in the Detroit museum.[6] The steamy cloud in
the *modello* has given way to what looks like a large wad
of cotton wool on which the Child rests. Joseph's total
absorption in the baby also makes the mood more
intimate. The stand of trees has been moved forward,
and the attributes lying in the foreground are not those
of a carpenter but of a traveler. In the distance is the
skyline of a city.

With this transformation in mind, Tiepolo must have
made various drawings, including this *Angel with a
Basket of Flowers*. Stylistically speaking, the chalk study
of the Christ Child lying on a cloth, now in an
American private collection, is closely related.[7] There,
too, the handling of the white chalk is highly varied and
dynamic. The pen drawing by Giandomenico clearly
shows the angel with the flower basket and the vaguely
sketched second angel in the Rotterdam drawing. At the
moment he made our drawing, Tiepolo apparently knew
exactly what form he would give the cloud and the
drapery, for the visible part of the angel and even the
empty areas between hand and cloth correspond exactly
in the two drawings. The spot where the angels are
located in the fragment of the original canvas was
painted over, leaving only the basket,[8] but thanks to a
recent restoration, part of the wing and the head of the
second angel are once again visible (fig. b).

This drawing was ascribed to Giandomenico Tiepolo
before its relationship with the Aranjuez painting had
been demonstrated,[9] but given its brilliant quality there
is scarcely any reason to take that attribution seriously.
Rather, the drawing offers a valuable insight into the
final development of Giambattista's masterly
draftsmanship.

1. F.J. Sanchez Canton, *J.B. Tiepolo en España*, Madrid 1953,
and M. Levey, *Giambattista Tiepolo: His Life and Art*, New
Haven, London 1986, ch. 10: "Spain: from 'Grandiosas Ideas'
to Death," pp. 255-86.
2, F.J. Sanchez Canton, "Los Tiépolos de Aranjuez," *Archivo
Español de Arte y Arqueologa* III, 1927, pp. 1-17; C. Whistler,
"G.B. Tiepolo and Charles III: the Church of S. Pascual
Baylon at Aranjuez," *Apollo* CXXI, no. 279, 1985, pp. 321-27.
3. A. Pallucchini, *L'opera completa di Giambattista Tiepolo*, Milan
1968, pp. 134-35, no. 299 A-G.
4. See (A.S.), *Italian Paintings & Drawings at 56 Princes Gate
London*, London 1959, pp. 161-65, nos. 172-75, and H. Braham
in exhib. cat. *The Princes Gate Collection*, London, Courtauld
Institute Galleries, 1981, pp. 75-81, nos. 111-16.
5. Knox (1980), vol. I, p. 194, no. K.20.
6. Inv. 44.213; A. Morassi, *A Complete Catalogue of the Paintings
of G.B. Tiepolo*, London 1962, p. 10.
7. Glen Falls, The Hyde Collection, see G. Knox, exhib. cat.
Tiepolo. A Bicentenary Exhibition 1770-1970, Cambridge, Mass.,
Fogg Art Museum, 1970, no. 97, (ill.), and Knox (1980), vol. I,
p. 222, no. M.110, vol. II, fig. 263.
8. For the condition of the painting with the overpaint see
Morassi, op. cit. (note 6), fig. 196, and for detail photographs
after the restoration, (A.S.), op. cit. (note 4), figs. 63-64.
9. Vigni 1959, and Byam Shaw 1967. The discussion centered
around the question of whether all the drawings associated
with paintings or frescoes by Giambattista, such as the studies
for the ceiling paintings in the Residenzgalerie in Würzburg,
some of which are in Stuttgart, really are by the elder Tiepolo.
For the general issue of attribution see J. Eckhart von Borries,
"Bemerkungen zu den Kreidezeichnungen von Giambattista
und Domenico Tiepolo," *Zeitschrift für Kunstgeschichte* XXXIV,
1971, pp. 135-46, and J. Byam Shaw, "Tiepolo Celebrations:
Three Catalogues," *Master Drawings* IX, 1971, pp. 264-76.

GL

fig. a

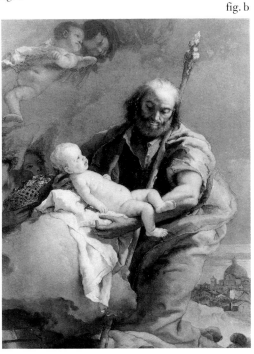

fig. b

75

Giandomenico Tiepolo
Venice 1727–1804 Venice
THE LANDING

Pen and brown ink over a sketch in red and black chalk,
brown wash; 259 × 353 mm.
At lower left, in pen and brown ink: *Dom. Tiepolo inv. f*
Watermark: crown surmounted by a half moon and the
word *IMPERIAL*
Inv. MB 1955/T 1

Provenance: B. Geiger, Vienna; sale London (Sotheby's),
December 7-10 1920, no. 337; R. Owen, London;
B. Ford, London; sale London (Sotheby's), November
10 1954, no. 42; P. Cassirer, Berlin and Amsterdam;
acquired by the museum in 1955.

Exhibitions: Exeter 1946, no. 253; London, Birmingham
1951, no. 139; Venice 1951, no. 142; Groningen,
Rotterdam 1964, no. 98; 's-Hertogenbosch, Heino,
Haarlem 1984, no. 35; Venice, Florence 1985, no. 109.

Literature: W. R. Juynboll, "Een Caricatuur van Giovanni
Domenico Tiepolo," *Bulletin Museum Boymans* VII,
1956, pp. 67-81; Vigni 1959, pp. 58, 61; Byam Shaw
1962, p. 50, and under no. 77.

Giovanni Battista Tiepolo was highly receptive to the
amusing caricatures drawn by his seventeenth-century
countrymen Bernini, Guercino and Mola, and he
himself left at least three albums of such drawings at
his death, mostly done in his favorite technique – a
combination of pen, brush and brown ink.[1] At least one
of those albums passed into the possession of the artist's
son Giandomenico who, when he tried his hand at the
genre following his father's death, referred frequently to
the drawings in the *Tomo terzo di caricature*, which
remained intact until 1943.[2] Whereas his father would
draw isolated figures, Giandomenico preferred to
involve them in a narrative. The types he "borrowed"
from his father occasionally stand somewhat
superfluously to one side, like the pipe smoker with
wig and pigtail in this sheet.[3]

Traditionally entitled *The Landing*, this is one of
four known caricatures by Giandomenico with such
dwarf-like characters. Their grotesque heads are much
too large for their bodies, and in this respect they are
reminiscent of the paintings by Faustino Bocchi (1659–
1741), who was active in Brescia. Giandomenico could
have become familiar with Bocchi's scenes of deformed
creatures during his sojourn in Brescia around 1755.
It is assumed that he was also influenced by the prints
of caricaturists such as Johann Heinrich Ramberg
(1763–1840) or Philibert Louis Debucourt (1755–1832),
since his father rarely gave his figures such distorted
proportions, leaving the impression that they could
really have existed.[4]

Some of Giandomenico's caricature drawings are
dated 1791, and in fact he is thought to have produced
most of his work in this genre during that final decade
of the eighteenth century. Three drawings similar to the
Rotterdam sheet are preserved in West Berlin (fig. a),
Hartford (fig. b), and Paris respectively.[5] All three being
of approximately the same size, it is altogether possible
that they once belonged to a larger series, though the
iconographical relationship between them remains
unclear.

The satire's bark is worse than its bite in this case:
it is neither insulting nor politically colored, as has
sometimes been claimed.[6] The centrally placed servant
(or *códega*, in the Venetian dialect), equipped with a
sword and a lantern, is important to the meaning of the
image. In broad daylight he lights the way of the richly
dressed couple, who allow him to make fools of them.[7]
The three gentlemen on the right could be playing a
similar role, for they too seem to be awaiting their
chance to offer the unsuspecting dupes their no doubt
equally superfluous services. The two furthest to the left
are identified as a clergyman and a shopkeeper
respectively.[8] What the pipe smoker is supposed to
represent remains unclear.

In a replica of this drawing, dated 1791 and now in
the Goldyne family collection in America (fig. c), the
heads of the couple have normal proportions, while the
group on the right has been omitted.[9]

1. The 1854 catalogue of the Algarotti-Corniani collection
mentions "*due grossi libri con una copiosa collezione di disegni
umoristici del Tiepolo*," see G. Knox in exhib. cat. *Tiepolo.
A Bicentenary Exhibition 1770-1970*, Cambridge, Mass. 1970,
under no. 87.
2. The *Tomo terzo* was auctioned in Edinburgh (Dowells),
November 25 1925, no. 1004, entering the collection of A. Kay,
Edinburgh. It was then dismembered and sold in London
(Christie's), April 8-9 1943, no. 244.
3. The present location of the drawing is unknown, but it
comes from the album in the Kay Collection (see note 2) and
was published in a selection from the *Tomo terzo*, O. Lancaster,
Twenty-five Caricatures by Giovanni Battista Tiepolo, London
1943, pl. 16; Juynboll (1956), pp. 75 and 73, fig. 6.
4. See Juynboll (1956), pp. 76-77, for the influence of other
caricaturists. For a number of Giambattista's caricatures with
large heads see M. Muraro, *Catalogue of the Exhibition of
Venetian Drawings from the Collection Janos Scholz*, Venice,
Fondazione Giorgio Cini, 1957, no. 71, (ill.), and A. Rizzi,
exhib. cat. *Disegni del Tiepolo*, Udine, Loggia del Lionello,
1965, no. 49 (Trieste, Musei Civici di Storia ed Arte).
5. For the drawing in the Berlin printroom see Juynboll
(1956), pp. 77-78, fig. 8, and for the sheet in the Wadsworth
Atheneum, Hartford, which was purchased in 1931 from the
Hermitage, see Byam Shaw 1962, no. 77 (ill.). The drawing in
the Stohlin Collection in Paris contains a scene with a dancing
bear; ibid., under no. 77.
6. See A. Mariuz, "De tekeningen van Giandomenico Tiepolo,"
in exhib. cat. Brussels 1983, pp. 74-75, and Byam Shaw 1962,
pp. 50-51.
7. B. Aikema in exhib. cat. Venice, Florence 1985, no. 109.
A jaunty lantern bearer, but this time with a mask, appears in
Giandomenico's frescoes in the Villa Valmarana in Vicenza,
see the illustration in R. Chiarelli, *I Tiepolo a Villa Valmarana*,
Milan 1980, pl. 22. Six caricature drawings by Giandomenico
were made into prints with inscriptions which shed some light
on the satirical meaning, but it appears that those prints are
very rare. A. Urbani de Gheltof, *Tiepolo e la sua famiglia*,
Venice 1879, pp. 92-96, published the inscriptions, of which
one, "*Il Cavalier Servente*," might even apply to the Rotterdam
drawing; see Byam Shaw 1962, pp. 50-51, note 4.
8. Juynboll (1956), p. 73.
9. Juynboll (1956), pp. 74 and 71, fig. 3, believed that the
replica was in the Louvre, but see T. Pignatti in exhib. cat.
Venetian Drawings from American Collections, Washington,
National Gallery of Art, Fort Worth, Kimbell Museum of Art,
St Louis, St Louis Art Museum, 1974-75, no. 111 (ill.).

GL

figs. a, b, c

76

Francesco Guardi
Venice 1712–1793 Venice
LANDSCAPE

Pen and brown ink, brown wash; 257 × 388 mm.
Watermark: shield with a half moon over the letters *CF*
Inv. I 1141

Provenance: W. Mayor, London (L. 2799);
R.P. Goldschmidt, Berlin (L. 2926); sale Frankfurt,
October 4-5 1917, no. 249; P. Cassirer, Berlin;
F. Koenigs, Haarlem (L. 1023a), acquired in 1923;
D.G. van Beuningen, Rotterdam, acquired in 1940 and
donated to the Boymans Museum Foundation.

Exhibitions: Amsterdam 1929, no. 219; Amsterdam 1934,
no. 561; Rotterdam 1938, no. 288; Paris 1952, no. 19;
Rotterdam 1952, no. 113; London 1954-55, no. 576;
Paris, Rotterdam, Haarlem 1962, no. 196; Venice 1962,
no. 82; Brussels 1983, no. 111; Venice, Florence 1985,
no. 102.

Literature: Von Hadeln 1933, pl. 21; Juynboll 1938,
pp. 23, 25; R. Pallucchini, *I disegni del Guardi al Museo
Correr di Venezia*, Venice 1942, p. 54; De Tolnay 1943,
p. 129, no. 143; J. Byam Shaw, *The Drawings of Francesco
Guardi*, London 1951, p. 77, no. 71; Haverkamp
Begemann 1957, no. 51; Byam Shaw 1967, p. 49, no. 12;
R. Stuart Teitz, "A Landscape by Francesco Guardi,"
Worcester Art Museum Bulletin, new series II, no. 2, 1973,
pp. 1-6; A. Morassi, *I Guardi*, Venice 1973, p. 495, under
no. 999; L. Rossi Bortolatto, *L'Opera completa di Francesco
Guardi*, Milan 1974, under no. 611; A. Morassi, *Guardi.
Tutti i disegni di Antonio, Francesco e Giacomo Guardi*,
Venice 1975, no. 649, fig. 622.

In common with other early twentieth-century
collectors of drawings, Franz Koenigs was greatly
attracted to the proto-impressionism of Francesco
Guardi. His collection included a remarkably strong
group of drawings by the Venetian master, all of which
are very dissimilar in function and technique.[1] This
superb sheet is one of the finest of the group, and
occupies a special position among Guardi's drawn
landscapes.

The whimsical, imaginary composition corresponds
closely with a very brushy painting by the artist (fig. a).
That canvas is persistently reported as being in the
Nationalmuseum in Stockholm,[2] even in the most
recent Guardi literature, despite the fact that it was
acquired by the Worcester Art Museum in 1970. It was
once in the Lamm Collection at Nasby Castle near
Stockholm, but was auctioned in New York back in
1923. The probable buyer was John M. Woolsey, who
bequeathed it to the Worcester museum in 1970.[3]

It is debatable whether the Rotterdam drawing is a
preparatory study for that painting, or a later repetition
by the artist himself, although the latter is more likely.
It seems that Guardi had the painting close at hand,
and rapidly copied the outlines of the larger masses and
the background hills with brusque strokes of the pen.
The division of light and shaded areas broadly follows
that in the painting, although the lighter wash of the
water and sky, and the sketchy rendering of the dark
brown passages in the rocks and foreground give the
drawing a brighter tone. The mood of the painting,
which is dramatic and almost romantic, has now become
idyllic, in the manner of Zuccarelli. Guardi probably
wanted to have a *ricordo* of the scene which, as so often,
he had painted directly onto the canvas.

The drawing may have been made for sale or for
Guardi's own use. The lefthand group of trees, for
instance, is repeated in a slightly modified landscape
now in the Musée de Picardie, Amiens (fig. b).[4] That
painting also has some of the same figure staffage: the
man with the pole, the woman with a basket on her
head, and the bending figures on the right, who are also
wielding long poles (possibly scoop nets). The motif of
the crossed trees recurs several times in Guardi's œuvre.
Trees identical to those in the Rotterdam sheet appear
in a drawing of a wolf hunt and in a painting, formerly
in the Carlo Broglio Collection in Paris, and also in a
drawing in the Museo Correr in Venice.[5] The
Hermitage in Leningrad has a painted landscape in
which the same figuration with trees occupies the very
center of the picture.[6]

The paintings in Worcester and Amiens are
considered to date from Guardi's mature period around
1770–80, when, presumably under the influence of
Marco Ricci, his landscapes became more dynamic.
Although it is generally difficult to fix a precise date to
Guardi drawings, this one probably comes from that
period.

1. For the other drawings in the Koenigs Collection see Byam
Shaw (1951), and Morassi (1975), index p. 455.
2. Morassi (1973), p. 495, no. 999.
3. Stuart Teitz (1973), *passim*.
4. Morassi (1973), no. 1000. A painted repetition of that
picture, unquestionably autograph, is in a New York private
collection: ibid., no. 1001, fig. 886.
5. Byam Shaw (1951), no. 70. For the drawing in the Museo
Correr: Morassi (1975), no. 650, fig. 623; and T. Pignatti,
Disegni antichi del Museo Correr di Venezia, vol. III, Venice 1983,
no. 583.
6. Morassi (1973), no. 998, fig. 880.

GL

fig. a

fig. b

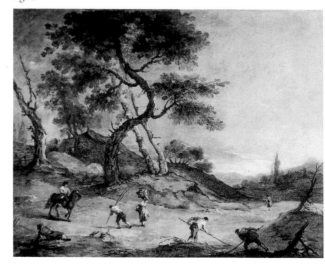

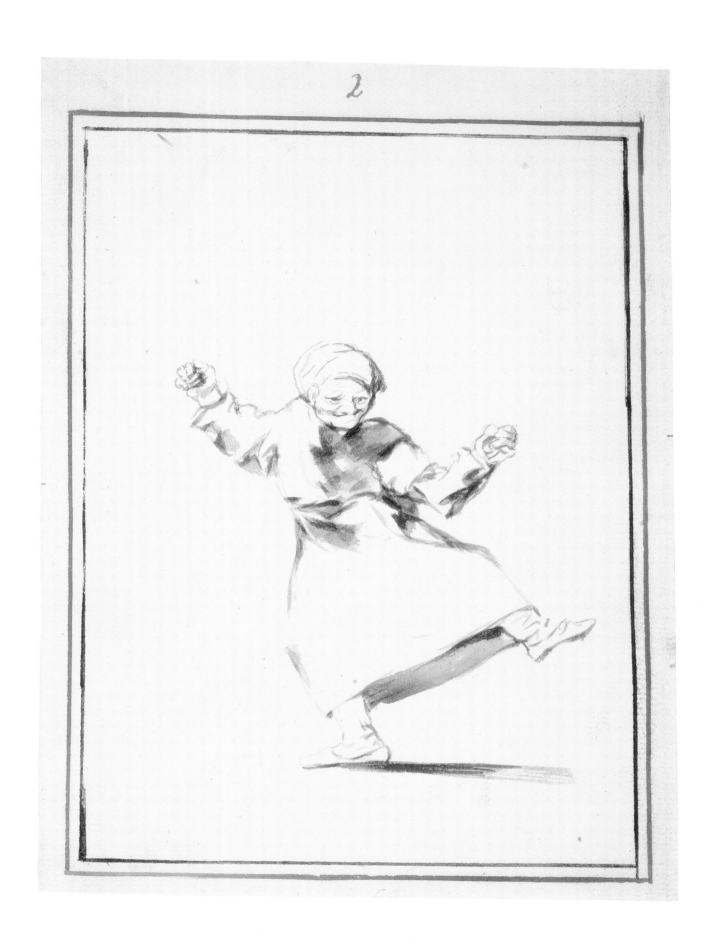

Spanish School

77

Francisco de Goya y Lucientes
Fuentetodos 1746–1828 Bordeaux
OLD WOMAN WITH CASTANETS DANCING

Brush and gray ink; 240 × 175 mm.
Two sets of framing lines, in dark gray and brown ink;
numbered in pen and brown ink: 2
Annotated in pencil: *...con su...*
Watermark: fragment of a Dutch lion rampant on a
pedestal, inside which is the name *(HO)NIG* and the
letters *(J H) & Z*, the watermark of J. Honig & Sons,
Zaandijk.[1]
Inv. S 3

Provenance: anonymous sale, Paris, April 3 1877, no. 1;
E. Féral, Paris; A. Stroelin, Paris; F. Koenigs, Haarlem
(L. 1023a); D.G. van Beuningen, Rotterdam, acquired in
1940 and donated to the Boymans Museum Foundation.

Exhibitions: Paris 1979, no. 169, fig. 162.

Literature: Gassier 1953, p. 15 (ill.); E.A. Sayre, "An Old
Man Writing", *Bulletin Museum of Fine Arts Boston* LVI,
1958, p. 135; Gassier and Wilson 1970, vol. III, no. 1385
(ill.); P. Gassier, "Une source inedite de dessins de Goya
en France au XIXe siècle," *Gazette des Beaux Arts*,
LXXX, July/August 1972, p. 112; Gassier 1973, p. 211,
no. E 2, fig. on p. 171; Boudaille 1979, p. 76, fig. 96.

In the winter of 1792–93, Goya contracted a serious
infection which left him completely deaf and in 1797
forced him to resign as Director de Pintura of the
Royal Academy of San Fernando in Madrid. In the
years before his resignation he had spent many months
in the south of Spain, hoping to find a cure. Up until
then, drawings had occupied a relatively minor place in
his *œuvre*. In 1796, however, in San Lucar near Cadiz,
Goya produced his first two sketchbooks of brush
drawings which can be regarded as works of art in their
own right. In the following thirty years, until his death
in 1828, he produced another six of these sketchbooks,
which are identified in later literature by the letters
A to H.[2] They are not in fact sketchbooks in the true
sense, as they do not record personal experiences or
impressions, such as sketches of buildings or landscapes
or portraits of people he had met on a journey, for
instance. Goya's sketchbooks are more in the nature of
a journal in the form of pictures. Often highly critical
or caricatural, but often humorous, they allude to
political and social events, episodes from daily life, the
predicaments in which people find themselves, religion
and a wide range of other subjects. They reflect Goya's
perception of the world and of the times in which he
lived, and he annotated many of the sheets with
additional information on the subjects. The drawings in
the "journal albums," as the eight sketchbooks are

called, were not intended for publication, unlike those
for the *Caprichos*, for instance, which were published as
a series of etchings in 1799.

Shortly after Goya's death in 1828, his son Javier
Goya (1784–1854) pasted most of the drawings from the
albums onto sheets of pink paper, which he then had
bound into three large volumes.[3] Between 1840 and
1850 Javier made a number of compilations from these
books, ensuring that each one represented a variety of
drawing techniques, and this practice was continued
after his death by his son Mariano Goya (1807–74).
These selections – the word *Escojidos* is clearly legible on
the surviving binding of one of them – were intended to
be sold to collectors.[4] As a result, the composition of
the original albums and the sequence of the drawings
they had contained were completely lost. Only in the
1970s was it possible to reconstruct Goya's original
journal albums with some degree of reliability.[5]

The drawing of an old woman dancing is from Album
E, which is also known as the album with black framing
lines, since nearly all the sheets it contains have dark
gray borders drawn with a brush and ruler.[6] This is
sheet two of the album, as can be seen from the
autograph numbering at the top. Most of Goya's
annotation at the bottom has been cut away. However,
the two words which are still visible – *con su* – and the
title by which the drawing was identified at an
anonymous auction in 1877 enable us to reconstruct it
as *Contenta con su suerta* (content with her lot). We can
only speculate on what Goya might have had in mind
when he made the drawing, although it conjures up the
idea of a woman dancing in a world of her own,
oblivious to whatever is going on around her.

It is not entirely certain when Album E was executed.
Some believe it to be from 1805 to 1812,[7] others from
1814 to 1817,[8] which would be after the French had left
Spain.

1. See Voorn 1960, p. 170, no. 100. This watermark is found in
paper as early as 1807, and became the registered mark of
Honig from 1815, see ibid., p. 125.
2. See Sayre (1958), pp. 130ff.
3. Traces of this pink paper are found on the reverse of many
of the drawings, including another in the Boymans-van
Beuningen Museum of a hunter firing his gun (from Album
F); see Gassier 1973, no. F 97, fig. on p. 467.
4. See note 6.
5. For the reconstruction and later history of Goya's journal
albums see Gassier 1973, pp. 9-16.
6. See H.B. Wehle, *Fifty Drawings by Francisco Goya*, New York
1938, p. 11.
7. Gassier 1973, p. 168.
8. E.A. Sayre in exhib. cat. *Goya and the Spirit of Enlightenment*,
Madrid, Museo del Prado, Boston, Museum of Fine Arts, New
York, Metropolitan Museum of Art, 1988-89, pp. CXIIIff.

AM

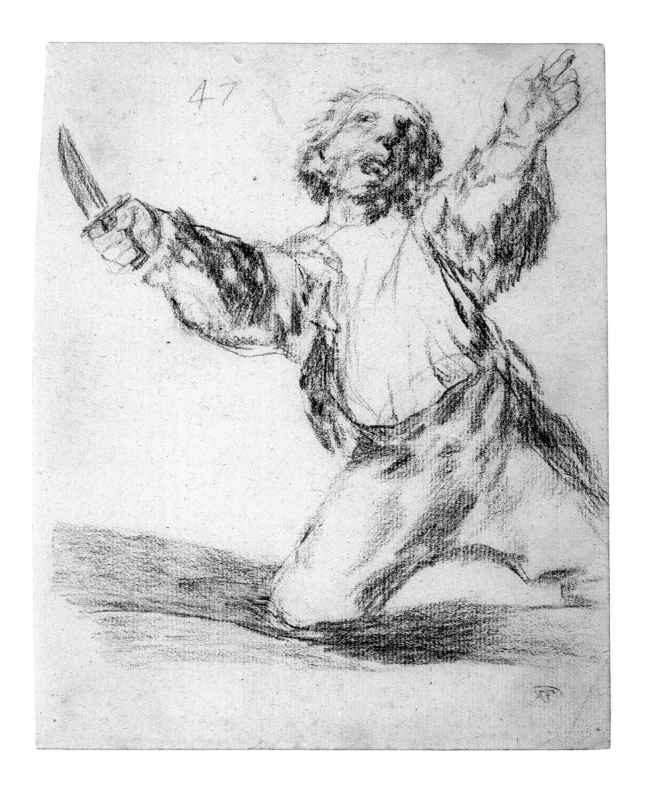

78

Francisco de Goya y Lucientes
Fuentetodos 1746–1828 Bordeaux
MAN WITH OUTSTRETCHED ARMS HOLDING A KNIFE

Black chalk and a darker shade of lithographic chalk;
191 × 150 mm.
Numbered in black chalk: *47*
No watermark
Inv. S 15

Provenance: J.W. Böhler, Lucerne; F. Koenigs, Haarlem
(L. 1023a); acquired in 1929; D.G. van Beuningen,
Rotterdam, acquired in 1940 and donated to the
Boymans Museum Foundation.

Exhibitions: Basel 1953, no. 151; Rotterdam 1956,
no. 141; Paris 1979, no. 183, fig. 174; Hamburg 1980,
no. 188 (ill.).

Literature: Gassier 1953, p. 17, fig. on p. 16; Haverkamp
Begemann 1957, no. 87 (ill.); Gassier and Wilson 1970,
cat. V, no. 1807 (ill.); Gassier 1973, p. 644, no. H 47, fig.
on p. 617; Boudaille 1979, fig. on p. 4; exhib. cat. *Goya*,
Frankfurt, Städelsches Kunstinstitut, 1981, under no. L
89; J. Fauque and R. Villanueva Etcheverria, *Goya y
Burdeos*, Saragossa 1984, p. 159, fig. 332.

This drawing, which is also from one of Goya's eight
journal albums, is sheet 47 of Album H. He produced
Albums G and H in Bordeaux, where he lived in exile
from 1824 together with a large number of Spanish
liberals who, like himself, had fled the absolutist regime
of Ferdinand VII. The community of exiles included
members of the Spanish aristocracy who had supported
King Joseph Bonaparte, and officers who had served in
his army.

What the drawings in these two albums have in
common is that Goya used not only ordinary black
chalk but also an extremely dark shade of lithographic
chalk. This change in technique occurred around the
time he met the printer and lithographer C. Gaulon
(1777–1858) in Bordeaux. Earlier, in 1819, he had tried
to make lithographs by drawing on the stone with brush
and ink, but the results were generally unsuccessful,[1]
and it was presumably Gaulon who taught him to use
lithographic chalk instead.

Only a few of the sheets in Album H are annotated,
so it is not entirely clear what this subject is meant to
signify.[2] It might be related in some way to a popular
contemporary pantomime in four acts entitled *The
Count and the Dagger, or The Spaniards' Revenge*.[3]

1. See T. Harris, *Goya: Engravings and Lithographs*, vol. I,
Oxford 1964, p. 215.
2. In Fauque and Villanueva Etcheverria (1984), p. 159, it is
titled "*No tienne que un cuchillo para defenderse.*"
3. Ibid., p. 626.

AM

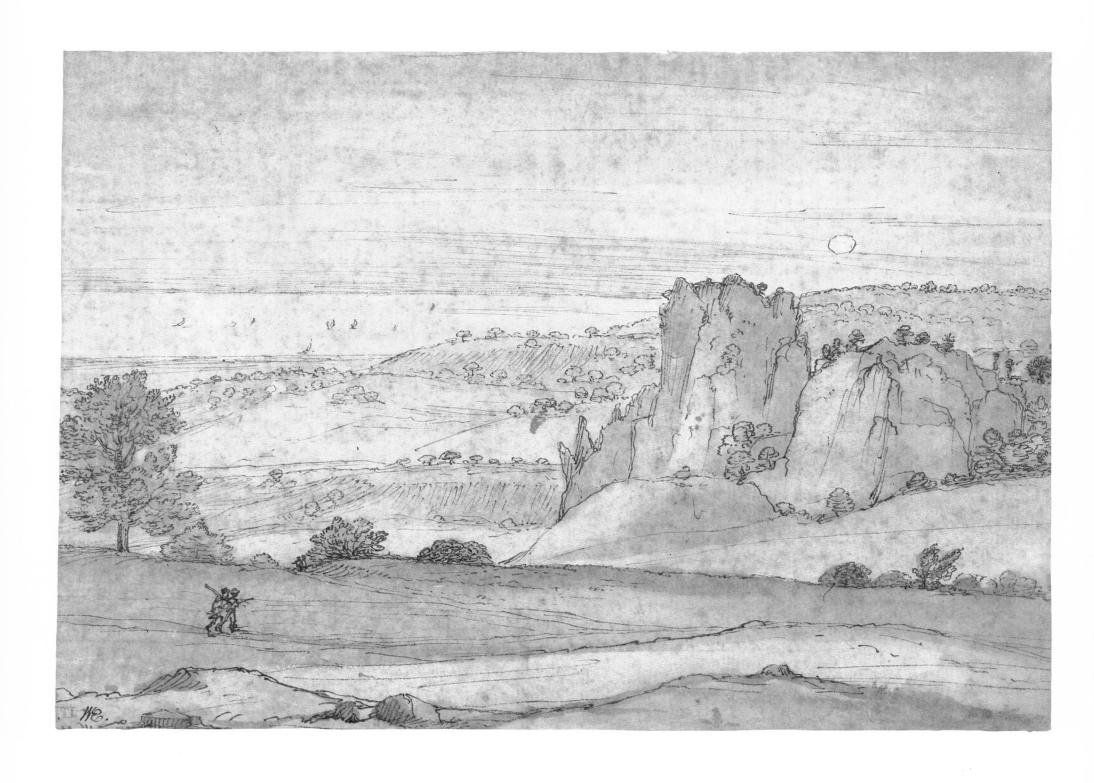

French School

79

Claude Lorrain
Chamagne near Toul 1600–1682 Rome
"VISTA DEL SASSO"

Pen and brown ink, brown and gray wash;
190 × 268 mm.
Signed and dated on the verso in pen and brown ink:
Vista del Sasso faict l'ano 1649/Claudio Gellee .I.V.[1]
No watermark
Inv. F I 85

Provenance: Giovanni Rist[.]gy, Rome (?);[2] A. Pond,
London; Sir Thomas Lawrence, London (L. 2445);
W. Esdaile, London (L. 2617), acquired in 1836 at the
fifth sale exhibition of the Lawrence Collection;
H. Wellesley, London; his sale, London, June 25 1866,
no. 482; F. Lugt, Maartensdijk, no. I 2797; F. Koenigs,
Haarlem (L. 1023a), acquired in 1928; D.G. van
Beuningen, Rotterdam, acquired in 1940 and donated
to the Boymans Museum Foundation.

Exhibitions: London 1836, no. 1; Rotterdam 1934-35,
no. 11, fig. III; Paris 1952, no. 60; Rotterdam 1952,
no. 117; Vienna 1964, no. 93.

Literature: Knab 1956, p. 113, cat. no. 6, fig. 10;
E. Knab, "Stylistic Problems of Claude's Draftmanship,"
Acts of the 20th International Congress of the History of Art,
vol. III, Princeton 1963, p. 116, fig. XL, 14;
Roethlisberger 1968, p. 260, no. 670, (ill.); H. Diane
Russell in exhib. cat. *Claude Lorrain 1600-1682*,
Washington, National Gallery of Art, 1982, under
no. 40; H. Langdon, *Claude Lorrain*, Oxford 1989,
fig. 80.

Claude Gellée, also known as le Lorrain, was born in
the Duchy of Lorraine. At the age of twenty-seven he
decided to settle in Rome, where he emerged as the
foremost landscape painter in seventeenth-century Italy.
His classical, heroic or Arcadian landscapes incorporate
motifs taken from the Italian countryside, with human
figures playing a relatively subordinate role. Not
surprisingly, then, the vast majority of his extant
drawings, which number approximately one thousand,
are likewise of landscapes. They fall broadly into two
categories: studies from nature, such as landscapes and
trees, and drawings in which a variety of elements are
combined to form an integrated composition. The
Rotterdam sheet is of the first type.

As Claude noted on the reverse, the drawing is a view
of the Sasso, a rock formation near the village of Sasso
to the south of Civitavécchia. In the background is the
Mediterranean, dotted with ships. A drawing in
Haarlem shows the Sasso from the other side. On top
of the big rock lies the monastery of San Antonio and
to the right the Palazzo del Sasso (fig. a).[3]

Claude made frequent excursions into the countryside
around Rome, particularly during the 1630s and 1640s,
to draw and paint from nature. He was often
accompanied on these occasions by the painter Jakob
von Sandrart, who lived in the same house as Claude
from 1628 to 1635 – a period he was later to describe
in considerable detail. Claude made another two
drawings in the vicinity of Sasso. The verso of one of
them has the inscription "*dal naturale*,"[4] and from the
scene depicted we can assume that Claude must also
have visited the more distant town of Civitavécchia.

1. The letters I and V, which Claude appended to most of
his signatures on both drawings and paintings, might signify
In Urbe, i.e. living in Rome.
2. On the verso there is a penciled annotation in a late
seventeenth- or early eighteenth-century hand: *Co(m)prati dal
studio di Giovanni Rist[.]gy* (Purchased in the studio of Giovanni
Rist[.]gy).
3. Roethlisberger 1968, no. 761 (ill.).
4. Ibid., nos. 622, 623vo, the latter being annotated by the
artist: *Claudio Loranese dal naturale*.

AM

fig. a

80

Claude Lorrain
Chamagne near Toul 1600–1682 Rome
LANDSCAPE WITH PAN AND SYRINX

Pen and brown ink, over graphite, brown wash,
heightened with white (partly oxidized), on brown tinted
paper; 260 × 409 mm.
Signed and dated on the verso in pen and brown ink:
CLAVDIO Gillee I V 165(6)
Watermark: crown with a star
Inv. F I 9

Provenance: Earl of Essex;[1] F. Koenigs, Haarlem
(L. 1023a), acquired in 1927; D.G. van Beuningen,
Rotterdam, acquired in 1940 and donated to the
Boymans Museum Foundation.

Exhibitions: Rotterdam 1934-35, no.23; Amsterdam,
Paris 1964, no.9, fig.14.

Literature: Knab 1956, pp.119, 121, cat. no.10, fig.19;
Roethlisberger 1968, p.301, no.801 (ill.).

The drawing is of a scene from Ovid's *Metamorphoses*.[2]
It is the tale of Syrinx, a naiad or river nymph
renowned for her beauty and chastity. One day, as she
descended from Mount Lycaeus in Arcadia, she
encountered Pan, who made dishonorable advances
towards her. She fled from him, only to be stopped
short by the River Ladon – "*his illum cursum
impedientibus undis*" in Ovid's words. When Pan tried to
embrace her, however, he found himself clasping an
armful of reeds. The melodious sound of the wind
blowing through them so enchanted him that he cut
some of the reeds and bound them together, creating
the instrument known as panpipes.

The drawing shows Syrinx, pursued by Pan, arriving
at the banks of the River Ladon. On the left is the
personification of the river. Claude Lorrain has
rendered Ovid's text quite faithfully: Mount Lycaeus is
shown on the left in the background, while Syrinx, true
to Ovid's description, is clad in the same tunic as that
worn by Diana, the goddess of the hunt. It is unusual,
however, for a personification, in this case the river god
Ladon, to play an active part in a story. The gesture he
is making with his left hand is obviously intended to
halt Syrinx. Judging from the *pentimento* in his left arm,
which Claude had initially drawn in a raised position, it
must originally have been even more explicit.

Like the majority of Claude's extant drawings, this
sheet is a well-rounded, finished composition.

He made fewer studies from nature after the
mid-1650s, and his manner of drawing became more
painterly, chiefly due to the white heightening applied
with the brush. This *Pan and Syrinx* marks the
beginning of this period in his work.

1. According to the early inscription in pencil on the verso,
which reads: *From the collection of the Earl of Essex Cassiobury
Park/original drawing by Claude signed and dated.*
2. Book I, lines 689-712.

AM

81

Jean-Antoine Watteau
Valenciennes 1684–1721 Nogent-sur-Marne
STUDY SHEET WITH SOLDIERS AND A STANDING WOMAN

Red chalk; 179 × 198 mm.
Verso: tracing in red chalk of the soldier at lower left
No watermark
Inv. F I 150

Provenance: P.-J. Mariette, Paris (L. 1852); his sale,
Paris, November 15 1775, in lot no. 1389; F. Koenigs,
Haarlem (L. 1023a), acquired in 1927; D.G. van
Beuningen, Rotterdam, acquired in 1940 and donated to
the Boymans Museum Foundation.

Exhibitions: Rotterdam 1934-35, no. 84; Amsterdam
1935, no. 22; Cologne 1939, no. 55, fig. 8; Paris,
Brussels, Rotterdam 1949-50, no. 55; Paris 1952, no. 66;
Rotterdam 1952, no. 123; Paris, Amsterdam 1964,
no. 38, fig. 28; Amsterdam 1974, no. 117 (ill.);
Washington, Paris, Berlin 1984-85, p. 99, no. 34 (ill.),
p. 282, fig. 4.

Literature: Foerster 1930, no. 6 (ill.); Parker 1931, p. 17;
Juynboll 1938, p. 26 (ill.); Parker and Mathey, vol. I,
1957, no. 249 (ill.); Haverkamp Begemann 1957, no. 57
(ill.); J. Cailleux, "Four Studies of Soldiers by Watteau,
an Essay on the Chronology of Military Subjects,"
Burlington Magazine CI, 1959, suppl., pp. III, V-VII;
Cormack 1970, no. 10; M.P. Eidelberg, *Watteau's
Drawings* (diss. Princeton 1965), London, New York
1977, p. 16; Leymarie, Monnier and Rose 1979, p. 174,
(ill.); Posner 1984, p. 40, fig. 32; I.S. Nemilova,
*The Hermitage. Catalogue of Western European Painting:
French Painting, Eighteenth Century*, Moscow, Florence
1986, p. 450, under no. 350; Zolotof *et al.* 1986, p. 109
(ill.), under nos. 29-30.

In the early stages of his artistic career, Watteau
produced ten paintings of military subjects, a genre he
later abandoned. Some have been lost over the years
and are only known from the prints made of them
shortly after his death. It was not battlefields or sieges
that interested him so much as the everyday routine of
an army on the move. In this respect he was following
in a tradition that originated in the Netherlands in the
seventeenth century, and in the Southern Netherlands
in particular, where paintings depicting subjects of this
type enjoyed tremendous popularity. Valenciennes, the
capital of Hainaut and the town in which Watteau was
born, had originally belonged to the Southern
Netherlands, and was only conquered by Louis XIV in
1677. In Paris, where Watteau worked from 1702 to
1709 and from 1712 until his death in 1721, he was
therefore regarded as a *peintre flamand*.[1]

Although these paintings cannot be dated with any
accuracy, they are assumed to have been executed
between 1709 and 1715. Watteau was back in
Valenciennes from 1709 until 1712, having failed –
to his great disappointment – to win the annual Prix
de Rome in Paris. In those years, Valenciennes was
embroiled in the War of the Spanish Succession,
whereby Louis XIV hoped to annex the Spanish
Netherlands to France once and for all. The movements
of troops in and around Valenciennes gave the artist
ample opportunity to observe and draw military themes
and soldiers.

Among the last paintings he produced of this subject
are two small pendants on copper, *Les Fatigues de la
guerre* and *Les Délassements de la guerre*,[2] which Watteau
is thought to have painted in 1715 in Paris, to which he
had returned in 1712. The latter has a number of
soldiers and women in the background, reposing under
a large sheet of canvas suspended from the trees above
them (fig. a). In front are several soldiers reclining, some
of them asleep. For the background Watteau used a
drawing – with numerous changes – which we know

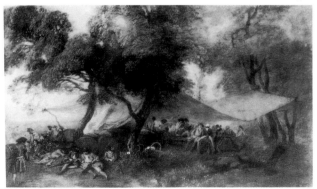

from the engraving later made after it by Boucher (fig. b).[3] The four soldiers in the drawing reproduced here are also depicted sitting or lying next to each other in the painting, although their relative positions are different. The man resting his chin in his hand appears again in *L'Escorte d'equippage*, a painting which is only known from a print (fig. c). When composing a painting, Watteau appears to have heeded the advice he himself gave his younger pupil Nicolas Lancret (1690–1743). According to the latter's biographer, Watteau had recommended that he draw landscapes in the vicinity of Paris, then make figure studies, and finally combine elements from the two to create a composition of his own invention.[4] The advice apparently served Lancret well, as he was admitted to the Académie Royale de Peinture shortly afterwards, in 1718, on the strength of two paintings he had made in this way. Watteau's method was highly unorthodox in the eyes of an *académicien* and unworthy of emulation, as we know from a frequently cited passage from the lecture on Watteau delivered by his friend, the art critic and collector, the comte de Caylus, before the Academy in 1748.[5] Watteau made drawings without a specific painting in mind, he remarked, and instead of making composition sketches he compiled his paintings from drawings selected from the collection he kept in his many sketchbooks. As a result, the same figure studies appear in more than one painting. In this respect, Watteau broke with the long-standing convention of first designing the composition as a whole, then making studies for the figures and principal details in a *modello* or cartoon, and finally producing the actual painting. We know from Watteau's hundreds of extant figure studies that he seldom adopted this method. Nevertheless, Caylus's criticism is not entirely valid. A few composition sketches are known in the original or have been reconstructed from prints after his work, while some of his figure studies were indeed made with a particular painting in mind.[6]

The drawing was probably executed shortly before 1715, when Watteau's style was characterized by strong, well-defined lines and small, well-placed accents.

1. See, for example, the 1734 prospectus of the *Recueil Jullienne* in E. Dacier and A. Vuaflart, *Jean de Jullienne et les graveurs de Watteau au XVIIIe siècle*, vol. II, Paris 1922, fig. 8,1.
2. Both in the Hermitage, Leningrad; cf. Nemilova (1986), nos. 350-51 (ill.). These two pictures were engraved for the *Recueil Jullienne*, cf. Dacier and Vuaflart, op. cit. (note 1), vol. IV, figs. 125, 216.
3. François Boucher (1703–77) made the print for the *Figures des différents caractères*; see cat. no. 82.
4. Quoted in G. Wildenstein, *Lancret*, Paris 1924, p. 11, and taken from the *Eloge* on Lancret by his biographer, Sylvain Ballot Savot, of 1743.
5. A.-C.-P. comte de Caylus, *La Vie d'Antoine Watteau*, in P. Rosenberg (ed.), *Vies anciennes de Watteau*, Paris 1984, pp. 78-79.
6. Cf. Eidelberg (1977), and cat. no. 84.

AM

fig. b

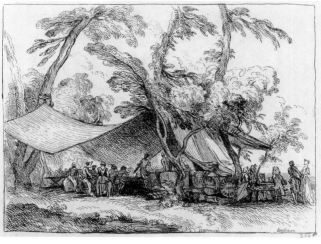
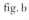

fig. c

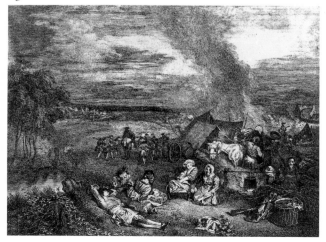

82

Jean-Antoine Watteau
Valenciennes 1684–1721 Nogent-sur-Marne
STUDY OF TWO BOYS WITH STOOLS

Red and black chalk, laid down; the shoes completed
in red chalk and graphite on the mount; 222 × 217 mm.
Annotated on the verso in pen and brown ink: *dessein
que Watteau a laisse en/mourant a moy son ami
Caylus/juillet 1721*[1]
Watermark: not visible
Inv. F I 68

Provenance: A.-C.-P. comte de Caylus, Paris; L. Bonnat,
Paris; F. Koenigs, Haarlem (L. 1023a), acquired in 1927;
D.G. van Beuningen, Rotterdam, acquired in 1940 and
donated to the Boymans Museum Foundation.

Exhibitions: Amsterdam 1929, no. 314; Rotterdam
1934-35, no. 88, fig. 14; Amsterdam 1935, no. 15 (ill.);
Paris 1937, no. 599; Rotterdam 1938, no. 374; Cologne
1939, no. 60; Paris, Brussels, Rotterdam 1949-50, no. 53,
fig. 23; Rotterdam 1952, no. 125; Paris 1952, no. 69,
fig. 20; Washington etc. 1952-53, no. 58, fig. 20; Paris,
Amsterdam 1964, no. 43, fig. 26; Amsterdam 1974,
no. 131 (ill.); Washington, Paris, Berlin 1984-85, no. 53
(ill.).

Literature: E. Dacier, "Caylus, graveur de Watteau,"
L'Amateur d'Estampes VII, January 1927, p. 55, nos. 39,
41; K.T. Parker, "Critical Catalogue, with Illustrations,
of the Drawings of Watteau in the British Museum,"
Old Master Drawings V, 1930-31, p. 24, fig. 12; Parker
1931, p. 14; A.E. Brinckmann, *J.-A. Watteau*, Vienna
1943, p. 35, fig. 86; Parker and Mathey 1957, no. 499
(ill.); Haverkamp Begemann 1957, no. 59 (ill.); Mongan
1962, no. 682 (ill.); Cormack 1970, no. 14; Posner 1984,
pp. 27, 205, fig. 19; M. Roland Michel, *Watteau: an
Artist of the Eighteenth Century*, London, Paris 1984,
p. 135, fig. 105; Zolotov *et al.* 1986, p. 111 (ill.), under
no. 36; Roland Michel 1987, p. 159, fig. 183.

Watteau has drawn two different boys, each carrying a
three-legged stool on his back, showing one from the
front and the other from the rear. He apparently
wanted to record their costume, which was presumably
a mark of their trade. The writer, engraver and
collector, the comte de Caylus (1692–1765), was an
acquaintance of the artist and the first person to acquire
the drawing. At the request of Jean de Jullienne
(1686–1766), who was likewise a friend and a collector
of Watteau's work, Caylus made separate prints of each
of the two figures (figs. b, c). Shortly after Watteau's
death, Jullienne decided to publish a large number of
his drawings as prints. The first volume appeared in
1726 entitled *Figures de différents caractères, de paysages,
et d'Études dessinées d'après nature par Antoine Watteau ...
Gravées à l'Eau forte par des plus habiles Peintres et
Graveurs du Temps tirées des plus beaux cabinets de Paris.*
The second appeared in 1728 under the same title.
The two volumes together contained some 350 etchings
after drawings by Watteau.[2] They were selected by
Jullienne, who had access to several collections of
Watteau's drawings in Paris. That belonging to Abbé
P.-M. Haranger (*c.* 1660-1735), another of Watteau's
acquaintances, was the largest, comprising over 1,100
sheets.[3] Jullienne, however, rejected Caylus's engraving
of the boy viewed from the front in favor of an
engraving by P.-C. Trémolières (1703–39) (fig. d), which
was reproduced as no. 38 in the first volume of *Figures
des différents caractères*. Caylus's engraving of the boy
seen from the back appears as no. 170 in the second
volume (fig. b). As Caylus's drawing is not indented,
both he and Trémolières must have copied the sheet
and made the engraving after the copy. A few prints
were also made of Caylus's rear-view engraving, one of
which is at the Bibliothèque National in Paris.[4] It is the
Decrotteur Mercure, referred to by Mariette,[5] and it was
possibly because Caylus had added Mercury's caduceus –
symbolizing commerce and diligence – that Jullienne
refused his engraving.

fig. a

fig. b

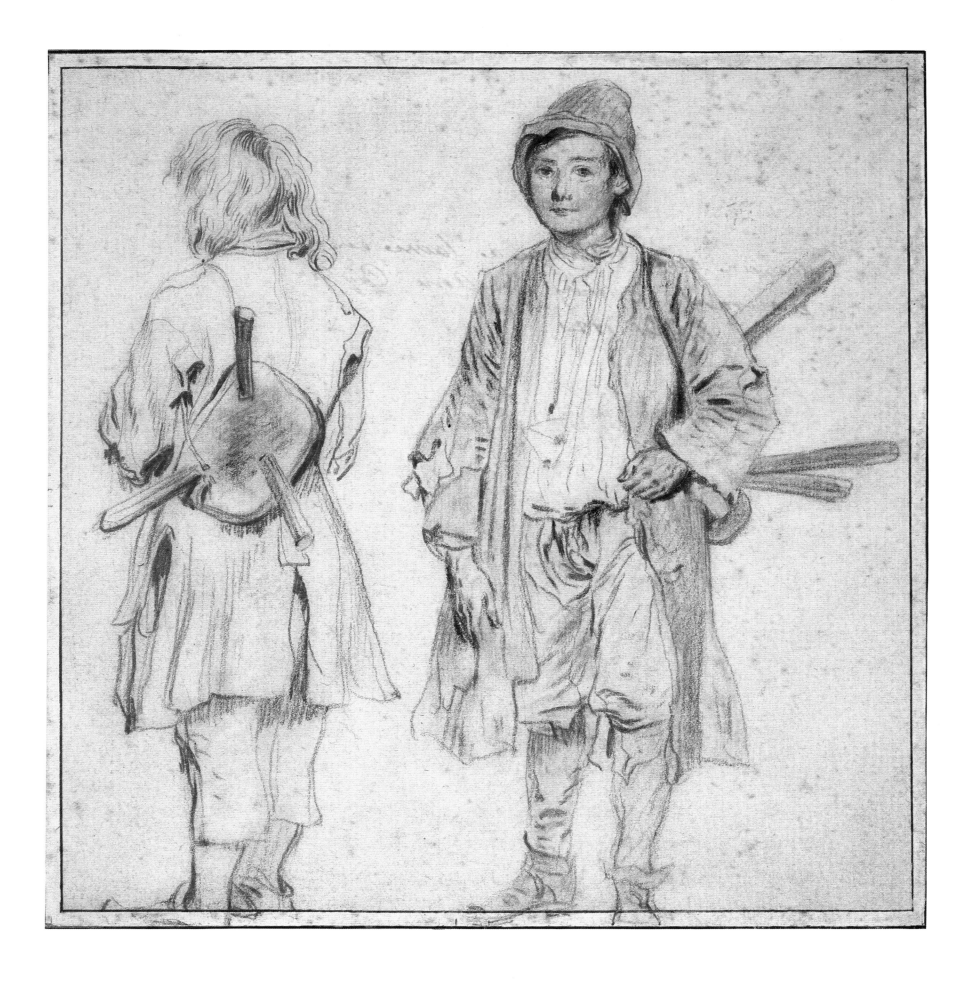

It is difficult to ascertain the boys' occupation. The literature suggests that they may have been milkboys, chimney sweeps, or bootblacks. The latter is the most closely related to the title – *décrotteur* – which was used even in the eighteenth century, for example by the connoisseur and collector P.-J. Mariette (1694–1774).[6] In modern French, the word means nothing more nor less than a shoe-cleaner. A dictionary published in Paris in 1690, however, defines *décroter* as *oster la crotte des souliers*, which is to remove dirt and mud from footwear,[7] while the entry under *décroteur* in a French dictionary from 1732 gives the meaning as *on décrote proprement les souliez* and *Appeller un décroteur*.[8] The boys were therefore not shoe cleaners as we understand the term, but earned their living by removing mud from shoes. The object (a scraper?) in the hand of the boy in both engravings appears to substantiate this hypothesis, although it does not appear in the drawing.

It has been suggested that Watteau might have made such drawings with the intention of producing a series of prints of street waifs and peddlers such as knife grinders, purveyors of hard liquor and Savoyards with their peepshows.[9] Series of this type were often known as *Cris de Paris*, an allusion to the hails of the vendors advertising their wares. The title of one such series, produced by E. Bouchardon (1698–1762) in 1737, *Études prises dans le bas peuple ou cris de Paris*, is self-explanatory. Watteau had also undoubtedly seen the series by N. Guérard (active at the beginning of the eighteenth century), which appeared in 1715 under the title *Diverses petitte Figure des Cris de Paris*.

The drawing must have been made around 1715/16.

1. The mount hides Caylus's annotation, which is only partly visible from the front. It is identical to that on the verso of a drawing in the British Museum in London (fig. a).
2. Two further volumes of prints after Watteau appeared in Paris in 1735 under the title *L'ŒUVRE GRAVÉ D'ANTOINE WATTEAU... GRAVÉ... d'après ses Tableaux & Dessiens originaux... Par le Soins de M. de Jullienne*. All four volumes are referred to as the *Recueil Jullienne*, cf. E. Dacier and A. Vuaflart, *Jean de Jullienne et les graveurs de Watteau au XVIIIe siècle*, 4 vols., Paris 1921-29.
3. See J. Baticle, "Le chanoine Haranger, ami de Watteau," *Revue de l'Art*, 1985, no. 69, pp. 55-68.
4. M. Roux, *Inventaire du fonds français: Graveurs du XVIIIe siècle*, vol. IV, Paris 1940, p. 138, no. 477.
5. See note 6.
6. In a handwritten note containing a list of Caylus's prints after Watteau, Mariette calls his two etchings after the Rotterdam drawing: *Décrotteur veu par le dos, ayant la sellette*, and *Décrotteur Mercure*; cf. Dacier (1927), p. 75.
7. A. Furetiere, *Dictionnaire universelle*, Paris 1690, ed. Paris 1978, s.v. *décrotter*.
8. P. Richelet, *Dictionnaire de la Langue françois*, vol. I, Amsterdam 1732, s.v. *Décroteur*.
9. Cf. exhib. cat. Washington, Paris, Berlin 1984-85.

AM

figs. c & d

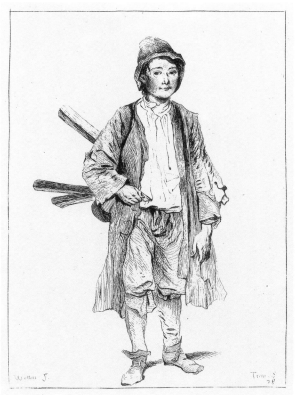
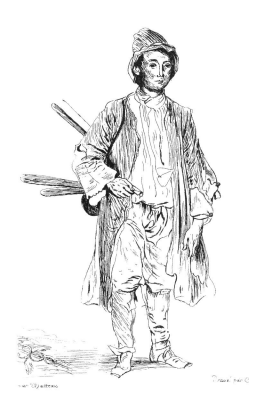

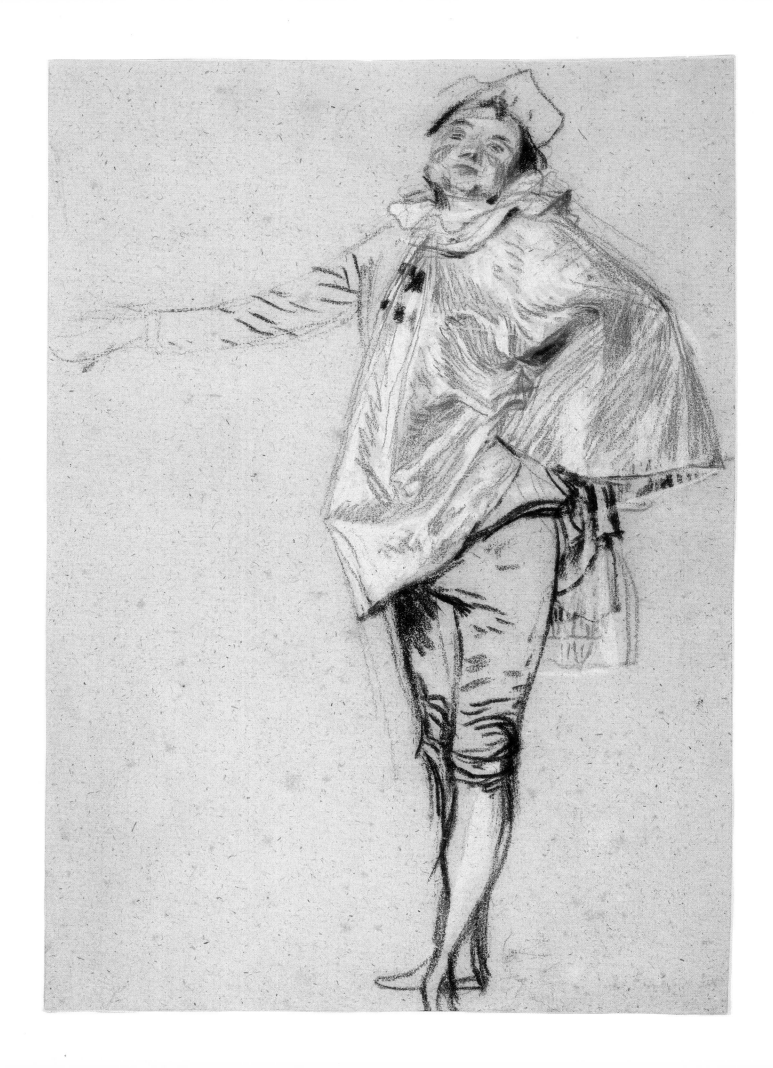

83

Jean-Antoine Watteau
Valenciennes 1684–1721 Nogent-sur-Marne
STANDING MAN WITH AN OUTSTRETCHED ARM

Red, black and white chalk, laid down; 272 × 189 mm.
Watermark: not visible
Inv. F I 281

Provenance: private collection, Lyons; M. Marignane,
Paris; G. Bourgarel, Paris; his sale, Paris, June 15-16
1922, no. 239 (ill.); N. Beets, Amsterdam; F. Koenigs,
Haarlem (L. 1023a), acquired in 1929; D.G. van
Beuningen, Rotterdam, acquired in 1940 and donated to
the Boymans Museum Foundation.

Exhibitions: Amsterdam 1929, no. 318 (ill.); Rotterdam
1934-35, no. 83, fig. 15; Amsterdam 1935, no. 2 (ill.);
Paris 1937, no. 600 (ill.); Rotterdam 1938, no. 375;
Cologne 1939, no. 50; Paris, Brussels, Rotterdam
1949-50, no. 63; Paris 1952, no. 73, fig. 12; Rotterdam
1952, no. 129; Washington etc. 1952-53, no. 64, fig. 23;
Hamburg, Cologne, Stuttgart 1958, no. 62; Paris,
Amsterdam 1964, no. 52, fig. 39; Washington, Paris,
Berlin 1984-85, no. 58 (ill.), p. 392, fig. 4.

Literature: Foerster 1930, no. 2 (ill.); Haverkamp
Begemann 1957, no. 55 (ill.); Parker and Mathey 1957,
no. 662 (ill.); Mongan 1962, no. 684 (ill.); C. Zoege von
Manteuffel, *Französische Zeichnungen. Vom 15.
Jahrhundert bis zum Klassizismus*, Hamburg 1966, fig. on
p. 69; Cormack 1970, no. 88.

It was mainly under Watteau's influence that the *fête
galante* became so popular in eighteenth-century French
painting. The official title of "*Peintre des Fêtes Galantes*,"
conferred on him upon his admission to the Académie
Royale de Peinture, is an acknowledgement of the
impact he had on the genre. *Fête galante* paintings
characteristically depict an elegant company of men and
women courting, often outdoors in a park or similar
setting, where they may be dancing, making music,
acting or engaged in conversation.

The man Watteau has portrayed here is a *danseur*,
sporting black silk pantaloons and a red silk cape.
Because of the similarity between the pose of the
danseur in this drawing and that of the figure in
Watteau's painting of *L'Indifférent* (fig. a)[1] – a title
sometimes applied to the drawing as well – the two
works have often been associated with each other.
However, the resemblance is not as strong as it seems
at first sight.

The dancer in the painting is in the fourth position,
which would be appropriate for the start of a minuet,
for example. His arms are in the corresponding
position, with the left one raised, in opposition to his
right foot, which is pointing forward, and his right arm
extended in front of the middle of his body. The man
in the drawing, however, is shown three-quarters from
the side, with his left arm under his cape and his hand
on his hip, which is not a pose in the highly formalized
repertoire of dance steps. A few *fête galante* paintings
depict *danseurs* in a pose similar to the one assumed by
the man in the drawing;[2] they are among the spectators,
however, and not actually dancing.

Watteau is known to have kept a number of theatrical
and other costumes, in which he would have friends and
acquaintances pose for him. This, at least, is what we
are told by Caylus, who also wrote that Watteau always
drew garments from a live model rather than from a
mannequin, which accounts for his realistic rendering of
drapery on the human form.[3] He made various drawings
of the costumes of his *danseurs*, examining them from
different angles. A drawing in the Louvre, for instance,
shows the costume from the side and from the front
(fig. b).[4] Another sheet, in a private collection, depicts a
danseur in a pose almost identical to the one in the
Rotterdam drawing, except that there he is seen in
three-quarter rear view (fig. c).[5] Yet another drawing of
a *danseur* could be the pendant of the Rotterdam sheet
(fig. d).[6] Watteau was thus obviously interested in the
costumes, as he had been with the two *décrotteurs* (see
cat. no. 82). He was especially meticulous in rendering
the fabrics, in this case the red silk cape which the man
has casually tossed over his shoulder. We may assume
that the cape is of silk because, according to Caylus,
it was the only material Watteau ever painted.[7]

The drawing is a fine example of the technique in
which Watteau excelled – the *manière aux trois crayons* –
a combination of red, black and white chalk, which
highlights to superb effect the differences between
the various garments.

1. Paris, Musée du Louvre; the work illustrated here is the
etching (reversed left for right) that Boucher made of the
painting for the *Figures des différents caractères*.
2. For instance, the figure at the extreme right in the painting
Les Plaisirs du bal (Dulwich, Dulwich Picture Gallery),
cf. Washington, Paris, Berlin 1984-85, no. 51 (ill.).
3. A.-C.-P. comte de Caylus, *La Vie d'Antoine Watteau*, in
P. Rosenberg (ed.), *Vies anciennes de Watteau*, Paris 1984,
pp. 78-79.
4. Parker and Mathey 1957, no. 673 (ill.).
5. Ibid., no. 680 (ill.).
6. Ibid., no. 672 (ill.).
7. See De Caylus, op. cit. (note 3), p. 74.

AM

fig. a

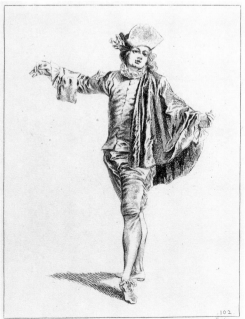

fig. b

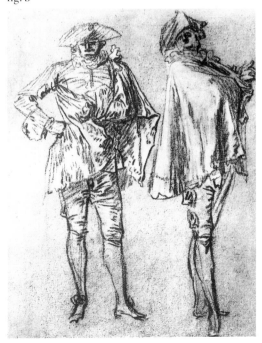

fig. c

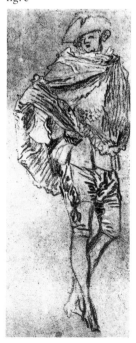

fig. d

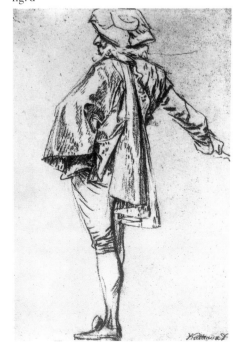

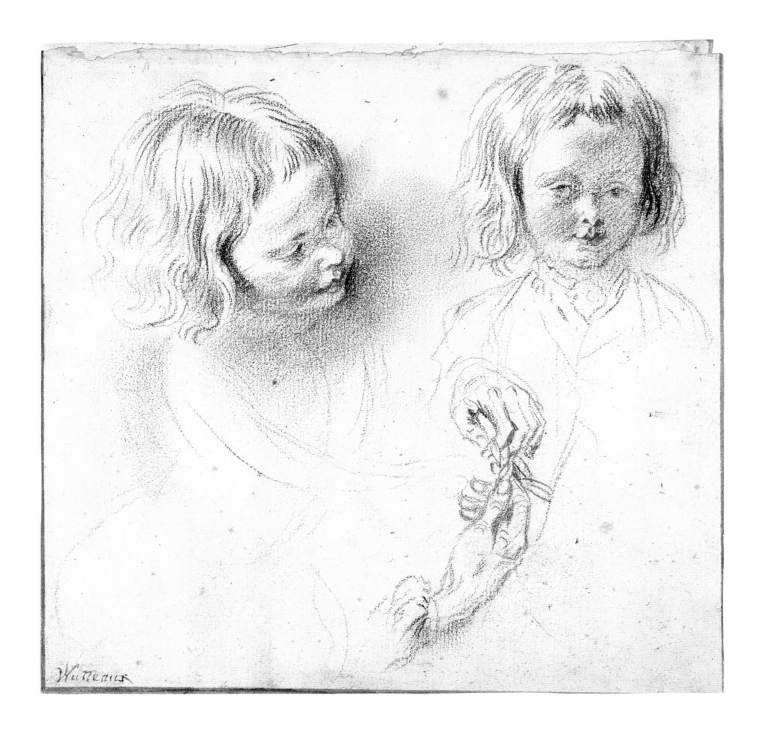

84

Jean-Antoine Watteau
Valenciennes 1684–1721 Nogent-sur-Marne
TWO STUDIES OF A BOY

Red and black chalk; 175 × 176 mm.
Annotated with the brush in gray ink: *Watteau*
No watermark
Inv. F I 49

Provenance: J.P. Tassaert, Paris, Berlin; L. Knaus, Berlin;
his sale, Berlin, October 30 1917, no. 49 (ill.);
F. Koenigs, Haarlem (L. 1023a); D.G. van Beuningen,
Rotterdam, acquired in 1940 and donated to the
Boymans Museum Foundation.

Exhibitions: Rotterdam 1934-35, no. 95, fig. XVII;
Amsterdam 1935, no. 39 (ill.); Cologne 1939, no. 56;
Paris 1952, no. 68; Rotterdam 1952, no. 124; Paris,
Amsterdam 1964, no. 53, fig. 40; Washington, Paris,
Berlin 1984-85, no. 122 (ill.), pp. 197, 440, fig. 7.

Literature: Parker and Mathey 1957, no. 702 (ill.);
M. Morgan Graselli, "New Observations on Some
Watteau Drawings," *Antoine Watteau (1684-1721):
Colloque International Paris 1984*, Paris, Geneva 1987,
p. 96, fig. 3.

fig. a

This is a preliminary study for the painting *Les
Comédiens italiens* – actors in the *Commedia dell' Arte* –
at the National Gallery of Art in Washington (fig. a).[1]
The boy is at lower left in the painting, plaiting a
garland of flowers. The face and hair have been worked
out in meticulous detail, while the right arm and the
attitude of the body are roughly outlined in black chalk.
Watteau made a separate study of the boy's hands.
A total of sixteen studies for this painting are known.
Four are composition drawings,[2] and the other twelve,
including this sheet, are studies for various elements of
the painting.[3] It is apparent from the detailed study of
the boy's hands twining flowers that Watteau made this
drawing, at least, specifically for the painting, and that
in this instance he did not use an earlier study from one
of his albums, as he generally did when composing a
picture.[4]

He produced the painting during his stay in London
from late 1719 until the end of 1720. There is little
doubt that the purpose of his visit was to consult Dr.
R. Mead (1673–1754), physician to the king of England
and one of the most eminent doctors of the day,
concerning the tubercular affliction from which he was
suffering. Mead had a large collection of paintings and
drawings,[5] and Watteau is believed to have made both
this painting and another as a token of his appreciation
for him.[6] Given the direct relationship between the
painting and the drawing, the latter must also have been
executed in London in 1720. The sheet clearly shows
the change in Watteau's style at this time. The linear
effect of his work from 1715 and the preceding period
has given way to a soft, almost *sfumato* manner which
reduces the sharp contrast between red and black chalk
and creates a more subdued effect, while the paper itself
now serves the purpose for which he had formerly used
white chalk.[7]

Watteau nevertheless seems to have relied on
drawings from his albums for some of *Les Comédiens
italiens*. The drawing in red chalk for the guitarist on
the left of the painting is one example (fig. b).[8] This
sheet, which is generally believed to date from 1713
and which he had already used for another painting,[9]
is a good example of the style which distinguished
his drawing in the years around 1715. The drawing
of an old man leaning on a stick, which is known in
a counterproof, is another example.[10] However, a study
in red and black chalks for the garland of flowers lying
on the ground in front corresponds in style to the
Rotterdam sheet.[11] This means that if the dates are
correct, Watteau would have been using two different
types of preparatory drawing towards the end of his life.

Having failed to find a cure in London, Watteau
returned to France at the end of 1720. He died of
tuberculosis the following year.

1. Samuel H. Kress Collection, exhib. cat. Washington, Paris,
Berlin 1984-85, no. 71 (ill.).
2. Parker and Mathey 1957, nos. 245v, 873-74, 876.
3. Ibid., nos. 561, 682-83, 702, 739, 768, 810, 827r and v, 830,
877, 883.
4. See cat. no. 81.
5. For Dr R. Mead see L. 1805.
6. The other was *L'Amour paisible*, which is now only known
from the engraving made of it in England by B. Baron
(1697–1762) for the *Recueil Jullienne* (see cat. no. 81, note 1), cf.
E. Dacier and A. Vuaflart, *Jean de Jullienne et les graveurs de
Watteau au XVIIIe siècle*, vol. IV, Paris 1929, fig. 268. Baron
also made the engraving after *Les Comédiens italiens*; see ibid.,
fig. 204. Mead is listed as the owner on both engravings.
7. Cf. Morgan Graselli (1987), p. 96.
8. Alençon, Musée des Beaux-Arts; Parker and Mathey 1957,
no. 810.
9. *Le Rendez-vous*, New York, Wildenstein Collection; see
M.P. Eidelberg, "Watteau's 'Le rendez-vous'," *Gazette des
Beaux-Arts* LXX, 1967, pp. 285-94, fig. 1.
10. Whereabouts unknown; Parker and Mathey 1957, no. 683.
11. London, private collection; ibid., no. 883.

AM

fig. b

85

Jean-Baptiste Pater
Valenciennes 1695–1736 Paris
STUDY SHEET WITH TWO WOMEN

Red chalk; 181 × 248 mm.
Watermark: pitcher with two ears
Inv. F I 99

Provenance: J.P. Heseltine, London (L. 1507);
F. Koenigs, Haarlem (L. 1023a), acquired in 1927;
D.G. van Beuningen, Rotterdam, acquired in 1940 and
donated to the Boymans Museum Foundation.

Exhibitions: Paris, Amsterdam 1964, no. 64, fig. 54;
Amsterdam 1974, no. 87 (ill.).

Literature: *Drawings by François Boucher, Jean-Honoré
Fragonard and Antoine Watteau in the collection
J.P.H[eseltine]*, n.p. 1900, no. 19; J. Guiraud, *Dessins de
l'école française du XVIIIe siècle provenant de la collection
J.P.H[eseltine]*, Paris 1913, no. 87 (ill.); J. Mathey, "Deux
Dessins de J.-B. Pater," *Gazette des Beaux-Arts* XXXIV,
July 1948, p. 134, fig. 2.

Jean-Baptiste Pater, together with Nicolas Lancret
(1690–1743), was the main exponent of the *fête galante*
genre popularized by Watteau. Indeed, both artists
studied under Watteau for a short time as his only
pupils. After alternating between Paris and Valenciennes
for several years, Pater finally settled in Paris in 1718.
In 1728 he was admitted to the Académie Royale de
Peinture, like Watteau, as a *"peintre des fêtes galantes"*.

Pater's style, notably in his drawings, is so similar
to Watteau's that many of his sheets were long ascribed
to the latter. This drawing is one of them, and it was
only in 1948 that Mathey recognized it as Pater's work.
Now that more drawings can be firmly attributed to
Pater, it is easier to distinguish his work from
Watteau's. The heads of Pater's figures, for instance,
are fairly small in relation to the size of the body, and
in this drawing the women's skirts billow voluminously
as though filled with air, whereas the garments on
Watteau's figures tend to cling more closely to the
contours of the body. Pater's rendering of fabric and
drapery is also different. He conveys the texture of silk,
for example, by means of parallel hatching.

There is little doubt that Pater adopted the same
manner of working as Watteau. Numerous sheets are
known by him which, like Watteau's, were obviously
drawn from models rather than an inanimate
mannequin. He too kept them in sketchbooks and used
them, sometimes with slight modifications, to compose
his paintings. As a result, many of the same studies
appear in more than one picture. The motif of a young
woman on a swing, like the one on the left of this
sheet, was borrowed from Watteau, who had introduced
it as an element in the eighteenth-century *fête galante*
(fig. a).[1] We are continually meeting her in the work of
both Pater and Lancret, as in Pater's *La Balançoire* in
the Louvre (fig. b),[2] and in an identical piece by him
which was auctioned in London in 1976.[3] The woman
leaning forward on the right appears in the lower right
corner of *Le Bain rustique*, which was formerly in the
Arenberg Collection in Brussels.[4] Pater's lifelong
commitment to Watteau's example makes his drawings
difficult to date.

1. Etching by L. Cars (1699–1771) after Watteau, *Figures des
différents caractères*, pl. 340. For the motif of a young woman on
a swing see D. Posner, "The Swinging Women of Watteau
and Fragonard," *Art Bulletin* LXIV, 1982, pp. 75-88.
2. See F. Ingersoll-Smouse, *Pater*, Paris 1921, no. 277bis,
fig. 76.
3. Formerly in the Digby Collection, London; sale London
(Christie's), November 26 1976, no. 19 (ill.).
4. Cf. Ingersoll-Smouse, op. cit. (note 2), no. 311, fig. 86.

AM

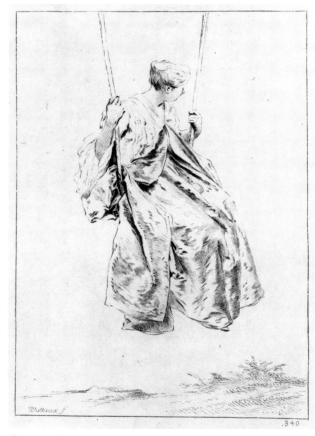

fig. a

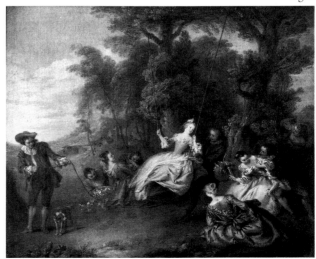

fig. b

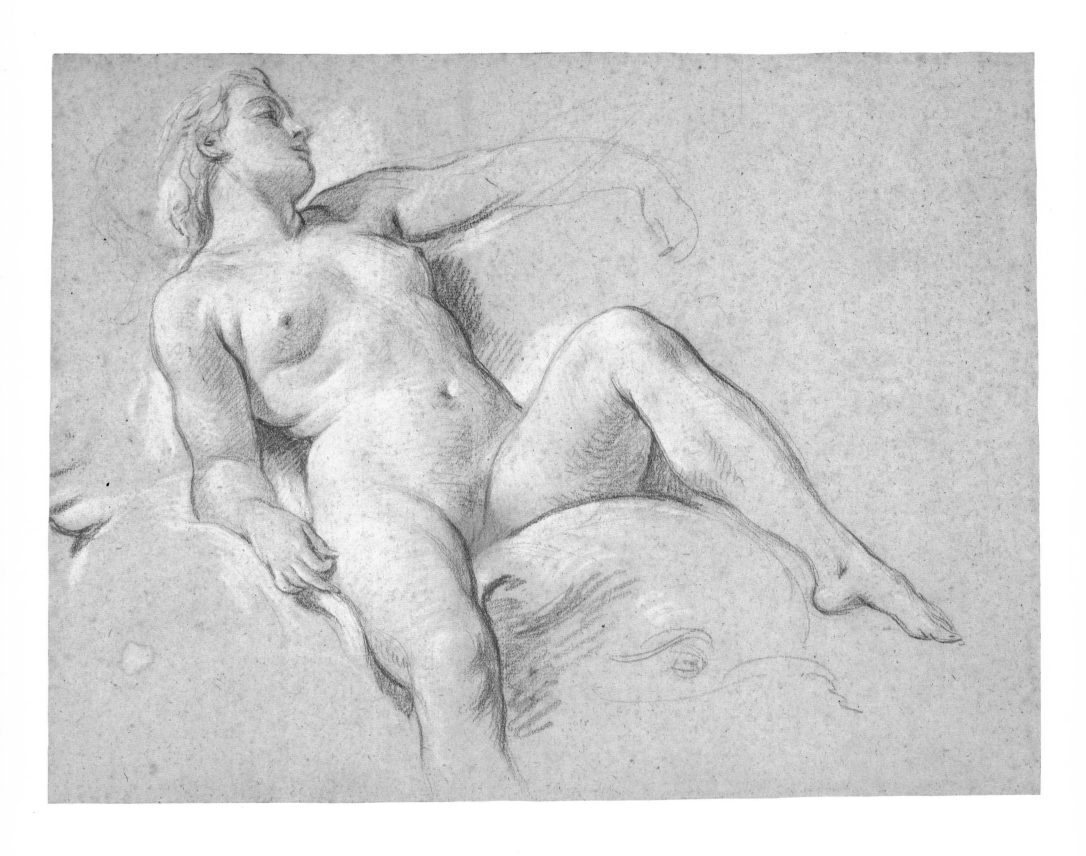

86

François Boucher
Paris 1703–1770 Paris
WOMAN ON A DOLPHIN

Red chalk, heightened with white, on coarse
cream-colored paper; 307 × 390 mm.
Illegible watermark
Inv. F I 243

Provenance: J.W. Böhler, Lucerne; F. Koenigs, Haarlem
(L. 1023a), acquired in 1929; D.G. van Beuningen,
Rotterdam, acquired in 1940 and donated to the
Boymans Museum Foundation.

Exhibitions: Amsterdam 1974, no. 12 (ill.).

Not otherwise published

In 1731 Boucher left Rome, where he had previously
spent four years after winning the Prix de Rome for
painting in 1723, to return to Paris. He was accepted by
the Académie Royale as *peintre d'histoire* in 1734, and
appointed professor of painting in 1737. The work he
had produced in the years before his departure for
Rome included etchings after a large number of
drawings by Watteau, which Jullienne had
commissioned for his publication of *Figures des différents
caractères*. The drawings were collected by a few
connoisseurs both during Watteau's lifetime and after
his death.[1] The two volumes of *Figures des différents
caractères* appeared in 1726 and 1728, with Boucher
contributing about 120 of the 350 prints. The collection
of Watteau's drawings published in print prompted a
small circle of connoisseurs and amateurs to start
collecting drawings by contemporary artists, thus setting
a trend that was taken up by a much wider public later
in the century. Moreover, from the early 1740s a
number of artists, including Boucher, began exhibiting
drawings as well as paintings at the annual Salons.
Drawings were also coming to be regarded less as an
intermediate stage in the creation of a painting, and
acquired a value of their own as wall decorations.
Since originals were of course quite rare and costly,
the reproduction of prints after Boucher's drawings
developed into a flourishing industry in France in the
second half of the eighteenth century. This is not to say
that Boucher's drawings ceased to be preliminary studies
for his paintings; nevertheless he was now increasingly
making them with a view to their reproduction. In
other words, his drawings gradually evolved into works
of art in their own right. Mounted in decorative
passepartouts and beautifully framed, both originals and
prints became fashionable wall decorations.[2]

However, this was only after the 1730s, and around
that time, Boucher made a number of informal studies
of female nudes, including this one of a woman on a
dolphin. He applied the same technique in nearly all of
them, using red and white chalk on the same brownish
paper as this sheet. Several of these studies can be
traced in his paintings.

The drawing must have been made as a true study
from a model posing in Boucher's studio. This is
apparent from his experiments with the position of her
left arm, which he never in fact completed. On the left
of the sheet he made a separate drawing of the left side
of her body, examining the folds of her skin when she
was seated. Her hair, too, was left unfinished. The
dolphin's head, which he has drawn under her straddled
legs, makes the woman a naiad. Similar water nymphs
appear in several of Boucher's paintings, such as the
Birth of Venus from the early 1730s and the *Triumph of
Venus* of 1740.[3] The drawing may therefore have been
made as a study for such a painting, although none of
them contains this particular naiad. The erotic element
in nude studies of this type was toned down in the
actual painting.

1. See cat. no. 82.
2. For this aspect of Boucher's work, and for the altered
perception of drawings in France in the second half of the
eighteenth century, see B. Schreiber Jacoby, "François
Boucher's Stylistic Development as a Draftsman: the Evolution
of his Autonomous Drawings," in W. Strauss and T. Felker
(eds.), *Drawings Defined*, New York 1987, pp. 259-79.
3. The present whereabouts of the *Birth of Venus* are
unknown; cf. A. Ananoff and D. Wildenstein, *François Boucher:
peintures*, vol. I, Lausanne, Paris 1976, no. 177 (ill.); the
Triumph of Venus is in Stockholm, Nationalmuseum, ibid.,
no. 178 (ill.).

AM

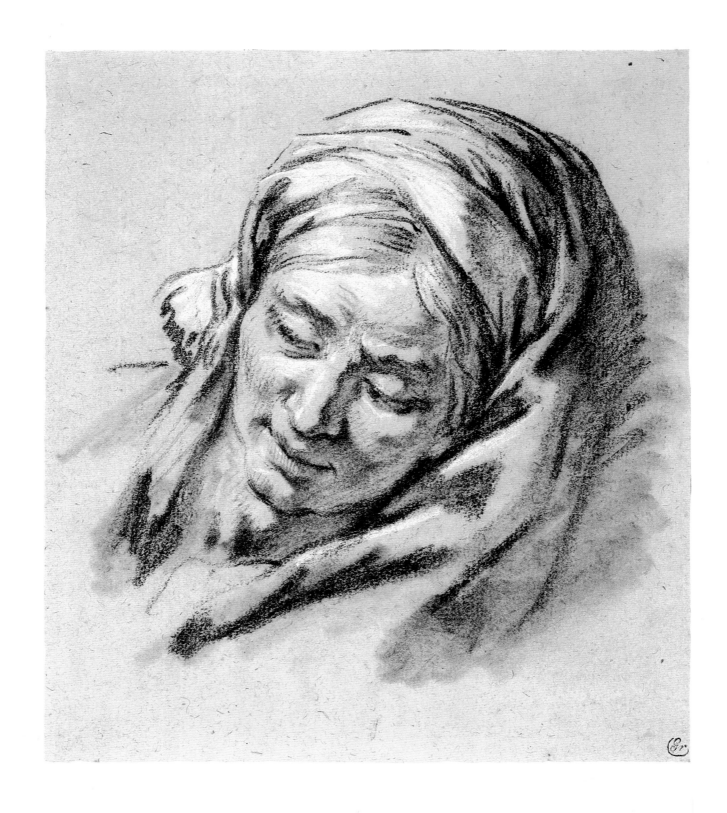

87

François Boucher
Paris 1703–1770 Paris
HEAD OF AN OLD WOMAN

Black, red and white chalk, on buff paper;
201 × 176 mm.
No watermark
Inv. F I 34

Provenance: Madame Blondel d'Azaincourt, Paris;[1]
A. Grahl, Dresden (L. 1199); his sale, London, April 27
1885, no. 34; anonymous sale, London, October 7-12
1920, no. 384; F. Koenigs, Haarlem (L. 1023a), acquired
in 1927; D.G. van Beuningen, Rotterdam, acquired in
1940 and donated to the Boymans Museum Foundation.

Not previously exhibited

Literature: A. Ananoff and D. Wildenstein, *François
Boucher: peintures*, vol. II, Lausanne, Paris 1976,
no. 340/6, fig. 983; exhib. cat. *François Boucher*, Paris,
Galeries Nationales du Grand Palais, 1986-87, p. 43,
and under no. 57, fig. 163.

fig. a

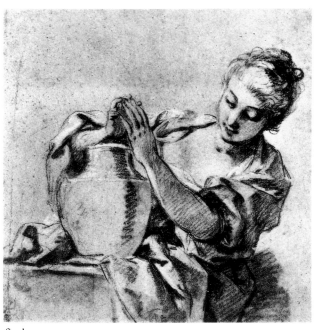

In or around 1748, Jeanne-Antoinette Le Normant
d'Etiole-Poisson, better known as Madame de
Pompadour (1721–64), commissioned Boucher to make
an altarpiece for the small chapel in her castle at
Bellevue, to the southwest of Paris on the road to
Versailles. Madame de Pompadour had been Louis XV's
official mistress since 1745, and the castle at Bellevue
was her retreat from the bustle of life at court. Boucher
exhibited the *modello*, which has since been lost,[2] at the
Salon in 1748, while the altarpiece itself was completed
in 1750 (fig. a).[3] It is an adoration of the Christ Child
by Mary and various other figures, who, as has been
suggested, represent the ages of man.[4] Christ is depicted
in accordance with St John's gospel as the light of the
world,[5] and the engraving that Etienne Fessard
(1714–77) made in 1761 after Boucher's painting was
in fact entitled *La Lumière du Monde*.[6]

The commission marked the beginning of a long
friendship between the artist and Madame de
Pompadour. Boucher gave her lessons in drawing and
engraving and received numerous commissions both
from her personally and from her circle of
acquaintances.

The woman in the drawing also appears in the
painting, with her hands clasped over a milk canister.
The hands, however, were taken from another drawing
in red and white chalk of a younger woman whose
hands are joined over an urn (fig. b).[7]

The drawing was produced in print by Gilles
Demarteau (1722–76) when the sheet was still in the
Blondel d'Azaincourt Collection (fig. c). D'Azaincourt
and his wife had collected some 500 drawings by
Boucher, more than half of which were engraved and
published by Demarteau. His print after this drawing
has a background of dense hatching, which heightens
the monumental effect. The print was rendered in
the crayon manner, which Jean-Charles François
(1717–69) invented round the middle of the century.
The technique employs a variety of instruments and red
or black ink to imitate as faithfully as possible the
effect of red or black chalk on paper. However, it was
Demarteau, who had been established in Paris as an
independent graphic artist and publisher since 1755,
who developed the technique and realized its full
commercial potential. In 1767, he also succeeded in
producing facsimiles of drawings in three different
colors of chalk – red, black and white – in which the
paper itself served as the white. In the same year, he
presented a series of five prints after Boucher to the
Académie, one of which was the head of the woman in
this drawing.[8] The other four were likewise of heads,
one of an old man and three of young women.
Drawings of this type, known as *têtes de caractère*, or
character heads, were part of the basic curriculum at art
academies in the eighteenth century, and they too were
used as wall decorations, either in the original or in
print. Listed as numbers 95-106 in the inventory of the
Abbé Saint-Non's estate from 1792, which is referred to
in cat. no. 91 were twelve prints in gilt frames, two of
which were *têtes de caractère*.[9]

1. According to the annotation on Demarteau's print (fig. c).
2. Cf. Ananoff and Wildenstein (1976), no. 339.
3. Ibid., no. 340 (ill.); Lyons, Musée des Beaux-Arts.
4. See exhib. cat. Paris (1986-87), p. 246.
5. John 1:9 and 8:12.
6. Reproduced in Ananoff and Wildenstein (1976), no. 340/2,
fig. 991.
7. Vienna, Graphische Sammlung Albertina.
8. Cf. P. Jean-Richard, *L'Oeuvre gravé de François Boucher dans
la Collection Edmond de Rothschild* (Inventaire général des
gravures. Ecole française I), Paris 1978, nos. 719-23 (ill.).
9. Cf. G. Wildenstein, "L'abbé de Saint-Non, artiste et
mécène," *Gazette des Beaux-Arts* LIV, 1959, p. 241.

AM

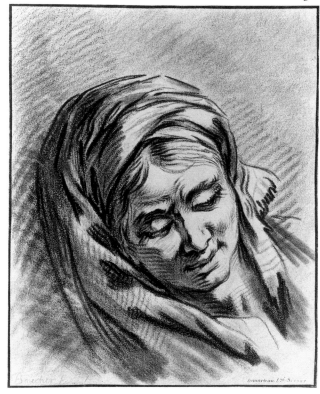

fig. b

fig. c

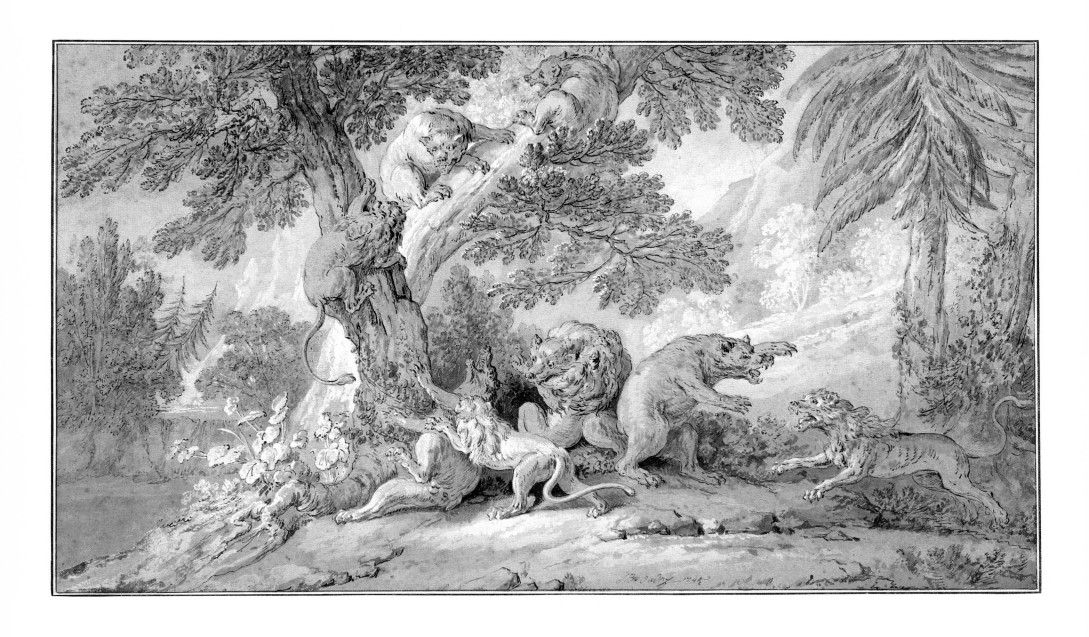

88

Jean-Baptiste Oudry
Paris 1686–1755 Beauvais
LIONS AND BEARS FIGHTING

Pen and black and brown ink, brush in gray and white,
gray wash, heightened with white, over black chalk, on
blue paper; 315 × 540 mm.
Signed and dated in pen and brown ink: *JB. Oudry 1745*
Watermark: fleur de lis
Inv. MB 342

Provenance: J.B. de Graaf, Amsterdam (?) (L. 1120);[1]
J.H.J. Mellaart, London; donated to the Boymans
Museum in 1922.

Exhibitions: Paris 1982-83, no. 109 (ill.).

Literature: *Jaarverslag Museum Boymans*, Rotterdam
1922, p. 3; H.N. Opperman, "Oudry aux Gobelins,"
Revue de l'Art XXII, 1973, p. 61, no. 12, fig. 1;
H.N. Opperman, *Jean-Baptiste Oudry*, (diss. Chicago
1972), New York, London 1977, vol. II, cat. no. D 644,
fig. 327.

The most important project that Oudry undertook in
his career as an artist was Louis XV's commission to
design a number of tapestries on the theme of the
Chasses royales de Louis XV. He received the assignment
in 1733, having gained a reputation as a painter of
animal pieces and hunting scenes. The large canvas
of Louis XV on a deer hunt, which dates from 1730,
was widely acclaimed in the eighteenth and nineteenth
centuries and is a good example of his work in this
genre.[2] In 1728, the king had commanded Oudry to
accompany him and his party on some of their hunts,
so that he could make drawings of the events. Two
years previously, he had been appointed *peintre ordinaire
des chasses du roi* and *peintre officiel des tapisseries de
Beauvais*. In 1734, he became director of the
Manufacture de Beauvais, with a contract for twenty
years. He was also responsible for supervising the
weaving of the *Chasses royales*. This series of tapestries
was woven at the Manufactures des Gobelins, which,
unlike the more or less independent atelier at Beauvais,
worked exclusively on royal commission. The tapestries
were intended for the royal chambers at the castle of
Compiègne, Louis XV's hunting lodge. Although he
had originally intended to have three tapestries made,
in the end he ordered a total of nine.
Oudry's work as the designer of the *Chasses royales*
involved making drawings, then oil sketches, and finally
a cartoon – which in this case was actually an oil
painting. At this point, work on the tapestry itself could
begin. The first was completed in 1736 and the last in
1750. Oudry's final oil sketch for the *Chasses royales* is
dated 1745 – the year in which he started a series of
drawings of various animals fighting. With the end of

the *Chasses royales* series in sight, he was apparently
preparing to embark on a new project. In 1751, a year
after the first series of tapestries was completed, but
three years before his contract was due to expire, he
submitted a proposal to the director of the Bâtiment du
Roi, suggesting that he make a number of paintings to
be produced as another series of tapestries on the theme
of "*combats de différents animaux*." He enclosed a list of
twelve subjects, and Opperman, much to his credit, has
managed to identify all but three of the corresponding
drawings. Their whereabouts in some cases are known,
while others have been mentioned in auction catalogues
or in the literature.[3]
All the drawings associated with this project are dated
1745; they were executed in the same technique and on
blue paper of the same large format. Moreover, Oudry
produced several versions of the different scenes of
animals locked in combat. The fight between bears and
lions illustrated in this drawing was number nine on his
list. Another version of a confrontation between bears
and lions was once in a private collection (fig. a).[4]
The tapestry project, however, was never carried out.

1. The small stamp at lower right on the old mount, which
has now been removed, matches the collector's mark of J.B. de
Graaf (1742–1804), L. 1120. It is not inconceivable, of course,
that it was affixed by the frame-maker J.B. Glomy (second half
of the eighteenth century), but that would mean he was using
a different mark from L. 1119.
2. Toulouse, Musée des Augustins; exhib. cat. Paris 1982-83,
no. 59 (ill.).
3. Opperman (1973), p. 59.
4. Formerly in the collection of E. Wolf, New York.

AM

fig. a

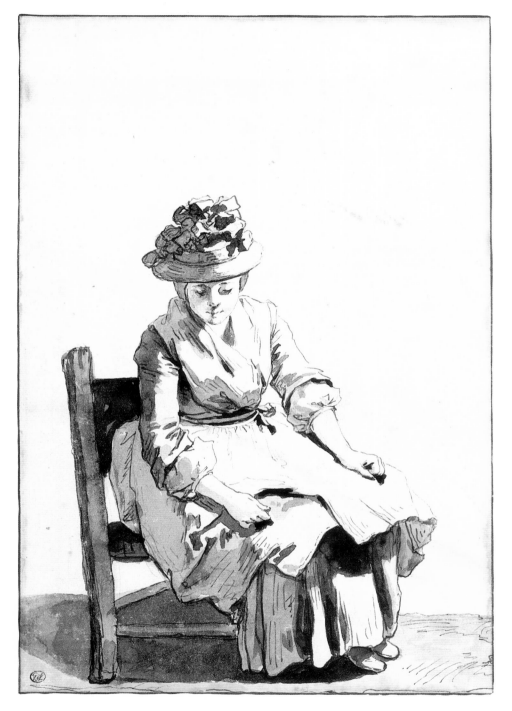

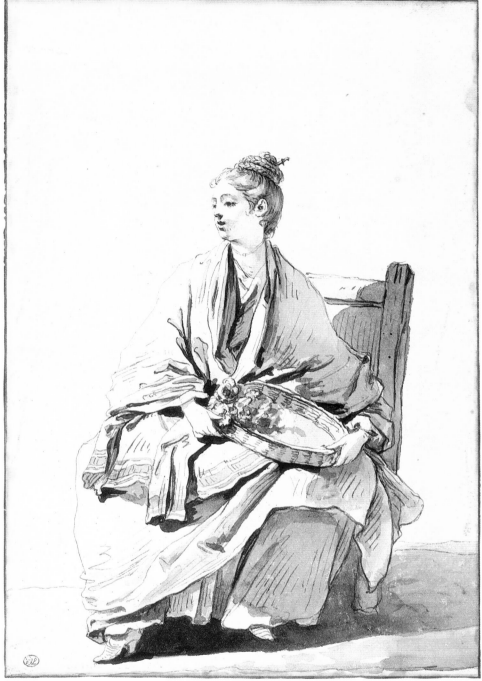

89

Jean-Baptiste Greuze
Tournus 1725–1805 Paris
PARMESAN PEASANT WOMAN

Pen and gray ink, gray wash, over black chalk;
202 × 135 mm.
Verso, in pencil: *9*
Signed and dated in pen and brown ink on the old
passepartout: *Greuze f. 1755 Parmeggiana*
Greuze f. 1755
Watermark: fleur de lis (partly visible)
Inv. F I 204

GENOESE FLOWER SELLER

Pen and gray ink, gray wash, over black chalk;
202 × 135 mm.
Verso, in pencil: *7*
Signed and dated in pen and brown ink on the old
passepartout: *Greuze f. 1755 Parmeggiana*
Donna Genovese col mezzo calato che vende fiori (Genoese
woman with a shawl over her shoulders, selling flowers)
No watermark
Inv. F I 205

Provenance: L. Gougenot, Paris;[1] Randon de Boisset,
Paris; his sale, Paris, February 27-March 25 1777, in lot
no. 376; Vasal de Saint-Hubert, Paris; his sale, Paris,
March 29-April 13 1779, in lot no. 164, and Paris, April
24-May 5 1783, no. 159; L. Coblenz, Paris, his sale,
Paris, March 13-14 1908, no. 48; G. Lasquin, Paris
(L. 1139a); his sale, Paris, June 7-9 1928, no. 85;
F. Koenigs, Haarlem (L. 1023a); D.G. van Beuningen,
Rotterdam, acquired in 1940 and donated to the
Boymans Museum Foundation.

Exhibitions: Hartford etc. 1976-77, nos. 7, 8 (ill.).

Not otherwise published

The young Greuze, originally from Tournus in
Burgundy and since 1750 a pupil at the Académie in
Paris, enjoyed a huge success at the 1755 Salon de Mai.
Not only were three of the nine paintings he had
entered sold immediately, but his work was highly
acclaimed by the critics. In the same year, Abbé Louis
Gougenot (1719–67) was preparing for a journey to
Italy with a confrère. Gougenot was one of many abbés
in Paris without official duties, who nevertheless enjoyed
an income from the proceeds of the abbey to which
they were attached. They were given the title of *abbé
commendataire*.[2] Gougenot was *abbé commendataire* of the
abbey of Saint Benoît near Chezal-Benoît, a small
village south of Bourges.

Shortly before the two men were due to leave for
Italy, Gougenot's companion changed his plans and
decided not to make the journey. "At the point when
all my plans seemed set at naught by this setback,
I suggested to the young painter Greuze, who had
been received with great praise by the Académie, that
he should accompany me, entirely at my expense,"
Gougenot noted in the diary he kept during the
journey.[3] Greuze and Gougenot left Paris in September
1755 and arrived in Rome in January of the following
year. Although Gougenot returned to Paris in May
1756, Greuze was to remain in Rome until the summer
of 1757.

On the way to Rome, Greuze, like many other artists
who visited Italy, drew illustrations of the local and
regional costumes he saw en route. Pieter Lastman
(*c.* 1583-1633), for example, made drawings of this type
at the beginning of the seventeenth century (fig. a),
as did Nicolas Vleughels (1668–1737) in the 1730s.

fig. a

Contadina di Lombardia
7

Vleughels produced a series of six paintings of women in the traditional costumes worn in the environs of Rome, which Edme Jeaurat (1688–1738) engraved in 1734.[4] Greuze's drawings can be dated with considerable accuracy from the detailed information in Gougenot's journal and the notes on the original passepartouts indicating where they were made. The Genoese flower seller was drawn between October 30 and November 4 1755, which the journal gives as the day they returned from a visit to Genoa. Gougenot also describes the women in some detail, remarking on the long, silk *mezzi* with which they covered their heads and shoulders, and which Bergeret was later to write about in the most disparaging terms, referring to them in his journal as "*fort vilain*"–exceedingly ugly.[5] The drawing of the peasant woman from Parma was made during a brief visit to the town between November 6 and 9 1755.

The costume studies Greuze made in Italy remained in Gougenot's possession until the *abbé's* death in 1767. A year later, an album of twenty-four engravings was published in Paris under the title *Divers Habillements suivant le costume d'Italie. Dessinées d'après nature par J.B. Greuze... ornés de fonds par J.B. Lallemand et gravés d'après les desseins tirés du cabinet de M. l'abbé Gougenot.* The two drawings reproduced here appear in the engravings numbered 7 and 9 (figs. b, c). Jean-Baptiste Lallemand (1716–1803) placed the Genoese flower seller – quite oddly – in a vast, desolate arcade; the Parmesan peasant appears against the rather more appropriate background of a farmhouse kitchen. Lallemand probably copied Greuze's drawings and added the background subsequently. He seems not to have used the original drawings for the engravings as there is no trace of indentation on them. There are also various discrepancies between the figures in the prints and those in the drawings. The album of Italian regional costumes after the drawings by Greuze was published by Pierre-Etienne Moitte (1722–80) who, in association with some of his children, produced prints of Lallemand's copies of the drawings.[6] The title page of *Divers Habillements* is in fact somewhat misleading, as it suggests that all twenty-four engravings were based on Greuze's drawings, whereas numbers 11, 22 and 23 are engravings after paintings by other artists. For numbers 11 and 22, Lallemand made drawings after two considerably earlier paintings by Jean Barbault (c. 1705-1766), while number 23 was based on a picture from Nicolas Vleughels's series of six women from the region around Rome. The painting in question is of a young woman from Frascati in a landscape with a farmhouse in the background.[7] In Lallemand's drawing, which was intended for one of the Moittes to make an engraving for *Divers Habillements*, the landscape has been replaced by a church interior. We can assume that Moitte needed Lallemand's three drawings after paintings by Barbault and Vleughels to fill the last quire of the album, half of which would otherwise have remained blank, as Greuze had made only twenty-one of these costume drawings. This is borne out by the fact that on each occasion when the drawings were auctioned between the time of Gougenot's death and 1783, they are listed as a single lot of twenty drawings by Greuze for *Divers Habillements*.[8] The missing sheet evidently disappeared from Gougenot's cabinet very early on, possibly even while he was still alive, and only finally emerged at an auction in 1922.[9] At present only four of the original twenty-one sheets are known. Two are in the Boymans-van Beuningen Museum, and two in the Metropolitan Museum in New York.[10] The whereabouts of the remaining seventeen are unknown.

1. According to the text on the title page of the *Divers Habillements*.
2. Of the 750 or so monasteries, 650 were administered by deputy abbots acting in the name of the *commendataires*; see P. Lacroix, *XVIIIe siècle: institutions, usages et costumes*, Paris 1885, p. 143.
3. L. Gougenot, *Album de voyage en Italie*, De Soucy manuscript collection, Paris, vol. I, p. 141; here quoted from exhib. cat. Hartford etc. 1976-77, p. 52: "*Sur le point donc de rompre tous mes projets pour ce contre temps, je proposai à M. Greuze jeune peintre... qui venoit d'être reçu avec applaudissement à l'Académie de m'accompagner en le défrayant tout pendant le voyage.*"
4. See note 7.
5. See Bergeret de Grancourt, *Voyage d'Italie 1773-1774*, ed. J. Wilhelm, Paris 1948, p. 41. See also the next cat. no.
6. See Thieme-Becker, vol. XXV, pp. 24-25.
7. New York, private collection; see B. Hercenberg, *Nicolas Vleughels*, Paris 1975, cat. no. 124, fig. 137.
8. See exhib. cat. Hartford etc. 1976-77, under the provenance for no. 7.
9. De Varennes Collection, sale Paris, May 12 1922, no. 102.
10. See J. Bean, *15th-18th Century French Drawings in the Metropolitan Museum of Art*, New York 1986, nos. 123-24 (ill.).

AM

fig. b

fig. c

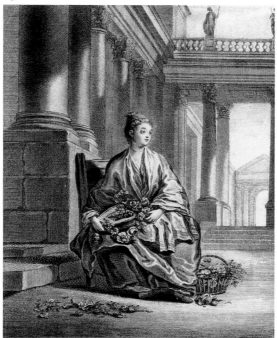

90

Hubert Robert
Paris 1733–1808 Paris
THE ARCH OF GALLIENUS IN ROME

Red chalk; 465 × 630 mm.
Verso: THE CAVE OF THE NYMPH EGERIA
Black chalk, counterproof; 330 × 450 mm. (image size; fig. d)
Illegible watermark
Inv. F I 78

Provenance: C. Morin, Paris (L. 597); his sale, Paris, March 19 1924, no. 54 (ill.); F. Koenigs, Haarlem (L. 1023a), acquired in 1925; D.G. van Beuningen, Rotterdam, acquired in 1940 and donated to the Boymans Museum Foundation.

Exhibitions: Amsterdam 1929, no. 204 (ill.); Rotterdam 1934-35, no. 65; Paris, Brussels, Rotterdam 1949-50, no. 83; Bern 1954, no. 47, fig. XII; Besançon 1956, no. 49, fig. XIX; Rome 1961, no. 141; Paris, Amsterdam 1964, no. 119, fig. 100; Amsterdam 1974, no. 95 (ill.); Bremen 1977, no. 190 (ill.).

Literature: Fosca 1954, p. 55 (ill.); Réau 1956, p. 216; Ananoff 1961-70, vol. III, no. 1492; P. Schneider, *The World of Watteau*, New York 1967, p. 171; Lemeyrie, Monnier and Rose 1979, p. 179 (ill.).

fig. a

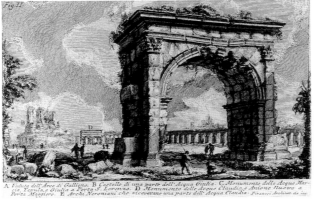

fig. b

In 1754 Hubert Robert traveled to Italy in the company of the comte de Stainville (1719–85), the later duc de Choiseul-Amboise. A year earlier, Stainville, a French statesman and a favorite of Madame de Pompadour, had been appointed ambassador to the Vatican. Robert's father was attached to the household of the marquis de Stainville, the comte's father and the duc de Lorraine's envoy to the French court. In Rome, where the two men arrived at the end of 1754, Stainville used his influence to assist Robert, and his association with Natoire, the director of the Académie de France, secured Robert's admission as a *pensionnaire*, despite his not having been a pupil at the Académie de Peinture in Paris.[1] Hubert Robert was to remain in Rome for eleven years before settling in Paris as an independent artist.

He soon established a close friendship with the *pensionnaire* Fragonard, who arrived in Rome in 1756, and the two men frequently made excursions together to draw Roman and other architectural structures in the city and its surroundings. Robert's stay in Rome was to have a lasting effect on his career as an artist. His name appears in the deaths register for the first *arrondissement* in Paris as "*Robert, dit Robert des Ruines.*"[2] Although he mastered a wide range of genres, he is best known for his drawings of Roman buildings and ruins, and for paintings which incorporate them.

The high office which his patron Stainville held in Rome brought Robert into contact with the Abbé de Saint-Non. In 1760 they traveled to Naples together to visit the excavations near Herculaneum and, above all, to draw.

For a long time, it was uncertain which arch Robert had depicted here – those of both Hadrian and Gallienus being considered possibilities.[3] However, comparison with an engraving of the Arch of Gallienus which Piranesi (1720–78) made in the 1750s removes all doubt (fig. a).[4] The Arch of Gallienus is not a triumphal arch like that of Constantine, for example, but was erected during the reign of Emperor Augustus (63 B.C.– 14 A.D.) as a city gate with three entrances (fig. b).[5] In the third century, a citizen of Rome dedicated the surviving central passage to Emperor Gallienus (218–268). Today, the Arch of Gallienus in Via di S. Vito near S. Maria Maggiore is still in reasonably good condition (fig. c).[6]

Hubert Robert's drawing of the arch is one of the largest he produced in Rome. Moreover, it is rare to find a sheet with the deckle edges intact, as they were frequently trimmed off.

Robert's rendering of the arch is extremely true to life, although he embellished it by adding houses on the right and a well to the left, from which a washerwoman is about to draw water. Washerwomen frequently appear as staffage in his work, and were probably intended to highlight the contrast between the monuments of antiquity and the concerns of everyday life.[7] The relief on the interior surface of the arch and the obelisk in the background are also Robert's additions.

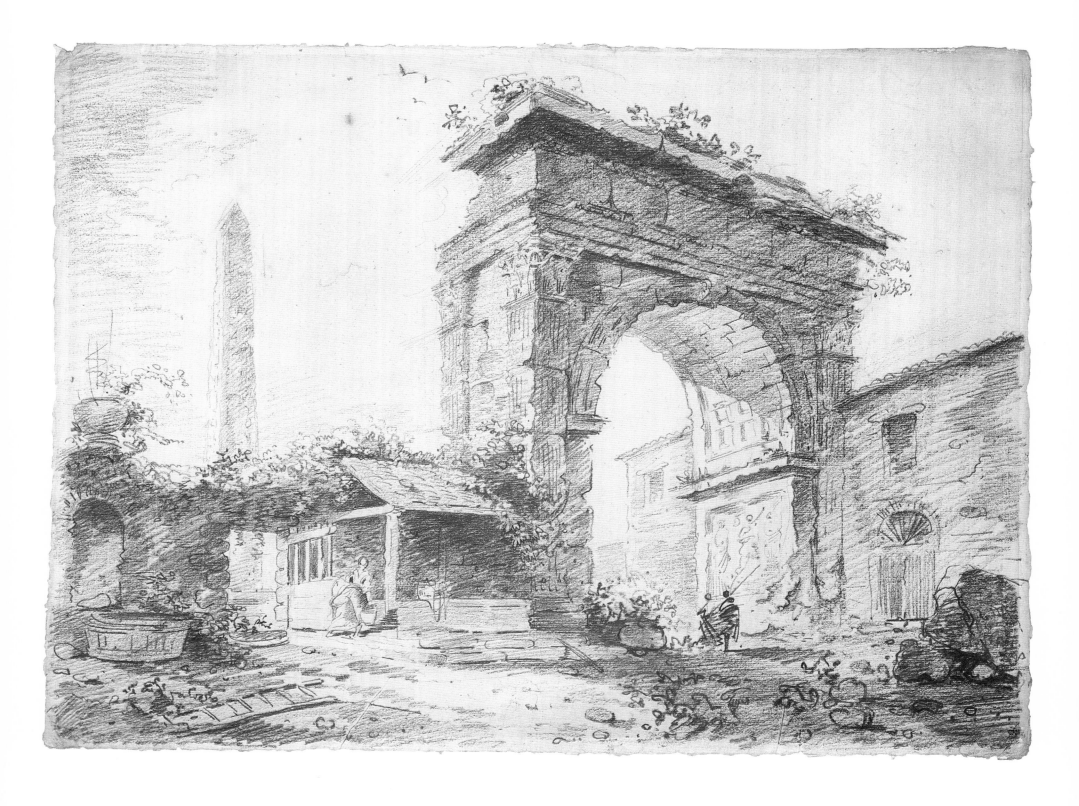

The counterproof on the verso shows a large vaulted ruin with a spring to the left and a pond with people fishing in the center. It is known as the "Cave with the Spring of the Nymph Egeria," seen from the interior looking out. Piranesi's 1756 engraving of the nymphaeum shows it from the outside looking in (fig. e).[8] The distinctive protrusions and niches in the side wall, as well as the water basin, are easy to identify. What in the seventeenth and eighteenth centuries was taken to be the cave of Egeria the nymph is in fact a nymphaeum which formed part of the villa complex built by the wealthy Roman senator and writer Herodes Atticus (101–177) near the Via Appia at the foot of the Alban Hills to the south of Rome.[9] The real cave of Egeria is in a different place altogether. Whether Hubert Robert also produced the original from which this counterproof was made seems likely, although it has never been firmly established.

Just as some of Fragonard's Roman drawings were mistaken for Robert's, the reverse was likewise the case. At the auction of the Morin Collection in 1924, this sheet was ascribed to Fragonard. In the Koenigs Collection it was initially listed as a Robert, only to be reattributed to Fragonard later. It continued to be accepted as a Fragonard until Cailleux firmly attributed it to Hubert Robert in 1963 and dated the sheet 1760-63.[10] This attribution is now generally accepted.

1. See V. Carlson in exhib. cat. *Hubert Robert: Drawings and Watercolors*, Washington, National Gallery of Art, 1978, p. 18.
2. See P. Sentenac, *Hubert Robert*, Paris 1929, p. 26.
3. P. Schatborn in exhib. cat. Amsterdam 1974.
4. G.B. Piranesi, *Le Antichità romane*, vol. I, Rome 1756; cf. H. Focillon, *Giovanni Battista Piranesi*, a cura di M. Calvesi, A. Monferini, Paris 1963, no. 194 (ill.).
5. Reconstruction drawing by G. Gatti in E. Nash, *Bildlexikon zur Topographie des antiken Rom*, vol. I, Tübingen 1961, p. 115, fig. 119.
6. Ibid., p. 116, fig. 120.
7. H. Burda, *Die Ruine in den Bildern Hubert Roberts*, Munich 1967, p. 75.
8. G.B. Piranesi, *Le Vedute di Roma*, vol. I, Rome 1748; cf. Focillon, op. cit. (note 4), no. 782 (ill.).
9. Cf. R. Keaveny, *Views of Rome from the Thomas Ashley Collection in the Vatican Library*, London 1988, p. 210.
10. Letter dated June 10 1963.

AM

fig. d

fig. c

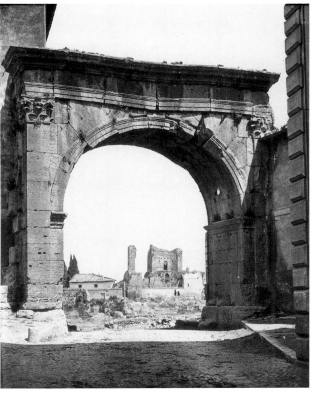

fig. e

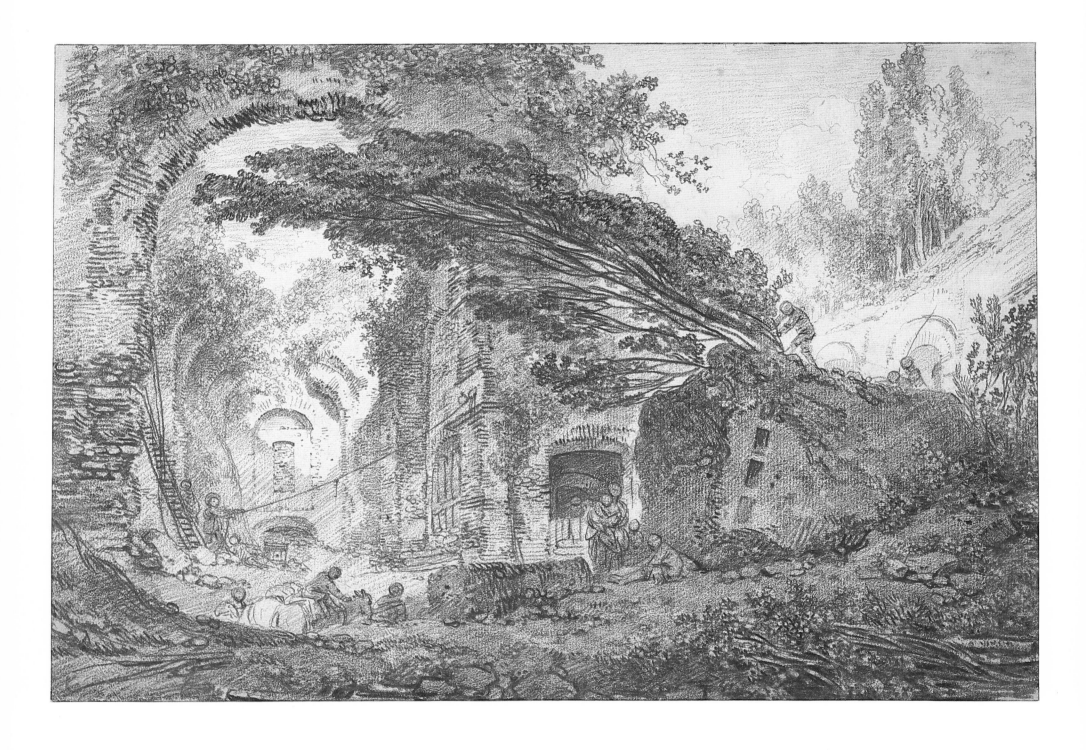

91

Jean-Honoré Fragonard
Grasse 1732–1806 Paris
VIEW IN A ROMAN RUIN

Red chalk; 264 × 383 mm.
Annotated in pencil at upper right by an
eighteenth-century hand: *fragonard*
No watermark
Inv. F I 162

Provenance: R. Owen, London; F. Koenigs, Haarlem
(L. 1023a); D.G. van Beuningen, Rotterdam, acquired in
1940 and donated to the Boymans Museum Foundation.

Exhibitions: Paris 1925, no. 441; Bern 1954, no. 66;
Amsterdam 1974, no. 39 (ill.).

Literature: C. Martine, *Dessins de maîtres français: Honoré
Fragonard*, Paris 1926, no. 51 (ill.); Réau 1956, p. 224;
Ananoff 1961-70, vol. IV, cat. no. 2281, fig. 592; exhib.
cat. Paris, New York 1987-88, p. 95, fig. 7.

In 1752 the Académie awarded the Prix de Rome for
painting to Fragonard, which was fairly exceptional, as
he was not a pupil there. However, his apprenticeship
to Boucher, the most important and influential painter
in France at the time, would certainly have been a
major consideration.[1] The prize included a trip to
Italy and four years in Rome as a *pensionnaire* at the
Académie de France. Fragonard left Paris in the fall of
1756, arriving in Rome towards the end of the year.

He soon made the acquaintance of Hubert Robert
(1733–1808), a young French artist who had been in
Rome since 1754. Following the advice of
Charles-Joseph Natoire (1700–77), director of the
French academy in Rome since 1752, the two men
made numerous drawings of Rome and its surroundings,
some of them of the same scene. Natoire was a firm
believer in the benefits of drawing from nature.
"I consider this [drawing from nature outside Rome] to
be a most essential part of the training of our young
artists; I encourage them not to neglect it by setting the
example myself," he wrote to his superiors in Paris in
1759.[2] Through his association with Robert, Fragonard
met the Abbé Claude-Richard de Saint-Non (1727–91)
who arrived in Rome in 1759. Since 1758, Saint-Non
had been *commendataire* of the abbey of Saint-Pierre de
Pothières near Châtillon-sur-Seine in the north of
Burgundy.[3] Though himself an amateur engraver and
painter of some merit, he is best remembered for his
friendship with Fragonard, whom he supported
throughout his life.

Saint-Non and Fragonard passed the summer of 1760
together at the Villa d'Este near Tivoli. It is not certain
whether or not Robert accompanied them, although it is
assumed that he did.[4] The Villa d'Este, built in the
sixteenth century as the country seat of the d'Este
family, was acquired by the dukes of Modena in the

eighteenth century, however they seldom made use of
it. The gardens, in particular, were a favorite haunt of
artists wishing to draw from nature. "For a long time
now there has not been a painter who left Rome
without having made drawings in the gardens of the
Villa d'Este," Bergeret observed in his journal ten
years later, when he visited Tivoli with Fragonard.[5]
The garden was much admired for its majestic pines
and cypresses, while its layered terraces offered a
kaleidoscope of enchanting views and sudden
perspectives. Fragonard, too, produced numerous
drawings in the gardens, the loveliest of which are those
in red chalk, now in the museum at Besançon.[6] During
this visit he also made drawings, both large and small,
in the vicinity of Tivoli. Together with Saint-Non,
he visited the ruins of Roman villas, notably that of the
Villa Adriana, which had originally been built for the
emperor Hadrian (76–138) in the second century. Little
of it remained in the eighteenth century, according to
Saint-Non, except for a large number of dilapidated
walls, large fragments of which were scattered across
the site and overgrown with trees and wild shrubs.[7]
This view in a Roman ruin, as the work is generally
known, was in all probability made at the Villa Adriana.
It is not quite clear what the men in the picture are
doing; they seem to be using a length of rope to bring
part of the wall down.

Some of the drawings made by Hubert Robert and
Fragonard during their stay in Rome are so similar in
style that the attribution of a number of them is still
uncertain. A case in point concerns a drawing of the
same fragment of wall with a tree growing on it, as in
this Rotterdam sheet, but now viewed from the opposite
side. It too was once in the Koenigs Collection.
Although attributed to Hubert Robert (fig. a),[8] it is
probably in fact a Fragonard. The attribution of the
Rotterdam drawing has never been in any doubt, but it
is in any event endorsed by the eighteenth-century
inscription *fragonard*, which an early owner (Saint-Non
perhaps?) apparently added in order to identify the
artist.

In April 1761, Saint-Non invited Fragonard to return
to France with him. A short while earlier, he had
dispatched him to Naples to make copies of sixteenth-
and seventeenth-century Italian paintings. The drawings
Fragonard made in Rome and Naples after he had
completed his term as a *pensionnaire* and was working
under the patronage of Saint-Non were, as was
customary in the eighteenth century, the latter's
property. Saint-Non later had prints made after them
for his *Raccolta di vedute disegnate d'apresso natura, nelle
ville ed'intorno di Roma* of 1761-65, for example, which
included six views of Rome and its surroundings, three
after Fragonard and three after Robert.[9] The return
journey, which took them to the most important centers
of art in Italy, including Venice and Genoa, lasted for
almost five months. En route, Fragonard again made
numerous copies for Saint-Non of Italian paintings in
the churches and collections they visited along the way.
They finally reached Paris in September 1761.

1. Told of this objection, Boucher replied: "*ça ne fait rien, tu es
mon élève;*" see exhib. cat. New York, Paris 1987-88, p. 38.
2. *Correspondance des Directeurs de l'Académie de France à Rome
avec les Surintendants des Bâtiments*, publiée d'après les
manuscrits des Archives Nationales par A. de Montaiglo et
J. Guiffrey, 17 vols., Paris 1887-1912; here cited from exhib.
cat. *Charles-Joseph Natoire*, Troyes, Musée des Beaux-Arts,
1977, p. 28: "*Je regarde cette partie... fort nécessaire dans l'étude de
nos jeunes élèves; je les encourage à ne pas la négliger en les
prêchant d'exemple.*"
3. Cf. L. Guimbaud, *Saint-Non et Fragonard*, Paris 1928, p. 53.
4. See Cuzin 1987, p. 60.
5. Bergeret de Grancourt, *Voyage d'Italie 1773-1774*, ed.
J. Wilhelm, Paris 1948, p. 97: "*Depuis longtemps les peintres ne
quittent jamais Rome sans avoir fait nombre de desseins dans les
jardins de la Villa d'Este.*" See also cat. no. 92.
6. M.L. Cornillot, *Collection Pierre-Adrien Pâris Besançon*,
Besançon 1957, nos. 32-41 (ill.).
7. P. Rosenberg and B. Brejon de Lavergnée, *Saint-Non,
Fragonard. Panopticon Italiano: un diario di viaggio ritrovato*,
Rome 1986, p. 160.
8. Sale Paris, March 25 1925, no. 102 (ill.).
9. Cf. Guimbaud, op. cit. (note 3), p. 193.

AM

fig. a

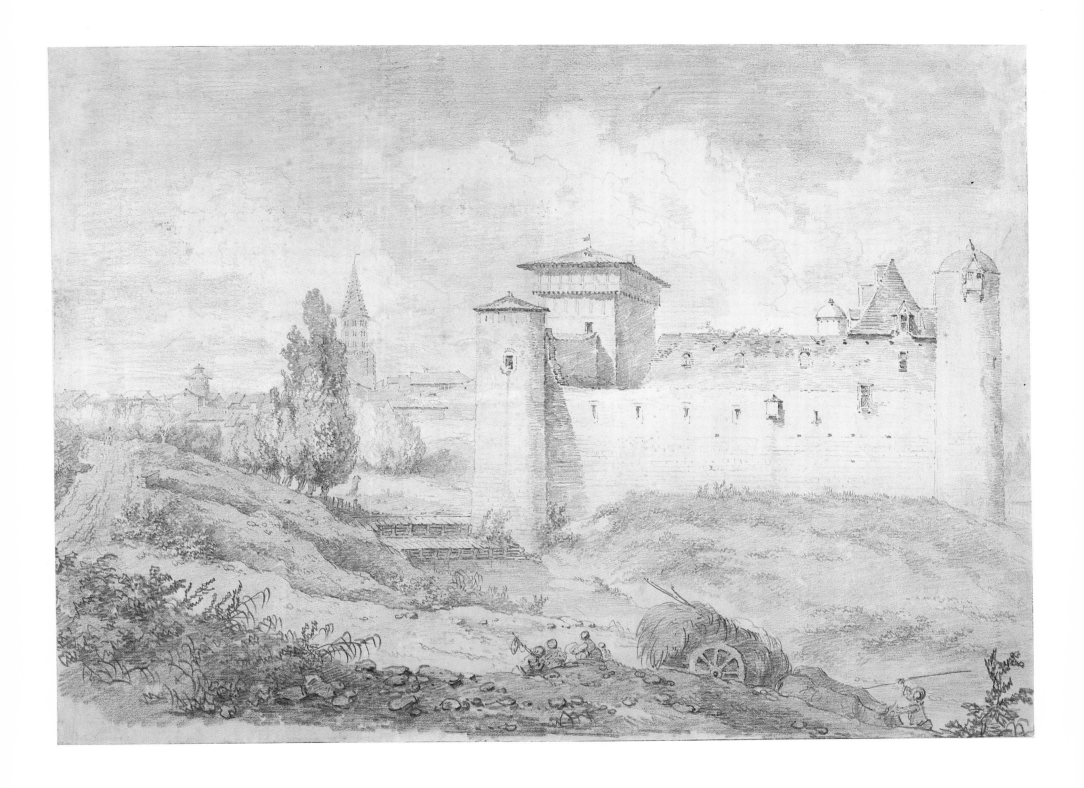

92

Jean-Honoré Fragonard
Grasse 1732–1806 Paris
VIEW OF THE CHATEAU DE NÉGREPELISSE

Red chalk; 362 × 484 mm.
Watermark: *Angoumois Fin*
Inv. F I 244

Provenance: [J.-O. Bergeret de Grancourt, Paris;
P.-J. Bergeret, Paris]; Madame de la Girennerie, Paris;
sale Paris, November 21-23 1895, no. 224 (?);
Mrs. C.F. Hofer, U.S.A.; F. Koenigs, Haarlem (L. 1023a),
acquired in 1929; D.G. van Beuningen, Rotterdam,
acquired in 1940 and donated to the Boymans Museum
Foundation.

Exhibitions: Rotterdam 1934-35, no. 64; Cologne 1939,
no. 17; Paris 1952, no. 90; Rotterdam 1952, no. 135;
Amsterdam 1974, no. 37 (ill.); Paris, New York 1987-88,
no. 171 (ill.), p. 372, fig. 1 (reversed).

Literature: Réau 1956, p. 225; M. Méras, "Fragonard à
Négrepelisse," *Bulletin de la Société Archéologique du
Tarn-et-Garonne*, 1961, pp. 5-6 (ill.); Ananoff 1961-70,
vol. I, no. 381, fig. 132; M. Méras, "Deux tableaux
retrouvés des collections Bergeret de Grandcourt au
château de Négrepelisse," *Gazette des Beaux-Arts* LXXX,
December 1972, p. 334, note 3, fig. 1 (reversed); Cuzin,
1987, no. 191 (ill.); cat. anonymous sale Monte Carlo,
December 2-3 1988, p. 89 (ill.).

Ten years after Fragonard's first visit to Italy, he was
invited to accompany Bergeret de Grancourt (1715–85)
to Rome. One of the wealthiest men in France in the
second half of the eighteenth century, Bergeret was
Receveur Général des Finances for the Montauban region
from 1751, though he discharged his duties in this
capacity by procuration rather than in person. His home
was in Paris, where he led the life of the grand seigneur
he indeed was, taking an active interest in astronomy
and other sciences as well as in the arts.[1] Fragonard
must have known Bergeret for some time before
receiving the invitation, as the latter had been married
to a sister of the Abbé Saint-Non. From the praise
Bergeret lavished on the artist at the beginning of
the diary he kept of the journey,[2] it is clear that he
expected to benefit from Fragonard's company.
What he undoubtedly had in mind was the experience
Fragonard had gained during his first visit to Italy.
Fragonard's wife was also invited to accompany the
party, which further comprised the maid of Bergeret's
late wife – whom Bergeret was later to marry – one of
his sons, two coachmen, two menservants and a cook.

The company left Paris on October 5 1773 and on
October 12 arrived in Négrepelisse, a small village near
Montauban, where Bergeret owned land and a castle
that he had bought from his father in 1751. He writes
that the weather on the day of their arrival was fine,
that the party ate heartily and engaged in pleasant
conversation.[3] Château de Négrepelisse was a medieval
fortress with a solid donjon, built on the bank of the
Aveyron river, which can be seen running through the
middle of the drawing. A little further in the
background is the church tower of Négrepelisse, which
is still standing today. After being confiscated during the
French Revolution, the castle was partially demolished
and the stones sold. An attempt was made to rebuild it
in the nineteenth century, but it was razed almost to
the ground in 1842.[4]

Although the company spent fourteen days in
Négrepelisse, Bergeret's diary contains no further
reference to this period. Considering the length of their
stay, it is surprising too that so few of Fragonard's
drawings of the area have survived. Only four are
known: the sheet reproduced here, a drawing dated *8bre
1773*,[5] with the annotation "*Four banal de Negrepellise*,"
depicting the communal oven in which the villagers
baked their bread, and a drawing in brown ink, which
was formerly in the Chauffard Collection in Paris. The
latter is described in detail in an exhibition catalogue of
1930 as a view of the Château de Négrepelisse, with
Fragonard's wife sitting on a hill on the right, drawing.
That sheet is also dated *8bre 1773*.[6] The fourth
drawing, in red chalk, is of a castle which closely
resembles the one at Négrepelisse, except that the roofs
of the two corner towers are entirely different (fig. a).[7]
The view of the Château de Négrepelisse is one of the
last times Fragonard used red chalk for a landscape;
once in Italy he adopted a completely different
technique.

On November 4, Bergeret and his "*bande*," as he
referred to his party, arrived in Toulon. From there,
they proceeded partly by ship, reaching Rome on
December 5, after stopping en route to visit Genoa,
Florence, Siena, Pisa and various other places of
interest.

This superb drawing of the castle probably remained
in the possession of Bergeret and his heirs, since it was
after all their château. In the nineteenth century, in any
event, it belonged to Bergeret's granddaughter, Mme de
la Girennerie.[8]

1. Cf. G. Wildenstein, "Jacques-Onésyme Bergeret," *Gazette des
Beaux-Arts* CVII, July-August 1961, pp. 39-84.
2. Bergeret de Grancourt, *Voyage d'Italie 1773-1774*, ed.
J. Wilhelm, Paris 1948, p. 19.
3. Ibid., p. 22.
4. Méras (1972), p. 332.
5. New York, private collection; see Bergeret de Grancourt,
op. cit. (note 2), fig. on p. 23.
6. Present whereabouts unknown; cf. exhib. cat. *Exposition de
dessins de Fragonard*, Paris, Galerie Jacques Seligmann, 1931,
no. 70.
7. Present whereabouts unknown; Ananoff 1961-70, vol. III,
no. 1488, fig. 400.
8. See Wildenstein, op. cit. (note 1), p. 56.

AM

fig. a

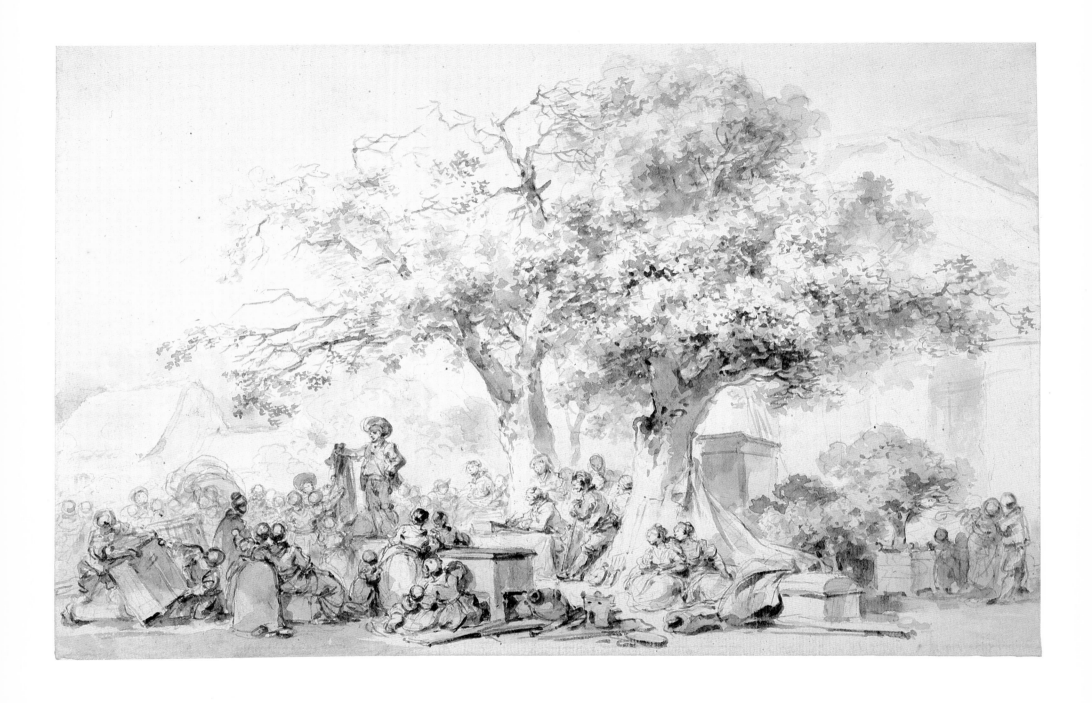

93

Jean-Honoré Fragonard
Grasse 1732–1806 Paris
OUTDOOR AUCTION

Brush and brown ink, over black chalk; 250 × 381 mm.
Watermark: *D & C BLAUW*[1]
Inv. MB 1953/T 21

Provenance: Grand Duke Ludwig von Hesse Darmstadt, acquired in 1812; Grossherzogliches Hessisches Landesmuseum, Darmstadt (L. 1257e) until 1933; F. Mannheimer, Amsterdam, acquired in 1933; taken to Germany during the Second World War for the Hitler Museum, Linz; returned to the Netherlands after the war; on loan since 1953 from the Rijksdienst Beeldende Kunst (Netherlands Office for Fine Arts), The Hague (inv. NK 3049).

Exhibitions: Paris 1946, no. 126; Amsterdam 1951, no. 169; Paris, Brussels, Rotterdam 1949-50, no. 92; Bern 1954, no. 94; Paris, Amsterdam 1964, no. 114, fig. 96; Bremen 1977, no. 186; Paris, New York 1987-88, no. 213 (ill.).

Literature: "Zeichnungen aus dem Kupferstichkabinett des Hessischen Landesmuseums zu Darmstadt," *Stift und Feder* I, no. 11, 1928 (ill.); E. Gradmann, *Französische Meisterzeichnungen des 18. Jahrhunderts*, Basel 1949, no. 47, fig. 81; Fosca 1954, p. 63, no. 32, (ill.); Réau 1956, p. 224; Ananoff 1961-70, vol. I, no. 266, fig. 93.

Bergeret and Fragonard remained in Rome from December 1773 until the beginning of July 1774, except for a brief interval between mid-April and mid-June, when they went to Naples to explore the excavations near Pompeii and various other sites. In Naples they met the painter Pierre-Jacques Volaire (1729–c. 1802), whom Bergeret commissioned to paint the eruption of Vesuvius, which was fairly active at the time. Volaire had specialized in depicting the volcano and its dramatic explosions of lava. Bergeret intended to take the painting home, according to his journal, and it is indeed known to have hung in the Château de Négrepelisse. It was later sold to another family, and was auctioned in Monte Carlo in 1988.[2]

Bergeret was accepted into Roman society. He was received by cardinals and ambassadors, was granted a private audience with the Pope, and met the director of the Académie de France, Natoire, on several occasions, as well as the *pensionnaires* in Rome at the time. His main occupation, however, was visiting churches and other important buildings to view the works of art on display. Drawing also took up a lot of time, and although most of the work was produced by Fragonard, a number of sheets were drawn by a young *pensionnaire*, François-André Vincent (1746–1816), who often joined Bergeret's party. Bergeret, too, enjoyed drawing, mainly making copies after Raphael and Michelangelo, as he noted in his journal.[3]

Outdoor Auction is the title by which this drawing has always been known. And indeed it shows the auctioneer standing on a long display case, holding a piece of cloth which several women are reaching out to feel. Between the two trees directly behind the scene of the auction is the miserly-looking bailiff, recording the names of the purchasers and the prices fetched. With reference to

another sheet by Fragonard, attention has been drawn to the fact that several of his genre pieces incorporate some small detail which seems to give the representation a deeper meaning than that suggested by the title.[4] This sheet too may well represent more than simply an outdoor auction. The disorderly array of goods to be sold consists entirely of household effects – curtains, chests, a large cupboard behind one of the trees, and, more to the foreground, a stone pitcher and a bucket. On the far right, almost isolated from the excited crowd, is a man drawn in profile. He has his arm around a woman's shoulders as though to comfort her, and two small children are standing beside them. They might be a family who have fallen on hard times and have been forced to sell their home. In this case, the drawing would not depict an ordinary auction but a sale under distress, with all the human tragedy that entails.

Here Fragonard has applied the technique he developed during his second visit to Italy. He first made a rough sketch of the scene in black chalk, and then brought it to life with the brush and various tones of ink, ranging from the palest brown to opaque dark brown. The sheet is therefore assumed to have been made during his stay in Italy or shortly afterwards, possibly on the journey home.[5] It is probably this method that Bergeret copied from Fragonard, referring to it as *stile de peintre*.[6]

In the first week of July 1774, Bergeret and his party left Rome to return to Paris. Their journey took them via Florence and Venice to Vienna, and then by way of Prague through Germany back to France. They finally arrived in Paris in September 1774. Sadly, the journey ended in a dispute between Bergeret and Fragonard. As was customary in the eighteenth century, Bergeret claimed possession of the drawings Fragonard had made while they were away. But Fragonard refused to part with his work and Bergeret decided to institute legal proceedings against him. The court eventually ruled that Bergeret should pay for the drawings if he wanted them, and in the end he did. In an attempt to get his own back, though, he deleted the flattering remarks he had made about Fragonard at the beginning of his journal and replaced them with scathing criticism of the conduct of Fragonard and his wife.[7]

1. Countermark no. 165 in Voorn 1960, dated 1768.
2. See cat. no. 92, under Méras (1972), fig. 4.
3. Bergeret de Grancourt, *Voyage d'Italie 1773-1774*, ed. J. Wilhelm, Paris 1948, p. 72.
4. Cf. E. Williams, exhib. cat. *Drawings by Fragonard in North American Collections*, Washington, National Gallery of Art, 1978-79, p. 80
5. Ibid., p. 92; cf. exhib. cat. Paris, New York 1987-88, p. 444.
6. See note 3. It is not clear precisely what Bergeret meant by "*stile Oriental*," the style he used before he adopted Fragonard's technique, but it might refer to drawing with Indian ink.
7. Cf. exhib. cat. Paris, New York 1987-88, p. 370, fig. 6, with an illustration of the relevant page in Bergeret's journal.

AM

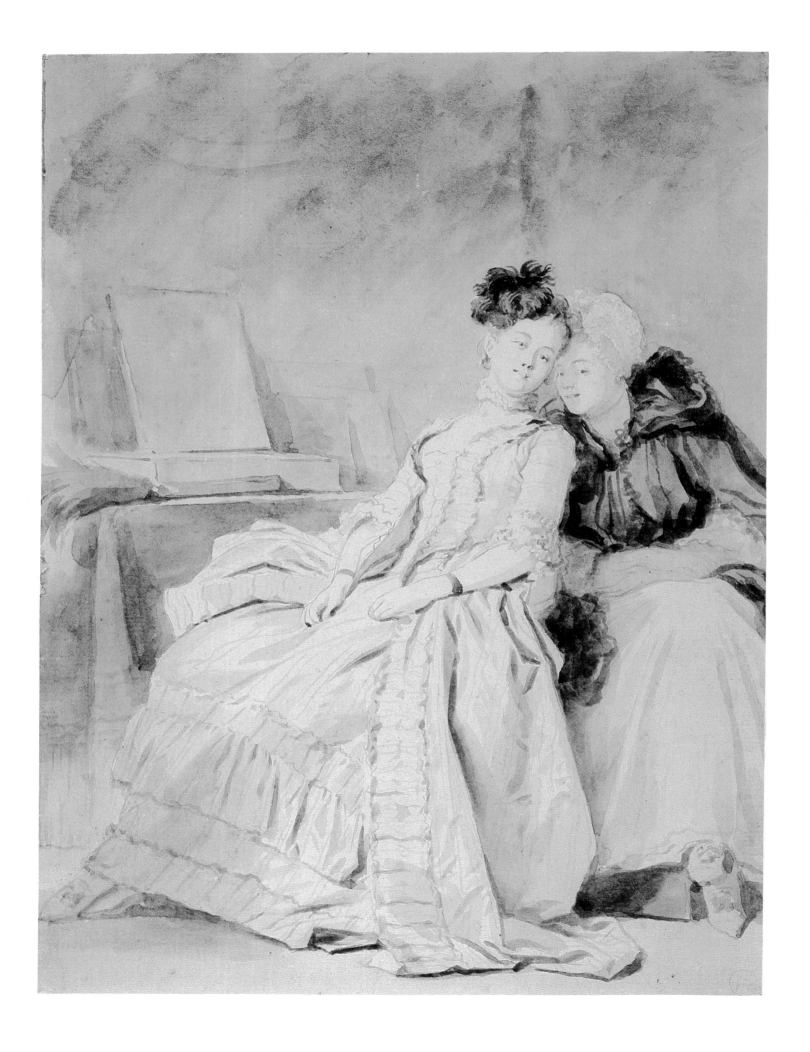

94

Jean-Honoré Fragonard
Grasse 1732–1806 Paris
LA CONFIDENCE

Brush and brown ink, over black chalk; 281 × 210 mm.
Watermark: fleur de lis
Inv. F I 228

Provenance: [Chabot and duc de la Mure, sale Paris,
December 17-22 1787, no. 171; anonymous sale Paris,
July 8 1793, no. 66; Desmarets, sale Paris, March 17
1797, no. 88; Brunet-Denon, sale Paris, February 2
1846, no. 264][1]; M. Paulme, Paris (L. 1910), acquired in
1925; his sale, Paris, May 13 1929, no. 86, fig. 58;
F. Koenigs, Haarlem (L. 1023a), acquired in 1929;
D.G. van Beuningen, Rotterdam, acquired in 1940 and
donated to the Boymans Museum Foundation.

Exhibitions: Paris 1931, no. 53; Rotterdam 1934-35,
no. 58, fig. XXVII; Paris 1937, no. 541 (ill.); Rotterdam
1938, no. 268, fig. 298; Paris, Brussels, Rotterdam
1949-50, no. 87, fig. VI; Rotterdam 1952, no. 138; Paris
1952, no. 93; Paris, Amsterdam 1964, no. 116, fig. 95;
Amsterdam 1974, no. 45 (ill.); Paris, New York 1987-88,
no. 269, fig. on p. 528.

Literature: Foerster 1930, no. 18 (ill.); Juynboll 1938,
p. 26 (ill.); Réau 1956, pp. 211-12, fig. 10; Haverkamp
Begemann 1957, no. 65 (ill.); Ananoff 1961-70, vol. II,
no. 722, fig. 204;[2] exhib. cat. *De Raphaël à Picasso:
dessins de la Galerie Nationale du Canada*, Paris, Musée
du Louvre, 1969-70, under no. 44, fig. 21; G. Norman,
"More than 30 'Fragonard' Drawings May Be Fakes,"
The Times, London, March 8 and 9 1978; Pignatti 1981,
p. 276, fig. on p. 277; Roland Michel 1987, p. 202,
fig. 237.

Many of Fragonard's drawings have been described as
fleeting glimpses of everyday life – a quality which the
artist has captured to superb effect in this sheet. The
older woman seems to be whispering something to her
companion that she does not wish the observer to hear.
It has been suggested that the women might have been
Marie-Anne Gérard (1745–1823),[3] who married
Fragonard in 1769, and her younger sister Marguerite
(1761–1837). The hypothesis is in any event not
contradicted by the known portraits of the two women.[4]
In addition, we have a description of Marguerite from a
declaration issued by the Paris authorities in 1794,
which gives her place of residence as the Louvre. She is
described in the document as "... citizeness Margueritte
Gérard, single, aged 32 years... brown hair and
eyebrows, brown eyes, well-formed nose, small mouth,
pointed chin, oval face, fresh complexion."[5] Moreover,
the portrait miniature of her, made in 1793 by one of
the witnesses to the document, the painter François
Dumont (1751–1831), bears out the description (fig. a).[6]

Although Marguerite would only have been about
twenty years old in the drawing, the similarities between
the written description, the woman in the portrait and
the young woman in the drawing are too great to be
merely coincidental. The lace-trimmed cap that
Marie-Anne Fragonard is wearing in the drawing is also
known from other portraits of her.

From 1775 Marguerite Gérard lived with the
Fragonards at the Louvre in Paris, where Fragonard had
a studio and the family occupied an apartment. The
artist gave his sister-in-law lessons in engraving as well
as painting, and under his supervision Marguerite
Gérard emerged as a competent artist who enjoyed
considerable acclaim during her lifetime. The hand of
her tutor, however, remains clearly discernible in many
of her paintings.[7]

If the two women have indeed been identified
correctly, the sheet would probably have been made in
Fragonard's studio. The object on the table could be a
fresh canvas or perhaps a drawing board, such as the
one Marguerite is using in the drawing that Fragonard
made of her at work.[8] There also seem to be paintings
or prints hanging on the wall.

The two women are also portrayed in a drawing
entitled *La Lecture* (fig. b).[9] The size of that sheet is
identical to the one used for *La Confidence*, and the
drawings could therefore be pendants. Like the
preceding entry (cat. no. 92), it has been executed with
the brush and brown ink over a light, preparatory
sketch in black chalk.

Judging by Marguerite Gérard's age, the drawing
must have been made in the late 1770s. This is
substantiated by the watermark which came to light
when the nineteenth-century mount was removed; it
is the countermark of the watermark of *D & C Blauw*,
and is identical to the watermark on the sheet of
La Première Leçon d'equitation,[10] which is believed to
date from the latter half of the 1770s.

The National Gallery in Ottawa used to have a
second version of this drawing.[11] However, when the
mount was removed and the ink examined, it was found
to be a twentieth-century copy, or, judging by the
collectors' marks, more likely a forgery. On the verso
of the sheet is a pencil drawing with a copy after
La Lecture, in a manner which is in any event not
Fragonard's.[12]

1. It is not certain that this drawing was in these collections
and sales, cf. exhib. cat. Paris, New York 1987-88, p. 525.
2. It is a matter of debate whether this is an illustration of the
Rotterdam sheet. The letter D in a circle at lower right on
that reproduction is not found on the drawing, or on the
facsimile in Foerster 1930.
3. By Roland Michel 1987, p. 202, for example.
4. Cf. exhib. cat. Paris, New York 1987-88, nos. 291-92,
295-96 (ill.).
5. "...la citoyenne Margueritte Gérard, fille majeur agé de 32
ans...cheveux et sourcils brun, yeux brun, nez bien fait, bouche petite,
menton pointu, visage ovalle, teint vif animé," quoted from
J. Doin, "Marguerite Gérard," *Gazette des Beaux-Arts* LIV,
1912, p.440, note 1. This *Certificat de Résidence* is reproduced in
exhib. cat. Paris, New York 1987-88, p. 586, fig. 5.

6. Paris, Musée du Louvre.
7. S. Wells-Robertson, "Marguerite Gérard et les Fragonard,"
Bulletin de la Société de l'histoire de l'art français 1977, 1979,
pp. 179-89. On Marguerite Gérard's paintings see Cuzin 1987,
pp. 215-24, nos. 409-20 (ill.).
8. Vienna, Graphische Sammlung Albertina; see exhib. cat.
Paris, New York 1987-88, no. 268 (ill.).
9. Paris, Musée du Louvre.
10. Chicago, Art Institute; cf. E. Williams, exhib. cat. *Drawings
by Fragonard in North American Collections*, Washington,
National Gallery of Art, 1978-79, p. 179 (ill.).
11. A.E. Popham and K.M. Fenwick, *European Drawings in the
Collection of the National Gallery of Canada*, Ottawa 1965,
no. 320, fig. on p. 220.
12. For the Fragonard fakes see Norman (1978).

AM

figs. a & b

95

Louis-Gabriël Moreau
Paris 1739–1805 Paris
VIEW OF A WALLED GARDEN

Bodycolor, laid down; 309 × 473 mm.
Watermark: not visible
Inv. F I 285

Provenance: Marquis le Franc de Pompignan, chateau
de Hordosse; his sale, Paris, June 20 1927, no. 2 (ill.);
F. Koenigs, Haarlem (L. 1023a), acquired in 1929;
D.G. van Beuningen, Rotterdam, acquired in 1940 and
donated to the Boymans Museum Foundation.

Exhibitions: London 1932, no. 822; Rotterdam 1934-35,
no. 76; Rotterdam 1938, no. 305, fig. 308; Amsterdam
1951, no. 194; Rotterdam 1952, no. 139; Paris 1952,
no. 94, fig. 24; Amsterdam, Paris 1964, no. 127, fig. 107;
Amsterdam 1974, no. 73 (ill.).

Literature: Foerster 1930, no. 21 (ill.); F. Boucher and
P. Jaccottet, *Le Dessin français au XVIIIe siècle*, Lausanne
1952, no. 117 (ill.); anonymous sale, London, July 7-9
1981, under no. 209.

In the left background of this sheet is a large tree-lined
terrace on which people are strolling. It is viewed from
an oblique angle, down the length of the white
plastered wall of a park or garden. Halfway along the
wall is a small doorway which could well be the service
entrance of the house to which the gardens belong, and
next to it is a watchdog in a kennel. Beside a stack of
wine barrels to the left of the entrance, five men are
enjoying a game of *boules*. On the far left is a figure
seated under a tree, drawing.

It was for this type of drawing in gouache that
Moreau, who was called *l'aîné* to distinguish him from
his illustrious younger brother Jean-Michel Moreau,
was best known during his lifetime. The technique is a
tricky one, and requires a skillful and steady hand,
since the binding medium of water dries quickly, making
it difficult for the artist to introduce any changes.[1]

Overshadowed by his brother in his own time, and
doomed to almost complete obscurity in the nineteenth
century, Louis-Gabriël Moreau was reappraised in the
first quarter of the twentieth century, when the fresh
and unpretentious quality of his landscapes came to be
more widely appreciated. He is now regarded as a
precursor of nineteenth-century French landscape artists
such as Corot.[2] The 1922 exhibition of work by Hubert
Robert and Moreau at Jean Charpentier's gallery in
Paris represented a watershed in the revival of Moreau's
work, and this sheet, not surprisingly, fetched 100,000
francs at an auction only five years later. Besides
paintings, Moreau produced mainly watercolor and
gouache landscapes, the majority of them in the vicinity
of Paris and the Ile-de-France which, especially before
the Revolution, had boasted so many of these fine old

country residences with their parks and gardens.
However, few of the scenes he depicted can be
identified with any precision. Human figures are
relatively unobtrusive in his landscapes. Invariably tiny,
they are reduced to insignificance by the vastness of
their surroundings, while the commonplace activities in
which they are engaged, such as strolling or playing
games, are equally unremarkable. What lends Moreau's
landscapes such originality is the vantage point from
which he observed them. This composition, dominated
by the long garden wall rather than the large open
square, is a good example.

The Marquis de Pompignan, from whose collection
the drawing was acquired, was a descendant of
Jean-Jacques le Franc de Pompignan (1709–84), a native
of Pompignan in the Montauban region, who had been
an *académicien* in Paris from 1757 to 1763. His efforts to
reconcile Catholic doctrine with the precepts of the
Enlightenment were violently opposed by Voltaire and
various other philosophers.[3] Pompignan had a large
collection of works of art, among which were a number
of paintings.[4] The Pompignan auction in 1927 was in
many respects the dispersal of an estate. The inventory
included a harpsichord, a commode with marquetry
work by the French furniture maker Nicolas Petit,
candelabras, a folding screen and various other items of
eighteenth-century furniture. We can assume that this
sheet by Moreau (Pompignan in fact had seven in all)
was part of the family heritage originally acquired by
Jean-Jacques. In this event, it would have been made
before 1784, the year in which Pompignan died.

A second version of this view of a walled garden, with
only a few minor differences, was auctioned in London
in 1981 (fig. a).

1. For Moreau in general see G. Wildenstein, *Louis Gabriël
Moreau*, Paris 1923.
2. Cf. J. de Cayeux, "Un précurseur, Louis Moreau,"
Connaissance des Arts, March 1955.
3. "Why did Jeremiah lament so piteously? Because he foresaw
that he was going to be translated by Le Pompignan," ran the
verse by Voltaire of *c.* 1760, which was published in the Paris
press.
4. For the marquis de Pompignan see T.E.D. Braun, *Le Franc
de Pompignan*, Paris 1972, p. 55.

AM

fig. a

96

Jean-Auguste-Dominique Ingres
Montauban 1780–1867 Paris
PORTRAIT OF MADAME REISET AND HER DAUGHTER

Pencil, heightened with white; 308 × 245 mm.
Signed and dated in pencil: *Ingres Del/à Monsieur
Reiset/1844*
Inv. F II 168

Provenance: M.-F. Reiset, Paris; T.-H.-M. vicomtesse
M. de Ségur-Lamoignon, née Reiset; vicomtesse
M.-J.-F.-J.-M. Amelot de la Roussille, née
Ségur-Lamoignon; Pasquier Collection; vicomte
B. d'Hendecourt; his sale, London, May 8 1929, no. 211
(ill.); F. Koenigs, Haarlem (L. 1023a), acquired in 1929;
D.G. van Beuningen, Rotterdam, acquired in 1940 and
donated to the Boymans Museum Foundation.

Exhibitions: Paris 1911, no. 153; Paris 1921, no. 109;
Berlin 1929-30, no. 74 (ill.); Haarlem 1931, no. 195;
Rotterdam 1933-34, no. 81 (ill.); Basel 1935, no. 12;
Rotterdam 1935-36, no. 54 (ill.); Zurich 1937, no. 249;
Amsterdam 1938, no. 73; Amsterdam 1946, no. 119;
Paris, Brussels, Rotterdam 1949-50, no. 138 (ill.); Paris
1952, no. 96; Washington etc. 1952-53, no. 117;
Hamburg, Cologne, Stuttgart 1958, no. 129; Rome,
Milan 1959-60, no. 125, fig. 61; Paris, Amsterdam 1964,
no. 143, fig. 117; Paris 1967-68, no. 233 (ill.); Baltimore
etc. 1986-87, no. 59 (ill.).

Literature: H. Delaborde, *Ingres*, Paris 1870, no. 406;
H. Lapauze, *Les Portraits dessinés de J.A.D. Ingres*, Paris
1903, fig. 81; H. Lapauze, *Ingres, sa vie et son œuvre*,
Paris 1911, p. 387 (ill.); J. Alazard, *Ingres et l'Ingrisme*,
Paris 1950, p. 106; Brinsley Ford, "Ingres' Portraits of
the Reiset family," *Burlington Magazine* XCV, 1953,
p. 356; Haverkamp Begemann 1957, no. 68 (ill.);
D. Ternois, *Inventaire général des dessins des musées de
Province III: les dessins d'Ingres au Musée de Montauban, les
portraits*, Paris 1959, under no. 169; A. Mongan, H. Naef,
exhib. cat. *Ingres Centennial Exhibition*, Cambridge,
Mass., Fogg Art Museum, 1967, under no. 88; Hoetink
1968, no. 157 (ill.); J.-M. Paisse, "Ingres et le portrait
d'enfant," *Bulletin du Musée Ingres* XXIV, December
1968, pp. 17, 22-23; M. Delpierre, "Ingres et la mode de
son temps," *Bulletin du Musée Ingres* XXXVII, July 1975,
p. 23; H. Naef, *Die Bildniszeichnungen J.-A.-D. Ingres*,
vol. III, Bern 1979, pp. 348ff., fig. on p. 351, no. 5; ibid.,
vol. V, Bern 1980, no. 400 (ill.); Pignatti 1981, p. 297,
fig. on p. 296.

A substantial part of Ingres's *œuvre* consists of portrait
drawings – 450 in number. The principal representative
of Neo-Classicism in France, Ingres drew these portraits
with a fine pencil, sometimes adding a few highlights in
white bodycolor, as in this sheet. His portraits are
distinguished by their extreme simplicity and by the
artist's scrupulous attention to details such as dress and
hairstyles.

The young woman in this drawing is Augustine-
Modeste-Hortense Reiset (1813–93). She is wearing a
fashionable gown and has arranged her hair in the style
known as *anglaises à la Sévigné*,[1] the ringlets which were
in vogue in the 1840s. Ingres has portrayed her with her
eight-year-old daughter Thérèse-Hortense-Marie
(1836–99), who was affectionately known as Bibiche.
In November 1835, Hortense Reiset married her
twenty-year-old cousin Frédéric Reiset (1815–91).
They spent their honeymoon in Italy, and in 1836 met
Ingres in Rome, where he had recently been appointed
director of the Académie de France. A close and lasting
friendship was to develop between Ingres and the Reisets.

Besides the drawing of Hortense Reiset, whom he
portrayed on two occasions, Ingres also drew portraits
of her father Louis Reiset (1779–1852), a former officer
in Napoleon's army, and of her husband Frédéric

(figs. a, b).[2] All are dated 1844, and three are inscribed
Enghien. The Reiset family had a country home near
Lake Enghien to the north of Paris, where Ingres was a
frequent and welcome guest. It was in Enghien that
he drew the portraits of his friends in 1844 and,
overwrought after the death of his wife in 1849, it was
there he returned to seek comfort. He was warmly
received and stayed with the Reisets for a considerable
time.

On Ingres's recommendation, Frédéric Reiset was
appointed the first curator of the collection of Old
Master drawings at the Musée du Louvre in Paris.
During his ten years in office, he catalogued many
of these drawings, which had hitherto been largely
neglected. He ended his career as director of the
Musées Nationaux in France, a post to which he had
been appointed in 1874. Ingres's drawings of the Reisets
remained in the family until the beginning of the
twentieth century. They have since been sold and are
now dispersed among various collections.

1. See Delpierre (1975), p. 23.
2. Naef (1980), nos. 397-98.

AM

fig. a

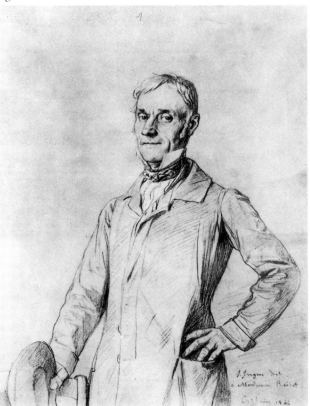

fig. b

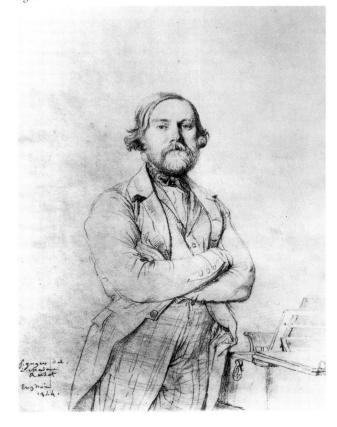

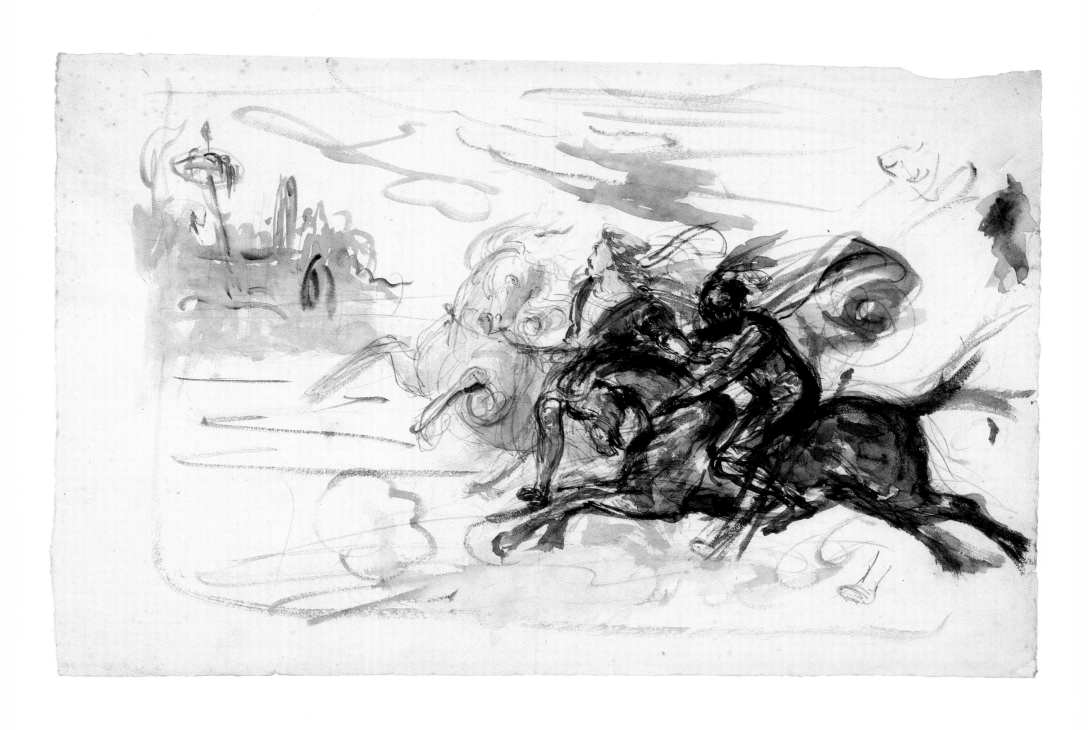

97

Eugène Delacroix
Charenton-Saint-Maurice 1798–1863 Paris
FAUST AND MEPHISTOPHELES

Brush and brown ink, over pencil; 305 × 465 mm.
No watermark
Inv. F II 3

Provenance: F. Koenigs, Haarlem (L. 1023a), acquired in
1924; D.G. van Beuningen, Rotterdam, acquired in
1940 and donated to the Boymans Museum Foundation.

Exhibitions: Rotterdam 1934/35, no. 55; Basel 1935,
no. 55; Rotterdam 1935-36, no. 28; Brussels 1936,
no. 80; Amsterdam 1946, no. 79; Paris 1952, no. 106;
Winterthur 1955, no. 235; Hamburg, Cologne, Stuttgart
1958, no. 143; Paris 1963, no. 114; Paris, Amsterdam
1964, no. 151, fig. 125; Hamburg 1980, no. 488a (ill.);
Tübingen, Brussels 1986, no. 98 (ill.); Frankfurt 1987,
no. E 27.

Literature: A. Robaut and E. Chesneau, *l'Oeuvre complèt
d'Eugène Delacroix*, Paris 1885, under no. 1531;
M. Sérullaz, *Mémorial de l'exposition Delacroix*, Paris 1963,
no. 117 (ill.); P. Hofer, *Some Drawings and Lithographs
for Goethe's Faust by Eugène Delacroix*, Cambridge, Mass.
1964, p. 3 (ill.); *Le Vie del Mondo* XXVI, 1964, p. 753
(ill.); C. Maltese, *Delacroix*, Milan 1965, pp. 17, 150,
fig. 19; Hoetink 1968, no. 97 (ill.); G. Busch, *Eugène
Delacroix: der Tod des Valentin*, Frankfurt 1973, p. 56,
fig. 45.

This drawing is one of Delacroix's preparatory studies
for a series of seventeen lithographs which appeared in
1828, and were inspired by the first volume of *Faust* by
J.W. von Goethe (1749–1808), published in 1808.[1] The
sheet illustrates a short scene at the end of *Faust* I, in
which Mephistopheles and Faust are galloping posthaste
to the dungeon where Faust's beloved Margaret has
been imprisoned. The text is as follows.

NIGHT, OPEN COUNTRY
*Faust, Mephistopheles, mounted upon black horses,
in furious gallop*

Faust: What things are they weaving on Gallows-hill?
Mephistopheles: Their brewing and doing is nobody's
knowing.
Faust: Swooping, ascending, bowing and bending.
Mephistopheles: A guild of witches.
Faust: They make libation and consecration.
Mephistopheles: On, and away.[2]

The horseman bringing up the rear is Faust, aghast at
the sight he encounters as they approach the gallows
field known as the Rabenstein (upper left on the sheet)
where witches, according to the folklore, celebrated
their sabbath. Faust is drawing in the reins and, with his
left arm, tries to restrain Mephistopheles, who gallops
on relentlessly. The drawing is a perfect reflection of
the brief exchange between the two men, echoing
Faust's astonishment at the spectacle before them and
Mephistopheles's curt bidding to ride on.

For all the similarities between the original drawing
and the lithograph, there are marked differences
between them (fig. a). The lithograph shows the two
men after they have passed the gallows-field, and the
scene has consequently lost much of its dramatic
impact. Delacroix's arrangement of the subject matter
seems to have been inspired by the illustrations in two
earlier editions of *Faust* I. The composition of the
drawing recalls the line etching made by Moriz Retzsch
(1779–1857) in 1816 (fig. b), while the lithograph bears

fig. a

fig. b

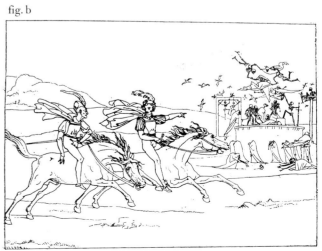

a closer resemblance to the engraving after a drawing by Peter Cornelius (1783–1867), which appeared in his Faust illustrations, likewise published in 1816 (fig. c). Indeed, in 1862 Delacroix wrote that he remembered having seen Retzsch's prints in or around 1821,[3] while Cornelius's engravings might have been the ones he was referring to in his diary in 1824, which he said had filled him with a desire to paint a subject from Goethe's *Faust*.[4] What finally prompted him to do so, however, was an operatic performance – an *opéra-drame* as he referred to it – that he attended at the Drury Lane Theatre in London in 1825.[5] He had arrived in London in the middle of 1825 and remained there until the end of the year. He was obviously greatly moved by this performance of *Faust*, and described it enthusiastically in letters to his friends in Paris. It must have been a true "spectacular," with sound and lighting effects that left a deep impression on him.[6]

For his illustrations of *Faust*, Delacroix tried his hand at a relatively new medium, lithography, which was being used mainly for reproductions in France at the time. His choice of a medium which comparatively few artists had attempted would certainly have been influenced by Théodore Géricault (1791–1824), who had published his first lithographs in 1817. Delacroix had met Géricault at the studio of Pierre Guérin (1774–1833), where the two men were working. Delacroix was an ardent admirer of Géricault and, like him, went to London in search of work as a lithographic artist. Shortly after his return to Paris at the end of 1825, he tackled the subject of *Faust*. His work was printed by Charles Motte (1785–1836), who had established a lithographic studio in Paris in 1817. Motte was also the father-in-law of Achille Devéria (1800–57), who had specialized in lithography, and designed and produced the lithographs for the front and back wrappers of the first edition.[7] Although they had originally intended to issue an album consisting solely of Delacroix's lithographs, the publisher, Sautelet, was in favor of an edition that combined text and illustrations. The text he used was a translation by Albert Stapfer (1802–92), which he had previously published in 1823. Delacroix's illustrations of *Faust* can be regarded as one of the first *livres de peintres*,[8] forerunners of the modern artist's book.

The *Faust* illustrations, like the paintings Delacroix exhibited in the 1820s, met with harsh criticism, as they flouted the Neo-Classical idiom; only a small circle of artists and critics appreciated his romantic works. This lends a certain poignancy to Goethe's reaction – himself one of the initiators of Neo-Classicism – on seeing the lithograph with Faust and Mephistopheles at the end of 1826, which must therefore be the year in which it was made: "Mr Delacroix", Goethe remarked, "is a great talent, one that has found perfect sustenance in "Faust." The French reproach him for lack of restraint, but here it stands him in good stead. One hopes that the whole of "Faust" will be done ..."[9]

1. L. Delteil, *Le Peintre graveur illustré. III. Ingres & Delacroix*, Paris 1908, no. 73 (ill.).
2. W. von Goethe, *Faust*, Leipzig, Vienna n.d., p. 194 (*Goethes Werke*, ed. K. Heinemann, vol. 5).
3. *Correspondance générale d'Eugène Delacroix*, ed. A. Joubin, vol. IV, Paris 1938, p. 303.
4. *Journal d'Eugène Delacroix*, ed. P. Flat and R. Piot, vol. I, Paris 1893, p. 63.
5. Ibid., p. 304.
6. For this staging see G. Doy, "Delacroix et Faust," *Nouvelles de l'estampe* XXI, 1975, pp. 18-23.
7. Cf. B. Mitchell, *The Complete Illustrations from Delacroix's "Faust"*, New York 1981, figs. 2-3.
8. J. Adhémar in exhib. cat. *Delacroix et la gravure romantique*, Paris, Bibilothèque Nationale, 1963, p. 8.
9. *Goethes Gespräche mit Eckermann*, ed. F. Deibel, Leipzig 1921, p. 230 (November 11 1826).

AM

fig. c

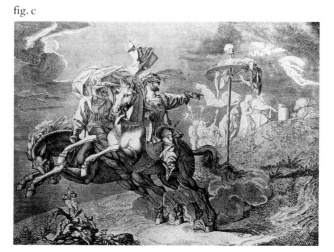

98

Johan Barthold Jongkind
Lattrop 1819–1891 La Côte-Saint-André
"MARSEILLE"

Watercolor over black chalk; 180 × 478 mm.
Annotated at lower left in black chalk:
marseille 14 oct 1880,
and at lower right in pen and brown ink: *23*
Verso: *View of Marseilles Harbor*
Watercolor over black chalk
Annotated at lower right with the brush in brown:
marseille 15 oct 1880
No watermark
Inv. MB 1976/T 21

Provenance: Jongkind's studio, Paris (L. 1401);
P. Vallouin, Paris; V. Bloch, The Hague and Paris;
bequeathed by him to the Boymans-van Beuningen
Museum in 1975.

Exhibitions: Paris 1963, no. 60; Paris 1971, no. 117,
fig. XLIV; Dordrecht 1982, no. 104 (ill.).

Literature: V. Hefting, *Jongkind*, Paris 1975, no. 738,
(ill.); cat. Rotterdam 1978, no. 18 (ill.).

Although Jongkind was a Dutchman, he is regarded,
particularly in France, as a French painter, principally
because of the important role he played in the
development of French painting in the second half of
the nineteenth century. In 1882 the distinguished critic
Edmond de Goncourt drew attention to the influence
Jongkind was having on his contemporaries. After
attending an exhibition of Jongkind's work at the
Détrimont Gallery in Paris in 1862, he wrote: "One
thing strikes me in this gallery and that is Jongkind's
influence. Every landscape that has any merit can
ultimately be traced back to him; the skies, the
atmosphere, the motifs, are all borrowed from him.
This is so immediately obvious, and yet no one has
remarked on it."[1] In addition, it was above all the
Impressionists who saw in him, as they themselves
said, the example *par excellence* of what they were
trying to achieve. In 1900 Claude Monet (1840–1926)

recalled his first encounter with Jongkind in 1862.
He considered him, he realized in retrospect, as the
decisive influence on his own development. From then
on he viewed him as his master and the person who
had taught him to look.[2] Monet and the other
Impressionists particularly admired Jongkind's
watercolors, which were executed out of doors.

When he made this watercolor, Jongkind had been
living for two years with the Fesser family in La
Côte-Saint-André, a small village some fifty kilometers
south east of Vienne in the heart of the Dauphiné,
although he had not relinquished his house in Paris and
frequently returned to stay there. Jongkind was given an
apartment and a studio in the house at La Côte-Saint-
André, belonged to Jules Fesser, the son of Joséphine
Fesser (*c.* 1820–91). Jongkind had met her in 1860 at
Martin's Gallery in Paris, where the artist's work was
sold. He had returned to Paris that year on the verge of
a physical and mental breakdown after spending five
years in the Netherlands, where he had suffered
frequent bouts of depression. Joséphine Fesser
befriended him and was to take care of him for the rest
of his life – *mon ange*, he once called her. Mme Fesser
had by then been living in Paris for a considerable time,
and gave drawing lessons at a girls' school. She
accompanied Jongkind whenever he traveled, and also
managed his business affairs for him.

On September 14 1880, the two of them left La
Côte-Saint-André on a journey which lasted over a
month and took them through southern France and
along the Mediterranean coast. Jongkind produced a
large number of watercolors on this trip, most of which
are dated and have inscriptions identifying the
locations.[3] On October 14, after visiting Avignon,
Narbonne, Nîmes, Toulon, and various other towns,
they arrived in the vicinity of Marseilles, where
Jongkind made this watercolor. It is of the coast road
near Marseilles, with small boats drawn up on the beach
on the right and the blue sea beyond. The next day
they went on to Marseilles itself, where on the verso of
this sheet Jongkind drew a view of the city from the
harbor, with a three-master at anchor (fig. a). In the
background is the large rock which is such a prominent
feature of Marseilles, and the silhouette of the basilica
of Notre-Dame-de-la-Garde, designed by the architect
H.-J. Espérandieu (1829–74) and completed in 1864,
with beside it the famous tower bearing the statue of
the Virgin. Jongkind repeated the silhouette of the
church on the right of the sheet. On the same day he
made another, more elaborate watercolor of Marseilles
harbor (fig. b).[4] The verso of the Rotterdam sheet and
the more detailed watercolor version later served as the
basis for a painting (fig. c), which is dated 1881.[5]

During the journey along the Côte d'Azur, Jongkind
used double sketchbook sheets, probably to give a
better impression of the extensive landscapes. The two
perforations at upper left and right, indicate that the
sheet was pinned to his drawing board and suggest that
he removed it from the sketchbook by untying the
binding thread.

1. Quoted from Hefting (1975), p. 385: "*Une chose me frappe dans ce salon; c'est l'influence de Jongkindt. Tout le paysage qui a une valeur, à l'heure qu'il est, descend de ce peintre, lui emprunte ses ciels, ses atmosphères, ses terrains. Cela saute aux yeux, et n'est dit par personne.*"
2. Cf. J. Rewald, *The History of Impressionism*, New York 1961, p. 70.
3. For example, Hefting (1975), nos. 735-43.
4. Whereabouts unknown; see P. Signac, *Jongkind*, Paris 1927, fig. 49.
5. Whereabouts unknown; Hefting (1975), no. 745 (ill.).

AM

fig. a

fig. b
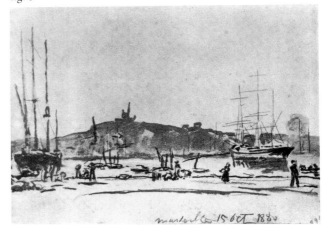

fig. c
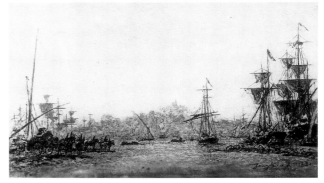

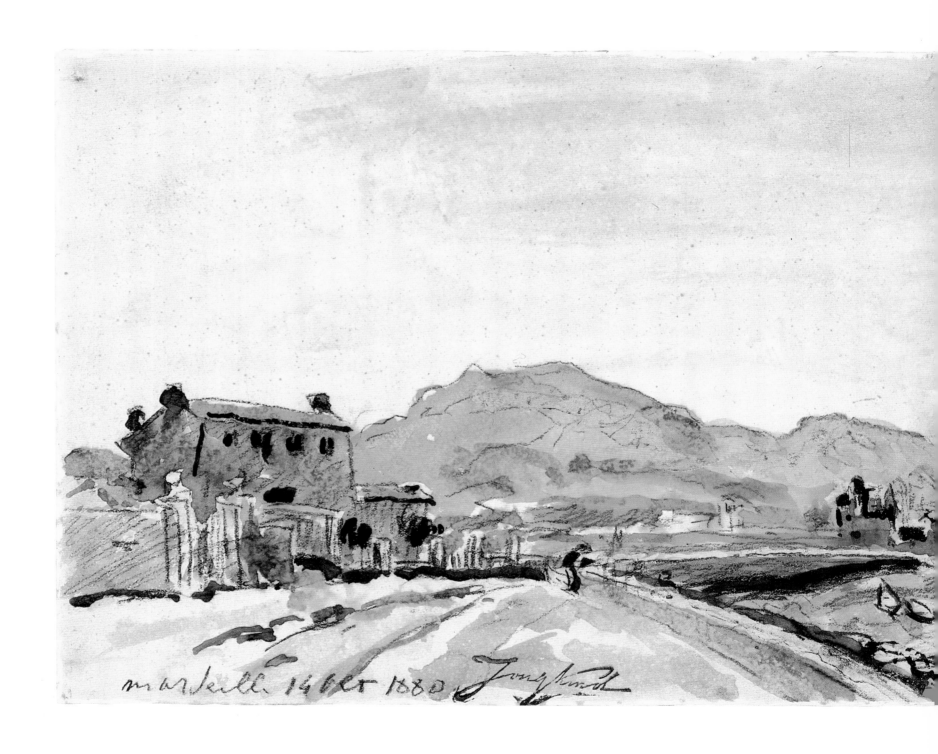

marseille 14 ber 1880 Jongkind

VENTE
COROT

99

Jean-Baptiste-Camille Corot
Paris 1796–1875 Paris
WOODLAND VIEW WITH ROCKS

Pencil; 338 × 413 mm.
No watermark
Inv. MB 1976/T 16

Provenance: Corot's studio (L.460), his posthumous sale, Paris, May 31 1875, probably among nos. 498-552; H. Rouart, Paris; E. Rouart, Paris; V. Bloch, The Hague and Paris; bequeathed to the Boymans-van Beuningen Museum in 1975.

Exhibitions: Paris 1938, no. 11; Paris, Amsterdam 1964, no. 150, fig. 123; Edinburgh, London 1965, no. 110; Baltimore etc. 1986-87, no. 21 (ill.).

Literature: A. Robaut, *L'Oeuvre de Corot*, vol. IV, Paris 1965, no. 2533; cat. Rotterdam 1978, no. 9 (ill.).

Among the first nineteenth-century artists to work in the Forest of Fontainebleau, some fifty kilometers south east of Paris, were Corot and Théodore Caruelle d'Aligny (1798–1871), who went there to make drawings and oil studies from nature. In the early 1820s d'Aligny was a regular guest at Ganne's inn – which later became widely celebrated – in the village of Barbizon at the edge of the woods. Barbizon, the cradle of nineteenth-century French landscape art, was the adopted home of dozens of artists – the Barbizon School – who lived and worked there from the middle of the century. For Corot, too, it remained a fruitful source of inspiration.

D'Aligny spent the years from 1824 to 1827 in Rome, and it was there that he met Corot, who arrived in 1825. The two men became close friends and made frequent excursions into the Roman *campagna* to draw and sketch in oils. Their main subjects were landscapes or details of landscapes, which was fairly unusual under the strict Neo-Classicist regime that held sway at the time. While there were indeed Neo-Classicists who drew from nature, they were mainly interested in the remains of classical antiquity. Corot, however, remained a traditionalist in the sense that his drawings and oil sketches were a starting point for the pictures he subsequently produced in his studio. The painting he did outdoors was mainly intended to capture the mood of the landscape as he experienced it, and especially the light.

While neither d'Aligny, who later became a painter of biblical and mythological subjects, nor Corot, who emerged as one of the most highly acclaimed landscapists, were members of the Barbizon School, both can be regarded as the immediate forerunners of the movement.

After returning to Paris a year after d'Aligny, Corot renewed his acquaintance with his companion from Rome. D'Aligny had rented a house near Barbizon, and the two artists resumed their excursions into the countryside to work from nature. Corot achieved his first success with his Fontainebleau landscapes at the Salon of 1832, when he was awarded a medal for a painting of a view in the forest.[1]

Although the drawing in Rotterdam was originally thought to date from Corot's first visit to Italy,[2] it is more likely to have been made in the 1830s. The manner of drawing corresponds to a sheet in Paris, which Corot annotated "*Route d'Orléans*" (fig. a) and which is generally believed to have been executed in 1835.[3] The Route d'Orléans cuts through the Forest of Fontainebleau, and the rock formations and huge oak trees depicted in both drawings are typical of the vegetation and terrain to be found there. The Rotterdam drawing also might date from 1835, when Corot spent much of the year at Chailly-sur-Bière.[4] He had actually hoped to pass that spring and summer in Rome, as he had done the previous year, but a cholera epidemic raging through the city forced him to abandon his plans. An oil sketch from the first half of the 1830s (fig. b),[5] which has always been known as *Chênes Noirs de*

Bas-Bréau, shows the oaks firmly rooted among the sandstone rocks of the Bas-Bréau – a scene which closely resembles the one in our drawing. The rocks of the Bas-Bréau are near Chailly on the Route de Paris, which runs through the village. Corot used the oil sketch with the oaks and rocks of the Bas-Bréau for the large painting of *Hagar in the Wilderness*, which he completed in 1835.[6]

Corot had very firm ideas on the method to be followed when drawing, and in 1825 he lamented in his notebook: "I see too how important it is to work strictly from nature and not make do with a hasty sketch. How often, when looking at my drawings, I have regretted not spending an extra half hour on them!"[7] In 1835 he wrote to a fellow artist: "Work well there, draw strong and true."[8] The drawing reproduced here seems to illustrate Corot's views perfectly.

1. Robaut (1965), vol. I, p. 56, vol. II, no. 257 (ill.).
2. Ibid., vol. IV, no. 2533.
3. Paris, Musée du Louvre; see exhib. cat. *Hommage à Corot*, Paris, Orangerie des Tuileries, 1975, no. 155 (ill.).
4. Robaut (1965), vol. I, p. 75.
5. Cf. sale New York, October 12 1979, no. 222 (ill.).
6. New York, Metropolitan Museum of Art; reproduced in J. Selz, *La Vie et l'œuvre de Camille Corot*, Courbevoie (Paris) 1988, p. 107.
7. *Corot raconté par lui-même*, ed. P. Courthion, Vésenaz, Geneva 1946, p. 87: "*Je vois aussi combien il faut être sévère d'après nature et ne pas se contenter d'un croquis à la hâte. Combien de fois j'ai regretté, en regardant mes dessins, de n'avoir pas eu le courage d'y passer une demi-heure de plus!*"
8. Robaut (1965), vol. I, p. 75: "*Travaillez bien là-bas, dessinez ferme et vrai.*"

AM

fig. a

fig. b

100

Honoré Daumier
Marseilles 1808–1879 Valmondois
THE COLLECTOR

Black chalk, pen and black ink, watercolor, laid down;
189 × 237 mm.
Signed in black chalk: *h.D*
Watermark: not visible
Inv. F II 12

Provenance: J. Dieterle, Paris; H. Eissler, Vienna;
F. Koenigs, Haarlem (L. 1023a), acquired in 1926;
D. G. van Beuningen, Rotterdam, acquired in 1940
and donated to the Boymans Museum Foundation.

Exhibitions: Paris 1901, no. 192; Berlin 1926, no. 83;
Rotterdam 1933-34, no. 34 (ill.); Basel 1935, no. 78;
Rotterdam 1935-36, no. 11 (ill.); Vienna 1936, no. 59
(ill.); Zürich 1937, no. 45; Amsterdam 1946, no. 36;
Essen 1954, no. 30; Winterthur 1955, no. 229;
Baltimore etc. 1986-87, no. 30 (ill.).

Literature: E. Fuchs, *Der Maler Daumier*, Munich
1927-30, no. 244a (ill.); J. Lassaigne, *Daumier*, Paris
1938, fig. 69e; K. E. Maison, "Further Daumier Studies,"
Burlington Magazine XCVIII, 1956, p. 165; Hoetink
1968, no. 49 (ill.); K. E. Maison, *Honoré Daumier:
catalogue raisonné*, vol. II, Paris 1968, no. 374, fig. on
p. 120.

One of the recurring themes in Daumier's *œuvre*,
besides those relating to law, the legal profession and
political life, is that of the art lover and collector. The
man he has drawn here is sitting at a table in a dimly lit
room, with four paintings just barely visible
on the wall behind him. He is taking a print out of a
portfolio while looking at another one on the table in
front of him. A second watercolor of the same scene
shows an older man on the left, whose full attention is
focused on the print on the table (fig. a).[1] This figure
originally appeared in the Rotterdam drawing as well,
but Daumier apparently had second thoughts and
deleted him, leaving an empty space which he masked
with chalk and watercolor. He also enlarged the back of
the chair in which the man with the portfolio is sitting
by adding a few pen lines to the side and upper
surfaces. The outlines of the second figure are
nevertheless still visible on close inspection. We can
only speculate on Daumier's reasons for removing the
elderly gentleman from this drawing, but it may have
been because he wanted to use the sheet for a different
purpose from the one he had originally envisaged.

There is a third drawing (fig. b) of a similar scene,[2]
which has been made on tracing paper. The man with
the portfolio has been indented and a second figure
subsequently drawn in black chalk. The latter, however,
is in a completely different position from the old man
in the Winterthur drawing. It is difficult to ascertain
when the drawing was made. Apart from the sheets
which Daumier himself dated and those which are
directly related to other datable works, it is virtually
impossible to determine the chronological order of
Daumier's drawings.[3]

1. Winterthur, O. Reinhardt Collection; Maison (1968),
no. 376, fig. on p. 121.
2. Whereabouts unknown; Maison (1968), no. 375,
fig. on p. 120.
3. Ibid., p. 8.

AM

fig. a

fig. b

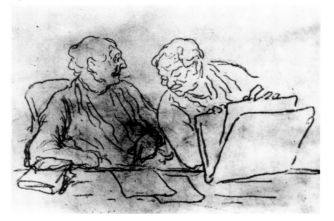

101

Edouard Manet
Paris 1832–1883 Paris
PORTRAIT OF A YOUNG MAN

Red chalk; 325 × 232 mm.
Signed in red chalk: *Ed.Manet*
No watermark
Inv. F II 104

Provenance: F. Koenigs, Haarlem (L. 1023a), acquired in 1929; D.G. van Beuningen, Rotterdam, acquired in 1940 and donated to the Boymans Museum Foundation.

Exhibitions: Haarlem 1935, no. 48; Paris 1952, no. 127; Amsterdam 1964, no. 174, fig. 143; Paris, New York 1983, no. 110 (ill.); Baltimore etc. 1986-87, no. 65 (ill.).

Literature: A. de Leiris, *The Drawings of Manet*, n.p. 1957, p. 158, fig. 36; Mongan 1962, no. 794 (ill.); M. Sérullaz, *Drawings of the Masters: French Impressionists*, London 1963, fig. 68; J. Mathey, *Graphisme de Manet*, vol. III, Paris 1966, p. 15, fig. 4; Hoetink 1968, no. 182 (ill.); A. de Leiris, *The Drawings of Edouard Manet*, Berkeley, Los Angeles 1969, no. 232, fig. 247; S. Kovàcs, "Manet and his Son in 'Déjeuner dans l'atelier'," *The Connoisseur* CLXXXI, 1972, pp. 196-202, fig. 4; H. Joachim, *The Helen Regenstein Collection of European Drawings*, Chicago, Art Institute of Chicago, 1974, under no. 72; D. Rouart and D. Wildenstein, *Edouard Manet: catalogue raisonné*, Lausanne, Paris 1975, vol. II, no. 465 (ill.); W. Hoffman, *Edouard Manet: das Frühstuck im Atelier*, Frankfurt 1985, fig. 12; K. Adler, *Manet*, Oxford 1986, p. 137, fig. 119.

fig. a

This portrait is now generally assumed to be of Léon Koëlla-Leenhoff (1852–1927), the son of Suzanne Leenhoff (1830–1906), a Dutch pianist who had made her home in Paris and who taught piano to Edouard Manet and his brother Eugène from 1849. When Léon was born in 1852, Suzanne registered his father's name as Koëlla, but no trace of him has ever been found. Manet acted as the child's godfather at the christening,[1] and is widely and probably correctly believed to have been Léon's father. The child's second name, for instance, was Edouard. Manet married Suzanne Leenhoff in 1863, immediately after the death of his father, from whom he had always concealed his relationship with Suzanne and Léon's very existence. It is conceivable that Manet and Suzanne invented the unusual name of Koëlla, and that it contains an allusion we will never discover. An appealing suggestion has been put forward by Kovàcs, who felt it might be a corruption of *goéland* – seagull. In a letter to his parents in 1849, written while on a voyage as a sailor, Manet marveled at the many birds he had sighted so far from land, "*tels que goëlands*."[2] Whatever the truth of the matter (and it is of course curious that Léon never assumed Manet's name), after the death of Manet's father and the marriage to Suzanne, Léon became part of the family and went through life as Suzanne's younger brother. He and Suzanne were the beneficiaries of Manet's will, as we know from the artist's will: "I appoint Suzanne Leenhoff, my lawful wife, as my sole heir. All that I have left her she shall bequeath by testament to Léon Koëlla, named Leenhoff, ... and I trust that my brothers will regard this as perfectly natural."[3] The comment was made necessary by the fact that Manet, officially at least, had no children.

This drawing of Léon is related to Manet's painting *Le Déjeuner dans l'atelier* (fig. a),[4] although it is not a direct preliminary study. Léon, in roughly the same pose, occupies the central position in the painting. There is also a photograph of him, taken some time later, in a similar, nonchalant stance.[5] Manet conceived the idea for the painting while on holiday in Boulogne-sur-Mer, where he spent part of the summer of 1868. The drawing with the portrait of Léon dates from that period. The sketch he produced around the same time, which has now been lost but is referred to by Tabarant,[6] formed the basis for the painting he made on his return to Paris. This was the canvas Manet chose, together with *Le Balcon*,[7] to submit to the Salon of 1869. Both works attracted a great deal of criticism. Jules Castagnary (1830–88), a leading art critic and one whom Manet held in high regard, wrote that although Manet was indeed talented, and displayed his skill to best effect when he painted still lifes, his work in general was sterile and meager. The reason for this, he claimed, was that Manet based his work entirely on nature and consequently lost sight of the ultimate objective of art, which was to interpret life. A more specific rebuke, prompted by *Le Déjeuner*, was that "he arranges his figures at random, without any reason or meaning for the composition. The result is uncertainty

and often obscurity in the thought."[8] Castagnary went on to ask what the young man leaning on the table is actually doing and where, in fact, he is. If he were indeed in a dining room, logic dictates that there would be a wall between him and the observer, since he is shown with the room behind him. Underlying Castagnary's criticism were the injunctions of authoritarian academicism which prevailed in France during the Second Empire. A picture had to be anchored in an idea, and must be comprehensible to the viewer, while the people portrayed were to fulfill a specific role both in the scene as a whole and in relation to one another. Manet's painting was obviously unorthodox. On the other hand, he was enthusiastically hailed by the slightly younger generation of artists, later to be known as the Impressionists, not least because of his courage in defying the rigid academic conventions and formulas. At a much later date, Renoir, for instance, was to say that "Manet was as important for us as Cimabue or Giotto for the Italians of the Renaissance."[9]

What is true of Manet's paintings is also true in a sense of most of his drawings, for they too failed to comply with the artistic requirements of the day. The majority are rapidly and spontaneously drawn sketches, mostly in pencil, of people in situations or attitudes Manet found interesting. It has rightly been observed that his drawings always betray the hand of a painter.[10] Even in this portrait of Léon Leenhoff, he seems more concerned to capture the casual nonchalance of the young man's pose than to give an accurate account of his features or dress.

1. Cf. A. Tabarant, *Manet et ses œuvres*, Paris 1947, p. 17. According to Adler (1986), p. 229, note 6, there are now indications that Léon was the son of Manet's father.
2. See Kovàcs (1972), p. 202, note 1.
3. Rouart and Wildenstein, vol. I, (1975), p. 25; "*J'institue Suzanne Leenhoff, ma femme légitime, ma légataire universelle. Elle léguera par testament tout ce que je lui ai laissé à Léon Koëlla, dit Leenhoff, ... et je crois que mes frères trouveront ces dispositions toutes naturelles.*"
4. Munich, Neue Pinakothek.
5. There is a copy of this photograph in the Pierpont Morgan Library, New York.
6. Tabarant, op. cit. (note 1), p. 152.
7. Paris, Musée d'Orsay; cf. Rouart and Wildenstein (1975), no. 134 (ill.).
8. Quoted in J. House, "Manet's Naïveté," in exhib. cat. *The Hidden Face of Manet*, London, Courtauld Institute, 1986, p. 18, note 18: "*...il distribue ses personages au hasard, sans que rien de nécessaire et de forcé ne commande leur composition. De là l'incertitude, et souvent l'obscurité dans la pensée.*"
9. J. Renoir, *Pierre-Auguste Renoir, mon père*, Paris 1981, p. 117: "*Manet était aussi important pour nous que Cimabue ou Giotto pour les italiens de la renaissance.*"
10. Cf. Joachim (1974), p. 148.

AM

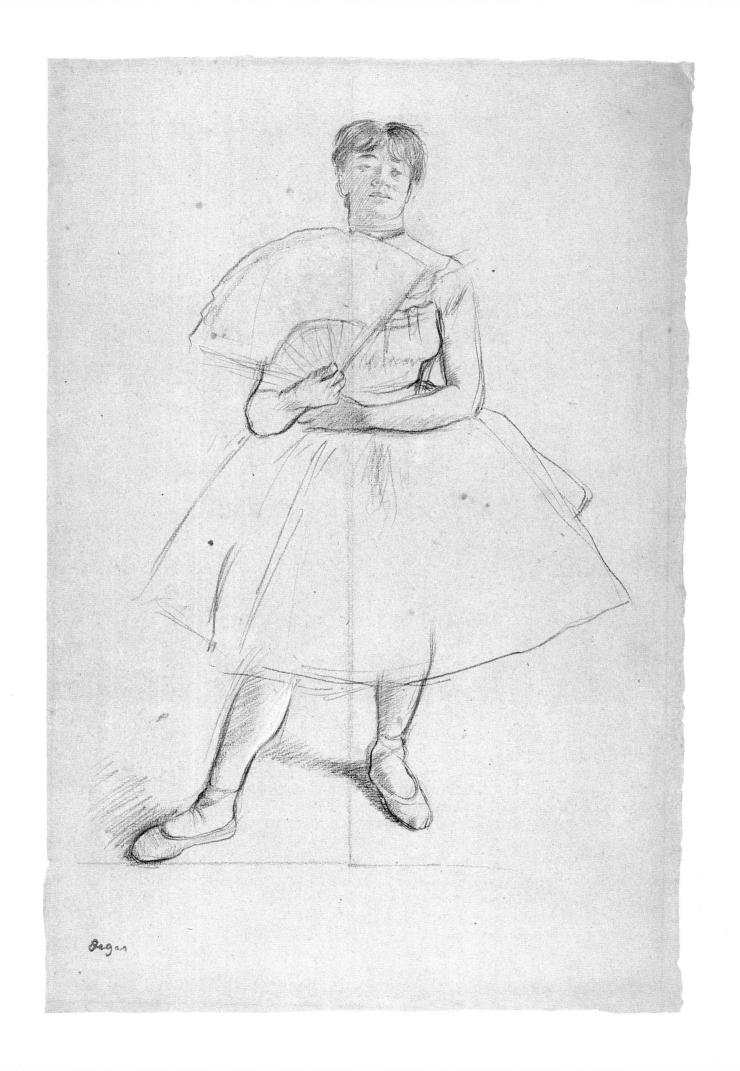

102

Hilaire-Germain-Edgar Degas
Paris 1834–1917 Paris
DANCER WITH A FAN

Black chalk, heightened with white, on blue-gray paper;
480 × 315 mm.
Verso: annotation in black chalk in Degas's hand: *no 1*
No watermark
Inv. F II 222

Provenance: Degas's studio (L.657);[1] sale Degas, Paris
(L.658), April 7 1919, no.339 (ill.); G.Viau, Paris;
F.Koenigs, Haarlem (L.1023a), acquired in 1931;
D.G.van Beuningen, Rotterdam, acquired in 1940
and donated to the Boymans Museum Foundation.

Exhibitions: Berlin 1929-30, no.35; Rotterdam 1933-34,
no.44 (ill.); Amsterdam 1938, no.50; Amsterdam 1946,
no.69 (ill.); Bern 1951-52, no.92; Paris, Amsterdam
1964, no.184 (ill.); Edinburgh 1979, no.19 (ill.);
Tübingen, Berlin 1984, no.109; Paris 1984-85, no.29,
fig.141; Baltimore etc. 1986-87, no.40 (ill.).

Literature: L.Browse, *Degas Dancers*, London 1950,
p.358, fig.57a; Haverkamp Begemann 1957, no.77
(ill.); J.Sutherland Boggs in exhib. cat. *Drawings by
Degas*, St. Louis, City Art Museum, 1967, under no.74;
Hoetink 1968, no.91 (ill.); G.Adriani, *Edgar Degas:
Pastelle, Ölskizze, Zeichnungen*, Cologne 1984, no.109
(ill.).

In the 1870s Degas made numerous drawings of dancers
– members of the opera *corps de ballet* as well as classical
ballerinas. Some of these drawings were executed during
the course of a performance, but more often he drew
his dancers during rehearsals or offstage. What interested
him most was an unusual pose or unexpected movement.

Louisine Havemeyer (1855–1929), who bought her
first Degas in Paris at the age of twenty, and who was
to be an avid collector of his work for the rest of her
life, once asked the artist why he always drew and
painted dancers. "Because, madame," came the reply,
"it is all that is left us of the combined movement of
the Greeks."[2] Although, as a rule, pronouncements of
this sort attributed to an artist should be treated with
some reserve, there is reason to take this particular
statement seriously. It is certainly revealing as far as
Degas's views on art are concerned. He is known to
have been an ardent admirer of Ingres, the undisputed
leader of Neo-Classicism, so it is not surprising that he
chose Louis Lamothe (1822–69), a pupil and follower of
Ingres, as his tutor at the École des Beaux-Arts in 1855.
"Draw lines, lots of lines, and you will become a good
artist," was the advice Ingres gave Degas during a brief
meeting around this time.[3]

Degas was later to become a passionate collector of
Ingres's work, and by the end of his life he owned
twenty of his paintings and ninety drawings.[4] A critic
reviewing the Fifth Impressionist Exhibition in Paris in
1880 commented that the drawings shown by Degas
betrayed not only a more than competent hand, "but a
pupil of the great Florentines, of Lorenzo di Credi and
Ghirlandaio, but above all of a great Frenchman,
Monsieur Ingres."[5] And indeed, a comparison of this
sheet of a ballerina with a fan, which must have been
drawn in the latter half of the 1870s, with Ingres's 1844
portrait of Mme Reiset (cat. no.96), reveals the full
extent of Degas's debt to the older master.

One characteristic of Degas's drawings of dancers and
ballerinas is the sketchlike rendering of the women's
faces. Hardly a single one of them has any discernible
facial expression, let alone any distinguishing feature
by which they might be identified. This drawing of a
dancer holding a fan is one of the rare exceptions.
Before starting it, Degas drew in a horizontal base line
and a vertical axis. Two extremely fine symmetrical lines
mark the shoulder line, the one on the left still being
visible beneath the fan. Only then did he start on the
actual drawing. The woman's face, which is clearly a
portrait, shows her to be older than most of the dancers
in Degas's *œuvre*. She may have been a former dancer
who posed in the artist's studio, and may in fact be the
same woman as the one in a drawing of the same
period which is now in Paris (fig.a).[6]

1. L.657 was applied to the verso of this sheet by officials
after the seals placed on Degas's studio after his death had
been broken. L.658 was put on all the auctioned works.
2. L.W. Havemeyer, *Sixteen to Sixty: Memoirs of a Collector*,
New York 1961, p.256.
3. See exhib. cat. *Degas*, Paris, Galeries Nationales du Grand
Palais, Ottawa, National Gallery of Canada, New York,
Metropolitan Museum of Art, 1988-89, p.37: "*Faites des lignes,
beaucoup de lignes, et vous deviendrez un bon artiste.*"
4. Cf. T. Reff, *Degas: the Artist's Mind*, New York 1976, p.54.
5. See C. Ephrussi, "Exposition des artistes indépendants,"
Gazette des Beaux-Arts XXII, no.1, 1880, p.486: "*...mais un
élève des grands Florentins, de Lorenzo di Credi et de Ghirlandajo,
mais surtout d'un grand Français M. Ingres.*" For the relationship
between Ingres and Degas see Reff, op.cit. (note 4), pp.37-55.
6. Paris, Petit Palais; cf. Boggs (1967), no.74.

AM

fig. a

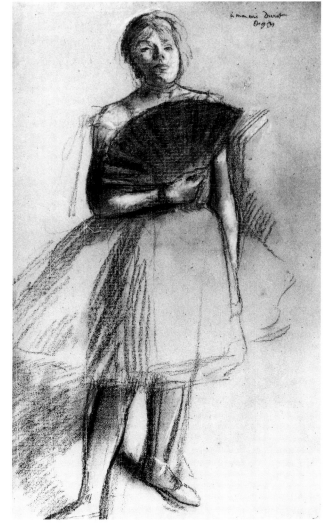

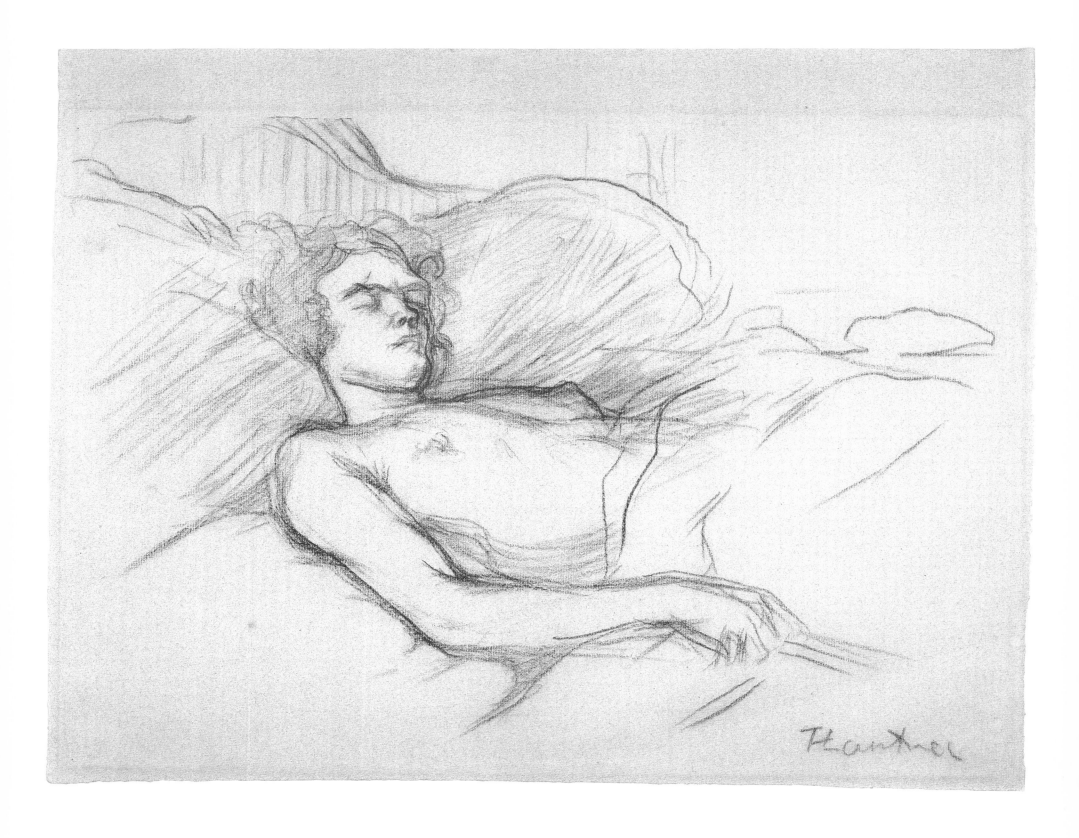

103

Henri de Toulouse-Lautrec
Albi 1864–1901 Château de Malromé
SLEEPING WOMAN

Red chalk on blue paper; 377 × 480 mm.
Signed in red chalk: *HTLautrec*
Watermark: *ED & CIE*
Inv. F II 160

Provenance: F. Koenigs, Haarlem (L. 1023a); acquired in
1929; D.G. van Beuningen, Rotterdam, acquired in 1940
and donated to the Boymans Museum Foundation.

Exhibitions: Paris 1902, no. 134; Amsterdam 1938,
no. 78; Amsterdam 1946, no. 181; Brussels, Amsterdam
1947, no. 109; Vienna 1966, no. 61; Stockholm 1967-68,
no. 129 (ill.); Albi 1976, no. 48, fig. on p. 19; Baltimore
etc. 1986-87, no. 95 (ill.).

Literature: F. Daulte, *Le Dessin français de Manet à
Cézanne*, Lausanne 1954, no. 39 (ill.); Haverkamp
Begemann 1957, no. 86 (ill.); Mongan 1962, no. 835
(ill.); P. Huisman and M.G. Dortu, *Lautrec par Lautrec*,
Lausanne 1964, p. 142 (ill.); Hoetink 1968, no. 251 (ill.);
M.G. Dortu, *Toulouse-Lautrec et son œuvre*, vol. VI, New
York 1971, no. D4.100 (ill.); G. Adriani, *Toulouse-
Lautrec: das gesamte graphische Werk*, Cologne 1976,
under no. 188; *Henri de Toulouse-Lautrec: Dormeuses*, ed.
M.G. Dortu and J.A. Meric, Paris 1976, no. 3;
R. Thompson, *Toulouse-Lautrec*, London 1977, ill. 63;
W. Wittrock, *Toulouse-Lautrec: the Complete Prints*,
London 1985, under no. 154.

In 1896 the Parisian publisher Gustave Pellet produced
an album of ten lithographs by Toulouse-Lautrec
entitled *Elles*.[1] The series gives an impression of
everyday life in the *maisons closes*, the bordellos of Paris.
Toulouse-Lautrec allows us a glimpse of women at their
toilet, bathing, waiting for clients, or simply lying in
bed. He had experienced the daily life of these
establishments firsthand, having rented a room in one of
them, in the Rue des Moulins near the Opéra, at the
beginning of the 1890s.

The lithograph printed in red ink, entitled *Le Sommeil*,
which Pellet also published in the same year, has been
related to the *Elles* album, although it is not part of
it (fig. a).[2] Various preliminary studies are known for
Le Sommeil, and also for the lithographs in *Elles*.[3]
In them we can trace Toulouse-Lautrec's attempts to
capture the precise attitude of the woman asleep in bed.
A red chalk drawing of the same dimensions and on the
same grayish blue paper as the Rotterdam sheet shows
the woman lying on her stomach with her arm under
her head, while a third drawing depicts her lying full
length. The drawing he ultimately used for the figure in
the lithograph is executed in red chalk on transparent
paper (fig. b).[4] There, as in the lithograph but in
contrast to the Rotterdam drawing, the woman's right
hand is under the bedclothes.

1. Wittrock (1985), nos. 155-65 (ill.).
2. Ibid., no. 154 (ill.).
3. Dortu (1971), nos. 4.264, 4.265-4.267.
4. Rotterdam, Boymans-van Beuningen Museum.

AM

fig. a

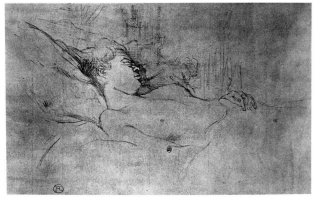

fig. b

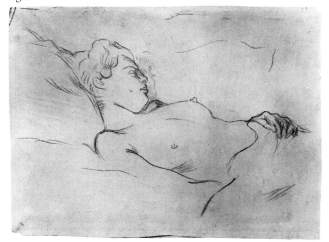

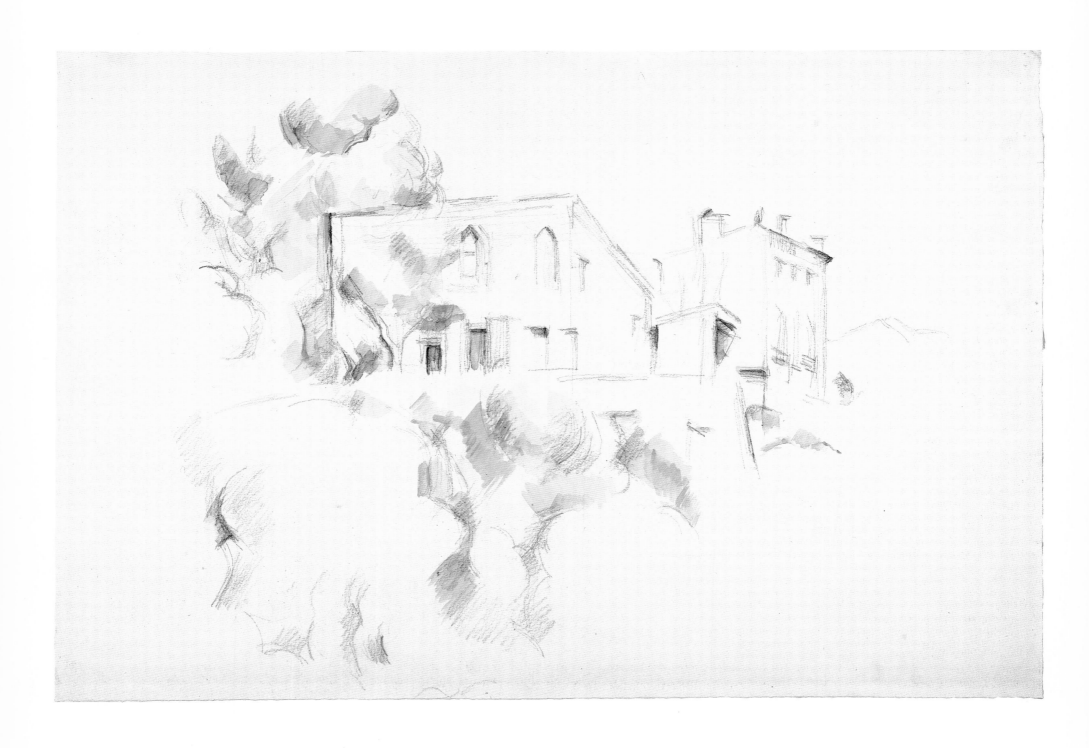

104

Paul Cézanne
Aix-en-Provence 1839–1906 Aix-en-Provence
VIEW OF THE CHÂTEAU NOIR

Watercolor over pencil, laid down; 360 × 526 mm.
Watermark: not visible
Inv. F II 212

Provenance: F. Koenigs, Haarlem (L. 1032a); acquired in
1930; D.G. van Beuningen, Rotterdam, acquired in 1940
and donated to the Boymans Museum Foundation.

Exhibitions: Rotterdam 1933-34, no. 18; Basel 1935,
no. 176; Amsterdam 1938, no. 9; London 1946, no. 20;
Amsterdam 1951, no. 152; Paris 1952, no. 145; The
Hague 1956, no. 75; Zürich 1956, no. 122; New York
1963, no. 44 (ill.); Paris, Amsterdam 1964, no. 207 (ill.);
Newcastle upon Tyne, London 1973, no. 62 (ill.);
Tübingen 1982, p. 76, no. 40 (ill.); Baltimore etc.
1986-87, no. 18 (ill.).

Literature: J. Rewald and L. Marschutz, "Cézanne au
Château Noir," *L'Amour de l'Art* XVI, 1935, pp. 15-21,
no. 7; L. Venturi, *Cézanne: son art et son œuvre*, Paris
1936, no. 1034 (ill.); J. Rewald, *Cézanne, sa vie, son
œuvre, son amitié pour Zola*, Paris 1939, fig. 80;
Haverkamp Begemann 1957, no. 82 (ill.); A. Neumeyer,
Cézanne Drawings, New York 1958, no. 88 (reproduced
in reverse); S.C. Faunce, "Cézanne Watercolor
Exhibition," *Art Quarterly* XXVI, 1963, p. 118, fig. 2;
W.V. Andersen, "Watercolor in Cézanne's Artistic
Process," *Art International* VII, 1963, no. 5, p. 24 (ill.);
H. Hutter, *Die Handzeichnung*, Vienna 1966, p. 106,
fig. IX; Hoetink 1968, no. 30 (ill.); J. Leymarie, *Dessins
de la période impressioniste de Manet à Renoir*, Geneva
1969, p. 92, fig. on p. 95; F. Novotny, *Cézanne und das
Ende der wissenschaftlichen Perspektive*, Vienna, Munich
1970, p. 195, no. 8; U. Gauss, *Die Zeichnungen und
Aquarelle des 19. Jahrhunderts in der Graphischen
Sammlung der Staatsgalerie Stuttgart*, Stuttgart 1976,
under no. 85; L. Venturi, *Cézanne*, Geneva 1978, fig. on
p. 142; Pignatti 1981, p. 330 (ill.); J. Rewald, *Paul
Cézanne: the Watercolours*, London 1983, no. 313 (ill.);
J. Siblík, *Cézanne: Drawings and Watercolors*, St. Paul,
Minn. 1984, fig. 60.

In the early 1880s, disillusioned by the incessant and
often vituperative criticism of his work, Cézanne retired
to a life of semi-seclusion in his native Provence. The
even tenor of his life in the country was interrupted
only by the occasional visit to Paris and its environs.
Here, in the natural surroundings of Aix-en-Provence
and particularly around the Bibémus quarry in the
woods of the Château Noir estate, he would spend his
time drawing and painting. He produced numerous
watercolors during this period, with subjects inspired by
the Provençal landscape, many of which, as has been
pointed out, were essentially pencil drawings that he
subsequently heightened with touches of color.

The watercolor reproduced here is a view of the
Château Noir (fig. a),[1] an imposing country manor on
the road running east from Aix to the village of Le
Tholonet near Montagne Sainte Victoire. From 1886,
Cézanne rented a small room at the château in which to
store his materials and occasionally spend the night.
Commissioned by a coal magnate in the second half of
the nineteenth century, the unusual Neo-Gothic
complex of buildings was never completed. The origin
of its name is unclear, as it is not really a château nor is
it black, having been built of the yellowish orange stone
that is so abundant in the region. It may, however,
allude to the owner's occupation, or to the fact that he
was reputedly an alchemist. For this reason, perhaps,
it was also known as the *château de diable*.[2] On the right
of the sheet, next to the building with the chimney,
Cézanne outlined the silhouette of Montagne Sainte-
Victoire with a few fine pencil lines.

Opinions vary regarding the dating of this drawing, as
is the case with much of Cézanne's late work. Although
Venturi dates it 1902–06,[3] it differs substantially from
the painting with the Château Noir from that period,
which has been drastically simplified and rendered in
small blocks of color (fig. b).[4] The date proposed by
Rewald, 1887–90, therefore seems more probable,
since the emphasis on draftsmanship is still a prominent
element. This sheet, incidentally, is a fine example
of Cézanne's manner of drawing; instead of pure,
unbroken lines he used hatching and dense patches of
parallel shading lines. It also highlights his characteristic
manner of juxtaposing color to reflect an almost
fragmented perception of reality. This effect is even
stronger in the paintings and watercolors that he
produced after the turn of the century, and the works
he showed at various exhibitions in the early 1900s were
later to have a formative influence on the Cubists, such
as Georges Braque (1882–1963).[5]

In 1896, Ambroise Vollard (1867–1939), who had
opened a gallery of contemporary art in Paris in 1893,
organized the first exhibition of Cézanne's work. The
show included a number of watercolors, which were
well received and won considerable acclaim from the
Impressionists. Claude Monet is known to have had a
painting of the Château Noir,[6] and once, when showing
it to a guest, he remarked, "Ah yes, Cézanne – the
greatest of us all."[7]

1. From a photograph taken in 1935 by John Rewald;
see Rewald (1983), p. 161.
2. Cf. J. Rewald, *Cézanne: a Biography*, New York 1986, p. 241.
3. This was the date Venturi was planning to give in the
revised edition of his 1936 monograph, which was left
uncompleted on his death in 1961; see Rewald (1983), pp. 10,
82, and under no. 313.
4. Private collection, Switzerland.
5. See W. Rubin, "Cézannisme and the Beginnings of
Cubism," in *Cézanne: the Late Work*, ed. W. Rubin,
New York 1977, pp. 151-202.
6. Now in the Museum of Modern Art, New York.
7. Here quoted from exhib. cat. *Cézanne: les dernières années*,
Paris, Galeries Nationales du Grand Palais, 1978, under
no. 52: "*Eh, oui, Cézanne, c'est le plus grand de nous tous.*"

AM

fig. a

fig. b

Exhibition Catalogues

Albi 1976: *Lautrec; "Elles"*, Albi, Musée d'Albi, 1976

Amsterdam 1925: *Historische tentoonstelling der Stad Amsterdam*, Amsterdam, Rijksmuseum, 1925

Amsterdam 1929: *Tentoonstelling van oude kunst door de Vereeniging van Handelaren in Oude Kunst in Nederland*, Amsterdam, Rijksmuseum, 1929

Amsterdam 1932: *Rembrandt tentoonstelling*, Amsterdam, Rijksmuseum, 1932

Amsterdam 1933: *Rubens-tentoonstelling, ten bate van de Vereeniging "Rembrandt"*, Amsterdam, Kunsthandel J. Goudstikker, 1933

Amsterdam 1934: *Italiaansche kunst in Nederlandsch bezit*, Amsterdam, Stedelijk Museum, 1934

Amsterdam 1935: *Antoine Watteau als tekenaar*, Amsterdam, Museum Willet-Holthuysen, 1935

Amsterdam 1938: *Fransche meesters uit de XIXe eeuw, teekeningen, aquarellen, pastels*, Amsterdam, Paul Cassirer, 1938

Amsterdam 1946: *Teekeningen van Fransche Meesters, 1800-1900*, Amsterdam, Stedelijk Museum, 1946

Amsterdam 1951: *Het Franse landschap van Poussin tot Cézanne*, Amsterdam, Rijksmuseum, 1951

Amsterdam 1953: *De Venetiaanse meesters*, Amsterdam, Rijksmuseum, 1953

Amsterdam 1955: *De triomf van het Maniërisme: de Europese stijl van Michelangelo tot El Greco*, Amsterdam, Rijksmuseum, 1955

Amsterdam 1969: *Rembrandt 1669/1969*, Amsterdam, Rijksmuseum, 1969

Amsterdam 1974: *Franse tekenkunst van de 18e eeuw*, Amsterdam, Rijksmuseum, Rijksprentenkabinet, 1974 (J.W. Niemeijer and P. Schatborn)

Amsterdam, Washington 1981-82: *Figure Studies*, Amsterdam, Rijksprentenkabinet; Washington, National Gallery of Art, 1981-82

Antwerp 1927: *Teekeningen en prenten van Antwerpsche meesters der XVIIe eeuw*, Antwerp, Koninklijk Kunstverbond, 1927

Antwerp 1930: *Oud-Vlaamsche Kunst*, Antwerp, World Fair, 1930

Antwerp 1949: *Van Dyck*, Antwerp, Koninklijk Museum voor Schone Kunsten, 1949 Antwerp 1956: *Tekeningen van P.P. Rubens*, Antwerp, Rubenshuis, 1956 (L. Burchard and R.-A. d'Hulst)

Antwerp, Rotterdam 1960: *Antoon van Dyck*, Antwerp, Rubenshuis; Rotterdam, Museum Boymans-van Beuningen, 1960 (R.-A. d'Hulst and H. Vey)

Antwerp, Rotterdam 1966-67: *Tekeningen van Jacob Jordaens*, Antwerp, Rubenshuis; Rotterdam, Museum Boymans-van Beuningen, 1966-67 (R.-A. d'Hulst)

Antwerp 1977: *P.P. Rubens: schilderijen-olieverfschetsen-tekeningen*, Antwerp, Koninklijk Museum voor Schone Kunsten, 1977

Antwerp 1978: *Jacob Jordaens. Tekeningen en grafiek*, Antwerp, Museum Plantin-Moretus, 1978 (R.-A. d'Hulst)

Baltimore etc. 1986-87: *Nineteenth-Century French Drawings from the Museum Boymans-van Beuningen*, Baltimore, Museum of Art; Los Angeles, County Museum of Art; Fort Worth, Kimbell Art Museum, 1986-87 (A.W.F.M. Meij and J. Poot)

Basel 1935: *Meisterzeichnungen französischer Künstler von Ingres bis Cézanne*, Basel, Kunsthalle, 1935

Basel 1953: *Goya*, Basel, Kunsthalle, 1953

Berlin 1926: *Daumier Ausstellung*, Berlin, Galerie Matthiesen, 1926

Berlin 1929-30: *Ein Jahrhundert französischer Zeichnung*, Berlin, Paul Cassirer, 1929-30

Berlin 1930: *Rembrandt-Ausstellung*, Berlin, Akademie der Künste, 1930

Berlin 1975: *Pieter Bruegel der Ältere als Zeichner. Herkunft und Nachfolge*, Berlin, Kupferstichkabinett Staatliche Museen, 1975

Berlin, Regensburg 1988: *Albrecht Altdorfer*, Berlin, Kupferstichkabinett Staatliche Museen; Regensburg, Museen der Stadt, 1988 (H. Mielke)

Berlin (East) 1983: *Kunst der Reformationszeit*, East Berlin, Staatliche Museen, 1983

Bern 1951-52: *Degas*, Bern, Kunstmuseum, 1951-52

Bern 1954: *Fragonard*, Bern, Kunstmuseum, 1954

Besançon 1956: *Fragonard: peintures et dessins*, Besançon, Musée des Beaux-Arts, 1956

Bologna 1956: *Mostra dei Carracci: disegni*, Bologna, Palazzo dell'Archiginnasio, 1956 (D. Mahon)

Bologna 1975: *Mostra di Federico Barocci (Urbino 1535-1612)*, Bologna, Museo Civico, 1975 (A. Emiliani)

Boston 1888-89: *Exhibition of Albrecht Dürer's Engravings (...) Together with Eight Original Drawings from the Collection Von Franck*, Boston, Museum of Fine Arts, 1888-89

Braunschweig 1948: *Ausstellung Holländische Zeichenkunst des 17. Jahrhunderts*, Braunschweig, Herzog Anton Ulrich-Museum, 1948

Braunschweig 1979: *Jan Lievens: ein Maler im Schatten Rembrandts*, Braunschweig, Herzog Anton Ulrich-Museum, 1979

Bremen 1977-78: *Zurück zur Natur*, Bremen, Kunsthalle, 1977-78

Brussels 1910: *Exposition d'art ancien: l'art belge au XVIIe siècle*, Brussels, Musées Royaux d'Art et d'Histoire de Belgique, 1910

Brussels 1936: *Ingres, Delacroix: dessins, pastels et aquarelles*, Brussels, Palais des Beaux-Arts, 1936

Brussels 1937-38: *De Jérôme Bosch à Rembrandt: dessins hollandais du XVIe au XVIIe siècle*, Brussels, Paleis voor Schone Kunsten, 1937-38

Brussels 1938-39: *Dessins de P.P. Rubens*, Brussels, Koninklijk Paleis voor Schone Kunsten, 1938-39

Brussels, Amsterdam 1947: *Toulouse-Lautrec*, Brussels, Palais des Beaux-Arts; Amsterdam, Stedelijk Museum, 1947

Brussels, Paris 1949: *De Van Eyck à Rubens: les maîtres flamands du dessin*, Brussels, Koninklijk Paleis voor Schone Kunsten; Paris, Bibliothèque Nationale, 1949

Brussels 1953: *P.P. Rubens: schetsen en tekeningen*, Brussels, Museum voor Oude Kunst, 1953

Brussels, Hamburg 1961: *Hollandse tekeningen uit de gouden eeuw*, Brussels, Koninklijke Bibliotheek Albert I; Hamburg, Hamburger Kunsthalle, 1961

Brussels 1963: *De eeuw van Bruegel: de schilderkunst in België in de XVIe eeuw*, Brussels, Koninklijk Museum voor Schone Kunsten, 1963

Brussels etc. 1968-69: *Landschaptekeningen van Hollandse meesters uit de XVIIe Eeuw*, Brussels, Koninklijke Bibliotheek Albert I; Rotterdam, Museum Boymans-van Beuningen; Paris, Institut Néerlandais; Bern, Kunstmuseum, 1968-69 (C. van Hasselt)

Brussels 1980: *Bruegel: een dynastie van schilders*, Brussels, Paleis voor Schone Kunsten, 1980

Brussels 1983: *Venetiaanse tekeningen uit de 18de eeuw*, Brussels, Paleis voor Schone Kunsten, 1983

Cambridge, Mass., Montreal 1988: *Landscape in Perspective: Drawings by Rembrandt and His Contemporaries*, Cambridge, Mass., Arthur M. Sackler Museum; Montreal, Museum of Fine Arts, 1988 (F.J. Duparc)

Chicago, Minneapolis, Detroit: *Rembrandt after Three Hundred 1969-70: Years: an Exhibition of Rembrandt and His Followers*, Chicago, Art Institute; Minneapolis, Institute of Arts; Detroit, Institute of Arts, 1969-70

Delft 1949: *Elzasser schoonheid*, Delft, Prinsenhof, 1949

Dijon 1950: *De Jérôme Bosch à Rembrandt: peintures et dessins du Musée Boymans de Rotterdam*, Dijon, Musée de Dijon, 1950

Dordrecht 1934: *Nicolaes Maes 1634-1934*, Dordrecht, Dordrechts Museum, 1934

Dordrecht, Amsterdam 1959-60: *Bekoring van het kleine*, Dordrecht, Dordrechts Museum; Amsterdam, Koninklijk Oudheidkundig Genootschap, 1959-60 (L.J. Bol)

Dordrecht 1982: *Johan Barthold Jongkind 1819-1891*, Dordrecht, Dordrechts Museum, 1982

Dresden 1986: *Altdeutsche Zeichnungen aus der Sammlung Franz Koenigs*, Dresden, Kupferstich-Kabinett der Staatlichen Kunstsammlungen, 1986

Düsseldorf 1929: *Ausstellung alte Meister aus Privatbesitz*, Düsseldorf, Kunstverein, 1929

Edinburgh, London 1965: *Corot*, Edinburgh, Royal Scottish Academy; London, National Gallery, 1965

Edinburgh 1979: *Degas 1879*, Edinburgh, National Gallery of Scotland, 1979 (R. Pickvance)

Essen 1954: *Werke der französischen Malerei und Graphik des 19. Jahrhunderts*, Essen, Museum Folkwang, 1954

Exeter 1946: *Works of Art from the Ford Collection*, Exeter, Exeter City Gallery, 1946

Florence 1980: *Il primato del disegno*, Florence 1980

Frankfurt 1987-88: *Eugène Delacroix*, Frankfurt, Städelsches Kunstinstitut, 1987-88

Groningen 1949: *Oude Italiaanse tekeningen*, Groningen, Kunstlievend Genootschap Pictura, 1949

Groningen, Rotterdam 1964: *18e-eeuwse Venetiaanse tekeningen*, Groningen, Pictura; Rotterdam, Museum Boymans-van Beuningen, 1964

The Hague 1930: *Verzameling Dr. C. Hofstede de Groot III. Schilderijen, teekeningen en kunstnijverheid*, The Hague, Gemeentemuseum, 1930

The Hague 1956: *Paul Cézanne*, The Hague, Gemeentemuseum, 1956

The Hague, Cambridge, Mass. 1981-82: *Jacob van Ruisdael*, The Hague, Mauritshuis; Cambridge, Mass., Fogg Art Museum, 1981-82 (S. Slive)

Haarlem 1926: *Oude kunst*, Haarlem, Frans Halsmuseum, 1926

Haarlem 1931: *Kind en kunst*, Haarlem, Frans Halsmuseum, 1931

Haarlem 1935: *Fransche Impressionisten*, Haarlem, Frans Halsmuseum, 1935

Hamburg, Cologne, Stuttgart 1958: *Französische Zeichnungen von den Anfängen bis zum Ende des 19. Jahrhunderts*, Hamburg, Kunsthalle; Cologne, Wallraf-Richartz-Museum; Stuttgart, Würtembergische Kunstverein, 1958

Hamburg 1980: *Goya: das Zeitalter der Revolutionen*, Hamburg, Kunsthalle, 1980

Hamburg 1983: *Köpfe der Lutherzeit*, Hamburg, Kunsthalle, 1983

Hartford etc. 1976-77: *Jean-Baptiste Greuze 1725-1805*, Hartford, Wadsworth Atheneum; San Francisco, The California Palace of the Legion of Honor; Dijon, Musée des Beaux-Arts, 1976-77 (E. Munhall)

Helsinki 1952-53: *P.P. Rubens: esquisses-dessins-gravures*, Helsinki, Athenaeum, 1952-53

's-Hertogenbosch, Heino, : *Herinneringen aan Italië*, Haarlem 1984: 's-Hertogenbosch, Noordbrabants Museum; Heino, Hannema-De Stuers Fundatie; Haarlem, Teylers Museum, 1984

Ingelheim am Rhein 1964: *Holländische Zeichnungen des 17. Jahrhunderts*, Ingelheim am Rhein 1964

Cologne 1939: *Französische Zeichnungen aus der Sammlung Franz Koenigs*, Cologne, Wallraf-Richartz-Museum, 1939

Cologne 1977: *Peter Paul Rubens 1577-1640. Rubens in Italien: Gemälde, lskizzen, Zeichnungen*, Cologne, Kunsthalle, 1977 (J. Müller Hofstede)

Leningrad, Moscow, Kiev 1974: *Tekeningen van Vlaamse en Hollandse meesters uit de 17e eeuw, uit Belgische en Hollandse musea en uit het Institut Néerlandais te Parijs*, Leningrad, Hermitage; Moscow, Pushkin Museum; Kiev, Museum of Western and Oriental Art, 1974

London 1835-36: *Ten Exhibitions*, London, Lawrence Gallery, 1835-36

London 1877-78: *Drawings by the Old Masters*, London, Grosvenor Gallery, 1877-78

London 1879-80: *Winter Exhibition*, London, Royal Academy of Arts, 1879-80

London 1899: *Exhibition of Works by Rembrandt*, London, Royal Academy of Arts, 1899

London 1927: *Loan Exhibition of Flemish and Belgian Art, 1300-1900*, London, Royal Academy of Arts, 1927

London 1929: *Dutch Art 1450-1900*, London, Royal Academy of Arts, 1929

London 1930: *Italian Drawings Exhibited at the Royal Academy*, London, Royal Academy, 1930

London 1932: *Exhibition of French Art 1200-1900*, London, Royal Academy of Arts, 1932

London 1946: *Paul Cézanne: Watercolours*, London, Tate Gallery, 1946

London 1950: *A Loan Exhibition of Works by Peter Paul Rubens Kt*, London, Wildenstein and Co., 1950

London, Birmingham 1951: *Eighteenth-Century Venice*, London, Whitechapel Art Gallery; Birmingham, Museum and Art Gallery, 1951

London 1953-54: *Flemish Art, 1300-1700*, London, Royal Academy of Arts, 1953-54

London 1954-55: *European Masters of the Eighteenth Century*, London, Royal Academy of Arts, 1954-55

London, Birmingham, Leeds 1962: *Old Master Drawings from the Collection of Mr. C.R. Rudolf*, London, Arts Council Gallery; Birmingham, City Museum & Art Gallery; Leeds, City Art Gallery, 1962

Maastricht 1939: *Oude kunst*, Maastricht, Stedelijk Museum, 1939

Munich 1938: *Albrecht Altdorfer und sein Kreis*, Munich, Alte Pinakothek, 1938

Munich 1957: *Rembrandt-Zeichnungen*, Munich, Staatliche Graphische Sammlung, 1957

Munich 1958: *The Age of Rococo: Art and Culture of the Eighteenth Century*, Munich, Residenzgalerie, 1958

Nuremberg 1928-I: *Albrecht Dürer*, Nuremberg, Germanisches Museum, 1928

Nuremberg 1928-II: Ibid., second edition

Nuremberg 1971: *Albrecht Dürer 1471-1971*, Nuremberg, Germanisches Nationalmuseum, 1971

Newcastle upon Tyne, London 1973: *Watercolour and Pencil Drawings by Cézanne*, Newcastle upon Tyne, Laing Art Gallery; London, Hayward Gallery, 1973

New York 1889: *Eight Original Drawings by Albrecht Dürer*, New York, C. Klackner Gallery, 1889

New York etc. 1939-40: *Masterpieces of Art*, first shown at the 1939 World Fair in New York, then at the following venues: Cleveland, Museum of Fine Arts; San Francisco, M.H. de Young Memorial Museum; Detroit, Institute of Arts; Saint Louis, Art Institute; Minneapolis, Institute of Arts; Northampton, Smith College Museum of Fine Arts; Springfield, Museum of Fine Arts; Toledo, Museum of Arts, 1939-40

New York 1963: *Cézanne Watercolours*, New York, Knoedler, 1963

New York, Boston, Chicago 1972: *Dutch Genre Drawings of the Seventeenth Century*, New York, Pierpont Morgan Library; Boston, Museum of Fine Arts; Chicago, Art Institute, 1972 (P. Schatborn)

New York, Paris 1977-78: *Rembrandt and his Century: Dutch Drawings of the Seventeenth Century from the Collection of Frits Lugt, Institut Néerlandais, Paris*, New York, Pierpont Morgan Library; Paris, Institut Néerlandais, 1977-78 (C. van Hasselt)

New York 1986: *Drawings*, New York, N.G. Stogdon, Artemis Fine Arts, 1986

Oberlin 1962: *Seventeenth Century One-Block Woodcuts: an Exhibition*, cat. in *Allen Memorial Art Museum Bulletin* XIX, 1962, Oberlin, Allen Memorial Art Museum, 1962

Ottawa 1968-69: *Jordaens*, Ottawa, National Gallery of Canada, 1968-69 (M. Jaffé) Ottawa 1980: *The Young Van Dyck*, Ottawa, National Gallery of Canada, 1980 (A. McNairn)

Paris 1901: *Daumier*, Paris, École des Beaux-Arts, 1901

Paris 1911: *Ingres*, Paris, Galerie Georges Petit, 1911

Paris 1921: *Ingres*, Paris, Chambre Syndicale de la Curiosité et des Beaux-Arts, 1921

Paris 1925: *Exposition du paysage français de Poussin à Corot*, Paris, Palais des Beaux-Arts de la Ville de Paris (Petit-Palais), 1925

Paris 1931: *Fragonard*, Paris, Galerie Seligmann, 1931

Paris 1932: *Exposition de l'œuvre de Pisanello*, Paris, Bibliothèque Nationale, 1932

Paris 1935: *De Van Eyck à Bruegel*, Paris, Musée de l'Orangerie, 1935

Paris 1935-II: *Exposition de l'art italien de Cimabue à Tiepolo*, Paris, Petit Palais, 1935

Paris 1937: *Chefs-d'œuvre de l'art français*, Paris, Palais National des Arts, 1937

Paris 1938: *Dessins et quelques peintures par C. Corot*, Paris, Galerie M. Gobin, 1938

Paris 1946: *Les Chefs-Oeuvre des collections françaises retrouvés en Allemagne*, Paris, Orangerie des Tuileries, 1946

Paris 1947: *Les Primitifs flamands*, Paris, Musée de l'Orangerie, 1947

Paris, Brussels, Rotterdam 1949-50: *Le Dessin français de Fouquet à Cézanne*, Paris, Musée du Louvre; Brussels, Paleis voor Schone Kunsten; Rotterdam, Museum Boymans, 1949-50

Paris 1950: *Le Paysage hollandais au XVIIe siècle*, Paris, Musée de l'Orangerie, 1950

Paris 1952: *Musée Boymans de Rotterdam: dessins du XVe au XIXe siècle*, Paris, Bibliothèque Nationale, 1952

Paris 1952-II: *Chefs d'Oeuvre de la collection D.G. van Beuningen*, Paris, Petit Palais, 1952

Paris, Rotterdam, Haarlem 1962: *Italiaanse tekeningen in Nederlands bezit*, Paris, Institut Néerlandais; Rotterdam, Museum Boymans-van Beuningen; Haarlem, Teylers Museum, 1962

Paris 1963: *L'Aquarelle néerlandaise au siècle dernier*, Paris, Institut Néerlandais, 1963

Paris 1963: *Centenaire d'Eugène Delacroix*, Paris, Musée du Louvre, 1963

Paris, Amsterdam 1964: *Le Dessin français dans les collections hollandaises*, Paris, Institut Néerlandais; Amsterdam, Rijksmuseum, Rijksprentenkabinet, 1964

Paris 1967-68: *Ingres*, Paris, Petit Palais, 1967-68

Paris 1970: *Saenredam, 1597-1665: peintre des églises*, Paris, Institut Néerlandais, 1970

Paris 1971: *Aquarelles de Jongkind*, Paris, Institut Néerlandais, 1971

Paris 1974: *Dessins flamands et hollandais du dix-septième siècle*, Paris, Institut Néerlandais, 1974

Paris 1979: *Goya*, Paris, Centre Culturel du Marais, 1979

Paris etc. 1979-80: *Le Siècle de Rubens et de Rembrandt: dessins flamands et hollandais du XVIIe siècle de la Pierpont Morgan Library de New York*, Paris, Institut Néerlandais; Antwerp, Museum voor Schone Kunsten; London, British Museum; New York, Pierpont Morgan Library, 1979-80 (F. Stampfle)

Paris 1982-83: *J.-B. Oudry*, Paris, Galeries Nationales du Grand Palais, 1982-83 (H.N. Opperman)

Paris, New York 1983: *Manet 1832-1883*, Paris, Galeries Nationales du Grand Palais; New York, Metropolitan Museum of Art, 1983 (F. Cachin, C.S. Moffett)

Paris 1984: *Altdorfer et le Réalisme fantastique dans l'art allemand*, Paris, Centre Culturel du Marais, 1984 (F. Anzelewsky)

Paris 1984-85: *Degas, le modelé et l'espace*, Paris, Centre Culturel du Marais, 1984-85

Paris, New York 1987-88: *Fragonard*, Paris, Galeries Nationales du Grand Palais; New York, Metropolitan Museum of Art, 1987-88 (P. Rosenberg)

Philadelphia 1971: *Giovanni Benedetto Castiglione: Master Draughtsman of the Italian Baroque*, Philadelphia, Philadelphia Museum of Art, 1971 (A. Percy)

Pordenone 1984: *Il Pordenone*, Pordenone, Chiesa di San Francesco, 1984

Prague 1966: *Tri stoleti Nizozemské kresby 1400-1700*, Prague, Narodni Galerie, 1966

Princeton 1979: *Van Dyck as Religious Artist*, Princeton, Art Museum, 1979 (J.R. Martin, G. Feigenbaum)

Rome, Milan 1959-60: *Il disegno francese da Fouquet a Toulouse-Lautrec*, Rome, Palazzo di Venezia; Milan, Palazzo Reale, 1959-60

Rome 1961: *L'Italia vista dai pittori francesi*, Rome, Pallazzo delle esposizione, 1961

Rome 1972-73: *Il paesaggio nel disegno del cinquecento europeo*, Rome, Accademia di Francia, Villa Medici, 1972-73 (F. Viatte)

Rome 1988: *Da Pisanello alla nascità dei Musei Capitolini: l'antico a Roma alla vigilia del Rinascimento*, Rome, Musei Capitolini, 1988

Rotterdam 1933-34: *Teekeningen van Ingres tot Seurat*, Rotterdam, Museum Boymans, 1933-34

Rotterdam 1934: *Nederlandsche teekeningen uit de collectie Koenigs*, Rotterdam, Museum Boymans, 1934

Rotterdam 1934-35: *Honderd oude Fransche teekeningen uit de verzameling F. Koenigs*, Rotterdam, Museum Boymans, 1934-35

Rotterdam 1935-36: *Teekeningen van Ingres, Delacroix, Géricault, Daumier uit de verzameling Koenigs*, Rotterdam, Museum Boymans, 1935-36

Rotterdam, Amsterdam 1937-38: *Schilderijen en teekeningen Pieter Jansz. Saenredam 1597-1665*, Rotterdam, Museum Boymans; Amsterdam, Museum Fodor, 1937-38

Rotterdam 1938: *Meesterwerken uit vier eeuwen*, Rotterdam, Museum Boymans, 1938

Rotterdam 1939: *Tekeningen van Petrus Paulus Rubens*, Rotterdam, Museum Boymans, 1939

Rotterdam 1948-49: *Tekeningen van Jan van Eyck tot Rubens*, Rotterdam, Museum Boymans, 1948-49

Rotterdam 1949: *Meesterwerken uit de verzameling D.G. van Beuningen*, Rotterdam, Museum Boymans, 1949

Rotterdam 1952: *Choix de dessins*, Rotterdam, Museum Boymans, 1952

Rotterdam, Amsterdam 1956: *Rembrandt tekeningen*, Rotterdam, Museum Boymans; Amsterdam, Rijksmuseum, 1956

Rotterdam 1956: *Goya*, Rotterdam, Museum Boymans, 1956

Rotterdam, Haarlem 1958: *Hendrick Goltzius als tekenaar*, Rotterdam, Museum Boymans; Haarlem, Teylers Museum, 1958

Rotterdam, Paris 1974-75: *Willem Buytewech 1591-1624*, Rotterdam, Museum Boymans-van Beuningen; Paris, Institut Néerlandais, 1974-75

Rotterdam, Washington 1985-86: *Jacques de Gheyn II als tekenaar 1565-1629*, Rotterdam, Museum Boymans-van Beuningen; Washington, National Gallery of Art, 1985-86

Rotterdam 1987: *Duitse tekeningen uit de verzameling Koenigs terug in Nederland*, Rotterdam, Museum Boymans-van Beuningen, 1987

Stockholm 1956: *Rembrandt*, Stockholm, Nationalmuseum, 1956

Stockholm 1967-68: *Henri de Toulouse-Lautrec*, Stockholm, National Museum, 1967-68

Tokyo, Kyoto 1968-69: *The Age of Rembrandt: Dutch Paintings and Drawings of the 17th Century*, Tokyo, National Museum of Western Art; Kyoto, Municipal Museum, 1968-69

Tübingen 1982: *Paul Cézanne Aquarelle*, Tübingen, Kunsthalle, 1982 (G. Adriani)

Tübingen, Berlin 1984: *Edgar Degas: Pastelle, Ölskizzen, Zeichnungen*, Tübingen, Kunsthalle; Berlin, Nationalgalerie, 1984 (G. Adriani)

Tübingen, Brussels 1986: *Ingres und Delacroix Aquarelle und Zeichnungen*, Tübingen, Kunsthalle; Brussels, Palais des Beaux-Arts, 1986

Utrecht 1961: *Catalogue raisonné van de werken van Pieter Jansz. Saenredam*, Utrecht, Centraal Museum, 1961 (P.T.A. Swillens)

Utrecht 1988: *Utrecht: een hemel op aarde*, Utrecht, Rijksmuseum Het Catharijneconvent, 1988

Vancouver 1958: *The Changing Landscape of Holland*, Vancouver, Fine Arts Gallery, University of British Columbia, 1958

Venice 1951: *Mostra del Tiepolo*, Venice, Palazzo Ducale, 1951

Venice 1955: *Giorgione e i Giorgioneschi*, Venice, Palazzo Ducale, 1955 (P. Zampetti)

Venice 1962: *Canaletto e Guardi*, Venice, Fondazione Giorgio Cini, 1962 (J. Byam Shaw, K.T. Parker)

Venice 1963: *Vittore Carpaccio*, Venice, Palazzo Ducale, 1963 (P. Zampetti)

Venice, Florence 1985: *Disegni Veneti di collezioni olandesi*, Venice, Fondazione Giorgio Cini; Florence, Istituto Universitario Olandese di Storia dell'Arte, 1985 (B. Aikema, B.W. Meijer)

Washington etc. 1952-53: *French Drawings: Masterpieces from Five Centuries*, Washington, National Gallery of Art; Cleveland, The Cleveland Museum of Art; Saint Louis, City Art Museum; Cambridge, Mass., Fogg Art Museum; New York, Metropolitan Museum of Art, 1952-53

Washington 1958-59: *Dutch Drawings of Five Centuries*, Washington, National Gallery of Art, 1958-59

Washington, Paris, Berlin: *Watteau 1684-1721*, Washington, 1984-85: National Gallery of Art; Paris, Grand Palais, Berlin, Schloss Charlottenburg, 1984-85 (M. Morgan Graselli and P. Rosenberg)

Washington, New York 1986-87: *The Age of Bruegel: Netherlandish Drawings in the Sixteenth Century*, Washington, National Gallery of Art; New York, Pierpont Morgan Library, 1986-87

Washington 1988-89: *Places of Delight: the Pastoral Landscape*, Washington, Phillips Collection and National Gallery of Art, 1988-89

Vienna 1936: *Honoré Daumier: Zeichnungen, Aquarelle, Lithographien, Kleinplastiken*, Vienna, Albertina, 1936

Vienna 1956: *Rembrandt*, Vienna, Albertina, 1956

Vienna 1964: *Claude Lorrain und die Meister der Römischen Landschaft im XVII. Jahrhundert*, Vienna, Graphische Sammlung Albertina, 1964-65 (E. Knab)

Vienna 1966: *Henri de Toulouse-Lautrec*, Vienna, Österreichisches Museum für angewandte Kunst, 1966

Winterthur 1955: *Europäische Meister 1790-1910*, Winterthur, Kunstmuseum, 1955

Zürich 1937: *Zeichnungen französischer Meister von David zu Millet*, Zürich, Kunsthaus, 1937

Zürich 1956: *Paul Cézanne*, Zürich, Kunsthaus, 1956

Literature cited in
abbreviated form

Ananoff 1961-70: A. Ananoff, *L'Oeuvre dessiné de Jean-Honoré Fragonard (1732-1806)*, 4 vols., Paris 1961-70

Anzelewsky 1980: F. Anzelewsky, *Dürer: Wirk und Wirkung*, Freiburg, Stuttgart 1980

Anzelewsky 1983: F. Anzelewsky, *Dürerstudien*, Berlin 1983

Baard 1956: H.P. Baard, *Tekeningen van Rembrandt*, Deventer 1956

Von Baldass 1937-38: L. von Baldass, "Die Zeichnung im Schaffen des Hieronymus Bosch und der Frühholländer," *Die Graphischen Künste*, N.F. II, 1937-38, pp. 18-26

Baldass 1952: L. Baldass, *Jan van Eyck*, London 1952

Bartsch: A. von Bartsch, *Le peintre-graveur*, 21 vols., Vienna 1803-21

Benesch 1928: O. Benesch, *Beschreibender Katalog der Handzeichnungen in der Graphischen Sammlung Albertina, Die Zeichnungen der niederländischen Schulen des XV. und XVI. Jahrhunderts*, Vienna 1928

Benesch 1935: O. Benesch, *Rembrandt: Werk und Forschung*, Vienna 1935

Benesch 1947: O. Benesch, *A Catalogue of Rembrandt's Selected Drawings*, Oxford, London 1947

Benesch 1954-57: O. Benesch, *The Drawings of Rembrandt*, 6 vols., London 1954-57

Benesch 1970: O. Benesch, *Collected Writings I, Rembrandt*, London 1970

Benesch 1973: O. Benesch, *The Drawings of Rembrandt*, enlarged and edited by E. Benesch, 6 vols., London, New York 1973

Berenson 1938: B. Berenson, *The Drawings of the Florentine Painters*, 3 vols., Chicago 1938

Berenson 1961: B. Berenson, *I disegni dei pittori fiorentini*, 3 vols., Milan 1961

Bernhard 1976: M. Bernhard, *Rembrandt: Handzeichnungen*, Munich 1976

Bernhard 1977: M. Bernhard, *Rubens: Handzeichnungen*, Munich 1977

Bernt 1957-58: W. Bernt, *Die Niederländischen Zeichner des 17. Jahrhunderts*, 2 vols., Munich 1957-58

Boon 1978: K.G. Boon, *Netherlandish Drawings of the Fifteenth and Sixteenth Centuries in the Rijksmuseum*, 2 vols., The Hague 1978

Boudaille 1979: G. Boudaille, *Goya*, Paris 1979

Briquet: C.M. Briquet, *Les Filigranes*, 4 vols., Paris 1907

Broos 1981: B. Broos, *Oude tekeningen in het bezit van de Gemeentemusea van Amsterdam waaronder de collectie Fodor*, vol. III: *Rembrandt en tekenaars uit zijn omgeving*, Amsterdam 1981

Burchard and d'Hulst 1963: L. Burchard and R.-A. d'Hulst, *Rubens Drawings*, Brussels 1963

Byam Shaw 1962: J. Byam Shaw, *The Drawings of Domenico Tiepolo*, London 1962

Byam Shaw 1967: J. Byam Shaw, "Notes on some Venetian Drawings," *Apollo* LXXXVI, 1967, pp. 44-49

Cat. 1852: *Catalogus van teekeningen in het Museum te Rotterdam gesticht door Mr. F.J.O. Boymans*, Rotterdam 1852

Cat. 1869: *Beschrijving der teekeningen in het Museum te Rotterdam gesticht door Mr. F.J.O. Boymans*, Rotterdam 1869

Cat. 1927: *Catalogus der Schilderijen, teekeningen en beeldhouwwerken tentoongesteld in het Museum Boymans te Rotterdam*, Rotterdam 1927

Cat. 1978: *Legaat Vitale Bloch*, Rotterdam, Museum Boymans-van Beuningen, 1978; French edition: Paris, Institut Néerlandais, 1978

Commemorative Catalogue London 1930: *Commemorative Catalogue of the Exhibition of Dutch Art in the Galleries of the Royal Academy*, London, Oxford 1930

Cuzin 1987: J.-P. Cuzin, *Jean-Honoré Fragonard: vie et œuvre*, Freiburg 1987

Degenhart 1943: B. Degenhart, *Europäische Handzeichnungen aus fünf Jahrhunderten*, Munich 1943

Degenhart and Schmitt 1968: B. Degenhart and A. Schmitt, *Corpus der italienischen Zeichnungen 1300-1450. I Süd und Mittelitalien*, 2 vols., Berlin 1968

Delen 1943: A.J.J. Delen, *Teekeningen van Vlaamsche Meesters*, Antwerp 1943

Delen 1949: A.J.J. Delen, *Flämische Meisterzeichnungen*, Basel 1949

Díaz Padrón 1975: M. Díaz Padrón, *Escuela Flamenca Siglo XVII Museo del Prado. Catálogo de Pinturas*, 2 vols., Madrid 1975

Elen 1989: A.J. Elen, *Missing Old Master Drawings from the Franz Koenigs Collection Claimed by the State of the Netherlands*, The Hague 1989

Fischer 1986: C. Fischer, *Disegni di Fra Bartolommeo e della sua scuola. Gabinetto Disegni e stampe degli Uffizi*, Florence 1986

Flechsig 1931: E. Flechsig, *Albert Dürer*, Berlin 1931

Foerster 1930: C.F. Foerster, *Meisterzeichnungen aus der Sammlung Koenigs: Französische Meister des 18. Jahrhunderts*, XIV. Veröffentlichung der Prestel-Gesellschaft, Frankfurt 1930

Fosca 1954: F. Fosca, *Les Dessins de Fragonard*, Paris, Lausanne 1954

Friedländer 1967-76: M.J. Friedländer, *Early Netherlandish Painting*, 14 vols., Leiden, Brussels 1967-76

Von der Gabelentz 1922: H. von der Gabelentz, *Fra Bartolommeo und die florentiner Renaissance*, 2 vols., Leipzig 1922

Gassier 1953: P. Gassier, "De Goya-tekeningen in het Museum Boymans," *Bulletin Museum Boymans Rotterdam* IV, 1953, pp. 13-24

Gassier and Wilson 1970: P. Gassier and J. Wilson, *Vie et œuvre de Francisco Goya*, Freiburg 1970

Gassier 1973: P. Gassier, *Les Dessins de Goya: les albums*, Freiburg 1973

Van Gelder 1933: J.G. van Gelder, *Jan van de Velde, 1593-1641, teekenaar-schilder*, The Hague 1933

Giltaij 1988: J. Giltaij, *De tekeningen van Rembrandt en zijn school in het Museum Boymans-van Beuningen*, Rotterdam 1988

Glück and Haberditzl 1928: G. Glück and F.M. Haberditzl, *Die Handzeichnungen von Peter Paul Rubens*, Berlin 1928

Glück 1933: G. Glück, *Rubens, Van Dyck und Ihr Kreis*, Vienna 1933

Goldner 1988: G.R. Goldner, *European Drawings I. Catalogue of the Collections, J. Paul Getty Museum*, Malibu 1988

Van Gool 1750-51: J. van Gool, *De Nieuwe Schouburg der Nederlantsche Kunstschilders en Schilderessen*, 2 vols., The Hague 1750-51

Grossmann 1954: F. Grossmann, "The Drawings by Pieter Brueghel the Elder in the Museum Boymans," *Bulletin Museum Boymans Rotterdam* V, 1954, pp. 41-63

Haak 1968: B. Haak, *Rembrandt: zijn leven, zijn werk, zijn tijd*, Amsterdam 1968

Haak 1976: B. Haak, *Rembrandt tekeningen*, Amsterdam 1976

Von Hadeln 1933: D. von Hadeln, *Meisterzeichnungen aus der Sammlung F. Koenigs: Venezianische Meister*, Frankfurt 1933

Hannema 1949: D. Hannema, *Catalogue of the D.G. van Beuningen Collection*, Rotterdam 1949

Haverkamp Begemann 1955: E. Haverkamp Begemann, "Aanwinsten: Drie tekeningen van Albrecht Dürer," *Bulletin Museum Boymans Rotterdam* VI, 1955, pp. 82-89

Haverkamp Begemann 1957: E. Haverkamp Begemann, *Vijf eeuwen tekenkunst*, Rotterdam 1957

Haverkamp Begemann 1959: E. Haverkamp Begemann, *Willem Buytewech*, Amsterdam 1959

Haverkamp Begemann 1967: E. Haverkamp Begemann, "Rubens in Rotterdam," *Apollo* LXXXVI, 1967, pp. 38-43

Held 1959: J.S. Held, *Rubens: Selected Drawings*, London 1959

Held 1980: J.S. Held, *The Oil Sketches of Peter Paul Rubens, a Critical Catalogue*, 2 vols. Princeton 1980

Held 1986: J.S. Held, *Rubens: Selected Drawings* (2nd edition), Oxford 1986

Hell 1930: H. Hell, "Die späten Handzeichnungen Rembrandts," *Repertorium für Kunstwissenschaft* LI, 1930, pp. 4-43, 92-136

Heller 1827-31: J. Heller, *Das Leben und die Werke Albrecht Dürers*, 3 vols., Bamberg 1827-31

Henkel 1942: M.D. Henkel, *Catalogus van de Nederlandsche teekeningen in het Rijksmuseum te Amsterdam*, vol. I: *Teekeningen van Rembrandt en zijn school*, The Hague 1942

Hind 1915-31: A.M. Hind, *Catalogue of Drawings by Dutch and Flemish Artists Preserved in the Department of Prints and Drawings in the British Museum*, 5 vols., London 1915-31

Hind 1932: A.M. Hind, *Rembrandt, Being the Substance of the Charles Eliot Norton Lectures Delivered before Harvard University 1930-1931*, London 1932

Hoetink 1968: H. Hoetink, *Franse tekeningen uit de 19e eeuw: catalogus van de verzameling in het Museum Boymans-van Beuningen*, Rotterdam 1968

Hoetink 1969: H. Hoetink, *Tekeningen van Rembrandt en zijn school: catalogus van de verzameling in het Museum Boymans-van Beuningen*, vol. I, *Afbeeldingen*, Rotterdam 1969

Hofstede de Groot 1906: C. Hofstede de Groot, *Die Handzeichnungen Rembrandts: Versuch eines beschreibenden und kritischen Katalogs*, Haarlem 1906

Hollstein, *Dutch and Flemish*: F.W.H. Hollstein's *Dutch and Flemish Etchings, Engravings and Woodcuts, ca. 1450-1700*, Amsterdam 1949-

Hollstein, *German*: F.W.H. Hollstein's *German Engravings, Etchings and Woodcuts ca. 1400-1700*, Amsterdam 1954-

Houbraken 1718-21: A. Houbraken, *De Groote Schouburgh der Nederlantsche Konstschilders en schilderessen*, 3 vols., Amsterdam 1718-21

Hütt 1970: W. Hütt, *Albrecht Dürer 1471-1528*, Munich 1970

Jaffé 1962: M. Jaffé, "Italian Drawings from Dutch Collections," *Burlington Magazine* CIV, 1962, pp. 231-38

Jost 1960: I. Jost, *Studien zu Anthonis Blocklandt, mit einem vorläufigen beschreibenden Oeuvre-Verzeichnis*, diss. Cologne 1960

Judson 1970: R.J. Judson, *Dirck Barendsz. 1534-1592*, Amsterdam 1970

Juynboll 1938: W.R. Juynboll, "Le grandi collezioni, III, La raccolta Franz Koenigs," *Emporium Rivista d'Arte e di Cultura* XLIV, no. 87, 1938, pp. 17-28

Kirschbaum 1968-76: E. Kirschbaum, *Lexikon der Christlichen Ikonographie*, 8 vols., Rome etc. 1968-76

Kleinmann 1894-99: H. Kleinmann, *Handzeichnungen Alter Meister der holländischen Malerschule*, 6 vols., Haarlem 1894-99

Knab 1956: E. Knab, "Der heutige Bestand an Zeichnungen Claude Lorrains im Boymans Museum," *Bulletin Museum Boymans Rotterdam* VII, 1956, pp. 103-40

Knapp 1903: F. Knapp, *Fra Bartolommeo della Porta und die Schule von San Marco*, Halle 1903

Kuznetsov 1974: Y. Kuznetsov, *Risunki Rubensa*, Moscow 1974

Larsen 1988: E. Larsen, *The Paintings of Anthonie van Dyck*, 2 vols., Freren 1988

Lebeer 1969: L. Lebeer, *Catalogue raisonné des estampes de Pierre Brueghel l'ancien*, Brussels 1969

Lees 1913: F. Lees, *The Art of the Great Masters, as Exemplified by Drawings in the Collection of Emile Wauters*, London 1913

Leymarie, Monnier and Rose 1979: J. Leymarie, G. Monnier and B. Rose, *Drawing: History of an Art*, Geneva, London 1979

Lippmann and Hofstede de Groot 1888-1911: F. Lippmann and C. Hofstede de Groot, *Original Drawings by Rembrandt*, 4 vols., Berlin, The Hague 1888-1911

L.: F. Lugt, *Les Marques de collections de dessins & d'estampes*, Amsterdam 1921; *Supplément*, The Hague 1956

Lugt 1933: F. Lugt, *Musée du Louvre. Inventaire général des dessins des écoles du Nord: École hollandaise*, vol. III, Paris 1933

Van Mander 1604: K. van Mander, *Het schilder-boeck*, Haarlem 1604

Marchese 1879: V. Marchese, *Memorie dei più insigni pittori, scultori e architetti Domenicani*, 2 vols., Bologna 1879

Mariuz 1971: A. Mariuz, *Giandomenico Tiepolo*, Venice 1971

Marijnissen 1969: R.H.M. Marijnissen, *Bruegel*, Brussels 1969

Marijnissen et al. 1988: R.H.M. Marijnissen, P. Ruyffelaere, P. van Calster and A.W.F.M. Meij, *Bruegel: het volledige œuvre*, Antwerp 1988

Menzel 1966: G.W. Menzel, *Pieter Bruegel der Altere*, Leipzig 1966

Meij 1974: A.W.F.M. Meij, *German Drawings 1400-1700: Catalogue of the Collection in the Boymans-van Beuningen Museum*, Rotterdam 1974

Michel 1893: E. Michel, *Rembrandt, sa vie, son œuvre et son temps*, Paris 1893

Mitsch 1977: E. Mitsch, *Die Rubenszeichnungen der Albertina*, Vienna 1977

Mongan 1962: A. Mongan, *Great Drawings of All Time: French Thirteenth Century to 1919*, selected and edited by I. Moskowitz, vol. III, New York 1962

Müller Hofstede 1966: J. Müller Hofstede, "Review L. Burchard and R.-A. d'Hulst, *Rubens Drawings*," *Master Drawings* IV, 1966, pp. 435-54

Münz 1961: L. Münz, *Bruegel: the Complete Drawings*, London 1961

Musper 1952: H.T. Musper, *Albrecht Dürer*, Stuttgart 1952

Oldenbourg 1921: R. Oldenbourg, *P.P. Rubens: des Meisters Gemälde*, Stuttgart, Berlin 1921

Ottino 1968: A. Ottino della Chiesa, *L'opera completa di Dürer*, Milan 1968

Panofsky 1945: E. Panofsky, *Albrecht Dürer*, 2 vols., Princeton 1945

Panofsky 1953: E. Panofsky, *Early Netherlandish Painting: Its Origins and Character*, 2 vols., Cambridge, Mass., 1953

Parker 1931: K.T. Parker, *The Drawings of Antoine Watteau*, London 1931

Parker and Mathey 1957: K.T. Parker and J. Mathey, *Antoine Watteau: catalogue complèt de son œuvre dessiné*, Paris 1957

Piccard 1961: G. Piccard, *Die Kronenwasserzeichen*, Stuttgart 1961

Pignatti 1981: T. Pignatti, *Il Disegno da Altamira a Picasso*, Milan 1981

Popham 1931: A.E. Popham, *Italian Drawings Exhibited at the Royal Academy, Burlington House (1930)*, London 1931

Posner 1984: D. Posner, *Antoine Watteau*, Ithaca, N.Y., 1984

Réau 1956: L. Réau, *Fragonard*, Brussels 1956

Reznicek 1961: E.K.J. Reznicek, *Die Zeichnungen von Hendrick Goltzius*, 2 vols., Utrecht 1961

Von Ritgen 1865: H. von Ritgen, *Fünfzig Photographien nach Handzeichnungen aus der Sammlung des Grossherzogs Karl Alexander von Sachsen*, Weimar 1865

Roberts 1977: K. Roberts, *Rubens*, Oxford 1977

Roethlisberger 1968: M. Roethlisberger, *Claude Lorrain: the Drawings*, Berkeley, Los Angeles 1968

Roland Michel 1987: M. Roland Michel, *Le Dessin français au XVIIIe siècle*, Freiburg 1987

Rupprich 1956-69: H. Rupprich, *Dürer: schriftlicher Nachlass*, 3 vols., Berlin 1956-69

Schapelhouman 1987: M. Schapelhouman, *Nederlandse tekeningen omstreeks 1600: catalogus van de Nederlandse tekeningen in het Rijksprentenkabinet, Rijksmuseum, Amsterdam*, The Hague 1987

Schapelhouman and: M. Schapelhouman and P. Schatborn, Schatborn 1987: *Land & Water: Hollandse tekeningen uit de 17de eeuw in het Rijksprentenkabinet*, Zwolle, Amsterdam 1987

Schatborn 1985: P. Schatborn, *Tekeningen van Rembrandt, zijn onbekende leerlingen en navolgers: catalogus van de Nederlandse tekeningen in het Rijksprentenkabinet, Rijksmuseum, Amsterdam*, The Hague 1985

Schmidt-Degener 1911: F. Schmidt-Degener, "Notes on Some Fifteenth-Century Silverpoints," *Burlington Magazine* XIX, 1911, pp. 255-61

Schnackenburg 1981: B. Schnackenburg, *Adriaen van Ostade, Isack van Ostade: Zeichnungen und Aquarelle, Gesamtdarstellung mit Werkkatalogen*, 2 vols., Hamburg 1981

Schwartz 1984: G. Schwartz, *Rembrandt, zijn leven, zijn schilderijen*, Maarssen 1984

Slive 1965: S. Slive, *Drawings of Rembrandt*, 2 vols., New York 1965

Sonkes 1969: M. Sonkes, *Dessins du XVe siècle: groupe Van der Weyden* (Les Primitifs flamands III, contributions à l'étude des primitifs flamands 5), Brussels 1969

Strauss 1974: W.L. Strauss, *The Complete Drawings of Albrecht Dürer*, 6 vols., New York 1974

Sumowski 1979-85: W. Sumowski, *Drawings of the Rembrandt School*, 9 vols., New York 1979-85

Thieme-Becker: U. Thieme and F. Becker, *Allgemeines Lexikon der bildenden Künstler von der Antike bis zur Gegenwart*, Leipzig 1907-50

Tietze 1928: H. Tietze and E. Tietze-Conrat, *Kritisches Verzeichnis der Werke Albrecht Dürers*, vol. I, Augsburg 1928

Tietze 1937, 1938: H. Tietze and E. Tietze-Conrat, *Kritisches Verzeichnis der Werke Albrecht Dürers*, 2 vols., Basel, Leipzig 1937-38

Tietze, 1944: H. Tietze and E. Tietze-Conrat, *The Drawings of the Venetian Painters in the 15th and 16th Centuries*, New York 1944

Tolnay 1939: C. de Tolnay, *Le Maître de Flémalle et les Frères van Eyck*, Brussels 1939

Tolnay 1943: C. de Tolnay, *History and Technique of Old Master Drawings*, New York 1943

Tolnay 1952: C. de Tolnay, *The Drawings of Pieter Bruegel the Elder*, London 1952

Tijs 1983: R.J. Tijs, *P.P. Rubens en J. Jordaens: barok in eigen huis*, Antwerp 1983

Valentiner 1925, 1934: W.R. Valentiner, *Rembrandt: des Meisters Handzeichnungen*, Stuttgart, Berlin, Leipzig, vol. I (1925), vol. II (1934)

Vasari 1878-85: G. Vasari, *Le vite de' piu eccellenti pittori, scultori ed architettori scritte da Giorgio Vasari pittore Aretino*, con nuove annotazioni e commenti di G. Milanesi, 9 vols., Florence 1878-85

Vey 1956: H. Vey, "De tekeningen van Anthonie van Dyck in het Museum Boymans," *Bulletin Museum Boymans Rotterdam* VII, 1956, pp. 45-55, 82-91

Vey 1962: H. Vey, *Die Zeichnungen Anton van Dycks*, Antwerp 1962

Vigni 1959: G. Vigni, "Tekeningen van Giambattista, Domenico en Lorenzo Tiepolo in Nederlandse verzamelingen," *Bulletin Museum Boymans-van Beuningen Rotterdam* X, 1959, pp. 46-68

Vlieghe 1973: H. Vlieghe, *Saints* (Corpus Rubenianium Ludwig Burchard VIII, 2), Brussels, London, New York 1973

Vlieghe 1987: H. Vlieghe, *Rubens: Portraits of identified Sitters painted in Antwerp* (Corpus Rubenianum Ludwig Burchard XIX) London, New York 1987

Voorn 1960: H. Voorn, *De papiermolens in de provincie Noord-Holland*, Haarlem 1960

Wegner 1973: W. Wegner, *Die Niederländischen Handzeichnungen des 15.-18. Jahrhunderts: Kataloge der Staatlichen Graphischen Sammlung, Munich*, 2 vols., Berlin 1973

Wethey 1987: H.E. Wethey, *Titian and His Drawings, with Reference to Giorgione and Some Close Contemporaries*, Princeton 1987

Winkler 1936-39: F. Winkler, *Die Handzeichnungen Albrecht Dürers*, 4 vols., Berlin 1936-39

Winkler 1957: F. Winkler, *Albrecht Dürer*, Berlin 1957

Von Wurzbach 1906-11: A. von Wurzbach, *Niederländisches Künstler-Lexikon*, 3 vols., Vienna, Leipzig 1906-11

Von Zahn 1870: A. von Zahn, "Die Handzeichnungen des Fra Bartolommeo ins Besitz der Frau Grossherzogin Sophie von Sachsen-Weimar," *Jahrbücher für Kunstwissenschaft* III, 1870, pp. 174-201

Zolotov et al. 1986: Y.K. Zolotov, I.S. Nemilova, I. Kouznetsova, T.D. Kamenskaya and V.A. Alexeyeva, *Antoine Watteau: Gemälde und Zeichnungen in Sowjettischen Museen*, Düsseldorf, Leningrad 1986

Index of Artists